# HISTORY OF
# MODERN ART

*Painting • Sculpture • Architecture*

# HISTORY OF MOD

# H. H. ARNASON

*Vice President, Art Administration, The Solomon R. Guggenheim Foundation*

# ERN ART

## PAINTING · SCULPTURE · ARCHITECTURE

Prentice-Hall, Inc., Englewood Cliffs, N. J.

and Harry N. Abrams, Inc., New York

*For Elinor*

MILTON S. FOX, *Editor-in-Chief*     PHILIP GRUSHKIN, *Designer*

*Library of Congress Catalog Card Number: 68-26863*
*Printed and bound in Japan*

# CONTENTS

# PREFACE AND ACKNOWLEDGMENTS

The arts of painting, sculpture, and architecture are arts of space. For this reason it is essential to approach these arts in the twentieth century, or in any other period, through an analysis of the artist's attitude toward spatial organization. Since space is normally defined as extension in all directions, this attitude can be seen relatively easily in architecture and sculpture, which traditionally are three-dimensional masses or volumes surrounded by space and, in the case of architecture, enclosing space. Architecture is frequently defined as "the art of enclosing space," a definition which gives primary importance to the interior space, despite the fact that many architectural styles throughout history have been largely concerned with the appearance of the exterior, or the organization of outdoor space.

The classic and romantic eclecticism of the nineteenth-century academic styles in architecture added nothing new to the history of architectural spatial experiment. The development of reinforced concrete and structural steel, however, provided the basis for a series of new experiments in twentieth-century architecture. The most significant product of steel construction is, of course, the skyscraper, which in its characteristic spatial development is perhaps more interesting as an exterior form than as an interior space (if one excepts the new interior space effects resultant from the all-glass sheathing). It is in the flexible material of reinforced concrete that many of the most impressive twentieth-century architectural-spatial experiments have been realized, as well as in the use of new structural principles such as those embodied in Buckminster Fuller's geodesic domes.

Until the twentieth century a work of sculpture hàs characteristically been a three-dimensional object existing in surrounding space. The formal problems of the sculptor have thus involved the exploitation of his material (bronze, clay, stone, etc.), the integration of the sculptural elements with their environment, and the relation of these elements to surrounding space. In the various broad cycles of sculptural history—ancient, medieval, Renaissance, Baroque—the development of sculpture has tended to follow a pattern in which the early stages emphasized frontality and mass, and the later stages, openness and spatial existence.

In the twentieth century, sculpture has continued in one way or another most of the sculptural-spatial tendencies of the past. Modern experimental sculptors have also made fundamental new departures, particularly in the exploration of sculpture as construction or as assemblage; in experimentation with new materials; and in sculpture as enclosing space. Partly as a result of influence from primitive or archaic art, there has also been a contrasting abandonment of the developed systems of full spatial organization in favor of a return to frontality achieved through simplified masses.

It is probably more difficult for the spectator to comprehend the element of space in painting than in either architecture or sculpture. A painting is physically a two-dimensional surface to which pigments, usually without appreciable bulk, have been applied. Except insofar as the painter may have applied his paint thickly, in impasto, the painting traditionally has no projecting mass, and any suggestion of depth on the surface of the canvas is an illusion created through various technical means. The instant a painter draws a line on the blank surface he introduces an illusion of the third dimension. This illusion of depth may be furthered by overlapping or spacing of color shapes, by the different visual impacts of colors—red, yellow, blue, black or white—by different intensities or values, and by many other devices known throughout history. The most important of these, before the twentieth century, were linear and atmospheric perspective (discussed in Part One).

Perspective, although known in antiquity, became for the Renaissance a means for creating paintings that were "imitations of nature"—visual illusions that made the spectator think he was looking at a man, a still life, or a landscape rather than at a canvas covered with paint. Perhaps the greatest revolution of early modern art lay in the abandonment of this attitude and the perspective technique that made it possible. As a consequence, the painting—and the sculpture—became a reality in itself, not an imitation of anything else; it had its own laws and its own reason for existence. As will be seen, after the initial experiments carried out by the impressionists, post-impressionists, fauves, and cubists, there has been no logical progression. The call for a "return to nature" recurs continually, but there is no question that the efforts of the pioneers of modern art changed modern artists' way of seeing, and in some degree, modern man's.

The principal emphasis of this book revolves around this problem of "seeing" modern art. It is recognized that this involves two not necessarily compatible elements: the visual and the verbal. Any work of art history and/or criticism is inevitably an attempt to translate a visual into a verbal experience. Since the mind is involved in both experiences, there are some points of contact between them. Nevertheless, the two experiences are essentially different and it must always be recognized that the words

of the interpreter are at best only an approximation of the visual work of art. The thesis of this book, insofar as it has a thesis, is that in the study of art the only primary evidence is the work of art itself. Everything that has been said about it, even by the artist himself, may be important, but it remains secondary evidence. Everything that we can learn about the environment that produced it—historically, socially, culturally—is important, but again is only secondary or tertiary evidence. It is for this reason that an effort has been made to reproduce most of the works discussed. For the same reason a large part of the text is concerned with a close analysis of these works of art—and with detailed descriptions of them as well. This has been done in the conviction that simple description has an effect in forcing the attention of the spectator on the painting, sculpture, or building itself. If, after studying the object, he disagrees with the commentator, all the better. In the process he has learned something about visual perception.

This book is intended for the general reader and the student of modern art. As the title suggests, the emphasis is on the development of modern painting, sculpture, and architecture, although there is reference to the graphic arts—drawing and printmaking—and to the arts of design, when these are of significance in the work of an artist or of a period. The book deals predominantly with twentieth-century art, but attention has been paid to the nineteenth-century origins of modern painting. Whereas modern sculpture and architecture saw their beginnings at the end of the nineteenth century with a small number of pioneers, such as Auguste Rodin in sculpture and Louis Sullivan in architecture, the sources of modern painting must be traced much further back in the century.

A discussion of some changes in attitudes toward pictorial space around 1800 is followed by an account of Gustave Courbet's approaches to reality, both in subject and in materials—paint and picture surface. With Edouard Manet and the impressionists the account becomes more explicit in the examination of individual artists, their works, and the movements with which they were associated. It is, nevertheless, still necessarily selective, since only the major figures of impressionism, post-impressionism, and neo-impressionism can be discussed in any depth. Although there were many other excellent impressionist and post-impressionist painters, and some of these are mentioned, the main emphasis is on the artists of greatest stature. Another feature of the book should be mentioned at this point: every effort has been made to place the black-and-white illustrations as close as possible to the accompanying text. The colorplates are grouped with the chapters they illustrate.

Emphasis is placed on these matters of physical makeup because they are obviously important to any student, and because the approach used makes them important in a very particular sense. The main body of the book deals with the twentieth century, for the earlier part of which—up to 1940—the works and the attitudes of the pioneers of modernism are examined at length. In discussing their works, the approach is primarily the close examination of the works as aesthetic objects in which problems of space, color, line, and the total organization of the surface are studied. Iconography—the meaning of and attitude toward subject matter—significant in many phases of modern art such as expressionism, surrealism, and pop art, is given appropriate attention. Also, it is recognized that a work of art or architecture cannot exist in a vacuum. It is the product of a total environment—a social and cultural system—with parallels in literature, music, and the other arts, and relations to the philosophy and science of the period. Aside from being a broad, analytical survey of modern art and architecture, the book is conceived as a dictionary in which much factual information is included. This is particularly true of the latter part, art since 1945. As we approach our own time it is possible to discuss at length only a minority of the talented artists who are creating the art and architecture of the future. Thus, the accounts of these, with a few exceptions, are summary and factual, intended to suggest the main directions of contemporary art and architecture rather than to pretend completeness.

Since this is a history of international modern art and architecture, the criterion for inclusion has been art and architecture which have in some way had international implications. In the late nineteenth and earlier twentieth centuries the emphasis is largely on French, German, and Italian developments. In architecture, further accent is placed on English and American experiments, since these did have some international impact. Other national movements—De Stijl in Holland, suprematism and constructivism in Russia—are also discussed in detail for the same reasons. However, painting and sculpture in the United States and in England before World War II are discussed only briefly, since, despite the presence of many talented artists in these countries, they cannot be said to have affected the international stream of modern art until mid-century. For the same reason, abstract expressionism in the United States in the 1940s and 1950s, as well as British and American pop art, are treated at some length, as a consequence of their world-wide dispersion.

My primary acknowledgment is to Charles Rufus Morey (1875–1955), even though he might not have approved of the subject matter. I am indebted to Robert Goldwater for reading the manuscript and correcting numerous errors of fact. Needless to say he is in no sense responsible for opinions expressed by the author.

At the Solomon R. Guggenheim Museum, my thanks are due to: Anna Golfinopoulos, my research assistant, who achieved miracles of efficient organization under extreme pressure. Also to Susan Earl, research assistant during the first stages of the book; Joan Hall, librarian; Robert Mates and Paul Katz, photographers; Darrie Hammer, and Ward Jackson—all for aid beyond the call of duty.

At Harry N. Abrams, Inc., my thanks are due to: Milton S. Fox, editor-in-chief, whose sympathetic suffering has been a continuous comfort, as his sensitivity, perception, and humor have been continuous delights; and to Philip Grushkin, who designed this book and to Dirk Luykx, his assistant. Also to Sam Cauman, who read the manuscript; Barbara Adler; Mary Lea Bandy, Mr. Fox's assistant; and to all the other members of the Abrams firm who worked so hard on this project.

A particular note of appreciation goes to all the collec-

tors, museums, art galleries, and other institutions who so kindly granted permission to reproduce works of art and provided photographs or color transparencies.

In this context it will be obvious that I have drawn heavily on the resources of a few museums and collectors: first, the Museum of Modern Art, New York; then other New York museums such as the Solomon R. Guggenheim Museum, and the Whitney Museum of American Art. For sculpture, the greatest single source is the collection of Joseph H. Hirshhorn, which is to become a national museum of modern art in Washington, D.C. The reasons I have used these collections so intensively are: 1) They are among the greatest collections of modern art in existence. Taken together (and with the modern and American collections of the Metropolitan Museum of Art) they constitute the most comprehensive collections of modern painting and sculpture to be found in any one city. 2) I am most intimately familiar with the paintings and sculpture in these museums. 3) For the student who may wish to secure slides or additional research material, these institutions have extensive facilities. Again, my thanks to all who have helped me so generously.

H.H.A.

Unless otherwise noted, all paintings are oil on canvas. Measurements are not given for objects that are inherently large (architecture, architectural sculpture, wall painting), or small (drawings or prints). Height precedes width. A probable measuring error of more than one per cent is indicated by "c." A list of credits for the black-and-white illustrations appears at the end of the book.

# PAINTING IN THE NINETEENTH CENTURY

## The Prehistory of Modern Painting

Various dates are used to mark the point at which modern art supposedly began. The most commonly chosen, perhaps, is 1863, the year of the Salon des Refusés in Paris, where Edouard Manet first showed his *Déjeuner sur l'herbe* (fig. 11). But other and even earlier dates sometimes do service: 1855, the year of the Exposition, in which Courbet built a separate pavilion to exhibit *The Painter's Studio* (fig. 1); 1824, when the English landscapists John Constable, J. M. W. Turner, and Richard Parkes Bonington exhibited their brilliant, direct-color studies from nature at the Paris Salon; or even 1784, when J.-L. David finished his *Oath of the Horatii* (fig. 2) and the neo-classic movement began to assume a position of dominance in Europe and the United States.

Each of these dates has significance for the development of modern art, but none categorically marks a completely new beginning. For what happened was not that a new outlook suddenly appeared; it was that a gradual metamorphosis took place in the course of a hundred years. It embodied a number of separate developments: shifts in patterns of patronage, in the role of the French Academy, in the system of art instruction, in the artist's position in society and, especially, in the artist's attitude toward artistic means and issues—toward subject matter, expression, and literary content, toward color, drawing, and the problem of the nature and purpose of a work of art.

Pictorial space is the first matter to be considered. Neoclassicism has at times been called an eclectic and derivative style that perpetuated the classicism of Renaissance and Baroque art, a classicism that might otherwise have expired. Yet in neoclassic art a fundamental Renaissance tradition was seriously opposed for the first time—the use of perspective recession to govern the organization of pictorial space. Indeed, it may be argued that David's work was crucial in shaping the attitudes that led, ultimately, to twentieth-century abstract art. David and his followers did not actually abandon the tradition of a pictorial structure based on linear and atmospheric perspective. They were fully wedded to their idea that a painting was an adaptation of classical relief sculpture; they subordinated atmospheric effects, emphasized linear contours, arranged their figures as a frieze across the picture plane, and accentuated that plane by closing off pictorial depth by using such devices as a solid wall, a back area of neutral color, or an impenetrable shadow. The result, as seen in *The Oath of the Horatii* and even more clearly in *The Death of Socrates* (fig. 3), is an effect of figures composed along a narrow stage behind a proscenium; these exist in space more by the illusion of sculptural modeling than by their location within a pictorial space that has been constructed according to the principles of linear and atmospheric perspective.

Perspective space, the method of representing depth against which David was reacting, had governed European art for the preceding four hundred years. Its basis was single-point perspective, perfected in the early fifteenth century and the logical outcome of the naturalism of fourteenth-century art: a single viewpoint was assumed, and all lines at right angles to the visual plane were made to converge toward a single point on the horizon, the vanishing point. These mathematical-optical principles were discovered by Filippo Brunelleschi before 1420; they were applied by Masaccio in his fresco *The Holy Trinity* in 1425, and written down by Leone Battista Alberti about 1435. Fifteenth-century artists used perspective to produce the illusion of organized depth by the converging lines of roof beams and checkered floors, to establish a scale for the size of figures in architectural space, and to give to objects a diminishing size as they recede from the eye. Elaborations were developed by shifting the viewpoint to right or left along the horizon line, or above or below it; atmospheric perspective added to the illusion of depth by diminishing the contrast of color and of light-and-dark values in the distance. By these means, painters attained control over naturalistic representation of man and his environment.

In the sixteenth century the Renaissance conception of space reached a second major climax in such works as Raphael's *School of Athens* (fig. 4), in which the nobility of the theme is established by the grandeur of the architectural space. In the seventeenth century, in the hands of great decorators such as Pietro da Cortona (see fig. 5), perspective painting became an expressive instrument that was blended with architecture and sculpture in the creation of gigantic symphonies of space organization. Every illusionistic trick of perspective and foreshortening learned in two centuries of experimentation was resorted to. The opening up of illusionistic space continued to the end of the eighteenth century, notably with the deep-perspective Venetian scenes by Canaletto and Guardi, and the ceiling decorations of Giovanni Battista

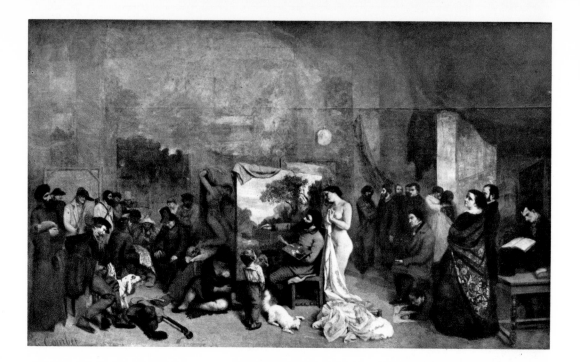

1. GUSTAVE COURBET.
*The Painter's Studio (Atelier).*
1854–55. 11' 10" x 19' 7".
The Louvre, Paris

Tiepolo (fig. 6). Only with the rise of neo-classicism at the end of the eighteenth century was there a halt in representing the expansion of space, a desire to limit it severely.

David's followers in the first half of the nineteenth century, whether his actual disciples or members of such related splinter groups as the barbus or primitives in France, or the nazarenes in Germany, increasingly laid emphasis on an art of ideal subject matter rendered in abstract line. Both neo-classicism and romanticism were flights from the immediate world, to a reality evoked from impressions of the Orient, Africa, or the South Seas; or, to a fictional world derived from the art and literature of classical antiquity, the Middle Ages, and the Renaissance. The differences between the two schools lay partly in the particular subjects selected, the classicists

obviously leaning to antiquity and the romantics to the Middle Ages or the exotic East. Even this distinction was blurred as the century wore on: for Ingres, the classicist, made rather a specialty of Oriental odalisques, and Delacroix, the romantic, at various times turned to Greek mythology. The approach to subject matter is even more similar. David's Horatii emotionalize in a romantic manner closer to the stage tradition of Racine than to that of classical Greek sculpture. Delacroix's *Michelangelo*, brooding in his studio, has a close spiritual affinity to David's *Brutus* mourning the death of his sons.

The clearest distinction between classicism and romanticism in the nineteenth century may be seen, perhaps, in the approaches to plastic form and techniques of applying paint. The neo-classicists continued the Renaissance tradition of glaze painting to attain an effect of uniform surface, whereas the romantics revived the textured surface of Rubens, Rembrandt, and the Rococo. Neo-classicism in painting established the principle of balanced frontality to a degree that transcended even the High Renaissance or the classical Baroque of Poussin. Romanticism reverted to the formula of asymmetry, diagonal recession in depth, and indefinite, atmospheric-coloristic effects more appropriate to the expression of the inner imagination.

The chronological sequence of neo-classicism, romanticism, and realism is, of course, only a convenient stratification of movements or tendencies so inextricably bound up with one another and with preceding movements that it is impossible to tell where one ended and another began. All three had renewed roots in the remote past, from antiquity to the Baroque, as well as continuity with the immediate past of the eighteenth century—that compound of sentimental naturalism and decorative-coloristic expression drenched by a tidal wave of archaeological classicism. Romanticism and realism emerged without appreciable interruption from Rousseau's notion of the "noble savage," Chardin's description of bourgeois life, and Greuze's exaltation of peasant

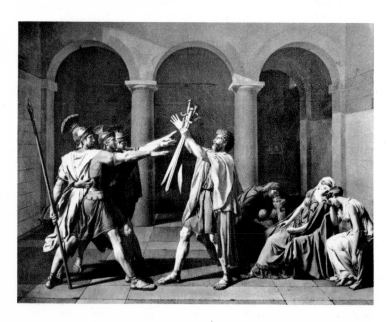

2. JACQUES-LOUIS DAVID. *The Oath of the Horatii.* 1784.
10' 10" x 14'. The Louvre, Paris

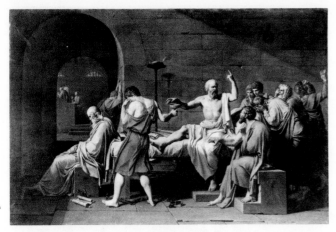

3. JACQUES-LOUIS DAVID. *The Death of Socrates*. 1787.
51 x 77¼″. The Metropolitan Museum of Art,
New York. Wolfe Fund, 1931

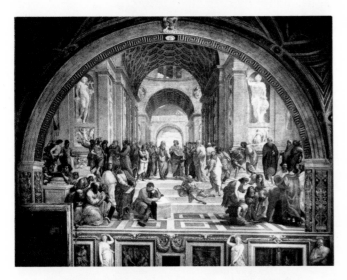

4. RAPHAEL. *School of Athens*. 1510–11. Fresco.
Stanza della Segnatura, Vatican Palace, Rome

virtues. David's late "neo-classic" portraits are masterpieces of specific realistic observation. Courbet's "realistic" self-portraits are very early instances of the modern formula of the artist as the romantic individual, the genius touched with divine madness.

Gustave Courbet exhibits the three-way conflict of past, present, and future more clearly than any other artist of his time. Today secure in his place as the father of modern realism, he alternated all of his life among pedantic classicism, an erotic academicism that anticipated Bouguereau, and an atmospheric-romantic interpretation of the artist's world. Almost incidentally, he also produced more telling, unsentimentalized records of contemporary life than any other artist since the seventeenth century. And, most notably in a number of his key landscape studies, he made highly explicit statements of the realities that were to dominate so much of twentieth-century painting: the reality of the picture plane, the reality of the material with which he painted—oil paint itself. It is questionable whether Courbet ever realized that in his paintings he was mounting a revolution far greater than the political revolution that caused him to flee from France in 1873.

*Funeral at Ornans* (fig. 7) is of significance in the history of modern painting for its restatement of neo-classic delimitation of illusionistic depth and its reiteration of the picture plane. In his assertion of the paint textures the artist drew on and amplified the intervening experiments of the romantics, although with a different end in view. Whereas the romantics used broken paint surfaces to emphasize the intangible elements of the spirit, Courbet used them as analogies of the most tangible aspects of ordinary, everyday life, commonplace but nevertheless profound in the statement of the realities of life and sorrow and death. The *Funeral* documents the artist's realization that his concern would be the reality of the world as he himself experienced it. Even more significant, it is one of the first documents of the artist's understanding that a painting is in itself a reality—a two-dimensional world of stretched canvas defined by the nature and textural consistency of oil paint—and that the artist's function is to define this world. The work established Courbet's position not only as a founder of modern realism but also as a pioneer experimenter in the kind of abstract design generally considered to be the antithesis of realism.

In a group of landscapes of the 1850s and 1860s, *The Source of the Loue* (fig. 8) among them, Courbet experimented with a form of extreme closeup of rocks

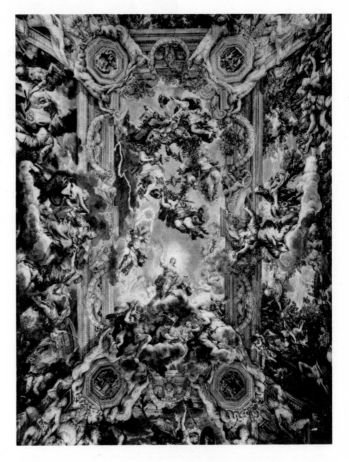

5. PIETRO DA CORTONA. *Glorification of Urban VIII's Reign*.
Ceiling of the Gran Salone. 1633–39. Fresco.
Barberini Palace, Rome

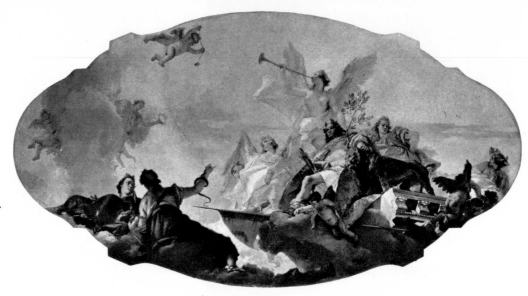

6. GIOVANNI BATTISTA TIEPOLO.
*The Glorification of Francesco Barbaro.*
Ceiling decoration for the
Barbaro Palace, Venice. c. 1745–50.
8′ x 15′ 4″. The Metropolitan Museum
of Art, New York.
Anonymous gift, in memory
of Oliver H. Payne, 1923

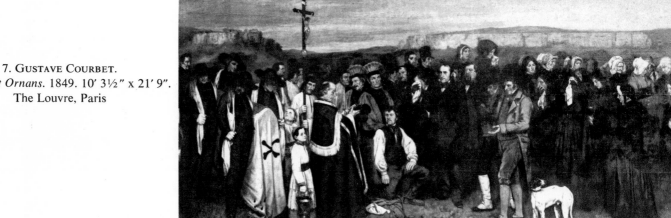

7. GUSTAVE COURBET.
*Funeral at Ornans.* 1849. 10′ 3½″ x 21′ 9″.
The Louvre, Paris

abruptly cut off at the edges of the painting to create the effect of a photographic detail. Such paintings may owe something to the emerging art of photography, both in their fragmentary impression and in their frequently subdued, sometimes almost monochromatic color. Analogies may be seen in photographs of the time, for example, some of Louis J. M. Daguerre's intimate studio views and Fox Talbot's architectural details. In the 1850s photographers came under the influence of the academic painting of the salons, and photographic landscapes began to look like romantic paintings of the Barbizon school. The rock landscapes of Courbet, however, combined a sense of observed reality with an even greater sense of the elements and materials with which the artist was working: the rectangle of the picture plane and the massed texture of the oil paint, which asserted its own nature at the same time that it was simulating the rough-hewn, sculptural appearance of exposed rocks.

Courbet, in his later career, experimented with as many different approaches to the subjects of landscape,

portrait, still life, or figure as there were tides of fashion. Nevertheless, his fascination with a type of realism in which precise observation of nature is combined with the aggressive, expressive statement of the pictorial means continued, and was climaxed in a group of seascapes of the late 1860s. In *The Waves* (fig. 9), he appears deliberately to have selected an unrelieved expanse of open sea in order to demonstrate his ability to translate this subject into a primarily two-dimensional organization in which the third dimension is realized as the relief texture of the projecting oil paint.

Courbet's contribution to painting is revealed when such landscapes as *The Source of the Loue* and *The Waves* are compared with a landscape by John Constable, *The Hay Wain* (colorplate 1). The appearance of paintings by Constable and Turner (see colorplate 2) at the Paris Salon of 1824 had a profound influence on the French romantics and particularly on the Barbizon school of landscapists. Constable's textural statement of brush gesture was well adapted to romantic narrative

and landscape, out of which Courbet's painting emerged. The radiant color used by both the Englishmen was a revelation. Its sun-filled naturalism, however, although it may have affected the course of French impressionist painting, was premature for the French realists and romantics. With the exception of Delacroix, they continued to prefer the more subdued color harmonies and the less vivid light of the studio when painting the out of doors. The paint texture of Constable's *Hay Wain* is direct and unconcealed to a degree rarely observed in painting before his time; but his landscapes are still seen with the eyes of the Renaissance-Baroque tradition. Space opens up into depth, and paint is converted into fluffy, distant clouds, richly leaved trees, and reflecting pools of water. Not only does Courbet's assertion of a unified picture plane and of paint texture contribute to the abstract quality of *The Waves*, but so does even its unified, subdued color palette.

## Impressionism

### EDOUARD MANET *(1823–1883)*

Manet's *Déjeuner sur l'herbe* (fig. 11), rejected by the Salon of 1863, created a major scandal when it was exhibited in the Salon des Refusés. Although the subject was based on such respectable academic precedents as Giorgione's *Pastoral Concert* (fig. 10) and a detail from an engraving by Marcantonio Raimondi of *The Judgment of Paris* (fig. 12) after a lost cartoon by Raphael, popular indignation arose because the classic, pastoral subject had been translated into contemporary terms. Raphael's goddesses and Giorgione's nymphs had become models, one naked, one partially disrobed, relaxing in the woods with a couple of respectably dressed but "obviously" dissolute bohemian artists. At this level, Manet's departure seems to have been made in terms of the realist conviction that the artist had to paint the world of his own experience, the world as he saw it. Venus or Danaë or even the romantics' odalisque had to become a seated nude or woman bathing.

To the more sophisticated, although not necessarily for that reason the more perceptive critics of the time, the manner of painting was an even greater affront than the subject. Manet, only thirty-one years of age, had already experimented with a broadly brushed, impressionist technique in such works as *Concert in the Tuileries* (fig. 13). The figures in *Concert*—elegant ladies in voluminous beige gowns, with bonnets that are accents of blue or red, gentlemen in black coats and top hats and light gray trousers—create across the surface a pattern of color shapes that is structurally controlled and defined by the mass of the foliage and the architectural accents of the tree trunks. The *Déjeuner* places the figures in the same sort of sealed forest setting, although the center is opened up to a limited depth, and the bending woman in the middle distance acts as the apex of the classical triangle of which the three foreground figures serve as the base and sides. In his abandonment of Courbet's impasto, Manet had moved a step further toward the asser-

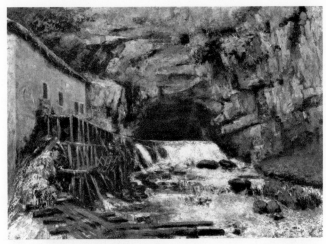

8. GUSTAVE COURBET. *The Source of the Loue.* c. 1862. 23⅜ x 28¾". The Metropolitan Museum of Art, New York. The H. O. Havemeyer Collection. Bequest of Mrs. H. O. Havemeyer, 1929

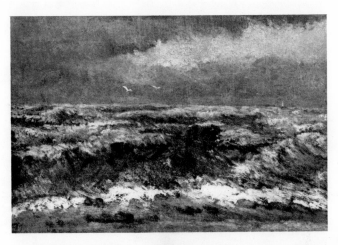

9. GUSTAVE COURBET. *The Waves.* c. 1870. 12¾ x 19". The Philadelphia Museum of Art. The Louis E. Stern Collection

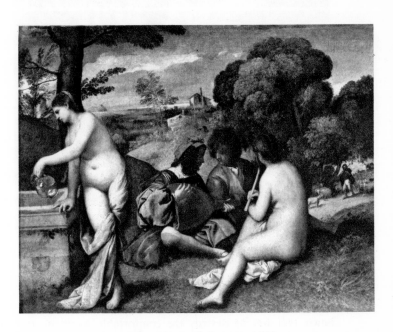

10. GIORGIONE. *Pastoral Concert.* 1510. 43¼ x 54¼". The Louvre, Paris

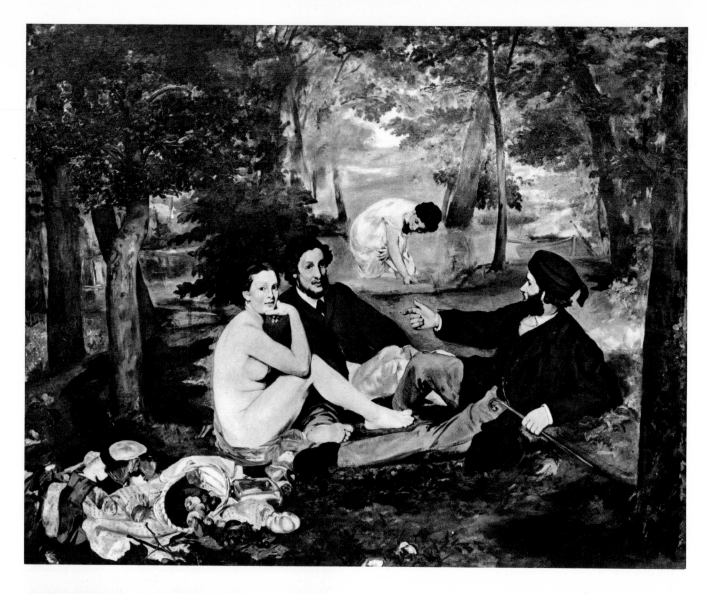

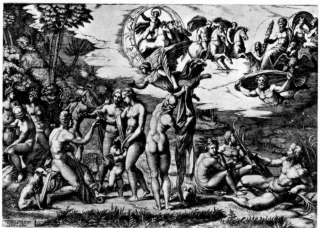

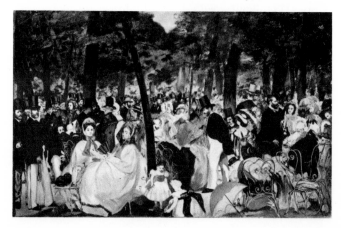

*above:* 11. EDOUARD MANET. *Le Dejeuner sur l'herbe.*
1863. 7′ x 8′ 10″. The Louvre, Paris

*left:* 12. MARCANTONIO RAIMONDI, after RAPHAEL.
*The Judgment of Paris.* c. 1520. Engraving.
The Metropolitan Museum of Art, New York.
Rogers Fund, 1919

*below:* 13. EDOUARD MANET. *Concert in the Tuileries.*
1862. 30 x 46½″. The National Gallery, London

tion of a painting as a two-dimensional surface that the
artist had the duty of reiterating in all elements of the
work. This conception as well as the sketchiness of tech-
nique infuriated the professional critics, almost as
though they sensed in this work the prophecy of a revo-
lution that was to destroy the comfortable world of se-
cure values of which they felt themselves to be the
guardians.

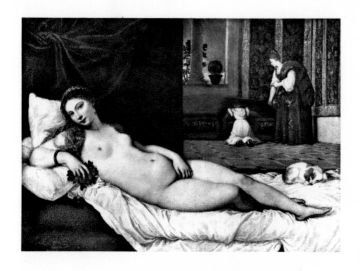

Manet's *Olympia* (fig. 16), painted in 1863 and exhibited in the Salon of 1865, created an even greater furor than the *Déjeuner*. Here, again, the artist's source was exemplary: Titian's *Venus of Urbino* (fig. 14), itself stemming from Giorgione's *Sleeping Venus* (fig. 15). The *Olympia,* however, was a slap in the face to all the complacent academicians who regularly presented their exercises in scarcely disguised eroticism as virtuous homage to the gods and goddesses of classical antiquity. Venus reclining has become simply a reclining nude—"obviously" of somewhat doubtful morals—who stares out at the spectator with an impassive boldness that bridges

*above:* 14. TITIAN. *Venus of Urbino.* c. 1538.
47¼ x 65″. Uffizi Gallery, Florence

*right:* 15. GIORGIONE. *Sleeping Venus.* c. 1508–10.
42½ x 68⅞″. Staatliche Kunstsammlungen, Dresden

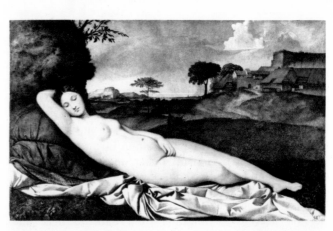

*below:* 16. EDOUARD MANET. *Olympia.* 1863.
51 x 74¾″. The Louvre, Paris

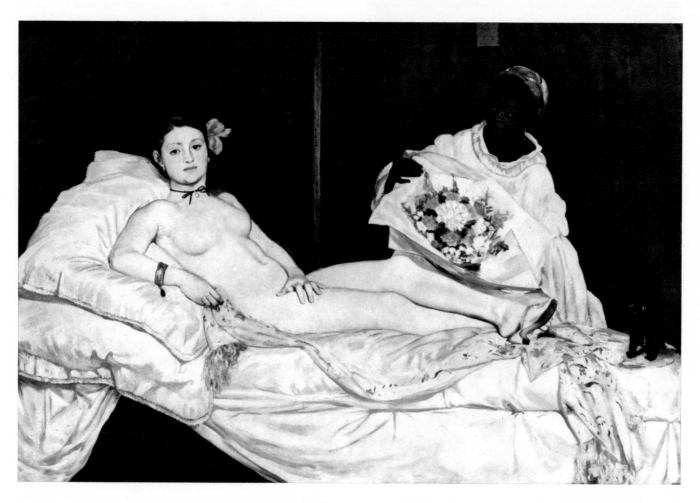

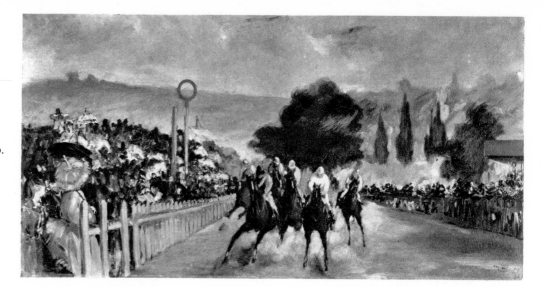

17. EDOUARD MANET.
*The Races at Longchamp, Paris.* 1872.
17 x 33½". The Art Institute of Chicago.
Potter Palmer Collection

the gap between the real and the painted world in a startling manner and effectively destroys any illusion of sentimental idealism in the presentation of the nude figure. The *Olympia* is a brilliant design in black and white, with the nude figure silhouetted against a dark wall enriched by the red underpainting that creates a Rembrandtesque glow of color in shadow. The Negro maidservant acts as a transition from dark to light and provides a classical balance to the inclined torso of the nude. The volume of the figure is created entirely through its contours—again, the light-and-dark pattern and the strong linear emphasis annoyed the critics as much as the shocking subject matter.

Manet's trip to Spain in 1865 and his exposure to Velázquez and particularly to Goya encouraged him in his development of impressionistic brush painting in which precision of detail is subordinated to an all-over effect of unified color and movement. Particularly evident in his smaller landscape sketches during the later 1860s, the approach began to penetrate his larger portraits and figure pieces by the early 1870s. In a series of paintings of *The Races at Longchamp* (fig. 17), there is apparent not only a successful attempt to render the thundering gallop of the racing horses and the excitement of the crowds as rapidly sketched, abstract color spots, but also a rendering of the scene in light blues and greens in a way that might be labeled impressionist.

This manner of landscape sketching, viewed as a sacrilege by most of the contemporary critics, affected the young painters who were later called impressionists. Before 1870 Manet's sketches alternated with more precise and formal figure pieces in which background and subsidiary details continued to be brushed in summary strokes. The *Portrait of Emile Zola* (fig. 18) has a rigid, rectangular division that suggests Mondrian to the twentieth-century spectator. This work, again, is a pattern of blacks and whites meticulously arranged on the frontal plane. Only the melange of books and writing materials on the desk suggests a continuing attention to specific detail stemming from the realistic tradition. The painting is important in a variety of ways. The intimacy

of the scene, the artist's or writer's studio with all the paraphernalia of his trade, together with the fact that what is presented is a corner, a fragment of an interior abruptly cut off at the edges, suggests the path that was to lead to both the iconography and the structure of cubism and twentieth-century abstraction.

This informal genre portrait not only continues the realists' attack on the academic concept of the grand and noble subject but, in addition, carries the attack several steps further in its emphasis on the plastic means. Manet painted into the work what are obviously credos of his own in addition to those of the writer who had so brilliantly defended him. The bulletin board at the right holds a small print of the *Olympia*, behind which is a reproduction of Velázquez' *Bacchus*. Beside the *Olympia* is a Japanese print, and behind Zola's figure is seen part of a Japanese screen. The Japanese print and screen are symptomatic of the growing enthusiasm for Oriental and specifically Japanese art then spreading among the artists of France and other parts of Europe. This enthusiasm resulted from the fact that in the art of the Orient experimental French painters found formal qualities that, consciously or unconsciously, they were seeking in their own work. The attraction of this art for Manet is evident in every aspect of the *Portrait of Zola*. Henri Fouquier denounced the painting in *Le National*, declaring: "The accessories are not in perspective, and the trousers are not made of cloth." The stupid phrase contained a remarkable truth: the trousers were not made of cloth; they were made of paint.

By 1870 Manet had turned his attention to out-of-doors painting in which he sought to apply his brush-sketch technique to larger figure compositions and to render these in full color that caught all the lightness and brilliance of natural sunlight. He had been in touch with the impressionists Monet, Renoir, Pissarro, Bazille, and Sisley, and had been their spiritual leader since the exhibition of *Déjeuner sur l'herbe* in 1863. Monet had been inspired to attempt his own *Déjeuner sur l'herbe* (fig. 19), in which the sun-saturated group of figures inaugurated the out of doors painting that, then in turn,

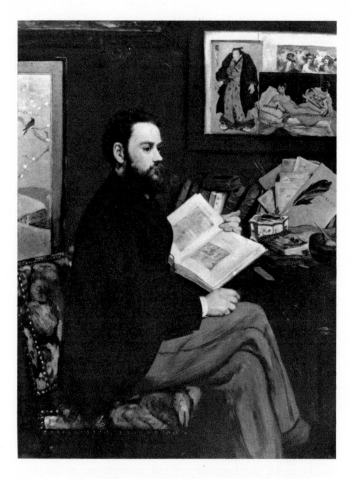

18. EDOUARD MANET. *Portrait of Emile Zola.* 1868. 57⅛ x 44⅞″. The Louvre, Paris

influenced Manet and inspired a flood of impressionist paintings.

A great part of the struggle of nineteenth-century experimental painters was an attempt to recapture the color and light of nature that had been submerged in the studio gloom of academic tonal formulas. The color of the neo-classicists had been defined in local areas but modified with large passages of neutral shadows to create effects of sculptural modeling. The color of Delacroix and the romantics flashed forth passages of brilliant blues or vermilions from an atmospheric ground. As Corot and the Barbizon school of landscape painters sought to approximate more closely the effects of the natural scene with its natural light, they were almost inevitably bent in the direction of the subdued light of the interior of the forest, of dawn, and of twilight. Color, in their hands, thus became more naturalistic, although they did choose to work with those effects of nature most closely approximating the tradition of studio light. One of the few landscapists of the mid-century who worked away from the forest in full sunlight was Eugène Boudin, who painted the sea and shore around Le Havre with a direct, on-the-spot brilliance that fascinated both Courbet and the poet Charles Baudelaire. It inspired Claude Monet and, through Monet, the movement of impressionism.

Impressionism in French painting, and its expansion throughout the world, has long been thought of as an ultimate refinement of realism. The more the realist artists of the mid-nineteenth century attempted to reproduce the world as they saw it, the more they realized that reality rested not so much in the simple objective nature of the natural phenomena—in mountains or trees or

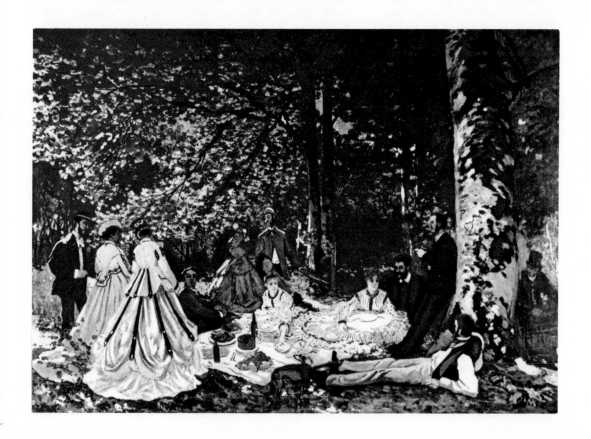

19. CLAUDE MONET. *Le Dejeuner sur l'herbe.* 1866. 48⅞ x 71¼″. Pushkin Museum, Moscow

human beings or pots of flowers—as in the eye of the spectator. Landscape and its sea, sky, trees, and mountains in actuality could never be static and fixed. It was a continuously changing panorama of light and shadow, of moving clouds and reflections on the water. Observed in the morning, at noon, and at twilight, the same scene was actually three different realities—or, if the time or spectators were varied, a hundred different realities. Further, as painters moved from the studio out of doors they came to realize that nature, even in its dark shadows, was not composed of black or muddy browns. The colors of nature were blues, greens, yellows, and whites, accented with notes of red and orange.

In the sense that the artists were attempting to represent specific aspects of the observed world more precisely than any artists before them, impressionism can be labeled as a kind of super realism, a specialized view of the world in terms of intense observation as well as of new discoveries in the science of optics. This view of impressionism, however, is only partial, and puts an undue emphasis on what is perhaps its least important aspect. In this sense it could be regarded as the end of a great tradition of realistic painting extending from antiquity through the eighteenth century and gradually narrowing its focus in the landscapists and genre painters of the mid-nineteenth. But impressionism was much more than this. Behind the landscapes of Monet and the figure studies of Renoir lay not only the social realism of Courbet and the romantic realism of Corot and Daubigny but the more significant sense of abstract structure that had appeared with David and Ingres and developed into a new aesthetic with Courbet and Manet.

With the emergence of impressionism begins one of the peculiar problems of modern art: the battle of labels. This development probably had to do with the expansion of art history and art criticism as separate disciplines during the later nineteenth and the early twentieth centuries. Labels had been attached to individual movements and periods throughout the history of art, but in general these were so broad that they simply indicated the characteristics of a century or an extremely large category—classical, medieval, Renaissance, Baroque, Rococo. In the earlier nineteenth century, in accordance with the eclectic and revivalist nature of the age, labeling accelerated and proliferated. Neo-classicism was followed by romanticism and then by realism, and each of these categories had subcategories not only in terms of its own divisions, but also in terms of the almost imperceptible transition from one category to another. Thus was born the hyphenated category—classic-romanticism, romantic-realism, etc.—which has increasingly haunted the art of the twentieth century. Anyone who writes about modern art must inevitably employ the labels that have proliferated during the last fifty years, if only because they have now entered the language and become an essential vocabulary for the verbalization of the visual. In doing so, however, it is necessary always to keep in mind the fact that these labels or categories are merely convenient tags whose dictionary definitions may be quite irrelevant to the actual style or movement being discussed. Normally the tag has been attached to the efforts of some group of artists after the fact, frequently by hostile critics, as a term of denigration or opprobrium. With familiarity, the labels have become neutral, but they are still dangerous in the sense that there is always a tendency to attempt to define them too closely, to fit the artists neatly into the category rather than to recall that artists are individual creative beings whose importance lies in their uniqueness, their concrete individuality, not in the abstract classification applied to them.

## CLAUDE MONET (1840–1926)

The term "impressionism" was the achievement of Louis Leroy, the unfriendly critic for *Le Charivari*, who found this apt epithet for the "outrageous" experiments submitted to an exhibition at the gallery of the great photographer Nadar in the title of one of Claude Monet's paintings. The painting (colorplate 3) is a romantic harmony of sky and water, an example of the type of atmospheric dissolution later developed further by Whistler in his Nocturnes (see fig. 20). It is a thin veil of light blue shot through with the rose-pink of the rising sun. Reflections on the water are suggested by short, broken brush strokes, but the painting as a whole has nothing of the quality of optical, scientific color analysis that critics and historians were soon to attach to the movement. The original impressionists— Monet, Auguste Renoir, Alfred Sisley, and also, for a time, Paul Cézanne and Pissarro—were less interested in scientific theories of light and color than in the simple but overwhelming experience of the natural world seen directly in all the splendor of full sunlight or in the cool and magical mystery of dawn or twilight. Not until later did the neo-impressionists—Georges Seurat, Paul Signac, and, for a time, Camille Pissarro—become fascinated with some of the new discoveries in scientific color perception. *Impression: Sunrise,* for Monet, was an attempt to capture the ephemeral aspects of a changing moment, more so, perhaps, than any of his paintings until the late Venetian scenes or *Water Lilies* (fig. 21). *The Bridge at Argenteuil* (colorplate 4) might be considered a more typical or even a more classic version of developed impressionism: it glistens and vibrates and gives the effect of brilliant, hot sunlight shimmering on the water. The water itself is rendered in hundreds of small brush strokes of yellow, orange, and green shot through with reflections of blue and red. Even the deepest shadows are rendered in positive color. Nevertheless, there is no uniform pattern of brush stroke to define the surface: the trees are rendered as a fluffy and relatively homogeneous mass; the foreground blue of the water and the blue of the sky are painted quite smoothly and evenly; the boats and the bridge are drawn in with firm, linear, architectural strokes. In other words, Monet here demonstrates an attention to the different aspects of the scene in many respects comparable to that in the early paintings of Camille Corot (see fig. 22) or Charles-François Daubigny. The differences, however, which are quite apparent, represent revolutionary changes. The complete avoidance of blacks and dark browns and the assertion of modulated hues in every part of the picture introduce a new world of light-and-color sensation. And even though distinctions are made among the textures of

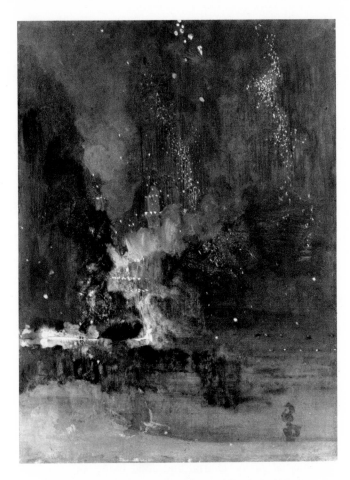

20. JAMES WHISTLER. *Nocturne in Black and Gold:*
*The Falling Rocket.* c. 1874. 23¾ x 18⅜″.
The Detroit Institute of Arts. Gift of Dexter M. Ferry, Jr.

patterns of clouds moving across the sky. This is the world as we actually see it: not a fixed, absolute perspective illusion in the eye of a frozen spectator within the limited frame of the picture window, but a thousand different glimpses of a constantly changing scene caught by a constantly moving eye. Such a scene represents a reaction not only against the stability but also against the sobriety of past landscape. Not even Watteau, Turner, or Constable ever painted such a world of sunlight and coloristic gaiety.

More significant still, impressionism also marks the moment at which a group of artists began, half-unconsciously, to assert the identity of a painting as a thing, a created object in its own right, with its own

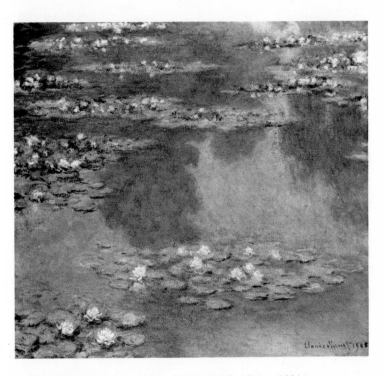

21. CLAUDE MONET. *Water Lilies.* 1905. 35¼ x 39¾″.
Museum of Fine Arts, Boston. Gift of Edward Jackson Holmes

various elements of the landscape—sky, water, trees, architecture—all elements are united in their common statement as paint. The assertion of the actual physical texture of the paint itself, heavily brushed or laid on with the palette knife, derives from the broken paint of the romantics, the heavily modeled impasto of Courbet, and the brush gestures of Manet. But now it has become an overriding concern with this group of young impressionists. The point has been reached at which the painting ceases to be solely or even primarily an imitation of the elements of nature. The experiments in limited picture-space organization pursued in other ways by Courbet and Manet have now been carried further. In *The Bridge at Argenteuil* Monet arranges all his elements in a careful grid. He closes the background in with the horizontal mass of trees and the architecture of the bridge. The staccato color strokes that make up most of the water have themselves the effect of limiting and defining depth and expressing recession as areas of color parallel to the picture plane.

In this work, then, impressionism can be seen as an ultimate refinement of optical realism, a statement of visual reality not simply as the persistent surface appearance of natural objects but as a never-ending metamorphosis of sunlight and shadow, reflections on water, and

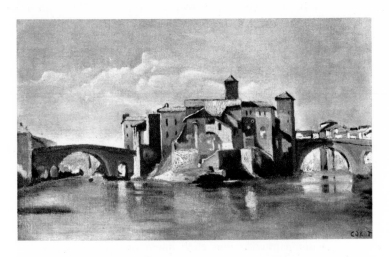

22. CAMILLE COROT. *The Island of San Bartolommeo, Rome.*
c. 1827. 10½ x 17″. Museum of Fine Arts, Boston

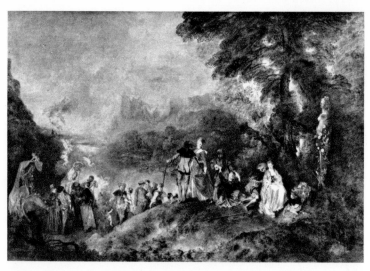

23. ANTOINE WATTEAU. *A Pilgrimage to Cythera.*
1717. 51 x 76½". The Louvre, Paris

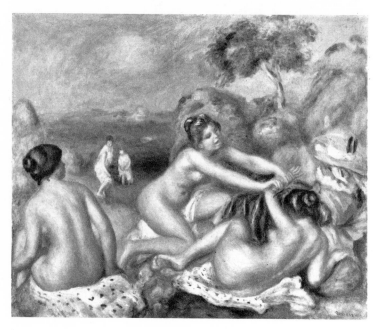

24. AUGUSTE RENOIR. *Three Bathers.* c. 1897. 21½ x 25⅞".
The Cleveland Museum of Art. Purchase, J. H. Wade Fund

structure and its own laws beyond and different from any property it might have as illusion or as imitation of the world of man and nature. It may thus at one and the same time be regarded as the end of the Renaissance tradition of illusionistic realism and the major beginning of twentieth-century exploration of expressive color, cubism, and abstraction.

## AUGUSTE RENOIR *(1841–1919)*

The artists associated with the impressionist movement were a group of diverse individuals, all united by common interest, but each intent on the exploration of his own separate path. Auguste Renoir was essentially a figure painter and one of the great colorists of all time.

He applied the principles of impressionism in the creation of a lovely dreamworld, a new Isle of Cythera (see fig. 23) transported to the Paris of the late nineteenth century. The *Moulin de la Galette* (colorplate 5), painted in 1876, epitomizes his most impressionist moment, but it is an ethereal fairyland in contemporary dress. Baudelaire had preached the doctrine of a heroic realist or romantic painting of the actual world in which the artist lived, with heroes in top hats or boaters and heroines in crinolines and bustles. This was the world that Manet created, though with a certain humorlessness, in *Le Déjeuner sur l'herbe,* where gods and nymphs are transported to the Bois de Boulogne. His efforts, insofar as subject matter was concerned, were only partially successful, but Renoir's succeeded superbly. In the *Moulin de la Galette* the commonplace scene of an outdoor bohemian dance hall is transformed into a color-and-light-filled dream of fair women and gallant men. The lights flicker and sway over the color shapes of the figures—blue, rose, and yellow—and details are blurred in a romantic haze that softens and enhances the beauty of all the delightful people. This painting and his many other comparable paintings of the period are so saturated with the sheer joy of a carefree life that it is difficult to recall the privations that Renoir, like Monet, was suffering during these years.

The art of the impressionists was largely urban. Even the landscapes of Monet had the character of a Sunday in the country or a brief summer vacation. But this urban art commemorated a pattern of life in which the qualities of gaiety, charm, and good living were extolled in a manner equaled only by certain aspects of the eighteenth century. Now, however, the good life was no longer the prerogative of a limited aristocracy; even the most poverty-stricken artist could participate in it. This was, of course, another form of romanticism, since the moments of carefree relaxation were relatively rare and spaced by long intervals of hard work and privation for those artists who, unlike Cézanne or Degas, were not blessed with private incomes. It is the peculiar nature of impressionism that most of its proponents seem to have been able to escape from the dreary realities of everyday life into a wonderful arcadia. Renoir's dreamworld was principally that of beautiful women; and there have been few artists in history who have extolled the sensual delight of women in a comparable manner. *Nude in the Sunlight* (colorplate 6), also painted in 1876, is a vision of luscious sensuousness emerging from a forest of brilliant, free brush strokes of abstract color. By blurring the details of the figure as though she were seen, sundappled, in the light and shadow of the forest, the artist integrates figure and background into a harmony of color. But by no stretch of the imagination could this painting be analyzed solely in abstract plastic terms.

Many historians of modern art criticize impressionism for having become too ephemeral, too transitory, and declare that Renoir (in his later years), Cézanne, and the neo-impressionists reacted against these weaknesses. Like many other clichés of art history, this contention has a certain amount of truth in it—but only a certain amount. Certainly Monet and Renoir in the 1870s painted many sketches or impressions that were color

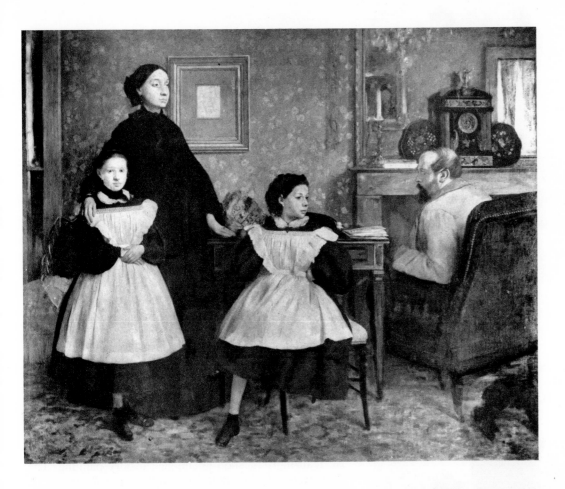

harmonies uncontrolled by precise drawing or modeling of the figure. In the same period, however, the period of impressionism at its height, they and Pissarro and Sisley painted works in which the sense of structure dominates and controls the dispersed and fragmented color. It is curious that sympathetic critics of impressionism should continue to confuse pictorial or plastic structure with the structure of the academic tradition based on Renaissance drawing, in which sculpturally modeled figures are set in clearly defined three-dimensional space. Even some leaders of the great revolution—Courbet, Manet, and Renoir—seem to have been drawn back guiltily at periodic intervals to the tradition of Ingres or Raphael or classical sculpture. Renoir, in 1881, went to Italy with the conviction that he had reached the end of impressionism and had to recapture the sculptural solidity of the Renaissance and the linear clarity of Ingres. The result, seen in *Three Bathers* (fig. 24), is a brilliant but strange pastiche of sculpturally modeled figures silhouetted in front of a delicately coloristic impressionist landscape. Out of this excursion into the academic past, however, there emerged the monumental figure compositions of Renoir's later years, in which the figures are securely anchored in the enveloping color frame of the landscape.

## EDGAR DEGAS *(1834–1917)*

When we think of the revolution in French painting of the later nineteenth century, we sometimes forget the fact that many of the experimental artists involved were

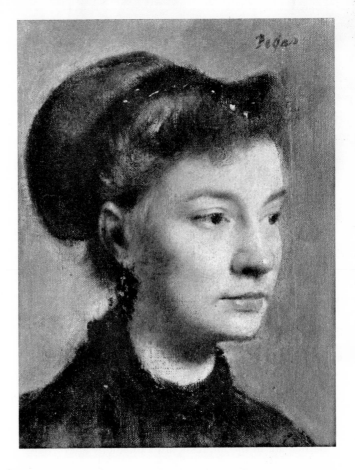

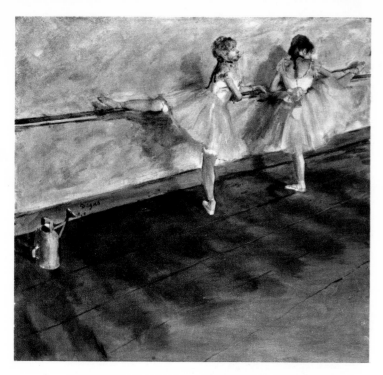

27. EDGAR DEGAS. *Dancers Practicing at the Bar*. 1877.
29¾ x 32″. The Metropolitan Museum of Art, New York.
The H. O. Havemeyer Collection.
Bequest of Mrs. H. O. Havemeyer, 1929

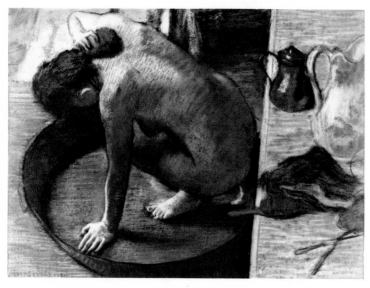

28. EDGAR DEGAS. *The Tub*. 1886. Pastel on cardboard,
23⅝ x 32⅝″. The Louvre, Paris

reluctant revolutionaries. The only road to success during most of the century was still the official Salon; and realists, impressionists, and post-impressionists, almost without exception, would have been delighted by recognition in the biennial exhibitions. Courbet, in the midst of all his realist explorations, regularly turned out, to the best of his abilities, what must be called Salon paintings, frequently successful in their primary objective of being accepted in the Salon. Manet, a member of the upper middle class with an eye for the class structure, declined to participate in the impressionist exhibitions after 1874,

which were organized outside the Salon as protests against the bigotry of the Salon juries. Although he was conscious of his position as an inspiration for the younger impressionists, although he was personally friendly with most of them, and although after 1870 he modified his own palette in the light of their discoveries, Manet nevertheless preferred to stand somewhat apart and to continue to seek his own recognition within the academic system. His only problem was that it was impossible for him to compromise his own painting in order to achieve such recognition. Monet, Renoir, and the other impressionists submitted regularly to the Salon, initially with some small success, until increasingly regular rejection drove them to the expedient of organizing their own exhibitions.

Edgar Degas represented an even more curious conflict of attitudes than did Manet. Of a family with some pretensions to aristocracy, he thought of himself as a draftsman in the tradition of Ingres. Nevertheless, he seems to have had little interest in exhibiting at the Salon after the 1860s or in selling his works. On the contrary, he took an active part in the impressionist exhibitions between 1874 and 1886, in which he showed his paintings regularly. Although associated with the impressionists, Degas did not share their enthusiasm for the world of the out of doors.

Degas' early attempts in the grand manner of classical academicism, such as *Spartan Boys and Girls Exercising*, 1860, were relatively wooden and mannered, and the artist, realizing this, soon abandoned history painting. The great works of the 1860s, *The Bellelli Family* (fig. 25), for example, were the portraits—strange psychological interactions of grouped individuals—deriving from Manet's black-and-white patterns but also suggestive of the Italian Mannerist portraits of the sixteenth century. The Italian Renaissance, seen through Ingres, haunts the portraits, which are beautifully drawn but with edges blurred to create a sense of atmospheric existence, as in the classically modeled head illustrated in fig. 26.

The race-horse scenes of the late 1860s and early 1870s involved Degas with out-of-doors subjects—which he painted in his studio—and lightened his palette, but only in about the same degree as Boudin's. To draw horses and people remained his primary interest, and his drawing style continued to be more precise than that of Manet's comparable race-track subjects. When Degas became really interested in light and color-light organization, an interest that arose from his enthusiasm for the world of the theater, the concert hall, and the ballet, it was in terms of dramatic indoor effects. Theater and ballet gave him unparalleled opportunities for the exercise of his brilliant draftsmanship (see fig. 27) and for the exploration of a kind of arbitrary, artificial, dramatic, and romantic light, which served as a means of divorcing the scene from actuality and finding an essentially abstract organization in the motions of ballet dancers. The importance of Degas, perhaps above the impressionists, lies in his sense of abstract form and color. He was a student of Japanese prints and was strongly influenced by their patterns. He was also an accomplished photographer and was one of the first painters able to use photography as a means for developing a fresh and original vision of the

world: *A Ballet Seen from an Opera Box* (colorplate 7) is a photographic fragment translated into a coloristic pattern.

This ballet scene, like many others created by Degas during the 1880s and 1890s, is presented from above, with the woman in the loge acting as the observer who also becomes a part of what is observed. The dancers in blue in the background are abruptly decapitated and the bowing ballerina in the foreground is seen in a truncated version, from the knees up. The movement from dense but colored shadow in the foreground figure, first to the illumination of the middle ground and then to the diminishing light intensity of the dancers in the background, creates a further sense of strangeness that takes the scene out of real time and place.

After the mid-1870s Degas increasingly turned to pastel or combinations of pastel and gouache for his ballet scenes, for he realized that his concern was with arbitrary rather than naturalistic color, and that in the medium of pastel he could best achieve the nondescriptive effects he sought. He was also concerned with the effect of light on those objects—such as ballet costumes—which could best suggest the colored reflections of stage lights; and for this he found pastel most congenial.

Although Degas was a misanthropic and isolated figure in his own time, his contributions are nevertheless immensely varied and significant in the history of early modern art. Through all the fantasies of his theater and ballet world he seems never to have lost that sense of precise observation and psychological insight which had made his early portraits so extraordinary. Many of the ballet scenes are far removed from the moment of magical beauty when the curtain rises, and dwell with sympathy on the long hours of backstage drudgery and the pitiful exhaustion of the pathetic little girls as they rest from interminable rehearsals. Increasingly, during the 1880s and 1890s, Degas also chose commonplace subjects: milliners in their shops; exhausted laundresses; simple bourgeois women occupied with the everyday details of their toilets: bathing, combing their hair, dressing, or drying themselves after the bath. Subjects such as these constitute a further development of the realist experiments of Courbet or Manet, but with a difference particularly apparent in the studies of nudes. In his *Olympia* Manet effectively attacked the academic concept of the reclining Venus as the excuse for the portrayal of a sentimental, erotic nude. *Olympia*, however, as the antagonistic critics perhaps sensed correctly, remains a naked model who poses somewhat self-consciously and stares belligerently back at the spectator. Manet's courage enabled Renoir to reintroduce the nude in all her unself-conscious beauty as a figure in the great tradition of Titian, Rubens, or Boucher. However, in such a work as *The Tub* (fig. 28) Degas goes beyond any of his predecessors in presenting the nude figure as part of a scene, of an environment in which she fits with unconscious ease. Here the figure is beautiful in the easy compact sculptural organization, but the routine character of the accessories takes away any element of the erotic just as the bird's-eye view and the cut-off edges translate the photographic fragment into an abstract arrangement reminiscent of Japanese prints.

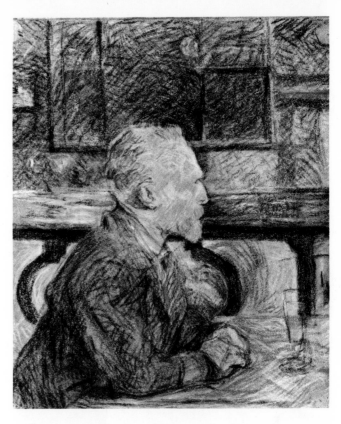

29. HENRI DE TOULOUSE-LAUTREC. *Portrait of Vincent van Gogh.* 1887. Pastel, 21¼ x 17¾". Vincent van Gogh Foundation, Amsterdam. V. W. van Gogh Collection

## HENRI DE TOULOUSE-LAUTREC *(1864–1901)*

During the nineteenth century the graphic arts of drawing, engraving, and lithography were given momentum by the development of modern printing techniques, and, as an offshoot, the progress of modern advertising methods. Book illustration, newspaper caricature, and poster advertisements became major industries after mid-century; and many painters were drawn into commercial art because of the relatively steady income that could be derived from it. Although Honoré Daumier was a brilliant painter who presented social-realist subjects in a powerful romantic-expressionist manner, and was also the first of the line of modern painter-sculptors, he made his major contribution in the thousands of lithographs he produced for such journals as *La Caricature* and *Le Charivari*. These prints, commentaries on the corruption, bureaucratic ineptitude, or economic injustice of France from the regime of Louis Philippe to that of Napoleon III, had wide influence, not only as political or economic satire, but in the expansion of informal, everyday subject matter, incisively and often devastatingly observed, and were ultimately to become a central part of the vocabulary of twentieth-century art. These lithographs, in essence black-and-white drawings, perpetuated and, through mass reproduction, disseminated widely a tradition of linear structure that was to form the basis of a new aesthetic at the end of the century.

The French painter who was the heir of Daumier in

the field of graphic art was Henri de Toulouse-Lautrec; and Toulouse-Lautrec in turn was one of the principal bridges between nineteenth-century experimental painting and many of the early twentieth-century expressionist or plastic tendencies of Edvard Munch, Pablo Picas-

30. HENRI DE TOULOUSE-LAUTREC.
*The Englishman at the Moulin Rouge.* 1892.
Oil on cardboard, 33¾ x 26".
The Metropolitan Museum of Art, New York.
Bequest of Miss Adelaide Milton de Groot, 1967

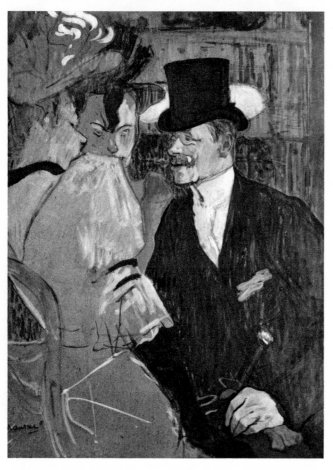

31. HENRI DE TOULOUSE-LAUTREC. *Cirque Fernando: The Equestrienne.* 1888. 39½ x 63½". The Art Institute of Chicago. The Joseph Winterbotham Collection

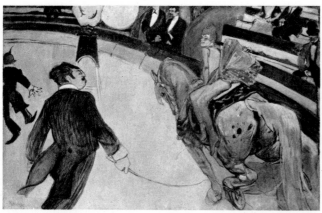

so, and Henri Matisse. Lautrec also looked back to Goya and the line drawings of Ingres, but first he was a passionate disciple of Degas, both in his admiration of Degas' draftsmanship and in his impersonal and detached attitude toward the familiar subjects of the theater and of the daily routine of the bourgeoisie. Although, after an academic training, Lautrec discovered and adapted the direct palette of the impressionists, he remained throughout most of his career, with the exception of isolated paintings, a draftsman who used color to heighten and accent the linear rhythm of his paintings and color lithographs. The *Portrait of Vincent van Gogh* (fig. 29), one of his very few pastels, adapts an impressionist hatched stroke, perhaps under the influence of Van Gogh himself, but his typical technique is that of drawings to which color is added in long, clearly defined brush strokes. Lautrec's fascination with the Paris of the bars, the night clubs, and the houses of prostitution brought him commissions for advertising posters and book jackets done in color lithography, in terms of which he virtually created a new art form. In color lithography he discovered the possibilities of flat areas of color encompassed by descriptive line (*The Englishman at the Moulin Rouge,* fig. 30), which paralleled the color patterns of Gauguin and the symbolist painters as an immediate prototype of early twentieth-century color abstractions. The possibilities of color as abstract shape, creating and controlling the form of the picture, rather than, in the traditional sense, a naturalistic description of objects, had already been explored in a number of his paintings of the late 1880s, notably the *Cirque Fernando: The Equestrienne* (fig. 31). Here he used Degas' tilted perspective, but in a mode more linear and sparse and even closer to the Japanese prints that he also had been studying assiduously.

In this work the artist simplified his colors to the red curves of the spectator benches and a few small accents in the performers' dress. The cut-off vision and the curvilinear movement of the design create an effect of abstract pattern that links this work to Matisse and the decorative wing of twentieth-century painting. The full implications of this transition between Renaissance perspective space and the delimited space of cubism were, as yet, not fully realized. There is a certain conflict between the modeled mass of the foreground figures and the two-dimensional space they occupy, a conflict that persists in Lautrec's works throughout his life. Nevertheless, in the *Cirque* he has moved several steps beyond previous experiments in the creation of a new kind of pictorial space.

The world of Lautrec's paintings had none of the joyous, bourgeois innocence of Renoir's. Actually, the real world was changing rapidly. The gay excursions of artists and their friends became the commercialized entertainments of Paris nightclubs, with solid Parisian bourgeois taking a night off from their respectable and protected homes. The youthful peasant Venus of Renoir, glowing with health, became Toulouse-Lautrec's aging, flabby, and cynical prostitute. *A La Mie* (fig. 32), inspired by Degas' *Absinthe* (fig. 33), is an imaginative study in degradation. In turn, it was to inspire Picasso's pathetic absinthe drinkers. Lautrec, however, never moralized

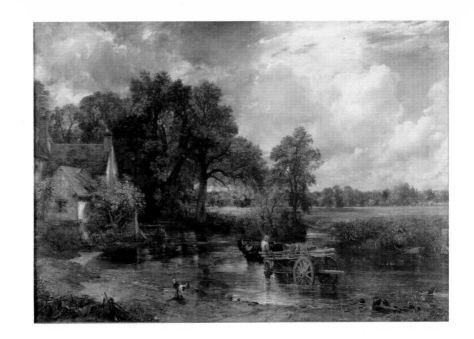

Colorplate 1. JOHN CONSTABLE.
*The Hay Wain*. 1819–21.
Oil on canvas, 51¼ x 73″.
The National Gallery, London

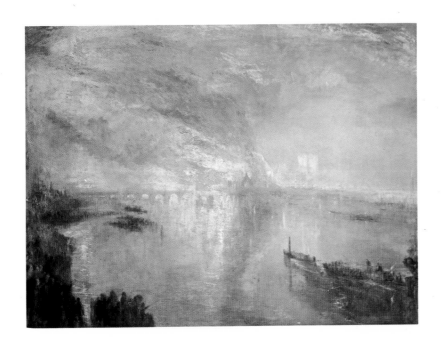

Colorplate 2. J. M. W. TURNER.
*The Burning of the Houses of Parliament.*
1834–35. Oil on canvas, 36½ x 48½″.
The Cleveland Museum of Art.
John L. Severance Collection

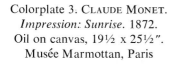

Colorplate 3. CLAUDE MONET.
*Impression: Sunrise*. 1872.
Oil on canvas, 19½ x 25½″.
Musée Marmottan, Paris

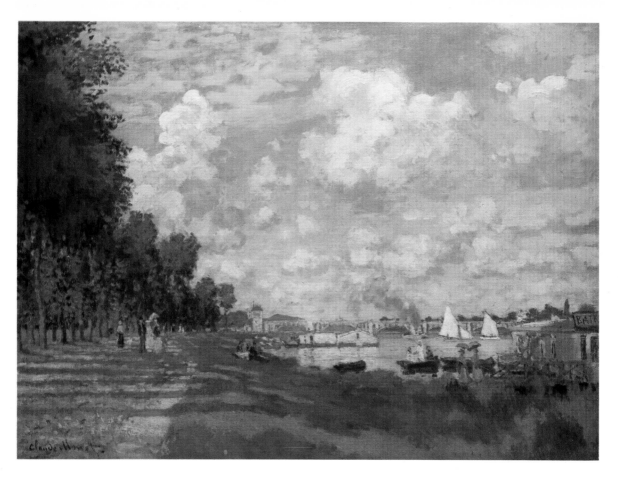

Colorplate 4. CLAUDE MONET. *The Bridge at Argenteuil*. 1874. Oil on canvas, 23½ x 31½″. The Louvre, Paris

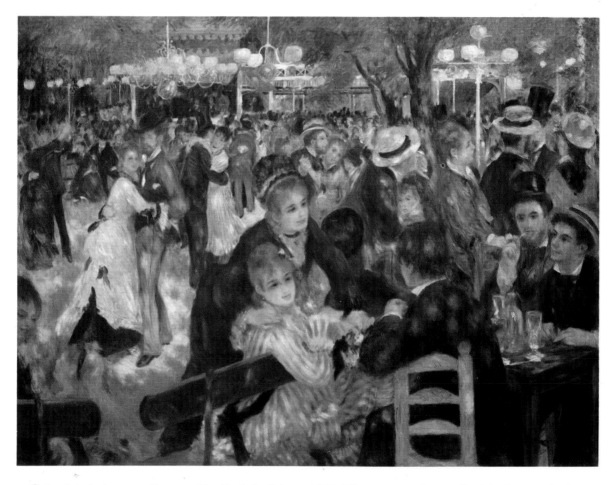

Colorplate 5. AUGUSTE RENOIR. *Moulin de la Galette*. 1876. Oil on canvas, 51½ x 69″. The Louvre, Paris

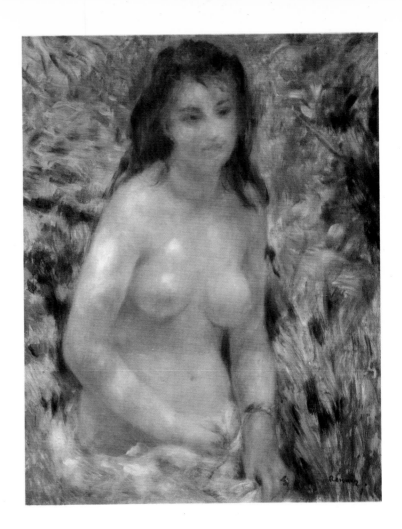

Colorplate 6. AUGUSTE RENOIR.
*Nude in the Sunlight*. 1876.
Oil on canvas, 31¼ x 25″.
The Louvre, Paris

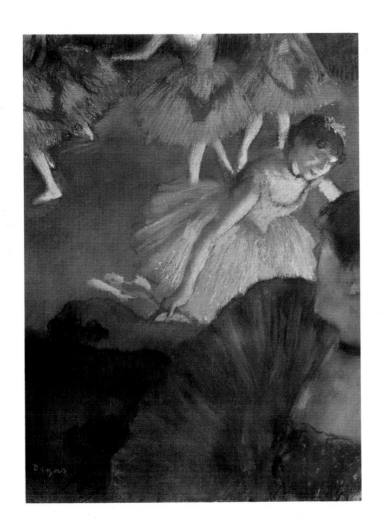

Colorplate 7. EDGAR DEGAS.
*A Ballet Seen from an Opera Box*.
1885. Pastel on paper, 25⅛ x 19¼″.
John G. Johnson Collection, Philadelphia

31

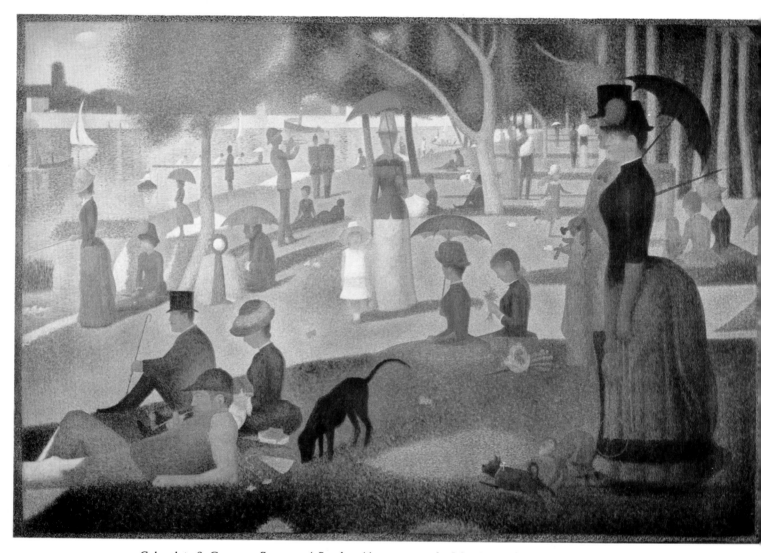

Colorplate 8. GEORGES SEURAT. *A Sunday Afternoon on the Island of La Grande Jatte*. 1884–86.
Oil on canvas, 6′ 9½″ x 10′ 1¼″. The Art Institute of Chicago. Helen Birch Bartlett Memorial Collection

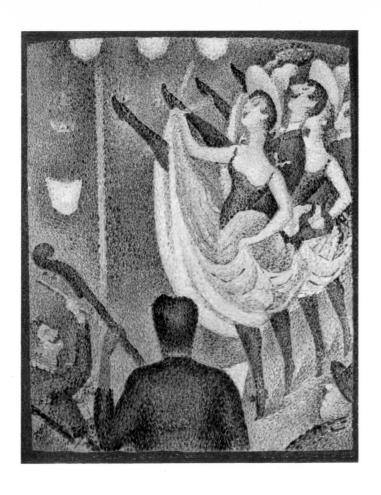

*left:* Colorplate 9. GEORGES SEURAT.
*Study for Le Chahut.* 1889. Oil on canvas, 26⅜ x 22⅝".
The Albright-Knox Art Gallery,
Buffalo, New York

*below:* Colorplate 10. PAUL GAUGUIN.
*Vision after the Sermon.* 1888.
Oil on canvas, 28¾ x 36¼".
National Gallery of Scotland, Edinburgh

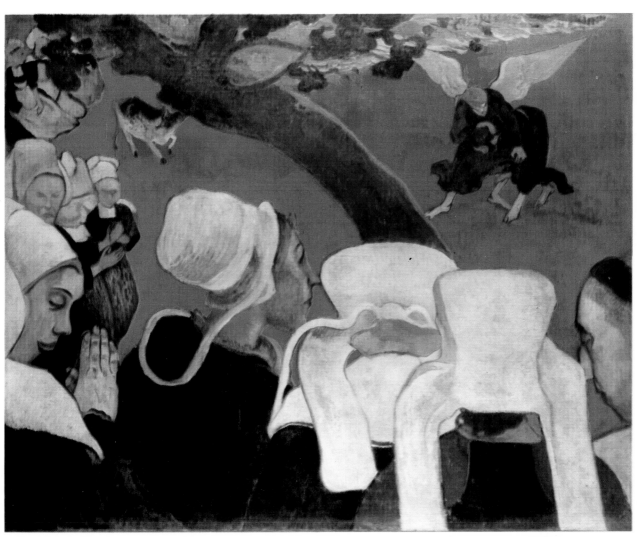

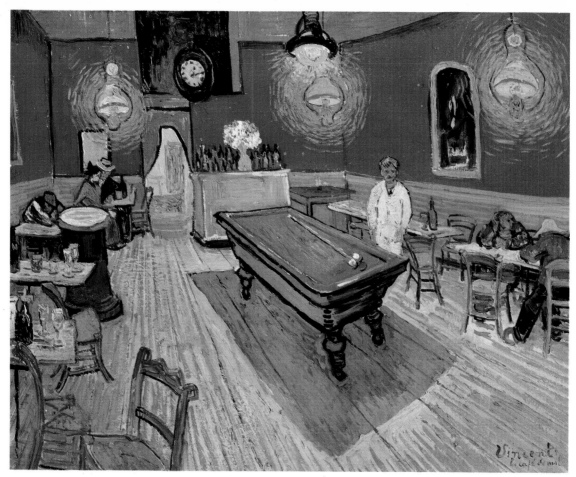

Colorplate 11. VINCENT VAN GOGH. *The Night Café*. 1888. Oil on canvas, 27½ x 35″.
Yale University Art Gallery, New Haven, Connecticut. Bequest of Stephen C. Clark

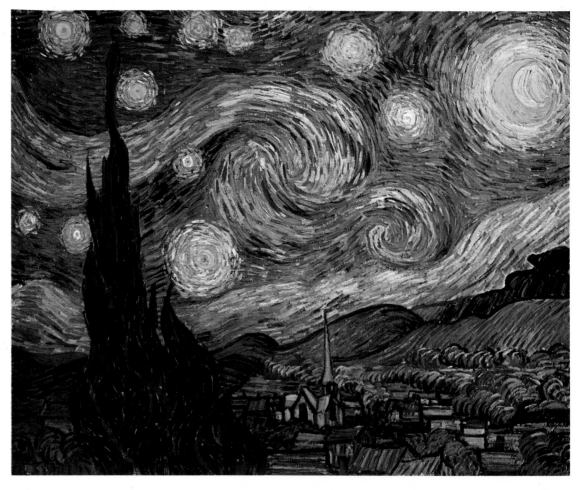

Colorplate 12. VINCENT VAN GOGH. *The Starry Night*. 1889. Oil on canvas, 28¾ x 36¼″.
The Museum of Modern Art, New York. Acquired through the Lillie P. Bliss Bequest

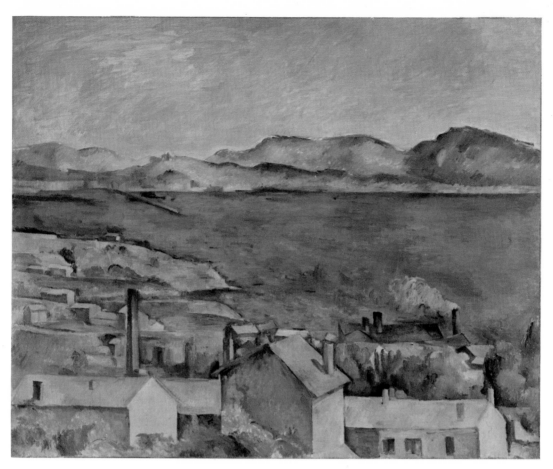

Colorplate 13. PAUL CEZANNE. *The Bay from L'Estaque.* 1886. Oil on canvas, 31½ x 38½".
The Art Institute of Chicago. Mr. and Mrs. Martin A. Ryerson Collection

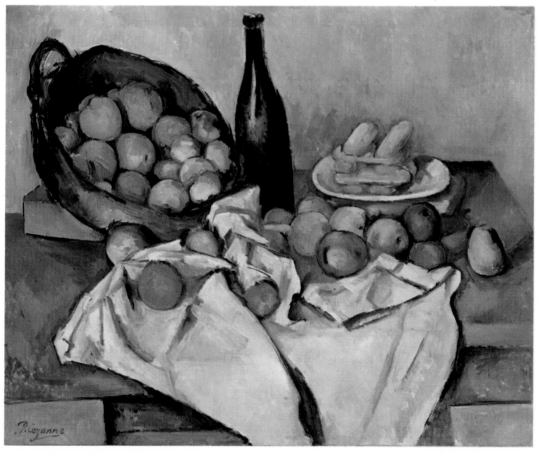

Colorplate 14. PAUL CEZANNE. *Still Life with Basket of Apples.* 1890–94. Oil on canvas, 24⅜ x 31".       35
The Art Institute of Chicago. Helen Birch Bartlett Memorial Collection

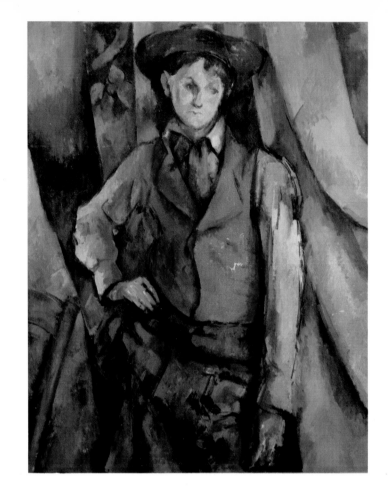

*right:* Colorplate 15. PAUL CEZANNE.
*Boy in a Red Vest.* 1890–95.
Oil on canvas, 36¼ x 28¾".
Collection Mr. and Mrs. Paul Mellon,
Upperville, Virginia

*below:* Colorplate 16. PAUL CEZANNE.
*Mont Sainte-Victoire.* 1904–06.
Oil on canvas, 25⅝ x 31⅞".
Collection Mr. and Mrs. Louis C. Madeira,
Gladwyne, Pennsylvania

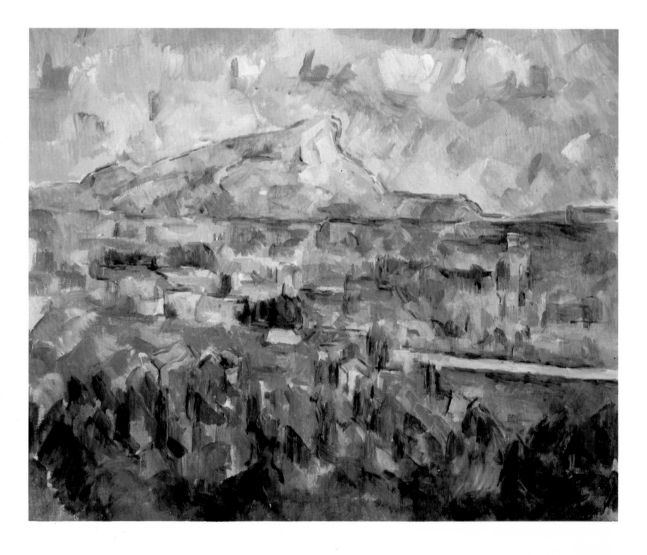

about the world he depicted. Even its most repulsive aspects were presented simply as part of something which existed and of which the artist was himself a part. Any emotion it entailed was the emotion of sympathetic understanding.

## Neo-Impressionism and Post-Impressionism

Toulouse-Lautrec was one of a number of less recognized painters who exhibited on occasion at the gallery of the art dealer Goupil under the sponsorship of Goupil's assistant Theo van Gogh, Vincent's brother. The other painters were Georges Seurat, Paul Signac, Paul Gauguin, Emile Bernard, and Vincent van Gogh himself. All these artists in some degree came out of impressionism, with the result that their diverse experiments, together with those of Paul Cézanne, who had already been associated with the original impressionists, have been grouped together under the neutral designation of post-impressionism. Actually, Seurat, Gauguin, Van Gogh, and Cézanne, the great quartet of this group, represent a vast range of diversified explorations, but together they embody the immediate sources of most of the ideas and attitudes of twentieth-century painting.

### GEORGES SEURAT (1859–1891)

Of these four, Georges Seurat is the least known (even today), seemingly the one most isolated from the others, and at the same time the closest in spirit to twentieth-century geometric abstraction. Trained in the academic tradition of the Ecole des Beaux-Arts, he was a devotee of classic Greek sculpture and of such classical masters as Piero della Francesca, Poussin, and Ingres. He also studied the drawings of Holbein, Rembrandt, and Millet, and learned principles of mural design from the academic symbolist Puvis de Chavannes. He early became obsessed with theories and principles of color organization, which he studied in the paintings of Delacroix and the scientific treatises of Eugène Chevreul, N. O. Rood, and Herman von Helmholtz. Seurat, indeed, was the first of a new breed of artists born of the scientific revolution: the artist-scientist. Working with his younger friend and disciple Paul Signac, he sought to synthesize the color experiments of the impressionists and the classical structure of the Renaissance tradition, combining the latest concepts of pictorial space, traditional illusionistic perspective space, and the newest scientific discoveries in the perception of color and light.

For all Seurat's theoretical apparatus, the incredible thing is that he produced such a body of masterpieces in so short a life (he died at thirty-one). His greatest work, and one of the landmarks of modern art, is *A Sunday Afternoon on the Island of La Grande Jatte,* more briefly known as *La Grande Jatte* (colorplate 8). He worked for two years on this monumental painting, preparing for it with at least twenty preliminary

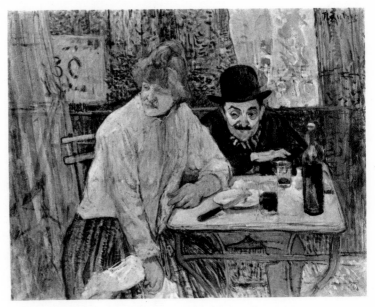

32. HENRI DE TOULOUSE-LAUTREC. *A La Mie.* 1891.
Watercolor and gouache on millboard, 21 x 26¾".
Museum of Fine Arts, Boston

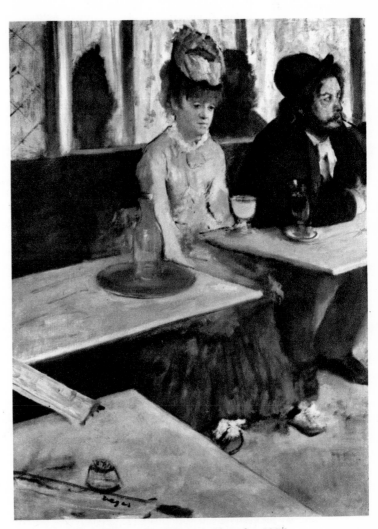

33. EDGAR DEGAS. *The Glass of Absinthe.* 1876.
36 x 27". The Louvre, Paris

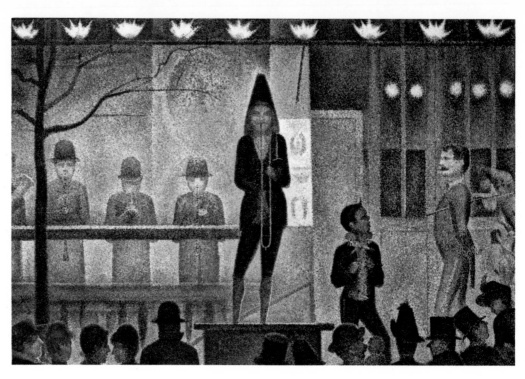

drawings and forty color sketches. In these preparatory sketches, ranging from studies of individual figures to oils that laid in most of the final composition, he analyzed, in meticulous detail, every color relationship and every aspect of pictorial space. The color system that Seurat propagated was based on the impressionists' intuitive realization that all nature was color, not neutral tone. Impressionism, for the most part, had involved no organized, scientific effort to achieve an optical impact through the placement of primary colors in close conjunction on the canvas and their fusion on the retina of the eye as glowing, vibrating patterns of mixed color. This optical effect appears in many paintings by Monet, as anyone realizes who has stood close to one of his works, first experiencing it simply as a pattern of color strokes, and then moving gradually away from it to observe all the elements of the scene come into focus.

Seurat, building on impressionism and nineteenth-century scientific studies of optical phenomena, constructed his canvases with small brush strokes of generally complementary colors—red-green, violet-yellow, blue-orange—with white. The intricate mosaic produced by his painstaking and elaborate technique was somewhat analogous to the actual medium of mosaic in its glowing depth of luminosity that gave an added dimension to color experience. The significance of Seurat's technique, to which the various names "divisionism," "pointillism," and "neo-impressionism" have been given, in great measure resides in the creation of an ordered, geometric structure closely approximating the pure abstract art of the twentieth century.

In *La Grande Jatte*, Seurat began with a simple contemporary scene of Parisians relaxing along the banks of the Seine. What drew him most strongly to the particular scene, perhaps, was the manner in which the figures arranged themselves in diminishing perspective on the grass under the trees along the banks of the river. At this point in the picture's evolution the artist was concerned as much with the re-creation of a fifteenth-century exercise in linear perspective as with the creation of a unifying pattern of surface color dots. Through many preliminary experiments, the figures were composed across the surface of the canvas and in calculated, mathematical diminution and repetition in depth. Broad contrasting areas of shadow and light, each built of a thousand minute strokes of juxtaposed color-dot complementaries, carry the eye from the foreground into the beautifully realized background. In a certain sense the painting might be considered a spatial departure from David, Courbet, Manet, and Monet, all of whom, in one form or another, were concerned with the assertion of the picture plane. Certainly, Seurat was here deliberately attempting to reconcile the classic tradition of Renaissance perspective painting and modern interest in light, color, and pattern.

More important in the painting than depth or surface pattern is the magical atmosphere that the artist was able to create from the abstract patterns of contemporary bourgeois Parisians. Seurat's figures are like those of a mural by Piero della Francesca in their quality of mystery and of isolation one from another. In all the accumulation of commonplace details there is a total effect of poetry that makes of the whole a profoundly moving experience. The fascinating fact about Seurat's paintings is that they anticipate not only the abstraction of Mondrian but also the surrealist strangeness of Giorgio de Chirico and René Magritte. Thus, this most scientific and objective of all painters of his time becomes, by a curious inversion, one of the most poetic and mysterious.

*La Grande Jatte* was almost an isolated experiment in its illusion of perspective depth; and even there the broad landscape planes of color, light, and shadow close and flatten the picture space. In the drawings and sketches preceding it, and in the paintings following it, everything tends to come back to the surface of the pic-

ture, to emphasize and reiterate the two-dimensional plane of which it is constructed. *La Parade* (fig. 34) is a luminous facade in which the silhouettes of the figures are arranged across a shelf of space formed out of light and color. The landscapes are all organized as horizontal planes made up of color-dot tesserae. In some of the later works, such as the *Study for Le Chahut* (colorplate 9), the color dots increase in scale to a point such that the figures and their spatial environment are dissolved in a pattern of large-scale tesserae that clings to the surface of the picture. At this point in the evolution of modern painting the transition from a representation of natural objects in terms of color-dot pattern to an abstraction composed of color-dot and flat, curvilinear pattern was almost complete. The next stage would be the color-line experiments of the fauves and the cubists.

In the hands of many of his followers, Signac included, Seurat's technique tended too often to decline into a decorative formula to be used in narrative exposition. This was also the fate of impressionism proper as it became first accepted and then immensely popular throughout the world. Unfortunately, the color and light, initially so shocking to the world, were all too quickly discovered to be charming, endearing, and capable of every kind of vulgarization. This vulgarization continues today in many forms of department-store art. Seurat's divisionism, on the other hand, affected not only fauvism and certain aspects of cubism in the early twentieth century, but also some art nouveau painters and designers, and many German expressionists. The art of Seurat, the least known of the four great founders of twentieth-century painting, has made itself felt, through one of its phases or another, in almost every major experimental wing of that painting until the present day.

## PAUL GAUGUIN *(1848–1903)*

The personalities of these four founders—Seurat, Gauguin, Van Gogh, and Cézanne—differ as widely as their actual contributions. Popularly, the names and attitudes of Gauguin and Van Gogh tend to be linked with the subsequent development of expressionism. Those of Seurat and Cézanne are associated as fathers of the classic, plastic traditions that led from cubism to geometric abstraction. These are considerable oversimplifications—a consequence of the modern obsession with categories and classifications.

Paul Gauguin, more than any other artist of the nineteenth century, perhaps, has become a romantic symbol, the personification of the artist as rebel against society. After years of wandering, first in the merchant marine, then in the French navy, he settled down, in 1871, to a prosaic but successful life as a stockbroker in Paris, married a Danish girl, and had several children. For the next twelve years the only oddity in his respectable, bourgeois existence was the fact that he began painting, first as a hobby and then with increasing seriousness. He even managed to show a painting in the Salon of 1876 and to exhibit in the sixth and seventh impressionist exhibitions in 1881 and 1882. Then, in 1883, he suddenly quit his position to paint full time. By 1886, after several years of family conflict and attempts at new starts in Rouen and Copenhagen, he had largely severed his family ties, isolated himself, and become involved in the little world of the impressionists, whom he first met through Camille Pissarro.

Gauguin seems almost always to have had a nostalgia for far-off, exotic places. This feeling ultimately crystallized in the conviction that his salvation and perhaps that

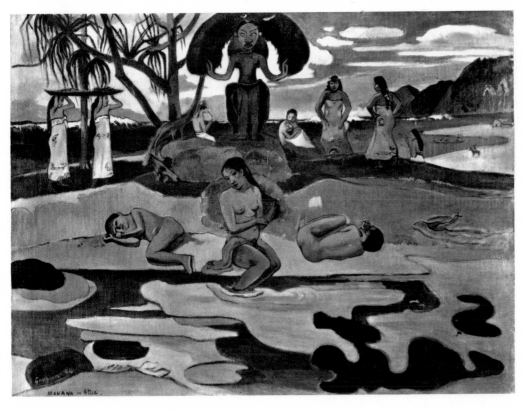

35. PAUL GAUGUIN.
*The Day of the God (Mahana No Atua).*
1894. 27⅜ x 35⅝".
The Art Institute of Chicago.
Helen Birch Bartlett Memorial Collection

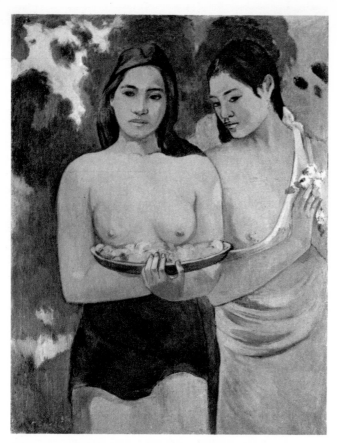

36. PAUL GAUGUIN. *Two Tahitian Women*
*(Femmes aux Mangos)*. 1899. 37 x 28½".
The Metropolitan Museum of Art, New York.
Gift of William Church Osborn, 1949

of all contemporary artists lay in abandoning modern civilization and its encumbrance of classical Western culture to return to some simpler, more elemental, primitive pattern of life. A desire to live like a savage resulted in 1887 in ill-fated trips to Panama and Martinique. Even earlier he had sought a less extreme version of the primitive life in the Breton village of Pont-Aven. He returned to Pont-Aven in 1888, after his stay in Martinique, and then went to Arles for the short but almost fatal visit with Van Gogh. After still another visit to Pont-Aven he tried Le Pouldu and, in 1891, after another stay in Paris, sailed for Tahiti. After two years in Tahiti he went back to France, where he stayed until 1895. He then returned to Tahiti. His final trip, after years of illness and suffering, was to the island of Dominique in the Marquesas, where he died in 1903.

The importance of Gauguin to modern art lies in large part in his conviction of the nature of a painting as something independent of nature, as a "synthesis" of remembered experiences rather than in immediate perceptual experience in the sense of the impressionists. He constantly used for painting the analogy of music, of color harmonies, of color and lines as forms of abstract expression. In his search he was attracted, to a greater degree even than most of his generation, to Oriental, pre-classical, and primitive art. In him we find the origins of modern primitivism, the desire to attain to a kind of expression that achieves truth by discarding the accumulation of Western tradition and returning to the elemental verities of prehistoric man and barbaric peoples.

The attraction of tropical islands is already evident in a Martinique landscape whose intense coloration takes it out of the normal experience of descriptive color. He embodied this attitude in *Vision after the Sermon* (colorplate 10), painted in 1888 on his return to Pont-Aven. This is a startling work, a pattern of red, blue, black, and white tied together by curving, sinuous lines to create a Byzantine mosaic translated into a Breton peasant's religious vision. It is a document of the new creed of synthetism, which was to affect the ideas of younger groups such as the nabis and the fauves. Perhaps the greatest single departure is the arbitrary use of color in the dominating red field within which the protagonists (Jacob and the Angel) struggle. This painting was one of the first complete statements of color as an expressive end in itself and not as something that describes some aspect of the natural world. As such, it marks one of the great moments of liberation in the history of Western art. Also, in terms of abstract statement of pictorial means, Gauguin has here constricted his space to such an extent that the dominant red of the background visually thrusts itself forward beyond the closely viewed heads of the peasants in the foreground.

In Gauguin's developed Tahitian paintings there is no necessary consistency in plastic or spatial exploration. The artist's imagination was too filled with different concepts, visual and symbolic, each of which had to be given the plastic expression most appropriate to it. Thus, *The Day of the God* (fig. 35) is in certain ways a traditional landscape organized in clear-cut statements of recession in depth. Its figures suggest the various non-Western influences that obsessed him, from ancient Egyptian to contemporary Polynesian. The "god" is a product of the artist's imagination. The mystery of the subject, of the devotions of the natives to the god, is very much on his mind, but he has integrated concern for mystical experience with concern for red, blue, and yellow color shapes, here framed in curving lines that move over the surface of the painting.

*Two Tahitian Women* (1899; fig. 36), on the other hand, is a simple hymn in praise of sensuous beauty. The two women are silhouetted against a frame of color ranging from yellow through various shades of green. From this background they emerge as bas-reliefs, modeled in line but with delicate variations in light and shadow over the heads and arms. This is a work in which the elaborate myth is forgotten and the artist's theories of plastic structure are subordinated to sheer delight in the portrayal of the subject. Although the color harmonies are as lovely as anything he ever attained and the picture space as closed and delimited, the relief projection of the modeled figures establishes a bond with the neo-classic simulation of classic relief sculpture.

## VINCENT VAN GOGH *(1853–1890)*

Although the names of Gauguin and Vincent van Gogh are coupled as pioneers of modern expressionism and as typical of the supreme individualism of the artist, it is difficult to envisage two personalities more different. Whereas Gauguin was an iconoclast, caustic in speech, cynical, indifferent, and, at times, brutal to others, Van

Gogh was filled with a spirit of naive enthusiasm for his fellow artists and overwhelming love for his fellow men. This love had led him, after a short-lived experience as an art dealer and an attempt to follow theological studies, to become a lay preacher in a Belgian coal-mining area. There he first began to draw in 1880. After study in Brussels, The Hague, and Antwerp, he went to Paris in 1886, where he met Toulouse-Lautrec, Seurat, Signac, and Gauguin, as well as members of the original impressionist group.

Among Van Gogh's early paintings, *The Potato Eaters* (fig. 37) is the masterpiece. It reveals the influence of Millet and the mid-century realists, who by this time themselves constituted something of an academy in art schools throughout Europe. But already there exists here a sense of heightened intensity, a passionate sympathy for the work-worn peasants, whose gathering together for the communal evening meal is given the ritualistic significance of the *Christ at Emmaus* by Rembrandt (fig. 38). The painting, in fact, belongs in the tradition of Baroque chiaroscuro painting of which Rembrandt was the exemplar, a tradition that was still alive in the Netherlands after two centuries, reinforced by the nineteenth-century romantics' and realists' rediscovery of Rembrandt. The early drawings of Van Gogh, to an even greater degree than the early paintings, illustrate his roots in traditional Dutch landscape, portrait, and genre painting. In the landscape drawings he extols, through the same perspective structures, the broad fields and low-hanging skies that Hobbema had loved in the seventeenth century. He never abandoned perspective even in later years, when he developed a style with great emphasis on the linear movement of paint over the surface of the canvas. For him—and this is already apparent in the early drawings—perspective depth took on an expressive, an emotional significance (see fig. 39). In the struggle between illusionistic depth and flat surface pattern arises much of the tension in his paintings.

After his exposure to the impressionists in Paris, Van Gogh's palette changed and lightened, and he discovered his deepest single love in color—brilliant, unmodulated color—which in his hands took on a character radically different from the color of the impressionists. Even when he used impressionist techniques, the peculiar intensity of his vision of man and nature gave the result a specific and individual quality that could never be mistaken. *The Orchard* (fig. 40), painted shortly after he had moved to Arles in his search for sun-saturated landscape, is one of his most impressionist works. The effect, however, is not that of color-reflecting light from the green fields, trees, and apple blossoms of a natural scene. The color is not reflected; it burns within the grass or the apple blossoms like a life force that charges every blade of grass with an agonized but ecstatic existence. Van Gogh was not looking at and attempting to reproduce the appearance of nature. He was seeing, with a frightening clarity, the innermost secrets of nature's everlasting process of growth and change: birth, life, death, and rebirth.

Van Gogh's passion arose from his intense, indeed overpowering, response to the world in which he lived and to the people whom he knew. It was not the simple response of a primitive or a child. His letters to his brother

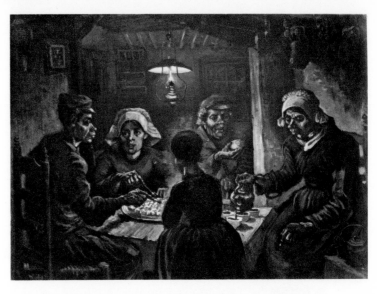

37. VINCENT VAN GOGH. *The Potato Eaters*. 1885. 32¼ x 45″. Vincent van Gogh Foundation, Amsterdam. V. W. van Gogh Collection

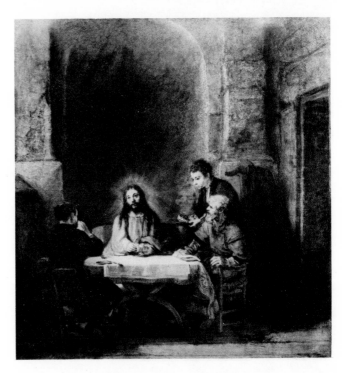

38. REMBRANDT. *Christ at Emmaus*. 1648. Oil on panel, 27 x 26″. The Louvre, Paris

Theo, which are among the most moving narratives by an artist, reveal a highly sensitive perception that is fully equal to his emotional response. He was acutely aware of the effects he was achieving through his yellows, more brilliant and saturated than ever before in the history of painting, or his blues, as intense as the bottomless depth of infinity. Although most of his color perceptions had to do with his love of man and nature and his joy in the expression of that love, he was also sensitive to a darker side. Thus, of *The Night Café* (colorplate 11) he says: "I have tried to express the terrible passions of humanity by means of red and green." *The Night Café* is a nightmare of deep-green ceiling, blood-red walls, and discord-

ant greens of furniture. The floor is a brilliant yellow area of directed perspective driving with incredible force into the red background, which, in turn, resists with equal force. The painting is a struggle to the death between perspective space and aggressive color attempting to destroy that space. The result is a terrifying experience of claustrophobic compression. This work anticipates the surrealist explorations of perspective as a means to fantastic expression, none of which has ever matched it in emotive force.

The universe of Van Gogh is forever stated in *The Starry Night* (colorplate 12). This is visionary beyond anything attempted by Byzantine or Romanesque artists

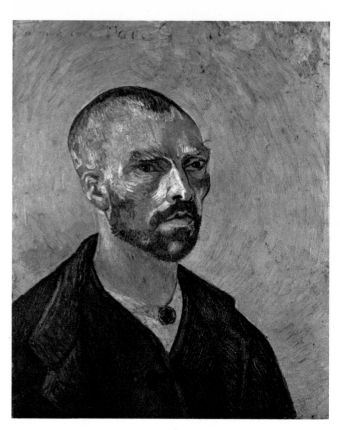

39. VINCENT VAN GOGH. *The Garden of the Presbytery at Nuenen, Winter.* 1884. Pen and pencil, 15¼ x 20¾ ″. Vincent van Gogh Foundation, Amsterdam. V. W. van Gogh Collection

40. VINCENT VAN GOGH. *The Orchard.* 1888. 23⅝ x 31⅞ ″. Vincent van Gogh Foundation, Amsterdam. V. W. van Gogh Collection

in their interpretations of the ultimate mystery of Christianity. The closeness of the exploding stars relates to the age of space exploration even more than to the age of mystical belief. Yet the vision is set down with a brush stroke of painstaking precision. When we think of expressionism in painting, we tend to associate with it a bravura brush gesture, uncontrolled or flamboyant, arising from the spontaneous or intuitive act of expression and independent of rational processes of thought or precise technique. The anomaly of Van Gogh's paintings is that they are supernatural or at least extrasensory experiences documented with a brush stroke as meticulous as though the artist were painfully and exactly copying what he was observing before his eyes. In a sense this is what was actually happening, since Van Gogh was an artist who saw visions and painted what he saw. *The Starry Night* is both an intimate and a vast landscape, seen from a high vantage point in the manner of the sixteenth-century landscapist Pieter Bruegel the Elder, although certain impressionist landscapes were a more immediate source. The great poplar tree looms and shudders before our eyes; the little village in the valley rests peacefully under the protection of the church spire; and over all the stars and planets of the universe whirl and explode in a Last Judgment, not of individual human beings but of solar systems. This work was painted in June 1889 at the sanatorium of St-Rémy, where he had been taken after his second mental breakdown, during one of the many lucid but emotionally

charged intervals in which he continued to paint. The color is predominantly blue and violet, pulsating with the scintillating yellow of the stars. The foreground poplar, in its deep green and brown, suggests the darkness of the night about to encompass the world.

Vincent van Gogh was one of the few artists of his generation who carried on the great tradition of portraiture. His passionate love of mankind made this inevitable; and he studied people as he studied nature, from his first essays in drawing to his last self-portrait (fig. 41), painted a few months before his suicide in 1890. This is a profoundly disturbing work that records the frightening intensity of the madman's gaze. Yet it is impossible for a painting as controlled and accomplished as this to have been executed by a madman or by anyone not in control of whatever he was doing. The beautifully sculptured head and the solidly modeled torso are silhouetted against a vibrant field of linear rhythms in gradations of blue. Everything in the painting is blue or blue-green, with the exception of the white shirt front and the red-bearded head of the artist. The coloristic and rhythmic integration of all parts, the careful progression of emphases, from head to torso to background, all demonstrate an artist in superb control of his plastic means. It is as though Van Gogh, for the moment completely sane, was able to record with scrupulous accuracy the vision of himself insane.

## PAUL CEZANNE *(1839–1906)*

Of all the nineteenth-century painters who might be considered prophets of twentieth-century experiment, the most significant for both achievement and influence was Paul Cézanne. Cézanne was a solitary who struggled throughout his life to express in paint his ideas about the nature of art, ideas which had their roots in the great tradition of Western painting, and which, at the same time, in their very inclusiveness, were among the most revolutionary in the history of art. Son of a well-to-do Aix-en-Provence merchant turned banker, he had to resist parental disapproval to embark on his career; but once having won the battle, unlike Monet or Gauguin, he did not need to struggle for mere survival. As we view the splendid control and serenity of his mature paintings, it is difficult to realize that he was a man of violent disposition, given to sudden rages and, on occasion, to hallucinatory dreams. This aspect of his character is evident in some of his early, mythological figure scenes, which were Baroque in their movement and excitement. At the same time he was a serious student of the art of the past, one who studied the masters in the Louvre, from Veronese to Poussin to Delacroix.

Cézanne's unusual combination of logic and emotion, of reason and unreason, represented the synthesis that he would seek in his paintings. All artists before him, at least since the Renaissance, had been faced with the dilemma of nature versus art—even when they did not realize it was a dilemma. Painting itself from the seventeenth to the nineteenth century had increasingly become a power struggle of drawing versus color: in the seventeenth century the Poussinists against the Rubenists; in the nineteenth century the neo-classicists against

the romantics, Ingres versus Delacroix. This dichotomy had been exaggerated during the nineteenth century as a result of over two centuries of the influence of the art academies. With the rise of the concept of official art in the seventeenth century, with the development of organized art criticism in the eighteenth century and of art history in the nineteenth, and with the expansion of official art schools, there came inevitably a consolidation of theory about art, the hardening of dogmatic lines on what was proper and good. The result was that the nineteenth-century rebels against the establishment quite logically took positions at the opposite end of the spectrum from the academicians. If the academy insisted on an ideal subject taken from antiquity and presented in meticulous drawing, perspective, and oil glazes, Courbet gave them nineteenth-century French peasants frontalized and roughly modeled, presented with no effort to conceal the texture of oil paint. The impressionists, in the 1870s, largely abandoned traditional drawing in their effort to state their visual discovery—that objects in nature are not seen as isolated phenomena separated from one another by defined contours. In their desire to realize the observed world through spectrum colors in terms of which the spaces between objects are actually color intervals like the objects themselves, they tended to destroy the objects as three-dimensional entities existing in three-dimensional space, and to re-create solids and voids as color shapes functioning within a limited depth. It was this destruction or at least subordination of the

42. PAUL CEZANNE. *Uncle Dominic as a Monk.* c. 1866. 25⅝ x 21¼". Collection Mrs. Ira Haupt, New York

43. PAUL CEZANNE.
*Bacchanal (La Lutte d'amour)*.
1875–76. 15 x 18½".
Collection the Honorable
and Mrs. W. Averell Harriman

distinction between the illusion of three-dimensional mass and that of three-dimensional depth which led to the criticisms of impressionism as formless and insubstantial. Even Renoir felt compelled to restudy the drawing of the Renaissance in order to recapture some of that "form" which impressionism was said to have lost. And Seurat, Gauguin, Van Gogh, each in his own way, consciously or unconsciously, was seeking a kind of expression based on, but different from, that of the impressionists.

Certainly, Cézanne's conviction that impressionism had taken a position excluding qualities of Western painting important since the Renaissance prompted his oft-quoted and frequently misunderstood remark that he wanted to "make of impressionism something solid like the art of the museums." By this, obviously—as his paintings document—he did not mean to imitate the old masters. And he had no thought that the Renaissance or Baroque masters were primarily concerned with simple imitation of the observed natural world. He realized, quite correctly, that in their paintings artists like Veronese or Poussin had created a world similar to but quite distinct from the world in which they lived. Not because they chose classical or biblical subjects; Veronese in fact transposed the village world of Christ into the urban sophistication of sixteenth-century Venice. Rather, the painting resulting from the artist's various experience emerged as a separate reality in itself. This kind of reality, the reality of the painting, Cézanne sought in his own works. As he felt progressively that his sources must be nature, man, and the objects of the world in which he lived rather than stories or myths from the past, these were the sources that he wished to transpose into the

new reality of the painting. For this reason he expressed his desire "to do Poussin over again from nature."

Cézanne's mature position was arrived at only after long and painful thought, study, and struggle with his medium. The theoretical position that, late in his life, he tried so inarticulately to express in words, was probably achieved more through the discoveries he made on his canvas with a fragment of nature before him than through his studies in museums. In the art of the museum he found corroboration of what he already instinctively knew. In fact, what he knew in his mature landscapes is in many ways already evident in such an early work as *Uncle Dominic as a Monk* (fig. 42). Uncle Dominic, his mother's brother, is painted in the white habit of the Dominican order, modeled out from the blue-gray ground in sculptured paint laid on in heavy strokes with the palette knife. The sources in Manet and Courbet are evident, but the personality revealed by the portrait—the spirit of the artist himself—is different from either of his predecessors. The painting, which is not so much a specific portrait as a study of passion held in restraint, belongs to both the classic tradition of the withdrawn, generalized type, and the romantic tradition of the involved, intense, and particularized individual. This painting may have been one of the first attempts to establish a balance or control over the Baroque violence that permeated his early figure studies. Cézanne attempted his own *Déjeuner sur l'herbe* in heavy-handed variants on Manet's painting, also with reminiscences of Titian. He exorcised his own inner conflicts in scenes of murder and rape. After his exposure to the impressionists, particularly to Pissarro, with whom he studied during 1872 at Auvers-sur-Oise, he returned to the violence

of these essays in his *Bacchanal* (*La Lutte d'amour,* fig. 43). Here he has moved away from the somber tonality and sculptural modeling of the 1860s into an approximation of the light blue, green, and white of the impressionists. Nevertheless, this is a painting remote from impressionism in its effect. The artist subdues his greens with grays and blacks, and expresses an obvious obsession with the sexual ferocity he is portraying, different from the stately bacchanals of Titian, and more intense even than the comparable scenes of Rubens. At this stage he is still exploring the problem of integrating figures or objects and surrounding space. The figures are clearly outlined, and thus exist sculpturally in space. However, their broken contours, sometimes seemingly independent of the cream-color area of their flesh, begin to dissolve solids and integrate figures with the shaped clouds that, in an advancing background, reiterate the carnal struggles of the bacchanal. The *Bacchanal* is a transitional work, but nevertheless one of tremendous power in itself and of significance in suggesting the direction in which Cézanne was moving. In it the solidity of the art of the museums is reappearing already—with a difference.

In the 1880s all of Cézanne's ideas of nature, man, and painting came into focus in a magnificent series of landscapes, still lifes, and portraits. During this period he was living at Aix, largely isolated from the impressionist and post-impressionist experiments in Paris, but nevertheless affecting them like some mysterious legend. *The Bay from L'Estaque* (colorplate 13) today is a work so familiar from countless reproductions that it is difficult to realize how revolutionary it was when it was painted. The scene was also viewed from the high vantage point familiar in the sixteenth-century landscapes of Bruegel, and revived in early impressionist landscapes. However, the space of the picture does not recede into a perspective of infinity in the Renaissance or Baroque manner. Buildings in the foreground are massed close to the spectator and presented as simplified cubes with the side elevation brightly lighted; they are thus given a prominence asserting their identity as frontalized color shapes parallel to the picture plane rather than at right angles to it. The foreground buildings and intervening trees are composed in ocher, yellow, orange-red, and green, with little distinction in definition as objects recede from the eye. Although the elements of the foreground—houses, roof tops, chimneys, trees—are perfectly recognizable as such, it is difficult to think of them as objects existing in natural space. If we try to envisage the space and air surrounding the solid objects, such as houses and chimneys, we realize that there is no empty space. The trees to the right of the foreground house, which should be some distance behind it in depth, are actually a variegated color shape beside it. Cézanne wished to re-create nature with color, feeling that drawing was a consequence of the correct use of color. In *The Bay from L'Estaque*, contours are the meeting of two areas of color. Since these colors vary substantially in value, contrasts or in hue, their edges are perfectly defined. However, the nature of the definition tends to join and unify the color areas rather than to separate them in the manner of traditional outline drawing. There is now apparent

in the composition of this painting Cézanne's intuitive realization of the perceptual concepts that Seurat had studied so assiduously in scientific texts. For Cézanne the important point was the discovery that the eye took in a scene both consecutively and simultaneously, with profound implications for construction of the painting.

Cézanne was certainly the father of twentieth-century cubism and abstract painting. Yet he never, even at the end of his life, had any desire to depart entirely from nature. When he spoke of "the cone, the cylinder, and the sphere" he was not thinking of these geometric shapes as the end result, the final abstraction into which he wanted to translate the landscape or the still life. Abstraction for him was a method, a way station at which he stripped off the visual irrelevancies of nature in order that he could begin rebuilding the natural scene as an independent painting. Thus, the end result was easily recognizable from the original motif, as extensive photographing of the scenes has proved, but it is essentially different: the painting is a parallel but separate and unique reality.

The middle distance of *The Bay from L'Estaque* is the bay itself, an intense area of dense but varied blue stretching from one side of the canvas to the other and built up of meticulously blended brush strokes. Behind this is the curving horizontal range of the hills, and, above these, the lighter, softer blue of the sky, with only the faintest touches of rose, as though from a setting sun. The abrupt manner in which the artist cuts off his space at the sides of the painting has the effect of denying the illusion of recession in depth. The blue of the bay asserts itself even more strongly than the ochers and reds of the foreground, with the result that space becomes both ambiguous and homogeneous. The painting must be read simultaneously as a panorama in depth and as an arrangement of color shapes on the surface.

Despite Cézanne's continual struggle, uncertainty, and dissatisfaction, in such a work as this there is no question that he succeeded superbly in what he set out to do. On the color and instantaneous vision of the impressionists, on the discipline and solid structure of the old masters, and, above all, on the intense and sensitive perception of his own view of nature he was able to build a new conception of painting, one that has affected the course of twentieth-century painting for more than sixty years.

Few if any artists in history have devoted themselves as intently as Cézanne to the separate themes of landscape, portrait, and still life. In order to understand this fact it is necessary to understand that to him these subjects involved identical problems. In all of them he was concerned with the re-creation, the realization, of the scene, the object, or the person. In *La Peau de chagrin* Balzac describes a "white tablecloth like a layer of fresh snow on which the napkins rise symmetrically with their crowns of little pale loaves." "All my youth," said Cézanne, "I wanted to paint that: the tablecloth of fresh snow. . . . Now I know one should only *want* to paint the napkins rising symmetrically and the little pale loaves . . . if I can really balance and evaluate my napkins and bread, as in nature, you can be sure that the crowns, the snow and all the rest will be there." In *Still Life with Basket of Apples* (1890–94; colorplate 14), as well as in many other still lifes, Cézanne succeeded in translating,

even transcending, Balzac's verbal images. The fascination of the still life for Cézanne, as for generations of painters before him and after, obviously lies in the fact that it involves a subject delimited and controllable as no landscape or portrait sitter can possibly be. After he had carefully arranged his tilted basket of apples and wine bottles, scattered the other apples casually over the mountain peaks of the tablecloth, and placed the plate of *petit-pain* at the back of the table—which, vertically, is also the summit—he had only to look until all these elements began to transform themselves into the relationships on which the final painting would be based. The apple obsessed Cézanne as the three-dimensional form most difficult to control as a separate object and to assimilate into the larger unity of the canvas. To attain this goal and at the same time to preserve the nature of the individual object, he modulated the circular forms with small, flat brush strokes, distorted the shapes, and loosened or broke the contours to set up spatial tensions among the objects and thereby unify them as color areas. By tilting the wine bottle out of the vertical, flattening and distorting the perspective of the plate, or changing the direction of the table edge as it moved under the cloth, he was able, while maintaining the illusion of real appearance, to remove the still life from its original environment into the new environment of pictorial form, where not the objects but the relations and tensions existing between them become the significant visual experience. As we look at this work some seventy years after it was painted, it is still difficult to express in words all the subtleties through which Cézanne gained his final result. However, now we can comprehend at many different levels the beauty of his achievement. He was one of the great constructors and one of the great colorists in the history of painting, one of the most penetrating observers, and one of the most subtle minds.

This still life, like all his still lifes, was a landscape. The ocher foreground, the light blue background, the "snowy peaks" of the tablecloth, the haphazard order of the apples flowing across the scene, all these take us back to the *Bay from L'Estaque* or to the many views of Mont Sainte-Victoire. The figure studies, such as the various versions of *The Card Players* (fig. 44), remind one in their massive, closed architecture of his paintings of quarries. So does the draped curtain enclosing the space of his *Boy in a Red Vest* (colorplate 15). After 1890, Cézanne's brush strokes became larger and more abstractly expressive, the contours more broken and dissolved, with color floating across objects to sustain its own identity independent of the object. These tendencies were to lead to the wonderfully free paintings of the very end of his life, of which the *Mont Sainte-Victoire* of 1904–06 (colorplate 16), is one of the supreme examples. Here the brush stroke acts the part of the individual musician in a superbly integrated symphony orchestra. Each stroke exists fully in its own right but each is nevertheless subordinated to the harmony of the whole. This is both a structured and a lyrical painting, one in which the artist has achieved the integration of classicism and romanticism, of structure and color, of nature and painting. It belongs to the great tradition of Renaissance and Baroque landscape, seen, however, as the eye actually sees, as an infinite accumulation of individual perceptions. Analyzed by the painter into their abstract components, these are then reconstructed into the new reality of the painting.

44. PAUL CEZANNE.
*The Card Players.*
c. 1885–87. 25½ x 32".
The Metropolitan Museum
of Art, New York.
Bequest of Stephen C. Clark, 1960

# TRANSITION TO THE TWENTIETH CENTURY

## Origins of Modern Architecture. Nineteenth-Century Pioneers

It is impossible to understand the attitudes and experiments of twentieth-century painters without understanding the ideas of a host of nineteenth-century forerunners: Courbet, Manet, Monet, Gauguin, Van Gogh, and Cézanne. We can hardly speak of nineteenth-century forerunners to twentieth-century architects and sculptors in anything like the same degree: the break between the past and the present occurred rather suddenly at the end of the nineteenth century. In architecture the nineteenth century continued and expanded the pattern of stylistic revivals that had predominated in Europe since the fifteenth century and in the Americas since the sixteenth. In the year 1800, the neo-classic revival, more specifically archaeological than its Renaissance and post-Renaissance predecessor revivals, and broadened to include neo-Greek, was well established in both Europe and America as the dominant style. During the later eighteenth century, however, particularly in England, a Gothic revival had gained considerable momentum and continued to make headway during the first half of the nineteenth. It was accompanied by revivals of Renaissance and Baroque classicism, movements that produced a substantial part of the monumental architecture of the late nineteenth century and the early twentieth.

### NINETEENTH-CENTURY INDUSTRY AND ENGINEERING

New ideas in architecture emerged during the nineteenth century in the context of engineering, with the spread of industrialization and the utilization of novel building materials, notably iron, glass, and hollow ceramic tile. The use of iron for structural elements, although there are sporadic instances during the eighteenth century, became fairly common in English industrial building only after 1800. During the first half of the nineteenth century, concealed iron-skeleton structure was used in buildings of all types, and exposed columns and decorative iron-work appeared, particularly in non-traditional structures and notably in the Royal Pavilion at Brighton (figs. 45, 46). Iron was also used extensively in the many new railway bridges built throughout Europe

45. JOHN NASH. The Royal Pavilion, Brighton, England. 1815–23

46. JOHN NASH. Kitchen, The Royal Pavilion, Brighton, England. 1818–21

47. GUSTAVE EIFFEL. Truyère Bridge, Garabit, France. 1880–84

(see fig. 47). Roofs of iron and glass over commercial galleries or bazaars became popular in acceptance and ambitious in design during the first half of the nineteenth century, particularly in Paris. In greenhouses, iron was gradually substituted for wood in framing the glass panes, with a consequent enlargement of total scale. The Jardin d'Hiver in Paris, designed by Hector Horeau in 1847 and since destroyed, measured 300 by 180 feet at the base and rose to a height of 60 feet. In works such as this originated the concept of the monumental all-glass-and-metal structure, of which Sir Joseph Paxton's Crystal Palace, created for the London Exposition of 1851, was the great exemplar (figs. 48, 49).

The sheds of the new railway stations, precisely because they were structures without tradition, provided the excuse for some of the most daring and experimental buildings in iron and glass. The Gare St-Lazare in Paris supplied Monet with a new experience in light, space, and movement. The use of exposed iron columns supporting iron and glass arches penetrated a few traditional structures, such as Henri Labrouste's Bibliothèque Ste-Geneviève (fig. 50). The use of stamped cast iron for decorative details resulted in a substantial development of prefabrication before 1850. For decades thereafter, however, in large part because of the didacticism of revival-oriented theorists in architecture, the structural and decorative use of cast iron declined. Only at the very end of the nineteenth century, with the new non-traditional style of art nouveau, did metal emerge once more as the architectural element on which much of twentieth-century architecture was to be based.

In architecture, as in the decorative arts, the latter half of the nineteenth century often represented a low point in the history of taste. The classical and Gothic revivals of the early century had been largely superseded by elaborate Renaissance and Baroque revivals, of which the Paris Opéra (1861–74, fig. 51) was perhaps the supreme example. These remained, far into the twentieth century, the official styles for public and monumental buildings. Residential or domestic architecture was characterized by a melange of historic styles and by shoddy construction in the mass tenement housing that followed the large-scale growth of cities during the Industrial Revolution.

The enormous expansion of machine production during the later eighteenth and the nineteenth centuries required the development of mass consumption for the new or more cheaply manufactured products. From this need for a mass market there arose early in the nineteenth century the credo of much modern advertising: that only the most ornate, the most unoriginal, and the most vulgar products would sell. By the time of the London Exposition of 1851, the vast array of manufactured objects exhibited in Paxton's daring glass and metal Crystal Palace represented and even flaunted the degeneration of taste brought on by the emergence of a machine economy.

The explanation for this degeneration is not easy to determine, and probably no single explanation is entirely adequate. To a romantic nineteenth-century reformer like William Morris the answer was simple: it was the curse of the machine, destroying the values of individual craftsmanship on which the high levels of past artistic achievement had rested. However, the machine of the nineteenth century, like the computer of today, could not exist and function independent of human control. There is no question that the manufacturer and designer of the most gruesome Victorian textiles and porcelains saw in these the same beauty as did the customer who was also attracted by the modest cost. At least, there was little qualitative difference in the home environment of the wealthy manufacturer and his humble customer. William Morris, poet, painter, designer, and social reformer, fought a rear-guard action against the rising tide of commercial vulgarization. In attempting to find the answer by turning back the clock and reviving the craft traditions of the Middle Ages, he was involved in a romantic fallacy that was actually a part of the academic, eclectic, revivalistic tradition he was attacking. Although Morris's solutions may be criticized as being in themselves derivative, the question was not so much derivation as taste, discrimination, and a sense of quality.

## DOMESTIC ARCHITECTURE IN ENGLAND AND THE UNITED STATES

Taste, discrimination, and a sense of quality mark the style of Philip Webb (1831–1915), the architect whom Morris asked to design his own house at Bexley Heath, Kent, in 1869. In the domestic architecture of Webb and Richard Norman Shaw (1831–1912) in England, as well as of H. H. Richardson (1838–1881) and Stanford White (1853–1906) in the United States, many of the first steps toward a rational architecture were achieved. Morris's home, The Red House (fig. 52), in accordance with his desires, was generally Gothic in design, but Webb interpreted his mandate freely. Into a simplified,

48. Sir Joseph Paxton. Crystal Palace, London. 1851

49. Sir Joseph Paxton. Interior,
Crystal Palace, London. 1851

traditional, red-brick, pitched-roof Tudor Gothic manor house he introduced exterior details of classic Queen Anne windows, oculi, and a Moorish-arch entryway. The total effect of the exterior is of harmony and compact unity, despite the disparate elements. The plan is an open L-shape with commodious, well-lit rooms arranged in an easy and efficient asymmetrical pattern.

Webb's town and country houses continued to demonstrate a harmonious wedding of stylistic borrowing with functional planning that anticipated concepts of twentieth-century experimental architecture. In Shaw's developed style, exemplified by the house at No. 170 Queen's Gate, London, 1888, the architect resolutely turned back to the elegant tradition of the English eighteenth-century town house. What appealed to him in this prototype was the simplicity and clarity of proportion of the many-windowed facade that helped create an airy, livable interior of light and spacious proportions.

The same ideals seem to have motivated Richardson and White in their American domestic architecture, which also was rooted in historic styles. Aware of Shaw's experiments, Richardson yet developed his own style, which fused native American traditions with those of medieval Europe. The Stoughton-Hurlbut house, Cambridge, Massachusetts, 1883 (fig. 53), is one of his

most familiar houses in the shingle style then rising to prominence on the Eastern Seaboard. The main outlines are reminiscent of Romanesque and Gothic traditions, but these are architecturally less significant than the spacious, screened entry and the extensive windows, which suggest his concern with the livability of the interior. The unornamented shingled exterior wraps around the main structure of the house to create a sense of simplicity and unity that takes it out of a particular time and place.

Although Stanford White, the most influential and talented designer for the firm of McKim, Mead and White, was in some degree responsible for the hold that academic classicism had on American public architecture for a half century, no one can deny his abilities. In his domestic architecture he realized the quality of American colonial building and, like Shaw and Webb, was able to select with taste the historic or geographic style that best suited the particular site or problem. The W. G. Low house, Bristol, Rhode Island, 1887 (fig. 54), a superb example of the shingle style, is revolutionary in contrast to the customary enormous, fashionable, and eclectic monstrosities familiar to Newport, Rhode Island. Although something like a greatly enlarged Swiss chalet, the Low house can nevertheless be compared with twentieth-century experimental architecture in its essential lack of historical association. The extensive porch and the many-windowed facade give it an effect of openness, and the all-encompassing pitched roof serves as a unifying factor.

The history of twentieth-century architecture is rooted in nineteenth-century technology—experiments in iron or steel, first used in the new bridges required by the expansion of rail communications; new types of structures, such as railway stations, department stores, and exhibition halls, which were without tradition and lent themselves to the large-scale use of metal-framed areas of glass. However, many of the most revolutionary concepts —of utility, of commodiousness, of beauty arising from undecorated formal relations, of structures without a

50. Henri Labrouste. Reading Room,
Bibliothèque Ste-Geneviève, Paris. 1843–50

51. CHARLES GARNIER. L'Opéra, Paris. 1861–74

52. PHILIP WEBB and WILLIAM MORRIS. The Red House,
Bexley Heath, Kent, England. 1859–60

debt to historic styles, of forms that followed functions
—were first conceived on the relatively modest scale of
individual houses and small industrial buildings. The pio-
neer efforts of Webb and Shaw in England and of Rich-
ardson and White in the United States were followed by
the important experimental housing of Charles F. Voy-
sey, Arthur H. Mackmurdo, and Charles Rennie Mackin-
tosh in the British Isles, and in the United States by the
revolutionary house designs of Frank Lloyd Wright.

Charles F. Voysey (1857–1941), through his wallpa-
pers and textiles, had an even more immediate influence
on Continental art nouveau than did the arts-and-crafts
movement of William Morris. The furniture he designed
had a rectangular, classical form and a lightness of pro-
portion that anticipated the better Bauhaus furniture.
The principal influence on Voysey's architecture was Ar-
thur H. Mackmurdo (1851–1942), who, in structures
such as his own house and his Liverpool exhibition hall,
went beyond Shaw and Webb in the creation of a style
that eliminated almost all reminiscences of English eigh-
teenth-century architecture. A house by Voysey in Bed-
ford Park, dated 1891 (fig. 55), is astonishingly original
in its abstract rhythms of grouped windows and door
openings against broad, white areas of unadorned walls.
In his later country houses he returned, perhaps at the
insistence of clients, to suggestions of more traditional
Tudor and Georgian forms. He continued to treat these,
however, in a ruggedly simple manner in which plain
wall masses were lightened and refined by articulated
rows of windows.

Glasgow, principally in the person of Charles Rennie
Mackintosh (1868–1928), was one of the most remark-
able centers of British architectural experiment at the
end of the nineteenth century. Mackintosh's most con-
siderable work of architecture, created at the beginning
of his career, is the Glasgow School of Art, 1898–99, and
its library addition, built 1907–09 (figs. 56, 57). The es-
sence of this building is simplicity, clarity, monumental-
ity, and, above all, an organization of interior space that
is not only functional but highly expressive of its function.
The huge, rectangular studio windows are imbedded in

53. HENRY HOBSON RICHARDSON. Stoughton-Hurlburt House,
Cambridge, Massachusetts. 1883

the massive stone facade, creating a balance of solids and
voids. The rectangular heaviness of the walls, softened
only by an occasional curved masonry element, is light-
ened by details of fantasy, particularly in the iron-work,
that show a relationship to art nouveau. The library addi-
tion is a large, high clerestory room with surrounding
balconies. Rectangular beams and pillars are used to cre-
ate a series of views that become three-dimensional, geo-
metric abstractions.

The same intricate play with interior vistas seen in the
library of the Glasgow School of Art is apparent in the
Cranston Tearoom in Ingram Street, 1897–98, 1907–11
(fig. 58), in which most details of the interior design,
furniture, and wall painting are the products of both
Mackintosh and his wife, Margaret Macdonald. The
stripped-down rectangular partitions and furniture, and
the curvilinear figure designs on the walls, illustrate the
contrasts that form the full spirit of art nouveau. The
decorations are close to the developed paintings of Gus-

tav Klimt (see p. 76) and the Vienna Secession, and in fact may have anticipated and influenced them. Mackintosh did exhibit with the Vienna Secession in 1900, and his architectural designs, furniture, glass, and enamels created a sensation.

After 1900, the architectural leadership that England had assumed, particularly through designs for houses and smaller public buildings by Shaw, Webb, Voysey, and Mackintosh, declined rapidly. In the United States, Frank Lloyd Wright and a few followers carried on their spectacular experiments in detached domestic architecture. However, for many years even Wright himself was given almost no large-scale building commissions. The pioneer efforts of Louis Sullivan (1856–1924) and the Chicago school of architects came to a dead stop in the face of the massive triumph of the Beaux-Arts tradition of academic eclecticism, which was to dominate American public building for the next thirty years.

## THE CHICAGO SCHOOL.
## THE ORIGINS OF THE SKYSCRAPER

Modern architecture may be said to have emerged in the United States clothed in Romanesque trappings in the works of H. H. Richardson. In his Marshall Field Wholesale Store (fig. 59), now destroyed, Richardson combined an effect of monumental mass achieved through the use of graduated rock-faced blocks of red Missouri granite and brownstone, and the extreme openness of the fenestration. The windows, arranged in continuously diminishing arcaded rows that mirror the gradual narrowing of the masonry wall from ground to roof, are integrated with the interior space rather than being simply holes punched at intervals into the exterior wall. Although Romanesque in its feeling of mass and stability, the Marshall Field building, with its ornamental details kept to a minimum, was actually a building without a style in a traditional sense—a prototype of and a direct influence on the Chicago school of modern architecture.

The progressive influence of Richardson on American architecture was counteracted after his death as more and more young American architects studied in Paris in the academic environment of the Ecole des Beaux-Arts. In particular, the energetic firm of McKim, Mead and White established a classical hold on public American building that has not yet been entirely shaken off. Collaborating with the Chicago firm of Burnham and Root, Charles Follen McKim designed the 1893 Chicago World's Fair as a vast and highly organized example of quasi-Roman city planning. The gleaming white colonnades of the World's Fair buildings (see fig. 60) affected a generation of architects and clients, and undoubtedly retarded the progress of experimental architecture in America by the same span of time.

At the moment that they were being in some degree superseded in the design of the Fair, Burnham and Root were working in Chicago on two of the most important early skyscrapers, the Monadnock Building (fig. 62) and the Reliance Building (fig. 63). Throughout the nineteenth century, continual expansion and improvement in the production of structural iron and steel permitted raising the height of commercial buildings, a necessity born of growing urban congestion, and, at the same time, there were sporadic experiments in increasing the scale of windows beyond the dictates of Renaissance palace facades. Chicago in 1870 was a city without architectural style or distinction and filled with hastily built balloon-frame wood construction. A vast proportion of the building was destroyed in the great fire of 1871—an event that cleared the way for a new type of metropolis utilizing the new techniques and materials of building developed in Europe and America over the previous hundred years.

The Home Insurance Building in Chicago (fig. 61), designed and constructed between 1883 and 1885 by the architect William Le Baron Jenney, was only ten stories high, no higher than other proto-skyscrapers already built earlier in New York. Its importance rested in the fact that it embodied true skyscraper construction in which the internal metal skeleton carried the weight of

54. STANFORD WHITE. W. G. Low House, Bristol, Rhode Island. 1887

55. CHARLES F. VOYSEY. The Forster House,
Bedford Park, London. 1891

56. CHARLES RENNIE MACKINTOSH. Facade,
School of Art, Glasgow. 1898–99

57. CHARLES RENNIE MACKINTOSH. Library,
School of Art, Glasgow. 1907–09

the external masonry shell. This innovation, although Jenney did not himself develop it further, together with the development of the elevator, paved the way for the indefinite extension of the height of commercial buildings and the creation of the world of the skyscraper. In the Tacoma Building (fig. 64), erected in 1887–89, the young architectural firm of Holabird and Roche carried the main facades entirely on the metal skeleton, and, using a minimum of brick and terra-cotta sheathing, clearly expressed the nature of the construction. Burnham and Root's Reliance Building, completed in 1894, illustrated the architects' understanding of the implications of metal-frame construction through the elimination of walls and the opening up of the facades as a glass box in which solid, supporting elements were, for that time, reduced to a minimum. The concept of the twentieth-century skyscraper as a glass-encased shell framed in a metal grid was here stated for the first time.

Among the many architects attracted to Chicago from the East or from Europe by the opportunities engendered by the great fire was the Dane Dankmar Adler. He was joined in 1879 by a young Boston architect, Louis Sullivan; and in 1887 the firm of Adler and Sullivan hired a twenty-year-old draftsman, Frank Lloyd Wright (1867–1959). Adler and Sullivan entered the field of skyscraper construction in 1890 with their Wainwright Building in St. Louis (fig. 65). In the Wainwright Building Sullivan attacked the architectural problem of skyscraper design by emphasizing verticality: the pilasters that separate the windows are uninterrupted through most of the building's height. At the same time he seemed already to have been aware of the peculiar design problem involved in the skyscraper, which is actually a tall building consisting of a large number of superimposed horizontal layers. Thus he accentuated the individual layers with ornamented bands under the windows and throughout the attic story,

58. CHARLES RENNIE MACKINTOSH. Miss Cranston's Tearoom in Ingram Street, Glasgow. 1897–98, 1907–11

61. WILLIAM LE BARON JENNEY. Home Insurance Building, Chicago (demolished 1929). 1883–85

59. HENRY HOBSON RICHARDSON. Marshall Field Wholesale Store, Chicago (demolished 1930). 1885–87

60. D. H. BURNHAM and C. F. McKIM. World's Fair, Chicago. 1893

62. BURNHAM and ROOT. Monadnock Building, Chicago. 1891

63. BURNHAM and ROOT.
Reliance Building, Chicago. 1890–94

frieze the treatment of windows and walls is rectangular and austere. The windows are large, divided in the Chicago style into a large central fixed pane and narrow side panels that can be opened. The emphasis is horizontal rather than vertical, with the horizontal layers wrapping around the facades to accentuate the stratification of the interior space.

Although the Chicago school of architecture maintained its vitality into the first decade of the twentieth century, the neo-academic styles were gaining in strength. Not only were they to invade all public buildings and most domestic housing; they were also to conceal the structure of commercial skyscrapers in trappings of Gothic or neo-classical ornament. The higher the skyscraper rose, particularly in New York, the more it lost the clarity of form and lucid statement of function that marked its inception in the Chicago school. By 1913, Cass Gilbert's Woolworth Building (fig. 68) loomed 792 feet—fifty-two stories of Late Gothic stone sheathing serving no purpose but to add weight and to disguise its metal-case construction frame. Still, as has been suggested, modern skyscraper architecture emerged largely from developments in America. Developments on the Continent will be discussed in a later chapter.

and crowned the building with a projecting cornice that brings the structure back to the horizontal.

In the Guaranty Trust Building (now the Prudential Building) in Buffalo, New York (fig. 66), Sullivan designed the first masterpiece of the early skyscrapers. The treatment of the columns on the ground floor emphasizes the openness of the interior space. The delicate pilasters between the windows soar almost the height of the building and then join under the attic story in graceful arches that tie the main facades together. The oval, recessed windows of the attic are lighter and more open than in the Wainwright Building, and blend into the elegant curve of the summit cornice. Sullivan's famed ornament covers the upper part of the building in a light, over-all pattern, both helping to unify the facade and emphasizing the nature of the terra-cotta sheathing over the metal skeleton as a weightless, decorative surface rather than a bearing member.

The last of Sullivan's great commercial buildings was the Carson Pirie Scott Department Store in Chicago (fig. 67), built in two stages, 1899–1901 and 1903–04. In this building the ornament (perhaps the major American contribution to international art nouveau) is confined largely to an allover stamped metal decorative frieze spreading the length of the first two stories. Above this

64. HOLABIRD and ROCHE.
Tacoma Building, Chicago. 1887–89

65. LOUIS SULLIVAN. Wainwright Building,
St. Louis, Missouri. 1890–91

67. LOUIS SULLIVAN. Carson Pirie Scott and
Company Department Store, Chicago. 1899–1901, 1903–04

66. LOUIS SULLIVAN. Guaranty Trust Building
(now Prudential Building), Buffalo, New York. 1894–95

68. CASS GILBERT. Woolworth Building,
New York. 1913

# The Origins
# of Modern Sculpture

In the twentieth century, sculpture has emerged as a major art for the first time since the seventeenth. Its development in the last sixty years has been even more remarkable than that of painting. The painting revolution was achieved against the background of an unbroken great tradition extending back to the fourteenth century. In the nineteenth century, despite the prevalence of lesser academicians and the substantial role they played, painting was the great visual art, producing during its first seventy-five years such artists as Goya, Blake, David, Ingres, Géricault, Delacroix, Constable, Turner, Corot, Courbet, and Manet. The leading names in sculpture during this same period were Canova, Thorwaldsen, Rude, David d'Angers, Barye, Carpeaux, Dalou, Falguière, and Meunier. Of these, perhaps only Canova and Carpeaux have continuing reputations. The sculpture of Daumier, now much admired, was a private art, little known or appreciated until its recent "discovery."

The eighteenth century also was an age of painting rather than sculpture. During that century, only the sculptor Jean-Antoine Houdon may be compared with such painters as Watteau, Boucher, Fragonard, Guardi, Tiepolo, or Goya. The seventeenth century was the last great age of sculpture before the twentieth century and then principally in the person of the Baroque sculptor, Bernini. In the United States, with the exception of one or two men of originality and competence, such as Augustus St. Gaudens, sculptors were secondary figures from the beginning of its history until well into the twentieth century.

When we consider the dominant place that sculpture has held in the history of art from ancient Egypt until the seventeenth century of our era, this decline appears all the more remarkable. The decline was not for want of patronage. Although the eighteenth century provided fewer large public commissions than the Renaissance or the Baroque, the nineteenth century saw mountains of sculptural monuments crowding the parks and public squares or adorning the architecture of the period. By this time, however, academic classicism had achieved such a rigid grip on the sculptural tradition that it was literally impossible for a sculptor to gain a commission or even to survive unless he conformed. The experimental painter could usually find a small group of enlightened private patrons, but for the sculptor the very nature of his medium and the tradition of nineteenth-century sculpture as a monumental and public art made this difficult.

## AUGUSTE RODIN (*1840–1917*)

This was the situation until the third quarter of the century, when Auguste Rodin emerged on the scene in Paris. It was Rodin's achievement to have recharted the course of sculpture almost single-handed and to have given the art an impetus that was to lead to a major renaissance. There is no one painter, not even Courbet, Manet, Monet, Cézanne, Van Gogh, or Gauguin, who occupies quite the place in modern painting that Rodin occupies in modern sculpture. He began his revolution, as had Courbet in painting, with a reaction against the sentimental idealism of the academicians, using as an avenue the closest return to nature. His *Man with the Broken Nose* (fig. 69) was rejected by the official Salon as being offensively realistic. His re-examination of nature was coupled with a re-examination of the art of the Middle Ages and the Renaissance—most specifically, of Donatello and Michelangelo. Although much of academic sculpture paid lip service to the High Renaissance, it was the Renaissance seen through centuries of imitative accretions that largely concealed the original works. Rodin looked at Donatello and Michelangelo as though they were masters of his own time to whom he was apprenticed, and thus he achieved the anomaly of turning their own gods against the academicians.

Rodin's achievement in the liberation of modern sculpture was one of degree rather than of kind. It is possible to find prototypes or analogues among his contemporaries for his treatment of subject matter, space, movement, light, and material. In no other sculptor of the nineteenth century, however, are all the elements and

69. AUGUSTE RODIN. *Man with the Broken Nose, Mask.*
1864. Bronze, height 12¼".
The Joseph H. Hirshhorn Collection

*far left:* 70. AUGUSTE RODIN.
*The Age of Bronze.* 1876.
Bronze, height 71".
The Minneapolis Institute of Arts.
John R. Van Derlip Fund

*left:* 71. AUGUSTE RODIN.
*St. John the Baptist Preaching.*
1878–80. Bronze, height 78¾".
The Museum of Modern Art, New York.
Mrs. Simon Guggenheim Fund

problems of sculpture attacked with comparable energy, imagination, and invention. In no other sculptor of his time can be found such brilliant solutions.

The basic subject for sculpture from the beginning of time until the twentieth century had been the human figure. It is in terms of the figure, presented in isolation or in combination, in action or in repose, that sculptors have explored the elements of sculpture—space, mass, volume, line, texture, light, and movement. Among these elements, volume and space and their interaction have traditionally been their primary concern. There may be observed in the development of classic, medieval, or Renaissance and Baroque sculpture similar progressions from archaic frontality to final solutions in which the figure is stated as a relatively coherent mass revolving in surrounding space, and, to some degree, interpenetrated by it. The greater sense of spatial existence in Hellenistic, Late Gothic, or Baroque sculpture inevitably involved an increase of implied movement, achieved by a twisting pose, extended gesture, or, frequently, by a broken, variegated surface texture whose light and shadow accentuated the feeling of transition or change.

The Baroque feeling for spatial existence and movement was part of the nineteenth-century sculptural tradition, particularly in the monumental works of Carpeaux and Dalou; and Rodin was in possession of the full range of historic sculptural forms and techniques by the time he returned from his brief visit to Italy in 1875. The *Man with the Broken Nose* of 1864, in fact, was already a mature and accomplished work suggesting the intensity of the artist's approach to subject as well as his uncanny ability to suggest simultaneously the malleable properties of the original clay and the light-saturated tensile strength of the final bronze material.

*The Age of Bronze* (fig. 70), Rodin's first major signed work, was accepted in the Salon of 1877, but its seeming scrupulous realism led to the suspicion that it might have been in part cast from the living model. Although Rodin had unquestionably observed the model closely from all angles and was concerned with capturing and unifying the essential quality of the living form, he was also concerned with the expression of a tragic theme, inspired perhaps by his reaction to the war of 1870, and expressed through the concept of a vanquished hero based firmly on the *Dying Slave* of Michelangelo. The influence of Michelangelo and more specifically of Donatello is evident in many of Rodin's early works. *St. John the Baptist Preaching* (fig. 71), and the related works, *The Walking Man* (fig. 72) and *Torso: Study for The Walking Man,* clearly derive from late works of Donatello in their intensity of spirit even more than in their adaptation of specific shapes or gestures. *The Walking Man* and the *Torso* were ultimately finished for Salon presentation as *St. John the Baptist Preaching.* To Rodin, however, they were primarily exercises in movement, figures through whose aggressive, striding pose or tilted torso he studied and expressed incomparably the full and varied muscular implications of the simple act of walking. Whereas the suggestion of movement, frequently violent and varied, was an essential part of the repertory of academic sculpture since the Late Renaissance, its expression in nineteenth-century sculpture normally took the form of a sort of tableau of frozen movement, as though the protagonists were acting out a scene as "living sculpture." Rodin studied his models in constant motion, in changing positions and attitude, as though he were seeing the act of motion for the first time. Thus, every gesture and transitory change of pose

72. AUGUSTE RODIN. *The Walking Man*. 1905.
Bronze, height 83¾". The Joseph H. Hirshhorn Collection

became part of his vocabulary. As he passed from this concentrated study of nature to the expressive and even impressionist later works, his most melodramatic subjects and most violently distorted poses were given credibility by their secure basis in observed nature.

In 1880 Rodin received a commission for a portal to the proposed museum of decorative arts in Paris. He conceived the idea of a free interpretation of scenes from Dante's *Inferno*. He had already made drawings based on Dante, and liked the idea of developing the theme, partially as a means of composing in masses of small, nude figures, to demonstrate his control of his medium. The innuendos about *The Age of Bronze* still rankled. Out of his ideas emerged *The Gates of Hell* (fig. 73), left unfinished at his death in 1917; but still it is one of his great masterpieces, and one of the masterpieces of nineteenth- and twentieth-century sculpture. They were not cast in bronze in their unfinished state until the late 1920s. As they exist today, *The Gates* are an imperfect work of art, not only because not completed, but also, perhaps, because they could never have been completed. Rodin was unable to plan and organize *The Gates* either iconographically or as a total design. Basing his ideas loosely on individual themes from the *Divine Comedy* of Dante but utilizing ideas from the poems of Baudelaire, which he greatly admired, Rodin built, from isolated figures, groups or episodes with which he experimented at random over more than thirty years. *The Gates* suffer from their very fertility of ideas and from the variety of the forms with which they are crammed. Saturated as they are with literary symbolism to the point where they

almost cease to exist as any sort of sculptural totality, they nevertheless contain a vast repertory of forms and images that the sculptor developed in this context and then adapted to other uses (and sometimes vice versa). The turbulence of the subjects involved inspired him to the exploration of expressionist violence in which the human figure was bent and twisted to the limits of endurance although with remarkably little actual naturalistic distortion.

The violent play on the human instrument seen here was a natural preamble to the expressionist distortions of the figure developed in the twentieth century. An even more suggestive preamble is to be found in the basic concept of the subject of *The Gates*—the concept of flux or metamorphosis, in which the figures emerge from or sink into the matrix of the bronze itself, are in the process of birth from, or death and decay into, a quagmire that both liberates and threatens to engulf them. Essential to the suggestion of change in *The Gates* and in most of the mature works of Rodin is the exploitation of light. A play of light and shadow moves over the peaks and crevasses of bronze or marble, becoming analogous to color in its creation of movement, of growth and dissolution, and thus of the essence of life itself. If there is any unifying element it is light.

Although Rodin, in the sculptural tradition that had persisted since the Renaissance, was first of all a modeler, starting with clay and then transforming the clay model into plaster and bronze, many of his most admired works are in marble. These also were normally based on clay and plaster originals, with much of the carving, as was customary, done by assistants. However, there is no question that Rodin himself closely supervised the work and finished the marbles with his own hand. His great feeling for the material is evident in the fact that he treated his marbles, even of the same subjects, in a manner entirely different from that which he used for bronzes. The marbles were handled with none of the expressive roughness of the bronzes (except in deliberately unfinished areas), and without deep undercutting. He paid close attention to the delicate, translucent, sensuous qualities of the marble, which in his later works he increasingly emphasized—inspired by unfinished works of Michelangelo—by contrasting highly polished flesh areas with masses of rough, unfinished stone. In this utilization of the raw material of stone for expressive ends, as in his use of the partial figure, the torso—obviously first suggested by fragments of ancient sculptures—Rodin was initiating the movement away from the human figure as the prime medium of sculptural expression. All his sculptures are rooted in the closest possible observation of the model, but the seeds of its destruction were growing in his very obsession with nature.

Many of the figures formulated for *The Gates of Hell* are at least equally famous as individual sculptures. *The Thinker* (Dante?), and also *Eve* and *The Three Shades* (figs. 74–76) all emerged as separate entities, and all show Rodin most specifically under the influence of Michelangelo. The tragedy and despair of *The Gates* are perhaps best summarized in *The Old Courtesan* (fig. 77) —supposedly inspired by a poem by François Villon but actually a sensitive study of an aged Italian woman, for-

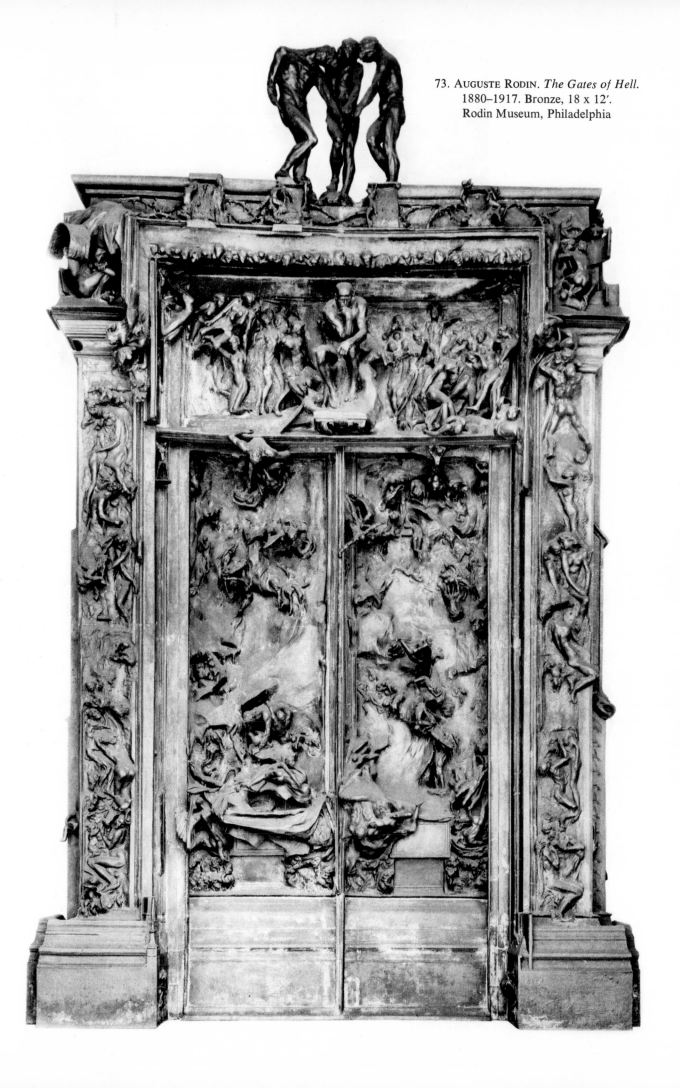

73. AUGUSTE RODIN. *The Gates of Hell.*
1880–1917. Bronze, 18 x 12'.
Rodin Museum, Philadelphia

*right:* 74. AUGUSTE RODIN.
*The Thinker.* 1880. Bronze, height 79″.
Rodin Museum, Paris

*far right:* 75. AUGUSTE RODIN.
*Eve.* 1881. Bronze, height 67¾″.
The Toledo Museum of Art.
Gift of Edward Drummond Libbey, 1952

merly a model—and the two figures known in their separate manifestations as *The Prodigal Son* and *The Crouching Woman.* *The Prodigal Son* is conceived as a single cry of despair expressed in one sweeping gesture of the entire figure. *The Crouching Woman* (fig. 78) looks at first glance like an extreme of anatomical distortion. Actually there is little distortion involved, and the pose, which could have been ugly or ludicrous, attained in Rodin's hands a beauty that is rooted in intense suffering. The figure, a compact, twisted mass, is wonderfully realized in surrounding space. The powerful diagonals, the enveloping arms, the broken twist of the head, all serve both an expressive and a formal purpose, emphasizing the agony of the figure and carrying the eye around the mass in a series of integrated views.

In the *Iris* (fig. 79) the artist achieved an even greater violence of pose, bringing the sensuality that characterizes so many of the later figures to the point of brutality. The headless, one-armed torso, by its maimed, scarred, and truncated form, reaches a climax of vitality. The *Iris* is probably a sketch, but one that reaches a completeness to which nothing could be added.

Rodin's portrait sculptures represent a chapter in themselves in their search for personality or for symbolic statement. Even in his figure sculpture Rodin felt that what differentiated his works from those of the Greeks was his search for the psychology of the individual human being rather than simply the logic of the human body. The *Balzac* (fig. 80) in its final form was an exploration of the nature of genius expressed by means of sculptural impressionism. The many preliminary versions (fig. 81), on the contrary, represented various attempts

to re-create Balzac's appearance and personality; and gradually, from these more or less finished sketches and studies, he approached a generalized statement. The final *Balzac,* whether or not it is a success as pure sculptural form, is perhaps the closest approximation of nineteenth-century sculpture to pure abstract symbol.

If, among Rodin's sculptures, the *Balzac* most closely approximates some of the ideals of twentieth-century expressionist sculpture, *The Burghers of Calais* (fig. 82) sums up most successfully his transformation of the past into a monument that becomes both contemporary and personal. The debt of *The Burghers of Calais* to the fourteenth- and fifteenth-century sculptures of Claus Sluter and Claus de Werve is immediately apparent, but this influence has been combined with an assertion of the dignity of the common man analogous to the nineteenth-century sculptures of Constantin Meunier. The rough-hewn faces, powerful bodies, and the enormous hands and feet transform these burghers into laborers and peasants and at the same time enhance their power. Rodin's tendency to dramatic gesture is apparent here, and the theatrical element is emphasized by the unorthodox organization, with the figures scattered about the base like a group of stragglers wandering across a stage. The informal, open arrangement of the figures is one of the most daring and original aspects of the sculpture. It is a direct attack on the classical tradition of closed, balanced groupings for monumental sculpture. The detached placing of the masses gives the intervening spaces an importance that, for almost the first time in modern sculpture, reverses the traditional roles of solid and void, of mass and space. Space not only surrounds the figures but inter-

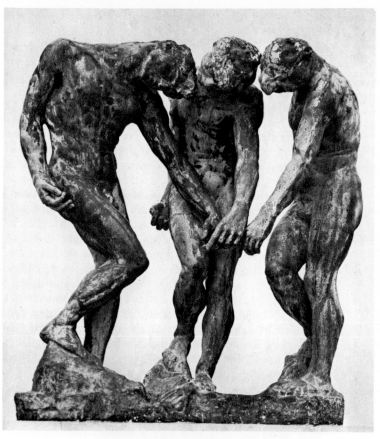

76. AUGUSTE RODIN. *The Three Shades.*
1880. Bronze, height 75½".
Lincoln Park, San Francisco

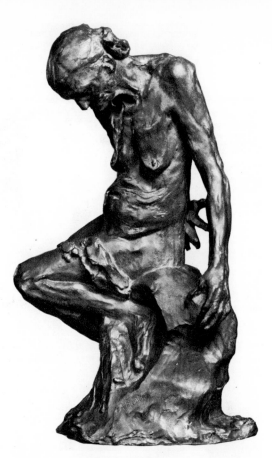

77. AUGUSTE RODIN. *The Old Courtesan.* 1885.
Bronze, height 19¾". The Metropolitan Museum
of Art, New York. Gift of Thomas F. Ryan, 1910

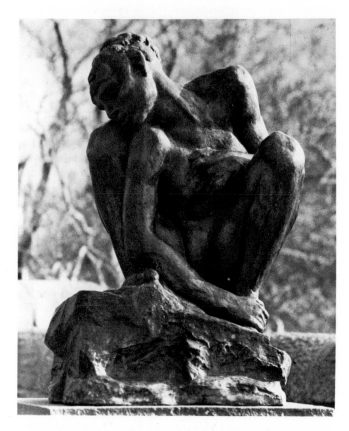

78. AUGUSTE RODIN. *The Crouching Woman.* 1880–82.
Bronze, height 33¾". The Joseph H. Hirshhorn Collection

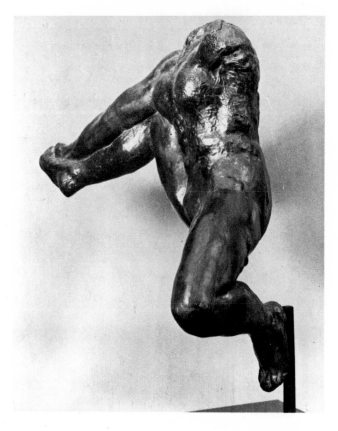

79. AUGUSTE RODIN. *Iris.* 1890–91. Bronze, height 33".
The Joseph H. Hirshhorn Collection

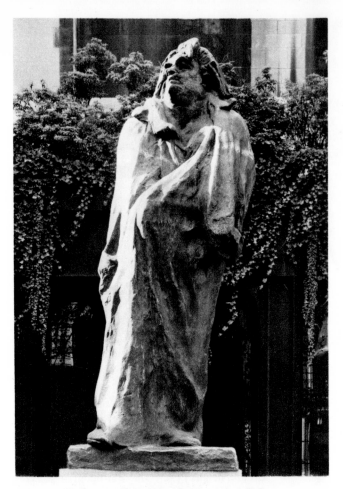

80. AUGUSTE RODIN. *Monument to Balzac.*
1897. Bronze, height 9′ 3″.
The Museum of Modern Art, New York

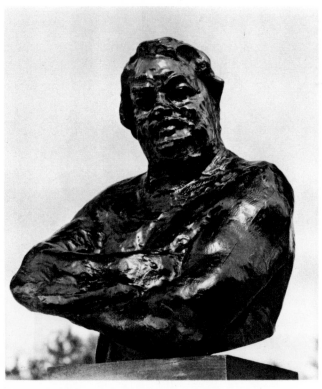

81. AUGUSTE RODIN. *Bust of Balzac.* 1893–95.
Bronze, height 18¼″. The Joseph H. Hirshhorn Collection

penetrates the group to create a balance anticipating some of the most revolutionary innovations of twentieth-century sculpture.

## ARISTIDE MAILLOL *(1861–1944)*

The other French sculptors who may be classified as pioneers of twentieth-century sculpture—Aristide Maillol, Antoine Bourdelle, and Charles Despiau—represent opposition to Rodin in their attempts to preserve but at the same time purify the classical ideal. Maillol concentrated his whole attention on this restatement of classicism, stripped of all the academic accretions of sentimental or erotic synthetic idealism, and brought down to earth in the homely actuality of his peasant models. Concentrating almost exclusively on the subject of the single female figure, standing, sitting, or reclining, and usually in repose, he stated over and over again the fundamental thesis of sculpture as integrated volume, as mass surrounded by tangible space. At the same time the nudes of Maillol always contain the breath of life, a healthy sensuousness that reflects the living model rather than any abstract classical ideal.

Maillol began as a painter and tapestry designer, and was almost forty when, alarmed because of a dangerous eye disease, he decided to change to sculpture. Beginning with wood carvings that had a definite relation to his paintings and to the nabi and art nouveau environment in which he had been working at the turn of the century, he soon moved to clay modeling and developed a mature style that changed little throughout his long and productive life. *The Mediterranean* (fig. 83) and *Night* (fig. 84) are two of his first sculptures and two masterpieces that summarize his achievement. Both are massive, seated female nudes, magnificently integrated as curving volumes in space, almost textbook examples of the classic definition of sculpture. At the same time, in their quality of withdrawal, of relaxed and composed reserve, they approximate the spirit of Greek sculpture of the fifth century B.C., the Phidian ideal of classic art, to a degree rarely equaled since that time. Maillol could attain to an art of movement much more particularly dynamic, as in *Action in Chains* (fig. 87), and even more effectively, late in his life, in *The River* (fig. 85), a work which may have been affected by the late paintings and the sculptures of Renoir. He could also, being an economical artist, repeat the same subject over and over again, as a complete figure or variously segmented torso with or without drapery, varying the title in accordance with the particular commission. Although he rarely attempted the subject of the male nude, his *Young Cyclist* (fig. 86) is a work of great sensitivity and importance, in its lean and youthful realism the ancestor of the expressive wing of twentieth-century figurative sculpture. In his portrait of Renoir (fig. 88) he departed also from his formula of classical generalization to demonstrate the degree to which his classicism was based on close observation of nature. Maillol was a superb sculptural draftsman, and his woodcuts, illustrating fine editions of poems by Vergil, Ovid, and Horace (see fig. 89), helped to reestablish the art of the book in Europe during the 1920s and 1930s.

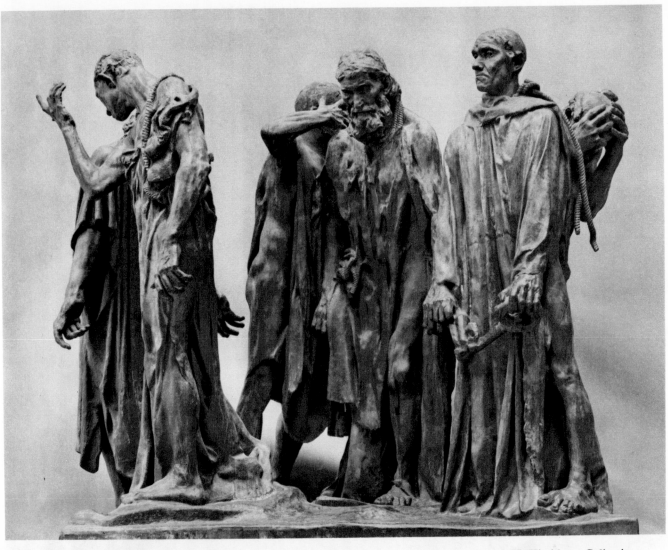

82. AUGUSTE RODIN. *The Burghers of Calais.* 1884–88. Bronze, 85 x 98 x 78″. The Joseph H. Hirshhorn Collection

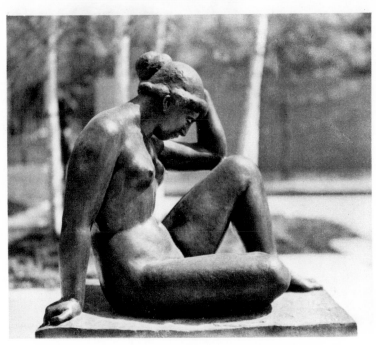

83. ARISTIDE MAILLOL. *The Mediterranean.* c. 1901.
Bronze, height 41″. The Museum of Modern Art, New York.
Gift of Stephen C. Clark

84. ARISTIDE MAILLOL. *Night.* 1902.
Bronze, height 41¾″.
Collection Dina Vierny, Paris

85. ARISTIDE MAILLOL. *The River*. c. 1939–43.
Lead, 53¾ x 90″. The Museum of Modern Art, New York.
Mrs. Simon Guggenheim Fund

86. ARISTIDE MAILLOL. *Young Cyclist*.
1907–08. Bronze, height 38⅝″.
Musée National d'Art Moderne, Paris

87. ARISTIDE MAILLOL. *Action in Chains*.
1906. Bronze, height 84⅝″.
Musée National d'Art Moderne, Paris

88. ARISTIDE MAILLOL. *Portrait Head of Renoir*.
1907. Bronze, height 16″. The Art Institute of Chicago.
Gift of Mrs. E. C. Chadbourne

89. ARISTIDE MAILLOL. *Shepherd Corydon,* from
the *Eclogues of Vergil.* 1912–14. Woodcut.
The Museum of Modern Art, New York. Henry Church Fund

## ANTOINE BOURDELLE *(1861–1929),*
## CHARLES DESPIAU *(1874–1926)*

Antoine Bourdelle, a student and assistant of Rodin, sought, like Maillol, to revitalize the classical tradition. His approach, however, involved an eclectic, somewhat archaeological return to the appearance of archaic and early fifth-century Greek sculpture, as well as of Gothic sculpture. A youthful portrait bust called *La Marquise* has a serenity that in feeling is both classic and reminiscent of eighteenth-century portraits. *The Warrior* (fig. 90), from the *Monument to the Fighters at Montauban,* represents the moment of greatest indebtedness to Rodin, and with all its immense power of gesture points to the danger of an attempt to out-Rodin Rodin. A more successful and individual adaptation is *Hercules the Archer* (fig. 91), the scarred modeling of whose powerful body recalls Rodin's *Thinker* translated into violent action. However, the organization of Hercules, who is braced against the rocks in a pose of fantastic effort, is essentially a profile, two-dimensional alternation of large areas of solid and void, possibly inspired by the Greco-Roman copy of the *Discobolus* by Myron. The archaistic Greek head of the *Hercules* further suggests a specific origin, although the figure is a curiously eclectic assimilation of an archaic head to a Hellenistic body. The *Head of Apollo* (fig. 92), used with slight variations in other contexts as well, is a more successful effort at archaism, a sensitive and somewhat romantic portrayal, whose scarred and broken surface suggests the influence both of fragmented Greek sculpture and of Rodin's bronzes.

Bourdelle's sculpture of the female nude is entirely different from Rodin's. The torso of the figure called *Pomona* (fig. 93) relates mass and spatial existence to a flowing, linear movement of contour. Although this

work and other female nude figures by Bourdelle may be compared with those of Maillol, they are always individual in their restless activity, which is attained by accenting moving outlines.

The most immediate inheritor of the Maillol tradition was Charles Despiau, a limited but sensitive artist. His figures have a repose and a withdrawn elegance that transcend Maillol's; and his portrait heads (see fig. 94) have a reticence achieved by the utmost simplification in modeling and the elimination of all extraneous details. In these portraits Despiau seems to have been smoothing away naturalistic details beyond the demands of classic idealism and toward the abstraction of Brancusi. But, his half-measures in simplification resulted in a generation of followers who were content with a sort of pseudo-modernism in which naturalistic simplification was equated with the basic transformation that was the essence of cubism and abstract sculpture.

## THE PAINTER-SCULPTORS:
## HONORE DAUMIER, EDGAR DEGAS,
## AUGUSTE RENOIR, MEDARDO ROSSO

One of the most conclusive symptoms of the revival of sculpture at the turn of the century was the large number of important painters who practiced sculpture—Gauguin,

90. ANTOINE BOURDELLE. *The Warrior.* 1900. Bronze,
height 70″. The Joseph H. Hirshhorn Collection

91. ANTOINE BOURDELLE. *Hercules the Archer.* 1909.
Bronze, 14¾ (without bow) x 24".
The Art Institute of Chicago. A. A. Munger Collection

assert a sculptural mass in a complex spatial interplay.

Renoir's sculptures, created toward the end of his life, mostly with the help of the sculptor Richard Guino, are even directly translations of, or improvisations on, his late paintings (figs. 100, 101). These paintings, however, since they strongly emphasize the modeling of the figures, are logical and natural subjects for translation; and the sculptures emerge as simplified, classically massive figures in repose or slow movement. The tradition is that of late antiquity, as seen also in Maillol's classic peasants. Maillol, in turn, may have been influenced by Renoir's paintings; the accent in both is on sculptural mass in repose rather than on space.

Medardo Rosso, born in Turin, Italy, in 1858, worked as a painter until 1880. After an unsuccessful term of study at the Accademia di Brera in Milan, from which he was dismissed in 1883, he lived in Paris for two years, worked in Dalou's atelier, and met Rodin. After 1889 he spent most of his active career in Paris, until his death in 1928, and thus was associated more with French sculpture than with Italian. In a sense, Rosso always remained a painter. Rodin, even in his most impressionist works, never entirely abandoned his sense of sculptural mass and form; thus it is wrong, perhaps, even to refer to him as an impressionist. Rosso, on the other hand, deliberately dissolved the sculptural forms until only an impression remained. His favorite medium, wax (see figs. 102, 103), allowed the most imperceptible transitions, so that

Degas, Renoir, and Bonnard among them. These were followed a little later by Picasso, Matisse, Modigliani, Braque, Derain, Léger, and others. Maillol and Medardo Rosso were both painters before they became sculptors. The pioneer painter-sculptor of the nineteenth-century was Honoré Daumier (1810–1879). Most of his wonderful, sculptured caricature heads (see fig. 95) were created between 1830 and 1832, and anticipate the late Rodin in the directness of their deeply modeled surfaces. His *Ratapoil* (fig. 96), a caustic caricature of Neo-Bonapartism, is a completely realized work of sculpture. The arrogance and tawdry elegance of the pose are presented in terms of spatial existence and movement in which the fluttering, light-filled flow of clothing is a counterpoise to the bony armature of the figure itself.

Daumier's sculpture was a prototype for the beginnings of modern sculpture but not an influence, since it was little known to the sculptors of the first modern generation. The same is true of the sculpture of Degas, most of which was never publicly exhibited during his lifetime. Degas was unquestionably the greatest of the late nineteenth-century painter-sculptors. His sculptures were concerned with the traditional formal problems of sculpture. Both his dancers and his horses (see figs. 97, 98) represent continual experiments in space and movement. The posthumous bronze casts retain the feeling of the original wax material, built up, layer by layer, to a surface in which every fragment of wax is articulated. The genre scenes, such as *The Masseuse* (fig. 99) seem at first to be curiously transitional between genre painting and sculpture. On closer analysis, however, they also

92. ANTOINE BOURDELLE. *Head of Apollo.* 1900.
Bronze, height 16½". The Joseph H. Hirshhorn Collection

93. ANTOINE BOURDELLE. *Torso of Figure Called Fruit (Pomona)*. 1911. Bronze, height 34⅜".
The Joseph H. Hirshhorn Collection

94. CHARLES DESPIAU. *Jeanne (Mlle. Jeanne Kamienska)*.
1921. Bronze, height 15".
The Joseph H. Hirshhorn Collection

it becomes difficult to tell at exactly what point the wax becomes face or figure. Form is dissolved into amorphous shape and light-filled, vari-textured surface. The subjects themselves—detailed genre scenes and conversation pieces reminiscent of paintings by Edouard Vuillard—stretch the limits of traditional sculpture. Still, in his freshness of vision, his ability to catch and record the significant moment, Rosso added a new dimension to sculpture and anticipated the search for immediacy that characterizes so much of the experimental sculpture of our day.

# Symbolism and Synthetism in Painting

The formulation of modern art at the end of the nineteenth century involved not only a search for new forms, a new plastic reality, but also a search for a new content and new principles of synthesis. As already noted, Courbet had tied his reality of subject to the equal reality of

95. HONORE DAUMIER. *Comte de Kératry (L'Obséquieux)*.
c. 1832. Bronze, height 4⅞".
Galerie Sagot-Le Garrec, Paris

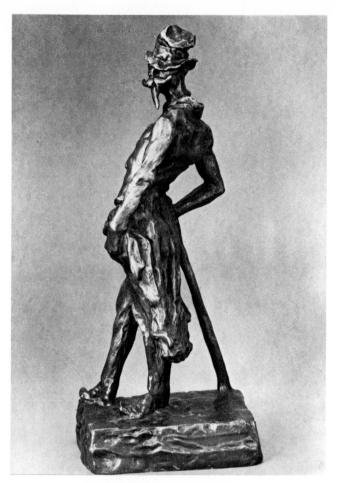

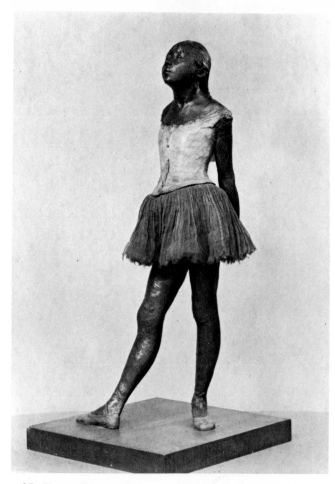

96. HONORE DAUMIER. *Ratapoil.*
c. 1850. Bronze, height 17″.
The Joseph H. Hirshhorn Collection

97. EDGAR DEGAS. *Statuette: Dressed Ballerina.* c. 1920.
Bronze, height 39″. The Metropolitan Museum of Art,
New York. The H. O. Havemeyer Collection.
Bequest of Mrs. H. O. Havemeyer, 1929

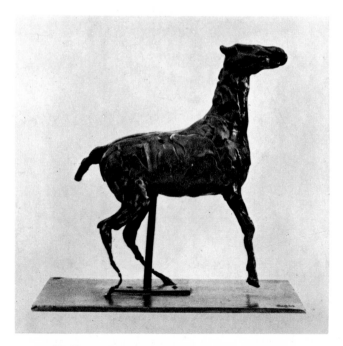

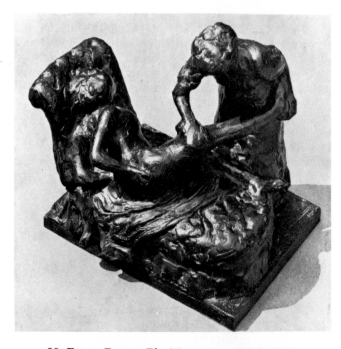

98. EDGAR DEGAS. *Prancing Horse.* 1865–81.
Bronze, height 10½″. The Joseph H. Hirshhorn Collection

99. EDGAR DEGAS. *The Masseuse.* c. 1896–1911.
Bronze, 16½ x 15″. The Joseph H. Hirshhorn Collection

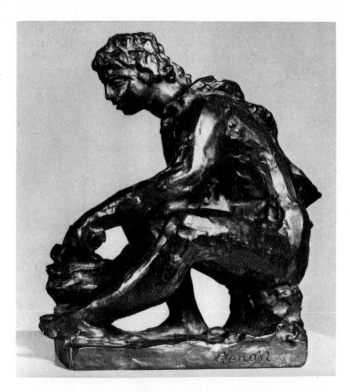

100. AUGUSTE RENOIR. *The Blacksmith (Fire)*. 1916.
Bronze, height 13″. Walker Art Center, Minneapolis

his medium of paint. The impressionists, in seeking the very ultimate refinement of optical reality through color and light, had progressively diminished the illusion of the tangible object. Cézanne had returned with a new intensity to the study of nature, whether man, landscape, or still life, the better to abstract its essence and remake it as a painting. In general, the direction of Cézanne and the impressionists, as well as of the early Seurat and the neo-impressionists, was toward the "non-subject," the subject sufficiently neutral and commonplace to serve simply as a point of departure for the artist. This can also be said about the later works of Degas, although Degas' obsession with the world of the theater and the ballet undoubtedly entailed elements of the exotic. Seurat's later works are marked, also, by an increasing symbolic-expressive quality. Toulouse-Lautrec's explorations of music halls and houses of prostitution involved a genuine narrative interest, which he translated into decorative patterns and linear movements.

The search for a new subject that would be meaningful in itself and not simply a continuation of outworn clichés taken from antiquity, French history, or Shakespearean drama manifested itself as a conscious program in Gauguin's paintings, first at Pont-Aven in Brittany and then in the South Seas. In Brittany it was the peculiar individuality and intensity of the Christian belief which intrigued him and which he wanted to capture in such works as *The Yellow Christ* (fig. 104) and *Vision after the Sermon* (see colorplate 10). In Tahiti it was the mystery of a beautiful people living in an earthly paradise haunted by the gods and spirits of their primitive religion. In both cases, the subjects he pursued were those of the romantic tradition: the exotic, the otherworldly,

the mystical. In this, Gauguin and the artists who were associated with him at Pont-Aven and later at Le Pouldu in Brittany, as well as very different painters like Odilon Redon and Gustave Moreau, were affected by the symbolist spirit, which, in poetry and criticism, stemmed from the reaction against realism in literature and against industrialization in life.

Symbolism in literature and in art was in fact a direct descendant of the romanticism of the eighteenth and the early nineteenth centuries. In literature, its founders were Charles Baudelaire and Gerard de Nerval; the leaders at the close of the century were Jean Moréas, Stéphane Mallarmé, and Paul Verlaine. In music, Richard Wagner was a great force and influence and Claude Debussy the outstanding master. Baudelaire had defined romanticism as "neither a choice of subjects nor exact truth, but a mode of feeling"—something found within rather than outside the individual—"intimacy, spirituality, color, aspiration toward the infinite. . . ." More narrowly defined, symbolism was an approach to an ultimate reality, an "idea" in the sense of Platonic philosophy that transcended particular physical experience. As such, it not only reflected some of the ideas of the philosophers Hegel and Schopenhauer, but it also directly paralleled the contention of Henri Bergson that reality could be achieved only through intuitive experience expressed particularly in the work of art. The credo that the work of art is ultimately a consequence of the emotions, of the inner spirit of the artist rather than of observed nature, not only dominated the attitudes of the symbolist artists but was to recur continually in the philosophies of twentieth-century expressionists, dadaists, surrealists, and even of Mondrian and the abstractionists.

For the symbolists the reality of the inner idea, of the dream or the symbol, could be expressed only obliquely, as a series of images or analogies out of which the final revelation might emerge. Symbolism led some poets and painters back to organized religion, some to religious cult-

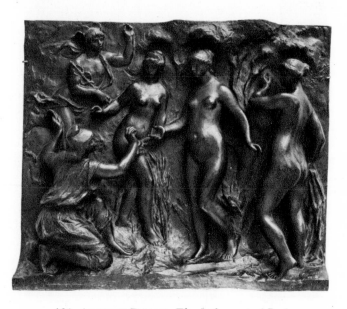

101. AUGUSTE RENOIR. *The Judgment of Paris*.
1916. Bronze, 29¼ x 35½″.
The Cleveland Museum of Art. Purchase, J. H. Wade Fund

102. MEDARDO ROSSO. *The Bookmaker*. 1894. Wax over plaster, height 17½″. The Museum of Modern Art, New York. Acquired through the Lillie P. Bliss Bequest

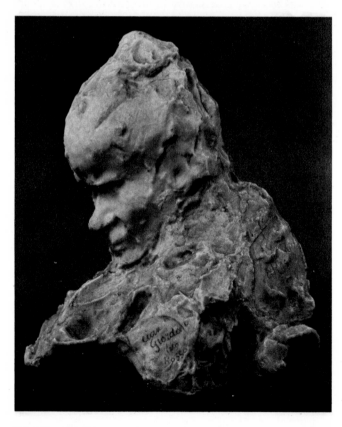

103. MEDARDO ROSSO. *The Concierge*. 1883. Wax over plaster, height 14½″. The Museum of Modern Art, New York. Mrs. Wendell T. Bush Fund

ism, and others to aesthetic creeds that were essentially anti-religious. During the 1880s, at the moment when artists were pursuing the ideal of the dream, Sigmund Freud was beginning the studies that were to lead to his theories of the significance of dreams and the unconscious.

Paul Gauguin sought in his paintings what he termed a "synthesis of form and color derived from the observation of the dominant element." He advised his friend, the painter Emile Schuffenecker, not to ". . . copy nature too much. Art is an abstraction; derive this abstraction from nature while dreaming before it, but think more of creating than the actual result." When Paul Sérusier, a leading theoretician of symbolism and a founder of the nabis group, was leaving Pont-Aven, Gauguin took him to the Bois d'Amour and asked him: "How do you see these trees? They are yellow. Well, then, put down yellow. And that shadow is rather blue. So render it with pure ultramarine. Those red leaves. Use vermilion."

In these statements may be found many of the concepts of twentieth-century experimental painting, from the idea of color used arbitrarily rather than to describe an object visually, to the primacy of the creative act, to painting as abstraction. Gauguin's synthetism also involved a synthesis of subject and idea with form and color, so that the *Vision after the Sermon* is given its mystery, its visionary quality, by its abstract color patterns.

## ODILON REDON (1840–1916)

Symbolism in painting found its most characteristic exponent in Odilon Redon, a painter of dreams who provides a direct link between nineteenth-century romanticism and twentieth-century surrealism. Like Gauguin, he was influenced by Oriental art and specifically by Japanese prints. His world, however, was one of dreams created from amorphous, flowing and changing color, which itself had the character of a dream. He frequently found his subjects in the study of nature, at times observed under the microscope, but in his hands transformed into beautiful or monstrous fantasies.

Redon first studied architecture, but, failing his examinations, he turned to painting. In actuality the first twenty years of his career were devoted almost exclusively to drawing, etching, and lithography in black-and-white. His first enthusiasms were for Renaissance masters of drawing: Albrecht Dürer, Hans Holbein, and Leonardo da Vinci. In Leonardo as well as in Rembrandt he was entranced by the expressive effects of light and shadow. Redon studied etching with Rodolphe Bresdin, a strange and solitary artist who created a graphic world of meticulously detailed fantasy based on Dürer and Rembrandt. Through him, Redon was drawn to these artists, but later he found a closer affinity with the etchings of Francisco Goya, the greatest master of fantasy of the early nineteenth century. Redon himself became one of the modern masters of the medium of lithography, in terms of which he created a world of dreams and nightmares based not only on the example of the past but also on his close and scientific study of anatomy and microbiology. It was this that made his monsters believable.

104. PAUL GAUGUIN. *The Yellow Christ.* 1889.
36⅜ x 28¾". The Albright-Knox Art Gallery,
Buffalo, New York

The artist's own predilection for fantasy and the macabre drew him naturally into the orbit of Delacroix, Baudelaire, and the nineteenth-century romantics. In his drawings and lithographs, where he pushed his blacks to extreme limits of expression, he developed and refined the fantasies of Bresdin in nightmare visions of monsters, or tragic-romantic themes taken from mythology or romantic literature. Redon was close to the symbolist poets, and was almost the only artist who was successful in translating their words into visual experiences. He dedicated a portfolio of his lithographs to Edgar Allan Poe, whose works had been translated by Baudelaire and Mallarmé; and he interpreted in lithography Gustave Flaubert's *Temptation of St. Anthony* (see fig. 105). The critic and novelist J.-K. Huysmans reviewed Redon's exhibitions enthusiastically at the same time that he was himself moving away from Zola's naturalism and into the symbolist stream with his novel *Against the Grain,* in which he also discussed at length the art of Redon and of Gustave Moreau.

It was not until 1895 that Redon began to work seriously in color, but almost immediately he demonstrated a capacity for lovely harmonies, both in oil and pastel, that changed the character of his art from the macabre and the somber to the joyous and brilliant. *Roger and Angelica* (colorplate 17), with little change or distortion other than the use of intense color, becomes an object of overpowering sensuality. The same theme is presented in a seemingly more explicit but actually more poetic form in the *Birth of Venus* (colorplate 18).

During his lifetime, Redon had only a modest success with the general public, but his reputation among his younger colleagues grew constantly. Maurice Denis (1870–1945) gave him a position of honor in his painting *Homage to Cézanne* (fig. 106), a work perhaps inspired by Fantin-Latour's *Homage to Delacroix* (fig. 107). The nabis, of whom Denis was a founder, paid homage to Redon although they were only peripherally influenced by his painting. The most comprehensive tribute paid him during his lifetime came, perhaps, at the Armory Show in New York in 1913. In the entire movement of symbolism in painting, which affected most of the progressive tendencies at the end of the nineteenth century and the beginning of the twentieth, there is no more central figure.

Symbolism in painting and sculpture—the search for a new content based on emotion rather than intellect or objective observation, and on intuition, inner force, and the idea beyond appearance—may be interpreted broadly to include most of the experimental artists who succeeded the impressionists and opposed them. The broader definition would encompass not only Gauguin but also Van Gogh and, in varying degrees, Seurat and Cézanne. However, all these artists were also, each in his different manner, concerned with other problems, problems of pictorial structure or personal expression. The artists who,

105. ODILON REDON. *Anthony: What is the purpose
of all this? The Devil: There is no purpose.*
Plate 18 from *The Temptation of St. Anthony,* third series.
1916. Lithograph, 12¼ x 9⅞". The Museum of Modern Art,
New York. Gift of Abby Aldrich Rockefeller

106. MAURICE DENIS. *Homage to Cézanne*. 1900.
71 x 94½″. Musée National d'Art Moderne, Paris.
From left: Redon, Vuillard, Mellerio, Vollard, Denis,
Sérusier, Ranson, Roussel, Bonnard, Mme. Denis

107. THEODORE FANTIN-LATOUR. *Homage to Delacroix*. 1864.
62½ x 99″. The Louvre, Paris. Standing, from left: Cordier,
Legros, Whistler, Manet, Bracquemond, De Balleroy. Seated,
from left: Duranty, Fantin-Latour, Champfleury, Baudelaire

aside from Redon, are most explicitly associated with symbolism in painting are lesser figures: Gustave Moreau (1826–1898) and Pierre Puvis de Chavannes (1824–1898).

Moreau was a recluse until he was appointed professor at the Ecole des Beaux-Arts in 1892. Here, during his last years, he displayed remarkable talents as a teacher, numbering among his students Henri Matisse and Georges Rouault, as well as others who were to be associated as the fauves, or "wild beasts," of early modern painting. The art of Moreau himself exemplified the spirit of end-of-the-century decadence, combining morbid subject, meticulous draftsmanship, and jewel-like color and paint texture (see fig. 108).

Puvis de Chavannes was a curious combination, an academic muralist admired by artists of the younger generation. The reasons for this seeming anomaly are apparent in retrospect when his murals in the Panthéon in Paris are studied (see fig. 109). The subject, the life of Ste-Geneviève, and its narrative treatment are sufficiently traditional, but the organization in large, flat, subdued color areas, and the manner in which the plane of the wall is respected and even asserted, had a natural appeal to the artists who were searching for the new reality of painting. Although the abstract qualities of the murals are particularly apparent to us today, the classic withdrawal of the figures transforms them into symbols of that inner light which the symbolists extolled.

# Art Nouveau

The end of the nineteenth century was a period of synthesis in the arts, a time when artists sought new directions that in themselves constituted a reaction against the tide of "progress" represented by industrialization. The search of the symbolist poets, painters, and musicians for spiritual values was part of this reaction. Gauguin gave to the liberating color and linear explorations that he pursued and transmitted to disciples, the name of synthetism: the synthesis of color and form into semi-abstract images. The phenomenal thing about this "synthetic" spirit—in its broader and less profound aspect—is that in the last decades of the nineteenth century and the first of the twentieth it became a great popular movement that affected the taste of every part of the population in both Europe and the United States. This was the movement called art nouveau. Art nouveau was a definable style that emerged from the experiments of painters, architects, craftsmen, and designers, and, for a decade, permeated not only painting, sculpture, and architecture, but graphic design, magazine and book illustration, furniture, textiles, glass and ceramic design, and even women's fashions. In its popular aspects it was practiced by numbers of relatively undistinguished artists and craftsmen, but few of the pioneers of twentieth-century art were uninfluenced by its forms and ideas.

Art nouveau grew out of the English arts-and-crafts movement whose chief exponent and propagandist was the artist-poet William Morris (1834–1896). The arts-and-crafts movement was a revolt against the new age of mechanization, a romantic effort on the part of Morris (see fig. 110) and others such as Mackmurdo to implement the philosophy of John Ruskin that true art should be both beautiful and useful. They saw the world of the artist-craftsman in process of destruction by industrialization, and they fought for a return to some of the standards of simplicity, beauty, and craftsmanship that they associated with earlier centuries, notably the Middle Ages. The ideas of the arts-and-crafts movement spread rapidly throughout Europe and found support in the comparable theories of French, German, Belgian, and Austrian artists and literary men. Implicit in the move-

ment was the concept of the synthesis of the arts based on an aesthetic of dynamic linear movement. Many names were given to the movement in its various manifestations, but ultimately "art nouveau" became the most generally accepted, probably through its use for the Parisian shop, Maison de l'Art Nouveau, which, with its exhibitions and extensive commissions to artists and craftsmen, was influential in propagating the style. In Germany the term "Jugendstil," after the periodical *Jugend,* became the accepted name.

The art nouveau artists searched for a style and an iconography that avoided the historical styles still dominating the mass of academic painting and sculpture. In 1890, it must be remembered, the majority of accepted painting, sculpture, and architecture was still that being produced in enormous quantity under the aegis of the academies. In contrast to the arts-and-crafts movement in which it had originated, art nouveau made use of new materials and technologies both in buildings and in decoration.

In actuality, art nouveau artists could not avoid the influence of past styles, but they explored those which were less well known and out of fashion with the current academicians, deriving from medieval, Oriental, or primitive art any forms or devices congenial to their search for an abstraction based on linear rhythms. Thus, the linear qualities as well as the decorative synthesis of eighteenth-century Rococo, the wonderful linear interlace of Celtic or Saxon illumination and jewelry, the bold, flat patterns of Oriental and specifically of Japanese art, and the high decorative quality of Chinese and Japanese ceramics and jades all entered into the picture. The art

110. WILLIAM MORRIS. Detail of "Pimpernel" Wallpaper. 1876. Victoria and Albert Museum, London

nouveau artists, while seeking a kind of abstraction, were not yet prepared for a completely non-objective point of view. Hence most of their decoration had a source in nature, particularly in plant forms, often given a symbolic or sensuous overtone, or in micro-organisms that the new explorations in botany and zoology were making familiar.

An aesthetic based on line was the natural conse-

quence of the reaction against materialism in painting and the other arts during the later part of the nineteenth century. Impressionism had moved toward the dematerialization of objective nature by means of color. In the later works of Seurat and his neo-impressionist followers, line took on a formal, co-ordinating, and also an abstract-expressive function. The synthetism of Gauguin and, after him, of those followers who called themselves the nabis, after the Hebrew word for prophet, was rooted in linear as well as color pattern. The sculptor Maillol's early paintings were in the form of decorative, outlined color areas; but when he turned to sculpture, his absorption in the new medium took him into a plastic concern for mass at variance with the art nouveau approach. Gauguin's sculpture was closer to this approach, particularly his reliefs, although like his wood blocks, the reliefs included a contrasting strong, primitive quality that was very much his own. Toulouse-Lautrec reflected (as well as influenced) the art nouveau spirit in his paintings and prints, particularly in his subtle use of descriptive, expressive line. Through his highly popular posters, aspects of art nouveau graphic design were spread throughout the Western world.

English art nouveau came largely from the less dynamic and more elaborately decorative and literary tradition of the pre-raphaelites Dante Gabriel Rossetti (see fig. 111) and Edward Burne-Jones. The mystical visions of William Blake (see fig. 112), expressed in fantastic rhythms of line and color, were an obvious ancestor, as was, in fact, the tendency of English art, from medieval times, toward the linear.

The drawings of Aubrey Beardsley (1872–1898) were immensely elaborate in their black-and-white decorative richness. Associated as they were with the so-termed "aesthetic" or "decadent" literature of Oscar Wilde and the *fin de siècle*, they probably constitute the most characteristic contribution of the English to art nouveau

*above:* 111. DANTE GABRIEL ROSSETTI. *Monna Vanna.* 1866. 35 x 34″. The Tate Gallery, London

*right:* 112. WILLIAM BLAKE. *The Great Red Dragon and the Woman Clothed with the Sun.* 1805–10. Watercolor, 16⅛ x 13⅛″. National Gallery of Art, Washington, D. C. Rosenwald Collection

*far right:* 113. AUBREY BEARDSLEY. *Salome with the Head of John the Baptist.* 1893. India ink and watercolor, 10⅞ x 5¾″. Princeton University Library, Princeton, New Jersey

114. HENRY VAN DE VELDE. *Tropon.*
c. 1899. Poster, 47⅝ x 29⅛".
Museum für Kunst und Gewerbe, Hamburg

115. GUSTAVE KLIMT. Detail of Dining Room Mural,
Palais Stoclet, Brussels. c. 1905–08.
Mosaic and enamel on marble

116. LOUIS SULLIVAN. Detail of cast-iron ornament
on the Carson Pirie Scott and Company
Department Store, Chicago. c. 1903–04

graphic art (see fig. 113). Beardsley, like Edgar Allan Poe and certain of the French symbolist writers, was haunted with romantic visions of evil, of the erotic and the decadent, although his expression of these qualities was so elegantly decorative that they cannot be said to have attained much impact. In watered-down form, his style in drawing appeared all over Europe and America in popularizations of art nouveau illustrations.

One of the most influential figures in all the phases of art nouveau was the Belgian Henry van de Velde (1863–1957). Trained as a painter, he produced, as early as 1890, completely abstract compositions in typical art nouveau formulas of color patterns and sinuous lines (see fig. 114). For a time he was converted to neo-impressionism and read widely in the scientific theory of color and perception. He soon abandoned this direction in favor of the symbolism of Gauguin and his school, and attempted to push his experiments in symbolic statement through abstract color expression further than had any of his contemporaries. Ultimately he came to believe that easel painting was a dead end and that the solution for contemporary society was to be found in the industrial arts. Thus it was finally as an architect and designer that he made his major contributions to art nouveau and the origins of twentieth-century art.

In Austria, the new ideas of art nouveau were given

117. LOUIS COMFORT TIFFANY. Table Lamp. c. 1900.
Bronze and favrile glass, height 27", shade 18" in diameter.
Lillian Nassau Antiques, New York

118. HECTOR GUIMARD. Desk. c. 1903. African and olive ash,
2′ 4¾″ x 8′ 5″. The Museum of Modern Art, New York.
Gift of Mme. Hector Guimard

expression in the founding in 1897 of the Vienna Seces-
sion and, shortly thereafter, of its publication, *Ver Sac-
rum*. The major figure of the Vienna Secession was Gus-
tav Klimt (1862–1918), in many ways the most complete
and most talented exponent of pure international art nou-
veau style in painting. Klimt was well established as a
successful decorative painter and fashionable portraitist,
noted for the brilliance of his drawings, when he began in
the 1890s to be drawn into the stream of new European
experiments. He became conscious of Dutch symbolists
such as Jan Toorop, of the Swiss symbolist Ferdinand
Hodler, of the English pre-raphaelites and of Aubrey
Beardsley. His own style was also formed on a study of
Byzantine mosaics. A passion for erotic themes led him
not only to the creation of innumerable drawings, sensi-
tive and explicit, but also to the development of a paint-
ing style that integrated sensuous nude figures with bril-
liantly colored decorative patterns of a richness rarely
equaled in the history of modern art. He was drawn more
and more to mural painting and his murals for the Uni-
versity of Vienna involved elaborate and complicated
symbolic statements composed of voluptuous figures float-
ing through an amorphous, atmospheric limbo. Those he
designed for Josef Hoffmann's Palais Stoclet in Brussels
between 1905 and 1910 (see fig. 115) are a document of
great importance in the history of modern art. Exe-
cuted in glass, mosaic, enamel, metal, and semi-precious
stones, they combined figures conceived as flat patterns
(except for modeled heads and hands) with an over-all
pattern of abstract advancing spirals. Although essen-
tially decorative in their total effect, the Stoclet murals
mark the moment when modern painting was on the very
edge of non-representation.

## Art Nouveau Architecture
## and Design

In architecture it is difficult to speak of a single, unified
art nouveau style except in the realms of surface orna-
ment and interior decoration. There are not many build-

119. HENRI DE TOULOUSE-LAUTREC. *Jane Avril*. 1899.
Lithograph poster, 22 x 14″.
The Museum of Modern Art, New York.
Gift of Abby Aldrich Rockefeller

ings that can be so classified even in a peripheral sense.
Yet, despite this fact, certain aspects, notably the use of
the whiplash line in ornament and a generally curvilinear
emphasis in decorative and, at times, even in structural
elements, derive from art nouveau graphic art and deco-
rative or applied arts. The art nouveau spirit of imagina-
tive invention, linear and spatial flow, and of non-tradi-
tionalism fed the inspiration of a number of architects in
France, Belgium, Germany, Austria, Spain, Italy, and the
United States, and enabled them to experiment more
freely than they might otherwise have done with ideas
opened up to them by the use of metal, glass, and rein-
forced-concrete construction. Since the concept of art
nouveau involved a high degree of special design and
craftsmanship, it did not lend itself to the developing field
of large-scale mass construction, which probably explains
why it did not result in many actual architectural monu-
ments. However, as already noted, it did contribute sub-
stantially to the outlook that was to lead to the rise of a
new and experimental architecture in the early twentieth
century.

The architectural ornament of Louis Sullivan in the

Guaranty Trust Building (see fig. 66) or the Carson Pirie Scott store (see fig. 67 and fig. 116) was the principal American manifestation of art nouveau spirit in architecture; and a comparable spirit permeated the early work of Sullivan's great disciple, Frank Lloyd Wright. The outstanding American name in art nouveau was that of Louis Comfort Tiffany, but his expression lay in the fields of interior design and decorative arts. In these he was not only in close touch with the European movements but himself exercised a considerable influence on them (see figs. 117–119).

## ANTONI GAUDI *(1852–1926)*

In Spain, Antoni Gaudí was influenced as a student by the ideas of Milo y Fontanas, who in Rome had been attracted to the nazarenes and to a romantic concept of the Middle Ages as a golden age, which for him became a symbol for the rising nationalism of Catalonia. Also implicit in Gaudí's architecture was his early study of natural forms as a spiritual basis for architecture. He was drawn to the French medieval-revival architect, Eugène Emmanuel Viollet-le-Duc (1814–1879), not only by the latter's passion for restoring Gothic monuments, but also,

and more particularly, by his strongly rational approach to Gothic structure, which he saw in the light of modern technical advances. Gaudí's early architecture belonged in the main current of Gothic revival, with the difference that it involved an imaginative use of materials, particularly in textural and coloristic arrangement, and an even more imaginative personal style in ornamental iron-work. His wrought-iron designs were arrived at independently and frequently in advance of the comparable experiments of art nouveau. Throughout his later career, from the late 1880s until his death in 1926, Gaudí followed his own direction, which at first was parallel to art nouveau and later was independent of anything that was being done in the world or would be done until the middle of the twentieth century, when his work was reassessed. Probably his greatest affinity is to the new romantic structural experimentalists of the present time, and his greatest potential influence on the next generation of architects.

Gaudí's first major commission was to complete the Church of the Sagrada Familia in Barcelona (fig. 120), already designed as a neo-Gothic structure by the architect Francisco de Villar. Gaudí worked intermittently on this church from 1883 until his death in 1926, leaving it far from complete even then. Although he abandoned Villar's plan, there are still Gothic elements in his own design of the interior. The main parts of the completed church, particularly the four great spires of one transept, are only remotely Gothic; and although influences of Moorish, primitive African, and other exotic architectural styles may be traced, the principal effect is of a building without historic style—or rather one that expresses the imagination of the architect in the most personal and powerful sense. In the decoration of the church —still only a fragment—emerges a profusion of fantasy in biological ornament flowing into naturalistic figuration and abstract decoration. Brightly colored mosaic decorates the finials of the spires.

In contrast with the Church of the Sagrada Familia, on which planning and construction progressed slowly, the

120. ANTONI GAUDI. Church of the Sagrada Familia, Barcelona. 1883–1926

121. ANTONI GAUDI. Detail of facade, Güell Palace, Barcelona. 1885–89

122. ANTONI GAUDI. Interior, College of Santa Teresa de Jesús, Barcelona. 1889–94

123. ANTONI GAUDI. Colonia Güell Chapel, Barcelona. 1898–1914

design of the Güell Palace (fig. 121) and of the Teresian convent school involved relatively sedate facades. On the Güell Palace facade appeared the parabolic arches that were to become one of Gaudí's trademarks. The arched entrances were filled with complex iron-work grilles. In the basement stables he used brick-and-tile mushroom columns supporting an elaborate but structurally functional system of vaulting. The spiral ramp by which the horses descended introduced an early example of flowing space. On the external walls of the Teresian convent school he used rubble, brick, and terra cotta in blended earth colors. In the arcades of the ground floor and first floor (fig. 122), the parabolic curve appeared in a high, narrow form of plaster arch on brick pier, to create an effect of exceptional austerity and precise structural articulation. These arcades seem to be in strong contrast to the heavily decorated or freely flowing structural elements of the later works; yet the same sense of structural control underlay both.

In the porch and crypt of the Colonia Güell Chapel (fig. 123) near Barcelona, Gaudí deserted the vertical, and, inclining or curving his columns as well as the arches they supported in accordance with the most meticulous structural calculations, endowed them with the expressive function of growing tree forms in nature. The Güell Park, Barcelona (fig. 124), is an exercise in terms of sheer fantasy and engineering ingenuity, a surrealist combination of landscaping and urban planning. This gigantic descendant of the romantic, Gothic English gardens of the eighteenth century is an enormous melange of sinuously curving

walls and benches, grottoes, porticoes, arcades, all covered with brilliant mosaics of broken pottery and glass. In it can be observed the strongly sculptural quality of Gaudí's architecture, a quality that differentiates it from most aspects of art nouveau. He composed in terms not of lines but of twisted masses of sculpturally conceived masonry. Even his iron-work has a sculptural heaviness that makes it transcend the normal elegance of art nouveau line.

Of Gaudí's major secular buildings of the early twentieth century, the Casa Batlló was actually a remodeling project. However, the architect completely transformed both the exterior and the interior through the imposition of his own vocabulary. The facade is treated as a lighter fantasy of curving projecting balconies, and, on the lower story, large free-form arcades and windows. The entrance vestibule is open space, with the simple plastered and tiled walls providing an airy contrast to the elaboration of the balustrades. The sense of flowing movement and light is evident in the plans and interior spaces of the principal apartments (fig. 125). Walls merge without interruption into ceilings and floors, and the organic-shaped windows seem to grow directly out of the walls that encase them. Gaudí designed furniture that carries the twisted sculptural quality of his architectural forms at the same time that it is composed for human use with the imaginative precision of his most expressive architecture.

The Casa Milá (fig. 126) is a much larger structure, freestanding around open courts, the whole designed in a continuous movement of sculptural masses. The facade,

124. ANTONI GAUDI. Detail of surrounding wall,
Park Güell, Barcelona. 1900–14

125. ANTONI GAUDI. Dining Room, Casa Batlló,
Barcelona. 1905–07

flowing around the two main elevations, is an alternation of sculptural mass and interpenetrating void. The undulating roof lines and the elaborately twisted chimney pots carry through the unified architectural-sculptural theme. Iron-work grows over the balconies like some luscious exotic vegetation. The sense of transition is continued in the floor plan, where one room or corridor flows without interruption into another. Walls are curved or angled throughout, to create a feeling of everlasting change, of space without end.

In his concept of architecture as dynamic space joining the interior and external worlds and as living organism growing out of its natural environment, in his daring engineering experiments, in his imaginative use of materials—from stone that looks like a natural rock formation to the most wildly abstract color organizations of ceramic mosaic—Gaudí, even though little known outside his own city to the mid-twentieth century, is actually a great pioneer, a prophet, one of the foundations on which architects at mid-century began to build.

### VICTOR HORTA (1861–1947)

If any architect might claim to have been the founder of art nouveau architecture, it was the Belgian Victor Horta. Trained as an academician, he was affected by Baroque and Rococo concepts of linear movement in space and inspired by his study of organic growth and of Viollet-le-Duc's structural theories. Although as a practicing architect Viollet-le-Duc was notorious for his ruthless reconstructions of medieval architecture in France, his writings on architecture, notably his *Entrétiens,* which appeared in French, English, and American editions in the 1860s and 1870s, were widely read by architects. His bold recommendations on the use of direct metal construction influenced not only Gaudí and Horta, but a host of other experimental architects at the end of the nineteenth century. Another influence on Horta was the engineer Gustave Eiffel (1832–1923), whose 984-foot tower (fig. 127), built for the Paris Exhibition of 1889, was the most dramatic conceivable demonstration of the possibilities of exposed metal construction.

Horta's first important commission was the house of Professor Tassel in Brussels (fig. 128), in which he substantially advanced Viollet-le-Duc's structural theories. The stair hall is an integrated harmony of linear rhythms, established in the balustrades of ornamental iron, the

*left:* 126. ANTONI GAUDI. Street elevation,
Casa Milá Apartment House, Barcelona. 1905–07

*below:* 126a. Casa Milá. Plan of typical floor

127. GUSTAVE EIFFEL. Eiffel Tower, Paris
(from a photo of 1932). 1889

128. VICTOR HORTA. Detail of iron-work, interior,
Tassel House, Brussels, 1892–93

the glass box of twentieth-century architecture, the interior is given variety and interest by the combination of vertical glass walls, angled metal struts, and open, curving ceiling. The salon of the Van Eetvelde house (fig. 131) represents a much more fanciful exercise in *rocaille* decoration translated into metal linear elements that support and frame a glass dome. Here the essentially decorative spirit of art nouveau takes over from the architectural or structural, although the open spatial flow is again in the line of twentieth-century organic architectural experiment.

Many of the chief examples of art nouveau architecture are to be found in the designs of department stores and similar commercial buildings. The large-scale department store was a characteristic development of the later nineteenth century, superseding the older type of small shop and enclosing the still older form of the bazaar. Thus it was a form of building without traditions, and its functions were appropriate to an architecture that emphasized openness and spatial flow as well as ornate decorative backgrounds. Horta's department store in Brussels, A L'Innovation (fig. 132), makes of the fa-

129. VICTOR HORTA. Maison du Peuple, Brussels. 1897–99

130. VICTOR HORTA. Auditorium, Maison du Peuple,
Brussels. 1897–99

wall and floor designs, and the spiral twists of the stair-steps themselves. In contrast to Gaudí's work, all the elements are extremely elegant, attenuated, and delicate. Line triumphs completely over any concept of sculptured mass. In Horta's Maison du Peuple, built in 1897–99 for the Belgian Socialist Party, the facade (fig. 129) is a curtain wall of glass supported on a minimum of metal structural frames and wrapped around the irregularly curving edge of an open *place*. The auditorium interior (fig. 130) is an effective glass enclosure in which the angled, exposed-frame girders form articulated supports for the double curve of the ceiling. Although it anticipates

131. VICTOR HORTA. Salon, Van Eetvelde House,
Brussels. 1895

133. FRANTZ JOURDAIN. Samaritaine Department Store,
Paris. 1905

132. VICTOR HORTA. A L'Innovation Department Store,
Brussels. 1901

cade a display piece of glass and curvilinear metal supports; and the Samaritaine store by Frantz Jourdain in Paris (fig. 133) combines elaborate metal tracery with large rectangular windows whose tripartite division is reminiscent of Sullivan's Carson Pirie Scott store (see fig. 67). Such department stores sprang up all over Europe and America at the beginning of the twentieth century. Their utilitarian purpose made them appropriate embodiments of the new discoveries in mass construction: exposed-metal and glass structure, and decorative tracery that could be elaborated and reduced to vulgarization with impunity. In various ways, however, they constituted vital opportunities for architectural experiment.

Many distinguished architects were associated with art nouveau in one context or another, but few of their works can be identified with the style to the same degree as Horta's. Hector Guimard's stations for the Paris Métropolitain (or Métro: subway; fig. 134) can be considered pure art nouveau, perhaps because they were less architectural structures than decorative signs or symbols. The same may be said of Otto Wagner's Stadtbahn station in Vienna or August Endell's Atelier Elvira in Munich (fig. 135). However, if one were to remove the elaborate "sea horse" ornament from the facade of the last-mentioned, what would remain would be a relatively simple and austere structure. Details of the interior, notably the stair hall, do continue the delicate undulations of art nouveau *rocaille*. The Palais Stoclet in Brussels (figs. 136, 137) by the Austrian architect Josef Hoffmann (1870–1955), although the dining-room murals by Klimt and the interior furnishings and decorations represent a typical art nouveau synthesis of decorative accessories, is nevertheless a flat-walled, rectangular structure

134. HECTOR GUIMARD. Entrance to a Métropolitain Station, Paris. 1898–1901

135. AUGUST ENDELL. Facade, Atelier Elvira, Munich. 1897

*above:* 136. JOSEF HOFFMANN. Dining Room, Palais Stoclet, Brussels. 1905–11

*right:* 137. JOSEF HOFFMANN. Palais Stoclet, Brussels. 1905–11

with analogies to the later international style and the Bauhaus. The same is true of Otto Wagner's Postal Savings Bank in Vienna, Mackintosh's School of Art in Glasgow, and the architecture of Peter Behrens and Van de Velde. The fact that these architects were also designers of interiors and creators of decorative objects in the art nouveau mode tended to obscure the actual nature of their architecture.

Art nouveau, although it drew on the expressive genius of such painters as Gauguin and Van Gogh and such architects as Gaudí, Mackintosh, and Van de Velde, remains largely a movement of the decorative arts. Architecturally, its most characteristic features have to do with interior design. Perhaps its greatest contribution lies in the fields of graphic design—posters and book illustration—and the design of lamps, textiles, furniture, ceramics, glass, and wallpaper. Much if not most of what was achieved within this framework has survived only as a curiosity or revival of a fashion. Nevertheless, art nouveau—short-lived as a creative period—had importance as a movement simply because it was a widespread popular revolt against the academicism of traditional historical styles. By attacking and even destroying the constant references to the classic periods of Western culture, by attempting to substitute a naturalistic or semi-abstract pattern in painting and sculpture and an organic linear or spatial flow in architecture, art nouveau prepared the way for many of the experiments of twentieth-century art and architecture.

## *The Nabis*

Although the origins of twentieth-century painting are to be found specifically in the ideas and achievements of the great masters of the late nineteenth—in particular Cézanne, Gauguin, Van Gogh, and Seurat—these ideas were transmitted in large degree through many lesser artists associated with the dominant trends in art at the turn of the century—neo-impressionism, symbolism, art nouveau, and the nabis. Neo-impressionism, created by Seurat and Signac, made its appearance in 1884, when a number of artists who were to be associated with the

movement exhibited together at the Groupe des Artistes Indépendants in Paris. Later in 1884 the Société des Artistes Indépendants was organized through the efforts of Seurat, Henri-Edmond Cross, Redon, and others, and was to become important to the advancement of early twentieth-century art as an exhibition forum. Also important were the exhibitions of Les XX (Les Vingt, or The Twenty) in Brussels. Van Gogh, Gauguin, Toulouse-Lautrec, and Cézanne exhibited at both the Indépendants and Les XX. James Ensor, Van de Velde, and Jan Toorop exhibited regularly at Les XX and its successor, La Libre Esthétique, whose shows became increasingly dominated first by the attitudes of the neo-impressionists and then of the nabis.

By 1885, as noted, Seurat and Signac had begun experimenting with the characteristic small, regular brush stroke, bringing geometric order into impressionist color. They were soon joined by Camille Pissarro (1830–1903), a much older man and an established impressionist. Pissarro was a man of personal prestige and influence among the impressionists and their followers, and his conversion to neo-impressionism—although he soon seceded—assisted substantially in its spread.

As has already been suggested, Seurat and the neo-impressionists, painting in a mosaic of small strokes of pure color, were not only concerned with blending colors in the eye of the spectator, but, by continually mingling fragments of red, blue, yellow, and their complementaries, with setting up visual vibrations to activate the surface of the canvas. As important as the actual color strokes themselves was their meticulous arrangement, which created a sense of geometric organization of impressionist color. This organization was reinforced by patterns of linear rhythms directly related to those of art nouveau, emphasizing further the artists' intentions of creating abstract color patterns. The color structure of Delacroix, as well as his researches into the visual impacts of complementaries, were as important to the neo-impressionists as the writings of the scientist Chevreul.

Neo-impressionism spread rapidly during the later 1880s, affecting particularly younger Belgian artists through the exhibitions at Les XX. Henry van de Velde was the most important Belgian convert, and it was he who carried aspects of neo-impressionism into the art nouveau movement. Van Gogh took over neo-impressionist brushwork and even neo-impressionist emphasis on linear movement, adapting these to his own expressive ends. In this context, Seurat's own convictions concerning the expressive, symbolic functions of colors and their contexts must not be forgotten.

Even before Seurat's death in 1891, a number of those artists originally involved in neo-impressionism, aside from Pissarro, had begun to desert the movement. But Signac and Cross then were able to develop their pointillist technique into an even more categorically abstract-decorative formula. The brush strokes grew larger and more precise, the lines more pronounced, and these tendencies set the stage for the revolt of the fauves in the early years of the twentieth century.

The nabis were a somewhat eclectic group of artists whose principal contributions—with two outstanding exceptions—lay in a synthesizing approach to masters of the earlier generation, not only to Seurat but also to Gauguin, Redon, and Cézanne. Of particular importance was Gauguin's theory of synthetism as well as the direct example of his painting.

Gauguin had been in some degree affected by the ideas of his young friend, Emile Bernard, when the two were working seriously together in Pont-Aven in the summer of 1888. He may well have derived important elements of his synthetism from Bernard's cloisonnisme, which was based on medieval enamel and stained-glass techniques, in which flat areas of color were bounded by emphasized contours. The dominant personality, however, and the artist of genius in this relationship, was Gauguin; despite Bernard's later angry claims, the spread of synthetism in painting owes most to the older artist. It has already been pointed out that the arbitrary, nondescriptive color, the flat areas bounded by linear patterns, the denial of depth or sculptural modeling—these elements, stated in such works as *Vision after the Sermon* (colorplate 10) or *The Yellow Christ,* as well as in most of the Tahitian paintings, were congenial to and influential for the nabis as well as for art nouveau decoration. The religious, mystical, or primitive-arcadian subject matter also was appealing to those artists who continued to seek the inner vision of the romantics and symbolists. Gauguin himself, in the synthetic spirit of the times, turned his hand to ceramic design or painted vases and became one of the leading masters in developing a new approach to woodcut—strong, contrasted, primitivist—that was to affect the course of German expressionist graphic art in the twentieth century.

Paul Sérusier, after listening to Gauguin's edicts on color at Pont-Aven in the summer of 1888, painted a small scene on the cover of a cigar box and returned to Paris with this painting, which he called his "Talisman" (fig. 138). Out of the enthusiasm for his revelation, as reported to a number of artist friends, emerged the group who called themselves the nabis. These included Sérusier, Maurice Denis, Pierre Bonnard, Paul Ranson, and later Maillol, Edouard Vuillard, Felix Vallotton, K.-X. Roussel, and Armand Séguin. The nabis were artists of varying abilities, but included three outstanding talents: Bonnard, Vuillard, and Maillol. They were important in spreading and at the same time consolidating the influence of Gauguin as well as of Redon. Aside from these artists and Cézanne, their paintings reflected in different degrees the widespread influence of Oriental painting and even, at times, of the academic symbolist Puvis de Chavannes.

The nabis were symptomatic of the various interests and enthusiasms of the end of the century. There were first of all the literary tendencies toward organized theory and elaborate celebrations of mystical rituals. Maurice Denis and Sérusier wrote extensively on the theory of modern painting; and Denis was responsible for the formulation of the famous phrase, "a picture—before being a war horse, a female nude, or some anecdote—is essentially a flat surface covered with colors assembled in a particular order." During the nineteenth century, artists were increasingly obsessed with the problem of the nature of a work of art. They talked and wrote about the problem of experimental art, the scientific or mystical

138. PAUL SERUSIER. *Le Talisman (Landscape of the Bois d'Amour)*. 1888. Oil on cigar box cover, 10½ x 8⅜". Collection Mme. Denis-Boulet, Clermont d'Oise, France

bases of art, its larger social implications. The nabis, despite their brief existence as a group, were, in their theorizing and their issuance of dogmatic manifestoes, immediate ancestors of all those groupings, manifestoes, and theories which have marked the course of twentieth-century art. They also sought a synthesis of the arts through continual activity in architectural painting, the design of glass and decorative screens, book illustration, poster design, and in stage design for the advanced theater of Henrik Ibsen, Maurice Maeterlinck, August Strindberg, Oscar Wilde, and notably, for Alfred Jarry's *Ubu Roi.*

The *Revue Blanche,* founded in 1891, became one of the chief organs of expression for symbolist writers and painters, nabis, and other artists of the avant-garde. Bonnard, Vuillard, Denis, Vallotton, and Toulouse-Lautrec (who was never officially a nabi, although associated with the group) all did posters and illustrations for the *Revue Blanche.* The magazine was a meeting ground for likeminded artists and writers from every part of Europe, including Van de Velde, the Norwegian painter Edvard Munch, Marcel Proust, André Gide, Henrik Ibsen, August Strindberg, Oscar Wilde, Maxim Gorki, and Filippo Marinetti.

With the exception of Maillol, Bonnard, and Vuillard, who were to go on to substantial personal achievements, the importance of the nabis is limited to their propagation of Gauguin's ideas and their dedicated support of Cézanne and Redon. Their search for a new approach to religious or specifically mystical subjects, through the means of abstract color shapes and linear patterns, af-

fected the thinking of other experimental painters even though they themselves—with the exceptions noted—did not produce many significant paintings. The writings of Sérusier and Denis were notable documents for the genesis of abstraction and expressionism. Without the nabis and the neo-impressionists, the outburst in the arts during the first decades of the twentieth century might not have been possible.

## EDOUARD VUILLARD *(1868–1940)*

The nabis did produce two painters of genius, Edouard Vuillard and Pierre Bonnard, whose long working lives can remind us how short a time actually separates us from the world of the nineteenth century, a world so different from our own that it might have existed eons ago. Vuillard, after a considerable success in the 1890s, seems to have been content to avoid the furor of new developments in the first years of the twentieth century, particularly avoiding public exhibition. Only with the retrospective exhibition at the Musée des Arts Décoratifs in 1938, two years before his death, did it become possible to evaluate his achievement. This is not to say that he was unsuccessful during his lifetime. Both he and Bonnard sold extremely well and were much admired by connoisseurs. Their reputations, however, were for a long time private rather than public.

Until the twentieth century, such histories of art as existed characteristically featured the established artists, the men of the academy. Since that time, histories of modern art have been increasingly written in terms of the experimentalists, the avant-garde of one generation who become the masters of the next. When we talk today of Cézanne, Van Gogh, or even Picasso and Matisse, it is not considered in any way odd to refer to them as the old masters of modern art. Yet the first two during their entire careers and the second two during most of their careers belonged to a struggling minority surrounded by a crowd of successful artists who now are largely forgotten.

It is, of course, appropriate that the history of art should be written in terms of experimentalists. On their experiments are built the traditions of the next generation, which are then attacked by a new group of experimenters. By 1910, academic painters all over Europe and America were painting their narrative scenes in an impressionist technique which by that time had become a relatively traditional framework. It seems fitting that they—and our own contemporary academic artists—should sink into obscurity. Most of them are and always have been simply more or less skillful technicians with an eye for what is immediately salable. Vuillard's example, however, should serve to remind us that from such a background artists of great talent occasionally arise.

The world of both Vuillard and Bonnard is an intimate world, consisting of corners of the studio, the living room, the familiar view from the window, and portraits of family and close friends. Vuillard's *Self-Portrait* (colorplate 19) shows him at the moment when he was closest to the theories of Gauguin and the nabis. In their later works he and Bonnard followed their own directions, though both drew on the impressionists or any other congenial source for the evocation of their personal en-

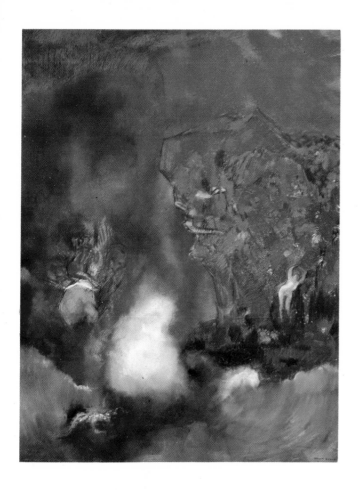

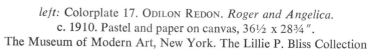

left: Colorplate 17. ODILON REDON. *Roger and Angelica.*
c. 1910. Pastel and paper on canvas, 36½ x 28¾ ".
The Museum of Modern Art, New York. The Lillie P. Bliss Collection

below: Colorplate 18. ODILON REDON. *The Birth
of Venus.* 1912. Oil on canvas, 56½ x 24⅜ ".
Kimbell Art Foundation, Fort Worth, Texas

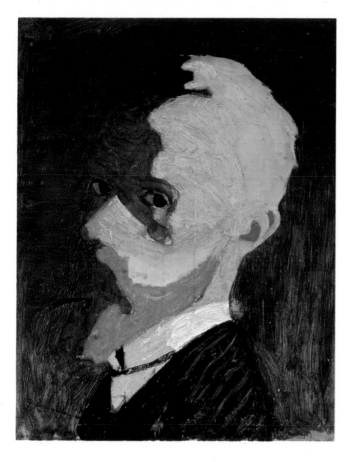

left: Colorplate 19. EDOUARD VUILLARD. *Self-Portrait.*
1892. Oil on board, 14 x 11″.
Collection Mr. and Mrs. Sidney F. Brody, Los Angeles

Colorplate 21. PIERRE BONNARD. *Dining Room in the Country*. 1913.
Oil on canvas, 64½ x 80″. The Minneapolis Institute of Arts

Colorplate 20. EDOUARD VUILLARD.
*Toulouse-Lautrec in a Theater Aisle*.
1895–96. Oil on panel, 11 x 8⅝″.
Collection Mrs. Raphael Salem, Paris

Colorplate 22. PIERRE BONNARD. *Dining Room on the Garden*. c. 1933.
Oil on canvas, 50⅛ x 53½″. The Solomon R. Guggenheim Museum, New Yo

*left:* Colorplate 23. PIERRE BONNARD.
*Still Life (Corner of a Table)*. 1935.
Oil on canvas, 26½ x 25".
Musée National d'Art Moderne, Paris

*below:* Colorplate 24. PAUL CEZANNE.
*The Large Bathers*. 1898–1905.
Oil on canvas, 82 x 98".
The Philadelphia Museum of Art.
Wilstach Collection

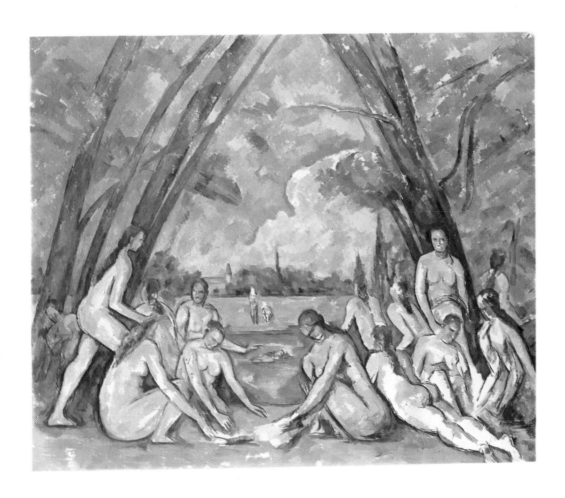

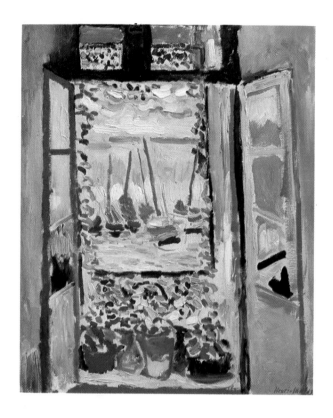

Colorplate 25. HENRI MATISSE.
*Open Window, Collioure.* 1905.
Oil on canvas, 21¾ x 18⅛". Collection
Mr. and Mrs. John Hay Whitney, New York

Colorplate 26. HENRI MATISSE.
*Woman with the Hat.* 1905.
Oil on canvas, 32 x 23¾". Collection
Mrs. Walter A. Haas, San Francisco

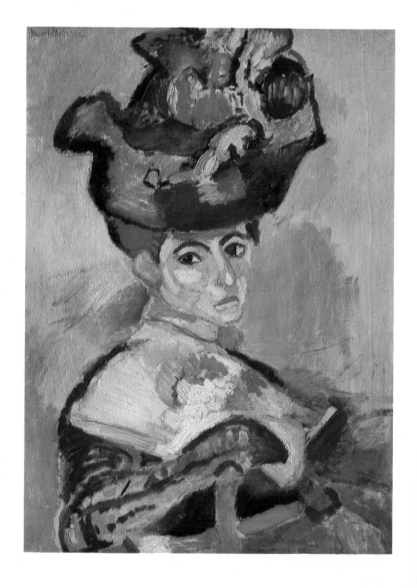

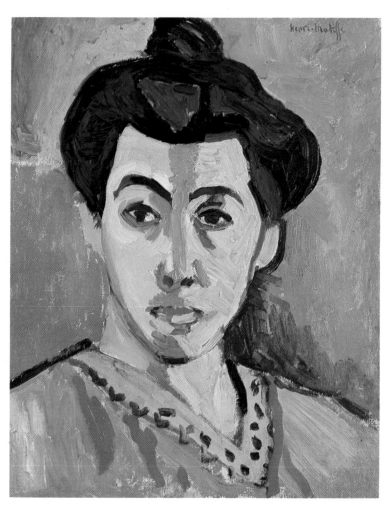

Colorplate 27. HENRI MATISSE. *Green Stripe (Madame Matisse).*
1905. Oil and tempera on canvas, 15⅞ x 12⅞".
Statens Museum for Kunst, Copenhagen. Rump Collection

Colorplate 28. OTHON FRIESZ.
*Portrait of Fernand Fleuret.* 1907.
Oil on canvas, 28¾ x 23⅝".
Musée National d'Art Moderne, Paris

Colorplate 29. RAOUL DUFY.
*Street Decked with Flags, Le Havre.*
1906. Oil on canvas, 31⅞ x 25⅞ ".
Musée National d'Art Moderne, Paris

Colorplate 30. HENRI MANGUIN.
*The Fourteenth of July at Saint-Tropez.*
1905. Oil on canvas, 24 x 19¾ ".
Manguin Collection, Paris

Colorplate 31. PABLO PICASSO.
*The Fourteenth of July,*
*Montmartre.* 1901.
Oil on board mounted on
canvas, 19 x 24⅞ ".
Thannhauser Collection,
New York. Courtesy of
Thannhauser Foundation

left: Colorplate 32. ALBERT MARQUET.
*The Fourteenth of July, Le Havre.*
1906. Oil on canvas, 30¾ x 24½".
Collection M. and Mme. Georges Besson, Paris

below: Colorplate 33. RAOUL DUFY.
*Indian Model in the Studio at L'Impasse Guelma.*
1928. Oil on canvas, 31⅞ x 39⅜".
Collection A. D. Mouradian, Paris

*above:* Colorplate 34. ANDRE DERAIN.
*London Bridge.* 1906. Oil on canvas, 26 x 39″.
The Museum of Modern Art, New York.
Gift of Mr. and Mrs. Charles Zadok

*right:* Colorplate 35. HENRI MATISSE.
*Le Luxe II.* 1907–08. Casein on canvas,
82⅛ x 54¾″. Statens Museum for Kunst,
Copenhagen. Rump Collection

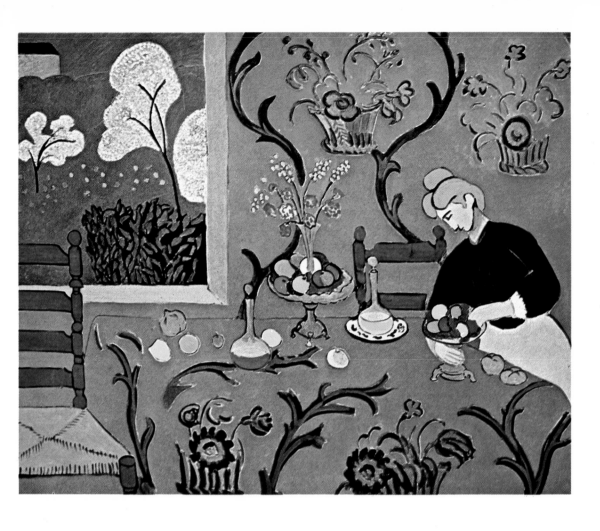

Colorplate 36.
HENRI MATISSE.
*Harmony in Red*
*(La Chambre rouge;*
*La Desserte—*
*Harmonie rouge).*
1908–09. Oil on canvas,
71¼ x 96⅞".
The Hermitage Museum,
Leningrad

Colorplate 37.
HENRI MATISSE.
*Red Studio.* 1911.
Oil on canvas,
71¼ x 86¼".
The Museum of Modern Art,
New York. Mrs. Simon
Guggenheim Fund

93

*right:* Colorplate 38. HENRI MATISSE.
*Piano Lesson.* 1916–17. Oil on canvas,
96½ x 83¾". The Museum of Modern Art,
New York. Mrs. Simon Guggenheim Fund

*below:* Colorplate 39. HENRI MATISSE.
*Decorative Figure*
*Against an Ornamental Background.*
1927. Oil on canvas, 51⅛ x 38½".
Musée National d'Art Moderne, Paris

OPPOSITE PAGE:

*above left:* Colorplate 40.
PABLO PICASSO. *Woman Ironing.* 1904.
Oil on canvas, 45¾ x 28⅝".
Thannhauser Collection, New York.
Courtesy of Thannhauser Foundation

*above right:* Colorplate 41. PABLO PICASSO.
*Les Demoiselles d'Avignon.* 1907.
Oil on canvas, 96 x 92". The Museum
of Modern Art, New York. Acquired
through the Lillie P. Bliss Bequest

*below left:* Colorplate 42.
GEORGES BRAQUE. *Houses at L'Estaque.*
1908. Oil on canvas, 28¾ x 23⅝".
Hermann and Margit Rupf Foundation,
Kunstmuseum, Bern

*below right:* Colorplate 43.
GEORGES BRAQUE. *Violin and Palette.*
1909–10. Oil on canvas, 36¼ x 16⅞".
The Solomon R. Guggenheim Museum,
New York

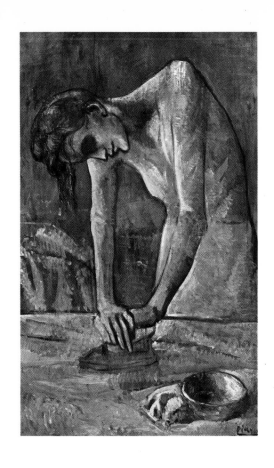

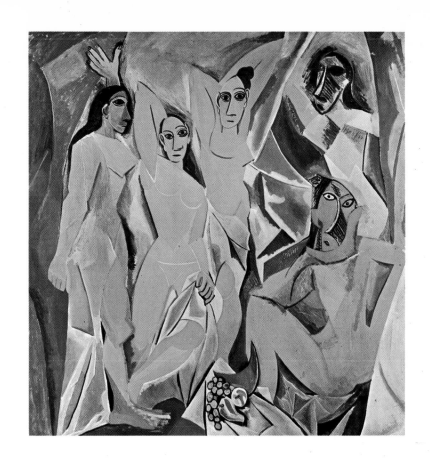

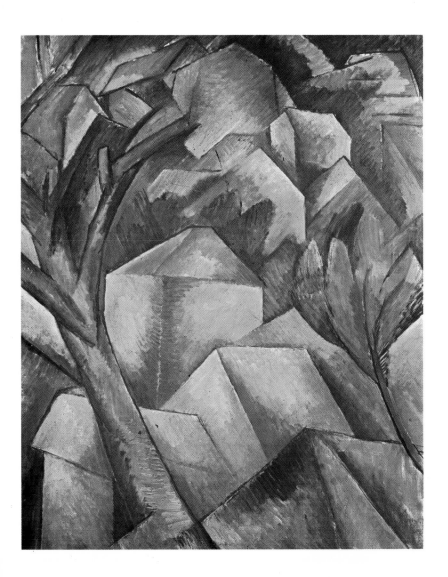

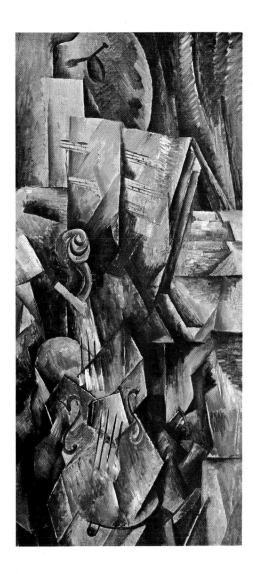

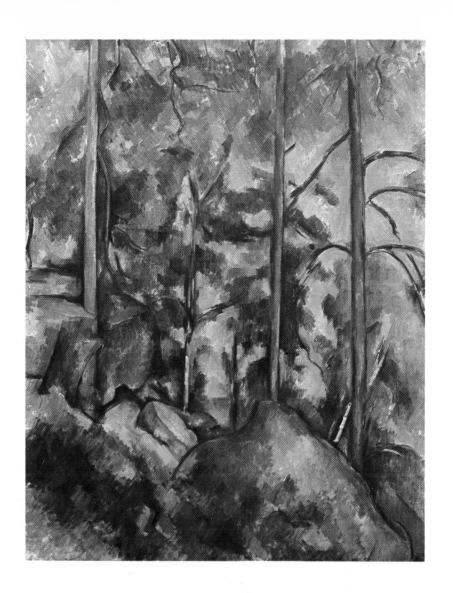

Colorplate 44. PAUL CEZANNE.
*Pines and Rocks.* c. 1904.
Oil on canvas, 32 x 25¾″.
The Museum of Modern Art, New York.
The Lillie P. Bliss Collection

Colorplate 45.
PABLO PICASSO.
*Green Still Life.* 1914.
Oil on canvas, 23½ x 31¼″.
The Museum of Modern Art,
New York.
The Lillie P. Bliss
Collection

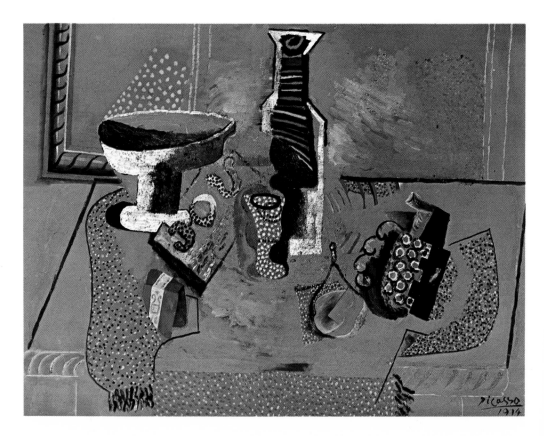

96

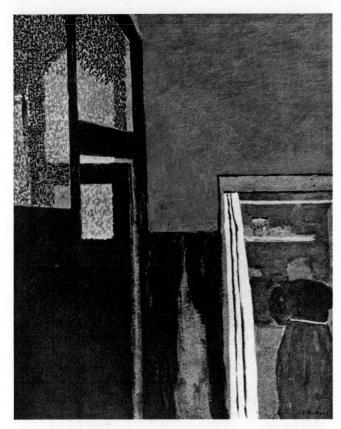

139. EDOUARD VUILLARD. *Interior*. 1898.
19¾ x 16¼". Private collection, Paris

vironments. The *Self-Portrait* is an unusually bold attempt at the use of vivid, even harsh, abstract color patterns of yellow, red, ocher, blue, and umber. That it is a self-portrait is made very clear, nevertheless; what is portrayed is a particular and identifiable individual, reminiscent of some of the late self-portraits of Van Gogh.

*Interior* (fig. 139) represents Vuillard's extreme limit in the direction of abstraction and is in fact a remarkable work for the time. Here the artist has not only presented a cut-off fragment of an interior, but has abandoned the normal perspective formula of a corner of enclosed, tilted space and frontalized the scene in a manner that anticipates the cubist designs of Matisse of about 1916, such as *The Moroccans* and *Piano Lesson* (see fig. 171 and colorplate 38). Vuillard's *Interior* is composed in his usual palette of muted browns and grays with flickering accents of rose-pink and yellow, but the stark severity of the organization in broad rectangular areas of color is unusual for him. Only the busy pattern of small, regular, pointillist brush strokes in the upper left-hand corner and the shadowy figure of the woman seen through the door to the right recall the environment of the overdecorated, constantly busy, petit-bourgeois home in which the artist lived with his mother. For years he transformed it, with little if any distortion, into a magical place of quiet and repose whose shadowed interiors are composed of and filled with subdued but immensely rich color.

Vuillard in his early works characteristically used the broken paint and small brush stroke of the neo-impressionists, but with a difference. In *Mother and Child* (fig. 140), he portrayed a scene that seems oppressive today,

with its end-of-the-century clutter of flowered wallpaper, figured upholstery, and patterned dresses. In his hands the scene became a beautiful surface pattern of blues, reds, and yellows, comparable to a Persian painting in its harmonious richness. Space is indicated by the perspective of the chaise longue and the angled folds of the standing screen, but it is still a delimited, geometrically defined space. Characteristically, Vuillard defines his color areas by the contours of figures and objects, and thus, in a sense, uses color more naturalistically than a number of his contemporaries. The contours, however, are organized into a linear pattern, which helps control the color and gives to the painting an art nouveau feeling of rhythmic surface decoration.

The many screens that Vuillard painted for the homes of friends and patrons continued the nabi and art nouveau credo that a painting should become part of a decorative totality and not be simply an isolated object on the easel. In *Place Vintimille* (fig. 141) his sense of intimacy, of the portrayal of a most personal, familiar, and loved world, is carried to the immediate outdoors as he might have seen it from his studio window. The tall shape of the two panels emphasizes the nature of the scene as fragments isolated and framed in a deep, recessed window of the same shape. The shape fortifies the sense of rectangular structure on the picture plane, something which is further accented by the solid blocks of buildings sealing in the background toward the top.

Vuillard, like Bonnard, was a superb draftsman, and participated in the revival of printmaking at the end of the nineteenth century. A small, free oil sketch, *Toulouse-Lautrec in a Theater Aisle,* done about 1895–96 (colorplate 20), is a masterpiece of immediate and penetrating observation, and reveals a satiric vein in the artist which is surprising but which may help to explain the control with which he could catch and make significant the most transitory moment and commonplace event.

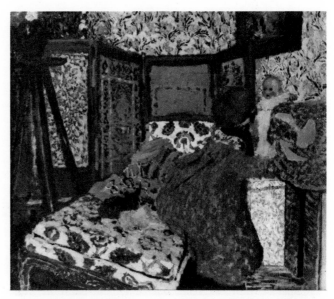

140. EDOUARD VUILLARD. *Mother and Child*. 1899.
Oil on cardboard, 19⅛ x 22¼". Glasgow Art Gallery
and Museum. Presented by Sir John Richmond, 1948

141. EDOUARD VUILLARD. *Place Vintimille*. c. 1908.
Tempera on board mounted on canvas in two sections,
each 76 x 25½″. Thannhauser Collection, New York.
Courtesy of Thannhauser Foundation

## PIERRE BONNARD *(1867–1947)*

Pierre Bonnard, of all the nabis, was the closest to
Vuillard; the two men were friends until Vuillard's death
in 1940. Like Vuillard, Bonnard lived a quiet and unob-
trusive life; but whereas Vuillard remained a bachelor,
Bonnard early became attached to a young woman whom
he ultimately married in 1925. It is she who appears in
so many of his paintings, as a nude bathing or combing
her hair, or as a shadowy but ever-present figure seated
at the breakfast table, appearing at the window, or boat-
ing on the Seine. At first destined for a career in the law,
Bonnard turned to painting professionally after having
sold a poster to advertise champagne. He soon gained a
modest success making lithographs and posters, illustrat-
ing books, and also designing occasionally for Louis Tif-
fany. He lived a comfortable and unobtrusive life, wholly
dedicated to intensive study of his circumscribed world.

Bonnard, like many of his generation, began in reac-
tion against impressionism; but of all the nabis he and
Vuillard were the least influenced by Gauguin. Yet he
was affected by his study of Japanese prints, particularly
in his adaptation of the Oriental approach to limited and

tilted space in the painting. This is not so immediately
apparent as it might be, since from the beginning Bon-
nard evinced a love of paint texture, a love that led him
from the relatively subdued palette of his earlier works to
the full luminosity of impressionist color rendered in
fragmented brush strokes. His large *Screen (Promenade
of Nurses: Frieze of Fiacres;* fig. 143) shows him at his
most Japanese and decorative in the spirit of art nou-
veau. At the same time, the figures of mother and chil-
dren as well as the three heavily caped nurses reveal (as
was also true of Vuillard) a touch of gentle satire that
well characterizes the frequently surprising penetration
of observation he combined with simplicity of spirit.

In the *Interior,* 1898 (fig. 142), a work with close af-
finities to Vuillard's *Interior* of the same year, Bonnard
was still painting in a relatively muted palette with, how-
ever, a sense of coloristic richness in the underpainting.
In a manner reminiscent of interiors by the seventeenth-
century Dutch painter Pieter de Hooch, he lit the back-
ground dining room seen through the door and placed
the foreground in shadow. The result is both an opening
up of perspective space and a bringing forward of the
more coloristic background to the picture plane. Like
Vuillard, again, Bonnard frontalized the abruptly cut-off
section of the room in a precise, flattened way—an art
nouveau anticipation of Matisse and even of Mondrian.

142. PIERRE BONNARD. *Interior*. 1898. 20½ x 13¾″.
Collection Mr. and Mrs. Norton Simon, Los Angeles

Bonnard differed from Vuillard in many important respects. As he proceeded, his color became constantly brighter and gayer, until in a painting like *Dining Room in the Country* (colorplate 21) he had recovered the entire spectrum of bright color presented in large areas of clearly drawn architecture and used as counterpoint to the broken brush strokes of the landscape. The full impressionistic sunlight stems from the late Monet. Yet Bonnard actually belongs in the tradition of the late Manet, Renoir and, most specifically, of Degas. Furthermore, in 1913, when the *Dining Room* was painted, many of the revolutions of early twentieth-century painting had already occurred. Fauvism, with its arbitrary, expressive color, and cubism, with its reorganization of Renaissance pictorial space, had both won their first notable victories. Painting everywhere was well on the way to abstraction, expressionism, or fantasy in various forms. Bonnard was well aware of what was happening around him, but he was content to go his own way. Since he frequently did not date his works and since his style, once established, remained so consistent, it is often difficult to place the paintings accurately within several years. The *Dining Room on the Garden* (colorplate 22), probably painted in the early 1930s, is remarkably close to the 1913 version. In both there are evidences that Bonnard had looked closely at fauve and cubist paintings, particularly the works of Matisse—who was a devoted admirer of Bonnard—and had used what he wanted of the new approaches without at any time changing his basic attitudes. Like the experimentalists, Bonnard did not paint from direct observation. A few strokes of the brush were enough to serve as notes of both color and organization. Gradually, from these notes—frequently long afterward and in a different environment—his own conception would emerge, based on the scene but changed and modified in a hundred ways, much as Picasso might have transformed a still life into a cubist grid.

In late works, such as *Still Life* (*Corner of a Table;* colorplate 23), or *Self-Portrait* (fig. 144), Bonnard's color became at times more forceful and independent in an expressionist manner. His picture space became contracted and his forms distorted, but his basic vision remained consistent. The astonishing thing about Bonnard's painting, narrow as it might seem in its focus, is the high level he maintained for over fifty years.

# PART THREE

# EARLY TWENTIETH CENTURY PAINTING

## *Fauves and Cubists*

HENRI MATISSE *(1869–1954)*
AND FAUVISM TO 1912

Henri Matisse was born only two years after Bonnard and outlived him by seven years. These men of genius were not only exact contemporaries, but had much in common as artists: they were two of the greatest colorists of the twentieth century, and each learned something from the other. Yet Matisse, one of the pioneers of twentieth-century experiment in painting, seems to belong to a later generation, to a different world. Like Bonnard, he was destined for a career in the law, but by 1892 he was enrolled in the Académie Julian, studying with the academician A.-W. Bouguereau. The following year he entered the Ecole des Beaux-Arts and was fortunately able to study in the class of Gustave Moreau. Moreau, though a symbolist, was a dedicated teacher who encouraged his students to find their own directions through constant study in the museums, as well as through individual experiment. In his class, Matisse met Georges Rouault, Albert Marquet, Henri-Charles Manguin, Charles Camoin, and Charles Guérin, all of whom were later to be associated as the fauves.

Matisse developed slowly from the dark tonalities and the literal subjects he first explored. By 1896 he was be-ginning to discover Degas, Toulouse-Lautrec, impressionism, and Japanese prints, and then Renoir and Cézanne. In 1899, in the atelier of Carrière, who was associated with symbolism, he met André Derain. In the same year he began to experiment with figures and still lifes painted in direct, non-descriptive color. Shortly thereafter he made his first attempts at sculpture and demonstrated the abilities that were to make him one of the great painter-sculptors of the twentieth century. In 1901, through Derain, he met Maurice de Vlaminck, and thus the fauve group was almost complete.

Among the paintings that Matisse copied in the Louvre while he was a student with Moreau was a still life by the seventeenth-century Dutch painter Jan Davidsz. de Heem (fig. 145). Matisse's version (fig. 146) is a free copy, considerably smaller than the original. This work, of which he was to make a cubist variation about 1916 (see fig. 170), might almost be a symbol of the direction his painting was to take throughout his career—toward eliminating details and simplifying line and color to their elements. Even when he returned, as he did periodically, to an extreme of colorism and pattern elaboration, the elaborate phase was preliminary to yet another process of stripping off non-essentials. At the Salon de la Société Nationale des Beaux-Arts (known as the Salon de la Nationale) of 1897, he exhibited *Dinner Table* (*La Desserte;* fig. 147), a work highly traditional on the face of it, but one of his most complicated and carefully con-

145. JAN DAVIDSZ. DE HEEM. *The Dessert*. 1640.
58⅝ x 80". The Louvre, Paris

146. HENRI MATISSE. Free copy of *The Dessert* by De Heem.
1893–95. 28⅞ x 39½". Musée Cimiez-Nice, France

*above:* 147. HENRI MATISSE. *Dinner Table (La Desserte).* 1897.
39¼ x 51½". Collection Mr. and Mrs. Stavros Niarchos, Paris

*right:* 148. HENRI MATISSE. *Male Model.* c. 1900.
39¾ x 28¾". Private collection

*below right:* 149. HENRI MATISSE. *Carmelina.* 1903.
31½ x 25¼". Museum of Fine Arts, Boston

structed to that date. This painting, although dark in
tone, revealed in its red luminosity his interest in the im-
pressionists; and in the abruptly tilted table that crowds
and contracts the space of the picture it anticipated his
move toward a sort of architectural simplification that
was the ancestor of his own version of cubism. *Male
Model,* c. 1900 (fig. 148)—the model is the same as in
his sculpture, *Slave* (see fig. 177)—carried this process
of simplification and contraction several stages further,
even to the point of some distortion of perspective, to
achieve a sense of delimited space, in a manner suggest-
ing influences from both Van Gogh and Cézanne. Al-
though it was painted in an almost uniform brown tonal-
ity, with emphasis on the architectural structure, Matisse
was at that time also painting out of doors and exploring
the divided-color palette of the impressionists and the
abstract color patterns of the neo-impressionists. The
*Carmelina* (fig. 149) returned to the corner of the studio
in a frontalized arrangement based on Cézanne, with the
model projecting sculpturally from the rectangular design
of the background.

During the first years of the century Matisse had con-
tinued working on his sculpture, particularly of the nude
figure (see p. 115). At about the same time he also em-
barked on his first series of nude studies in paintings and
drawings. Between 1902 and 1905 he exhibited at the
gallery of Berthe Weill, then at that of Ambroise Vol-
lard, who was rapidly becoming the principal dealer for
the avant-garde artists of Paris. When the more liberal
Salon d'Automne was established in 1903, Matisse
showed there, along with Bonnard and Marquet. In the
Salon d'Automne of 1905, a room of paintings by Ma-
tisse, Vlaminck, Derain, and Rouault, among others, is
supposed to have occasioned the remark that gave the

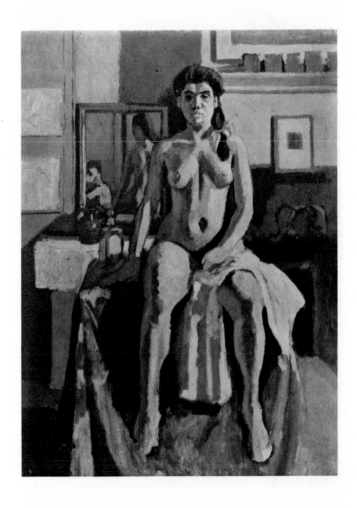

group its permanent name. According to the anecdote, the critic Louis Vauxcelles, observing a Donatellesque sculpture in the midst of the wildly coloristic paintings, exclaimed, *"Donatello au milieu des fauves!"* ("Donatello among the wild beasts!") Whether the remark was made on this occasion or later at the 1906 Salon des Indépendants, the name stuck.

The word "fauves" had particular reference to the brilliant, arbitrary color, more intense than the scientific color of the neo-impressionists and the non-descriptive color of Gauguin and Van Gogh, and to the direct, violent brushwork with which Matisse and his friends had been experimenting for the previous year at Collioure and Saint-Tropez in the south of France. The fauves accomplished that final liberation of color toward which, in their different ways, Gauguin, Van Gogh, Seurat, the nabis, and the neo-impressionists had been experimenting. Using similar means, the fauves were still intent on different ends. They wished to use violent color squeezed directly from the tube, not to describe objects in nature, not simply to set up retinal vibrations, not to accentuate a romantic or mystical subject, but to build new pictorial values apart from all these. Thus, in a sense, they were using the color of Gauguin and Seurat, freely combined with their own linear rhythms, to reach effects similar to those which Cézanne constantly sought. It is no accident that of the artists of the previous generation, it was Cézanne whom Matisse revered the most.

Matisse had already exhibited in the Indépendants of 1905 his large neo-impressionist composition, *Luxe, calme et volupté* (fig. 150), a title taken from a couplet in Baudelaire's *L'Invitation au voyage:*

> *Là, tout n'est qu'ordre et beauté,*
> *Luxe, calme et volupté.*

In this work, which went far along the path to abstraction, he combined the mosaic landscape manner of Si-

150. HENRI MATISSE. *Luxe, calme et volupté.* 1904–05. 37 x 46". Private collection, Paris

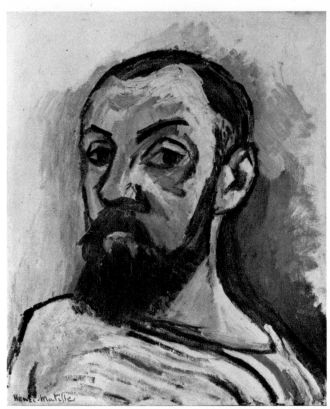

151. HENRI MATISSE. *Self-Portrait.* 1906. 21⅝ x 18⅛". Statens Museum for Kunst, Copenhagen

gnac (who bought the painting) with figure organization based on versions of the *Bathers* by Cézanne (colorplate 24) and on his studies of sculpture. The painting was the first major example of a type of figure-landscape composition that was to produce several of the most important works of the next few years.

At the Salon d'Automne of 1905, Matisse also exhibited *Open Window, Collioure* (colorplate 25) and a portrait of Madame Matisse called *Woman with the Hat* (colorplate 26). The *Open Window* is perhaps the first fully developed example of a theme that was to be favored by Matisse throughout the rest of his life. It is simply a small fragment of the wall of a room, taken up principally with a large window whose casements are thrown wide to the outside world—a balcony with flowerpots and vines, then sea, sky, and boats. Here the inside wall and the casements are composed of broad, vertical stripes of vivid greens, blues, purples, and orange; and the outside world is a gay pattern of brilliant small brush strokes, ranging from stippled dots of green to broader strokes of pink, white, and blue in sea and sky. In this painting he has already moved far beyond Bonnard or any of the neo-impressionists toward a suggestion of coloristic abstraction. But, as always with Matisse, the sense of an actual, transient scene is very strong.

His *Woman with the Hat* caused even more of a furor than the *Open Window,* because of the seemingly wild abandon with which the paint was indiscriminately smeared over the surface, not only the background and hat but in the face of the lady, whose features are outlined in bold strokes of green and vermilion. Shortly thereafter, Matisse painted another portrait of Madame Matisse which in a sense was even more audacious, precisely because more tightly and meticulously rendered.

152. Photograph of Matisse, autumn, 1909

This is the work entitled *Green Stripe* (colorplate 27), with a face dominated by a brilliant green band dividing it from hairline to chin. At this point Matisse and his fauve colleagues were building on the thesis put forward by Gauguin, the symbolists, and the nabis: that the artist is free to use his color independently of natural appearance, building a structure of abstract color shapes and lines foreign to the woman, tree, or still life that remains the basis of the structure. Perhaps Matisse's version was more immediately shocking because his subject was so simple and familiar. This use of color was more acceptable in the exotic scenes of Gauguin or the mystical fantasies of Redon. In comparison with the fauve portraits of his wife, Matisse's 1906 *Self-Portrait* (fig. 151), although powerfully drawn and penetratingly realized, is almost traditional (see fig. 152).

The artist continued to experiment with arcadian figure compositions, as Cézanne and Gauguin had done, and Poussin and the Venetians before them. In the *Pastorale*, 1905, he returned to an impressionist pattern of broken color; and then in the great *Joy of Life* (*Bonheur de vivre; Joie de vivre;* fig. 153), he combined his various experiments in one of his finest figure-landscape paintings. The *Joy of Life* is filled with reminiscences, from Giovanni Bellini's *Feast of the Gods* to Persian painting, but in it the artist has blended all these influences into a masterful arrangement of sinuous, undulating lines of figures and trees which, despite deliberate perspective diminutions, live as a pattern on the picture plane. It is a true pastoral, filled with a mood of sensual languor and the spirit of arcadian delights. Like Picasso's *Demoiselles d'Avignon*, produced the following year, it was an ancestor of abstraction in modern painting. Its influence may even have transcended that of Picasso's

great work, since the latter was not exhibited publicly until 1937, whereas the *Joy of Life* was bought immediately by Gertrude and Leo Stein, and for many years was well known in their collection. Certainly Picasso saw it either at the Indépendants, where it was exhibited in 1906, or at the Steins' apartment.

The curvilinear rhythms of the *Joy of Life* relate it to the tradition of art nouveau, although it transcends in quality any other painting of this tradition. Related to it also are many studies of the nude, some of which he later developed into other paintings and sculptures. In fact, Matisse's delight in drawing and painting the nude seems to have gained its first great impetus in the *Joy of Life* studies. He experimented with *contrapposto* in the *Blue Nude* (fig. 154), painted early in 1907, establishing a form which he carried into sculptured versions in terra cotta and bronze, in figures both draped and nude (fig. 155). The type appears in the right central figure in *Joy of Life,* but the *Blue Nude* is modeled more sculpturally, and the *contrapposto* is asserted even more aggressively in the sculptures. In turn, the sculpture appears as a dominant element in a number of paintings executed between 1908 and 1915 (*Goldfish and Sculpture,* fig. 156).

The wild beasts of the Salon d'Automne of 1905 included artists of varying talents, among them Matisse, André Derain, Maurice de Vlaminck, Georges Rouault, Albert Marquet, Henri Manguin, Kees van Dongen, Othon Friesz, Jean Puy, and Louis Valtat. Of these, the unquestioned leader and by far the greatest talent was Matisse.

The manner in which the different fauves attained their avowed goals varied with the interests and abilities of the individuals. Also, as was usual with such groups, they were together for only a limited time. Within a very few years each painter had begun to go his own way, some to greater achievements, some, being no longer supported by the genius and enthusiasms of the leaders, to obscurity.

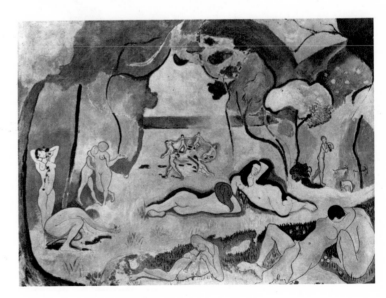

153. HENRI MATISSE. *Joy of Life*
*(Bonheur de vivre; Joie de vivre).* 1905–06. 68½ x 93¾".
The Barnes Foundation, Merion, Pennsylvania

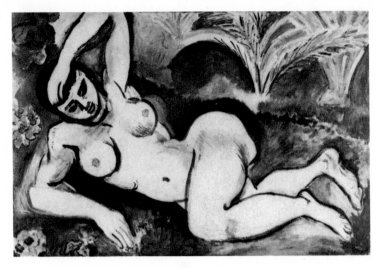

154. HENRI MATISSE. *The Blue Nude.* 1907.
36¼ x 55⅛".
The Baltimore Museum of Art. The Cone Collection

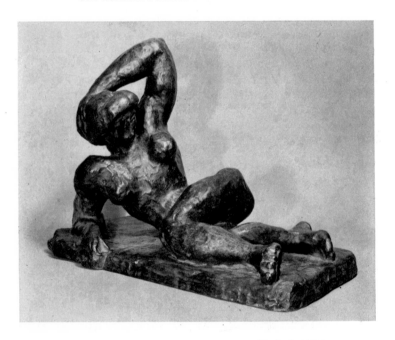

155. HENRI MATISSE. *Reclining Nude I.* 1907.
Bronze, 13½ x 19¾". The Museum of Modern Art, New York.
Acquired through the Lillie P. Bliss Bequest

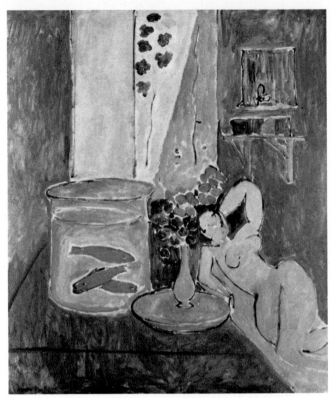

156. HENRI MATISSE. *Goldfish and Sculpture.* 1911.
46 x 39⅝". The Museum of Modern Art, New York.
Gift of Mr. and Mrs. John Hay Whitney

ALBERT MARQUET *(1875–1947),*

OTHON FRIESZ *(1879–1949),*

KEES VAN DONGEN *(b. 1877)*

Of all the group, Albert Marquet was closest to Matisse on a personal level, although he was not one of its strongest painters. After a brief flirtation with fauvism (see colorplate 32), which resulted principally from his friendship with Matisse, Marquet soon reverted to the nostalgic and simplified naturalism that was his essential interest. For most of his long career he painted landscapes of the Seine, or scenes of Paris and France, in which he combined the lyrical atmosphere of a latter-day

Corot with finely controlled organization, demonstrating his substantial abilities as a draftsman. *Ciboure* (fig. 157), painted in the full tide of fauvism, is actually a subdued and harmonious landscape illustrating the artist's ability to lay in the essence of the scene with an absolute minimum of brush strokes and color areas.

Of the other fauves, Othon Friesz had moved toward a rather conventional adaptation of the Cézanne tradition, then very much on the rise (*Portrait of Fernand Fleuret,* colorplate 28). Kees van Dongen, a brilliant draftsman and virtuoso colorist, adapted fauve color to fashionable portraits and satiric sketches of café society (fig. 158).

RAOUL DUFY *(1877–1953)*

Raoul Dufy was shocked out of his reverence for the impressionists and Van Gogh by his discovery of Matisse's painting, *Luxe, calme et volupté,* in 1905 (see fig. 150). In a sense, he remained faithful to this vision and to fauve color throughout his life. In his *Street Decked with Flags, Le Havre* (colorplate 29), the flags help to create a gay scene, but the close-up view creates a strong feeling of abstract geometric pattern. The theme of the street with flags has been almost a symbol of the search for free, abstract color from Manet to the present. Manet painted such a street, and similar flag-decked streets (usually in celebration of the Fourteenth of July holiday) were painted by Monet, Van Gogh, James Ensor, Henri Manguin (*The Fourteenth of July at Saint-Tropez;*

colorplate 30), Picasso (*The Fourteenth of July, Montmartre;* colorplate 31), Marquet (*The Fourteenth of July, Le Havre;* colorplate 32), and others. The appeal of the subject to artists, who in one way or another were seeking dynamic coloristic expression, is obvious.

Influenced by Georges Braque, his fellow painter from Le Havre, Dufy after 1908 experimented with a modified form of cubism, but he was never really happy in this vein. Gradually he returned to his former loves—decorative color and elegant draftsmanship—and formulated a personal style based on his earlier fauvism. This style he maintained with variations until the end of his life. In his paintings he combined influences from Matisse, Rococo art of the eighteenth century, Persian and Indian painting, and occasionally modern primitives such as Henri Rousseau, transforming all these, however, into a delightful, intimate world of his own. In *Indian Model in the Studio at L'Impasse Guelma* (colorplate 33) he attempts to outdo Matisse in the introduction of Oriental pattern into the studio setting. This work shows many of the characteristics of Dufy's developed painting manner. The oil color is laid on in thin washes suggestive of watercolor—a medium in which he worked extensively. The broad, clear area of very light blue that covers the studio wall forms a background to the intricate pattern of rugs and paintings whose exotic focus is the delightful Indian model herself. The importance of descriptive line is such that the painting—and this is true of many if not most of

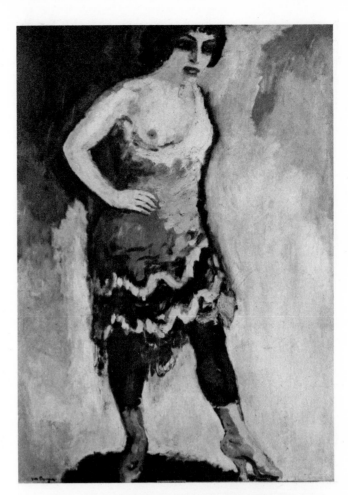

158. KEES VAN DONGEN. *Female Acrobat.* 1910. 45½ x 29½". Musée National d'Art Moderne, Paris

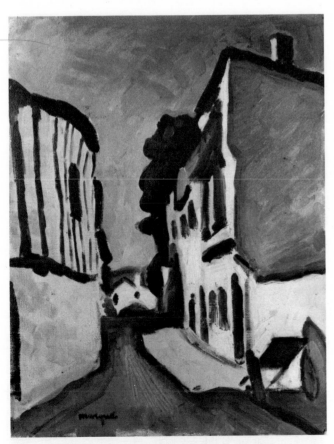

157. ALBERT MARQUET. *Ciboure.* 1907. 16¼ x 13½". Private collection, New York

Dufy's works—seems a delicately colored ink drawing.

He can take a panoramic view and suggest, in minuscule touches of color and nervous arabesques of line, the movement and excitement of crowds of holiday seekers. Horse races at Deauville or Ascot, regattas at Henley, Cowes, or Deauville, boats in sun-filled harbors, the circus, the concert hall—all these made up the world of Raoul Dufy. Conscious of the revolutions surrounding him on all sides, he flirted occasionally with abstraction, only to turn it into elegant decoration. His talent was charming, if eclectic; his aims were never sufficiently ambitious to make the most of his natural abilities. Yet his reputation throughout his life and since his death has remained remarkably high. His early association with the fauves and the continuing charm of his later works have established him popularly as a leader of modern art.

## ANDRE DERAIN *(1880–1954)*

André Derain met Matisse at Carrière's atelier in 1899, as already noted, and was encouraged by him to proceed with his career as a painter. He already knew Maurice de Vlaminck, whom Derain in turn had led from his various careers as violinist, novelist, and bicycle racer into the field of painting. Unlike Vlaminck, who

combined the physical energy of an athlete with the naïve enthusiasm of a child, Derain was a serious student of the art of the museums, a man who, despite his initial enthusiasm for the explosive color of fauvism, was constantly haunted by a concept of painting more ordered and classic in a traditional sense. At first he tried to assimilate the various contributions of Van Gogh, Gauguin, and impressionism to those of Cézanne, and to bring them up to date in terms of Matisse and the fauves. He tried his hand at a Cézanne still life in 1904, and experimented with late neo-impressionism in works like *Morning Light* (fig. 159).

Although Derain's fauve paintings embodied every kind of variation, from large-scale pointillism to free brushwork, most characteristic, perhaps, are works like *London Bridge* (colorplate 34), in which he took a high vantage point and laid out the large, main color areas of green, blue, red, and yellow. The perspective is tilted; the background sky is rose-red. The buildings against the sky are silhouettes in green and blue. The meticulous reiteration of large color areas, foreground and background, and the abruptly foreshortened space, serve the purpose of delimiting the depth, almost in a textbook manner. The color is an accomplished arrangement of harmonies and dissonances, excellently co-ordinated by the architecture of bridge and buildings.

Derain's fauve paintings are among his best, but nevertheless reveal the flaw that was to become continually more apparent in his later works. He was essentially an academic painter who happened to become involved in a revolutionary movement, participated in it effectively,

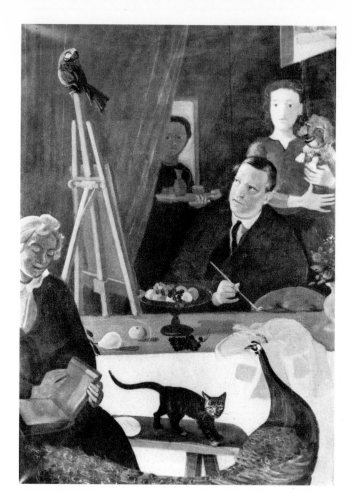

160. ANDRE DERAIN. *The Painter with His Family*. c. 1939. 68½ x 48⅞". Private collection, Chambourcy, France

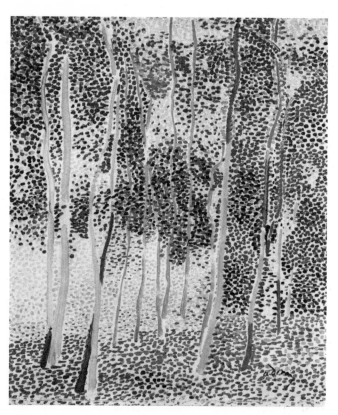

159. ANDRE DERAIN. *Morning Light*. 1904–05. 29⅞ x 25¾". Private collection, Rome

but was never completely happy in the context. In 1906 he became a friend of Picasso and was drawn into the vortex of proto-cubism. He was one of the first to discover African art and to develop an interest in primitivism in a broader sense. His *Bathers*, 1908, is a combination of Cézanne, Picasso's proto-cubism, and various researches into primitivism. But during the next few years, when Picasso and Braque were developing the concepts of analytical cubism, Derain was moving back consistently to Cézanne and to Cézanne's sources in Poussin and Chardin. His direction was always away from the experiments of the twentieth century, back through the classic innovators of the late nineteenth century, to the Renaissance. His return to optical realism involved a return to portraiture, drawn with a hard emphatic line. *The Painter with His Family* (fig. 160) effectively summarizes his career. As is normal in his later paintings (except when he sporadically went to the other extreme of soft, romantic, atmospheric rendering), it is harshly drawn, neutral in color, and filled with the arrogance of a successful bourgeois artist who effectively hides his own insecurities in the parade of his possessions and his devoted family and pets. It is, nevertheless, an impressive study, affected by intervening developments in surrealism and magic realism. Derain is a painter who had many of the qualities of greatness—but not conviction. He was fortunate in that he was on hand when the art of the twentieth century was coming to birth.

## MAURICE DE VLAMINCK (1876–1958)

The career of Maurice de Vlaminck presents many parallels with Derain's, even though the artists were so different in personality and in their approach to the art of painting. Vlaminck was born in Paris in 1876 of Flemish stock, something which was of considerable importance to him personally and which may have contributed to the nature of his painting. From the time he met Derain and turned to painting, as previously noted, he was enraptured with color. Thus the Van Gogh exhibition at the Bernheim-Jeune Gallery in 1901 was a revelation to him. At the Salon des Indépendants in the same year, Derain introduced him to Matisse who, despite his wisdom and his qualities of leadership, was less successful in directing the exuberant Vlaminck than he was with any of the other younger fauves. Van Gogh remained Vlaminck's great love, and his fauve paintings are close to the expressionist aspect of Van Gogh's paintings if not to their inner structure. The *Man with a Pipe* (*Le Père Bouju;* fig. 161), done even before he was thoroughly exposed to Van Gogh, has some of the latter's qualities, although rendered with a chaotic intensity beyond even those

162. MAURICE DE VLAMINCK. *Picnic in the Country*. 1905. 35 x 45⅝". Private collection, Paris

161. MAURICE DE VLAMINCK. *Man with a Pipe* (*Le Père Bouju*). 1900. 28¾ x 19⅝". Musee National d'Art Moderne, Paris

163. MAURICE DE VLAMINCK. *The Flood, Ivry*. 1910. 23¾ x 36⅝". Whereabouts unknown

self-portraits that Van Gogh painted in the sanatorium.

In his fauve paintings, Vlaminck characteristically used the short, choppy brush strokes of Van Gogh to attain a comparable kind of coloristic dynamism. However, as is evident in *Picnic in the Country* (fig. 162), he could never manage Van Gogh's complete integration of all elements. The two figures, modeled freely but rather literally, are isolated within the coil of swirling color patches; they are foreigners from the world of nature, picnicking in a forest of paint.

164. MAURICE DE VLAMINCK. *Self-Portrait*. 1910.
28¾ x 23⅝". Private collection, Paris

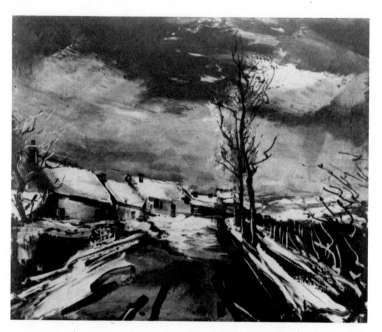

165. MAURICE DE VLAMINCK. *Hamlet in the Snow*. 1943.
5⅛ x 6¼". Whereabouts unknown

By 1908 Vlaminck was beginning to be affected also by the new view of Cézanne that resulted from the exhibitions after Cézanne's death in 1906; and although for a time he was in touch with the new explorations of Picasso and Braque leading toward analytical cubism and

even used various forms of simplification based on their ideas, in actuality he, like Derain, was gradually retreating into the world of representation by way of Cézanne. *The Flood, Ivry* (fig. 163) illustrates the point at which his painting was closest to Cézanne's. The color is generally subdued to a gray-green-blue tonality, with only slight accents of red and yellow in the buildings. The buildings are abstracted to cubes, and the trees looming up in the foreground—like Cézanne's—serve to control depth. All the obvious Cézanne accessories are present, but Vlaminck seems to have missed the entire point. In Cézanne, buildings, water, trees, and sky are all tightly constructed from the common denominator of paint and exist as elements of the painted surface. In Vlaminck's work these remain simply what they seem to be as natural objects—a visual illusion of buildings, water, trees, and sky, meticulously and harmoniously arranged in depth as well as across the surface. Thus, although he has learned much from Cézanne in terms of the architectural disposition of his elements, and although the sense of actual paint texture throughout is greater than it might have been in earlier painting, the work has more in common with a well-organized landscape of the Renaissance tradition, such as a Corot of the Roman period, than with Cézanne and the twentieth century.

A *Self-Portrait* dated 1910 (fig. 164) suggests a degree of cubist geometric simplification and cubist sealed-in depth, although these attributes are essentially superimposed and do not reveal any profound comprehension of the new structural principles then being propounded by Picasso, Braque, and a host of other painters. In it one observes, rather, Vlaminck the expressionist straining at the bonds of classical form—and looking as though he would burst in the process.

The effort finally became too much and, by 1915, Vlaminck had moved toward a kind of expressive realism that he continued to pursue for the rest of his life. His first great love had been Van Gogh, and to Van Gogh he finally returned. Throughout his career he remained closer to the northern or Germanic expressionist tradition than any French painter with the possible exception of Georges Rouault. His characteristic later landscapes take us back to the world of Ruisdael, Hobbema, and seventeenth-century Dutch landscape, interpreted in heavily textured brush painting. His color becomes generally tonal; the effect is of threatening skies over a road winding through a desolate countryside (see *Hamlet in the Snow;* fig. 165). The formula ultimately arrived at by Vlaminck is highly effective, skillfully presented, and charged with emotion. He was content simply to play variations on it throughout most of his life. Yet, with it he was able to maintain and even to increase his reputation until his death in 1958.

## THE SIGNIFICANCE OF THE FAUVES

The fauve revolt was the first violent explosion of twentieth-century art. It established a precedent for the whole series of revolutions that have characterized the history of art since the beginning of the century. Yet it was a curious phenomenon, different in essence from such movements as cubism, abstraction, surrealism. Fau-

vism as a movement lasted only for a very few years. Although artists associated with the movement were creating what could be described as fauve paintings as early as 1903, the movement as such took shape in 1905 or 1906. Within two or three years members of the group were beginning to explore other directions, and by 1908 fauvism as a movement had ceased to exist. The fauves were not actually introducing a new concept into twentieth-century painting. Rather, they were carrying to their logical conclusions—and in the process, destroying—the concepts of great innovators of the previous generation—Gauguin, Van Gogh, and Seurat. The art world was still principally the world of the academies, whose certainties were being undermined by the symbolist painters' search for an esoteric subject matter, the nabis' eclectic adaptations of Gauguin, Redon, and Cézanne, and by the art nouveau attempts to create a new harmony of all the arts on the basis of decorative linear pattern.

The fauves wanted to escape from the restraints of their environment by going back to the principles of color organization propounded by Gauguin and Seurat, and by Van Gogh as well. Although they continued to paint the objective world—landscapes, figures, portraits, and still lifes—they made these subjects abstract by violently detaching paint from its descriptive function. Using color directly, in all its unblended brilliance, they made it function independently. All this had been preached and practiced by Gauguin and Van Gogh and, in a different mode, by Seurat and his followers. The fauves, however, put the principles into practice with an energy and boldness transcending even their masters'. Color was thus used expressively as well as structurally, and fauvism can be called a form of expressionism. Logically enough, its most immediate and enduring influence was to be on the expressionist wing of modern art, especially as it matured in Germany during the first decades of the twentieth century.

A phenomenon of fauvism is that a number of otherwise undistinguished painters produced the best works of their lives while directly associated with the movement. For Matisse, of course, fauvism was only a beginning from which he went on to greater achievements. Derain and Vlaminck, however, did nothing subsequently that had the vitality of their fauve works. This was also true of Marquet; it might also be argued that Marquet never actually was a fauve. Van Dongen became a fashionable painter of portraits and night life. Friesz, Camoin, Manguin, Valtat, and Puy, artists of varying talent (Friesz was in fact an artist of considerable ability), nevertheless sank for a long time into relative obscurity after their moment in the cage of fauves. It is interesting to speculate on why these young men should briefly have outdone themselves, but the single overriding explanation is probably the presence of Henri Matisse—older than the others, wiser, more mature and developed as an artist, the natural leader and teacher of the group and, simply, a genius destined to become one of the greatest masters of twentieth-century painting.

Two other painters associated with fauvism were also to go on to greatness. These were Georges Rouault and Georges Braque, whose careers belong properly to subsequent chapters in the history of modern art.

## MATISSE AFTER FAUVISM

Only during 1905 and 1906, with such works as *Open Window, Collioure* (see colorplate 25), and *The Gypsy* (fig. 166), does Matisse really seem to have pushed his riotous colors and brush textures to their limits. Even within the same period, his analytical mind and broad perception were devoted to other problems. The *Luxe, calme et volupté* of 1904–05 (see fig. 150) was an exercise in neo-impressionism; in the *Joy of Life* (see fig. 153), he was already beginning to control the brush gesture and to order his color in large areas defined by sinuous curves of figures and trees. The *Young Sailor* (fig. 167) illustrates still another aspect of his wide-ranging explorations, perhaps affected by his growing interest in sculpture. The figure is simply and solidly modeled in terms of heavy contour lines worked over the broad areas of paint, blue in the blouse and green in the trousers. The background from which the figure projects is a plane of light pink. The sculptural approach is further evident in *Blue Nude,* and the organization of space in color planes reaches its first great climax in *Le Luxe II* (colorplate 35). Here the artist was completely successful in his attempt to create a new kind of pictorial space in contrasting, juxtaposed color areas. Although he had abandoned perspective except for the arbitrary diminution of one figure, and modeling in light and shadow, the painting is not merely surface decoration. The figures, modeled only by the contour lines, have substance; they

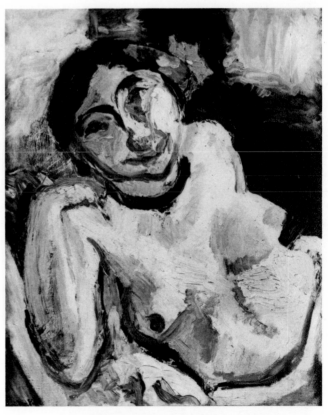

166. HENRI MATISSE. *The Gypsy.* 1906.
21⅝ x 18⅛″. Musée de l'Annonciade, Saint-Tropez, France

exist and move in space, with the illusion of depth, light, and air created solely by color shapes that also confirm the integrity of the picture plane. Thus, at the moment when Picasso and Braque were making their first experiments in a form of proto-cubism, or even before, Matisse had already created a new kind of pictorial space. The first version, *Le Luxe I,* was painted early in 1907.

His exploration of this space was carried still further in *Harmony in Red (La Chambre rouge; La Desserte—Harmonie rouge;* colorplate 36). This was begun early in 1908 as *Harmony in Blue* and was repainted in the spring of 1909. Here Matisse returned to the formula of the *Dinner Table (La Desserte;* see fig. 147), which he had painted early in 1897. A comparison of the two paintings reveals dramatically the revolution that had occurred in this artist's works—and in fact in modern painting—during a ten-year period. Admittedly, the first *Dinner Table* was still an apprentice piece, a relatively conventional exploration of impressionist light and color and contracted space, actually more traditional than paintings executed by the impressionists twenty years earlier. Nevertheless, when submitted to the Salon de la Nationale it was severely criticized by the conservatives as being tainted with impressionism. In *Harmony in Red* we have moved into a new world, more strange and esoteric than anything ever envisioned by the impressionists or even by Gauguin. The space of the room interior is defined by a single unmodulated area of red, whose

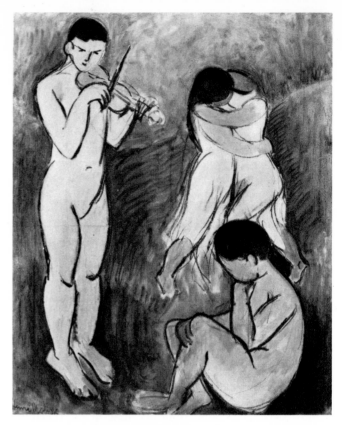

168. HENRI MATISSE. *Music (Sketch).* 1907.
29 x 24″. The Museum of Modern Art, New York.
Gift of A. Conger Goodyear in honor of Alfred H. Barr, Jr.

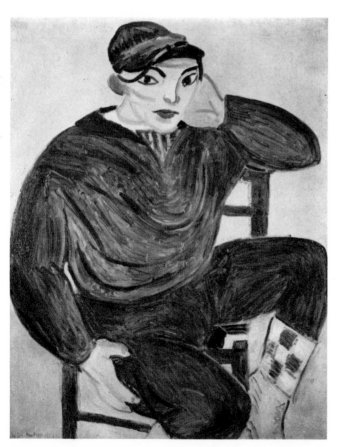

167. HENRI MATISSE. *Young Sailor II.* 1906. 39⅜ x 31⅞″.
Collection Mr. and Mrs. Leigh B. Block, Chicago

adherence to the picture plane is reinforced by arabesques of plant forms flowing impartially across walls and table surface. The out of doors is defined by abstract tree and plant forms silhouetted against the green ground and blue sky. The red building in the extreme upper distance, which reiterates the color of the room, in some manner establishes the illusion of depth in the landscape. Although abandoning formal perspective, the artist has used a few minor perspective touches such as the frame of the window, the chair in the left foreground, the placing of the objects on the table, and the way in which arabesques on the table curve around its edges. In essence, however, he has again—and in an even greater degree than in *Le Luxe II*—created a new, tangible world of pictorial space through color and line.

The exploration of line-color-space continued in a group of figure paintings in which the figures, boldly outlined, were isolated against grounds of intense color. From the time he had discovered Cézanne, a version of whose *Bathers* he had purchased in 1899 when he could ill afford it, Matisse had been intrigued by the arcadian theme of nudes in a landscape, as noted earlier. The *Pastorale* and *Joy of Life* constituted early experiments carried much further in *Le Luxe II.* During 1907, 1908, and 1909 he pursued his investigations in a number of important pictures: *Music* (sketch, 1907; fig. 168), *Game of Bowls,* 1908, *Bathers with Turtle,* 1908, and *Nymph and Satyr,* 1909. The group was followed by two huge paintings of the first importance, *Dance,* 1909 (fig. 169), and *Music,* 1910, commissioned by the Russian collector Sergei Shchukin. In these, Matisse reached the

climax of his early explorations of color, line, and space, as well as of relations of form and content.

The origins of *Dance* have been variously traced to Greek vase painting or peasant dances. Specifically, the motif was first used by Matisse in the background group of *Joy of Life,* although there the figures revolve in a more literally illusionistic depth. In *Dance,* the colors have been limited to an intense green for the ground, an equally intense blue for the sky, and brick-red for the figures. The figures are sealed into the foreground by the color areas of sky and ground, but they nevertheless dance easily in an airy space created by these contrasting juxtaposed hues and by their own modeled contours and sweeping movements. The depth and intensity of the colors change in different lights, at times setting up visual vibrations that make the entire surface dance. *Music* is a perfect foil for the violence of *Dance,* in the static frontalized poses of the figures, each isolated from the others to create a mood of trancelike withdrawal. In both paintings the arcadian worlds of earlier painters have been transformed and transported into the twentieth century, while retaining their original magic and mystery.

The art of Matisse throughout his life tended to alternate between extreme simplification and decorative elaboration. *Dance* and *Music* were followed by a number of paintings of interiors, particularly studio interiors, in which his love of rich Oriental tapestries was given full rein. Visits to Spain in 1910–11, and to Morocco in 1911–12 and 1912–13, resulted in a number of the most lush and exotic landscapes of his career, and seem to have confirmed him in that love of sunlight on color which had already appeared in his painting, and which was to be perhaps the one characteristic of his work that transcended all others.

In *Red Studio* (colorplate 37) he carried the principle of the single, unifying color much further than in *Harmony in Red.* The studio interior is described by a uniform area of red, covering floor and walls. A corner is identified by a single white line, which angles inward to create the corner by joining a second line more or less parallel to the picture plane. Furnishings—table, chair, cupboard, and sculpture stands—are ghost objects outlined in white lines. The tangible accents are the paintings of the artist, hanging on or stacked against the walls; ceramics, sculptures, vase, glass, and pencils. By 1911, when this was painted, Picasso, Braque, and the other cubists had in their own ways been experimenting with the organization and contraction of pictorial space for some five years. Matisse was affected by their ideas, but he had to find his own solutions. Nevertheless, it was

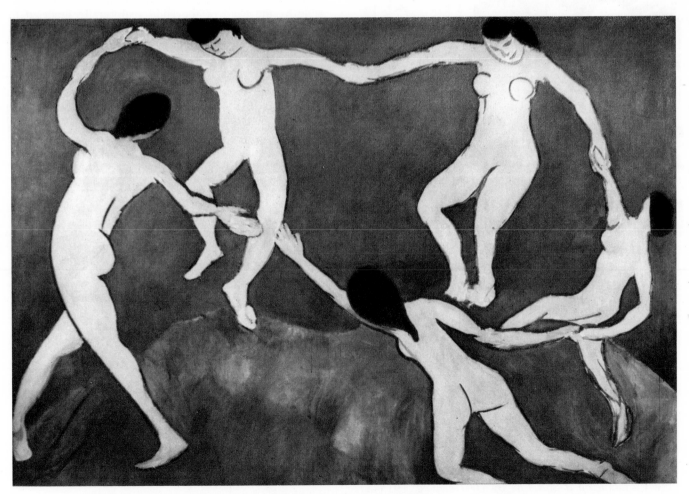

169. HENRI MATISSE. *Dance.* 1909. 8′ 6½″ x 12′ 9½″. The Museum of Modern Art, New York. Gift of Governor Nelson A. Rockefeller in honor of Alfred H. Barr, Jr.

170. HENRI MATISSE. *Variation on a Still Life by De Heem.*
c. 1915–17. 71 x 87¾". Mrs. Florene May Schoenborn
and Samuel Marx Collection, New York

171. HENRI MATISSE. *The Moroccans.* 1916. 6′ x 9′ 2″.
The Museum of Modern Art, New York.
Gift of Mr. and Mrs. Samuel A. Marx

probably in consequence of analytical cubism (see below, p. 124) that he simplified his organization to a rectangular frontality. *Red Studio* marks the beginning of Matisse's own version of cubism, which was to engage him for the next few years. It was a form of geometric simplification in which objects were flattened and frontalized; but there was never the degree of fragmentation, of shifting and tilted planes, that in the works of the cubists proper created the sense of constantly changing vision on the part of the spectator.

Perhaps Matisse's most orthodox cubist painting was the *Variation on a Still Life by De Heem,* c. 1915–17 (fig. 170), in which he demonstrated and clarified for himself the development that had taken place since his

first free copy executed in 1893–95 (see fig. 146). The palette is much lighter; the space is closed in and frontalized; the tablecloth and the architecture of the room are geometrized, as are the fruits and vessels on the table. The result is a successful example of developed or synthetic cubism (see below, p. 130); but, as far as Matisse was concerned, it was simply an exercise performed for his own information. After exploring the range of endeavor of his cubist colleagues, he again pursued his own directions. Still, his studies of cubism were extremely helpful to him, for they taught him how to simplify his pictorial structures, to control his occasional tendency to be overly decorative, and to use the rectangle as a counterpoint for the curvilinear arabesque that came most naturally to him. *The Moroccans,* 1916 (fig. 171), is for Matisse a somber painting, extraordinarily powerful in structure, with a black background framing the flatly silhouetted architecture and curving planes of the praying Moroccans in a pattern approximating absolute abstraction. Even more austere, perhaps, is *Piano Lesson,* 1916 or 1917 (colorplate 38), which is the artist's most successful and characteristic excursion into cubism. This work is a large, abstract arrangement of geometric color planes—lovely grays and greens, and a tilted plane of rose pink. The planes are accented by decorative curving patterns based on the iron grille of the balcony and the music stand of the piano. The environment is made tangible by the head of the child sculpturally modeled in line, by the seated figure in the background, and the indication of Matisse's sculpture *Decorative Figure* (see fig.

172. HENRI MATISSE. *White Plumes.* 1919. 28¾ x 23¾".
The Minneapolis Institute of Arts

173. HENRI MATISSE. *Dance II*. 1932–33. Mural. The Barnes Foundation, Merion, Pennsylvania

178), which appears in so many of his paintings. Here again, his interpretation of cubism is intensely personal, with none of the shifting views and tilted perspective that mark the main line of Picasso, Braque, and Juan Gris. Its frontality and its dominant uniform planes of geometric color areas show that Matisse here is moving close to the later non-objective paintings of Mondrian and the abstractionists. Yet the sense of a subject and of a living space in which personages can move and breathe is always evident; and the mood of nostalgia and contemplation is the essence of the painting.

Toward the end of World War I, and immediately thereafter, Matisse, like Picasso and many others who had led the revolt against representation, seems to have relapsed into a sort of *détente* in which he manifested a need to refresh himself at the springs of nature. Even when making his most extreme excursions into cubism, Matisse had never felt the same need to abandon drawing from nature. Like Picasso, he had continued to draw from the model and to make beautiful and rather literal portrait and figure drawings. His excursions into a modified form of cubism were paced by free, coloristic paintings, of figures in interiors or landscapes, which had much in common with his fauve paintings. In 1919 he produced a number of paintings and drawings more specifically naturalistic than anything he had attempted since the turn of the century. *White Plumes* (fig. 172), for which there are a number of related drawings, introduces this new period of relative realism. The model, in a yellow dress and a hat ornamented with sweeping plumes, is silhouetted against a red background and given a sense of three-dimensional existence by the tonal modeling of the figure and most specifically of the face. This is a classic portrait, severely linear and suggestive of the tradition of Ingres. In its way, it is as pure and simplified a statement as the great figure compositions of ten years earlier. It led into another period of decorative richness in the early 1920s, the period of the Odalisques, when the sensuous color pattern of Matisse reached a peak never attained before or afterward in his career. The *Decorative Figure Against an Ornamental Background* (colorplate 39) epitomizes this most Rococo phase of the artist's work, although again it is given a personal variation by the sculptural modeling of the nude, suggestive of his continuing

174. HENRI MATISSE. *The Cowboy*.
Plate 14 from *Jazz*. 1947. Color stencil, 16⅝ x 25⅝".
The Museum of Modern Art, New York. Gift of the Artist

175. HENRI MATISSE.
Chapel of the Rosary of the Dominican Nuns, Vence, France.
Consecrated June 25, 1951

and developing interest in sculpture. Such solidly modeled figures appear in his sculptures of this period and also in the lithographs which he was then making.

From this moment of maximum plasticity in his paintings, drawings, and prints he passed abruptly to a phase of the utmost linearism. This may have been inspired by a mural on the theme of the dance, commissioned by the Barnes Foundation in Merion, Pennsylvania, in 1931. He worked on this during 1931 and 1932, only to find that the measurements for the space were erroneous. He therefore began all over again, and completed the second mural in 1933 (fig. 173). The first is now in the Petit Palais in Paris. The two versions of this later *Dance* represent experiments in extreme simplification transcending even those of the earlier *Dance* (see fig. 169). The figures are flat gray outlines silhouetted against abstract planes of black, bright blue, and rose pink. Of particular interest is the fact that, in testing the color relationships, the artist used cut-out colored papers—an early excursion into the *papiers collés* which were to represent some of the finest works of the end of his life.

During the period when he was engaged with the Barnes murals Matisse produced, for an edition of the poems of Mallarmé, some of his most beautiful book illustrations. Illustrations for James Joyce and Baudelaire followed during the 1930s and 1940s, as well as a book entitled *Jazz*, which he designed and decorated with *papiers collés* (fig. 174). The *papiers collés* summarize the tendencies of the late paintings toward an extremely delicate form of linearism that reached its apotheosis in the decorations for the chapel at Vence (fig. 175), on which the artist worked during the late 1940s and which was consecrated on June 25, 1951.

## THE SCULPTURE OF MATISSE

The late David Smith, one of the outstanding American sculptors of the twentieth century, frequently contended that modern sculpture was created by painters. Although this cannot be taken as literally true when one considers the achievements of Rodin, Brancusi, Duchamp-Villon, and Lipchitz, certainly major contributions to sculpture were made by such painters as Degas, Renoir, Picasso, Modigliani, and Matisse. One of Matisse's first sculptures is *Bust of a Woman* (fig. 176), an impressionistic study close to late marbles by Rodin, but even closer to the painterly waxes of Medardo Rosso. The blurred features of the head suggest a relationship with his small statue of 1901 titled *Madeleine I,* a work featuring an undulating S-curve pose that he was to explore in a large number of his standing and reclining sculptures over the years. The S-curve, or *contrapposto,* of these figures relates them to Late Renaissance sculpture. In his approach to the problem of sculptural space Matisse frequently adhered to this tradition, in which the spatial existence of the work is established by its twisting pose. He was first influenced by Antoine-Louis Barye, the nineteenth-century sculptor of animals; his very first attempt at sculpture was a free copy of a jaguar by Barye, with the beast organized in a writhing, twisting pose of great tension. He studied for a time with Bourdelle, and was strongly influenced by Rodin, who was

then at the height of his powers and reputation. Matisse's *Slave* (fig. 177) was begun in 1900, but not completed until 1903. Although it was sculptured after a well-known male model, Bevilacqua, it was adapted in pose and concept (although on a reduced scale) from Rodin's *Walking Man* (see fig. 72). It is interesting to note that here Matisse carried the expressionist modeling of the surface even further than Rodin. There exist a number of studies painted from the model and related to the *Slave;* later Matisse was often to treat the same subject in paintings, sculptures, drawings, and lithographs.

The period around 1905–06 brought forth another group of small sculpture studies and one work of major importance, the *Decorative Figure* (fig. 178). Here the figure is seated and organized in a violent twisting pose of crossed legs and circling arms. The face is simplified in a remotely classical manner that gives it an obvious relation to the figures of *Le Luxe II.* Aside from the great figure compositions, Matisse in the years between 1905 and 1910 was studying the figure in every conceivable pose and in every medium—drawing, painting, linoleum cut, and lithography, as well as sculpture. Although he would use a number of mediums for the same or a similar pose, he revealed his awareness of their separate properties. Thus, his linoleum cuts, perhaps influenced by the woodcuts of Gauguin, have a harsh, primitive quality entirely different from the grace and sophistication of the drawings and lithographs. *Reclining Nude I* (see fig. 155) is the most successful of the early attempts at a reclining figure integrated with surrounding space through

176. HENRI MATISSE. Detail of *Bust of a Woman.* 1900. Bronze. The Joseph H. Hirshhorn Collection

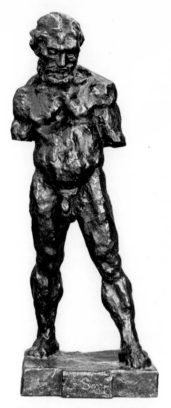

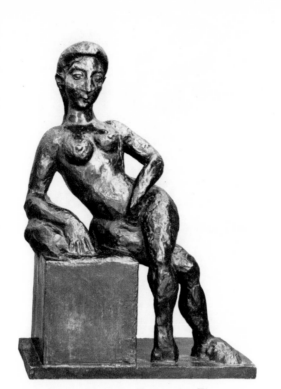

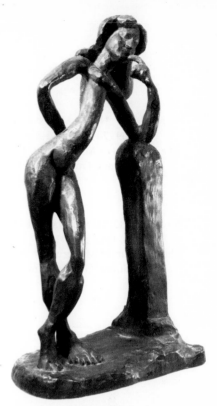

177. HENRI MATISSE. *Slave.*
1900–03. Bronze, height 36¼″.
The Joseph H. Hirshhorn Collection

178. HENRI MATISSE. *Decorative Figure.*
1903. Bronze, height 29″.
The Joseph H. Hirshhorn Collection

179. HENRI MATISSE. *La Serpentine.*
1909. Bronze, height 22¼″.
The Museum of Modern Art, New York.
Gift of Abby Aldrich Rockefeller

its elaborate, twisting pose. The artist was to experiment over the years with a number of variants, generally more simplified and geometrized. The most delightful expression is seen in *La Serpentine* (fig. 179), in which Matisse used extreme attenuation and distortion in order to emphasize the boneless relaxation with which the young girl drapes herself over the pillar. This is a work obviously related to the swirling figures of *Dance.*

About the same time, he tried his hand at a very different kind of sculptural arrangement, in the small sculpture *Two Negresses* (fig. 180), which consists of two figures standing side by side, one front view, and the other, back view. Although it may have some connection with Early Renaissance exercises in anatomy in which Pollaiuolo and others depicted athletic nudes in front and back views, there is a closer connection with some frontalized examples of primitive, specifically African sculpture. Picasso and others had been using motifs from African sculpture for a number of years. Matisse never came under the spell of the primitive in any great degree, but his inquiring mind did lead him on occasion to explore its possibilities in works such as this.

The exploration must have intrigued him, since it led him to his most ambitious excursion in sculpture, the first of the four great Backs, *Back I* (fig. 181), which he executed c. 1909. This work, more than 6 feet high, is a development of the theme stated in *Two Negresses,* now translated into a single figure in bas-relief, seen from the back. It is modeled in a relatively representational manner, freely expressive in the modulations of a muscular back, and it reveals the feeling Matisse had for sculptural form rendered on a monumental scale. *Back II* is simplified in a manner reflecting the artist's interest in cubism

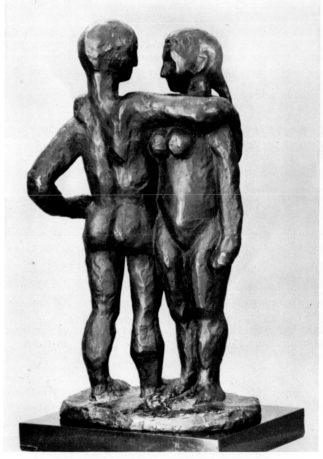

180. HENRI MATISSE. *Two Negresses.* 1909.
Bronze, height 18½″. The Joseph H. Hirshhorn Collection

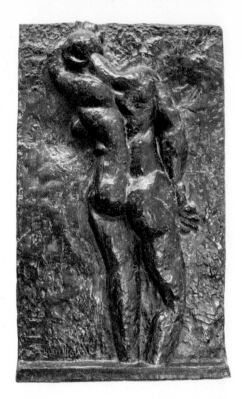

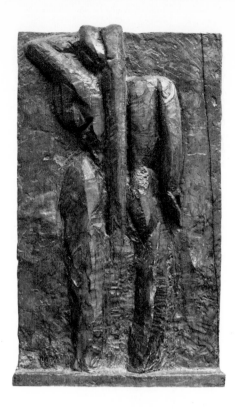

right: 181. HENRI MATISSE. *Back I.*
c. 1909. 74¼ x 44½ x 6½".
The Museum of Modern Art, New York.
Mrs. Simon Guggenheim Fund

far right: 182. HENRI MATISSE. *Back III.*
c. 1914. Bronze, 74½ x 44 x 6".
The Museum of Modern Art, New York.
Mrs. Simon Guggenheim Fund

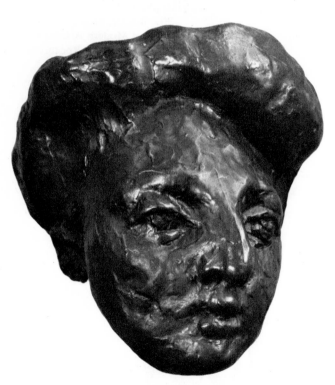

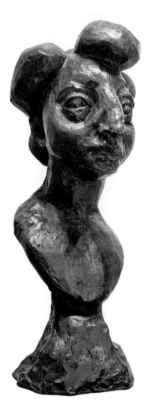

above: 183. HENRI MATISSE. *Jeannette II.*
1910. Bronze, height 10⅜".
The Museum of Modern Art, New York.
Gift of Sidney Janis

center right: 184. HENRI MATISSE. *Jeannette III.* 1910-11.
Bronze, height 24¾". The Museum of Modern Art,
New York. Acquired through the Lillie P. Bliss Bequest

far right: 185. HENRI MATISSE. *Jeannette V.* 1910-11.
Bronze, height 22⅞". The Museum of Modern Art,
New York. Acquired through the Lillie P. Bliss Bequest

at this time, and *Back III* (fig. 182) is so reduced to its
architectural components that it becomes almost a work
of abstract sculpture.

Matisse's other major effort in sculpture was the series
of heads called Jeannette (Jeanne Vaderin). *Jeannette I*
and *Jeannette II* (fig. 183) are direct portraits done from
life in the freely expressive manner of late Rodin bronzes.
But with *Jeannette III* (fig. 184), *Jeannette IV,* and
*Jeannette V* (fig. 185), he worked from his imagina-
tion in a progressive process of cubist simplification and

transformation of the human head, first into an expressionist study exaggerating all the features and then into a geometric organization of features in the mass of the head. Picasso had produced his cubist head of *Fernande Olivier* in 1909 (see fig. 205), and this work may have prompted Matisse's experiments. It is also possible that Matisse's most cubist version, *Jeannette V*, may have inspired Duchamp-Villon's 1911 head of *Maggy* (fig. 186), which resembles it closely.

The actual quantity of sculpture produced by Matisse is not great, but he did produce a number of pieces of unique quality and invention. These gave a new dimension to the Renaissance tradition and stimulated the imagination of younger sculptors in both Europe and America.

## PABLO PICASSO *(b. 1881)* BEFORE CUBISM

The most remarkable phenomenon of twentieth-century art is Pablo Ruiz y Picasso, in terms of whose achievements a large part of its history could be written. Born in Malaga, Spain, he participated in most art movements since the end of the nineteenth century, and himself created many of them. Picasso's father was an artist and art teacher, and Picasso grew up in an environment of art and artists. He received most of his training in Barcelona, then as now the most internationally aware and intellectually stimulating city in Spain. Picasso had, like all his young colleagues, a passionate ambition to go to Paris, and in the year 1900 he made his first excursion. Even before this time he had demonstrated considerable talent and prodigious technical accomplishment as he experimented with various styles, from that of academic realism to Toulouse-Lautrec and art nouveau. A small painting, *The End of the Road* (fig. 187), painted in Barcelona around 1898, suggests, in the curving areas of flat color, influences from Gauguin and art nouveau. The theme of suffering—here, the aged and infirm totter up the path to the gateway where the angel of death awaits —was one with which he was to be concerned for a number of years. The rather self-conscious social commentary and heavy-handed symbolism in the contrast of the wealthy in their carriages and the poverty-stricken on foot moving toward the same destination stems from the revolutionary spirit of the Barcelona of his youth.

In Paris in 1900 Picasso became conversant with the old masters in the Louvre, as well as with classical and pre-classical sculpture. He saturated himself in the work of the vanguard, the impressionists and post-impressionists. *Le Moulin de la Galette* (fig. 188), his first important painting in Paris, may have been suggested by Renoir's famous version of 1876 (see colorplate 5); there are relationships in the closely packed patterns of the figures and in the contrasting lights and darks in the constricted space of the club. Yet nothing could be further apart in spirit than these two works. The scene by Renoir is all light and innocent gaiety, a party of the artist and his friends. Picasso, obviously fascinated by Toulouse-Lautrec's interpretations of Paris night life, translates it into a dark and glowing assemblage of the demimonde as seen through the romantic eyes of a boy only recently ar-

186. RAYMOND DUCHAMP-VILLON. *Maggy*. 1911. Bronze, height 29⅛″. The Solomon R. Guggenheim Museum, New York

rived in the big and wicked city. It is a startling production for a nineteen-year-old.

During the next two or three years Picasso experimented with various styles, assimilating the influences of the impressionists, of Degas, Gauguin, and the nabis. Between 1901 and 1904 he used, in many paintings, a predominantly blue palette for the portrayal of figures and themes expressing suffering—frequently hunger and cold, the hardships he experienced while attempting to establish himself. Several times he was forced to return home for lack of funds, but each time Paris drew him back. The misery of those years as well as a deep-seated sympathy for the suffering of others is superbly expressed in *Woman Ironing* (colorplate 40) and the etching, *The Frugal Repast* (fig. 189). The *Woman Ironing* is a descendant of a number of studies that Degas made of poor working women and presented with deep understanding of their unhappy condition. Picasso, however, carries the theme far beyond sympathy and understanding, to make of this emaciated, desperately exhausted woman a symbol of all the underprivileged and exploited. The painting cannot, of course, be separated from its subject, but the elongated, angular figure, probably reflecting some influence from El Greco, is beautifully integrated into the surrounding space, both in terms of the drawing and of the unified, neutral colors of gray, blue, and ocher.

In 1904 Picasso moved into the famous (or infamous) tenement on Montmartre dubbed the Bateau-Lavoir, and here he lived until 1909 in the midst of an ever-growing

189. PABLO PICASSO. *The Frugal Repast*. 1904.
Etching. The Museum of Modern Art, New York.
Gift of Abby Aldrich Rockefeller

187. PABLO PICASSO. *The End of the Road*. c. 1898. Watercolor
and conte crayon, 17⅞ x 11¾″. Thannhauser Collection,
New York. Courtesy of Thannhauser Foundation

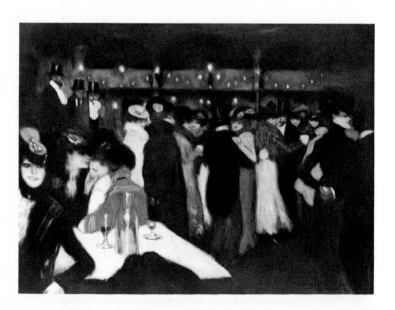

188. PABLO PICASSO. *Le Moulin de la Galette*. 1900. 35½ x 46″.
Thannhauser Coll., N. Y. Courtesy of Thannhauser Foundation

circle of friends: painters, poets, actors, and critics, including the devoted Max Jacob, who was to die in a Nazi concentration camp, and Guillaume Apollinaire, who was to become the literary apostle of cubism. Between 1905 and 1907 the melancholy of the artist lightened and took on a romantic quality in his so-termed rose period. During 1905 his subjects were largely circus performers, following a tradition established by Seurat and Toulouse-Lautrec. For Picasso, however, the interest again lay in the performers seen off guard, without the glamour, as rather pathetic individuals. Most of these paintings are drawings of figures set before a generalized background created out of a few broad tones of rose and blue, colors from which the figures themselves are also constructed (figs. 190, 191, 192). Thus they do not represent any remarkable innovations but simply exist as romantic paintings, executed with consummate skill and sensitivity, superbly drawn, and reflecting in a general sense the experiments that had been carried on by the previous generation of impressionist and symbolist painters.

An important change began to take place in the latter part of 1905, as Picasso entered his first classic phase. In *La Toilette,* 1906 (fig. 193), the figures have taken on an aura of beauty and serenity that suggests a specific influence from Greek white-ground vases. The element of pathos has disappeared, and we have what is in the truly classic sense a composition of two figures, draped and undraped, enclosed in a limited depth and organized in harmonious relation to each other as well as to the space

190. PABLO PICASSO. *The Mother Dressing.*
1905. Etching. Los Angeles County Museum of Art.
Gift of George Cukor

191. PABLO PICASSO. *Meditation.* 1904. Watercolor,
13¾ x 10⅛". Collection Mrs. Bertram Smith, New York

192. PABLO PICASSO. *Two Harlequins.* 1905.
Watercolor and gouache, 9¼ x 7". Thannhauser Collection,
New York. Courtesy of Thannhauser Foundation

they occupy. Compared with the classic compositions of Puvis de Chavannes, at which the artist unquestionably had looked, this is a work of a freshness and serenity, closer to the spirit of Athens in the fifth century B.C. than anything by Puvis or by the generations of academic neo-classicists who had sought so assiduously to recapture a lost ideal.

The first classic period was only a transitional moment interrupted by excursions into expressive angularity suggestive of El Greco. It was a moment of great importance, however, in the sense that the influence of Greek sculpture and vase painting must have assisted in the artist's re-evaluation of Renaissance space concepts. This generally sculptural-relief approach was accentuated by his "discovery" of pre-Roman Iberian sculpture, in terms of which he made his first essays into a kind of sculptural primitivism. The portrait of Gertrude Stein (fig. 194), with which he struggled before he left for Spain in 1906, and the face of which he repainted on his return, is perhaps the first document in a series that transformed the course of twentieth-century painting, and even of sculpture. Although Picasso and Matisse probably met in 1905, the younger artist was not drawn into the orbit of the fauves and their coloristic revolt. Up to this point he had not exhibited at the Salon d'Automne or the Salon des Indépendants; he was still living as a provincial in Paris among his fellow nationals and still-unrecognized poets and critics. Thus, he was able to go his own way and to introduce into modern painting elements foreign

193. PABLO PICASSO. *La Toilette*. 1906. 59½ x 39″.
The Albright-Knox Art Gallery, Buffalo, New York

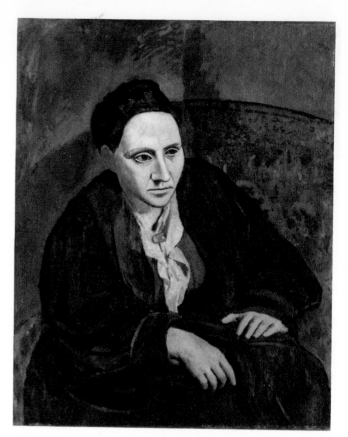

194. PABLO PICASSO. *Gertrude Stein*. 1905.
39¼ x 32″. The Metropolitan Museum of Art, New York.
Bequest of Gertrude Stein, 1946

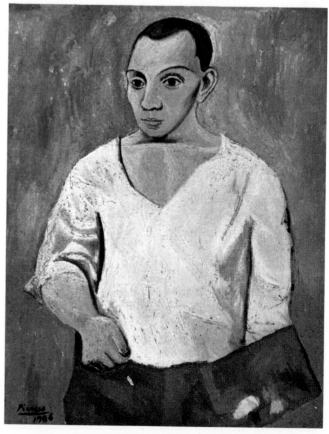

195. PABLO PICASSO. *Self-Portrait*. 1906. 35⅝ x 28″.
The Philadelphia Museum of Art. A. E. Gallatin Collection

to the ideas and approaches of the artists who had grown up in the French tradition. It must never be forgotten that Picasso was a Spaniard and has always remained one. Gertrude Stein, strongly modeled and painted in dark tones with glowing underpainting, fills her corner of space like some powerful, massive work of sculpture. The repainted face is given a stylized, masklike character that anticipates the primitivism of the next few years. A *Self-Portrait*, 1906 (fig. 195), carries even further the controlled Iberian barbarism in the face and the simplified but massive torso. *Two Nudes* (fig. 196) marks the extreme point of heavy, primitive, sculptural modeling in which the figures begin to take on a certain geometric angularity and the faces to approximate African Negro sculpture. In his colors the artist has moved away from rose pink and light blue to a more austere formula of yellow ochers and brick reds, suggestive of the colors of ancient painting.

Although his paintings were not immediately influenced by it, Picasso must by this time have been affected by the fauve exhibition in the 1905 Salon d'Automne; and there seems to be no doubt that he was strongly moved by the gallery of Cézanne's paintings shown at the same Salon, as well as by the Cézanne exhibition in 1906, the year of the old master's death, and

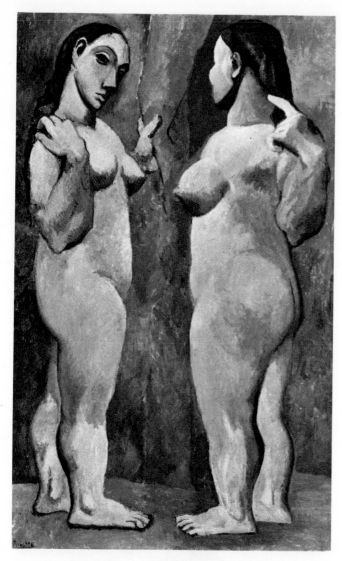

196. PABLO PICASSO. *Two Nudes.* 1906.
59⅝ x 36⅝". The Museum of Modern Art, New York.
Gift of G. David Thompson

design, the *Demoiselles* is crucial to the history of twentieth-century painting. Whether or not the *Demoiselles* may actually be considered to have been the first cubist painting, it was the first to give monumental expression to a concept of pictorial space toward which experimental painters had been groping for a hundred years.

From the time of David at the end of the eighteenth century, many of the leading painters had been re-examining the Renaissance concept of pictorial space as an illusion, created through the means of linear and atmospheric perspective, whereby a fixed spectator observed a cube of space in which the sense of depth was created by a geometric diminution of objects in scale and in clarity as, apparently, they receded into the distance. The neoclassicists had composed their figures as a frieze behind the surface of the painting. This formula was developed in the landscapes and some of the figure compositions of Courbet and the mid-century realists. Manet, and after him certain of the impressionists and post-impressionists—Degas, Toulouse-Lautrec, Seurat, Gauguin, Van Gogh, and above all Cézanne—had, by various means of limiting and controlling the illusion of depth, created a balance between three-dimensional illusion and the two-dimensional actual surface of the painting. This realization of the nature of a painting became explicit in Gauguin and Cézanne, and after them in the nabis and fauves.

In all these efforts, however, with the exception of the late paintings by Cézanne and some by Matisse, there was little distortion of figures or of the space they occupied. Color was used arbitrarily by Gauguin and the fauves, as an element independent of the natural objects it was supposed to be describing. Seurat and Gauguin modified fixed perspective and used a certain degree of geometric distortion in their figure patterns. But Picasso, in 1907—and Braque at the same moment—asserted for the first time the principle that even the figure could be

the retrospective of 1907 at the Salon d'Automne. These exhibitions, in fact, exercised a definitive influence on a large number of the younger experimental artists who were then working in Paris. The various influences were consolidated in the spring of 1907 with the production of Picasso's first masterpiece, *Les Demoiselles d'Avignon* (colorplate 41). The idea for this large figure study may have been generated by the example of Matisse who, between 1905 and 1907, was engaged in his own series of figure studies: *Luxe, calme et volupté*, 1905, *Joy of Life*, 1905–06, and *Le Luxe II*, 1907–08. However, the actual inspiration for the *Demoiselles* came more specifically from the late studies of *Bathers* by Cézanne, with the faces modified as a result of Picasso's explorations of Iberian and African Negro sculpture. The complex of influences makes this a somewhat eclectic and self-contradictory work. The staring faces of the central figures and the accentuated masks of the outer figures are disturbingly at variance with the artist's attempt to integrate the figures, as angular geometric planes, with the geometry of the sealed background. Despite any limitations of total

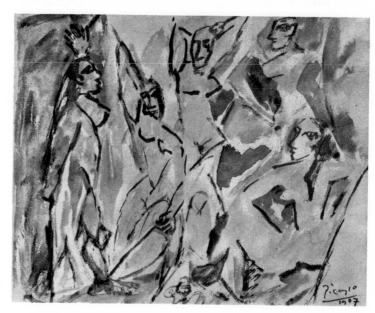

197. PABLO PICASSO. *Study for Les Demoiselles d'Avignon.*
1907. Watercolor, 6⅝ x 8¼".
The Philadelphia Museum of Art. A. E. Gallatin Collection

subordinated to the total painting. It could be distorted, cut up, transformed into a series of flat-color facets essentially indistinguishable from comparable planes composing the environment in which they existed. With this discovery there was only a short step to the realization that a painting could exist, independent of figures, landscape, or still life, as an abstract arrangement of lines and color shapes integrated in various ways on the picture surface.

The *Demoiselles* also illustrated many other principles that were to become part of the common vocabulary of cubism. Perspective painting had insisted on the single, unified point of view. What was painted was what could be observed by the fixed spectator. Here, however, using perhaps the example of various pre-classic arts, Picasso has shifted the point of view at will. Heads, noses, or eyes are seen simultaneously in profile and full face. Figures are seen in elevation, and the foreground table with fruits is seen in plan. In other words, the vision of the spectator is enlarged to include a number of different views, seen as though he were moving from point to point, now looking up and now looking down. Modern studies of perception have shown that this is indeed the way we see—not by one fixed, all-encompassing glance but by an infinite number of momentarily caught glimpses, formulated and codified in the mind of the spectator. Cubism thus introduced into painting not only a new kind of space, but even a new dimension—of time.

Picasso made many related studies both before and after the *Demoiselles* (fig. 197), studies manifesting the excitement he must have felt at the realization of the new voyage on which he was embarked. Since he claims not to have been acquainted with Negro art at the time he painted the *Demoiselles,* the strong masklike appearance of the right-hand figures probably results from their having been repainted after he had become so exposed. Even the color, with the raw ocher and pink figures integrated in the blue, gray, and rust ground—although related to that of the late *Bathers* of Cézanne—is a primi-

tivist parody of the gentle harmonies of Picasso's own color during the rose period.

The original concept of *Les Demoiselles d'Avignon,* as seen in the preliminary sketches, was that of a sailor seated in the midst of a group of nude women while another figure enters from the left carrying a skull as a *memento mori*. The title, added years later by a friend of the artist, refers to a house of prostitution in Barcelona, on Avignon Street. With successive sketches, the rather heavy-handed symbolism was eliminated, and the study in formal and spatial relations emerged as the final work.

## GEORGES BRAQUE (1882–1963) BEFORE CUBISM

Georges Braque met Picasso in 1907 and saw *Les Demoiselles d'Avignon* in his studio. Braque's father and grandfather were amateur painters, and as a boy he was encouraged to draw, first in Argenteuil near Paris, and then in Le Havre where he attended a night class at the Ecole des Beaux-Arts. Following his father's and grandfather's trade, he was apprenticed as a house painter in 1899 and, at the end of 1900, went to Paris to continue his apprenticeship. It is at least conceivable that some of the decorative and *trompe-l'oeil* effects that later penetrated his paintings and collages were a result of his initial training as a house painter-decorator. After a year of military service and brief academic training, Braque, in the summer of 1904, met Raoul and Jean Dufy at the village of Honfleur, on the Channel, and in the fall he set

199. GEORGES BRAQUE. *Seated Nude*. c. 1906.
24⅛ x 19¾". Milwaukee Art Center.
Gift of Harry Lynde Bradley, 1953

198. GEORGES BRAQUE. *Landscape near Antwerp*. 1906.
23¾ x 32". Thannhauser Collection, New York.
Courtesy of Thannhauser Foundation

up his own studio in Paris. Like his contemporaries, he studied the old masters in the Louvre and was drawn to Egyptian and archaic sculpture. He was similarly attracted by Poussin among the old masters, and his earlier devotion to Corot continued. During the same period he was discovering the impressionists and was at first more impressed by Van Gogh and Seurat than by Gauguin. In the year 1905, perhaps through Dufy and Friesz, fellow artists from Le Havre, he gradually became aware of Matisse and the new paintings of the fauves. During 1906 he himself began to turn from his earlier impressionism to the fauve bright color palette. The *Landscape near Antwerp* (fig. 198) is fauve in its color but still relatively traditional in its spatial organization. The soft green, yellow, and gray tints of the sky hold effectively in the distance, and the arrangement of foreground land and water has a certain perspective effect of convergence in depth. Of particular interest is a *Seated Nude* (fig. 199), a massively modeled figure in a constricted color space, seated, with her back to the spectator, on a chair that is slightly distorted and flattened. The figure, in its sculptural treatment and free, loose coloration, has points of analogy to Matisse's *Gypsy* (see fig. 166) of the same year. In 1907 Braque made another, more geometrically stylized version, suggestive of his growing interest in Cézanne.

He went to L'Estaque in the south of France, where Cézanne had painted, and after spending the fall and winter of 1906 there, he entered a group of his new paintings in the Salon des Indépendants in March 1907, and there emerged briefly as a fauve. In *Landscape at*

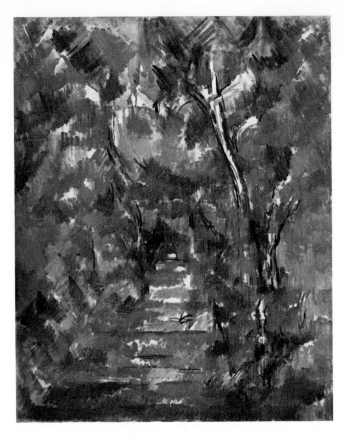

202. PAUL CEZANNE. *Forest Path.* 1895.
31¼ x 25½". Private collection

*La Ciotat* (fig. 200) he uses an approach more linear than in earlier works, tying the space together with the pattern of foreground trees in a manner suggestive of landscapes by Cézanne. Despite its brightness, the color here is actually less important than the linear structure of the painting. There appears also a strong suggestion of influence from Gauguin.

In the fall, the dealer D.-H. Kahnweiler, who was already handling works of Picasso, Derain, and Vlaminck, began to buy Braque's paintings, and then through the Kahnweiler Gallery Braque met Picasso. When Picasso showed him the canvas of *Les Demoiselles d'Avignon,* Braque was at first repelled, but toward the end of the year he himself painted a large, standing figure set against a background of loosely geometric planes. Though more massive and sculptural in style, it is nevertheless directly related to figures in Picasso's painting. *The Bather,* 1907 (fig. 201), is also a development from his and Matisse's earlier seated nudes. The color, however—grays, greens, and ochers—is much more subdued than in the two fauve nudes or even the *Demoiselles.* With this painting Braque moved definitely out of the orbit of the fauves and into that of Cézanne.

In L'Estaque again, in the summer of 1908, Braque painted a series of landscapes and still lifes. In still life he found, as Cézanne had found earlier, that it was possible to control space and light. Homage to Cézanne, and the search for a new vision based on his work, became evident. However, the difference between a landscape by Cézanne (*Forest Path,* 1895; fig. 202) and such a work as Braque's *Houses at L'Estaque* (colorplate 42) is even more evident. Whereas Cézanne here built his entire or-

ganization of surface and depth from his color, Braque in this work, and increasingly in the paintings of the next few years, subordinates color in order to attain a geometric structure of tilted planes defining the limited and controlled depth of the picture. The houses and trees become geometrical volumes, in the spirit of Cézanne's dictum (see p. 45), but with a significant emphasis on cubes. The buildings and trees are bounded by definite lines and edges; and the trees and roof tops are shaded to suggest volume as well as some existence of depth. Color is limited to the fairly uniform ocher of the buildings, and the greens and blue-green of the trees. The illusion of depth is not that of a single-point linear perspective, although some diminution in scale is used, but is an illusion gained by the apparent volume of the buildings and trees —their overlapping, and their tilted, shifting shapes that create the effect of a scene changing as it is observed from various positions. During the same summer Picasso was independently painting landscapes in which he also was simplifying his forms and subduing his color.

When Braque submitted his new work to the progressive Salon d'Automne in the fall of 1908, the jury, which included Matisse, Rouault, and Marquet, rejected all his entries. It was upon this occasion that Matisse is supposed to have referred to the *petits cubes* of Braque: *"Toujours les cubes!"* Although two of his paintings were reclaimed by jurors Marquet and Guérin, Braque refused to exhibit any, and instead held a one-man show of twenty-seven paintings in November 1908, at the Kahnweiler Gallery, with a preface to the catalogue by Guillaume Apollinaire. Vauxcelles, the critic who had coined the name for the fauves, reviewed the exhibition and, using Matisse's phrase, spoke of Braque's reducing "everything, landscape and figures and houses, to geometric patterns, to cubes." It was not long before the epithet "cubism" had become the official name of the most important single movement in the painting of the twentieth century.

### THE CUBISM OF PICASSO AND BRAQUE TO 1914

During 1909, Braque and Picasso, realizing that they were independently converging on the same point, decided to work together, which they did in close communion until 1914. The still life was to become their (and the other cubists') principal subject—still life, the iconography of which revealed the daily life, the continuing interests, and the intellectual enthusiasms of the artists. Braque's *Still Life with Musical Instruments* (fig. 203) is treated with a relatively sculptural projection like that of his *Houses at L'Estaque,* but in a similar painting, *Guitar and Compote* (fig. 204), he has increasingly flattened the cubes into planes of tonal color and assimilated the objects into the space surrounding them, so that everything begins to become a color plane, functioning within a limited but extremely tangible depth. Braque himself referred to "a tactile, I might almost say a manual, space" that he was seeking. With works such as this and comparable studies made by Picasso during 1908 and 1909, cubism's first developed phase, to which the name of *analytical cubism* has been given, was definitely launched.

After further studies of pictorial structure based on

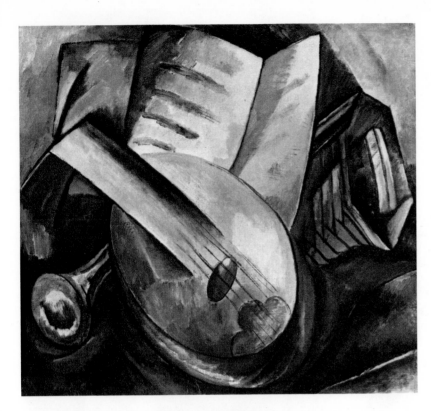

203. GEORGES BRAQUE. *Still Life with Musical Instruments.*
1908. 19⅝ x 24". Collection Laurens, Paris

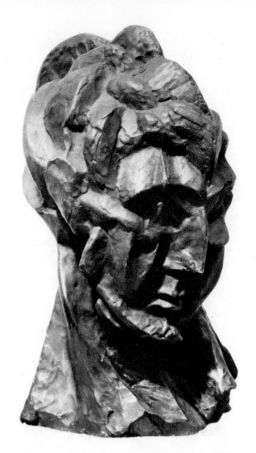

205. PABLO PICASSO. *Head of Fernande Olivier.*
1909. Bronze, height 16¼".
The Museum of Modern Art, New York

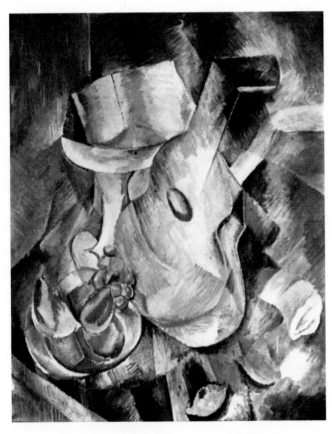

204. GEORGES BRAQUE. *Guitar and Compote.*
1909. 28¾ x 23⅝".
Hermann and Margit Rupf Foundation, Kunstmuseum, Bern

Cézanne, Picasso by 1909 had begun to push his initial investigations to their logical conclusions. In a series of portrait heads, including a number of Fernande Olivier, Picasso's young mistress, who shared his years of struggle, it is possible to see, almost step by step, the breaking down of the sculptural mass of the head into a series of flat planes that re-establish the sense of the picture surface. These experiments in painting led him to explore the same problem in reverse, in the bronze *Head of Fernande Olivier,* 1909 (fig. 205). Picasso had practiced sculpture sporadically since before 1900 in works that closely paralleled his contemporaneous interests in the field of painting and may have helped to clarify them. The *Head of Fernande Olivier* subordinates characterization in an attempt to create a three-dimensional design. The work is not entirely successful as cubist sculpture, since the geometry is worked in and out over the surface of the head. Although it is historically of the greatest significance as the first step toward an entirely new kind of sculpture—that of construction or assemblage—at this point Picasso had not yet realized the implications of cubism for sculpture.

Following Alfred Barr's scheme, the progress of analytical cubism in Picasso's hands may be charted in four studies of heads: the *Head of a Woman,* 1909 (fig. 206); the *Portrait of Braque,* 1909 (fig. 207); the *Girl with Mandolin,* 1910 (fig. 208); and *L'Arlésienne,* 1911–12 (fig. 209). Picasso began with a greater feeling for sculptural form than Braque, more primitive expressiveness, and less immediate concern for those tangible space qualities of which Braque spoke. By the end of

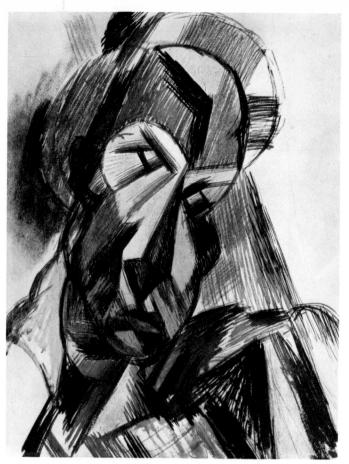

206. PABLO PICASSO. *Head of a Woman.* 1909. Gouache, 24¼ x 18¾". The Art Institute of Chicago. E. E. Ayer Fund

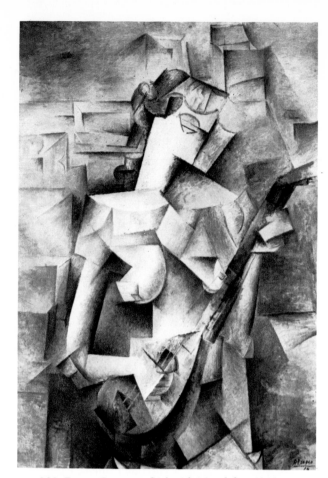

208. PABLO PICASSO. *Girl with Mandolin.* 1910. 40 x 29½". Private collection, New York

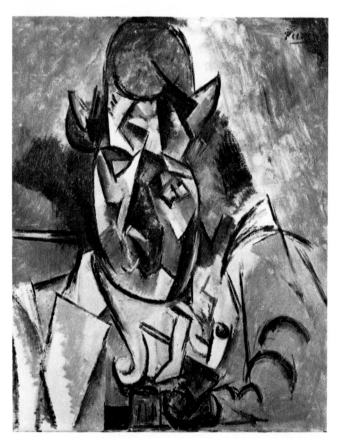

207. PABLO PICASSO. *Portrait of Braque.* 1909. 24¼ x 19¼". Collection Edward A. Bragaline, New York

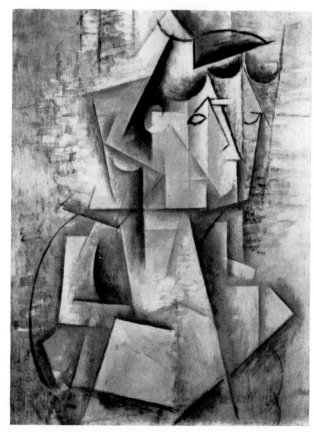

209. PABLO PICASSO. *L'Arlésienne.* 1911–12. 28¾ x 21¼". Collection Walter P. Chrysler, Jr., New York

1910, however, the two artists shared ideas and enthusiasms to the point where it is frequently impossible to differentiate between their paintings. The four heads by Picasso reveal a progressive transformation from sculptural relief modeling in geometric planes, to a system in which the third dimension is stated entirely in terms of flat, slightly angled planes organized within a linear grid on or near the surface of the painting. Picasso's color tended to be even more limited than Braque's, largely eliminating the greens and confined to tones of brown and ocher.

A still life by Braque, *Violin and Palette,* dated 1909–10 (colorplate 43), indicates that at this point he may have progressed even further than Picasso in his realization of the implications of cubism. It is a tall, narrow painting in which the still recognizable subjects are fragmented, tightly woven color facets that change before the eye of the spectator. Here are fully stated all those concepts of metamorphosis, of simultaneous and consecutive vision, in which the artist has finally liberated himself from the Renaissance world of nature observed by means of the arbitrary principle of geometric perspective. It is the painter's moment of liberation from a system that had held artists captive for five hundred years. Henceforth they would be free of the concept of a painting as an imitation of visual reality; they were free to explore any desired direction of vision, experience, or intuition.

Picasso's *Girl with a Mandolin* is still somewhat transitional in that the figure holding the mandolin is detached from the faceted ground, with arms and breast modeled in a sculptural manner. Thus it does not attain the complete integration of subject and total picture space already noted in Braque's *Violin and Palette* and, for that matter, in late works of Cézanne, which both artists had been studying (see *Pines and Rocks,* colorplate 44). However, by the time of Picasso's *Kahnweiler* (fig. 210), a portrait of the art dealer painted late in 1910, the figure has disappeared into the cubist grid of tilted color facets to emerge again in the geometry of a face, a hand, or a glass and bottle on a table. The process is carried even further in the *Accordionist,* 1911 (fig. 211). Here the presence of the figure is made evident principally by the concentration of geometric structure down the middle axis of the picture, at the same time that it becomes looser and more open toward the edges. Both Picasso and Braque at this stage combined linear structure with a delicately modulated brush stroke so short as to be reminiscent of Seurat's color dots. Since color had now been limited to muted grays, browns, soft greens, and subdued ochers, the character of the brush stroke served the important function of enriching the surface. Variation in values also created almost imperceptible change and even movement between the surface and depth. The surface paint texture was controlled and directed by the sharp geometry of the linear structure into the accumulation of variously tilted and angled planes. Both directional lines and tilted planes were used to suggest the subtle though strongly perceived shifts in position of figure and still life within the limited but constantly varied depth of the painting.

In *The Portuguese,* 1911 (fig. 212), Braque was at almost an identical state of exploration as Picasso in the *Accordionist.* Colors, textures, and linear structure are all virtually the same. Here, however, Braque introduced a new element—precisely hand-lettered words and numbers that seems to add a new variation to the cubist exploration of reality.

As early as 1908, Picasso had pasted a small piece of paper on the center of a drawing to make what is probably the first *papier collé,* or collage (fig. 213). Both artists, as early as 1910, used words and letters, and Braque particularly had already used *trompe-l'oeil* wood-grain effects. This insertion of elements of visual realism into the increasingly abstract cubist paintings was part of the artists' concern with the central problem: what is illusion and what reality? Is reality in the eye of the spectator? Or is it the absolute of the canvas? This concern led logically not only to the introduction of imitations of observed nature in painted passages, but also to the application of pieces of newspapers, restaurant menus, etc.—that is, elements of collage or, specifically, *papier collé*—to act as "real" themes in counterpoint to the abstract structure built up by the paint.

Picasso's *Still Life with Chair Caning,* 1911–12 (fig. 214), is his earliest integrated collage, although, as noted previously, in 1908 he had pasted a small piece of paper

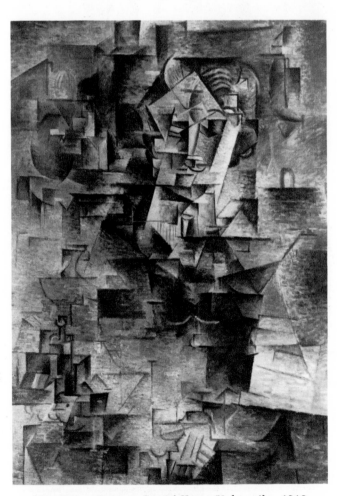

210. PABLO PICASSO. *Daniel-Henry Kahnweiler.* 1910. 39⅝ x 28⅝". The Art Institute of Chicago. Gift of Mrs. Gilbert W. Chapman

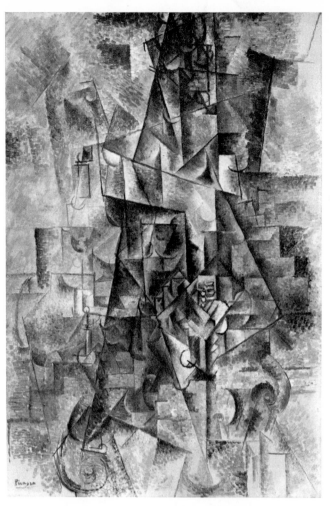

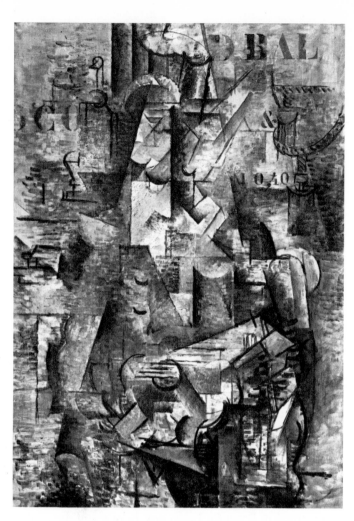

211. PABLO PICASSO. *Accordionist*. 1911. 51¼ x 35¼″.
The Solomon R. Guggenheim Museum, New York

212. GEORGES BRAQUE. *The Portuguese*. 1911.
46⅛ x 32″. Offentliche Kunstsammlung, Basel

213. PABLO PICASSO.
*La Rève*. 1908. Ink on brown
paper, center collage
in gouache, 10½ x 16¼″.
Thannhauser Collection,
New York. Courtesy of
Thannhauser Foundation

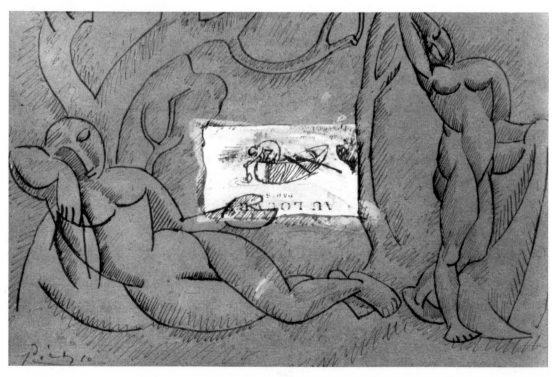

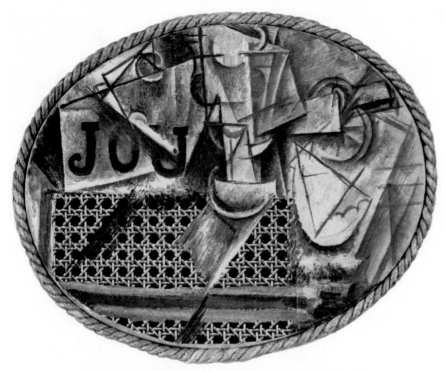

214. PABLO PICASSO. *Still Life with Chair Caning.* 1911–12.
Oil and pasted paper simulating chair caning on canvas,
oval, 10⅝ x 13¾". Collection the Artist

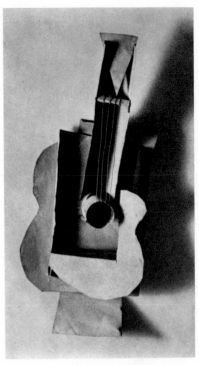

215. PABLO PICASSO. *Guitar.* 1912.
Sheet metal and wire, height 30¾".
Collection the Artist

as a central motif in a small sketch. In the *Still Life with Chair Caning,* Picasso used a piece of common oilcloth with a design of simulated chair caning, and then worked over it a particularly free and bold pattern of still-life shapes. Even the oval shape of the work—a shape that many cubists were exploring in reaction against the dominant rectangle of Renaissance painting—and the rope frame—contribute to the complication of the different levels of "reality" with which he was playing. In 1912, too, Picasso had made of sheet metal and wire a construction that was a three-dimensional projection of a painted cubist guitar (fig. 215). Such works are testimony, also, to his reviving interest in sculpture. In 1913 and 1914 he again translated cubist still-life paintings into constructions of wood, paper, and other materials, obviously in an investigation of the three-dimensional implications of cubist painted space. Or, to put it another way, these works were projections of his paintings and collages into three dimensions; and, although they continued the sense of subject that persisted in cubist painting, they were known to the Russian constructivist Vladimir Tatlin (1885–1956), whose abstract construction they affected as well as those of the other Russian constructivists. During 1914 Picasso carried his constructions further in a wood-and-metal assemblage of musical instruments, in which he opened up the potentials of construction for new concepts of sculptural space and abstract design (fig. 216).

The introduction of collage marked the end of the first or analytical phase of the cubism of Picasso and Braque. Having devoted some three years to analyzing, breaking down, and destroying the traditional subjects of the art-

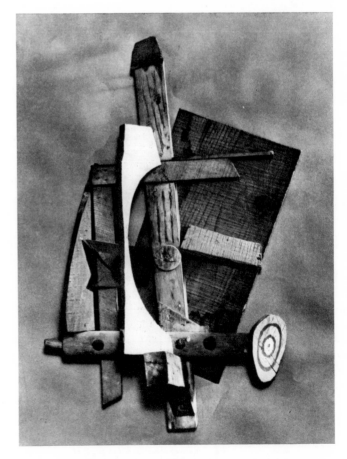

216. PABLO PICASSO. *Musical Instruments.* 1914.
Painted wood, height 23⅝". Collection the Artist

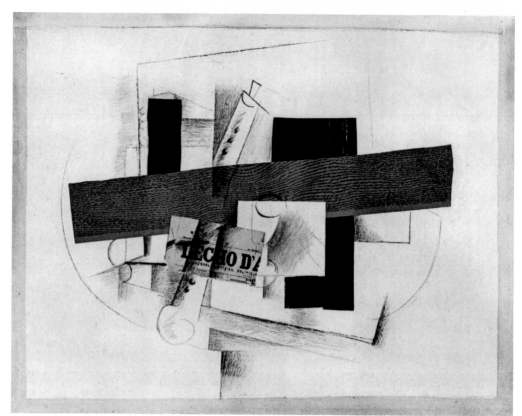

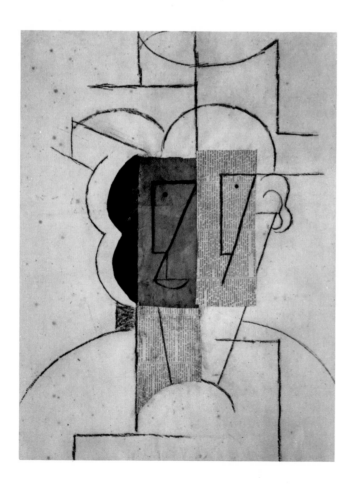

ist: portrait, figure, still life, landscape; and having created new concepts of visual, symbolic, or mnemonic reality, of picture space and structure, both artists were now ready for an enlargement and enrichment of their means. They began to create paintings that were not primarily a distillation of observed experience but, rather, were built up, using all the plastic means at their disposal, traditional as well as experimental, including any type of material that came to hand. This second and more extensive phase of cubism is called *synthetic cubism.* This term, unfortunately, is so broad as to be almost meaningless, and embraces many different and unrelated experiments carried on by Picasso, Braque, Juan Gris, and others over the next twenty years.

The transitional stage involving further exploration of collage during 1912 and 1913 was first a move toward simplification: a linear pattern was contrasted with elements of pasted wallpaper or newspaper (Braque, *The Clarinet,* fig. 217; Picasso, *Man with a Hat,* fig. 218). Whereas Braque stayed seriously with the decorative qualities of his *papier collé* elements, Picasso saw expressive and, frequently, funny implications in the new medium. The paintings of 1913 and 1914, influenced by collage, began to have larger, geometric color shapes and more positive color. Picasso's *Card Player* (fig. 219) is a key work, composed in broad, clearly differentiated areas, summarizing the experiments of analytical cubism and collage. The forms and the emergent sense of expressive mood or identity in the figures suggest the great cubist compositions of the early 1920s, such as the

versions of the Three Musicians (see colorplates 139, 140).

The principal trend of paintings by both Picasso and Braque after 1913, however, was toward enrichment of the plastic means—space, color, linear movement, and texture. Changes in expressive means included the reintroduction of subject, of personality in the figures, and of mood in the picture as a whole. In *Green Still Life* (colorplate 45) Picasso not only reintroduced positive color but opened up the space of the room and disposed the objects of the still life in a tangible manner that looked back to Cézanne, just as the stippled textural elements looked back to neo-impressionism. Thus, the painting can be considered an eclectic work in which the artist was attempting to see the relations of his analytical-cubist explorations to previous attempts to re-examine the illusionistic space of the Renaissance tradition. This could be considered a desertion of the structural purity of earlier cubism in favor of a decorative direction. At this point, however, it was essential for both Picasso and Braque to move from an intensive to an extensive approach, to enlarge the cubist vocabulary they had created. Also, during these years, from 1910 to 1914, cubist painting had spread in many variations throughout Europe; and even the founders could not help being affected by the different approaches of Robert Delaunay, Albert Gleizes, Juan Gris, and Fernand Léger.

Related to the decorative cubism of Picasso's *Green Still Life* is a sculpture, or "object," that he also made in 1914 and had cast in bronze and painted in six variants.

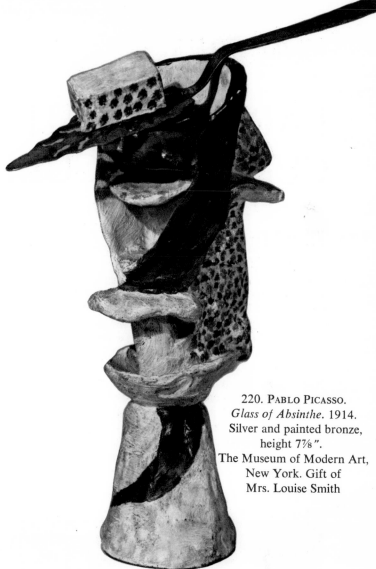

220. PABLO PICASSO. *Glass of Absinthe*. 1914. Silver and painted bronze, height 7⅞". The Museum of Modern Art, New York. Gift of Mrs. Louise Smith

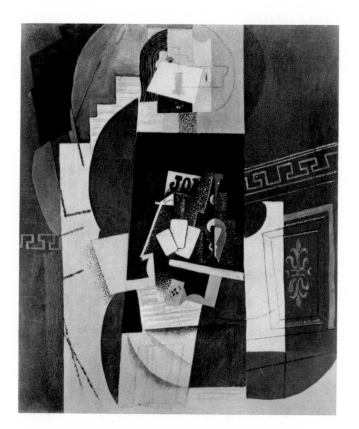

219. PABLO PICASSO. *Card Player*. 1913–14. 42½ x 35¼". The Museum of Modern Art, New York. Acquired through the Lillie P. Bliss Bequest

This is the *Glass of Absinthe* (fig. 220), in which he gives one of the first sculptural expressions to the passion for the "found object" which was to characterize much of his own subsequent sculpture as well as much of the other sculpture of the twentieth century—until it reached its climax in the junk sculpture and pop art of the 1950s and 1960s.

With the commencement of World War I in August 1914, the intimate collaboration of Picasso and Braque came to an end. Braque went into the French army, along with Apollinaire, Derain, Jean Cocteau, and many other leading young French artists and writers. Picasso, a Spaniard and a nonbelligerent, remained in Paris until 1917, when he went to Rome with Cocteau to join the Russian Ballet of Diaghilev as a designer. Thus, in France as in Germany, England, and Italy, the four years of war marked a terminal point to the first great period of twentieth-century experiment in the arts. The war also terminated the careers of some of Europe's most talented young artists and writers, Marc and Macke in Germany, Duchamp-Villon and Apollinaire in France, and Umberto Boccioni in Italy.

# PART FOUR

# EARLY TWENTIETH CENTURY SCULPTURE

## The Major Trends

In sculpture as in architecture, the nineteenth century produced few if any new spatial experiments. Neo-classical sculptors reverted to a concept of controlled sculptural forms within a limited space. Romantic and realist sculptors, although they once again sought to introduce movement and open space, cannot be said to have in any way enlarged the vocabulary of the Baroque. Even Rodin, generally considered the father of modern sculpture, was usually content to organize his groups within the rotating, spiral movements of the Late Renaissance and the Baroque. Only in a few of his major works, such as *The Burghers of Calais* (see fig. 82) and *The Gates of Hell* (see fig. 73), did he begin to explore new space concepts.

221. ANDRE DERAIN. *Crouching Man*. 1907. Stone, 13 x 11". Galerie Louise Leiris, Paris

The twentieth century has continued, in one form or another, most of the sculptural-spatial tendencies already discussed. But modern experimental sculptors have also made fundamental new departures, particularly in sculpture as construction or assemblage, in experiments with new materials, and in the exploration of sculpture as shaped space rather than as mass existing in surrounding space. In addition, partly as a result of influence from primitive and archaic art, there has been a contrasting abandonment of full spatial organization for a return to frontality and monumentality achieved through simplified masses.

## The Early Figurative Sculptors

Auguste Rodin, his reputation increasing until by the time of his death it had become world-wide, lived until 1917. Aristide Maillol did not die until 1944, and continued to be a productive sculptor until his death. Antoine Bourdelle lived until 1929, Charles Despiau until 1946. The figurative tradition of these masters was reinforced by the growing recognition accorded the sculpture of Edgar Degas and Auguste Renoir. Despite revolutionary new experiments being carried on by cubist and abstract sculptors, the figurative tradition continued to dominate the scene in every part of Europe and the United States, waning for a time between the two world wars, but gaining in strength once more after the end of World War II. Among the twentieth-century painter-sculptors, Matisse depicted the human figure throughout his life; Picasso began to desert naturalistic representation with a group of primitivist wood carvings, dated 1907, in which the influence of Iberian or archaic Greek sculpture is even more explicit than in his paintings of that year. Also in 1907, Derain carved in stone a *Crouching Man* (fig. 221), transformed into a single block of stone—a startling example of proto-cubist sculpture.

### WILHELM LEHMBRUCK *(1881–1919)*

With the exception of such older masters as Maillol and Despiau, the tradition of realist or realist-expressionist sculpture flourished more energetically outside France

than inside, after 1910. In Germany the major figure was Wilhelm Lehmbruck who, after an academic training, turned for inspiration first to the Belgian sculptor of miners and industrial workers, Constantin Meunier (1831–1905), and then to Rodin. The principal single influence on his sculpture was probably Maillol, although during the four years he spent in Paris, 1910–14, he became acquainted with Matisse, Constantin Brancusi, and Alexander Archipenko. A *Standing Woman,* 1910 (fig. 222), in which the drapery is knotted above the knees in a formula derived from Greek classical sculpture, illustrates the immediate impact of Maillol, as well as of antiquity. The details of the face are somewhat blurred, in a manner that Lehmbruck may have learned from the study of the fourth-century Greek sculpture of Praxiteles. This treatment gives the figure a peculiarly withdrawn quality, a sense of apartness and of inward contemplation, recalling not only the Praxitelean mode but also some of the mystical Madonnas of Gothic sculpture. It is eminently probable that all these elements—classical, Gothic, and modern—went into Lehmbruck's sculpture. Another important influence was the Belgian sculptor George Minne (1866–1941), who was associated with symbolism and art nouveau. The immediate ancestor of Lehmbruck's later style, seen in *Kneeling Woman,* 1911 (fig. 223), and *Standing Youth,* 1913 (fig. 224), was undoubtedly Minne's attenuated *Kneeling Figure,* 1897, which in 1898 he expanded in a group of figures for a fountain (fig. 225).

The emotional power of Lehmbruck's work comes not from his studies of the past but from his own sensitive and melancholy personality, from the suffering that finally, in 1919, led him to suicide. Lehmbruck's surviving works are not many, but three or four of them, at least, are of the first importance. The *Kneeling Woman,* the *Standing Youth,* and *The Fallen,* 1915–16 (fig. 226), are all sculptures in which the artist utilizes the

225. GEORGE MINNE. Fountain of Kneeling Figures.
1898–1906. Marble. Folkwang Museum, Essen, Germany
(transferred from Folkwang Museum, Hagen)

226. WILHELM LEHMBRUCK. *The Fallen.* 1915–16.
29½ x 94½". Collection Frau A. Lehmbruck, Stuttgart

most extreme distortion of elongation—possibly suggested by figures in Byzantine mosaics and Romanesque sculpture, as well as by Minne's fountains. In Lehmbruck's hands it carried the sense of contemplation and withdrawal expressed in the *Standing Woman* still further. The *Kneeling Woman,* despite elongation that might be regarded as grotesque, is a figure of the most delicate, feminine grace. Her inclined head with shadowed eyes is that of a medieval saint, and her delicately posed hands have all the elegance of a figure by Watteau. The *Standing Youth,* on the other hand, equally attenuated, equally withdrawn, gives forth a sense of wiry, masculine strength held in restraint. *The Fallen* expresses the artist's agony and despair over the insane destruction of war.

## GEORG KOLBE (1877–1941), ERNST BARLACH (1870–1938), KÄTHE KOLLWITZ (1867–1947), GERHARD MARCKS (b. 1889)

The human figure was so thoroughly entrenched as the principal vehicle of expression for sculptors after some six thousand years, that it was even more difficult for sculptors to depart from it than for painters to depart from landscape, figure, or still life rendered in the tradition of illusionistic space. It was also difficult for sculptors, while adhering to the subject of the recognizable figure, to say anything new or startlingly different from what had been said at some other point in history.

The other leading German sculptors of the early century were Georg Kolbe, Ernst Barlach, Käthe Kollwitz—even better known as a graphic artist—and Gerhard Marcks. Kolbe began as a painter and, influenced by Rodin, changed to sculpture. In his works were combined the formal aspects of Maillol's figures with the light-reflecting surfaces of Rodin's. After some essays in highly simplified figuration, such as *Assumption* (fig 227), he settled into a charming formula of rhythmic nudes, appealing but essentially reiterating a Renaissance formula with a Rodinesque broken surface (fig. 228).

Barlach embodied influences from Russian peasant art with aspects of medieval German sculpture and some of the superficial forms of cubist sculpture, all for an essentially narrative purpose. He was capable of sculptural organizations of sweeping power and the integration of the single gesture of humor and pathos and primitive tragedy, as in *The Avenger* (fig. 229) or *Russian Beggar Woman* (fig. 230). His was still a storytelling art, however, a kind of socially conscious expressionism that used the outer forms of contemporary experiment for a traditional narrative. Barlach was also a printmaker of some distinction, an exponent of the more explicit stream of German expressionist graphic artists, who were given to forms of exaggerated emotion.

Käthe Kollwitz was capable of just as exaggerated expression, but with a difference. Her intense emotionalism, whether for a cause (*Weavers' Riot,* fig. 231), or in memory of her son killed in World War I, arose from a profoundly felt grief that transmitted itself to her sculpture and prints. Her *Mother and Child* (*Pietà,* fig. 232) is the passionate cry of a suffering mother, expressed in a sculpture that is a compact, massive structure of figures that melt into one another. Her *Self-Portrait* (fig. 233) is

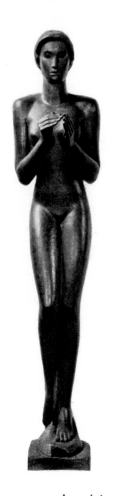
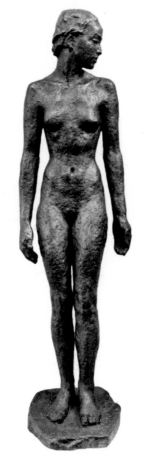

*above left:*
227. GEORG KOLBE. *Assumption.*
1921. Bronze, height 75".
The Detroit Institute of Arts

*above right:*
228. GEORG KOLBE. *Standing Nude.*
1926. Bronze, height 50½".
Walker Art Center, Minneapolis

*right:*
229. ERNST BARLACH. *The Avenger.*
1923. Bronze, width 23¼".
The Joseph H. Hirshhorn Collection

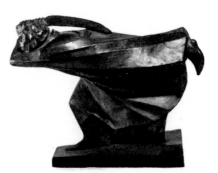

230. ERNST BARLACH. *Russian Beggar Woman.*
Bronze, height 9". 1907.
The Joseph H. Hirshhorn Collection

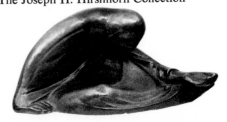

231. Käthe Kollwitz. *Weavers' Riot*. 1897. Etching. Collection, University Gallery, University of Minnesota, Minneapolis. Gift of Ione and Hudson D. Walker

*above:* 233. Kathe Kollwitz. *Self-Portrait*. 1936. Bronze, height 14¾″. The Joseph H. Hirshhorn Collection

*left:* 234. Gerhard Marcks. *Melusine II*. 1949. Bronze, height 43½″. Walker Art Center, Minneapolis

232. Käthe Kollwitz. *Mother and Child (Pieta)*. 1936. Bronze, height 28″. The Joseph H. Hirshhorn Collection

a beautiful characterization of a homely peasant face that has suffered and become beautiful through the understanding and acceptance of suffering.

Gerhard Marcks was the last of the original German expressionist sculptors. He taught pottery at the Bauhaus school at Weimar until 1925, at the same time making woodcuts close in style to the cubist-influenced woodcuts of the German expressionist painters. Turning increas-

ingly to sculpture in the late 1920s, he produced a number of small bronzes and made some larger-scale efforts in a classical vein, again probably influenced by Maillol. Like other leading German expressionists, he lived in seclusion during the Nazi regime (1933–1945). The sculpture of Marcks (fig. 234) combines the classical repose of figures by Maillol with a certain angularity and primitive humor harking back to medieval German sculpture.

235. CONSTANTIN BRANCUSI. *Sleeping Muse.* 1906.
Marble. National Gallery, Bucharest

236. CONSTANTIN BRANCUSI. *Sleeping Muse.* 1909–11.
Marble, height 11½". The Joseph H. Hirshhorn Collection

237. CONSTANTIN BRANCUSI. *The Newborn.* 1915.
Marble, height 5⅝". The Philadelphia Museum of Art.
Louise and Walter Arensberg Collection

238. CONSTANTIN BRANCUSI.
*The Beginning of the World.* 1924. Marble, height 7".
Roché Collection, Sèvres, France

239. CONSTANTIN BRANCUSI. *Mlle. Pogany.* 1913–31.
Marble, height 17¼". The Philadelphia Museum of Art

240. CONSTANTIN BRANCUSI.
*Torso of a Young Man.* 1924.
Polished brass, height 18″.
The Joseph H. Hirshhorn Collection

241. CONSTANTIN BRANCUSI.
*Princess X.* 1916.
Marble, height 28¾″.
Roché Collection, Sèvres, France

242. CONSTANTIN BRANCUSI. *The Kiss.*
1908. Limestone, height 23″.
The Philadelphia Museum of Art.
Louise and Walter Arensberg Collection

# Constantin Brancusi
# *(1876–1957)*

In France, during the early years of the twentieth century, the most individual figure—and one of the greatest sculptors of the century—was Constantin Brancusi. He was born in Rumania, the son of peasants. In 1887 he left home and worked for a time at odd jobs. Between 1894 and 1898 he was apprenticed to a cabinetmaker and studied in the provincial city of Craiova. Between 1898 and 1902 he continued his studies at the Bucharest Academy of Fine Arts. Then in 1902 he departed for Paris by way of Germany and Switzerland, finally arriving in 1904. After further studies at the Ecole des Beaux-Arts under the sculptor Mercier he began exhibiting, first at the Salon de la Nationale and then at the Salon d'Automne. Rodin, impressed by his contributions to the 1907 Salon d'Automne, invited him to become an assistant. Brancusi refused with the classic remark, "Nothing grows under the shade of great trees."

The sculpture of Brancusi is in one sense isolated, in another universal. He worked with few themes, never really deserting the figure, but he touched, affected, and influenced most of the major strains of sculpture after him. One of his first surviving works is an anatomical study based on the famous *Ecorché (Flayed Man)* of the

243. CONSTANTIN BRANCUSI. *The Miracle (Seal).* 1936. Marble, height 43″. The Solomon R. Guggenheim Museum, New York

eighteenth-century sculptor Jean-Antoine Houdon. From the tradition of Rodin came the *Sleeping Muse,* 1906 (fig. 235), in which the shadowed head sinks into the matrix of the marble, after the manner of late studies by that master. The theme of the Sleeping Muse was to become an obsession with Brancusi, and he played variations on it for some twenty years. In the next version, 1909–11 (fig. 236), and later, the head was transformed to an egg shape, with the features lightly but sharply cut from the ovoid mass. As became his custom with his basic themes, he presented this form in marble, bronze,

244. CONSTANTIN BRANCUSI. *Fish.* 1930.
Gray marble, 21 x 71″. The Museum of Modern Art, New York.
Acquired through the Lillie P. Bliss Bequest

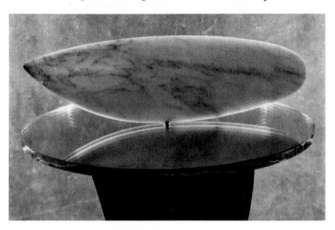

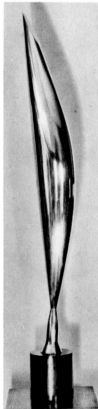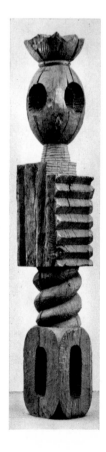

*right:* 245.
CONSTANTIN BRANCUSI.
*Bird in Space.* 1925.
Polished bronze,
height 49¾″.
The Philadelphia Museum
of Art. Louise and Walter
Arensberg Collection

*far right:* 246.
CONSTANTIN BRANCUSI.
*King of Kings.* 1956.
Wood, height 9′ 10″.
The Solomon R. Guggenheim
Museum, New York

and plaster, almost always with slight adjustments that turned each version into a unique work.

In a subsequent work, the theme was further simplified to a teardrop shape in which the features largely disappeared, with the exception of an indicated ear. To this piece he gave the name of *Prometheus,* 1911. This form in turn led to *The Newborn* (fig. 237), in which the oval volume is segmented in an indication of the screaming, gaping mouth of the infant, and finally to his ultimate return to the egg in the polished shape entitled, most appropriately, *The Beginning of the World* (fig. 238), which he also called *Sculpture for the Blind.*

This tale of the egg was only one of a number of related themes that Brancusi continued to follow, with a hypnotic concentration on creation, birth, life, and death. The influence of Cycladic and archaic Greek sculpture is evident in the *Girl's Head,* done 1907–08, at about the same time when the idea of a strange, goggle-eyed head inclined from a long and sinuous neck, began to appear. This form was developed further in a number of drawings and paintings, and then materialized in the many variations on the *Mlle. Pogany* (see fig. 239) in marble and polished bronze. The *Torso of a Young Man* (fig. 240) went as far as Brancusi ever did in the direction of precise cylinders, but still remains a phallic symbol, as does also the *Princess X* (fig. 241), which was removed from the 1920 Salon des Indépendants in the interest of decency. Brancusi, deeply offended by this action, stopped participating in all group exhibitions.

His subjects were so elemental and his themes so basic that, although he had few direct followers, nothing that happened subsequently in sculpture seems foreign to him. *The Kiss,* 1908 (fig. 242), is the ancestor of much cubist sculpture. Animals and birds are stated in their essence in the versions of *The Miracle (Seal),* 1936 (fig. 243), and the *Fish,* 1918–30 (fig. 244). The artist was particularly obsessed with birds and the idea of flight, which he progressively explored in the bird forms *Maiastra,* 1912, *Bird,* 1915, and *Bird in Space,* 1925 (see fig. 245), in which the image of the bird became the abstract concept of flight.

The art of Brancusi encompassed the nature of materials in all its manifestations. He finished his bronzes and marbles to a degree of perfection rarely seen in the history of sculpture. At the same time he placed these polished shapes on roughly carved stone pedestals, or on bases hacked out of tree trunks, in order to attain a mystical fusion of disembodied light-reflecting surfaces and solid, earthbound mass. In his wood sculptures, although he occasionally strove for the same degree of finish—as in the *Cock,* 1924, where the polished, stepped shape seems to give form to the repeated cock's crow—he more normally worked for a primitive, roughed-out totem, as in the *King of Kings* (fig. 246), where the great regal shape based on the forms of a massive old wine press expressed with tremendous authority the spirit of primitive Oriental religion.

Brancusi was a man who sought absolutes but who wished to be as a child. He himself said, "All my life I have sought the essence of flight. Don't look for mysteries. I give you pure joy. Look at the sculptures until you see them. Those nearest to God have seen them."

# EARLY TWENTIETH CENTURY ARCHITECTURE

## *United States*

### FRANK LLOYD WRIGHT *(1867–1959)*
### BEFORE 1920

Frank Lloyd Wright was dedicated by his mother to a career in architecture even before he was born. He studied engineering at the University of Wisconsin, where he read Ruskin and was particularly drawn to the rational, structural interpretation of Gothic architecture in the writings of Viollet-le-Duc. In 1887 he was employed by the Chicago firm of Adler and Sullivan (see p. 52), with whom he worked until he established his own practice in 1893. There is little doubt that many of the houses built by the Sullivan firm during the years of Wright's employment represented his ideas. For many years of his independent career Wright had few major commissions for public buildings, office buildings, or skyscrapers. The Larkin Building, Buffalo, New York, 1904 (see fig. 251), was his only large-scale structure prior to the Midway Gardens, Chicago, 1914, and the Imperial Hotel, Tokyo, 1915–22. All three, incidentally, have been destroyed.

Thus Wright's basic philosophy of architecture was stated primarily through the house form. His earliest houses, such as his own house in Oak Park, Illinois, 1889, reflect influences from the shingle-style houses of H. H. Richardson, Bruce Price, and McKim, Mead and White. These involved the development of the open, free-flowing plan of the English architects Philip Webb and Norman Shaw. The characteristically American feature of the veranda, open or screened, wrapping itself around two sides of the house, lent itself to an enhancement of the sense of outside space that penetrated to the main living rooms. Also, the cruciform plan, with space surrounding the central core of fireplace and utility areas, had an impact on Wright that affected his approach to house design as well as to more monumental design projects.

In the Ward Willitts House, Highland Park, Illinois, 1900–02 (fig. 247), Wright made one of his first individual and mature statements of the principles and ideas he had been formulating during his apprentice years. The plan, inspired largely by the Japanese exhibition hall of the 1893 Chicago Exposition, is based on a cross axis. The Japanese influence is seen in the dominant wide, low-gabled roof, and the vertical stripping on the facade. The sources, however, are less significant than the weld-

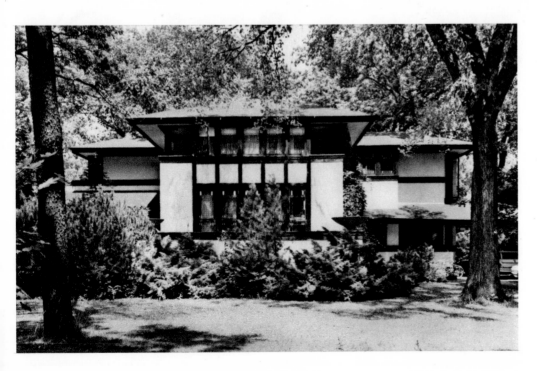

247. FRANK LLOYD WRIGHT. Ward Willitts House, Highland Park, Illinois. 1900–02

ing together of all elements of plan, interior and exterior in a single integration of space and mass and surface From the compact, dense center arrangement of fireplace and utility units, the space of the interior flows out in an indefinite expansion carried, without transition, to the exterior and beyond. The essence of the design in the Willitts house and in the series of houses by Wright and his followers to which the name "prairie style" has been given, is a predominant horizontal accent of roof lines, beams, and walls, held in tension by contrasting verticals.

The interior of the typical Wright prairie house is characterized by low ceilings, frequently pitched at unorthodox angles, a cavelike sense of intimacy and security, and constantly changing vistas of one space flowing into another (fig. 248). Such an interior has been contrasted with that of a Palladian villa, also cruciform in plan, but with clearly articulated rectangular rooms flanking the open, soaring dome of the central space. The Wright building is seen as an image of modern man seeking security in a world of constant change, the villa an image of Renaissance man comfortably occupying the ideal center of his self-contained, humanistic universe.

The masterpiece of Wright's prairie style is the Robie House, Chicago, 1909 (figs. 249, 249a, 250). Centered around the fireplace, the house is arranged on one dominant axis, with the sweep of the horizontal roof line cantilevered out with steel beams in great unsupported projections and anchored at the center, with the chimneys and upper gables at right angles to the principal axis.

Windows are arranged in long, symmetrical rows and are deeply imbedded into the brick masses of the structure. The principal horizontally oriented lines of the house are reiterated and expanded in the terraces and walls that transform interior into exterior space and vice versa. The elements of this house, combining the outward flowing space of the interior, the linear and planar design of exterior roof line and wall areas, with a fortresslike mass of chimneys and corner piers, summarize as well other experiments which Wright had carried on earlier in the Larkin Building, 1904 (figs. 251, 251a), and the Unity Temple, Oak Park, Illinois, 1906 (fig. 252)

Both of these structures represented radical differences from the prairie house in that they were organized as rectangular masses in which the problem the architect had set himself was an articulation of mass and space into a single, close unity. The Larkin Building was, on the exterior, a rectangular, flat-roofed structure, whose immense corner piers protect and support the window walls that reflect an open interior well surrounded by balconies. Before it was torn down "in the path of progress," this was one of those early modern industrial structures which suggested the tremendous possibilities for development of new kinds of internal, expressive space in the new tall buildings of America. The economics of industrial building was soon to destroy these possibilities.

Unity Temple continued on a smaller scale the experiments in rectangular mass and vertically-horizontally ar-

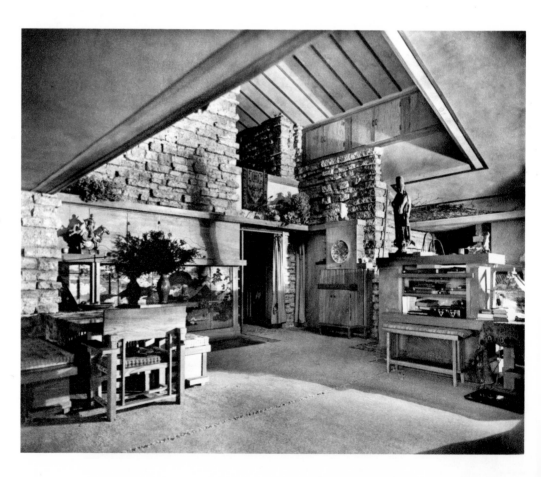

248. FRANK LLOYD WRIGHT.
Interior, Taliesin, Spring Green, Wisconsin. 1925

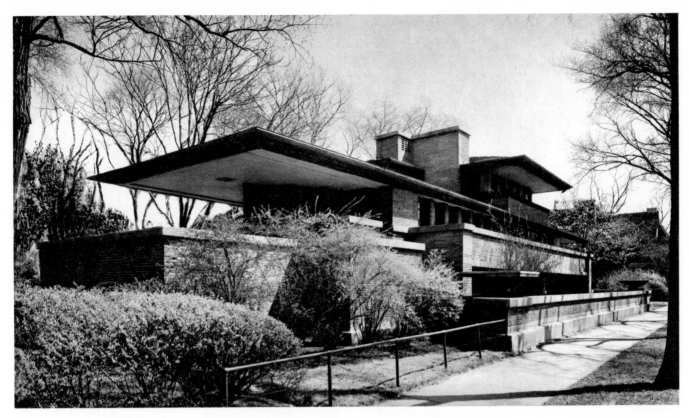

249. FRANK LLOYD WRIGHT. Robie House, Chicago. 1909

249a. Plans of Ground Floor and First Floor, Robie House

ticulated space. Here the architect used poured concrete, admirably textured on the exterior. The interior is compact and intimate, a rational expression of the rational beliefs of the congregation for which it was intended.

The place of Wright as a pioneer of the international modern movement is no longer a matter of controversy. Historically his experiments in architecture as organic space and as abstract design of a new kind antedate those of most of the twentieth-century European pioneers. The only question is the degree in which he influenced them directly. His designs had been published in Europe by 1910 and 1911, notably in the German editions of Ernst Wasmuth, and were studied by H. P. Berlage, Walter Gropius, and other architects. His works were known and admired by artists and architects of the Dutch De Stijl group, Robert van t'Hoff, J. J. P. Oud, Theo van Doesburg, Georges Vantongerloo, and Piet Mondrian. His design had common denominators not only with the classical formalism of these artists but also with the shifting planes and ambiguous space relationships of cubism. At the very moment he was becoming a world figure, however, Wright was entering upon a period of neglect and even vilification in his own country. His highly publicized personal problems, including the tragic destruction of his first home at Taliesin in Wisconsin, helped drive him from the successful midwestern practice he had built up in the early years of the century. Even more significant than these personal factors were cultural and social changes that, by the year 1915, had alienated the patronage for experimental architecture in the midwest. Shortly

250. FRANK LLOYD WRIGHT. Dining Room, Robie House, Chicago. 1909

*above:* 251. FRANK LLOYD WRIGHT. Larkin Building, Buffalo, N Y. 1904 (demolished 1950)

*right:* 251a. FRANK LLOYD WRIGHT. Interior, Larkin Building

after the turn of the century the industrial architecture of Sullivan and others in Chicago had been superseded by the rising tide of academic eclecticism. In domestic architecture, following the fashions of the Eastern Seaboard, various historical styles—Italian Renaissance, Queen Anne, colonial, and English Tudor Gothic followed one another in rapid succession. Large-scale construction of mass housing soon led to vulgarization of these styles.

Wright himself, about 1915, began increasingly to explore exotic styles, particularly Oriental and Mayan architecture. The Imperial Hotel, Tokyo (fig. 253), occupied most of his time between 1915 and 1922 and represents his most ornately complicated decorative period, filled with suggestions of Pre-Columbian influence. In addition, it embodied his most daring and intricate structural experiments to that date, experiments that enabled the building to survive the wildly destructive Japanese earthquakes of 1923 (only to be destroyed by man in 1968). For twenty years after the Imperial Hotel, Wright's international reputation was constantly enlarging, but he frequently had difficulty earning a living. He was indomitable, however, and continued to write, lecture, and teach, secure in the consciousness of his own genius and place in history, and inventing brilliantly whenever he received commissions.

# France

## AUGUSTE PERRET *(1874–1954),* TONY GARNIER *(1869–1948)*

Aside from Wright, a number of his followers, and a few isolated architects of talent such as Bernard Maybeck in California, American architecture between 1915 and 1940 was largely in the hands of the academicians and the builders. In England, also, there was little experiment for many years after the turn of the century. In continental Europe before 1914, the most significant innovations were to be found in Germany and Austria. These were fed by certain exciting new happenings, in painting and sculpture as well as in architecture, that originated in France, Holland, and Belgium. French architecture during this period was dominated by the Beaux-Arts tradition, except for the work of two architects of high ability, Auguste Perret and Tony Garnier. Both were pioneers in concrete, employed without pretense or stylistic concealment. Perret was the more important in actual achievement, Garnier's principal fame resting on his early (1901–04), vast and visionary plans for an Industrial City. Perret, whose family construction

business specialized in reinforced-concrete building, developed a mastery of this material that demonstrated for future generations of architects its immense structural flexibility and decorative possibilities.

In his apartment building at 25 bis Rue Franklin, Paris, 1902–03 (fig. 254), Perret covered the thin, reinforced-concrete skeleton with glazed terra-cotta tiles decorated in the art nouveau foliate pattern. The structure is clearly revealed, however, and allows for an almost complete concentration of large window openings on the facade. The architect increased the possibilities for daylight illumination by folding the facade around a front wall and then arranging the principal rooms so that all had outside windows. The strength and lightness of the material also substantially increased openness and spatial flow.

Other buildings, such as the Ponthieu garage, Paris, 1906, and the foyer of the Théatre des Champs Elysées, Paris, 1910–11, illustrated Perret's constantly developing ability to exploit and express the qualities of ferroconcrete, but his masterpiece in this material is probably his church of Notre Dame (fig. 255) at Le Raincy, Seine-et-Oise, near Paris, 1922–23. Here he used the simplest form of the early Christian basilica, a long rectangle with only a slightly curving apse, a broad, low-arched narthex, and side aisles just indicated by comparably low transverse arches. The miracle of this church, however, is the degree in which construction in reinforced concrete permitted the complete elimination of walls, something that Gothic architects always sought but never actually achieved, not even in the ultimate refinement of the Sainte-Chapelle in Paris. The roof rests completely on widely spaced slender columns, and the walls are simply constructed of stained glass (designed by Maurice Denis) arranged on a pierced screen of precast-concrete elements. Despite certain design flaws in the rendering of the facade tower, the church at Le Raincy remains one of the first monuments, not only in the structural use of ferroconcrete but also in the demonstration of its ultimate potential in design refinement.

Tony Garnier's project for an Industrial City (fig. 256) belongs to a long tradition of architectural visions of ideal metropolises rarely if ever realized. Its importance, however, like that of the others, is still great, in that it gave the architectural imagination free rein and in an uncanny manner predicted and even influenced the future. Garnier's concepts of spacious avenues and squares, functional distribution of work and play areas, his stripping down of buildings to unornamented rectangles, and his realization of the importance of nature, of trees and grass and even greenhouses—all these elements predicted in an astonishing degree the still largely unrealized concept of the garden city. After this highly promising beginning, his subsequent career, as architect of the city of Lyons and of many projects that followed, is disappointingly conventional.

Despite the great achievements in the 1920s and 1930s of Le Corbusier (to be discussed later), and despite the fact that Paris remained the world center for experimental painting and sculpture during the first half of the twentieth century, the phrase "curiously and disappointingly conventional" must also be used for the

252. FRANK LLOYD WRIGHT. Unity Temple, Oak Park, Illinois. 1906

253. FRANK LLOYD WRIGHT. Imperial Hotel, Tokyo. 1915–22 (demolished 1968)

254. AUGUSTE PERRET. Apartment House, Paris. 1902–03

preponderance of contemporaneous French architecture, as well as for British and American.

## Austria and Germany

OTTO WAGNER *(1841–1918),*

ADOLF LOOS *(1870–1933),*

JOSEF HOFFMANN *(1870–1956),*

JOSEF MARIA OLBRICH *(1867–1908),*

PETER BEHRENS *(1868–1940)*

Experimental architecture in Spain, Britain, France, and the United States during the first part of the twentieth century has been traced in terms of the work of a few isolated architects of genius—Gaudí in Spain, Mackintosh in Britain, Perret and Garnier in France, and Sullivan and Wright in the United States. There also emerged men of high talent in other countries: Horta and Van de Velde in Belgium; Wagner, Loos, Hoffmann, and Olbrich in Austria; Hendrik Petrus Berlage in The Netherlands; and Peter Behrens, Richard Riemerschmid, Hans Poelzig, and others in Germany. An important difference in the development of these architects lay in the degree to which, largely as a result of enlightened governmental and industrial patronage in Germany before 1930, their experiments, instead of depending only on the genius of individual men, were co-ordinated and directed toward the creation of a "school" of modern ar-

255. AUGUSTE PERRET. Church of Notre Dame, Le Raincy, France. 1922–23

chitecture. In this process, the contributions of certain patrons were of the greatest importance. Such patrons included the Archduke Ernst Ludwig of Hesse; the A.E.G (German General Electrical Company); the diplomat, critic, and educator Hermann Muthesius; Alfred Lichtwark, director of the Hamburg Gallery; politicians such as Friedrich Naumann; and others.

Otto Wagner was a relatively academic architect during the early part of his life. The stations for the Vienna subway, 1896–97, were simple and functional buildings dressed with Baroque details. In his book on modern architecture published in 1894, however, Wagner had already evidenced his ideas about a modern architecture that used modern materials. The hall of the Vienna Post Office Savings Bank, 1905 (fig. 257), is a monument to the unadorned use of metal and glass in the creation of airy, light-filled, and unobstructed space. There is a certain stylistic similarity here to the auditorium that Victor Horta built in his Maison du Peuple, Brussels, 1897–99

256. TONY GARNIER.
Apartment Houses. Plate 136 from
*Une Cité Industrielle*,
Paris, 1918

(see fig. 130), but also, a considerable advance in the elimination of structural elements for the creation of a single unified and simple space.

Also active in Vienna early in the century was Adolf Loos. After studying architecture at Dresden, Loos worked in the United States for three years from 1893, taking various odd jobs while learning about the new concepts of American architecture, particularly the skyscraper designs of Sullivan and other pioneers of the Chicago school. Settling in Vienna in 1896, he followed principles enunciated by Wagner and Sullivan, wrote extensively against the art nouveau decorative approach of the Vienna Secession and in favor of an architecture of pure form expressive of function. His shop interior in Vienna, 1898 (fig. 258), was even then a pure expression of his ideals in its abstract, rectangular design. His Steiner house, Vienna, 1910 (fig. 259), anticipates the unadorned cubic forms of the so-termed international style of architecture that was to develop from the concepts of J. J. P. Oud, Walter Gropius, Mies van der Rohe, and Le Corbusier in the 1920s and 1930s. The plan and facade are symmetrical; simple, large-paned windows arranged in horizontal rows are sunk into the facade without ornamental sash. Reinforced concrete was here applied to a private house for almost the first time. Although the architecture and ideas of Loos never gained the wide dissemination they deserved, he was an architect of the greatest importance, and the Steiner house is a key monument in the creation of the new style.

Among the art nouveau architects attacked by Loos were Olbrich and Hoffmann, who, with the painter Gustav Klimt, were the founders of the Vienna Secession movement. Hoffmann's Convalescent Home, Purkersdorf, 1903–04 (fig. 260), an early important work, is one of his purest. It is stripped of all ornament, thus actually coming very close to the architectural principles of Loos, by which he may have been affected. Like many of the pioneer modern German and Austrian buildings of the early twentieth century, the Convalescent Home is not only a prototype of the international style, but in its restrained and balanced classicism also reflects the early-nineteenth-century tradition of Karl Friedrich von Schinkel and German neo-classicism. Hoffman's masterpiece is the great house he built for the Stoclet family in Brussels, the Palais Stoclet (see fig. 137). Although this splendid mansion is characterized by severe rectangular planning and facades, and broad, clear, white areas framed in dark, linear strips, its essence is a virtuoso display of elegant and attenuated proportions that give the entire design a curiously insubstantial and even two-dimensional effect that relates it to the mainstream of art nouveau.

Hoffmann continued his long and successful career past the mid-century point, designing housing projects in Vienna and buildings for a number of international expositions. His work continued to be tasteful, pure, and essentially classic adaptations of the new ideas of the international school.

Hoffmann's importance as a pioneer is perhaps greater for his part in establishing the Wiener Werkstätte (Vienna Workshops) than for his achievement as a practicing architect. The Workshops, which originated around 1900, continued the craft traditions of William Morris and the English arts-and-crafts movement, with the contradictory new feature that the machine was now

accepted as a basic tool of the designer. For thirty years these workshops exercised a notable influence through the teaching of fine design not only in handicrafts but also in industrial objects. About the same time, a cabinetmaker, Karl Schmidt, had started to employ architects and artists to design furniture for his shop in Dresden. Out of this grew the Deutscher Werkstätte (German Workshops), which similarly sought to apply the principles of Morris to the larger field of industrial design. From these experiments, as well as others conducted at schools of arts and crafts in Austria and Germany, originated in 1907 the Deutscher Werkbund (German Work or Craft Alliance), which in turn was the immediate predecessor of the Bauhaus, one of the schools most influential in the development of modern architecture and industrial design.

Relations between Austrian and German architecture were extremely close in the early years of the century. When the Archduke Ernst Ludwig of Hesse wished to effect a revival of the arts by founding an artist's colony at Darmstadt he employed Olbrich to design most of the buildings, including the Hochzeitsturm (Wedding Tower; fig. 261), intended as the focal structure and symbol of the entire project. This tower, which still dominates Darmstadt, was intended less as a functional structure than as a monument. Although it was inspired by the American concept of the skyscraper, its visual impact owes much to the towers of German medieval churches. One innovation, however, was of significance for later skyscraper design. This is the manner in which rows of windows are grouped within a common frame and wrapped around a corner of the building.

The sense of tradition is strong in most of Olbrich's architecture. His building for the Vienna Secession, 1898–99, combines severe classic masses with an ornate dome decorated in the most lush art nouveau manner. Although the choice of Olbrich as chief architect suggests a certain caution in the Archduke's experiment, the Darmstadt project is important as an early modern example of a planned community and cultural center. The only building in the artist's colony not designed by Olbrich was the house that Peter Behrens built for himself.

Behrens, more than any other German architect of the early twentieth century, constitutes the bridge between the past and the present, between tradition and experiment. He began his career as a painter, producing art nouveau graphics, and then was led from an interest in crafts to the central problems of industrial design for machine production. Perhaps as a result of his experience in the artists' collaborative at Darmstadt, he turned to architecture. In 1903 he was appointed director of the Düsseldorf School of Art; and in 1907 the A.E.G. hired him as architect and coordinator of design in the broadest possible sense, including products and publications. This appointment by a great industrial organization of an artist and architect to supervise and improve the quality of all its products was an epoch-making event in the history of modern architecture and design. It was tied to the

*above:* 257. OTTO WAGNER. Post Office Savings Bank, Vienna. 1905

*right:* 258. ADOLF LOOS. Shop Interior, Vienna. 1898

educational process that had been carried on for a number of years by various German and Austrian governmental agencies through widespread schools of arts and crafts. A key figure in this process was the critic and educator Hermann Muthesius (1861–1927). Muthesius was attached to the German Embassy in London between 1896 and 1903 for the purpose of studying the English arts-and-crafts movement and developments in modern English architecture. He thus formed a link between these concepts and the course of twentieth-century architecture and industrial design in Germany. When appointed director of the Prussian board of trade for schools of arts and crafts on his return to Germany, he became an active propagandist for improved standards of design in German industry, his efforts leading to the formation of the Deutscher Werkbund in 1907.

In its ideal of improvement of all phases of industrial art the Deutscher Werkbund attracted many of the leading architects of the day, including Hoffmann, Riemerschmid, and Van de Velde. Although the Werkbund derived from the English arts-and-crafts movement, its importance rested primarily on its efforts to harness the machine for the improvement of mass-produced objects and every aspect of the human environment. Its ideas were propagated not only through teaching and laboratory experiments, but also—and especially—through great expositions of design. The most significant of these was held at Cologne in 1914, and included experimental buildings by Van de Velde, Behrens, and the young Walter Gropius. Although World War I arrested the progress of the Werkbund, its ideas were taken up and carried on by similar organizations in Austria, Switzerland, Sweden, and England.

The climaxes of the Werkbund's history were the expositions at Stuttgart in 1927 and Paris in 1930. The first of these, under the direction of Ludwig Mies van der Rohe, featured an entire housing exhibition, the design of which was the collaborative effort of a large proportion of the masters of twentieth-century architecture: Behrens, Gropius, Mies van der Rohe himself, and many others from Germany; Le Corbusier from France; and Oud and others from The Netherlands and Austria. This exhibition was in many ways a summary of major European experiments in domestic architecture since the beginning of the century. The German section of the 1930 Paris exposition was supervised by Walter Gropius with the assistance of Herbert Bayer, Marcel Breuer, and Laszlo Moholy-Nagy, all formerly with Gropius at the Bauhaus. With the advent of the Nazi regime, the Deutscher Werkbund, along with most of German experimental architecture and industrial design, was abandoned until the end of World War II.

The career of Peter Behrens spans most of this brilliant period in both German architecture and industrial design. One of his first buildings for A.E.G., and a landmark in the history of modern architecture, is the Turbine Factory in Berlin (fig. 262). Although the building is given a somewhat traditional appearance of monumentality by the huge corner masonry piers (which in actuality have nothing to do with the support of the building) and the overpowering visual mass of roof (which again belies its actual structural lightness), it is essentially a

glass-and-steel structure, a light frame of hinged steel beams that enable walls to be expanses of glass. Despite the carry-over of certain traditional forms, this is a building immensely important, not only in its bold structural engineering, but also in its frank statement of construction, and in the social implications of a factory built to include the maximum of air and space and light. It is functional in terms not only of the processes of manufacture but also of the working conditions of the employees —something rarely considered in earlier factories.

259. ADOLF LOOS. Steiner House, Vienna. 1910

260. JOSEF HOFFMANN. Convalescent Home, Purkersdorf, Austria. 1903–04

In the nineteenth century, during the vast expansion of the Industrial Revolution, factories, almost without exception, had been conceived as the most utilitarian buildings possible (as opposed to functional), produced at the lowest feasible cost, with an absolute minimum of amenities for the worker. Since the factory was not intended to be entered by the general public, the nineteenth-century industrialist could see no point in "wasting money on extras." The hiring of Behrens by the A.E.G. and similar appointments of consultants in design by other industries seem to have marked the emergence of some feeling of responsibility on the part of large-scale industry. Certain enlightened industrialists began to grasp the fact that well-designed products were not necessarily more expensive to produce than products that were badly designed and shoddily made. Also, in the rapidly expanding industrial scene and the changing political scene of the early twentieth century, the image presented by industry to the public at large was assuming increasing importance. After a century or more of short-sighted and senseless exploitation of natural and human resources, it was finally evident that an effort must be made to educate business and civic leaders, and the general public as well, to the importance of large-scale industry in creating an expanding economy, raising living standards, even in glorifying a national image.

Some such ideas may have influenced Behrens' attempt to transform his functional glass-and-steel turbine factory into a monument expressing and extolling the place and achievements of modern German industry. Certainly, they were a factor in the design of his later industrial buildings. In later works, such as the Höchst Dye Works offices (fig. 263), executed about the time he was

*above:* 261. JOSEF MARIA OLBRICH. Hochzeitsturm (Wedding Tower), Darmstadt, Germany. 1907

*right:* 262. PETER BEHRENS. A.E.G. Turbine Factory, Berlin. 1908–09

263. PETER BEHRENS.
Dye Works Offices,
Höchst, Germany. 1920–24

made director of the Vienna Academy School of Architecture, Behrens experimented with the expressionism that had entered German and Austrian architecture from the example of painting and sculpture. In the entrance hall he used brick, organized in staggered vertical piers to create a dramatic effect of compression. Behrens is important not only as an architect but as a teacher of a generation that included Gropius, Le Corbusier, and Mies van der Rohe—all of whom worked with him early in their careers.

chitecture, in some degree seen through the eyes of the American architect H. H. Richardson, whose work he knew and admired.

The complex relationship among English pre-raphaelite painting, Morris and the English arts-and-crafts movement, French impressionist, neo-impressionist, and symbolist painting, art nouveau design, and the beginnings of modern rational architecture is summarized and pointed up in the fertile career of the Belgian Henry van de Velde. Not only was Van de Velde a painter, craftsman, industrial designer, and architect; he was also a

## The Low Countries

### HENDRIK PETRUS BERLAGE (1856–1934), HENRY VAN DE VELDE (1863–1957)

In Holland, Hendrik Petrus Berlage was the first of the innovators. He was not an innovator in the sense of creating startling new concepts in design, materials, or structure. Throughout his life he considered himself a traditionalist. He was passionately devoted, however, to stripping off the ornamental accessories of academic architecture and expressing honest structure and function. He characteristically used brick as a building material, the brick that, in the absence of stone and other materials, has created the architectural face of Holland. His best-known building, the Amsterdam Stock Exchange (fig. 264), is principally of brick, accented with details of light stone. The brick is presented, outside and in, without disguise or embellishment, as is also the steel framework that supports the glass ceiling. The general effect, with the massive corner tower and the low arcades of the interior, is obviously inspired by Romanesque ar-

264. HENDRIK PETRUS BERLAGE.
Stock Exchange, Amsterdam. 1898–1903

critic who exercised an extensive influence on German architecture and design. Trained as a painter, first in Antwerp and then in Paris, he was in touch with the impressionists and interested in symbolist poetry. Back in Antwerp, painting in a manner influenced by Seurat, he exhibited with Les XX, the avant-garde Brussels group. Through them he discovered Gauguin, William Morris, and the English arts-and-crafts movement. As a result, he enthusiastically took up the graphic arts, particularly poster and book design, and then, in 1894, turned to the design of furniture. All the time, he was writing energetically, preaching the elimination of traditional ornament, the assertion of the nature of materials, and the development of new, rational principles in architecture and design. In 1895 he built a house for himself, designing it as a totality—not only the architecture but every detail of interior decoration, including furniture, draperies, and table services. He even designed dresses for his wife to harmonize with her environment.

In 1896 he designed the furniture and interiors of four rooms for the new shop that the art dealer S. Bing was opening in Paris under the name of L'Art nouveau. Van de Velde himself in his essay *Deblaiement d'art* in 1894 had pleaded for the formulation of "un art nouveau." The furniture he designed for his own house in 1895 was characterized generally by qualities of peasant simplicity and austerity. The rooms created for L'Art nouveau, however, were marked by a decorative lushness and integration of parts that drew from the critic De Goncourt the epithet "yachting style," a not inappropriate suggestion of its similarity to a ship's interior. The furniture, silver, and glass that Van de Velde created at the turn of the century represent some of the best and purest examples of the art nouveau style. They are composed of curvilinear forms constituting their own ornament (fig. 265). Despite the absence of any applied ornament, the decorative sense is strong, as Van de Velde himself later recognized when he admitted that his own and his contemporaries' search for principles of rational design was conditioned by continuing nostalgia for the tradition of German romanticism.

In 1899 Van de Velde moved to Germany and, over the next few years, turned to architecture. One of his first large commissions was the design of the interior of the Folkwang Museum in Hagen (fig. 266), a project that resulted in one of the most completely integrated and successful monuments of the art nouveau style. The classic columns, arches, and domes were transformed in his hands into flowing linear patterns suggestive of the spirit of some aspects of Romanesque architecture and sculpture. With the design of the Weimar School of Arts and Crafts, which he founded under the patronage of the Duke of Saxe-Weimar in 1906, Van de Velde moved decisively from the world of art nouveau decorative move-

*above:* 265. HENRY VAN DE VELDE. Candelabrum. c. 1902.
Silver-plated bronze, height 21¾".
Nordenjeldske Kunstindustrimuseum, Trondheim, Norway

*right:* 266. HENRY VAN DE VELDE. Folkwang Museum,
Hagen, Germany. 1900–02

*below:* 267a. Plan of the Werkbund Theater

ment into a realm of new, rational architecture. In the exterior he further simplified the shapes of Mackintosh's Glasgow School of Art in the alternation of plain piers with large window areas. Although the vestige of a traditional mansard roof remains, this also is largely dissolved in the extensive curved skylights. The studio interiors embody the essence of functional studios—large, uninterrupted areas; logical, easy circulation; and excellent natural light.

In the Werkbund Theater, Cologne, 1914 (destroyed, figs. 267, 267a), Van de Velde made contributions to the problems of theater design, particularly in the stage area. The exterior evidenced the emergence of a personal style in the manner in which the facades defined the volume of the interior. Following the end of World War I, the houses and other buildings on which he worked, notably the Kröller-Müller Museum at Otterlo, The Netherlands, are characterized by austerity and refinement of details and proportions—evidence, perhaps, of the reciprocal influence of younger experimental architects who had emerged from his original educational systems.

Not the least of Van de Velde's achievements by any means was the educational program he developed at the Weimar School. This put its emphasis on creativity, free experiment, and escape from dependence on past traditions. When Van de Velde left Weimar in 1914 he recommended as his successor for the directorship the young architect Walter Gropius. Gropius was appointed to the post in 1915 and assumed his duties after the war, in 1919, with full authority to reorganize the curriculum of the schools of fine and applied arts. He consolidated the separate schools under the new name of Das Staatliche Bauhaus, Weimar. Under the abbreviated designation of Bauhaus, this was to become the most influential school in the history of architecture and design.

The period of World War I, 1914 to 1918, obviously interrupted the many experiments in architecture, as well as in painting and sculpture, that had blossomed during the first years of the twentieth century. During these war years there was emerging a new generation of architects —Gropius and Mies van der Rohe in Germany; Le Corbusier in France; Oud and Gerrit Thomas Rietveld in Holland; Eliel Saarinen and Alvar Aalto in Finland. Together with Frank Lloyd Wright in the United States, these men were to build on the foundations of the pioneers to create one of the great architectural revolutions of history.

## Expressionist Architecture

The spirit of expressionism manifested itself in German architecture as well as in painting and sculpture between 1910 and 1925. Although this did not result initially in any large number of important buildings and although expressionism in architecture was terminated by the rise of Nazism, it did establish the base for a movement which has been realized only in the 1950s and 1960s. The first evidence of the expressionist attitude was probably that of monumentality, as was seen in Behrens' Turbine Factory and Van de Velde's Werkbund Theater. The expressionist attitude, however, soon made itself felt in buildings as eccentric and dynamic as those of Gaudí in Barcelona. Of these, the most impressive is the Grosses Schauspielhaus (Great Theater), Berlin, 1919 (fig. 268), created by the architect Hans Poelzig (1869–1936) for the theatrical impresario Max Reinhardt. This was actually a conversion of an old building, the Circus Schumann. Using stalactite forms over the entire ceiling and most of the walls, and filtering light through them, Poelzig created a vast arena of fantasy appropriate to Reinhardt's spectacular productions.

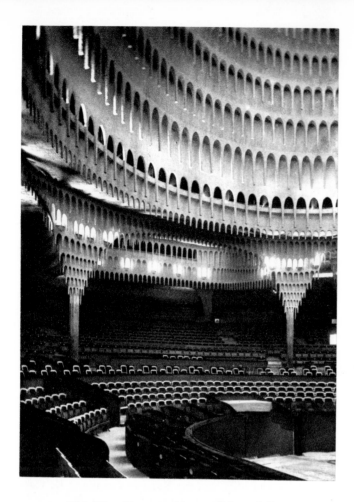

268. HANS POELZIG. Grosses Schauspielhaus
(Great Theater), Berlin. 1919

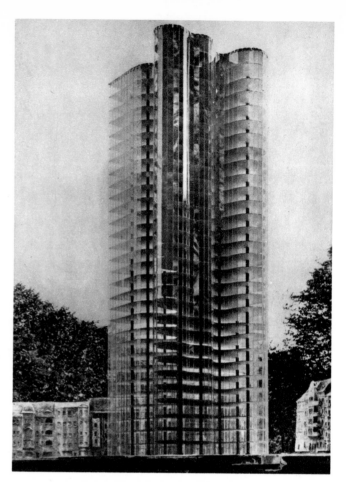

270. MIES VAN DER ROHE.
Model of the Glass Skyscraper. 1919–21

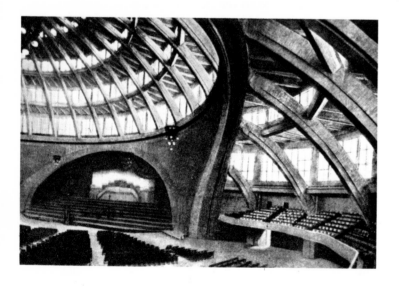

269. MAX BERG. Centenary Hall, Breslau, Poland. 1912–13

Comparable in its impact was Max Berg's (1870–1948) Centenary Hall in Breslau, 1912–13 (fig. 269). Although the circular exterior is relatively sedate, the huge interior is an overpowering space defined by the great ribbed dome. This is a work that looks forward to the mid-century architecture of engineers. The layout of the centennial buildings combines classic frontality with a

monumental confusion of styles that is, nevertheless, highly impressive.

The war years and the immediate postwar period saw many Utopian designs among the architects of both Germany and Holland. Even Mies van der Rohe's glass skyscraper designs made in 1919–21 (fig. 270), despite the fact that they were later to be realized, had at their inception a certain quality of fantasy and unreality. Of the buildings that were actually executed, Fritz Hoeger's Chile House in Hamburg, 1923 (fig. 271), employs an isolated triangular site to recreate the spirit of the German Middle Ages. Bruno Taut employed glass on a large scale, as Gropius and Mies van der Rohe were doing at the same moment, but for expressionist rather than functional ends.

Of the architects who emerged from German expressionism, perhaps the most significant was Erich Mendelsohn (1887–1953). Mendelsohn began practice in 1912 but his work was interrupted by World War I. Following the war, one of his first important buildings was the Einstein Tower in Potsdam, 1920–21 (fig. 272), the first designs of which he had made as early as 1917. This is one of the principal documents of expressionist architecture. On the exterior, Mendelsohn emphasized qualities of continuity and flow appropriate to the material of concrete. The windows flow around the rounded corners; the exterior stairs flow up and into the cavern of the entrance. The entire structure, designed as a monument as

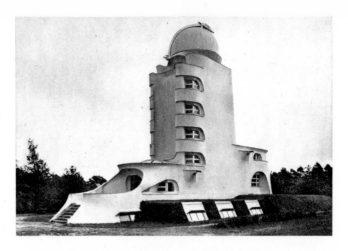

272. ERICH MENDELSOHN. Einstein Tower,
Potsdam. 1920–21 (destroyed)

271. FRITZ HOEGER. Chile House, Hamburg. 1923

273. ERICH MENDELSOHN. Schocken
(later Merkur) Department Store, Stuttgart. 1927

274. RUDOLF STEINER. Goetheanum II,
Dornach, Switzerland. 1925–28

well as a functioning interior, has a quality essentially organic, prophetic of the later works of Le Corbusier and the younger Saarinen.

The principal contribution of Mendelsohn to expressionist architecture lay in his essentially dynamic approach. The Schocken (later Merkur) Department Store in Stuttgart, 1927 (fig. 273), was obviously based on Louis Sullivan's Carson Pirie Scott store in Chicago. However, the intervening technological developments which permitted contrasts of uninterrupted glass areas with massive recessed windows enabled the architect to create effects comparable to those of a great functioning machine.

Many other architects, particularly in Germany and Holland, were affected by the spirit of expressionism during the 1920s. The educator, philosopher, and occultist Rudolph Steiner (1861–1925), although not trained as an architect, did produce remarkable examples of Utopian architecture in his Goetheanum I and II, the latter of which dates 1925–28 (fig. 274), a tremendous sculptural monument of concrete that again looks back to Gaudí and forward to the *architecture brut* of today.

Peter Behrens, in his Höchst Dye Works, employed expressionist features in the handling of the brickwork. Although expressionist architecture at this stage would seem to have been in direct opposition to the principles evolved by Gropius and others at the Bauhaus, it still had initial impact on details of international style buildings.

However, at this stage it must be regarded as an interval in the history of architecture whose implications did not begin to be realized for some thirty years, until the austerity and pristine elegance of the international style had begun to pall.

# PART SIX

# TOWARD EXPRESSIONISM IN PAINTING

During the last years of the nineteenth century and the first years of the twentieth, France dominated the scene in painting and sculpture to the point that other national styles—German, Italian, English, or American—can be considered little more than provincial offshoots. There were, of course, a few painters and sculptors of genius produced by these and other countries: Van Gogh (Holland), Edvard Munch (Norway), James Ensor (Belgium), Medardo Rosso (Italy). In most cases, however, the emergence of these artists only pointed up the barrenness that surrounded them in their native countries. In any event, many of them if not most were formed in the environment of Paris.

German painting during much of the nineteenth century was enmeshed in a morass of sentimental, naturalistic idealism. In the last years of the century the influence of the French Barbizon school was paramount. In Germany this style was given a romantic expression that, in some degree, anticipated the first stirrings of twentieth-century German expressionism. This lyrical naturalism also absorbed aspects of French impressionist color without radically changing its own essential nature. Max Liebermann, Lovis Corinth, and Max Slevogt were the principal German impressionists; and of these only Corinth seems to have made a personal statement tying impressionism to some of the more dynamic forces of expressionism.

At the turn of the century, German artists were ripe for new influences and movements, and thus were quick to seize on the forms and the program of art nouveau, which close cultural contacts with England had brought to their attention. The concept of a new ideal of arts and crafts or art and industry seems to have had an immediate appeal to the German temperament, and under the name "Jugendstil" this new style became popular and national. The subsequent development of Jugendstil (see p. 73) in Germany toward a modern, rational architecture and a synthesis of fine and applied arts emphasizes the importance of the appearance of art nouveau at the moment when there was an obvious vacuum to be filled in German art. In comparison with the architectural and design experiments that grew out of the environment of Jugendstil, there is little to comment on in painting and sculpture. The Austrian Gustav Klimt probably represents the high point of German as well as Austrian Jugendstil in painting and the decorative arts. The Swiss Ferdinand Hodler (1853–1918) exemplifies

the various, sometimes conflicting tendencies of naturalism, idealism, and symbolism which were in the air at the time and which may have retarded the emergence of a single strong expressive line. In retrospect it is apparent that Jugendstil was important more for the new ideas it evoked than for the immediate impetus given artists of talent and ability. Edvard Munch, in many ways the father of German expressionism, James Ensor, one of the fathers of surrealism and twentieth-century fantasy, and Vasily Kandinsky, one of the fathers of abstraction, all grew up in the environment of Jugendstil or art nouveau.

## EDVARD MUNCH (1863–1944)

Edvard Munch, the greatest of Norwegian painters and an international pioneer of modern expressionist painting, is that rare phenomenon, an artist of genius emerging from a national environment of no substantial original artistic tradition. Such figures are not easy to

275. EDVARD MUNCH. *The Sick Child*. 1885–86. 47 x 46⅝". National Gallery, Oslo

find, since experiment in the visual arts rarely seems to thrive unless there is, somewhere, a receptive public. Norway, about 1880, at the time Munch began to study painting seriously, had a number of accomplished painters and a degree of patronage for their works. But the tradition was overwhelmingly academic, rooted in French romantic realism of the Barbizon school and in German lyrical naturalism; impressionism began to penetrate to Norway only in the last decade of the nineteenth century.

In 1885, Munch was first given the chance to travel abroad to Belgium and, for three weeks, to Paris. Although, like any young student, he spent much of his time saturating himself in the old masters of the Louvre and visiting the Salon of that year, he discovered the works of Manet and was most impressed by them. Despite academic training, he developed his own approach out of the impressionist and symbolist experiments he observed around him. In 1892 his reputation had grown to the point where he was invited to exhibit at the Verein Berliner Künstler (Society of Berlin Artists). His exhibition resulted in such a storm that sympathetic leaders of the liberal wing of the Society, led by Max Liebermann, resigned from the organization and formed the Berlin Secession. This recognition—and controversy—encouraged Munch to settle down in Germany, where he spent most of his time, until 1908. During this period he came to maturity as an artist and began to exercise a crucial influence on German expressionist art as it developed.

In evaluating Munch's place in European painting it could be argued that he was formed not so much by his Norwegian origins as by his exposure first to Paris during one of the most exciting periods in the history of French painting, and then to Germany at the moment when a new and dynamic art was emerging. The singular personal quality of his paintings and prints, however, is unquestionably a result of an intensely literary and even mystical approach that was peculiarly Scandinavian, intensified in his case by his own strange and tortured personality. Norwegian literature rose to a new level at the end of the nineteenth century with the emergence of Henrik Ibsen as a dramatist of world reputation; and many of the best analogies for Munch's paintings are to be found in the plays of Ibsen. The painter moved in literary circles in Norway as well as in Paris and Berlin, was a friend of noted writers, among them August Strindberg and the influential German art historian and critic of modern art, Julius Meier-Graefe. In 1906 Munch made stage designs for Ibsen's plays *Ghosts* and *Hedda Gabler*.

Even in Norway it is customary to stress the international quality of Munch's paintings; but when one passes from the Munch rooms at the National Gallery in Oslo to the rooms that display other contemporary Norwegian painters, Munch's origins are obvious at a glance. By 1889–90 Munch was in control of the impressionists' palette of divided color, but even at this point of most immediate influence, a painting like *Night in St. Cloud,* 1890, is less an impressionist study in light and shadow than a painting of mood and melancholy, already suggestive of some undefined inward torment.

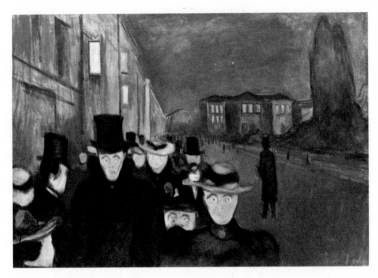

276. EDVARD MUNCH. *Evening on Karl Johan Street, Oslo.* c. 1892. 33¼ x 47⅝". Rasmus Meyers Samlinger, Bergen, Norway

Although he lived to be eighty years old, the specters of sickness and death hovered over him through much of his life. His mother and sister died of tuberculosis while he was still young, and he himself suffered from serious illnesses. Sickness and death began to appear early in his painting and recurred continually. Such themes, of course, were common in the art and literature of the period, but for Munch they had a particular pertinence. *The Sick Child* (fig. 275) was related to the illness and death of his sister. Other subjects that obsessed him were those of the awakening of sexual desire, and woman contrasted as innocent child and as blood-sucking vampire. Munch was emerging as a painter at the moment when Sigmund Freud was developing the theories of psychoanalysis; and the painter, in his obsessions with sex and death, at times seemed almost a classic example of the problems Freud was exploring. In the *Mystic Shore,* c. 1892, the moon and its long reflection in the water are transformed into a phallic symbol. This motif recurs with more explicit symbolic overtones in painting after painting, for instance *The Dance of Life,* 1899–1900 (colorplate 46).

The fears that haunted the artist were frequently given more general and ambiguous, though no less frightening, expression. In *Evening on Karl Johan Street, Oslo* (fig. 276), the pedestrians in the early winter darkness are transformed into a ghastly concourse of walking dead. *The Cry* (fig. 277) is an agonized shriek translated into visible vibrations that spread out like sound waves. In *The Red Vine* (colorplate 47), the house is turned by the vine into a domicile of horror from which the figure flees in panic.

Munch was enormously prolific, and throughout his life experimented with many different themes, palettes, and styles of drawing. The works of the 1890s and the early 1900s, in which the symbolic content is most explicit, are characterized by the sinuous, constantly mov-

ing, curving line of art nouveau, combined with color dark in hue but brilliant in intensity. Influences from Gauguin and the nabis are present in his work of this period. His studies of nudes may represent an actual influence from Bonnard, but in any event, Munch's interpretation is entirely different, more haunting and disturbing, closer to the spirit of German expressionism (*Puberty*, colorplate 48). This spirit—which Munch himself had helped create—manifests itself in later works, landscapes and scenes of peasants at work (for example, *Galloping Horse*, fig. 278), although, in these brightly painted subjects, there seem to be qualities of health, power, and optimism.

No simple progression can be noted in the works of Munch. He continually turned back to and reworked earlier subjects. His obsessions with sex, violence, and death continued throughout his life. These elements might be summarized in the *Death of Marat* (fig. 279), which he began in 1905 and did not complete until 1927. Similarly, his career might be summarized in the portraits, particularly the fascinating and disturbing self-portraits. An early *Self-Portrait in a Blue Suit*, utilizing the large, abstract color strokes of the fauves, presents the artist as an intellectual whose handsome, distinguished face is already ravaged by self-doubt and nervous tension. In his last, haunting self-portrait, titled *Between Clock and Bed*, the ancient Munch paints himself hovering on the

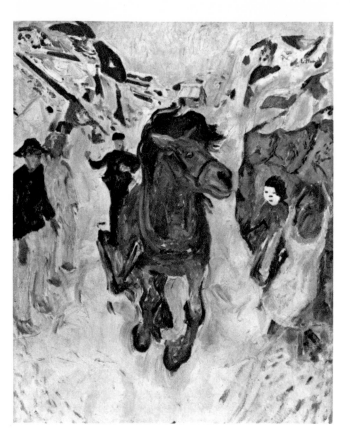

278. EDVARD MUNCH. *Galloping Horse*. 1912. 58¼ x 47". Munch Museum, Oslo

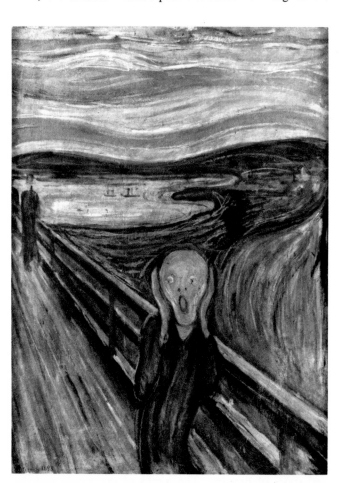

277. EDVARD MUNCH. *The Cry*. 1893. Oil and tempera on board, 35¾ x 29". National Gallery, Oslo

edge of eternity; but his sure hand for abstract color and structure demonstrates that he has never lost contact with new experiments.

Munch was a major graphic artist. He began making etchings and lithographs about 1894, and for a time was principally interested in using the mediums to restudy subjects he had painted earlier. The prints, however, were never merely reproductions of the paintings. In each case he reworked the theme in terms of the new medium, sometimes doing the same subject in drypoint, woodcut, and lithography, and varying each of these as each was modified from the painting.

## JAMES ENSOR *(1860–1949)*

James Ensor, whose long life almost exactly paralleled that of Munch, differed from the Norwegian in being the inheritor of one of the great traditions in European art —that of Flemish and Dutch painting. The consciousness of this heritage even compelled him to assume from time to time, though half satirically, the appearance of Rubens; and it is difficult to believe that he could have conceived his pictorial fantasies without knowledge of the works of Hieronymus Bosch (despite his denial that he was influenced by Bosch early in his career) and Pieter Bruegel the Elder. The son of an expatriate Englishman, a man of some culture and gentility, the artist was born at Ostend, on the coast of Belgium, where his Flemish mother and her relatives kept a souvenir shop filled with

toys, seashells, model ships in bottles, crockery, and, above all, the grotesque masks popular at Flemish carnivals. An element of strangeness, at times mixed with satire, had appeared early in his Rembrandtesque drawing *Mystic Death of a Theologian* (fig. 280), suggestive of some macabre vision, fed by individual studies—not only of Rembrandt, but also of Rubens, and other seventeenth-century Dutch and Flemish masters—that were to lead him to Bosch, Bruegel, and other masters of the fantastic, notably Goya and Jacques Callot. Another element of his early paintings is the atmosphere of melancholy, seen particularly in *Somber Lady* (fig. 281), a study of his sister dressed as though about to depart for church. Seated quietly in the corner of a room, she seems isolated from her pleasant, familiar surroundings.

After three years at the Brussels Academy of Fine Arts, 1877–80, Ensor's traditional realist-romantic paintings were so accomplished that in 1881 he was accepted in the Brussels Salon and by 1882 in the Paris Salon. His approach already was changing, however, through his discovery of French impressionism (which was still anathema among the Paris academicians and their provincial offshoots). Even more shocking, at the time, than the impressionist palette was Ensor's introduction of brutal or mocking subject matter, harshly authentic pictures of miserable, drunken tramps and inexplicable meetings of masked figures. It is often difficult, probably even impossible, for translated titles to convey the meanings of Ensor's fantasies. *Scandalized Masks,* for instance, shows simply his familiar setting, the corner of a room, with a masked figure sitting at a table (fig. 282). Another masked figure is entering through the open door. Each is frozen at the sight of the other. The masked figures obviously derive from the Flemish carnivals of familiar tradition; but here, isolated in their grim surroundings, reacting in shock at their meeting, they cease to be merely masked mummers. The mask becomes the reality and we feel involved in some communion of monsters. This troubling and fantastic painting reveals intensification of the artist's inner mood of disturbance. In any event, the new works did not please the judges of the Brussels Salon, and in 1884 all Ensor's entries were rejected.

Even members of the more liberal exhibiting group of Brussels, L'Essor, were somewhat uneasy about Ensor's new paintings. This led to a withdrawal of some members, to form the progressive society, Les XX, already mentioned several times. For many years the society was to support aspects of the new art in Brussels. Although it exhibited Manet, Seurat, Van Gogh, Gauguin, and Toulouse-Lautrec, and exerted an influence in the spread of art nouveau, hostility to Ensor's increasingly fantastic paintings grew even there. His greatest painting, *The Entry of Christ into Brussels in 1889* (colorplate 49), was refused admission and was never publicly exhibited before 1929. The artist himself was saved from expulsion from the group only by his own vote.

Ensor's mature paintings still, decades later, have the capacity to shock; and so, as we study the direction of his work during the 1880s, it is not difficult to understand what a state of shock it induced in even his liberal colleagues. He was a true eccentric, given to passages of mad humor; but to suggest that all this was the result of

severe mental derangement is too easy. He was much affected by nineteenth-century romanticism and symbolism; he was a passionate devotee of the tales of Edgar Allan Poe and of the poems of Baudelaire. He searched the tradition of fantastic painting and graphic art for inspiration—from the *danse macabre* of the end of the Middle Ages to the tormented visions of Matthias Grü-

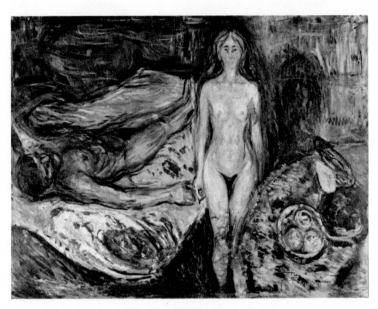

279. EDVARD MUNCH. *Death of Marat.* 1905–27.
59 x 78¾″. Munch Museum, Oslo

280. JAMES ENSOR. *Mystic Death of a Theologian.* 1880.
Drawing. Musée Royal des Beaux-Arts, Antwerp

281. JAMES ENSOR. *Somber Lady*. 1881.
39¼ x 31½". Musées Royaux des Beaux-Arts, Brussels

282. JAMES ENSOR. *Scandalized Masks*. 1883.
53 x 45". Musées Royaux des Beaux-Arts, Brussels

newald, Bosch, and Goya. He was affected by Daumier and his social satire, by the Belgian fantast and satirist Felicien Rops, by Gustave Doré and by Redon.

Whatever the sources of Ensor's macabre experiments, his position as a transitional figure in twentieth-century fantastic art is of the first importance, for he created an individual world of fantastic subjects expressed in dissonant color and palpitating line, whose "message" has more to do with our time than with the past.

During the late 1880s Ensor turned to specifically religious subjects, frequently based on the torments of Christ. They are not interpreted in a narrowly religious sense, but are rather a personal revulsion to a world of inhumanity that nauseated him. This feeling, essentially unreligious and misanthropic, was climaxed in the vast *Entry of Christ into Brussels in 1889* (painted in 1888), which depicts the passion of Christ as the center of an enormous Flemish kermess or carnival symptomatic of the indifference, stupidity, and venality of the modern world. Here, too, the artist gave early expression to his feeling about a horrible compression of humanity that denies and destroys the space of the picture. It is indicative of Ensor's bitter humor that he dated this obscene carnival—which is also his personal Last Judgment—one year in the future.

The sense of death was strong in Ensor, manifesting itself in innumerable paintings, drawings, and prints perpetuating the walking dead of the Late Middle Ages and the *danse macabre*. Skeletons try to warm their pathetic bones at a stove clearly imprinted *"pas de feu."* Death with his scythe mows down the people of Brussels. The artist in 1888 portrays himself in 1960 as a relatively cheerful skeleton on the verge of complete disintegration. In *Skeletons Fighting for the Body of a Hanged Man* (fig. 283), the drama is enacted on a narrow stage reminiscent of Callot and the tradition of the Italian *commedia dell'arte*.

Occasionally Ensor returned from his personal, visionary reality to glance again at the world around him, as though to reassure himself that his haunted dreams were no more than illusions based on a familiar and harmless world. During the 1890s he focused his talents for invective on the antagonists of his paintings, frequently with devastating results. This decade saw some of his most brilliant, morbid, gruesome, and at times obscene drawings and etchings. The masks reappeared at regular intervals, occasionally becoming particularly personal, as in *Portrait of the Artist Surrounded by Masks* (fig. 284), a painting in which he portrayed himself as Rubens—debonair mustache and beard, gay, plumed hat, and piercing glance directed at the spectator. Also, in a curious way, he is reminiscent of the Christ of Hieronymus Bosch, surrounded by his tormenters (Ensor's critics): the personification of Good, isolated by Evil but never overwhelmed.

Although Ensor's painting did not develop very much after 1900 (he frequently spent his time repainting versions of old pictures), his achievement by this date was such that he could well be described as the most significant pioneer of fantastic art in the twentieth century. Much of the early history of twentieth-century painting

and sculpture has been described, appropriately, in terms of the artists' re-examination of plastic means—of space, color, mass, line, and movement, and the abstract inter-relationships of these elements. These were the explorations that led from the neo-classicists through Cézanne, Picasso and Braque, and cubism, to geometric abstraction. Although Ensor early demonstrated abilities in abstract picture organization, in his mature, fantastic works he violated formal principles in the interest of delivering the greatest possible impact of his weird subjects. His crowd scenes destroy the space, air, and light of the painting. The seething masses appear as a dizzying accumulation of individual dissonant color spots, creating an effect of compression conducive to stifling claustrophobia. The discord of his space organization was a deliberate reflection of the discord and evil stupidity of the world he painted. Like Bosch, he was obsessed with the image of Hell, a Hell which already existed in this world and in which mankind was already insanely and obliviously imbedded. Yet, late works such as *The Studio of the Artist,* c. 1930 (colorplate 50), reveal that he had never really lost the structural and decorative abilities which he had subordinated in the cause of his personal expression.

## GEORGES ROUAULT *(1871–1958)*

Expressionism is usually associated with the Northern rather than the Latin tradition. The pioneers were Van Gogh, a Hollander; Munch, a Norwegian; Ensor, a Fleming. The principal center of the movement was Germany,

285. GEORGES ROUAULT. *The Child Jesus Among the Doctors.*
1894. 64¾ x 51¼ ". Musée d'Unterlinden, Colmar, France

and productive career, Rouault remained something of a primitive, a simple and naïve man who was deeply religious, deeply emotional, and profoundly moralistic. He came of a family of craftsmen, and he himself was first apprenticed to a stained-glass artisan. In the studio of Gustave Moreau he met Matisse and other future fauves, and soon became Moreau's favorite pupil. Although Moreau had a great capacity for encouraging the varied experiments of his students, he could not help feeling a particular affection for the one who followed most closely his own style and concepts. This, of course, was Rouault. Rouault's early painting *The Child Jesus Among the Doctors* (fig. 285) is a pastiche of Moreau and Rembrandt. The religious subject came easily to Rouault and, in this rather literal, heavily symbolic form, it brought him some immediate success. These first religious paintings, however, despite their origin in devout belief, were essentially apprentice, studio pieces that did not really show the intensity of his religious feelings.

By 1903, Rouault's art, like that of Matisse and others in the group of young rebels surrounding him, was suffering profound changes, reflecting a radical change in his emotional and moral outlook. Under the influence of the Catholic writer and propagandist Léon Bloy, he sought subjects appropriate to his sense of indignation and disgust over the evils of bourgeois complacency that,

286. GEORGES ROUAULT. *Before a Mirror.* 1906.
Watercolor on cardboard, 27⅝ x 20⅞ ".
Musée National d'Art Moderne, Paris

and the artists were almost all Germans or derived from the German culture in Austria, Switzerland, or Czechoslovakia. Even the two notable exceptions—the Russians Kandinsky and Jawlensky—spent a large part of their formative years in Germany.

The influence on the German expressionists of the Frenchman Paul Gauguin, however, may have been even greater than that of the Dutchman Van Gogh; and expressionism in the forms it took is inconceivable without the immediate example of French fauvism. The fauve painters in general were concerned more with the expressive power of color and less with the use of subject to evoke inner tension or some other specific expressive purpose. Their subjects were the traditional ones of landscapes, figures in a landscape, interiors, still lifes, and portraits, and were different from those of their predecessors mainly in their bold use of non-descriptive color. This in itself took on expressive overtones that transformed the subject, but the transformation lay in the eye of the artist rather than in any psychological or emotional significance of the subject.

The one fauve who was almost exclusively concerned with a deliberately expressionist subject matter is perhaps not to be considered a fauve at all. This is Georges Rouault, who exhibited three works in the 1905 Salon d'Automne and thus is associated with the revolt of the wild beasts, although his paintings were not actually shown in the room of the fauves. Throughout his long

left: 287. GEORGES ROUAULT. *Odalisque.*
1907. Watercolor, 25¼ x 38½"
Private collection, Switzerland

below left: 288. GEORGES ROUAULT.
*Circus Parade.* 1907.
Watercolor and pastel, 25½ x 41¼".
Private collection, Switzerland

below right: 289. GEORGES ROUAULT.
*Head of a Tragic Clown.* 1904.
Watercolor and pastel, 14½ x 10½".
Private collection, Switzerland

as it seemed to him, permeated society. The prostitute (*Before a Mirror,* 1906, fig. 286; and *Odalisque,* 1907, fig. 287) became his symbol of this rotting society. He depicted her with a fierce loathing for the corruption she represents, rather than objectively, with a touch of cynical sympathy, as in the work of Toulouse-Lautrec. In many of these studies, done in watercolor, the woman is set within a narrow space, highly atmospheric, and painted in predominantly blue hues, more murky than those used by Picasso slightly earlier. The yellow-white bodies of the prostitutes, touched with light blue shadows, are modeled sculpturally with heavy outlines. The faces are repulsive masks. and the figures exude an aura of decay and death. Rarely in the history of art has the nude been painted with such revulsion.

Rouault's moral indignation further manifested itself, like Daumier's, in vicious caricatures of judges and politicians, whom he saw as representatives of the evils inherent in the legal and political machinery. As a counterpoint to the prostitute as a symbol of corrupt society he used the figure of the circus clown, sometimes the gay nomad beating his drum, wandering free of care from city to city, as in the *Circus Parade,* 1907 (fig. 288), but more often a tragic, lacerated victim, as in *Head of a Tragic Clown,* 1904 (fig. 289). For a period, during his

early career, specifically religious subjects were subordinated to the prostitutes, corrupt judges, and clowns, which he infused with such powerful religious and moral overtones that they remained secular only in their identities (*Men of Justice* c. 1913; fig. 290). When the figure of Christ does appear it is as a tragic mask of the Man of Sorrows deriving directly from a crucified Christ by Grünewald or a tormented Christ by Bosch. In these subject

TOWARD EXPRESSIONISM / 161

290. GEORGES ROUAULT. *Men of Justice.* c. 1913.
Pencil, ink, and watercolor, 11¾ x 7½".
Musée d'Art Moderne de la Ville de Paris

more significant than changes in style and technique is the change in mood. Tragedy and sorrow persist in many works, particularly those dealing with the suffering of Christ. But optimism is frequent; and in all works there is a note of calm, as though in his deeply felt Christianity the artist saw hope for suffering mankind in the face of the evils still surrounding him. Although he never entirely gave up the spirit of moral indignation expressed in the virulent satire that marked his early works, the sense of calm and the hope of salvation in the later paintings mark him as one of the few authentic religious painters of the modern world.

By 1917 Ambroise Vollard had become his sole dealer; and under Vollard's patronage and inspiration Rouault, for ten years, devoted himself almost exclusively to the production of graphic works, notably the series published in 1948 under the title *Miserere.* These etchings and aquatints are filled with the artist's suffering from the horrors of World War I, yet with his hope and faith in man's ultimate salvation as well. Technically, the prints are masterpieces of graphic compression. The blacks, worked over and over again with an infinite patience that, in the artist's eyes, would never stop short of perfection, have the depth and richness of his most vivid oil colors, as in *It is hard to live* . . . (fig. 291).

291. GEORGES ROUAULT. *It is hard to live* . . .
Plate 12 from *Miserere.* 1922. Etching over heliogravure.
The Museum of Modern Art, New York. Gift of the Artist

paintings, as in landscapes up to about 1917, color was subordinated to rich but somber hues, and much of the dynamism was achieved by the fierce, uncouth power of his drawing.

Then, in such a work as the *Passion,* 1943 (colorplate 51), another change becomes evident. Subjects taken directly from the Gospels became the artist's predominant interest—the Crucifixion, Christ and His Disciples, and other scenes from the life of Christ, as well as the lives of the saints, particularly his beloved Joan of Arc. Pierrots and clowns of all descriptions recurred, and so, increasingly, did landscapes with figures—usually religious in significance—and heavily painted still lifes.

The characteristics of the developed style are seen in *The Old King,* 1937 (colorplate 52). The design has become geometrically abstract in feeling. Colors are intensified to achieve the glow of stained glass. A heavy black outline is used to define forms and control structure. Paint is usually applied heavily with the underpainting glowing through, in the manner of Rembrandt. Even

# PART SEVEN

# EXPRESSIONISM IN GERMANY

The development of expressionism in early twentieth-century German painting must be placed against the background of a body of theoretical, critical, and historical writing on art produced in Germany during the late nineteenth century. The neo-Kantian philosopher Conrad Fiedler (1841–1895) explored the possibility of an objective science of art, at the same time recognizing the problems of individual creation. He opposed existing concepts of art as imitation of nature, on the one hand, and as the expression of noble literary themes or pure human emotion, on the other. To him, the form of the work of art grew out of the content, the idea, and was indistinguishable from it. He was perhaps the first critic to see the work as the product of an "inner necessity," although he did not give to this phrase the sense of compulsion or mystical emphasis it later gained in the hands of the expressionist painters. Fiedler's principal contention was that the work of art was essentially the result of the artist's unique, visual perception, given free form by his powers of selection. His ideas were further developed in an important work by the sculptor Adolf von Hildebrand (1847–1921): *The Problem of Form in Painting and Sculpture* (see Bibliography).

At the same time, the pioneer psychologist Theodor Lipps (1851–1914) was advancing and expanding the somewhat older theory of empathy, according to which the spectator's identification with the work of art is the basis for aesthetic enjoyment and appreciation. This concept, which carried with it the suggestion that colors or lines or shapes or spaces have specific emotive qualities —are joyful or sad, inspiring or depressing, forceful or weak—was widespread in writings on neo-impressionism, art nouveau, and later, on cubism and expressionism as well. The most important result of Lipps's theories appeared in the crucial publication in 1908 of Wilhelm Worringer's *Abstraktion und Einfühlung (Abstraction and Empathy)*. Worringer built his thesis on a combination of the theory of empathy and theories developed by Alois Riegl (1858–1905), on the importance of the artist's intent. Whereas he recognized the significance of empathy in the creation of representational styles, he saw the crisis of the modern artist as a flight from nature, an "inner compulsion" toward the selective organization or abstraction of nature. As might be expected, Worringer became one of the chief supporters and propagandists of the expressionists, particularly after becoming acquainted with Vasily Kandinsky in 1908.

Even before the publication of Worringer's book, related ideas had appeared in the publications associated with art nouveau—notably *Jugend,* the critic Julius Meier-Graefe's journal *Pan,* and the Parisian journal *La Revue Blanche,* which reflected the stylistic theories of the nabis. Paul Signac's important work, *From Delacroix to Neo-Impressionism,* had been translated into German in the year of its original publication, 1899, and exercised a significant influence with its credo of abstract organization of color and line as the painter's primary concern. Its impact was the greater because the paintings of Seurat and the neo-impressionists had already been exhibited in Germany. Henry van de Velde, in addition, had preached the doctrine of line as an abstract force before the turn of the century.

The many influences that played on German artists about 1900 have already been suggested; all these strains were coming together in Germany about 1905, the year that the fauves appeared in Paris at the Salon d'Automne.

## PAULA MODERSOHN-BECKER *(1876–1907)*,
## CHRISTIAN ROHLFS *(1849–1938)*

The first stirrings of expressionism appeared in the works of three individuals not associated specifically with any of the alliances that punctuated German twentieth-century painting. They worked in isolation and were largely unaware of one another. Paula Modersohn-Becker painted in the artists' colony at Worpswede after 1899, but she was in touch with new developments in art and literature through her friendship with the poet Rainer Maria Rilke (who had been Rodin's secretary), as well as through a number of visits to Paris. In these she discovered successively the French Barbizon painters, the impressionists and then, in 1905 and 1906, the works of Gauguin and Cézanne. Her early death has left us with only a suggestion of what she might have achieved, but in works such as her *Self-Portrait with Camellia* (fig. 292) there is apparent her understanding of the broad simplification of color areas she had seen in Gauguin, assimilated to an atmospheric, romantic interpretation of personality that shows her roots in German lyrical naturalism and her link with twentieth-century German expressionism.

Christian Rohlfs, until the age of fifty, worked in a traditional form of naturalistic landscape that included gradual experiments with impressionism. Then he discovered the late works of Manet and the paintings of Van Gogh: they were a revelation to him. The result was a series of paintings of German Gothic cathedrals, executed in 1905–06 (*St. Patroclus in Soest,* fig. 293). Inspired by Monet's cathedral paintings they manifest an abstract, geometric organization of the picture space suggestive of some of the expressive offshoots of cubism evident in the paintings of Franz Marc and Lyonel Feininger, or of the Italian futurists.

*above left:* 292. PAULA MODERSOHN-BECKER. *Self-Portrait with Camellia.* 1907. 24¼ x 12". Folkwang Museum, Essen, Germany

*above right:* 293. CHRISTIAN ROHLFS. *St. Patroclus in Soest.* 1905–06. Oil on cardboard, 26¾ x 38⅝".
Wallraf-Richartz Museum, Cologne

## EMIL NOLDE *(1867–1956)*

The third pioneer of German expressionism was Emil Nolde. As a youth he studied wood carving and for a time worked as a designer of furniture and decorative arts in Berlin. His first paintings of mountains transformed into giants or hideous trolls revealed qualities of primitive Germanic fantasy that attracted the editors of the periodical *Jugend,* who reproduced two of his grotesques as postcards and used a number of his illustrations.

The sale of these cards enabled him to return to school and to take up painting seriously in Munich, Dachau, and Paris. In Paris, 1899–1900, like so many foreign students, he worked his way gradually from Daumier and Delacroix to Manet and the impressionists. Although he was initially disappointed in what he had learned from the impressionists, his color took on a new brilliance and violence as a result of his exposure. In 1906 he met Rohlfs and accepted an invitation to become a member of the new artists' alliance Die Brücke. About the same time, like many of his colleagues, he had begun to produce etchings and lithographs. Essentially a solitary, Nolde left Die Brücke after a year, and devoted himself more and more to a personal form of expressionist religious paintings and prints (*Prophet,* 1912, woodcut; fig. 294).

Among the first of Nolde's visionary religious paintings was *The Last Supper,* 1909 (colorplate 53). One thinks back to Rembrandt's *Christ at Emmaus* (see fig. 38), or even Leonardo da Vinci's *Last Supper,* but Nolde's mood and impact are different from the quiet and restraint of both the earlier works. The figures are crammed into a practically non-existent space, the red of their robes and the yellow-green of their faces flaring like

294. EMIL NOLDE. *Prophet.* 1912. Woodcut.
Kunstmuseum der Stadt, Düsseldorf

torches out of the surrounding shadow. The faces themselves are skull-like masks that derive from the carnival processions of Ensor. Here, however, they are given intense human personalities: they are no longer masked and inscrutable fantasies but individualized human beings passionately involved in a situation of extreme drama. The compression of the group packed within the frontal plane of the painting—again stemming from Ensor—heightens the sense of impending crisis until it becomes almost intolerable.

This painting exemplifies the qualities of Nolde's religious expression in an emotional frenzy that would be excessive if it were not so convincing. In *Christ Among the Children* (colorplate 54), Nolde uses a similar com-

297. EMIL NOLDE. *Self-Portrait*. 1947.
34⅞ x 26⅝″. Nolde Museum, Seebüll, Germany

295. EMIL NOLDE. *Dance Around the Golden Calf*. 1910.
34⅝ x 41⅜″. Bayerische Staatsgemäldesammlungen, Munich

position of compression, but unlike *The Last Supper*, with its rising climax of tragedy, the work is a paean of unadulterated joy. Even the colors in which he paints the children, predominantly brilliant yellows and light reds and purples, become abstract symbols of radiant happiness. The *Dance Around the Golden Calf* (fig. 295) uses the same colors, violent yellow or purple dancers madly whirling in a landscape of equally arbitrary yellows and blues and whites. In contrast, however, the frenzy is of lust and sensual sacrifice to strange gods, depicted in an open composition of a few figures distributed within space that expands and contracts in terms of the ambiguous distribution of color. The theme of the wildly dancing figures intrigued Nolde and he returned to it often and in a variety of mediums. One of the freest examples is the *Wildly Dancing Children* (fig. 296), in which the sense of the mad dance is effectively accentuated by the dissolution of the figures into broken spots and strokes of color whipped on with rapid slashes of the brush. Although the subject is still recognizable, the color and brush strokes operate so independently that the painting takes on the quality of what is later to be called abstract expressionism.

His last *Self-Portrait* (fig. 297), done in 1947 when he was eighty, is painted with a forceful brush stroke that seems to have lost none of its vigor with age. The candor of the gaze, which does not exclude a degree of with-

296. EMIL NOLDE. *Wildly Dancing Children*. 1901.
28¾ x 34⅝″. Kunsthalle, Kiel, Germany

drawal, somewhat belies the intricate personality of Nolde, who, despite original Nazi leanings, was denounced by the Nazis, along with most other expressionists, as a "degenerate artist."

Nolde was an individual expressionist in the sense that Rouault was one; there are points of analogy between the two men in the emotional nature of their religious convictions, but there are also important differences. Both were colorists, but they were different in their approach to color. Rouault's color seems almost subdued when placed side by side with the frequently garish brilliance of Nolde's; his compositions are more controlled. Even his interpretations of the Gospels become quiet and restrained by comparison with the German's. The striking differences, and the points of resemblance between the two men, raise the fascinating but difficult question of national characteristics in art.

## Die Brücke

In 1905, Ernst Ludwig Kirchner, together with Erich Heckel, Karl Schmidt-Rottluff, and Fritz Bleyl, formed the association known as Die Brücke (The Bridge—linking "all the revolutionary and surging elements"). These young architectural students, all of whom wanted to be painters, were drawn together by what they were against in the art that surrounded them, rather than by any preconceived program. Imbued with the persuasive spirit of

298. ERNST LUDWIG KIRCHNER. *Head of a Man with a Nude.* 1908. Lithograph. R.N.Ketterer, Campione, Switzerland

arts and crafts and Jugendstil, they rented an empty shop in a workers' district and began to paint, carve, and make woodcuts. The influence of the Middle Ages on them was strong, and consciously or unconsciously they sought to re-create the atmosphere of the medieval craftsmen's guilds. Although they worked in many mediums, probably their intensive study of the possibilities of woodcut did most to formulate their styles and to clarify their directions.

For them, Van Gogh was the clearest example of an artist driven by an "inner force," and "inner necessity"; his paintings presented an ecstatic identification or empathy of the artist with the subject he was interpreting. The graphic works of Munch were widely known in Germany by 1905, and the artist himself was spending most of his time there. His obsession with symbolic subject struck a sympathetic chord in young German artists, and from his mastery of the graphic techniques they could learn much. Among historic styles, the most exciting discovery was primitive art from African jungle or Pacific island, of which notable collections existed in the Dresden Ethnographic Museum.

In 1906 Nolde was invited to join Die Brücke, and the artist, who had long felt himself isolated in his experiments, accepted with delight. In the same year, Max Pechstein joined the group. Also in 1906 Heckel, then working for an architect, persuaded a manufacturer for whom he had executed a showroom, to permit the Brücke artists to exhibit there. This was the historic first Brücke exhibition, which marked the emergence of twentieth-century German expressionism. Little information about the exhibition has survived, since no catalogue was issued and it attracted virtually no attention. At that time, as a result of a close working relationship, the paintings and prints of the Brücke members except for those of Nolde, an older, established artist, had much in common.

Kirchner had arrived at a bold, simplified organization of large color masses deriving from his experimentation with woodcut. His lithograph *Head of a Man with a Nude* (fig. 298), with the extreme close-up of the face partially shrouded by the minuscule figure of the nude is a strange, erotic evocation, leaning heavily on Munch. Schmidt-Rottluff was still using heavy impasto with aggressive brush strokes, derivative from Van Gogh but moving beyond him in their undisciplined energy.

During the next few years the Brücke painters continued their program not only in exhibitions but also in publications designed by the various members and in manifestoes in which Kirchner's ideas were most evident. The human figure was studied assiduously in the way Rodin had studied the nude: not posed formally but simply existing in the environment. Despite developing differences in style, the natural consequence of the complicated personalities of the artists, a hard, Gothic angularity permeated the works of most of the group.

The Brücke painters soon became conscious of the revolution that the fauves were creating in Paris and were affected by their use of color. However, their own paintings remained different in the degree that they maintained the Germanic sense of expressive subject matter and form characteristic of jagged, Gothic structure. By 1911

299. ERNST LUDWIG KIRCHNER.
*Girl Under a Japanese Umbrella.* 1906. 36½ x 31⅝".
Kunstsammlung Nordrhein-Westfalen, Düsseldorf

most of the Brücke group were in Berlin, where a new style appeared in their works, a style that evidenced the increasing consciousness of French cubism as well as fauvism, given a Germanic excitement and narrative impact. By 1913 Die Brücke was dissolved as an association, and the artists proceeded individually to greater or lesser reputation.

## ERNST LUDWIG KIRCHNER *(1880–1938)*

Of the younger German artists, perhaps the most influential in the organization and direction of the energies and aspirations of his colleagues was Ernst Ludwig Kirchner. He was destined to become an artist from his high school days, and his ambition was reinforced by his discovery of the woodcuts of Dürer and his Late Gothic predecessors. Yet, his own first woodcuts, done before 1900, were probably influenced by Felix Vallotton and Edvard Munch. Between 1901 and 1903 Kirchner studied architecture in Dresden, and then, during 1903 and 1904, painting in Munich. Here he was influenced by art nouveau designs and repelled by the *retardataire* paintings he saw in the exhibition of the Munich Secession. He continued his study of Dürer and discovered the expressive economy of Rembrandt's drawings. His historical studies ranged over the art of all periods and cultures but, like so many of the younger German artists of the time, he was particularly drawn to the German Gothic. Of modern artists, the first revelation for Kirch-

ner was the work of Seurat. Going beyond Seurat's researches, his study of nineteenth-century color theories led him back to Goethe's *Zur Farbenlehre (History of the Theory of Colors).*

Kirchner's painting style about 1904 showed influences from the pointillism of the neo-impressionists but a larger, more dynamic brush stroke related to that of Van Gogh, whose work he saw, along with paintings by Gauguin and Cézanne, in the exhibition of the Munich Artists' Association held that year. On his return to Dresden and architecture school in 1904 Kirchner became acquainted with Heckel, Schmidt-Rottluff, and Bleyl and with them, as already noted, founded the Brücke group.

The development of Kirchner's work may be suggested in a few key paintings and prints. *Girl Under a Japanese Umbrella* (fig. 299) is a fauve work, with the stunning yellows and pinks of the flesh tones accented with greens and blues. The figure, the umbrella, and the decorative background are all massed in the frontal plane of the picture to create a pattern of abstract color splashes. *The Street,* 1907 (fig. 300), is an assembly of curvilinear figures who undulate like wraiths without individual motive power, drifting in a world of dreams. Another version of *The Street,* 1913 (fig. 301), painted after Kirchner had moved to Berlin, suggests the forces affecting young artists during these years. Whereas the earlier version is derivative from the linear arabesques of art nouveau and the fantasy of Edvard Munch, the latter acknowledges the debt to cubism, which was spreading from Picasso, Braque, Delaunay, and their Parisian followers. The structure is jagged and geometric, the space confined and well organized. Here, however, cubist pattern is combined with fauve color, and above all with a Gothic distortion and a Germanic emotional vibration that give the scene an intensity unlike anything in contemporary France. If Kirchner's *Market Place with Red*

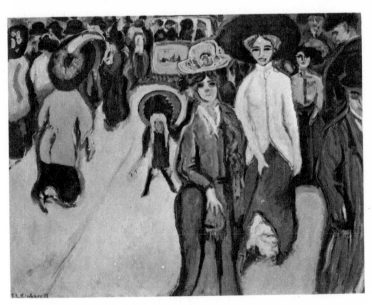

300. ERNST LUDWIG KIRCHNER. *The Street.* 1907.
59¼ x 78⅞". The Museum of Modern Art, New York

*right:* 301. ERNST LUDWIG KIRCHNER. *The Street.* 1913.
47½ x 35⅞". The Museum of Modern Art, New York

*below right:*
302. ERNST LUDWIG KIRCHNER. *Market Place with Red Tower.*
1915. 47½ x 35⅞". Folkwang Museum, Essen, Germany

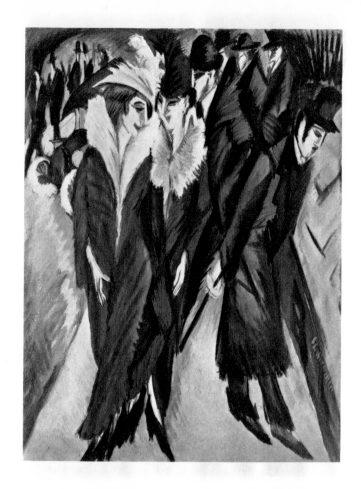

*Tower* (fig. 302) is compared with one of Delaunay's
Eiffel Towers, from which it obviously stems, the differ-
ence between the German and the French vision be-
comes evident. Delaunay's *Eiffel Tower in Trees,* 1909
(see colorplate 76), represents an expressive interpre-
tation of cubism in which the expression is achieved by
the dynamism of abstract color shapes and lines. What-
ever associations the spectator may read into the picture
are his own affair. The Kirchner painting *Market Place
with Red Tower*—like *The Street* and most other paint-
ings by the Brücke group—is expressive in a more ex-
plicit way. Although the artist has studied the works of
the cubists, he uses cubist geometry with caution and
without real understanding, combining it with defined
perspective space distorted in the manner of Van Gogh
for the similar end of creating a claustrophobic effect of
compression. The total structure owes as much to late
medieval paintings and manuscript illumination as to
cubism. The sense of the German Gothic past rarely
deserted Kirchner. He was the most articulate of the
original Brücke group, and continued to work, if not to
develop, as an artist, with long sieges of depression and
illness ending with his suicide in 1938.

## ERICH HECKEL *(b. 1883),*

## OTTO MULLER *(1874–1930)*

Heckel was a more restrained expressionist whose
early paintings at their best showed flashes of psychologi-
cal insight or lyricism. Too frequently his emaciated
figures suggest a mannerist formula rather than any
strong sense of inner conflict. In fact, after 1920 he
turned more and more to the painting of colorful but es-
sentially romantic-realist landscapes. A work such as
*Two Men at a Table* (fig. 303), however, is a successful
evocation of a dramatic interplay in which not only the
figures but the contracted, tilted space of the room is
charged with emotion. This painting, dedicated "To Dos-
toyevsky," is almost a literal illustration from the Rus-
sian novelist's *Brothers Karamazov.* The painting of the
tortured Christ, the suffering face of the man at the left,
the menace of the other, all refer to Ivan's story of Christ
and the Grand Inquisitor. At the other extreme, the artist
painted primitive arcadian scenes filled with a sense of
magic. His angular nudes in exotic landscapes, reflecting
Brücke adulation of Gauguin and of African or Pacific-
island art, show how cubist fragmentation has been used
to create the crystalline quality of sky and water, trans-
forming them into abstract geometric color shapes (see
colorplate 55). The most successful interpretations of
these themes were those of Heckel and of Otto Müller.

Müller's colors are the most delicate and muted of all
the Brücke painters, his paintings the most suggestive of

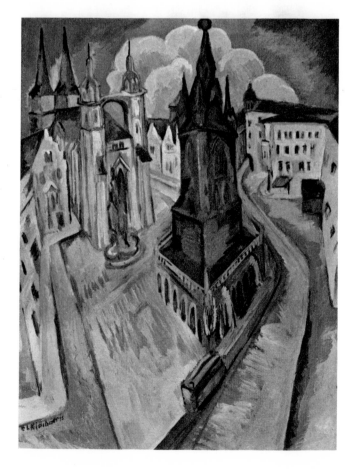

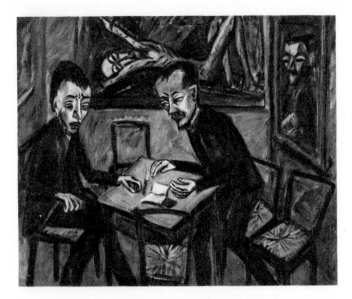

above: 303. ERICH HECKEL. *Two Men at a Table.*
1912. 38⅛ x 47¼". Kunsthaus, Hamburg

right: 304. OTTO MULLER. *Self-Portrait.* 1921.
Oil on burlap, 24½ x 16¼".
Collection Mr. and Mrs. Morton D. May, St. Louis, Missouri

an Oriental elegance in their organization. His nudes are attenuated, slant-eyed, awkardly graceful figures whose softly outlined, yellow-ocher bodies blend imperceptibly and harmoniously into the green and yellow foliage of their setting. His *Self-Portrait* (fig. 304) is characteristic of the expressionists' portraits of themselves and of one another in its haggard look and intensity of gaze, but it also incorporates those qualities of sensitivity and taste which mark all his paintings.

## MAX PECHSTEIN *(1881–1953),*

## KARL SCHMIDT-ROTTLUFF *(b. 1884)*

Pechstein and Schmidt-Rottluff represent a bolder, more coloristic vein of expressionism, although the two differed markedly from each other. Pechstein was the most eclectic of the Brücke group, capable of notable individual paintings which, however, go from one style to another. The early *Indian and Woman* (colorplate 56) shows him at his dramatic best in terms of the exotic subject, modeling of the figures, and fauve-inspired color. Pechstein's drawing is sculptural and curvilinear in contrast to that of Müller or Heckel. His color tends to be heavy and sometimes coarse, but from these very qualities he at times achieves considerable expressive power.

In 1910, Karl Schmidt-Rottluff portrayed himself in a green turtleneck sweater, complete with beard and monocle, against an abstract background of a yellow opening flanked by purple curtains—the perfect picture of the arrogant young expressionist (fig. 305). Although this was an exaggerated effect adopted for the particular painting, it does suggest qualities that characterize the artists of Die Brücke and specifically Schmidt-Rottluff himself. Aside from Nolde, he was the boldest colorist of the

305. KARL SCHMIDT-ROTTLUFF. *Self-Portrait with Monocle.*
1910. 33⅛ x 30".
Nationalgalerie, Berlin

*above left:* 306. ERNST LUDWIG KIRCHNER.
*Head of Henry van de Velde.*
1917. Woodcut. Staatliche Graphische Sammlung, Munich

*above right:* 307. ERICH HECKEL. *Resting Girl.* 1910.
Etching. The Philadelphia Museum of Art

*right:* 308. MAX PECHSTEIN. *Dialogue (Two Female Nudes).*
1920. Woodcut. The Museum of Modern Art,
New York. Gift of Paul Sachs

group, given to vivid blues and crimsons, yellows and greens, juxtaposed in jarring but effective dissonance. Although never an abstractionist, he was probably the member of Die Brücke who moved furthest and most convincingly in the direction of abstract structure (*Rising Moon,* colorplate 57). He organized cubist simplified interiors, fauve landscapes, and primitive figures with an authority suggestive of the later Picasso.

## *Expressionist Prints*

One of the principal contributions of German expressionism was the revival of printmaking as a major form of art. During the nineteenth century a large number of the experimental painters and sculptors made prints; and, toward the end of the century, in the hands of artists like Toulouse-Lautrec, Gauguin, Maillol, Redon, and Ensor, printmaking assumed an importance as an independent art form beyond anything that had existed since the Renaissance. The early twentieth-century artists outside Germany—Picasso, Munch, Matisse, Bonnard, Klee, Rouault—were all important printmakers as well as painters. In Germany, however, printmaking occupied a special place, and its revival contributed to the character of painting and sculpture. Of the Brücke group, Nolde was one of the first to realize the possibilities of woodcut. Although his *Prophet,* 1912 (fig. 294), owes something to Late Gothic German woodcuts and the woodcuts of

Gauguin, as well as to the lithographs of Goya, Nolde here achieves an intensity of black-and-white contrast that transcends the works of his predecessors. Kirchner, in both black-and-white and color woodcuts, developed a more intricate, linear pattern (*Head of Henry van de Velde,* fig. 306) that looked back to the woodcuts of Dürer and Schongauer. Heckel sought a sparse, abstract pattern in his simplified figures (*Resting Girl,* 1910, fig. 307), and both Pechstein and Schmidt-Rottluff were car-

309. KARL SCHMIDT-ROTTLUFF.
*Two Heads*
1918. Woodcut.
Brücke Museum, Berlin

310. ERNST BARLACH. Illustration
to Goethe's *Walpurgisnacht.*
1923. Woodcut.
The Museum of Modern Art, New York

311. WILHELM LEHMBRUCK.
*Four Female Nudes.* 1913. Etching.
National Gallery of Art, Washington,
D.C. Rosenwald Collection

*above:* 312. GERHARD MARCKS. *Cats.* 1921. Woodcut.
The Philadelphia Museum of Art

*right:* 313. KÄTHE KOLLWITZ. *Death Seizing a Woman.* 1934. Lithograph.
The Museum of Modern Art, New York. Abby Aldrich Rockefeller Fund

ried away by the medium to the creation of a kind of ex-
aggerated mannerism—see Pechstein, *Dialogue* (*Two
Female Nudes,* fig. 308); Schmidt-Rottluff, *Two Heads*
(fig. 309), in which he used a cubist mannerism to em-
phasize his effects.

Most of the German expressionist sculptors were also
printmakers. To Ernst Barlach the woodcut offered an
ideal medium for the creation of illustrations to folk sto-
ries and characteristically Germanic tales (*Illustration to*

*Goethe's Walpurgisnacht,* fig. 310). Lehmbruck studied
the classical nude in a series of delicately conceived etch-
ings (*Four Female Nudes,* 1913, fig. 311). Gerhard
Marcks created some of the most delightful patterned
studies of intelligent and aware animals in the history of
the medium (*Cats,* fig. 312). Käthe Kollwitz was a
sculptor of talent, but primarily a major graphic artist.
Perhaps no other artist of her day was so deeply imbued
with a feeling for the suffering of mankind or had such

ability to convey this feeling in graphic terms (*Death Seizing a Woman*, fig. 313).

# Der Blaue Reiter

## VASILY KANDINSKY *(1866–1944)* TO 1914

The Brücke artists were the first manifestation of expressionism in Germany but not necessarily the most significant. While they were active, first in Dresden and then in Berlin, a movement of more far-reaching implications was germinating in Munich around one of the great personalities of modern art, Vasily Kandinsky.

Kandinsky was born in Moscow in 1866 and studied law and economics at the University of Moscow. Visits to Paris and an exhibition of French painting in Moscow aroused his interest to the point that, at the age of thirty, he refused a professorship of law in order to study painting. He then went to Munich, where he was soon caught up in the atmosphere of art nouveau then permeating the city.

Munich, since 1890, had been one of the most active centers of experimental art in all Europe. The Munich Secession of 1892 represented a first effort of younger artists to secede from the academy-dominated organization of their elders. This new association included both realists and impressionists such as Slevogt, Corinth, and Liebermann. Kandinsky soon was taking a leading part in the Munich art world, even while undergoing the academic discipline of the studios of Anton Azbé and Franz von Stück. In 1901 he formed a new artists' association, Phalanx, and opened his own art school. In the same year he was exhibiting in the Berlin Secession, and by 1904 had shown works in the Paris Salon d'Automne and Exposition Nationale des Beaux-Arts. By 1909 he was leading a revolt against the Munich Secession that resulted in the formation of the Neue Künstler Vereinigung (NKV, New Artists Association). The Phalanx and the Munich Secession, in 1904, had shown the neo-impressionists, as well as Cézanne, Gauguin, and Van Gogh. In addition to Kandinsky, the NKV included Jawlensky, Gabriele Münter (whom Kandinsky had met in 1902), Alfred Kubin and, later, Franz Marc, Karl Hofer, and others. Its second exhibition, in 1910, showed the works not only of Germans but of leading French and Parisian experimental painters: Picasso, Braque, Rouault, Derain, Vlaminck, and Van Dongen.

During this period, Kandinsky's ideas about non-objective painting, or painting without literal subject matter, were germinating and, in 1910, he was working on his classic statement, *Concerning the Spiritual in Art*. In 1911, a split in the NKV resulted in the secession of Kandinsky, accompanied by Marc and Gabriele Münter. The immediate consequence was the formation of the association Der Blaue Reiter (The Blue Rider), a name taken from a book published by Kandinsky and Marc, which had in turn taken its name from a painting by Kandinsky. The historic exhibition held at the Thannhauser Gallery in Munich (December 1911–January 1912) included works by Kandinsky, Marc, August Macke, Hein-

314. VASILY KANDINSKY. *Blue Mountain, No. 84.* 1908.
41⅜ x 37⅞".
The Solomon R. Guggenheim Museum, New York

rich Campendonck, Gabriele Münter, the composer Arnold Schönberg, the two Frenchmen Henri Rousseau and Robert Delaunay, and others. Paul Klee, already associated with the group, showed with them in a graphics exhibition in 1912. This was a much larger show. The entries were expanded to include artists of Die Brücke and additional French and Russian artists: De La Fresnay, Malevich, and Jean (Hans) Arp, an Alsatian.

In *Concerning the Spiritual in Art*, published in 1912, Kandinsky formulated the ideas that had obsessed him since his student days in Russia. Always a serious student, he had devoted much time to the problem of the relations between art and music. The dematerialization of the object that he had first sensed in the paintings of Monet had continued to intrigue him as, through the exhibitions in Munich and his continual travels, he learned more about the revolutionary new discoveries of the neo-impressionists, the symbolists, the fauves, and the cubists. Advances in the physical sciences had shattered his remaining faith in a world of tangible objects, and at the same time strengthened his conviction that art had to be concerned with the spiritual rather than the material. Despite his strong scientific and legal interests, Kandinsky was attracted to theosophy, spiritism, and the occult. There was always a mystical core in his thinking—something he at times attributed to his Russian roots. Whatever it was, this mysticism, this sense of an inner creative force, a product of the spirit rather than of external vision or manual skill, it enabled him to arrive at an art entirely without subject matter except insofar as colors and lines and their relationships constituted a subject. "The harmony of color and form," he wrote, "must be based

solely upon the principle of the proper contact with the human soul."

The early paintings of Kandinsky went through various stages of impressionism and art nouveau decoration, but all were characterized by a feeling for color and many for a fairytale quality of narrative, reminiscent of his early interest in Russian folktales and mythology. Impressionism was followed by exercises in neo-impressionist patterned color and then by excursions into the greater freedom of fauvism. *Blue Mountain, No. 84* (fig. 314) is a romantic work of stippled color dots organized within a few large, flat, outlined shapes of mountains and trees, with silhouetted riders constituting a moving pattern on the frontal plane. Technical characteristics can be traced to the color space of Gauguin and the pointillism of Seurat; the decorative formula suggests art nouveau. It was only a short step from this painting to *Composition No. 2* (colorplate 58), in which the riders and other figures have become color spots or linear patterns, and the picture space a vibrant arrangement of rapidly moving color areas, with the story submerged in abstract pattern. By this time, having absorbed the implications of fauve color organization, Kandinsky was beginning to state his intent by using titles derived from music—"Composition," "Improvisation," "Lyrical," etc. About 1910 he produced a watercolor of wildly vibrating and interacting color and line shapes from which all elements of representation and association seem to have disappeared—perhaps the first example of a form of abstract expressionism (colorplate 59). The problem of whether Kandinsky produced the first completely abstract painting is never likely to be solved. Beyond question, however, he gave the initial impetus to a type of painting which, using analogues of music, developed the themes of abstract expressionism, themes in which the artist's intent was the statement of a spiritual conflict or resolution

316. PIET MONDRIAN. *Apple Tree.* c. 1912. 25⅝ x 29⅝". G. J. Nieuwenhuizen Segaar, The Hague, The Netherlands

through line and color, space and movement, presented without any specific reference to observed nature.

The cubism of Picasso, Braque, Juan Gris, and others, it must be recalled, simplified, geometrized, and reordered—but almost never deserted—the subject in nature, whether figure, still life, or studio interior. Delaunay's *Simultaneous Disks* and František Kupka's *Fugue in Red and Blue* (fig. 315), representing the most non-representational manifestations of cubism up to this point, first appeared in 1911–12, as did Piet Mondrian's first landscapes that might be termed abstract (*Apple Tree,* fig. 316). The suprematist compositions of the Russian Kasimir Malevich are variously dated between 1913 and 1916. Kandinsky himself, after his first foray into abstraction, did not continue unswervingly in that direction; but in 1912, with such works as *With the Black Arch, No. 154* (fig. 317), specific subject and visual associations disappear. The furious conflicts and tensions that make this painting dynamically expressive are the conflicts and tensions of colors, shapes, and lines fighting some cosmic battle. From this point forward the artist went on to the creation of a series of masterpieces of abstract expressionist painting. Occasionally, after 1914, his oppressive consciousness of World War I would cause him to reintroduce objects, such as the cannon in *Improvisation 30 (Cannon), No. 161* (fig. 318). Such objects became increasingly rare. The cannon, in fact, were not really necessary to the feeling of explosive destruction expressed by the abstract elements of the picture. Of his great 1914 series of the Seasons, *Autumn* and *Winter* are reproduced here (colorplates 60 and 61). *Autumn,* appropriately, is the more densely colorful, and *Winter* the more aggressive in its accelerated movement of small, broken colors and whirling or jaggedly spattered lines. The artist has suggested something of the nature of the seasons through a demonstration of the expressive, even descriptive powers of abstract means.

315. FRANTISEK KUPKA. *Fugue in Red and Blue.* 1912. 84⅝ x 88⅝". National Gallery, Prague

317. VASILY KANDINSKY. *With the Black Arch, No. 154.*
1912. 74 x 77⅛". Collection
Mme. Nina Kandinsky, Neuilly-sur-Seine, France

318. VASILY KANDINSKY. *Improvisation 30 (Cannon), No. 161.*
1913. 43¼ x 43¼". The Art Institute of Chicago

In 1914 the war forced Kandinsky to return to Russia; and, shortly thereafter, another phase of his long and productive career began. In looking at the work of the other members of Der Blaue Reiter up to 1914 it should be recalled that the individuals involved were not held together by common stylistic principles but rather constituted a loose association of young artists, enthusiastic about new experiments and united in their oppositions. Aside from personal friendships, it was the inquiring, mature mind and the personality of Kandinsky that gave the group cohesion and direction. The yearbook *Der Blaue Reiter,* edited by Kandinsky and Franz Marc, appeared in 1912 and served as a forum for the opinions of the group. The new experiments of Picasso and Matisse in Paris were discussed at length, and the aims and conflicts of the new German art associations were described. In the creation of the new culture and new approach to painting, importance was attached to the influence of all kinds of primitive and naïve art.

## FRANZ MARC *(1880–1916)*

Of the Blaue Reiter painters, Franz Marc was the closest in spirit to the traditions of German romanticism and lyrical naturalism. In Paris, in 1907, he sought personal solutions in the paintings of Van Gogh for his deep-rooted uncertainties and torment of soul. He also was seeking some inner harmony between himself and the world around him that he could express in paint. This harmony he found in the forms of animals, particularly horses and deer. The undulating movement of his earlier paintings of animals owed a great deal to the still important tradition of art nouveau. Through his friend the painter August Macke, he developed, about 1910, enthusiasms for color laid on in large areas, color whose richness and beauty were expressive also of the harmonies he was seeking. The great *Blue Horses,* 1911 (colorplate 62), is one of the masterpieces of Marc's earlier, curvilinear style. The three brilliant blue horses are modeled out sculpturally from the equally vivid reds, greens, and yellows of the landscape. The artist has here used an extreme close-up view, with the bodies of the horses filling most of the canvas. The horizon line is high; the curves of the red hills repeat the lines of the horses' curving flanks. Although the modeling of the horses gives them the effect of sculptured relief projecting from a uniform background, there is no real spatial differentiation between animals and environment except that the sky is rendered more softly and less tangibly in order to create some illusion of distance. In fact, the artist uses the two tree trunks and the green of the foliage in front of and behind the horses to tie foreground and background together. At this time Marc's color had a specifically symbolic rather than descriptive function. He saw blue as a masculine principle, robust and spiritual; yellow as a feminine principle, gentle, serene, and sensual; red as matter, brutal and heavy. In the mixing of these colors to create greens and violets, and in their proportions one to the other on the canvas, the colors-as-abstract-shapes took on spiritual or material significance independent of the subject.

Yet Marc, even though working closely with Kandinsky and aware of his historic experiments, could never bring himself to abandon recognizable subject matter entirely. Only at intervals at the end of his brief life, in sketches that he made in the notebook he carried until he was killed in the war in 1916, was there evidence finally of a move to abstraction. Although the animal theme arose in the first instance from his love of animals, it

soon became for him a symbol of that more primitive and arcadian life sought by so many of the expressionist painters.

During the period, 1911–12, he was absorbing the ideas and forms of the cubists and finding them applicable to his own concepts of the mystery and poetry of color. Marc's approach to art was religious in a manner that could be described as pantheistic, although it is suggestive that in his paintings only animals are assimilated harmoniously into nature—never man. Marc, with Macke, visited Delaunay in Paris in 1912, and the same year was impressed by the exhibition of Italian futurists he saw in Munich. Out of these two influences, as well as the example of Kandinsky, Delaunay's abstract, coloristic art, and futurists' use of cubist structures, emerged his own mature style—which, tragically, he was permitted to explore for only two or three more years.

In *Stables* (colorplate 63), the artist combined his earlier curvilinear patterns with a new rectangular geometry. The horses, massed in the frontal plane, are dismembered and recomposed as abstract-color areas; they appear now as flat shapes on the surface of the canvas. The forms are composed parallel to the picture plane rather than tilted in limited depth. This treatment was in accordance with the experiments of Delaunay in his *Window* and *Disk* series. At this stage, however, Marc's paintings were still far less abstract than Delaunay's, and their sense of nervous energy made them akin to those of the futurists. His color now achieved a translucence beyond anything he had attempted earlier. The sense of rapid metamorphosis is due to the action of color as color, rather than to the dismembered geometric shapes. Intense but light-filled blues and reds, greens, violets, and yellows flicker over the structurally and spatially unified surface to create an impact of dazzling illusion. At times the effect is of the changing, light-drenched color of Gothic stained-glass windows, at other times of a hall of mirrors creating an infinity of fragmented color-saturated images. Marc's use of color at this stage owed much to Macke, who frequently used the theme of people reflected in shop windows as a means of distorting space and multiplying images.

During 1913 Marc returned on occasion to a type of landscape virtually literal for him; but his main direction was toward greater abstraction and depiction of a world of conflict. His work suggests an immensely dynamic, dark premonition of destruction. The jagged diagonal lines crisscross like machine-gun fire; the trees crash as though struck by lightning, themselves destroyed and destroying the helpless deer and horses. Marc accelerated futurist speed and increased the sense of conflict of abstract forms, even though the animal victims are depicted quite literally. Implicit here is the artist's next stage, embodied in a painting almost completely abstract, the *Fighting Forms* of 1914 (colorplate 64). Here Marc returned to curvilinear pattern in a violent battle of black and red color shapes, of light and darkness. In this nonfigurative painting, Marc's most complete turn toward abstract expressionism, the forms are given such vitality that they take on the insane characteristics of forces in an ultimate encounter.

## AUGUST MACKE *(1887–1914)*

Artists associated with any movement may have become involved by historic accident rather than by firm personal conviction. This is particularly true of the Blaue Reiter group, which is usually classified as expressionist but actually included artists of widely differing motivations. Thus, among the lesser-known members, Gabriele Münter (1877–1962) was a charming and decorative disciple of Kandinsky; Heinrich Campendonck (1889–1957) applied cubist structure to a personal interpretation of naïve or primitive painting; and Alfred Kubin (1877–1959) was a graphic symbolist whose art looked back to nineteenth-century romanticism. Of the major figures, August Macke, despite his close association with and influence on Franz Marc, should probably not be considered an expressionist at all.

Macke, like Marc, was influenced by Kandinsky, Delaunay, and the futurists, and perhaps more immediately by the color concepts of Gauguin and Matisse. Since he was killed in September 1914, one month after the beginning of World War I, his achievement must be gauged by the work of only four years.

After some fauve- and cubist-motivated exercises in semi-abstraction, Macke began to paint city scenes in high-keyed color, using diluted oil paint in effects close to that of watercolor. The *Great Zoological Garden* (colorplate 65), a triptych, 1912, is a loving transformation of a familiar scene into a fairyland of translucent color. Pictorial space is delimited by foliage and buildings that derive from the later watercolors of Cézanne. One can sense the eclectic atmosphere of influences from Renoir, Seurat, and Matisse. The artist moves easily from passages as abstract as the architecture to passages as literally representational as the animals and the foreground figures. The work has a unity, however, despite the disparate styles it embodies: a unity of mood that is

319. AUGUST MACKE. *Landscape with Cows and Camel.*
1914. 18½ x 21¼". Kunsthaus, Zurich

gay, light, and charming, disarming because of the naïve joy that permeates it.

Macke occasionally experimented with abstract organization, but his principal interest during the last two years of his life continued to be his cityscapes, which were decorative colored impressions of elegant ladies and gentlemen strolling in the park or studying the wares in brightly lit shop windows. In numerous versions of such themes, he shows his fascination with the mirrorlike effects of windows as a means of transforming the perspective space of the street into the spatial effect of cubism.

The last works, inspired by his brief trip to Tunisia with Paul Klee in the spring of 1914, reveal a spirit of cubist structure derivative from later works of Franz Marc, as these in turn had been inspired by the color harmonies of Macke. *Landscape with Cows and Camel* (fig. 319) is more subdued in color than most of his cityscapes or the Tunisian watercolors. The animals are still depicted literally but are arranged with meticulous geometry within a landscape consisting of beautifully disposed color shapes. The mood is of pastoral and romantic melancholy. Macke's exciting Tunisian watercolors were on the edge of an abstract color exploration—which he was never to fulfill, and which Klee was to realize.

## ALEXEJ VON JAWLENSKY (1864–1941)

Jawlensky was well established in his career as an officer of the Russian Imperial Guard before he decided to become a painter. After studies in Moscow he enrolled in Azbé's school in Munich, where he met Kandinsky. Although not officially a member of Der Blaue Reiter, he was sympathetic to its aims and continued for years to be

321. ALEXEJ VON JAWLENSKY. *Mme. Turandot.* 1912. 23 x 20″. Collection Andreas Jawlensky, Locarno, Switzerland

close to Kandinsky. After the war he formed Der Blaue Vier (The Blue Four), along with Kandinsky, Klee, and Lyonel Feininger.

By 1905 he was painting in a fauve palette; and his drawings of nudes of the next few years are suggestive of Matisse. *Helene with Red Turban* (colorplate 66) might have been inspired by Matisse's portrait of Mme. Matisse entitled *Green Stripe* (see colorplate 27), as far as the color patterns are concerned. It embodies a different mood, however, one of reflection and melancholy indicative of the introspective, religious qualities that became manifest in Jawlensky's works. About 1910 he settled on his primary theme, the portrait head, which he explored thenceforward with mystical intensity (*Self-Portrait,* fig. 320). *Mme. Turandot* (fig. 321), is an early example, painted in a manner that combines characteristics of Russian peasant painting and Russo-Byzantine icons—qualities that were to become more and more dominant. A sense of geometry became strongly evident in the heads of the 1920s; but in the 1930s the geometry gradually loosened, and the artist dissolved the linear structure in an abstraction of forceful brush gesture.

The paintings of Jawlensky constitute a curious and seemingly isolated phenomenon in German expressionist painting. As a microcosm, they do epitomize a certain contemporary development, for he moved from colorism to Bauhaus geometry and then to a personal form almost of abstract expressionism. However, they maintain, from beginning to end, a sense of intense inward vision, that inner spiritual force which Kandinsky felt to be the essence of the expressionist attitude.

320. ALEXEJ VON JAWLENSKY. *Self-Portrait.* 1912. 21¼ x 19⅝″. Collection Andreas Jawlensky, Locarno, Switzerland

Colorplate 46.
EDVARD MUNCH.
*The Dance of Life.*
1899–1900.
Oil on canvas,
49½ x 75".
National Gallery,
Oslo

Colorplate 47. EDVARD MUNCH. *The Red Vine.* 1898.
Oil on canvas, 47 x 47⅝". Munch Museum, Oslo

Colorplate 48. EDVARD MUNCH. *Puberty.* 1894.
Oil on canvas, 59 x 43¾". National Gallery, Oslo

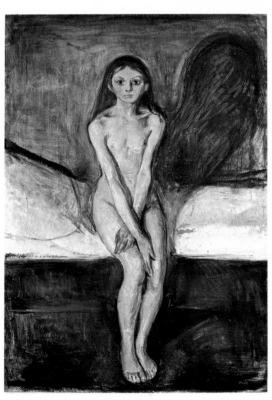

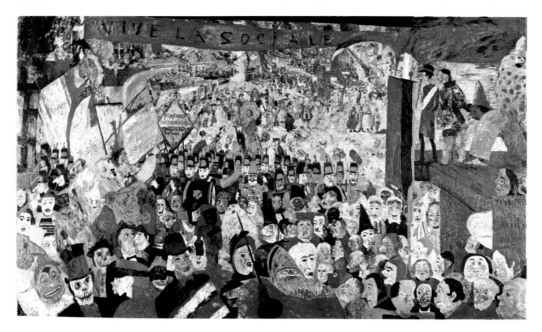

Colorplate 49. JAMES ENSOR.
*The Entry of Christ
into Brussels in 1889.* 1888.
Oil on canvas, 8′ 5″ x 12′ 5″.
Collection Colonel L. Frank,
London

Colorplate 50. JAMES ENSOR.
*The Studio of the Artist.* c. 1930.
Oil on canvas, 33 x 26″.
Boymans-van Beuningen Museum, Rotterdam

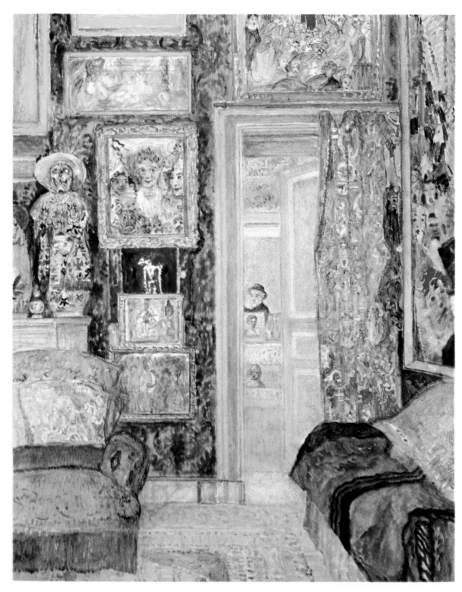

Colorplate 51. GEORGES ROUAULT.
*The Passion.* 1943. Oil on canvas, 41 x 29".
Collection Mr. and Mrs. Leigh B. Block,
Chicago

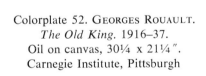

Colorplate 52. GEORGES ROUAULT.
*The Old King.* 1916–37.
Oil on canvas, 30¼ x 21¼".
Carnegie Institute, Pittsburgh

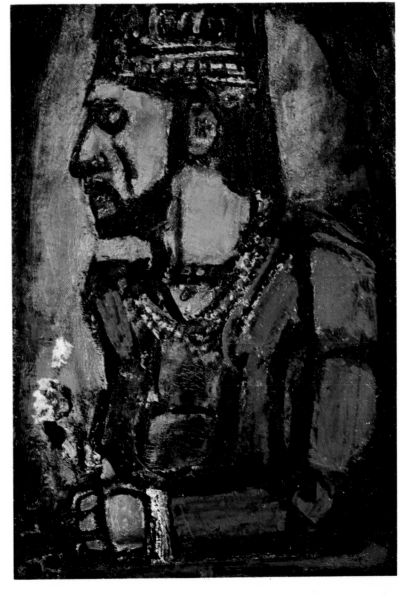

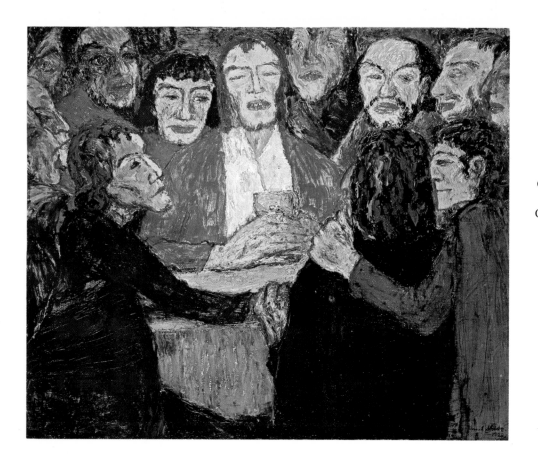

Colorplate 53. EMIL NOLDE.
*The Last Supper.* 1909.
Oil on canvas, 33⅞ x 42⅛".
Statens Museum for Kunst,
Copenhagen

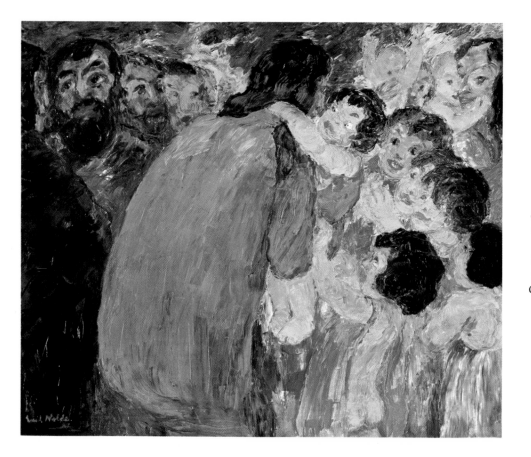

Colorplate 54. EMIL NOLDE.
*Christ Among the Children.*
1910. Oil on canvas,
34⅛ x 41⅞". The Museum
of Modern Art, New York.
Gift of Dr. W. R. Valentiner

*above left:* Colorplate 55. ERICH HECKEL. *Frauen am Meer.* 1913. Oil on canvas, 37¾ x 33⅛". Wilhelm-Lehmbruck Museum, Duisburg, Germany

*above right:* Colorplate 56. MAX PECHSTEIN. *Indian and Woman.* 1910. Oil on canvas, 32¼ x 26¼". Collection Mr. and Mrs. Morton D. May, St. Louis, Missouri

*left:* Colorplate 57. KARL SCHMIDT-ROTTLUFF. *Rising Moon.* 1912. Oil on canvas, 34½ x 37½". Collection Mr. and Mrs. Morton D. May, St. Louis, Missouri

*below:* Colorplate 58. VASILY KANDINSKY. *Composition No. 2.*
1910. Oil on canvas, 38⅜ x 51¾".
The Solomon R. Guggenheim Museum, New York

*bottom left:* Colorplate 59. VASILY KANDINSKY.
*First Abstract Watercolor.* 1910. Watercolor and ink, 19¼ x 25".
Collection Mme. Nina Kandinsky, Neuilly-sur-Seine, France

*above right:* Colorplate 60. VASILY KANDINSKY. *Painting (Autumn).*
1914. Oil on canvas, 64 x 48¼".
The Solomon R. Guggenheim Museum, New York

*right:* Colorplate 61. VASILY KANDINSKY. *Painting (Winter).*
1914. Oil on canvas, 64⅛ x 48⅜".
The Solomon R. Guggenheim Museum, New York

Colorplate 62. FRANZ MARC. *Blue Horses*. 1911.
Oil on canvas, 40¾ x 70⅞″. Walker Art Center, Minneapolis

Colorplate 63. FRANZ MARC. *Stables*. 1913–14. Oil on canvas, 29⅛ x 62¼″.
The Solomon R. Guggenheim Museum, New York

Colorplate 64. FRANZ MARC. *Fighting Forms*. 1914.
Oil on canvas, 35⅞ x 51¾".
Bayerische Staatsgemäldesammlungen, Munich

Colorplate 66. ALEXEJ VON JAWLENSKY. *Helene
with Red Turban*. 1910. Oil on board, 36½ x 31¼".
The Solomon R. Guggenheim Museum, New York

Colorplate 65. AUGUST MACKE. *Great Zoological Garden*. 1912.
Triptych, oil on canvas, 51⅛ x 90¾". Museum am Ostwald, Dortmund, Germany

# PART EIGHT

# THE SPREAD OF CUBISM

It was in 1911 that Picasso and Braque were working together so closely that it is difficult to separate their work. At this point Picasso was comparatively more developed as an artist than Braque, generally a more colorful personality and, despite his refusal to exhibit in official salons, better known to contemporary critics. Picasso was therefore widely credited with being the leader and the more original spirit in their collaboration. Braque's significance as a full partner with some claim to primacy in the development of cubism was recognized only gradually. In the previous year, 1910, a number of other emergent cubists had begun to formulate individual attitudes that were destined to enlarge the boundaries of the style. Of these, Albert Gleizes and Jean Metzinger were to develop also into talented critics and expositors of cubism. In their book, *On Cubism,* published in 1912, they produced one of the first important theoretical works on the movement. Gleizes and Metzinger met regularly with Robert Delaunay, Fernand Léger, and Henri Le Fauconnier (1881–1946) at the home of the socialist writer Alexandre Mercereau, at the café Closerie des Lilas and, on Tuesday evenings, at sessions organized by the journal *Vers et Prose.* At the café, these painters met with older, symbolist writers and younger, enthusiastic critics, such as Guillaume Apollinaire and André Salmon. At the moment when Braque joined Picasso in avoidance of the French salons, this second group of cubists gained rapid notice and began to exercise a substantial influence, not only in France, but in Germany, specifically on the artists of Der Blaue Reiter.

In the 1911 Salon des Indépendants, the group arranged to have their works hung together, and included a few other artists of sympathetic tendencies, among them Marie Laurencin. The concentrated showing of cubist experiment created a sensation; it received violent attacks from most critics, but also an enthusiastic championing from Apollinaire. This official emergence of cubism was followed by an exhibition of works of many of the group as well as those of the cubist sculptor Archipenko at the Société des Artists Indépendants in Brussels. Although Picasso and Braque did not take part in these 1911 salons, their innovations were widely known. Braque had shown cubist works in the Salon of 1909, and paintings by both artists could be seen at the galleries of the dealers Kahnweiler and William Uhde. Both Delaunay and Metzinger knew Picasso. Metzinger had written on Picasso's new work as early as 1910, particularly noting his development of multiple views and his abandonment of Renaissance perspective. Apollinaire also acted as an important link between Picasso and Braque and the others.

During 1911, Archipenko and Roger de La Fresnaye joined the Gleizes-Metzinger group, together with Francis Picabia, and Apollinaire's friend Marie Laurencin. The three brothers Jacques Villon, Marcel Duchamp, and Raymond Duchamp-Villon; the Czech František Kupka; and, most significant, the Spaniard Juan Gris were all new additions. Having lived next to Picasso since 1906 at the old tenement known as the Bateau-Lavoir, Gris was aware of the genesis of his cubism, although during much of this period he himself had given evidence only of being a clever draftsman who lived by doing satirical drawings for journals. However, he must have been studying assiduously, because, when he finally submitted his *Portrait of Picasso* to the Salon des Indépendants of 1912, his work was a masterly and personal interpretation of cubism. In that salon the cubists were now so well represented that protests against their influence were made in the Chamber of Deputies. Meanwhile, their influence abroad was increasing steadily as their works became known through exhibitions in Germany, Russia, England, Spain, and the United States. The Italian futurists had brought their expressionist variation of cubism back to Italy in 1911. In 1912, Kandinsky published works of Le Fauconnier and other cubists in *Der Blaue Reiter.* Paul Klee in the same year and Franz Marc and August Macke, somewhat later, were visiting Delaunay in his Paris studio and taking ideas back to Germany.

By 1912 not only the futurists but other artists were beginning to push the original cubist concepts to new limits. Delaunay was developing his art of "simultaneous contrasts of color" based on the ideas of that same color theorist, Chevreul, who had so strongly influenced Seurat, Signac, and the neo-impressionists. Out of this investigation grew the abstract style to which Apollinaire gave the name "orphism." In the large exhibition at the Gallerie de la Boétie, held in October 1912 and entitled (probably by Jacques Villon) "Section d'Or" (Golden Section), the entries by Marcel Duchamp, Picabia, and Kupka particularly were seen to be moving in new directions. The Dutch painter Mondrian had arrived in Paris in 1912 and was already beginning to use the cubist grid as the basis of an abstract type of construction. The move to complete abstraction was simultaneously in process, between 1911 and 1913, in Russia, where Mikhail Larionov had invented rayonnism and Kasimir Malevich was working toward suprematism.

During 1912 and 1913 appeared not only Gleizes and Metzinger's *On Cubism,* but Apollinaire's book *Les Peintres cubistes* and other articles or book chapters by André Salmon, Olivier Hourcade, Maurice Raynal, and other critics, who traced the origins of cubism and attempted to define its nature and its distinctions from Ren-

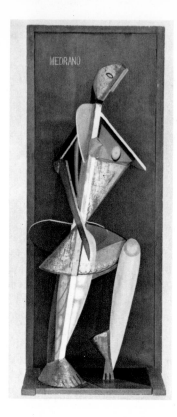

322. ALEXANDER ARCHIPENKO.
*Black Seated Torso.*
1909. Bronze, height 12″.
Collection
Mme. Alexander Archipenko

323. ALEXANDER ARCHIPENKO.
*Walking Woman.*
1912. Bronze, height 26⅜″.
Collection
Mme. Alexander Archipenko

324. ALEXANDER ARCHIPENKO.
*Medrano.* 1915. Painted tin, glass,
wood, and oilcloth, height 49½″.
The Solomon R. Guggenheim
Museum, New York

aissance perspective painting. Even today, when we are accustomed to the meteoric rise and fall of art movements and styles, it is difficult to appreciate the speed with which cubism, beginning in 1907–08 with isolated experiments of Picasso and Braque, had by 1912 become a world-wide movement whose history was already in process of being written and whose development was already branching off in different directions: toward abstraction, toward a new expressionism, and even toward new concepts of reality.

## Cubist Sculpture

Although Brancusi's contribution was unique and although he seems to have been a curiously isolated figure throughout his life, he was not alone in his search for absolutes. The revolutions of fauvism and cubism in painting were accompanied by comparable revolutions in sculpture, despite the vigorous persistence of the older tradition of sculptural figuration. As a result of the explorations of Picasso and Braque, cubist painting by 1910 had dispensed with three-dimensional modeling; strong color had been subordinated to a close harmony of subdued color; and the subject (usually figure or still life) had been transposed into a linear geometry of intersecting and frequently transparent planes, a sort of grid moving within a confined depth from the frontal plane of the painting.

The corresponding problem was a search for the fundamentals of sculptural form through stripping off all the illusionistic accretions of the Renaissance tradition. Brancusi carried on such explorations but they were less familiar to the younger experimental sculptors than the cubist innovations of the painters. With its strict geometry of spatial analysis, cubism seemed immediately applicable to the problem of sculpture. The first cubist sculptors were affected not only by cubist painting but, also like the cubist painters, by the discovery of African primitive sculpture. Picasso's carved wooden figures of 1907 already suggest the background of African or archaic Greek sculpture, and his 1909 *Head of Fernande Olivier* (see fig. 205) is an attempt at a literal translation into sculpture of a painted cubist head.

### ALEXANDER ARCHIPENKO (1887–1964)

Alexander Archipenko has a strong claim to priority as a pioneer cubist sculptor. Born in Kiev, Russia, he studied art in Kiev and Moscow until he went to Paris in 1908. By 1910 he was exhibiting in various German cities and had started his own school of sculpture in Paris. In his earliest works showing the impact of cubism, such as the *Black Seated Torso,* 1909 (fig. 322), his use of a barely suggested geometric structure gives the elegantly revolving figure a firmness that prevents it from becoming purely decorative in an art nouveau manner. By 1912 Archipenko had realized the implications of cubism for sculpture and had opened up voids within the mass of the

figure to the point where the historic concept of a sculpture as a solid surrounded by space was reversed. In *Walking Woman* (fig. 323), the sculptured figure became a series of voids or spaces shaped and defined by solid outlines. In 1913–14, Archipenko made another contribution by adapting the new technique of collage to sculpture, and making constructions out of various materials, such as wood, glass, and metal. Although the "Medrano" figures that he constructed during the next few years (for instance, fig. 324) tend toward the mannered, the technique that he devised was of importance to the emerging tradition of sculpture as a construction composed of space rather than mass.

Picasso's constructions or assemblages were more advanced than the Medrano constructions of Archipenko in their abstract constructive qualities, but the latter's cubist figures had more immediate influence, first because they were more widely exhibited at an early date, and second for the very reason that they were applying cubist principles to the long familiar sculptural subject of the human figure, which seemed to make the implications of mass-space reversals more easily comprehensible. Archipenko's contribution was made between the years 1910 and 1920, when he was in close touch with the cubist painters. After that date, particularly after he moved to the United States in 1923, his sculpture reverted to a pleasant, graceful form of figuration that used the forms of cubist art essentially as surface decoration.

## RAYMOND DUCHAMP-VILLON *(1876–1918)*

The artist of the greatest potential and, possibly, of the least fulfilled ability among the first cubist sculptors was Raymond Duchamp-Villon, whose great talents were cut off by his early death in 1918. He was one of a family of six children, of whom four became artists. His brothers were the painters Marcel Duchamp and Jacques Villon; his sister was the painter Suzanne Duchamp. Duchamp-Villon started in medicine but in 1900 abandoned it for sculpture. The following year he was exhibiting in the Salon de la Nationale. At first influenced by Rodin, like all his generation, he moved rapidly into the orbit of the cubists. But his head of *Baudelaire* (fig. 325) has the repose and classic generalization of ancient sculpture, achieved by balance and simplified features integrated into a strongly articulated skull. The bony, emaciated head at the same time exudes the ascetic, fanatic force of a Christian martyr carved by Donatello. The artist's progressive path toward his own version of abstraction may be traced in two other portrait heads, *Maggy* (see fig. 186) and *Professor Gosset* (fig. 326). In *Maggy*, features are translated into a mask of protruding eyes, bulbous nose, and deeply undercut brows, mouth, and chin, which, despite suggestions of caricature, has a hypnotic effect. Completely dehumanized into a barbaric mask of some African or Oceanic tribe, *Professor Gosset* gains expressive power from geometric stylization and high technical finish.

The *Seated Woman* (fig. 327) combines a traditional Renaissance twisting pose with integrated curves and planes to reach a complete three-dimensional spatial ex-

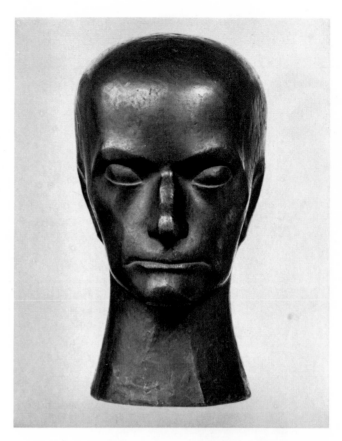

325. RAYMOND DUCHAMP-VILLON. *Baudelaire*. 1911. Bronze, height 16″. Collection Alexander M. Bing, New York

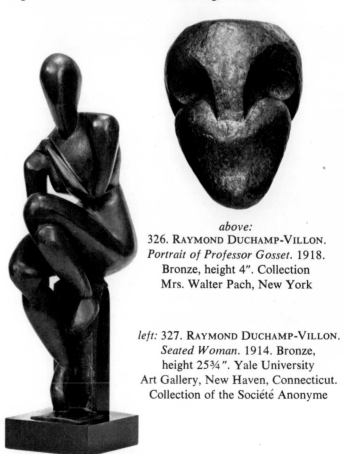

*above:*
326. RAYMOND DUCHAMP-VILLON. *Portrait of Professor Gosset*. 1918. Bronze, height 4″. Collection Mrs. Walter Pach, New York

*left:* 327. RAYMOND DUCHAMP-VILLON. *Seated Woman*. 1914. Bronze, height 25¾″. Yale University Art Gallery, New Haven, Connecticut. Collection of the Société Anonyme

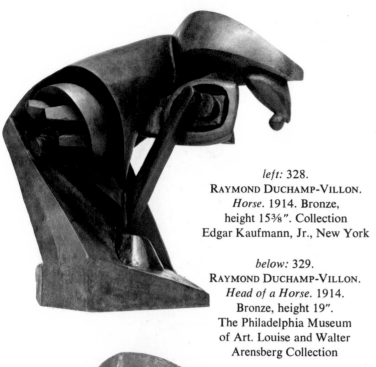

*left:* 328.
RAYMOND DUCHAMP-VILLON.
*Horse.* 1914. Bronze,
height 15⅜″. Collection
Edgar Kaufmann, Jr., New York

*below:* 329.
RAYMOND DUCHAMP-VILLON.
*Head of a Horse.* 1914.
Bronze, height 19″.
The Philadelphia Museum
of Art. Louise and Walter
Arensberg Collection

quite different, sought essences as Brancusi did. By continually stripping away extraneous details he came at last to complete sculptural experience. The portrait head became a mask of a few related shapes, lines, volumes *(Professor Gosset),* and the recognizable horse and rider twisting in space became the abstract space machine of the *Horse.*

## JACQUES LIPCHITZ *(b. 1891)*

No other sculptor has explored the possibilities of cubist sculpture as has Jacques Lipchitz, yet cubism is only one chapter in his extensive career. Born in Lithuania in 1891, Lipchitz arrived in Paris in 1909 and there studied at the Ecole des Beaux-Arts and the Académie Julian. In 1913 he met Picasso and began his association with the cubists. He was particularly close to Juan Gris, as well as to Amedeo Modigliani and Matisse. In 1913 he introduced some geometric stylization into a series of figure sculptures (fig. 330), and by 1916 was producing a wide variety of cubist works in stone, bronze, and wood construction. In the large *Head,* 1915 (fig. 331), the features are subordinated to the point of abstraction. A rectangular mass is intersected by a central diagonal ridge that rises into two curving, opposed, horizontal shelves,

330. JACQUES LIPCHITZ. *Sailor with Guitar.* 1914.
Bronze, height 30″. Collection the Artist

istence. In this work, the artist, although still suggesting a traditional sculptural space, has moved substantially toward abstraction. The final step was reached in the great *Horse* (fig. 328) and *Head of a Horse* (fig. 329). The various preliminary versions trace the development of Duchamp-Villon's idea from flowing, curvilinear, relatively representational forms to final abstraction of all elements into a powerful statement of diagonal planes and concave and convex shapes that move, unfold, and integrate space into the mass of the sculpture. Duchamp-Villon, thus, though his approach and solutions are

331. JACQUES LIPCHITZ.
*Head.* 1915. Bronze,
height 24″. The Joseph H.
Hirshhorn Collection

332. JACQUES LIPCHITZ.
*Standing Personage.* 1916. Stone,
height 42½″. The Solomon R.
Guggenheim Museum, New York

333. JACQUES LIPCHITZ.
*Joie de Vivre.* 1927–60.
Bronze, height 11′. The Whitney Museum
of American Art, New York

suggesting eyes, eyebrows, and ears. The whole, however, is essentially a structure of interpenetrating lines and masses, constituting one of the first successful cubist sculptures.

Between 1915 and 1917, Lipchitz, in his stone carvings and wood constructions, attained his highest degree of abstract simplification. An implicit figure had always been present, but this had now been reduced to a series of vertical and horizontal planes penetrating one another, with some counterpoint of curvilinear contours (fig. 332). Despite the classic repose of these sculptures, Lipchitz was not content with either their abstraction or their rectangular regularity, so, in 1917, he began to complicate the figures and at the same time to introduce a greater degree of mass. From 1917 through the early 1920s the sculptures involve a complex of qualities, both rich and monumental, and frequently take on a specific mood or personality. During the 1920s he executed some of his most monumental cubist works, such as the *Joie de vivre* (fig. 333).

Cubism, for Lipchitz, had been a liberating factor, and between 1915 and 1925, he created many important cubist sculptures. He early realized that cubism had as significant a role to play in sculpture as in painting. It was a means of re-examining the nature of sculptural form in its essence and of asserting the work of sculpture

334. JACQUES LIPCHITZ. *Reclining Nude with Guitar.* 1928.
Bronze, length 27″. The Joseph H. Hirshhorn Collection

as an entity all by itself rather than as an imitation of anything. The cubist sense of form has remained with Lipchitz throughout his life, even though his style has departed radically from geometric cubism.

In Lipchitz' maquettes (original clay or bronze sketches), however, there became evident by 1925 a desire for liberation from cubist forms and for discovery of

335. JACQUES LIPCHITZ. *Figure*. 1926–30. Bronze,
height 85¼". The Museum of Modern Art, New York.
Van Gogh Purchase Fund

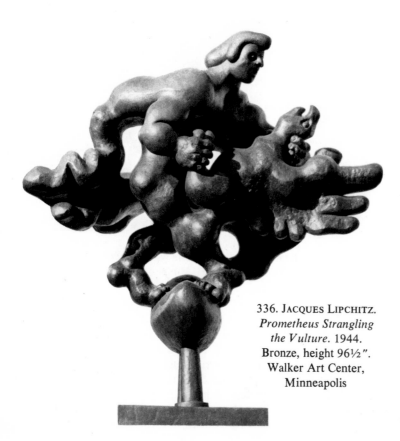

336. JACQUES LIPCHITZ.
*Prometheus Strangling
the Vulture*. 1944.
Bronze, height 96½".
Walker Art Center,
Minneapolis

a new subject content and a new expression. This was the moment when the artist began to create his transparents, in which he reversed solid and void in a series of experiments that were to have an important impact on the later history of modern sculpture. A number of experiments led to *Reclining Nude with Guitar,* 1928 (fig. 334), which in its blocky yet curving masses anticipated major works of the 1930s. This work and the works that led up to it involved an attempt on the part of Lipchitz to create a "Thinker" of his own—after Rodin. Lipchitz, like many of his generation, originally revolted against Rodin as too overpowering an influence. Now, however, he had begun to realize that Rodin was the master of them all, the father of modern sculpture. From this point forward, expressive content became paramount in his sculpture, and led to the free, baroque modeling of his later works. The monumental *Figure* (fig. 335) is a tremendous, primitive totem of overpowering presence. Although primitive art is a personal passion with Lipchitz, his own inspiration still comes primarily from classical and biblical sources.

A theme that fascinated him from the mid-1930s is Prometheus and the vulture. For the Paris World's Fair of 1937 he created a vast plaster of Prometheus strangling the vulture. To him the subject was a symbol of the victory of light over darkness, of knowledge over ignorance, and he explored it in many different versions. The definitive work was produced between 1944 and 1953. In this example (fig. 336), the geometry of cubism seems to have been replaced by a baroque, curvilinear movement of volumes. His original cubist disciplined control, however, is still evident in the balance of solids and voids.

Another theme that has continually obsessed him is the embrace, which on one level represents the passion of sexual love and on another a battle to the death. In *Jacob Wrestling with the Angel* (fig. 337) the figures struggle together in an ambivalence of love and death. The struggle of *Bull and Condor,* 1932, became a symbol of the insane brutality of a world dominated by fascism.

In May 1940, with the German invasion of France, Lipchitz left Paris and in 1941 was able to reach the United States, where he has lived since. The flight and arrival are commemorated in two sculptures on these themes. They were based on earlier projects expressive of his fears and uncertainties in the 1930s, now translated into an ecstatic prayer of thanks (*Return of the Child,* fig. 338). The optimism of these works has continued to manifest itself in the works of the last twenty years, most notably perhaps in the statue of *Notre Dame de Liesse* (fig. 339) and in related works on which he has worked since 1948. Lipchitz was deeply moved when he—as he said, "a Jew, true to the faith of his ancestors" —was asked to create a shrine for the Christian Madonna. The solution at which he finally arrived—the Madonna whose form becomes one with the heart-shaped mandorla surrounding her—drew on all the experience of his working life. The essence of the altarpiece lies in its profound statement of the concept of metamorphosis, a concept central to Lipchitz' sculpture during most of his career. In the idea of change, or becoming, are in-

337. JACQUES LIPCHITZ.
*Jacob Wrestling with the Angel.* 1932. Bronze, length 47½".
Collection the Artist

338. JACQUES LIPCHITZ. *Return of the Child.*
1941. Granite, height 45¾". The Solomon R.
Guggenheim Museum, New York

volved all the artist's thoughts on birth and life and death. Europa, assimilated to the bull, becomes one with the godhead. Theseus, killing the Minotaur, seems to be destroying part of himself. Jacob, in his struggle with the angel, absorbs the spirit of God. The Virgin of Mercy as she is transformed into a mandorla becomes a symbol of the transformation of the flesh and the spirit.

## HENRI LAURENS *(1885–1954)*

The cubist sculptures of Henri Laurens, whether still life or figure, generally retain a defined sense of subject. Laurens was that rare phenomenon of the School of Paris, an artist who actually was born, lived, and died in Paris. He was apprenticed in a decorator's workshop, where, like Braque, he may have absorbed certain techniques of embellishment later translated into his sculptures. In fact, in 1911 he met Braque, who was in the midst of his explorations of analytical cubism. The two were drawn to each other and remained lifetime friends. Laurens' close relations with the painters may explain his frequent use of color in his sculptures, color beautifully and soberly integrated into low reliefs (colorplate 67) or freestanding stone blocks. Many of the cubist sculptors experimented with color, just as the painters sought relief effects with collage. For Laurens the use of color had a special significance. Referring to the long tradition of color in sculpture from antiquity to the Renaissance, he emphasized its function in eliminating variations of light on sculpture. As he explained, "When a statue is red, blue, or yellow, it remains red, blue, or yellow. But a statue that has not been colored is continually changing

339. JACQUES LIPCHITZ. *Notre Dame de Liesse.* 1948.
Bronze, height 33". Collection the Artist

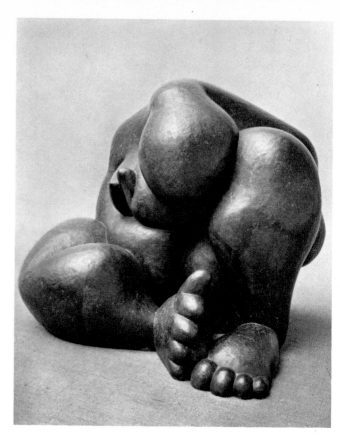

right: 340. HENRI LAURENS.
*Petite Amphion.* 1937.
Bronze, height 16".
The Marlborough-Gerson
Gallery, New York

far right: 341. HENRI LAURENS.
*Crouching Figure (Night).* 1936.
Stone, 36½ x 17⅜ x 20⅞".
Musée National d'Art Moderne,
Paris

under the shifting light and shadows. My own aim, in coloring a statue, is that it should have its own light."

Laurens was a fine designer and book illustrator and, like Picasso, with whom he became friendly in 1915, he designed sets for the Russian ballet of Diaghilev. During the 1920s he relaxed the more rigid geometry of his earlier cubist works and developed his personal form of curvilinear cubism. At first the curvilinear elements were balanced with rectilinear forms, but by the end of the decade his interest had shifted to the creation of curving volumes, and the rounded moving rhythms of his later style. The suggestion of specific subject matter, frequently taken from classical myth, is increased. The *Amphions* of 1937 (fig. 340) combine extremely free organic shapes, comparable to some of the surrealist bone figures of Picasso, with a pattern of rigidly parallel lines to evoke the magical lyre of the son of Zeus. The exploration of volumes is carried to its utmost point in the *Crouching Figure* (*Night,* fig. 341), a strange and somewhat gruesome compact of inflated volumes through which the artist expresses a mood of dark, brooding melancholy.

Despite his introduction of an element of personality in his figures and his more explicit subjects, either mythological or allegorical, Laurens remained throughout his career a sculptor interested essentially in his plastic means, expressed first in cubist forms and later in baroque movement of volumes in space. In this he differed from Lipchitz who, after the 1920s, turned more and more to subjects in which the idea expressed, whether taken from classical mythology, the Old or New Testament, or his personal agony or exultation, has increasingly dominated and directed the plastic means.

## OSSIP ZADKINE *(1890–1966)*

Zadkine never really deserted cubism, although from the very beginning his cubist sculptures took on expressionist overtones. Born in Smolensk, Russia, in 1890, he was in Paris in 1909, at the moment of the inception of cubism. After 1920 his cubism took on elaborately decorative, curvilinear qualities that also frequently suggested his close interest in the qualities of materials—wood, bronze, and stone—which he sought to express in their essence. A marble work, *Mother and Child* (fig. 342), illustrates the massive, closed quality of his first works. Solids and voids in the figures are interchanged; and the whole is exceptionally tightly organized. Interest in formal elements, however, did not prevent an intense statement of the mother-child relationship, which makes of this work essentially a subject sculpture.

Zadkine had a particularly fine feeling for the medium of wood, and his wooden sculptures retain the compact, living bulk of the tree form (*Female Torso,* 1928; fig. 343). His later sculptures move more and more toward mannered expression involving elaborations of geometric and curvilinear shapes (*Standing Figure,* 1925–28; fig. 344). Although the figures are constructed from a variety of semi-architectural fragments, solids interpenetrated by voids and lines playing over surfaces, they are still fundamentally human figures—actors gesturing, writhing, and suffering.

For sculpture, cubism was one of the greatest liberating forces. It opened the path to subjects other than the human figure; it led the way to complete abstraction; it defined the nature of sculpture as an art of mass, volume, and space; and it developed new possibilities in the utili-

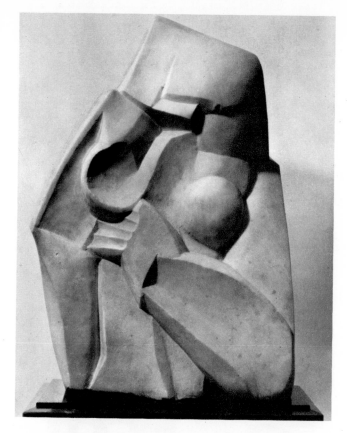

342. OSSIP ZADKINE. *Mother and Child*. c. 1920?
Marble, 23¾″. The Joseph H. Hirshhorn Collection

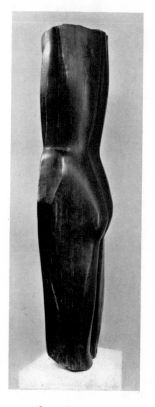
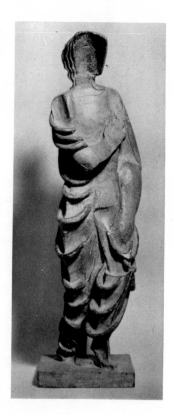

*above left:* 343. OSSIP ZADKINE. *Female Torso*. 1928.
Ebony, height 36″. The Museum of Modern Art, New York.
Gift of Mrs. Maurice Speiser

*above right:* 344. OSSIP ZADKINE. *Standing Figure*. 1925–28.
Bronze, height 25⅛″. The Joseph H. Hirshhorn Collection

zation and expansion of these elements. In sculpture as in painting, cubism has never really died. In one form or another, it continues to affect the ideas and the production of younger sculptors of all tendencies in every part of the world.

## Cubist Painting

### JUAN GRIS *(1887–1927)*

Gris' *Portrait of Picasso,* 1912 (fig. 345), is akin to Picasso's heads of 1909 in the arbitrary relations of head to surrounding space (see figs. 206, 207), but it has a mathematical control that is unrelated to anything that Picasso, Braque, or the other cubists had attempted. From this monochromatic painting Gris moved to a coloristic formula that may have anticipated the developed synthetic-cubist paintings of Braque and Picasso. The *La Place Ravignan, Still Life in Front of an Open Window* (colorplate 68) is an accomplished combination of Renaissance and cubist space—an anomaly that was to intrigue Picasso, Braque, and other cubists for many years to come, almost as an intellectual exercise in perception. The interior space embodies all the elements of synthetic cubism, with large, intensely colored geometric planes interlocking and absorbing the familiar collage components —the newspaper, *Le Journal;* the wine label, *Médoc;* the decorative grillwork. However, the foreground pattern of tilted color shapes leads the eye to the window space that opens out on a uniformly blue area of trees and buildings. Thus the space of the picture shifts abruptly from the ambiguity and multifaceted structure of cubism to the cool clarity of the detail of external space seen through the traditional Renaissance window. Gris was one of the first cubists to realize the possibilities of this double way of seeing.

Gris was largely instrumental in bringing light and color back into cubism, at times to the point of overly decorative lyricism. He was capable of a kind of mocking humor that could be directed at himself and his own intellectualization of cubism (*The Man in the Café,* fig. 346). At the end of his life he was beginning to explore a manner of utmost austerity, in which objects—mandolin, table, sheet music, or window and outer space—were simplified to elemental color shapes. In *Guitar with Sheet of Music,* 1926 (colorplate 69), he reduced these familiar objects of cubist still life to stark, simple shapes separated by intervals as tangible as solids. In his colors he eliminated the luminous iridescence from which had arisen much of the sensuous and decorative lyricism of earlier works. The paint is applied as a matte surface that reinforces the sense of architectural structure and, at the same time, asserts its own nature as paint. The bright primary colors—the blue of the sky, the yellow of the mandolin's body, the red of the cloth—are framed by neutral tones. The table and window frame are composed of low-keyed ochers that merge imperceptibly with varying values of brown, all within the deep gray shadow of the room. Within this subdued but beautifully integrated color construction, the artist has created, through

the linear geometry of his edges, a tour de force of shifting planes and ambiguous but structured space. He uses the full repertoire both of the cubist grid and of Renaissance perspective, playing innumerable tricks of illusion but always bringing us back to the picture plane—the painted surface. The left-hand window frame reverses itself before our eyes; the diagonal yellow line that bounds the red cloth on the left is drawn perfectly straight, yet is made to bend, visually, by the deeper value of the cloth as it (presumably) folds over the edge of the table. The deeper value of ocher between the mandolin body and the cloth and sheet music similarly bends away at the right as the black-and-white striped neck of the mandolin recedes into a perspective infinity. The white V of the open sheet music joins with the right-hand side of the table to rise up as a piece of constructivist sculpture. Gris here, in fact, integrates effects of architectural recession, sculptural projection, and flat painted surface into a tightly interlocked pictorial harmony. This is the important point—that the technical illusions are controlled as significant but subordinate elements in one of the last masterpieces of his short and brilliant career.

## ALBERT GLEIZES *(1881–1953)*,

## JEAN METZINGER *(1883–1956)*

The contributions of Gleizes and Metzinger to the cubist movement are usually overshadowed by the repu-

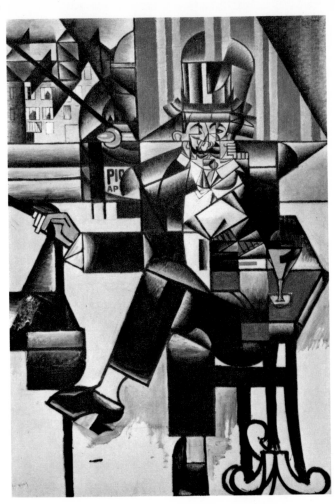

346. JUAN GRIS. *The Man in the Café.* 1912.
50½ x 34⅝". The Philadelphia Museum of Art.
Louise and Walter Arensberg Collection

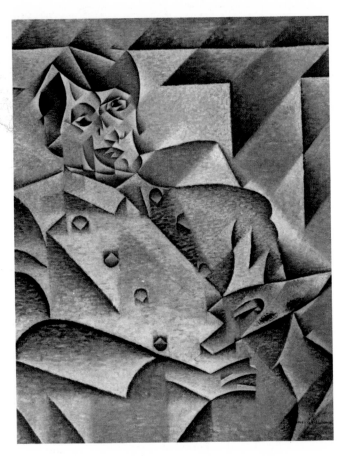

345. JUAN GRIS. *Portrait of Picasso.* 1912.
36¾ x 29¼". The Art Institute of Chicago.
Gift of Leigh B. Block

tation of their theoretical writings, specifically the pioneer *On Cubism* in which much of the pictorial vocabulary of cubism was first elucidated. Gleizes in particular was instrumental in expanding the range of the new art, both in type of subject and of attitude toward subject, for he himself, very early in the history of cubism, became involved with expressive as well as plastic and formal elements. His monumental painting, *Harvest Threshing,* 1912 (fig. 347), is a provocative opening up of the generally hermetic world of the cubists, and in its suggestions of the dignity of labor it has social implications. Although the total palette remains within the subdued range of Picasso and Braque at the same moment—grays, greens, browns, with flashes of red and yellow—Gleize's color achieves a richness that gives the work romantic overtones suggestive of Jean Millet or Jules Breton.

During the next few years Gleizes, like the other cubists, moved to a fuller palette. His visit to America in 1915 provided a new stimulus through the dynamism of the city of New York. The architectural beauty of subjects like the Brooklyn Bridge (fig. 348) inspired him to

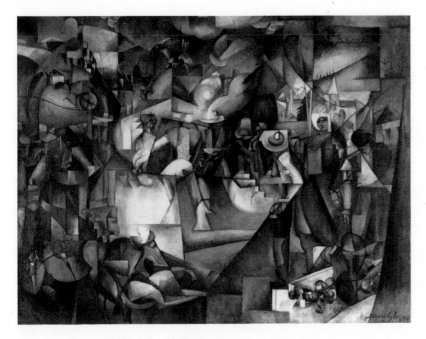

347. ALBERT GLEIZES. *Harvest Threshing.*
1912. 8' 10" x 11' 7".
The Solomon R. Guggenheim Museum, New York

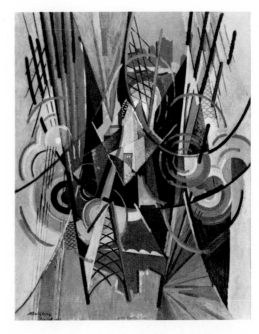

348. ALBERT GLEIZES. *On Brooklyn Bridge.*
1917. 63¾ x 51".
The Solomon R. Guggenheim Museum, New York

produce some of his most effective works and some of his most completely abstract. But in other works, done after his return to Paris, he created, in terms of pattern and color, a pastiche of nostalgic memories in which the literal abstraction of architecture and figures is close to the first attempts of American artists to combine cubist geometry and native realism. In his later works Gleizes turned to a form of lyrical abstraction based on curvilinear shapes, frequently inspired by musical motifs (*Symphony in Violet,* colorplate 70).

The early cubist paintings of Jean Metzinger are luminous variations on Cézanne, whereas slightly later works suggest an academic approach more intellectual than visual. *The Bathers* (fig. 349) illustrates his penchant for a carefully constructed rectangular design, in which the romantic luminosity of the paint plays against the classic geometry of the linear structure. Metzinger moved with every variation of the cubist breeze. For a time he toyed with effects derived from the Italian futurists. He moved easily into the synthetic-cubist realm of larger color shapes and more vivid color. Then, with the return to the object that marked so much painting toward the end of World War I, he assimilated photographic images of architectural scenes to a decorative cubist frame. His style was soon an idealized realism for which cubist pattern was a decorative background. This formula, unfortunately, enmeshed many of the lesser cubists and, at times, even so major a figure as Gris.

## ROGER DE LA FRESNAYE (*1885–1925*)

Roger de La Fresnaye came out of Cézanne almost more literally than did any of the other cubists. His early landscapes were even more traditional in their mode of

349. JEAN METZINGER. *The Bathers.* 1913.
58¼ x 41⅞". The Philadelphia Museum of Art.
Louise and Walter Arensberg Collection

*above left:* 350. ROGER DE LA FRESNAYE. *Female Nude.* 1911. Oil on cardboard, 50¾ x 22¼".
The Philadelphia Museum of Art. Louise and Walter Arensberg Collection

*above right:* 351. FERNAND LEGER. *Nudes in the Forest.* 1909–10. 47¼ x 66⅞". Kröller-Müller Museum, Otterlo, The Netherlands

representation than the Cézanne landscapes on which they were based. Paintings like *Female Nude* (fig. 350) are organized in terms of sculptural projection from the picture plane. However, with the *Seated Man,* 1913, De La Fresnaye moved on to a pattern of abstract shapes, strongly colored and contrasting with the literal rendition of the figure. The whole was rendered in thin washes of atmospheric paint suggestive of watercolor. This approach he employed on a monumental scale in his *Conquest of the Air,* 1913 (colorplate 71)—like Delaunay's large painting, *Homage to Blériot,* 1914 (see colorplate 80), a striking evidence of the enthusiasm of the experimental artists for the new world of technology that was paralleling their own explorations of new ways of transforming the universe. In their lyrical color and nebulous spatial transitions, the developed paintings of De La Fresnaye illustrate the degree to which cubism was a new way of seeing, a new perception that opened up a thousand new avenues of expression. For this reason, it has lasted as long as it has, feeding many movements down to the present day.

Individual variations on cubism were played in France and throughout the world by a large number of artists of varying talents. Louis Marcoussis (1881–1941) and Henri Hayden (b. 1883) were Poles who worked over the more common hard-edged approach. André Lhote (1885–1962), perhaps the most influential teacher associated with cubism, made of it an academic formula with which he indoctrinated generations of students.

## FERNAND LEGER (1881–1955)

The impact of cubism was tremendous. Not only did it spread rapidly; it led at once to variations on existing styles and to the creation of new styles. In Germany and Italy it served as a base for expressionist approaches; in Holland and Russia it was a first step toward absolute abstraction; in the United States it led to a new approach to realism; and throughout the world it fed the new arts of fantasy, dada, and surrealism.

One almost inevitable offshoot was an art commemorating the ever-expanding industrial machine world. The geometric basis of much cubist painting provided analogies to machine forms and an excuse for a machine iconography. Of the French cubists only one of the great masters devoted his life to the application of cubist forms to machine iconography. This was Fernand Léger—ironically enough of Norman peasant stock and maintaining many of the qualities of his peasant ancestors throughout his life. Léger's painting passed from the influence of Cézanne to that of Picasso in his proto-cubist, sculptural stage. One of his first major canvases, *Nudes in the Forest* (fig. 351), was possibly inspired by Picasso's 1908 *Nude in the Forest* (The Hermitage, Leningrad). But in Léger's hands it became an unearthly habitation of machine forms and robots. Here Léger seems literally to be attempting to create a work of art out of the cylinders and cones to which Cézanne referred. The sobriety of the colors, coupled with the frenzied activity of the robots,

creates an atmosphere of demonic action symbolic of a new, dehumanized world. It is an anticipation of the world that the Italian futurists sought to create in painting, here with an emphasis on doom, however, rather than on hope and progress.

Léger soon lightened his palette and began to experiment with atmospheric effects; and from this phase he moved to an examination of machine forms freely rendered in predominantly primary colors. These color shapes were sometimes made to suggest mechanical figures; at other times the abstract structure was made explicit by such titles as *Contrast of Forms* (fig. 352). Although Léger's passion for geometric shapes rendered in bright color periodically led him to the edge of non-representational art, it was the fascination of subject, normally with some machine symbolism of social significance, that always drew him back.

*The City*, 1919 (colorplate 72), marks another major step in the artist's exploration of reality and the painted surface. In most of the earlier works he had painted in an unabashedly sculptural manner, modeling his forms out from the surface of the canvas even to the point where they seemed to detach themselves. In *The City* he obviously set out to control his sculptural exuberance through a rigid architecture establishing the primacy of the two-dimensional picture plane. Still, he used the range of developed synthetic cubism to play every sort of illusionistic variation. The foreground column is modeled as a bas-relief. Tilted planes suggest the illusion of perspective depth. Literal elements of machines, buildings, robot figures mounting a staircase, stenciled letters, signs, all contribute to the kaleidoscopic glimpses of the industrial world of *The City*. In the figure compositions of the 1920s and 1930s, he creates a disciplined and somewhat frightening symbol of the brave new world of the machine in a manner that stems from the French classic tradition of Poussin and David. *Three Women* (*Le Grand Déjeuner*, colorplate 73), 1921, in its depersonalization of the figures, which are machine volumes modeled out from the rigidly rectangular background and which stare fixedly, uniformly, and impersonally at the spectator, is a further step toward abstraction at the same time that it evokes a world of machine fantasy. Léger only rarely produced paintings that could be considered entirely abstract.

During the last twenty years of his life, he concentrated his efforts on a few basic themes, which he explored in many different ways, from the most abstract efforts of his career to the most representational. In these he sought to sum up his experiences in the exploration of man and his place in the contemporary industrial world. Although it was only in part a social exploration, this element was important to him. It was also a visual exploration of his world as an artist, a final and culminating assessment of his plastic means for presenting it. In the many versions of The Divers the artist explored variations of a flowing, interwoven composition of boldly outlined figures presented as flat or modeled color shapes moving in and out of shallow depth (fig. 353). In contrast with The Divers, where the artist's emphasis is on the formal problem of composing figures moving in space, the series of The Cyclists returns to more easily comprehended subject matter. In one version made in 1948–49, *Homage to Louis David* (fig. 354), he shows the happy petit-bourgeois family on its Sunday outing, the women in shorts and bathing suits, the men overdressed for the occasion, and the entire family stiffly posed for the itinerant photographer. Like all Léger's late paintings, the picture has a cubist structural frame. But it is also a realistic if stylized presentation, with suggestions of the primitive or naïve, elements of social commentary, even of surrealist fantasy; and all of these characteristics reflect concepts, styles, and movements that had merged, flourished, and—in some cases—declined in the first forty years of the twentieth century. Despite his dedication to his own form of machine cubism, Léger was not untouched by those developments.

*The Great Constructors* (fig. 355) is the climax of another of Léger's late themes. Here, the architectural grid of beams and girders on which the construction men are working has provided the artist with a severe and powerful geometric structure in planes of red, yellow, and black against a vivid blue sky. In contrast, *The Country Outing* (fig. 356) returns to a pastoral theme, a development from The Cyclists. The reclining figures, composed within a barely suggested landscape, take us back through the arcadian tradition of figures in a landscape from Cézanne, Renoir, and Manet to Poussin, Titian, and Giorgione. Now the artist has completely detached color from line. The figure and landscape elements are realistically drawn in heavy black outlines on a white

352. FERNAND LEGER. *Contrast of Forms.* 1913. Oil on burlap, 51 x 38". Philadelphia Museum of Art. Arensberg Collection

353. FERNAND LEGER. *The Polychrome Divers.* 1942–46.
98⅜ x 72⅞". Musée Fernand Léger, Biot, France

ground. Floating over the surface is a series of free planes of red, blue, orange, yellow, green, and gray.

*The Great Parade,* 1954 (colorplate 74), is not only the climax of this series of late themes, but the culmination of a lifelong obsession with circus themes, an obsession that Léger shared with many masters of modern art. In this huge canvas he returned to the structural approach of *The Constructors* and the classic frontality of *Homage to Louis David.* As in *The Country Outing,* the figures are rendered predominantly as black outlines on a light ground, and color is presented independently in large, flat areas.

Despite the proportionately greater interest in specific representation, illustrative subject, and social observation, these last works are remarkably consistent with his earliest essays in cubism based on machine forms. He was one of the few artists who, quite literally, never really deserted cubism but was able to demonstrate, in every phase of his prolific output, its potentials for continually fresh and varied expression.

## PURISM:

### CHARLES-EDOUARD JEANNERET *(1887–1966),*

### AMEDEE OZENFANT *(1886–1966)*

The machine cubism of Léger bears some relationship to the variant on cubism called "purism," developed around 1918 by the architect-painter Charles-Edouard Jeanneret (called Le Corbusier) and the painter Amédée Ozenfant. In their manifesto entitled *After Cubism,* published in 1918, Ozenfant and Jeanneret attacked the then cur-

*above:* 354. FERNAND LEGER. *Homage to Louis David.* 1948–49.
60½ x 72¾". Musée National d'Art Moderne, Paris

*right:* 355. FERNAND LEGER. *The Great Constructors.* 1950.
9' 11" x 7' 1". Musée Fernand Léger, Biot, France

left: 356. FERNAND LEGER. *The Country Outing.* 1954.
8' x 9' 5". Collection Aimé Maeght, Paris

below: 357. AMEDEE OZENFANT. *Still Life.* 1920. 31⅞ x 39¼".
The Solomon R. Guggenheim Museum, New York

rent state of cubism as having degenerated into a form of elaborate decoration. In their painting they sought for an architectural simplicity of vertical-horizontal structure, and elimination of decorative ornateness as well as suggestion of illustrative or fantastic subject. To them the machine became the perfect symbol for the kind of pure, functional painting they sought to achieve—just as, in his early, minimal architecture, Le Corbusier thought of a house first as a machine for living. Purist principles are illustrated in Ozenfant's *Still Life,* 1920 (fig. 357), and Jeanneret's *Still Life,* 1920 (fig. 358). In both works, the still-life objects are arranged frontally, with colors subdued and shapes modeled in an illusion of projecting volumes. Symmetrical and mechanical curves move across the rectangular grid with the antiseptic purity of a well-tended, brand-new machine. Jeanneret continued to paint throughout his life, but his theories gained significant expression only in the great architecture he produced as Le Corbusier. Ozenfant had enunciated his ideas of purism in two magazines: in *L'Elan,* from 1915 to 1917, before he met Jeanneret; and with Jeanneret, in *L'Esprit Nouveau,* from 1920 to 1925. He later turned to mural painting.

## ORPHISM:

### ROBERT DELAUNAY *(1885–1941),*

### FRANTISEK KUPKA *(1871–1957)*

. Unlike Léger, Robert Delaunay moved rapidly through his apprenticeship of cubism and by 1912 had arrived at a formula of brilliantly colored abstractions with only the most tenuous roots in naturalistic observation. His restless and inquiring mind had ranged over the entire terrain of modern art, from the color theories of Chevreul and the space concepts of Cézanne to Braque and Picasso and Henri Rousseau. Delaunay avoided the figure, the still life, and the constricted interior, and in his first cubist paintings took as themes two great works of architecture, the Gothic church of St-Severin and the Eiffel Tower. The different versions of St-Severin were

358. CHARLES-EDOUARD JEANNERET. *Still Life.* 1920.
31⅞ x 39¼". The Museum of Modern Art, New York

usually painted in the low-keyed palette of analytical cubism. That the church interior was almost a textbook illustration of the perspective recession of the church interior was unquestionably what intrigued him. The problem of retaining it and at the same time establishing the arched shapes firmly on the picture plane was seemingly insuperable, yet he solved it time after time, producing

tension, conflict, and resolution of spatial values (colorplate 75).

The Eiffel Tower series presented a somewhat different problem, solved, at times, in terms of recollections of Cézanne. *Eiffel Tower in Trees,* 1909 (colorplate 76), is framed behind a foreground tree, depicted in light hues of ocher and blue, with a pattern of circular cloud shapes that accentuate the tempo of the painting. The fragmentation of the tower and foliage here serves the purpose not only of suggesting the shifting vision of cubism, but also of suggesting rapid motion, so that the tower and its environment seem carried into the dimension of outer space.

These cubist paintings owe much to the tradition of fauvism; their expressive qualities of motion and struggle appealed to the German expressionists Marc and Macke when they visited Delaunay's studio in 1912, and prompted Kandinsky to invite Delaunay to exhibit with Der Blaue Reiter.

By 1910 Delaunay was beginning to move beyond the fauve-cubist spirit of the Eiffel Tower and St-Severin paintings, into an area of geometric abstraction charted by no other painter except Kupka. In *Window on the City No. 4 (La Ville,* colorplate 77), 1910–11, Delaunay used a checkerboard pattern of color dots, rooted in pointillism and framed in a larger pattern of geometric shapes to create a kaleidoscopic world of fragmented images. To all intents and purposes it is a work of abstraction—one of the first in modern painting—closely following in time, yet independent of Kandinsky's initial essays in abstract expressionism.

In *The City of Paris* (fig. 359), a monumental work painted for the 1912 Salon des Indépendants, he introduced three elongated nudes, posed as the Three Graces, into an urban landscape of buildings, bridges, church, and the Eiffel Tower, all dissolved into a pattern of rectilinear color shapes intensified in brilliance and luminosity. Delaunay was one of the first to bring a full-color palette into analytical cubism and thus to prepare the way for synthetic cubism. By 1912 he had abandoned even the overtone of subject, creating an arrangement of vividly colored circles and shapes that have no reference in observed nature.

At the same moment Kupka, working in Paris, had arrived at the same point of abstraction. He probably, in fact, had arrived there somewhat earlier; but since he was then relatively unknown compared with Delaunay, his immediate influence could not have been comparable. As early as 1909, Kupka, in *The First Step* (colorplate 78), had made an abstract pattern of color spheres suggestive of planets revolving around dead white suns; it is a document in the origins of abstraction. In 1912, with the painting he entitled the *Disks of Newton (Study for Fugue in Two Colors,* colorplate 79), he created an abstract world of vibrating, rotating color circles. During the same year, Kupka produced geometric abstractions involving curves other than the circle and, most important, his *Vertical Planes,* 1912–13 (fig. 360), a somber study of vertical rectangles in low-keyed grays, blacks, and whites, with one accent of violet, a work that anticipates the suprematism of Malevich.

Delaunay had given his circular disks the title of *Disques Simultanés (Simultaneous Disks,* a title derived from Chevreul), but Apollinaire named the abstract experiments of Delaunay and Kupka "orphism," a recognition that what was involved was an art in its way as di-

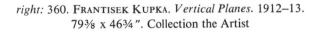

*above:* 359. ROBERT DELAUNAY. *The City of Paris.* 1910–12.
8′ 9″ x 13′ 4″. Musée National d'Art Moderne, Paris.

*right:* 360. FRANTISEK KUPKA. *Vertical Planes.* 1912–13.
79⅜ x 46¾″. Collection the Artist

*below:* Colorplate 67. HENRI LAURENS.
*Guitar and Clarinet.* 1920.
Polychrome stone, 12½ x 14 x 3½ ".
The Joseph H. Hirshhorn Collection

*above right:*
Colorplate 68. JUAN GRIS.
*La Place Ravignan,*
*Still Life in Front of*
*an Open Window.* 1915.
Oil on canvas, 45⅞ x 35⅛".
The Philadelphia Museum
of Art. Louise and Walter
Arensberg Collection

*left:*
Colorplate 69. JUAN GRIS.
*Guitar with Sheet of Music.*
1926. Oil on canvas,
25⅝ x 31⅞". Collection
Mr. and Mrs. Daniel
Saidenberg, New York

201

above opposite: Colorplate 72.
FERNAND LEGER. *The City*. 1919.
Oil on canvas, 7′ 7″ x 9′ 9″.
The Philadelphia Museum of Art.
A. E. Gallatin Collection

below opposite: Colorplate 73.
FERNAND LEGER. *Three Women*
(*Le Grand Déjeuner*). 1921.
Oil on canvas, 72¼ x 99″.
The Museum of Modern Art, New York
Mrs. Simon Guggenheim Fund

above: Colorplate 70. ALBERT GLEIZES.
*Symphony in Violet*. 1930–31.
Oil on canvas, 77 x 51½″.
Collection Rudolf Indlekofer, Basel

right: Colorplate 71. ROGER DE LA FRESNAYE.
*Conquest of the Air*. 1913.
Oil on canvas, 92⅞ x 77″.
The Museum of Modern Art, New York.
Mrs. Simon Guggenheim Fund

203

Colorplate 74. FERNAND LEGER.
*The Great Parade.* 1954.
Oil on canvas, 9′ x 13′ 1″.
The Solomon R. Guggenheim
Museum, New York

Colorplate 75. ROBERT DELAUNAY. *St-Severin.*
1909. Oil on canvas, 44⅞ x 35⅛″.
The Solomon R. Guggenheim Museum, New York

Colorplate 76. ROBERT DELAUNAY. *Eiffel Tower in Trees.*
1909. Oil on canvas, 49⅞ x 36½″.
The Solomon R. Guggenheim Museum, New York

Colorplate 77. ROBERT DELAUNAY. *Window on the City No. 4 (La Ville).* 1910–11.
Oil on canvas, 44¾ x 51½". The Solomon R. Guggenheim Museum, New York

Colorplate 78. Frantisek Kupka.
*The First Step.* 1909.
Oil on canvas, 32¾ x 51″.
The Museum of Modern Art, New York.
Hillman Periodicals Fund

Colorplate 79. Frantisek Kupka.
*Disks of Newton (Study for Fugue
in Two Colors).* 1912.
Oil on canvas, 39⅜ x 29″.
The Philadelphia Museum of Art.
Louise and Walter Arensberg Collection

206

Colorplate 80.
ROBERT DELAUNAY.
*Homage to Blériot*. 1914.
Watercolor on canvas,
98½ x 98½ ″.
Kunstmuseum, Basel

Colorplate 81.
JACQUES VILLON.
*Soldiers on the March*. 1913.
Oil on canvas, 25⅝ x 36¼ ″.
Galerie Louis Carré, Paris

207

left: Colorplate 82. MARCEL DUCHAMP.
*Nude Descending a Staircase, No. 2.*
1912. Oil on canvas, 58 x 35″.
The Philadelphia Museum of Art.
Louise and Walter Arensberg Collection

below: Colorplate 83. FRANCIS PICABIA.
*Catch as Catch Can.* 1913.
Oil on canvas, 39⅝ x 32¼″.
The Philadelphia Museum of Art.
Louise and Walter Arensberg Collection

vorced as music from the representation of the visual world or literal subject. Kandinsky, it will be recalled, had equated his abstract-expressionist paintings with pure musical sensation.

Kupka continued to experiment with abstract forms, but Delaunay alternated abstraction with representation, returning from time to time to his favorite Eiffel Tower theme. He introduced literal images into his compositions of disks, as in *Homage to Blériot,* 1914 (colorplate 80), in which appear airplanes, propellers, suggestions of figures, and even the Eiffel Tower, all encompassed in spinning disks. His disks thus become symbols of the planets now, at the threshold of the space age, becoming accessible through the miracle of aviation.

## JACQUES VILLON *(1875–1963).*

## MARCEL DUCHAMP *(b. 1887)*

## AND FRANCIS PICABIA *(1879–1953)* TO 1914

From the middle of the nineteenth century, artists, in a sense, had been groping their way toward a goal achieved, within a year or two of one another, by Kandinsky in Germany and Kupka and Delaunay in France: an art of non-representation in which the illusion of nature was completely eliminated, and whose end purpose was organization of the artist's means—color, line, space, and their interrelations and expressive potentials. It is, thus, curious that the impact of the actual achievement was not initially greater or more widespread. The quest for an abstract vocabulary continued to be carried on during the second decade of the twentieth century, particularly by a few artists in Holland, Russia, and Germany;

but during the same period World War I was disrupting all creative effort everywhere. New forces, new attitudes, were beginning to make themselves felt.

Among the first artists to desert cubism in favor of a new approach to subject and expressive content was Marcel Duchamp, one of the most fascinating, controversial, and influential figures in the history of modern art. As previously noted, Duchamp (the youngest) was one of three brothers, all of whom contributed significantly to the art of the twentieth century. Jacques, who took the name Villon, was at the other extreme from Marcel. He established a personal, highly abstract, and poetic approach to cubism, and maintained this approach with elegance and consistency throughout his long life. In *Soldiers on the March,* 1913 (colorplate 81), the colors are cool and delicate, and the crystalline structure of jagged triangular shapes with precisely ruled contours becomes predominant. This is the type of structure which Villon made his own and on which he played variations throughout his life. The sense of rapid, clearly defined motion represents a personal exploration of cubism that was to have an impact on the development of futurism.

During the 1920s and 1930s Villon moved back and forth between abstraction and a kind of simplified realism. The abstract work was based on cubist forms but with no suggestion of cubist subject. In the realistic work, portrait heads were built up of geometric facets projecting from the picture plane, in a manner comparable to some of Picasso's first cubist heads but with the notable addition of light and color. The *Portrait of the Artist's Father* (fig. 361), in which the white head of the old man projects from planes of yellow, is a work of romantic sensibility. Contrasting with this, *Color Perspective* (fig. 362)

363. JACQUES VILLON. *The Chessboard.* 1920. Etching.
The Museum of Modern Art, New York. Gift of Ludwig Charell

is a geometric abstraction in which Villon's sole concern is the formal relationships of the color shapes and the space they occupy and create.

Villon was a fine graphic artist. Printmaking was a medium to which he gravitated naturally because of his passion for line. His etching *The Chessboard,* 1920 (fig. 363)—he painted the same subject in 1919—reveals his technical virtuosity and his delight in illusionistic effects, achieved through intricate combinations of reality and abstraction, of Renaissance perspective and cubist fragmentation. This fascination with illusion is also evident in the painting entitled simply *Abstraction* (fig. 364), a starkly painted perspective box with the window opening on the infinity of the blue sky. The box turns itself inside out before the spectator, and is given a quality of fantasy by a whiplash line that swirls inexplicably in empty space.

The art of Marcel Duchamp has always been at the opposite pole from his brother Jacques' delicate, sensitive, and consistent art. Until 1910 he worked in a relatively conventional manner based on Cézanne and the impressionists. In 1911 he painted *Portrait of Chess Players* (fig. 365), obviously after coming under the influence of Picasso's and Braque's cubist explorations. The color is low-keyed and virtually monochromatic, the space, ambiguous. The linear rhythms are curvilinear rather than rectangular; the figures concentrate with tense energy, and are characterized by an individuality that causes their fragmentation to invoke a fantastic rather than a structural presence. Even at the moment

when he was learning about cubism, Duchamp was already revolting against it, transforming it into something entirely different from the conceptions of its creators.

During the same year he painted the first version of the work by which he is best known, *Nude Descending a Staircase, No. 1* (fig. 366), which was destined to become internationally notorious as a popular symbol of the madness of modern art. In this, the staircase is presented quite literally and the figure, multiplied into several figures as well as fragmented into loosely organic shapes, is easily recognizable. In the second version (colorplate 82), the figure is fragmented and multiplied even further; the facets are more sharply geometrized; the motion becomes accelerated and staccato. Other cubists objected to the work for its literary title and explicit subject, and Duchamp withdrew it from the 1912 Salon des Indépendants. The critics were right. This is not simply a cubist painting; it is a painting in which cubist means are used for some peculiarly personal expressive effect. The rapidly descending figure was not merely an organization of abstract lines and shapes but also a living figure set in a common enough environment, engaged in a routine but disconcertingly transformed activity. Duchamp here was deliberately attempting to reintroduce elements of subject—action, mood, personality—into cubist painting. In so doing he was striking at the bases of cubist thinking, and initiating a new kind of subject emphasis that was to affect Italian futurist painting and sculpture immediately; later, and even more directly, it was to shape the course of dadaism, surrealism, and other explorations into fantasy and expression. Duchamp was an instinctive dadaist, an iconoclast in art even before the creation of dada, so it is natural that he should have been immediately recognized by the first dadaists and surrealists as a great forerunner. From an attack on cubism that involved a new approach to subject, he passed, between 1912 and 1914, to an attack on the nature of subject painting, and finally to a personal re-evaluation

364. JACQUES VILLON. *Abstraction.* 1932.
21¾ x 26⅛". The Philadelphia Museum of Art.
Louise and Walter Arensberg Collection

365. MARCEL DUCHAMP.
*Portrait of Chess Players.* 1911.
39¾ x 39¾". The Philadelphia Museum of Art.
Louise and Walter Arensberg Collection

366. MARCEL DUCHAMP.
*Nude Descending a Staircase, No. 1.* 1911.
37¾ x 23¾". The Philadelphia Museum of Art.
Louise and Walter Arensberg Collection

of art and an attack on its very nature. This phase of his career is properly examined later, along with fantastic, irrational, and accidental art, as well as anti-art—all slowly becoming major opposition to cubism and abstraction.

The transition of Francis Picabia from cubism to dadaism parallels that of Duchamp, but Picabia cannot be considered an artist of the same magnitude. Until 1912 he was involved with the cubist exhibitions and propaganda of Gleizes and Metzinger and exhibited with the Section d'Or; he then went over to orphism. *Dances at the Spring* (fig. 367) reveals a gay, dynamic approach to cubism in which considerable emphasis is placed on the sculptural geometry of the figures. In *Catch as Catch Can* (colorplate 83) the colors are both more intense and more somber, with an interplay of blacks and reds suggesting the rhythmic pattern of the procession. Like the *Dances,* this painting demonstrates a departure from orthodox cubism in giving stress to actual incident—a dance or procession—and attempting to retain the literal character of the event within the cubist context. This concern with subject led him, in 1913, to abandon cubism and begin creating a world of unearthly machines. In New York in 1915, together with Duchamp and Man Ray, he founded the American wing of what was to become international dada. From that moment forward, Picabia was intensely involved in dada and surrealism.

367. FRANCIS PICABIA. *Dances at the Spring.* 1912.
47½ x 47⅜". The Philadelphia Museum of Art.
Louise and Walter Arensberg Collection

# FUTURISM IN ITALY

Cubism, although it began to affect German expressionism only in the later paintings of Marc, Macke, and Lyonel Feininger, was implicit in Italian futurist painting and sculpture at the very birth of the movement. Futurism was first of all a literary concept, born in the mind of the poet and propagandist Filippo Tommaso Marinetti in 1908, and propagated in a series of manifestoes in 1909, 1910, and subsequently. Essentially a Milanese movement, it began as a rebellion of young intellectuals against the cultural torpor into which Italy had sunk during the nineteenth century; and, as so frequently happens in such movements, its manifestoes were initially intent on what they had to destroy. The first manifesto demanded the destruction of the libraries, the museums, the academies, and the cities of the past that were themselves mausoleums. It extolled the beauties of revolution, of war, of the speed and dynamism of modern technology: " . . . a roaring motorcar, which looks as though running on shrapnel, is more beautiful than the *Victory of Samothrace*." Much of the spirit of futurism reflected the flamboyant personality of Marinetti himself; and he in turn was an extreme case of the indignation that his generation felt over the cultural and political decline of Italy. The futurism of Marinetti and his followers was rooted in the philosophies of Henri Bergson and Friedrich Nietzsche and in the prevalent atmosphere of anarchism. It was attacking the ills of a lopsided aristocratic and bourgeois society; in the field of politics it unfortunately became a pillar of Italian fascism.

Early in 1909 the painters Umberto Boccioni, Carlo Carrà, and Luigi Russolo joined with Marinetti. Later they were also joined by Gino Severini, who had been working in Paris since 1906, and Giacomo Balla. The group drew up its own manifesto in 1910. This again attacked the museums, the libraries, and the academies, and paid homage to the idea of simultaneity of vision, of metamorphosis, and of motion that constantly multiplied the moving object. Particular emphasis was given to the unification of the painted object and environment, so that no clear distinction could be drawn between the two. The targets of the futurists included all forms of imitation, concepts of harmony and good taste, all art critics, all traditional subjects, tonal painting, and even that perennial staple, the painted nude.

At this point, the paintings of the futurists had little in common and demonstrated no startling originality. Many of their ideas still came from the unified color patterns of the impressionists and even more explicitly from the divisionist techniques of the neo-impressionists. But unlike impressionism, post-impressionism, fauvism, and cubism, all of which were generated by a steady interaction of theory and practice, futurism emerged as a fullblown theory based on and anticipated by literary theories; the artists then set themselves to produce paintings that illustrated the theory. This was really a sort of academy of the avant-garde; and it is remarkable that so substantial a number of effective and, at times, original works should have been produced by it. The futurists were passionately concerned with the problem of establishing an empathic identity between the spectator and the painting, "putting the spectator in the center of the picture." In this they were close to the German expressionists, as noted previously. And although they absorbed the technical vocabulary of cubism, their aim was not formal analysis but direct appeal to the emotions.

The art of the futurists extolled metropolitan life and modern industry. This did not result in a machine aesthetic in the manner of Léger, since they were concerned with unrestrained expression of individual ideals, with mystical revelation achieved through an orgiastic involvement in total action. Despite their identity of purpose, the art of the futurists cannot be considered a unified style like impressionism or cubism. Balla, the oldest of the group and the teacher of Severini and Boccioni, early in the century was painting realistic pictures with social implications. He then became a leading Italian exponent of neo-impressionist divisionism, and in this context most strongly influenced the younger futurists.

368. UMBERTO BOCCIONI. *The Laugh*. 1911.
43⅜ x 57¼". The Museum of Modern Art, New York.
Gift of Mr. and Mrs. Herbert M. Rothschild

Balla's painting *The Street Light—Study of Light* (colorplate 84) is one of the earliest examples of pure futurism. Using V-shaped brush strokes of complementary colors radiating from the central source of the lamp, he created an optical illusion of light rays translated into dazzling colors so intense that their vibration becomes painful to the eye. Carlo Carrà, in his *Funeral of the Anarchist Galli,* 1910–11 (colorplate 85), uses violent reds and blacks organized in acute diagonals of figure movement to re-create the wild riot that erupted on that occasion. Whereas in the Balla work a divisionist technique was used in creation of emotional color impact, in Carrà's *Funeral* we remain conscious of a cubist structure translated into action.

Boccioni, perhaps the most talented of the futurists, produced his first important futurist painting in *Riot in the Gallery,* 1909 (colorplate 86), a work that combines some of the elements of Balla's *Street Light* and Carrà's *Funeral.* Color is used in a divisionist manner and, combined with the angular, linear surging of the mob, creates a picture of wild excitement. It resolves itself, however, into a decorative pattern from which nothing very serious can ensue. This work was preparatory to one of his most monumental efforts, *The City Rises,* 1910–11 (colorplate 87), in which he sought his first "great synthesis of labor, light, and movement." In this painting, which is dominated by the large, surging figure of the foreground horse before which the human figures fall like ninepins, he made one of the first major statements of the qualities of violent action, speed, the disintegration of solid objects by light, and their reintegration into the totality of the picture by the very same light. Such a statement represents one aspect of the futurist credo: the dynamism of work, of labor, in modern industrial society, with sheer power symbolized by rearing, thundering horses. Another aspect appears in the same artist's painting *The Laugh* (fig. 368), in which the scene is a restaurant or night club with all the paraphernalia of gay dissipation rendered in garish colors. The type of scene represented here and in Severini's night-club paintings was not done in condemnation; rather, the gaiety, the color, and the wild tempo of pleasure and dissipation were shown as part of the dynamism of the new world the futurists were seeking. Their revolt was against the deadly dullness of late nineteenth-century bourgeois morality.

Of the group, Luigi Russolo (1885–1947) was perhaps the least original as an artist but one of the strongest theoreticians. In the *Solidity of Fog* (colorplate 88), he translates the light radiating from the darkened sun through the dense fog into circles of emanation so tangible that they segment the dark figures of the foreground and absorb them into the rhythm of light and atmosphere. Russolo became so much interested in the possibilities of a futurist music that for a number of years he gave up painting in order to devote his time to the development of his noise organs, with which he was able to produce a startling range of both commonplace and extraordinary sounds. This music was an ancestor of the electronic music of today.

The futurist exhibition in Milan in May 1911 was the first of their efforts to make their theories concrete. Intoxicated by this initial effort, they then sought, through

369. UMBERTO BOCCIONI. *States of Mind I: The Farewells.* 1911. 27¾ x 37⅞". Private collection, New York

the agency of Marinetti, to invade the great art world of Paris. In the fall of 1911 Carrà and Boccioni visited Paris in order to study the latest manifestations before attempting an exhibition there. What they learned is evident in the repainted version of Boccioni's *Farewells,* 1911 (fig. 369), which is part of his triptych *States of Mind.* Within the vibrating, curving pattern he introduced a cubist structure of interwoven facets that sets up a tension of forces, of linear movement. Space is constricted and controlled; the effect is of compression rather than indefinite expansion. Boccioni even added the shock of a literal, realistic collage-like element in the scrupulously rendered numbers on the cab of the dissolving engine. It will be recalled that Braque, earlier in the year, and Picasso, toward the end of the year, introduced lettering and numbers into their analytical cubist works.

The exhibition of the futurists, held in February 1912 at the gallery of Bernheim-Jeune in Paris, was widely noticed and reviewed favorably by Apollinaire himself. It later circulated to London, Berlin, Brussels, The Hague, Amsterdam, and Munich. Within the year, from being an essentially provincial movement in Italy, futurism suddenly became a significant part of international experimental art.

### GIACOMO BALLA *(1871–1958)*

Balla, who was older than the other four members of the group, worked in Rome rather than in Milan. He pursued his own distinctive experiments, particularly in rendering motion through simultaneous views of many aspects of objects. His *Dynamism of a Dog on a Leash (Leash in Motion,* fig. 370), with its multiplication of arms and legs, has become one of the familiar and delightful creations of futurist simultaneity. The little terrier scurries along on short legs accelerated and multiplied to the point where they almost turn into wheels.

370. GIACOMO BALLA. *Dynamism of a Dog on a Leash (Leash in Motion)*. 1912. 35 x 45½″. Courtesy George F. Goodyear and the Buffalo Fine Arts Academy, New York

This device for suggesting rapid motion or physical activity later became a cliché of the comic strips and animated cartoons. The transformation of figures and objects into a moving pattern of color and line is seen again in his *Flight of the Swifts,* 1913 (colorplate 89), a bold interplay of rectilinear and curvilinear elements, both in their entirety and fragmented. The curving horizontal of the swifts' rapid flight contrasts with the zigzag organization of wings and feathers, and both gain force from the off-vertical lines that stand up like poles. The birds are literal and non-literal but the sense of flight is striking. Balla was a lyrical painter who achieved his effects without the noise and violence of some of his colleagues.

## GINO SEVERINI *(1883–1966),*

## CARLO CARRA *(1881–1966)*

Gino Severini, living in Paris, was for several years more closely associated with the growth of cubism than the other futurists. His approach to futurism is summarized in *Dynamic Hieroglyph of the Bal Tabarin* (colorplate 90), a gay and amusing distillation of Paris night life. The basis of the composition lies in cubist faceting put into rapid motion within large, swinging curves. The brightly dressed chorus girls, the throaty chanteuse, the top-hatted, monocled patron, the waiters, the food, the wine, the flags, the carnival atmosphere are all presented in a spirit of delight. This work is a tour de force involving almost every device of cubist painting and collage: not only the color shapes that are contained in the cubist grid, but elements of sculptural modeling that create effects of advancing volumes; the carefully lettered words, "Valse," "Polka," "Bowling"; and the sequins of the girls' costumes added as collage. The color has impressionist freshness, its arbitrary distribution fauve boldness. Many areas and objects are mechanized and finely stippled in a neo-impressionist manner. Severini even included one or two passages of literal representation, such

as the minuscule Arab horseman and the tiny but explicit nude riding a large pair of scissors.

The sense of fragmented but still dominating reality that persisted in Severini's cubist paintings between 1912 and 1914 found its most logical expression in a series of works involving transportation, which began in 1912 with studies of the Paris Métro. With the coming of the war, the theme of the train flashing through a cubist landscape began to intrigue him. *Red Cross Train,* 1914 (fig. 371), is a stylization of motion, much more deliberate in its tempo than the *Bal Tabarin.* The telescoped, but clearly recognizable train, with regular balloons of smoke billowing forth, cuts across the middle distance of large, handsome planes of strong color that intersect the train and absorb it into the total pattern. The divisionist brush stroke is used in the color areas, and the total effect is static rather than dynamic, and surprisingly abstract in feeling. Perhaps the most significant development in Severini's painting during those two years was a movement toward total abstraction stemming from the influence of Delaunay. In *Spherical Expansion of Light (Centrifugal,* colorplate 91), Severini organized what might be called a futurist abstract pattern of triangles and curves, built up of divisionist brush strokes.

Carlo Carrà, from 1912, was moving steadily toward an orthodox version of cubism that had little relation to the ideals of speed and dynamism of the futurist manifestoes. He returned to the nude, a subject that led him toward a form of massive, sculptural modeling (*Simultaneity, Woman on a Balcony,* 1912–13; fig. 372). It was only a short step from this work to the metaphysical painting of Giorgio de Chirico, which Carrà began to adopt about 1916. In the collage painting *Patriotic Celebration (Free Word Painting,* colorplate 92), Carrà followed Marinetti's invention of "free words," which were to supersede "free verse" and, through their visual associations, to affect and stimulate the spirit and imagination directly, without the intervention of reason. Again, the futurists anticipated tendencies that were not to become dominant until almost half a century later.

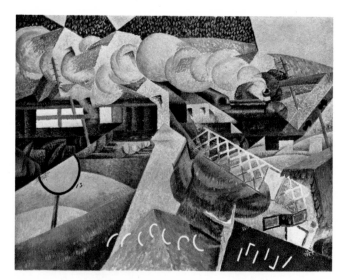

371. GINO SEVERINI. *Red Cross Train.* 1914. 35¼ x 45¾″. The Solomon R. Guggenheim Museum, New York

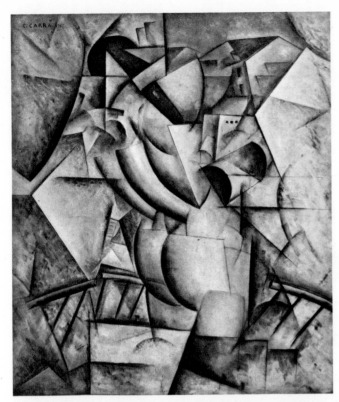

372. CARLO CARRA. *Simultaneity, Woman on a Balcony.*
1912–13. 57⅛ x 52⅜".
Collection Riccardo and Magda Jucker, Milan

## FUTURIST SCULPTURE:

## UMBERTO BOCCIONI *(1882–1916)*

Umberto Boccioni's career, cut short in 1916, demonstrated greater consistency than that of most of his fellow futurists. For a time he, like other futurists, played back and forth between precise realism and a cubist-futurist structure of transparent color planes. His *Dynamism of a Cyclist* (fig. 373) illustrates a move toward abstraction almost as complete as Severini's, with the difference that Boccioni faithfully maintained a suggestiveness of abstract shapes, to the point where they resemble Kandinsky's more ordered abstraction of the same moment. But the greatest contribution of Boccioni during the last few years of his life was the creation of futurist sculpture. Taking off from the impressionist sculptures of Medardo Rosso (see figs. 102, 103)—perhaps the only other Italian sculptor of stature working in the early years of the twentieth century—Boccioni sought to assimilate the figure or object to the surrounding environment in the manner of his paintings. This he did first by attacking the age-old problem of how to organize three-dimensional, intangible space so that it is expressed as fully as solid mass. In his *Technical Manifesto of Futurist Sculpture,* 1912, he began with the customary attack on all academic tradition. The attack became specific and virulent on the subject of the nude, which still dominated the work not only of the traditionalists but even of the leading progressive sculptors Rodin, Bourdelle, and Maillol. In Rosso's impressionist sculpture and contemporary themes Boccioni found the most exciting innovations for sculpture; yet he recognized that, in his concern for the transitory moment, Rosso was bound to the subject in nature in the same way as the impressionist painters.

Boccioni, on the other hand, sought for eternal values in sculpture—"the style of movement" and "sculpture as environment." "Absolute and complete abolition of definite lines and closed sculpture. We break open the figure and enclose it in environment." He reaffirmed the sculptor's right to use any form of distortion or fragmentation of figure or object, and insisted on the use of every kind of material—"glass, wood, cardboard, iron, cement, horsehair, leather, cloth, mirrors, electric lights, etc., etc."

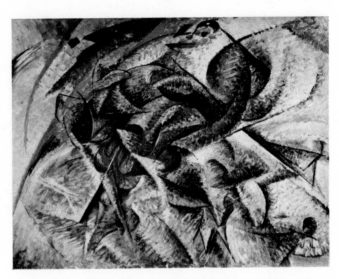

373. UMBERTO BOCCIONI. *Dynamism of a Cyclist.* 1913.
37⅜ x 27⅝". Collection Gianni Mattioli, Milan

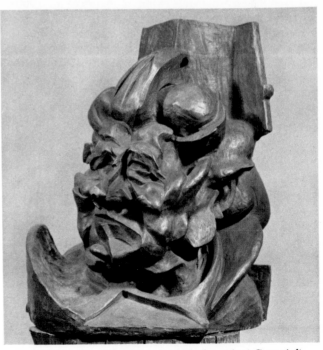

374. UMBERTO BOCCIONI. *The Mother (Anti-Graceful).*
1912. Bronze, height 24".
Collection Mrs. Barnett Malbin, Birmingham, Michigan

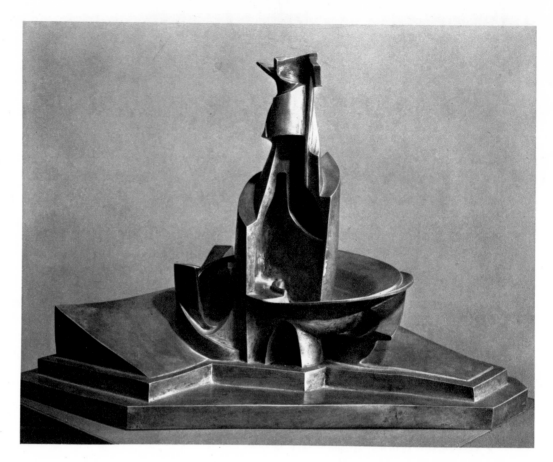

375. UMBERTO BOCCIONI.
*Development of a Bottle in Space.*
1912. Bronze, height 15″.
The Museum of Modern Art,
New York.
Aristide Maillol Fund

The sculpture manifesto was even more important than the painting manifestoes in the degree that it prophesied the development of constructivist sculpture, dada and surrealist assemblage, sculpture as literal motion, and even the environments of pop sculptors of the 1960s. Boccioni did not mention Picasso's 1909 cubist head or Archipenko's or Duchamp-Villon's first cubist experiments, and he may not have been aware of these. The program he was proposing, however, went beyond anything envisaged in these early and tentative efforts at cubist sculpture. Picasso's first cubist constructions date from 1912–13, and the first thorough exploration of collage by Picasso and Braque, from 1912. Yet it is difficult to conceive of Boccioni's early futurist portrait *The Mother* (*Anti-Graceful,* fig. 374), without the precedent of Picasso's 1909 *Head of Fernande Olivier* (see fig. 205). The forms are more fluid, the concentration on characterization more explicit, but the fragmentation of masses is closely comparable. In total, the Boccioni portrait seems to lie somewhere between Picasso's cubist sculptural faceting of surface and Rosso's impressionist diffusion of surface. On the other hand, the *Development of a Bottle in Space* (fig. 375), although cast in bronze, constituted an enlargement of the tradition for the analysis of sculptural space. The bottle is stripped open, unwound, and integrated with an environmental base that makes of the homely object, only fifteen inches high, the model of a vast monument of three-dimensional masses existing totally in surrounding three-dimensional space. More ambitious, though less successful as sculptural environments, were the artist's two destroyed works of 1912, *Fusion of*

376. UMBERTO BOCCIONI. *Unique Forms of Continuity in Space.* 1913. Bronze, height 43½″. The Museum of Modern Art, New York. Acquired through the Lillie P. Bliss Bequest

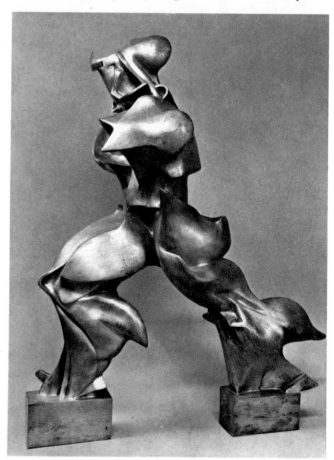

*a Head and a Window* and *Head & House & Light,* in which he attempted a literal fusion of figure and architectural elements, using all sorts of materials. These noble experiments, although disastrous in execution, were nevertheless prophetic prototypes of dada and surrealist assemblages and pop art environments.

Boccioni's most impressive sculpture, the *Unique Forms of Continuity in Space* (fig. 376), was also his most sculpturally traditional and the one most specifically related to his paintings. The striding figure, made up of fluttering, curving planes of bronze, moves essentially in two dimensions, like a translation of his painted figures into relief. In effect, it is comparable with the *Victory of Samothrace,* with her wings and draperies flowing out behind her, rather than like the total sculptural environment for which he pleaded in his own sculptural manifesto.

## FUTURIST ARCHITECTURE:

### ANTONIO SANT'ELIA *(1888–1916)*

In the First Free Futurist Exhibition, held in Rome in 1914, a number of younger artists—Giorgio Morandi, Mario Sironi, Enrico Prampolini, and others—joined with the original five. The most interesting new recruit was the young architect Antonio Sant'Elia, who drew up his own *Manifesto of Futurist Architecture,* probably with the ever-present assistance of Marinetti. Like Toni

Garnier in his plans for the Industrial City, Sant'Elia conceived of cities built of the newest materials, in terms of the needs of modern man, and as expressions of the dynamism of the modern spirit. His ideas, largely monumental visions, remained on the drawing board. Today they have the dated appearance of a classical pseudo-modernism, but his *Manifesto* is perhaps his greatest achievement, for it was an important contribution to the development of modern architecture in Europe. However, in some of his daring engineering concepts (fig. 377) there is a suggestion of the magnificent achievements of Pier Luigi Nervi, the Italian master and one of the world's masters of structural engineering.

World War I wrote finis to the first and only significant stage of Italian futurism, although many of the more propagandist ideas and slogans were integrated into the rising tide of fascism and used for political and social ends. The futurists themselves, still led by Marinetti, were drawn more and more into specific war propaganda. Carrà devised the hysterical if fascinating propaganda collage (see colorplate 92). Using radiations of colors and lines and verbal symbols, he extolled the king and the army, and simulated visually the noises of sirens and mobs. Boccioni, in the *Cavalry Charge,* extolled his subject in jagged diagonals of lances, and Severini followed his more temperate series of Red Cross Trains with an *Armored Train,* 1915, a pictorial monument to mechanized warfare.

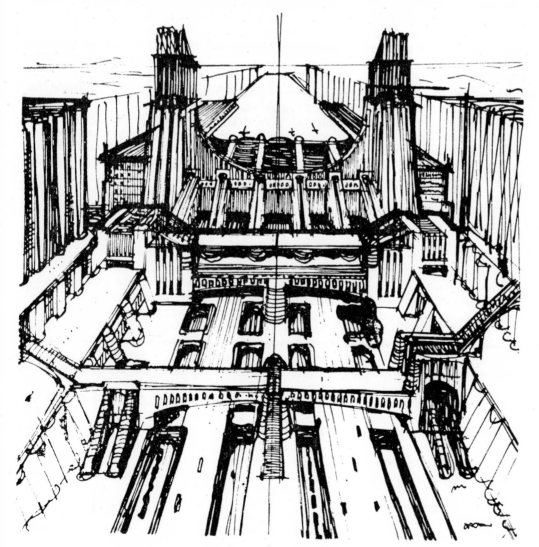

377. ANTONIO SANT'ELIA.
Project for Città Nuova.
1914

217

# PART TEN

# ABSTRACTION AND CONSTRUCTIVISM IN RUSSIA

## The Emergence of Abstract Art

The term "abstraction," understood as something abstracted from nature, has always been a matter of controversy, perhaps because of the implication that to "abstract" something is to lessen or demean it. Music and architecture have always been recognized as abstract arts whereas, in the classical tradition from the time of Aristotle, literature and the visual arts of painting and sculpture have been conceived of as imitative arts. From at least the middle of the nineteenth century artists were consciously or unconsciously moving toward a conception of painting as an entity in itself and not an imitation of anything else. The difficulty with abstract as a term for art that does not represent nature is that it has been used indiscriminately for all art in which the subject is subordinated or distorted in order to place the emphasis on the plastic or expressive means. The term is sometimes loosely applied to certain fauve and cubist paintings where subject does not predominate, as well as to examples of cubist sculpture. However, as long as there is a residue of recognizable subject, abstract is not really an unexceptionable designation. Cubism, as already seen, may be on the road to abstraction, but it is not in itself abstract.

Various efforts have been made to find a more satisfactory name for the waves of non-imitative paintings and sculptures that the twentieth century has produced. Theo van Doesburg proposed the term "concrete" in 1930; and "non-objective" has been widely used for the abstractions of Mondrian and his followers. No really satisfactory substitute has been found, however, and there seems no reason why the term abstract should not continue to be used.

Kandinsky seems to have the best claim to have been the first abstract painter who realized the implications of the non-representational, expressionist works he created. Beyond question, however, abstract paintings existed before Kandinsky: a number of art nouveau paintings by Van de Velde and others have no recognizable subject matter, although they may be loosely based on plant forms. Delaunay in 1911 was creating color patterns from which the naturalistic subject had virtually disappeared; and Kupka was working in an almost completely abstract manner at the same moment.

It is at least conceivable that the almost total absence of experiment in Russian art made certain artists, aware of developments in France and other countries, feel that the only solution was the most violent form of revolution against the dominant academic past. In any event, in sculpture as in painting, Russia passed with little transition from nineteenth-century academicism to complete abstraction. Only a few artists were involved—among the painters, Mikhail Larionov, Natalia Goncharova, Kasimir Malevich, El Lissitzky and, of course, Kandinsky; among the sculptors, Vladimir Tatlin, Alexander Rodchenko, Naum Gabo, and his brother, Anton Pevsner—but their influence was crucial for all subsequent twentieth-century art.

In the attempt to evaluate the Russan achievement in the early century, a number of points must be kept in mind. Russia, since the eighteenth century of Peter and Catherine the Great, had maintained a tradition of patronage of the arts and had close and continuous ties with the West. Russians who could afford it traveled frequently to France, Italy, and Germany. Through periodicals they were aware of new developments in art, music, and literature. Russian literature and music had attained great heights during the nineteenth century, and theater and ballet had made substantial strides. The nineteenth-century Russian proclivity for utopian communities made itself evident in the arts, in groups such as The Wanderers, a colony of artists brought together in the 1870s by Savva Mamontov, a wealthy, nationalistic Russian connoisseur and social idealist. Mamontov was also active as a patron of the theater and opera, and helped to open up theater design to practicing artists. This wedding of painting and theater was to become characteristic of the expansion of Russian experiment in the arts.

Perhaps the most talented of the Russian pioneers who eased the transition to the twentieth century was Mikhail Vrubel (1856–1910), a man who received little recognition during his own lifetime. Through Vrubel, who was a brilliant draftsman saturated in the Russian Byzantine tradition, much of the spirit of Western art nouveau entered Russian art. Art nouveau and the ideas of French symbolists and nabis made themselves widely felt in the late 1880s through the movement known as the World of Art, under the leadership of Alexander Benois, a talented entrepreneur, artist, theater designer, cosmopolitan critic and scholar who preached and practiced the integration and the unity of the arts.

Léon Bakst, who later gained international fame as a stage designer, was one of the first professional artists associated with the World of Art. In 1890 the group was joined by Sergei Diaghilev, who was destined to become perhaps the greatest of all impresarios of the ballet. The *World of Art* periodical, first appearing in 1898, brought together the younger leaders among poets and artists and served to introduce, to a Russian audience, the French symbolist poets, the English and Austrian art nouveau artists and architects, and the French post-impressionists. A few years later, Diaghilev was launched on his career as an impresario, arranging exhibitions, concerts, theatrical and operatic performances, and ultimately the Russian ballet, which opened in Paris in 1909 and went from success to success. From then on, Diaghilev was to draw on many of the greatest names in European painting to create sets.

After the *World of Art* magazine came other avant-garde journals. Through them, and through journeys to Paris and Italy, young Russian artists could watch the progress of fauvism, cubism, futurism, and their offshoots. Great collections of the new French art were formed by Sergei Shchukin and Ivan Morozov in Moscow. Shchukin's collection by 1914 contained over 200 works by French impressionist, post-impressionist, fauve, and cubist painters, including more than 50 by Picasso and Matisse, as well as examples by Manet, Monet, Renoir, Cézanne, and Van Gogh. Morozov's slightly less experimental collection of 130 works included Cézanne, Renoir, and Gauguin, and many works by Matisse. Both collectors were most generous in opening their collections to Russian artists, and their effect on these artists were incalculable. Through these collections of modern art and the exhibitions of the Jack of Diamonds group founded in 1910 by Larionov, cubist experiments were known in Leningrad and Moscow almost as early as they were inaugurated. Marinetti, apostle of futurism, visited Russia in 1914 (and perhaps earlier), and his ideas may have affected some of the Russian avant-garde.

## RAYONNISM AND SUPREMATISM:

## MIKHAIL LARIONOV *(1881–1964),*

## NATALIA GONCHAROVA *(1881–1962)*

Early in 1911 Larionov and Goncharova were in correspondence with Kandinsky, who was much interested in their experiments. They started a movement called "rayonnism," and in the 1913 exhibition called "The Target," the first group of rayonnist works were shown. Rayonnism was an offshoot of cubism, and was related to Italian futurism in its emphasis on dynamic, linear light rays. Through these, Larionov sought to express visually the new concepts of time and space that had taken shape in the thought of the mathematicians Arthur Cayley and Felix Klein, the philosopher-physicist Ernst Mach, the physicist Albert Einstein, and others. In Larionov's manifesto, a seeming satire on futurist manifestoes, he extolled the everyday objects of current civilization, denied the existence of individuality, and praised the Orient as against the West.

Larionov and Goncharova left Russia in 1914 to de-

378. MIKHAIL LARIONOV. *Blue Rayonnism.* 1912. 25½ x 27½ ". Collection Boris Tcherkinsky, Paris

sign for Diaghilev. Neither artist produced more than a few rayonnist paintings that were significant (fig. 378); but their ideas, involving an art that was a synthesis of cubism, futurism, and orphism and, in addition, "a sensation of what one may call, 'the fourth dimension,' " were of the greatest significance in their influence on Malevich and the development of suprematism.

## KASIMIR MALEVICH *(1878–1935)*

More than any other individual, even Delaunay or Kupka, it was Kasimir Malevich who first took cubist geometry to its logical conclusion of absolute geometric abstraction. Malevich studied art in Moscow, where he was introduced to the new tendencies through the opportunity of visiting the collections of Shchukin and Morozov. In 1906 he met Larionov and in 1910 exhibited with him and Goncharova in the first Jack of Diamonds show. By 1911 he was painting in a cubist manner. *Morning in the Country After Rain* (colorplate 93) is composed with cylindrical sculptural figures of peasants in a mechanized landscape, with houses, trees, and groundlines modeled in light, graded hues of red, white, and blue. The resemblance to Léger's somewhat later machine cubism is startling, but it is questionable whether either man saw the other's early works. For the next two years Malevich explored different aspects and devices of cubism and futurism, but he was obsessed with the anomaly of residual subject matter in his work until, according to his own description: ". . . in the year 1913, in my desperate attempt to free art from the burden of the object, I took refuge in the square form and exhibited a picture which consisted of nothing more than a black square on a

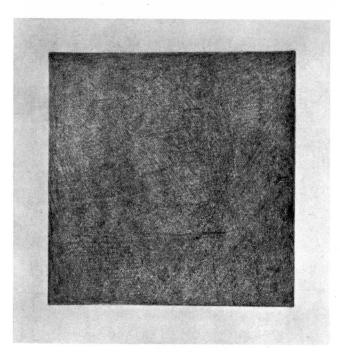

379. KASIMIR MALEVICH. *Basic Suprematist Element*. 1913.
Drawing. Russian State Museums, Leningrad

white field." This was a pencil drawing, the first example of the style to which Malevich gave the name "suprematism" (fig. 379). The artist in his book *The Non-Objective World,* defined suprematism as "the supremacy of pure feeling in creative art." "To the suprematist," he went on, "the visual phenomena of the objective world are, in themselves, meaningless; the significant thing is feeling, as such, quite apart from the environment in which it is called forth."

As with Kandinsky and his first abstract watercolor, the creation of this simple square on a white ground was a moment of spiritual revelation to Malevich, who was a devout Christian mystic. For the first time in the history of painting, he felt, it had been demonstrated that a painting could exist completely independent of any reflection or imitation of the external world—whether figure, landscape, or still life. Actually, of course, he had been preceded by Kandinsky, Delaunay, and Kupka in the creation of abstract paintings, and he was certainly aware of their efforts. Malevich, however, has an important claim to primacy in having carried abstraction to an ultimate geometric simplification—the black square of the drawing within the white square of the paper. It is tempting to reflect on the fact that the two dominant wings of twentieth-century abstraction—the abstract expressionism of Kandinsky and the geometric abstraction of Malevich—should have been founded by two Russians. Each of these men had a conviction that his discoveries were spiritual visions rooted in the traditions of Old Russia. The coincidence is intriguing.

During 1913 Malevich continued with his suprematist pencil drawings, creating first, after the initial square, an off-center circle within a square, then a horizontal rectangle crossing a vertical rectangle within the square to

form a square cross. In the initial suprematist composition, the black square within a white square was neutral in effect. In the second composition, the black circle hovering in the corner of a white square began to develop associative as well as spatial inferences. In the next composition in the series, by intensifying the dark value of the superimposed horizontal rectangle, a definite sense of the third dimension was introduced. The rectangle seems to float forward, creating the illusion of a layer of space between the horizontal and the vertical planes. From these works, Malevich developed a variation on the suprematist square involving a new, biplanar suprematist composition. This is simply two black rectangles staggered side by side in a vertical-horizontal-vertical effect, a modest but important anticipation of the shaped canvas of artists of the 1960s. In his attempts to define the fundamental new vocabulary he felt himself to be creating, he tried other combinations of rectangle, circle, and cross, oriented vertically and horizontally. Already within the year 1913, his passionate curiosity about the expressive relations of abstract geometric shapes had led him to desert the static rectangular structure and to move to a more dynamic organization of diagonally oriented rectangles arranged in a complex state of tension with one another.

It was the world of aviation and modern technology that he began to explore late in 1913 as he tilted his rectangles from the vertical. Thus between 1914 and 1918 he created suprematist compositions "expressing the sensation of flight . . . . the sensation of metallic sounds . . . . the feeling of wireless telegraphy"; "white on white, expressing the feeling of fading away . . . . magnetic attraction"; conveying the feeling of movement and resistance, the feeling of a mystic "wave" from "outer space,"

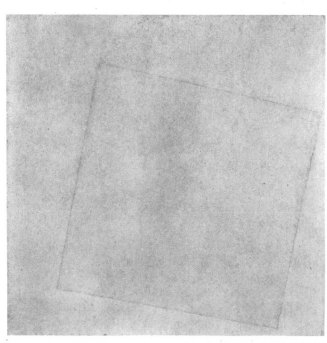

380. KASIMIR MALEVICH. *Suprematist Composition: White on White*. c. 1918. 31¼ x 31¼".
The Museum of Modern Art, New York

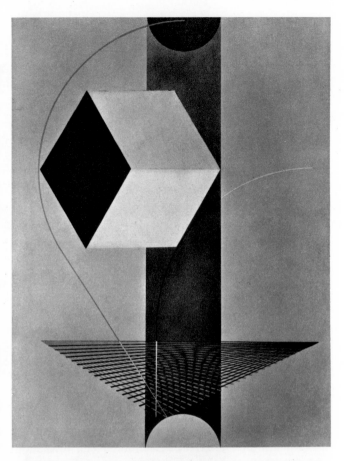

381. EL LISSITZKY. *Construction 99 (Proun 99)*. 1924–25. Oil on wood, 50½ x 38¾". Yale University Art Gallery, New Haven, Connecticut. Gift of the Société Anonyme

and even "the feeling of non-objectivity." In 1918, after the period of complication, he returned to a further simplification in the series of paintings of white on white. One example displays an acutely tilted square of white within the canvas square of a somewhat different value of white (fig. 380)—a reduction of painting to the simplest relations of geometric shapes.

Malevich understood the historic importance of architecture as, basically, an abstract visual art, and between 1915 and 1923 he experimented with three-dimensional drawings and models in which he studied the problems of form in three dimensions. These abstract three-dimensional models not only were of significance in the growth of constructivism in Russia but, transmitted to Germany and Western Europe by his disciples, notably El Lissitzky, they influenced the design teachings of the Bauhaus and the course of the international style of modern architecture.

## EL LISSITZKY *(1890–1956)*

Of the artists emerging from Russian suprematism the most influential internationally was El (Eleazar) Lissitzky, who studied engineering in Germany and on his return to Russia was associated with the non-objectivism of Rodchenko and the constructivism of Tatlin until the hostility of the Russian revolutionary government forced him to leave again for Berlin in 1921. In Berlin he was associated with the Dutch abstractionist Theo van Doesburg and the Hungarian Laszlo Moholy-Nagy. He significantly influenced the bringing together of Russian suprematism, non-objectivism, and constructivism, Dutch De Stijl, and the ideas of the German Bauhaus and, through Moholy-Nagy, the transmittal of these ideas to a generation of students in the United States and elsewhere. Lissitzky was not an original talent but a most important intermediary in the communication of the various concepts of abstraction then emerging simultaneously and independently in different parts of Europe. In his non-objective painting-constructions, to which he gave the name "Proun," he played with the elements of contemporary geometric abstraction combined with perspective illusions at an abstract level paralleling the contemporary efforts of Picasso, Gris, and other cubists at their stage of developed synthetic cubism (*Proun 99, 1924–25;* fig. 381).

## KANDINSKY IN RUSSIA, 1914–21

A far greater figure in the transmission of Russian experiments in abstraction and construction to the West was Vasily Kandinsky. Forced by the outbreak of war to leave Germany, he went back to Russia in 1914. After the Russian revolution, he was appointed professor at the Fine Arts Academy in Moscow in 1918, and in 1919 helped reorganize Russian museums. In 1920, he was appointed a professor at the University of Moscow, and a government-sponsored one-man exhibition of his works was held in Moscow. By the next year, the previously favorable climate for experiment in modern art had changed and, toward the end of 1921, Kandinsky returned once more to Germany, soon to be appointed a professor and later vice-president of the newly formed Bauhaus at Weimar.

Until 1920 Kandinsky continued to paint in the manner of free abstraction that he had first devised about 1910. In the year of his Moscow retrospective, he began to introduce, in certain paintings, regular shapes and straight or geometrically curving lines. During 1921, the geometric patterns took over altogether, and the artist moved into another major phase of his career. There can be no doubt that Kandinsky had been affected by the geometric abstractions of Malevich, Rodchenko, and the constructivists. Despite the change from free forms to color shapes bounded by regular, hard edges, the tempo of the paintings remained rapid, and the action continued to be the conflict of abstract forms. *White Line, No. 232* (colorplate 94) is a transitional work in which the major color areas are painted in a loose, atmospheric manner. However, they are accented by a pattern of sharp straight lines and regular-curve-bounded areas that brings to the work a briskness of geometric control. The circle as a central motif intrigued him during the mid-1920s, perhaps as a result of his ever-increasing fascination with the themes of universal space and the interaction of galaxies (*Several Circles, No. 323,* 1926; colorplate 95). Kandinsky's style of the 1920s takes the story of abstraction in painting into another chapter.

# Constructivism

One of the significant new concepts to develop in twentieth-century sculpture was that of construction. Sculpture, from the beginning of its history, had involved a process of creating form by taking away from the amorphous mass of the raw material—the carving of wood or stone—or by building up from the mass—modeling in clay or wax. These approaches presuppose emphasis on sculpture as an art of mass rather than of space. Even in such eras as the Hellenistic or the Baroque, when attention was paid to sculpture as an art of space, the three-dimensional masses of the carved or modeled figures were still dominant. Traditional techniques persisted well into the twentieth century, even in the work of so revolutionary a figure as Brancusi. As has been pointed out, the first cubist sculpture of Picasso, the 1909 *Head of Fernande Olivier* (see fig. 205), involved a deep faceting of the surface that respected the central mass.

True constructed sculpture, in which the form is created from elements of wood or metal, glass, or plastic, was a predictable consequence of the cubists' experiments in painting. In 1912 Picasso designed a three-dimensional cubist construction from paper and string, and in the same year was making drawings for other constructions. His 1912 *Guitar* and 1914 *Musical Instruments* (see figs. 215, 216) are constructions of sheet metal and wire, or wood, cubist in form. Although they

382. VLADIMIR TATLIN. Model for *Monument to the Third International*. 1919–20. Wood, iron, and glass. Russian State Museums, Leningrad

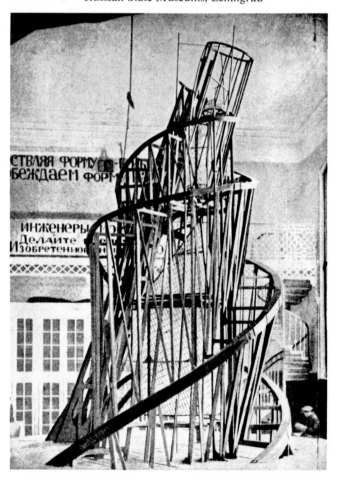

were crude in execution, the artist stated in them the basic problem of constructivist sculpture—the assertion of sculptural space rather than of sculptural mass.

It is curious that after these pioneer efforts of Picasso, the subsequent development of constructed sculpture, particularly in its direction toward complete abstraction, should have taken place not in France but elsewhere. Archipenko, working in Paris, had made a contribution to space sculpture with his 1912 *Walking Woman* (see fig. 323), but this was still a modeled figure built up from clay in the traditional manner. Boccioni's futurist sculpture manifesto of 1912 recommended the use of unorthodox materials suitable to construction, but his actual constructed sculpture was tied to literal or cubist subject. Archipenko's constructed Medrano figures (see fig. 324), executed between 1912 and 1914, were experiments in space-mass reversals, but the artist never deserted the subject—figure or still life—and soon reverted to a form of cubist sculpture modeled in clay for casting in bronze.

In France and Italy the traditional techniques of sculpture—modeling, carving, bronze casting—were probably too powerfully imbedded to be overthrown, even by the leaders of the modern revolution. Sculptors who attended art schools—Brancusi and Lipchitz for example—were trained in technical approaches unchanged since the eighteenth century. Modern sculpture in France emerged from the Renaissance tradition more gradually and imperceptibly than modern painting. Thus, it is possibly a consequence of this evolutionary rather than revolutionary process that most of the pioneer experimentalists continued to utilize traditional techniques and the traditional human figure. Aside from Picasso's isolated experiments and the more developed constructions of Henri Laurens, the translation of cubist collage into three-dimensional abstract construction was achieved in Russia first, then in Holland and Germany.

## VLADIMIR TATLIN (1895–1956)

The founder of Russian constructivism was Vladimir Tatlin. In 1913 he visited Berlin and Paris. He saw the paintings in Picasso's studio in Paris and not only was affected by them, but also—and particularly—by the constructions in which Picasso was investigating the implications of collage for sculpture. The result, on Tatlin's return to Russia, was a series of reliefs constructed from wood, metal, and cardboard, with surfaces coated with plaster, glazes, and broken glass. They were among the first complete abstractions, constructed or modeled, in the history of sculpture—the ancestors of the dada sculptures of Kurt Schwitters or the junk sculpture of the 1960s.

Tatlin's attitudes toward abstraction closely paralleled those of Malevich. Tatlin's first abstract reliefs have disappeared, and the only record of them is a number of indifferently reproduced illustrations. Even these, however, show, between 1913 and 1916, an obsession with space as the primary concern of the sculptor: detached, without a solid base, they embody the idea of flight. The so-called counter-reliefs, begun in 1915, were suspended by wires across the corner of a room, as far removed from the earthbound tradition of past sculpture as the limited

technical resources of the artist permitted. His interest in engineering and architecture saw its most ambitious result in his model for a *Monument to the Third International* (fig. 382). Had the full-scale project been built, it would have been approximately 1300 feet high, the biggest sculptural form ever conceived by man. Even as architecture, which in essence it was, it would have had no parallel, except, perhaps, Frank Lloyd Wright's concept of the Mile High Skyscraper. It was to have been a metal spiral frame tilted at an angle and encompassing a glass cylinder, cube, and cone. The various glass units, housing conferences and meetings, were to revolve, making a complete revolution once a year, once a month, and once a day. It anticipated, and in scale transcended, all subsequent developments in constructed sculpture as space, environment, and motion.

## ALEXANDER RODCHENKO *(1891–1956)*

Rodchenko, who in 1914–15 had come under the influence of Malevich, worked with Tatlin in 1916 and soon began to experiment with constructions. By 1920 he, like Tatlin, was turning more and more to the idea that the artist must serve the revolution through a practical application of his art in engineering, architecture, and industrial design. In his *Construction of Distance* (fig. 383), he massed rectangular blocks in a horizontal-vertical grouping as abstract as a Mondrian painting and even more suggestive of the developing forms of the international style in architecture. His *Hanging Construction* (fig. 384) is a nest of intersecting circles which move slowly in currents of air. This is one of the first introductions into constructed sculpture of actual movement, in a form suggestive of the fascination with space travel that underlay many of the ideas of Russian constructivists.

The constructivist experiments of Tatlin and Rodchenko came to an end in the early 1920s, as the Russian revolutionary regime began to discourage abstract experiment and to encourage practical enterprises useful to a struggling economy. Many of the artists involved in suprematism and constructivism—in which Russia for a short period even held a position of world-leadership—left Russia after 1920. The most independent contributions of those who remained, including Tatlin and Rodchenko, were to be in theater design.

Despite the importance of the pioneer work in constructivism in Russia, the expansion and development of this concept were to occur elsewhere. The fact that painters like Kandinsky and sculptors like Naum Gabo and Anton Pevsner left Russia and carried their ideas to Western Europe was of the first importance in the creation of a new international style in art and architecture.

## NAUM GABO *(b. 1890),*

## ANTON PEVSNER *(1886–1962)*

The two leading Russian figures in the spread of constructivism were the brothers Anton Pevsner and Naum Gabo. Pevsner was first of all a painter whose history summarized that of many younger Russian artists. His exposure to non-academic art first came about through his introduction to traditional Russian icons and folk art.

383. ALEXANDER RODCHENKO. *Construction of Distance.* 1920. Wood. Private collection

384. ALEXANDER RODCHENKO. *Hanging Construction.* 1920. Wood. Wheareabouts unknown

385. NAUM GABO. *First Constructed Head*. 1915.
Wood, height 28". Whereabouts unknown

He then discovered the impressionists, fauves, and cubists in the Morozov and Shchukin collections. In Paris, between 1911 and 1914, he knew and was influenced by Archipenko and Modigliani. Between 1915 and 1917 he lived in Norway with his brother Naum and, on his return to Russia after the revolution, he received a teaching appointment at the Moscow Academy, as did Malevich, Kandinsky, and Tatlin.

Naum Gabo (Naum Neemia Pevsner), who changed his name to avoid confusion with his elder brother, was sent to Munich in 1910 to study medicine, but turned to mathematics and engineering. His interest in art was awakened by the exhibitions of Der Blaue Reiter in 1911 and 1912 and the lectures of the great art historian and critic Heinrich Wölfflin. In Norway during the war, Gabo was fascinated by the vast spaces of the Norwegian landscape and the contrasts of solid and void. In the winter of 1915–16 he began to make a series of heads and whole figures of pieces of cardboard or thin sheets of metal, figurative constructions transforming the masses of the head into lines or plane edges framing geometric voids (fig. 385).

In 1917, after the Russian revolution, Gabo returned to Russia with Pevsner. In Moscow he was drawn into the orbit of the avant-garde, meeting Kandinsky and Malevich and discovering Tatlin's constructions. Between 1917 and 1920 the hopes and enthusiasms of the Russian experimental artists were at their peak. The struggle for a new art of the twentieth century seemed to have been won. Most of the abstract artists, according to Gabo, were enthusiastic about the revolution, because they hoped that from it would come the liberation and triumph of all progressive tendencies in art.

By 1920, however, Tatlin and the group around him had become increasingly doctrinaire in their insistence that art had to serve the revolution in specific, practical ways. Artists had to abandon or subordinate pure experiment in painting and sculpture, and turn their energies to engineering, industrial, or product design. This position was opposed by Gabo and Pevsner and their followers, who fought for the survival of the independent artist and his right to follow his own path of free experiment wherever this might lead.

The first major result of this conflict of attitudes was the publication in Moscow on August 5, 1920, of the so-called Realistic Manifesto. It was signed by Gabo and Pevsner, but Gabo drafted it and was principally responsible for the ideas it contained. In a larger sense, however, as Gabo himself has pointed out, the manifesto was the culmination of ideas that had been fermenting in the charged atmosphere of Russian abstract art over the previous several years. One reason the term "realistic" was used for the manifesto was that the label "constructivist" had not at that time gained any general circulation (although Gabo and others were already referring to their works as constructions); but more important was the deliberate use of "realistic" to underline the artists' conviction that what they were doing in their abstract paintings and constructions constituted a new reality, a Platonic reality of ideas or forms more absolute than any imitation of nature.

The manifesto is a passionate plea for a new great style in art, appropriate to the "unfolding epoch of human history." The essence of the new program was a rebirth of space and time as the "only forms on which life is built and hence art must be constructed." Descriptive color, line, space, and mass were denounced; all elements were to have their own reality; and time and movement were to become basic in their works.

Although Gabo has described the manifesto as a resumé of what was then going on in his group rather than a program, it is nevertheless a document of the highest importance in the history of twentieth-century art, one that summarizes brilliantly a large portion of the issues and problems with which the emerging abstract painters and sculptors had been struggling since the origins of cubism.

Until 1920, the experimentalists were allowed the freedom they were, first, probably, because of the continuing civil war, and second, because they filled a vacuum in the schools and academies caused by the flight of the older academicians. Anatoly Lunacharsky, the commissar of education, was a cultivated man sympathetic to the new trends; and Lenin, busy with more immediate problems, was content to leave the decisions on artistic matters to him. With the return of more peaceful and stable conditions, however, the old academic ideals and the new technological ideals soon assumed control. Both were now in the service of communist philosophy: art had to be understandable to the masses and useful to industry. The result was the departure from Russia of many leading spirits of the new art—Kandinsky, Gabo, Pevsner, and Lissitzky. They emigrated when they saw there was nothing further they could do in Russia, and continued to develop their ideas and spread them throughout the Western world.

left: Colorplate 84. GIACOMO BALLA.
*The Street Light—Study of Light.* 1909.
Oil on canvas, 68¾ x 45¼".
The Museum of Modern Art, New York.
Hillman Periodicals Fund

*below:* Colorplate 85. CARLO CARRA.
*Funeral of the Anarchist Galli.* 1910–11.
Oil on canvas, 6' 6" x 8' 6".
The Museum of Modern Art, New York.
Acquired through the Lillie P. Bliss Bequest

*right:* Colorplate 86. UMBERTO BOCCIONI.
*Riot in the Gallery.* 1909.
Oil on canvas, 30 x 25¼".
Collection Emilio Jesi, Milan

*below:* Colorplate 87. UMBERTO BOCCIONI.
*The City Rises.* 1910–11.
Oil on canvas, 6' 6" x 9' 10".
The Museum of Modern Art, New York.
Mrs. Simon Guggenheim Fund

Colorplate 88. LUIGI RUSSOLO.
*The Solidity of Fog.* 1912.
Oil on canvas, 39⅜ x 28⅝".
Collection Gianni Mattioli, Milan

Colorplate 89. GIACOMO BALLA.
*Flight of the Swifts.* 1913.
Watercolor on paper, 23 x 33".
Collection Mr. and Mrs. Joseph Slifka,
New York

227

above: Colorplate 90. GINO SEVERINI.
*Dynamic Hieroglyphic of the Bal Tabarin.* 1912.
Oil on canvas, with sequins, 63⅝ x 61½".
The Museum of Modern Art, New York.
Acquired through the Lillie P. Bliss Bequest

right: Colorplate 91. GINO SEVERINI.
*Spherical Expansion of Light (Centrifugal).*
1914. Oil on canvas, 24 x 20".
Collection Riccardo and Magda Jucker, Milan

*left:* Colorplate 92. CARLO CARRA.
*Patriotic Celebration (Free Word Painting).*
1914. Collage on cardboard, 15¼ x 11¾".
Collection Gianni Mattioli, Milan

*below:* Colorplate 93. KASIMIR MALEVICH.
*Morning in the Country After Rain.* 1911.
Oil on canvas, 31½ x 31⅜".
The Solomon R. Guggenheim Museum, New York

Colorplate 94. VASILY KANDINSKY. *White Line, No. 232*. 1920. Oil on canvas,
38⅝" x 31½". Collection Mme. Nina Kandinsky, Neuilly-sur-Seine, France

left: Colorplate 95. VASILY KANDINSKY.
*Several Circles, No. 323.* 1926.
Oil on canvas, 55⅛ x 55⅛″.
The Solomon R. Guggenheim Museum,
New York

below: Colorplate 96. PIET MONDRIAN.
*The Red Tree.* 1908. Oil on canvas,
27½ x 39″. Gemeente Museum,
The Hague, The Netherlands

*above:* Colorplate 97.
PIET MONDRIAN.
*Composition in Blue B.* 1917.
Oil on canvas, 24 x 19".
Kröller-Müller Museum,
Otterlo, The Netherlands

*right:* Colorplate 98.
GERRIT RIETVELD.
Model of the Schröder House.
1923–24. Glass and wood,
17⅜ x 28⅜ x 19¼"
without glass case.
Stedelijk Museum, Amsterdam

# PART ELEVEN

# DE STIJL IN HOLLAND

World War I, history's bloodiest conflict before our own time, marked the terminal point of the first waves of twentieth-century invention, and interrupted or ended the careers of many artists. During the war every nation was isolated, and French domination of experiment in art broke down. Rethinking of concepts of modern painting, sculpture, and architecture led to the emergence of new experiments and new ideas in which other nations began to assume a position of leadership. The Russian experiments in abstraction, suprematism, and constructivism might not have attained the position they did, had not war and revolution isolated Tatlin, Kandinsky, Malevich, and Gabo from the rest of Europe.

A striking instance of the effect of isolation is to be seen in the notable native development of art in Holland, neutral during World War I, and thus culturally as well as politically removed from both sides. In the nineteenth century, Holland had produced a number of painters of talent and one of genius—Vincent van Gogh, who had attained his moment of supreme achievement through exposure to the French impressionists and post-impressionists. Dutch experimentalists at the beginning of the twentieth century, such as Van Dongen, had been drawn to Paris and assimilated into the French movements of fauvism or cubism.

In general, Dutch artists and architects seem to have moved rather cautiously into the twentieth century. In architecture, Berlage was the first important innovator and, as such, almost alone. International art nouveau had less impact on Holland than on Belgium, Austria, or France, except on the painters Jan Toorop (see *The Three Brides,* fig. 386) and Jan Thorn-Prikker and a few designers, such as J. Juriaan Kok. The transition to revolutionary modern art during World War I may be traced in the career of Piet Mondrian, one of the century's masters.

In 1914 Mondrian returned to Holland for a visit and was caught by the outbreak of war. Soon he discovered other Dutch artists with aspirations similar to his own. These were Bart van der Leck and Theo van Doesburg. Van Doesburg, eleven years younger than Mondrian, was the leading spirit in the formation of the De Stijl group and the creation of the periodical *De Stijl.* Also to be associated with De Stijl were the Hungarian painter Vilmos Huszar, who had settled in Holland; the Belgian sculptor Georges Vantongerloo; and the architects J. J. P. Oud and Robert van't Hoff.

During 1915 Van Doesburg was already discussing the idea for a new periodical with Mondrian, who, however, felt that the time was not ripe. Nevertheless, Van Doesburg continued to pursue his project after he was demobilized in 1916, and in 1917 the periodical *De Stijl* ap-

peared. It was dedicated to the "absolute devaluation of tradition . . . the exposure of the whole swindle of lyricism and sentiment." The artists involved emphasized "the need for abstraction and simplification": mathematical structure opposed to impressionism and all "baroque" forms of art. Van Doesburg, even earlier than Mondrian, had become convinced of the paramount importance of the straight line in art, and had even thought of naming his periodical *The Straight Line.* They sought "for clarity, for certainty, and for order." Almost at once their works began to display these qualities, transmitted through the straight line, the rectangle, or the cube, as well as through colors simplified to the primaries red, yellow, and blue and the neutrals black, white, and gray. It should be stressed that for the De Stijl artists these simplifications had their own symbolic significance based on Oriental philosophy and the current teachings of theosophy.

Of the greatest importance in the idea of De Stijl was the concept of the collaboration of artists, the development of a common point of view among painters, sculptors, architects, and graphic and industrial designers. This is a familiar concept, already noted in connection with several earlier movements.

The De Stijl artists were well aware of developments in modern art in France, Germany, and Italy—fauvism,

386. JAN TOOROP. *The Three Brides.* 1893. 30¾ x 38⅝".
Kröller-Müller Museum, Otterlo, The Netherlands

387. PIET MONDRIAN. *Blue Chrysanthemum.* 1906–08.
Watercolor, 10⅝ x 8⅞".
The Solomon R. Guggenheim Museum, New York

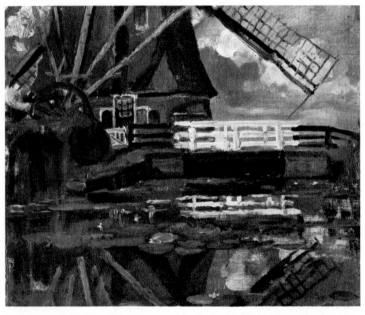

388. PIET MONDRIAN. *Landscape with Mill.* Before 1905.
Oil on canvas mounted on cardboard, 11⅞ x 15".
The Museum of Modern Art, New York

sian experiments in abstraction until the end of the war had re-established communication.

The influential theoreticians of De Stijl were Mondrian and Van Doesburg. Van Doesburg, in 1917, published a book, *The New Movement in Painting,* and Mondrian published in *De Stijl* a series of articles, including "Neo-Plasticism in Painting," which in 1920, after he had returned to France, he expanded into his book *Le Néo-Plasticisme,* one of the documents of abstract art (see Bibliography).

Mondrian, obsessed by the mystical implications of the vertical-horizontal opposition, spent the rest of his life exploring them. Van der Leck reverted to representation. By 1924, Van Doesburg was seeking a new and individual variation which he named "elementarism," and in which he continued to use a composition consisting of rectangles, but tilted them at 45 degrees to achieve what he felt to be a more immediately dynamic form of expression. At this point Mondrian left De Stijl, offended by what he regarded as Van Doesburg's heresy in deserting the vertical axis.

## PIET MONDRIAN *(1872–1944)*

## AND NEO-PLASTICISM TO 1918

Mondrian, originally Pieter Mondriaan, was trained in the Amsterdam Academy, and until 1904 was a naturalistic painter. About 1908 he came under the influence of Toorop and began painting in a manner associated with symbolism. Even earlier his landscapes contained anticipations of his characteristic vertical-horizontal composition, restricted but defined picture space, emphasis on linear structure and, above all, fascinated observation of a single scene or object, whether a windmill, trees, a solitary tree, or an isolated chrysanthemum (*Blue Chrysanthemum,* fig. 387).

The early landscapes also adhered to a principle of frontality and, particularly in the windmill paintings, to cut-off, close-up presentation. The instinct to controlled, abstract organization of picture space seems to have been intense from the outset (*Landscape with Mill,* fig. 388).

By 1908 Mondrian was becoming aware of some of the innovations of modern art. His color blossomed in blues, yellows, reds, and greens. In forest scenes he emphasized the linear undulation of saplings, in shore and seascapes the coloristic movement of sand dunes and water. For the next few years, church facades and haystacks were presented frontally in planes of abstract, arbitrary color or in patterns of red and yellow color spots deriving from the pointillists and in even greater degree from the short, harsh, but disciplined brush strokes of Van Gogh. In portraiture and figure painting, Mondrian since 1900 had also emphasized a frontalized, close-up view, sometimes reminiscent of Edvard Munch. This approach was accentuated in his triptych of *Evolution,* c. 1911, a work that is also an early evidence of his absorption in Oriental mysticism, with the symbolism of male and female principles joined in the central panel.

In 1911, Mondrian left Holland for Paris, where he was caught in the tide of cubism, and he sensed in it the approach toward which he had been moving intuitively. With any of his favorite subjects—the tree, the dunes and

cubism, German expressionism, and Italian futurism. But they recognized as masters only a few pioneers: such as Cézanne in painting and Frank Lloyd Wright, Berlage and, perhaps, Behrens and the later Van de Velde in architecture. They had little or no awareness of the Rus-

ocean, the church or windmill, all rooted in the familiar environment of Holland—one can trace his progress from naturalism through symbolism, impressionism, post-impressionism, fauvism, and cubism, to abstraction. In *The Red Tree* (colorplate 96), he combines the tortured expression of Van Gogh, the non-descriptive color of the fauves, and the linear pattern of art nouveau in a work that is still individual and structural in a plastic sense. Over the next few years the same subject is treated in a mode of more linear abstraction, which by 1912 had approximated to cubist facets. Although Mondrian, during his first years in Paris, subordinated his colors to grays, greens, and ochers under the influence of the analytical cubism of Picasso and Braque, his most cubist paintings still maintained an essential frontality: he rarely attempted the tilted planes or sculptural projection that gave the works of the French cubists their defined though limited sense of three-dimensional spatial existence. Even while absorbing the tenets of cubism he was already moving beyond to eliminate both subject and three-dimensional illusionistic depth.

As early as 1912 the tree had virtually disappeared into a linear maze that covered the surface of the canvas (fig. 389). The feeling for centralized composition is evident in the greater central density with the gradual loosening of the pattern toward the edges. This centralized emphasis was also articulated through use of the oval frame (inspired by the cubists), and the contained linear structure became rectangular and abstract (fig. 390), leading inexorably toward a geometric abstraction of verticals and horizontals. By 1913 the artist was also beginning to experiment with bright colors again, asserting their identity within linear rectangles.

In Paris, as we have noted, Mondrian was first attracted by the position of the cubists, but gradually began to feel that cubism "did not accept the logical consequences of its own discoveries: it was not developing abstraction toward its ultimate goal, the expression of pure reality. I felt that this could only be established by *pure plastics (plasticism)."* In this statement, made in 1942, he emphasized the two words that summarize his lifelong quest—"plastic" and "reality." To him "plastic expression" meant simply the action of forms and colors. "Reality" or "the new reality" was the reality of plastic expression, or the reality of forms and colors in the painting. Thus the new reality was the present reality of the painting itself as opposed to an illusionistic reality based on imitation of nature, or romantic or expressive associations.

Gradually, as the artist tells it, he became aware that: "(a) in plastic art reality can be expressed only through the equilibrium of *dynamic movements* of form and color; (b) pure means afford the most effective way of attaining this." These ideas led him to the organizational principle of the balance of unequal opposites achieved through the right angle, and the simplification of color to the primary hues plus black and white. It is important to recall that Mondrian did not arrive at his final position solely through theoretical speculation. As we have seen, his paintings almost from the beginning were moving inexorably toward a pattern of abstract simplification based on the rectangle of the picture plane.

During 1914 all vestiges of curved lines were eliminated, and the structure became predominantly vertical and horizontal. The paintings were still rooted in subject: a church facade or sand and ocean, but these were now simplified to a pattern of short, straight lines, like plus and minus signs, through which he sought to suggest the

389. PIET MONDRIAN. *Flowering Apple Tree.* 1912. 30¾ x 41¾". Gemeente Museum, The Hague, The Netherlands

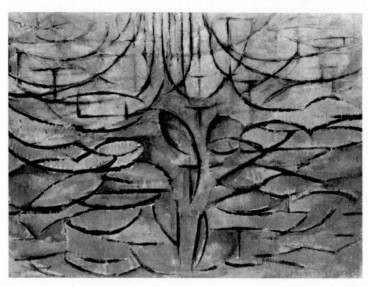

390. PIET MONDRIAN. *Color Squares in Oval.* 1914–15. 42⅜ x 31". The Museum of Modern Art, New York

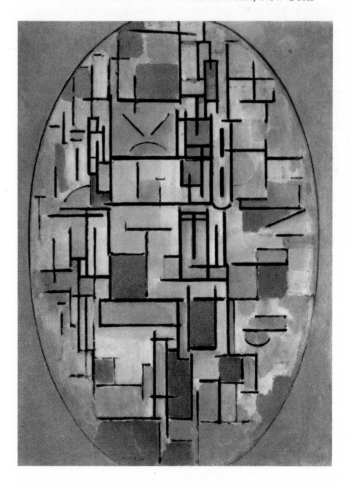

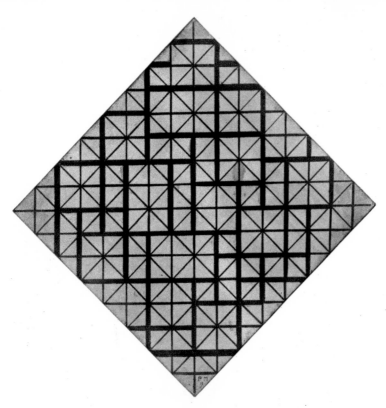

391. PIET MONDRIAN. *Composition in Gray*. 1919.
33⅜ x 33¼" (on the diagonals). The Philadelphia
Museum of Art. Louise and Walter Arensberg Collection

392. PIET MONDRIAN. *Composition (Checker Board,*
*Bright Colors)*. 1919. 33⅞ x 41¾".
Collection S. B. Slijper, Blaricum, The Netherlands

underlying structure of nature. During 1917 and later he explored another variation—rectangles of flat color without defined edges, suspended in a sometimes loose, sometimes precise rectangular arrangement (colorplate 97). The color rectangles sometimes touch, sometimes

float independently, and sometimes overlap; they appear positively as forms in front of the white or generally light background. Their interaction creates a surprising illusion of depth, even though kept rigidly parallel to the picture surface.

He soon realized that the detached color planes created both a tangible sense of depth and a differentiation of foreground and background which interfered with the unity he was seeking. This discovery led him during 1918 and 1919 to a series of works organized on a rectangular grid, at first with heavily outlined squares or rectangles arranged on a neutral ground (for a time he explored the possibility of a diamond-shaped frame, fig. 391), then with the rectangles defined as hues of primary colors, red, yellow, and blue, against white, black, or gray (fig. 392). These checkerboard paintings still appeared to the painter as foregrounds of color forms against a ground of white or gray—and thus "impure" in color, lacking a total unity. So, finally, he united the field by making the heavy lines move through the rectangles to create a linear structure in tension with the color rectangles. Thus, about 1919, Mondrian came to the fulfillment of his ideals of the expression of universals through dynamic balance of vertical and horizontal linear structure and fundamental hues of color.

Always, it must be repeated, Mondrian, through his "equivalence of opposites," was seeking the expression of a unity that in its turn would be expressive of the higher mystical unity he sensed in man and the universe. This was his ultimate aim, not creation of abstract structure through elimination of recognizable subject. Nevertheless, like the other members of the De Stijl group, he recognized the implications of their abstract principles for the new architecture and for new concepts of pure design in all fields.

### BART VAN DER LECK *(1876–1958)*

Although Mondrian was incomparably the greatest artist associated with De Stijl, his achievement cannot be separated from that of the other members, particularly Van Doesburg and Van der Leck. Van der Leck, even before 1910, had developed within the framework of naturalistic painting a feeling for construction in flat color planes applied to a subject matter of social commentary —laborers and factory workers. Simultaneously he was simplifying his colors so that primaries predominated. Mondrian learned both the flat planes and the emphasis on primaries from Van der Leck during the period they were living at Laren, near Amsterdam, after 1914. By 1917, in *Composition* (fig. 393), Van der Leck abandoned subject for a rectangular composition comparable to the Mondrian abstractions of the same period. He favored an open composition with the surface broken up by a grid of short lines and rectangular patches rather than the larger squares and rectangles of Mondrian. But the figure kept creeping back through the geometry. Van der Leck was momentarily mesmerized by the enthusiasm of Van Doesburg and the analytical obsession of Mondrian, but the vein was not fundamentally congenial to him. By 1918 he had left De Stijl and returned to a form of figuration.

## THEO VAN DOESBURG *(1883–1931)*

As already noted, Van Doesburg was the moving spirit in the formation and development of De Stijl. During his two years in the army (1914–16) he studied the new experimental painting and sculpture, and was particularly impressed by Kandinsky's essay, *Concerning the Spiritual in Art,* which became for him almost a bible. In 1916 he was experimenting with free abstraction in the manner of Kandinsky, as well as with forms of cubism, but was still searching for his own path. This he found in his composition of *Card Players,* 1916–17 (fig. 394), a work based on Cézanne, but with the figures simplified to a complex of interacting shapes based on rectangles, the colors flat and delimited, although not to the point of absolute primaries. During 1918 and 1919, fascinated by the mathematical implications of his new abstraction, Van Doesburg explored its possibilities in linear structures related to those of Van der Leck, as in a later version of the *Card Players,* 1917 (fig. 394a). For a time Mondrian was unquestionably affected by the fertility of Van Doesburg's imagination. When artists work together as closely as the De Stijl painters did during 1917–19, it is extremely difficult and perhaps pointless to establish absolute priorities. Van Doesburg, Mondrian, and Van der Leck for a time were all nourished by one another. By 1920, however, each was again beginning to go in his own direction.

Van Doesburg, after the war, continued to be the most articulate propagandist for the principles of De Stijl, traveling widely and lecturing. He had notable influence on students and on some of the faculty of the Weimar Bauhaus (despite antagonism from its administration), and on artists in Berlin and elsewhere. His lively interest in dada also manifested itself in poems written under the

pseudonym of I. K. Bonset; and he and Kurt Schwitters made a dada cultural tour of Holland.

Van Doesburg's interests did not conflict with his painting, and he followed neo-plastic principles until he published his *Fundamentals of the New Art* in 1924. He then began to abandon the rigid vertical-horizontal for-

394. THEO VAN DOESBURG. *Card Players.* 1916–17.
Tempera on canvas, 58 x 46½″.
Collection Mme. Pétro Van Doesburg, Meudon, France

393. BART VAN DER LECK. *Geometric Composition.* 1917. 37 x 39⅜″. Kröller-Müller Museum, Otterlo, The Netherlands

394a. THEO VAN DOESBURG. *Card Players.* 1917. 45⅝ x 41¾″. Gemeente Museum, The Hague, The Netherlands

*above:* 395. THEO VAN DOESBURG. Interior,
Café L'Aubette, Strasbourg. 1926–28 (destroyed 1940)

*right:* 396. GEORGES VANTONGERLOO. *Construction of Volume
Relations.* 1921. Mahogany, height 16⅛". The Museum
of Modern Art, New York. Gift of Miss Silvia Pizitz

mula of Mondrian and De Stijl and to introduce diagonals. This heresy led to Mondrian's resignation from De Stijl. In a 1926 manifesto in *De Stijl,* Van Doesburg named his new departure "elementarism," and argued that the inclined plane reintroduced surprise, instability, and dynamism. In his murals at the Café L'Aubette, Strasbourg (decorated in collaboration with Arp and Sophie Taeuber-Arp; see p. 343), Van Doesburg makes his most monumental statement of elementarist principles (fig. 395): he tilted his boldly colored rectangles at 45-degree angles and framed them in uniform strips of color. The tilted rectangles are in part cut off by the ceiling and base; across the center runs a long balcony with steps at one end that add a horizontal and diagonal to the design. Incomplete rectangles emerge as triangles or irregular geometric shapes. In his elementarist paintings Van Doesburg seems deliberately to have substituted an expanding, fragmentary structure for the unified, hermetically sealed world of Mondrian.

### GEORGES VANTONGERLOO *(1886–1965)*

In sculpture the achievements of De Stijl were not comparable to those of the Russian constructivists and were, in fact, concentrated principally in the works of the Belgian Georges Vantongerloo. Vantongerloo was not only a sculptor but also a painter, architect, and theoretician. His first abstract sculptures, 1917 and 1918, were still conceived in the traditional sculptural sense as masses carved out of the block rather than as construc-

tions built up out of separate elements. They constitute notable transformations of De Stijl painting into three-dimensional design. Later, Vantongerloo turned to open construction, sometimes in an architectural form (*Construction of Volume Relations,* 1921, fig. 396), and sometimes in free linear patterns. In his subsequent painting and sculpture he frequently deserted the straight line in favor of the curved, but throughout his career he maintained an interest in a mathematical basis for his art, to the point of deriving compositions from algebraic equations.

## De Stijl Architecture

Despite the uniqueness of Mondrian, the principal impact of De Stijl on modern art came from architecture. During the war years, neutral Holland was one of the very few countries in Europe where building could continue, with the consequence that the transition from pre-war to post-war architectural experiment can be followed most clearly in that country. Many of the ideas and theories fermenting everywhere in Europe before 1914 came to their first realization in Holland at this time. The Dutch solutions, consequently, were studied by artists and architects everywhere the instant the war ended.

The formative influences on De Stijl architects were Hendrik Berlage and Frank Lloyd Wright. Berlage, in

his writings, insisted on the primacy of interior space. The walls defining the spaces had not only to express the nature of their materials, but their strength and bearing function undisguised by ornament, as well. Above all, Berlage through systematic proportions sought a total effect of unity and repose built from diversity, and thus ultimately an enduring style analogous to but not imitated from that created by the Greeks of the fifth century B.C. He conceived of an interrelationship of architecture, painting, and sculpture, but with architecture in the dominant role.

Berlage's approach to architecture was affected by that of Frank Lloyd Wright, whose work he knew through publications and then saw on a trip to the United States. He was enthusiastic about Wright and particularly about the Larkin Building (see fig. 251), with its obvious analogies to his own Amsterdam Stock Exchange (see fig. 264). What appealed to Berlage and his followers in Wright was his rational, mechanistic aspect: Wright as the architect who sought to control and utilize the machine, to explore new materials and techniques in the creation of a new society.

## ROBERT VAN'T HOFF *(1852–1911)*,
## J. J. P. OUD *(1890–1963)*,
## GERRIT RIETVELD *(1888–1964)*,
## COR VAN EESTEREN *(b. 1897)*

Oud, Van't Hoff, and Rietveld were affected by the ideas of Berlage and Wright and acquainted with the early modernists in Germany and Austria—Behrens, Loos, Hoffmann, and Olbrich—but their association with Mondrian and Van Doesburg also influenced the forms their architecture assumed. M. J. H. Schoenmaekers, with his mystical cosmogony based on the rectangle, and his Neo-platonic doctrine of ultimate realities, provided the philosophical base not only for Mondrian's paintings but for the architects' thinking. From these ingredients arose an architecture of flat roofs, with plain walls arranged according to definite systems to create an interior space that was both functional and harmonious. Here was a major inception of the style to which the name "international style" has been given and which was to dominate monumental building during the middle years of the twentieth century, especially the forms of the skyscraper.

In their aesthetic, the architects and artists of De Stijl were much concerned with the place of the machine and its function in the creation of a new art and a new architecture. They shared this concern with the Italian futurists, with whom Van Doesburg corresponded (Severini was a regular corresponding member of De Stijl), but they departed from the emotional, expressionist, futurist exaltation of the machine in favor of a position that sought to utilize the machine in the creation of a new collective order. From this approach arose their importance for subsequent experimental architecture.

The actual buildings created by these architects before 1921 were not numerous. A house built by Van't Hoff, Huis ter Heide, in 1916 (fig. 397) antedated the formation of De Stijl, and was almost entirely based on his observations of Wright in Chicago, as may be seen in the

cantilevered cornices, the grouping of windows, the massing of corners, as well as the severe rectangularity of the whole. Oud's 1917 project for seaside housing on the Strand Boulevard at Scheveningen gives the future international style formula for housing in a flat-roofed, terraced row of rather monotonously repeated individual rectangular units. A 1919 project by Oud for a small factory was a more imaginative and mature combination of cubic masses alternating effectively with vertical chimney pylons and horizontal windows in the Wright manner. Instead of the typical early Wright pitched roof, however, the De Stijl architects, almost from the beginning, opted for a flat roof, thus demonstrating a relationship to the De Stijl painters.

Oud shared something of Berlage's conservatism and, after being appointed city architect of Rotterdam in 1918, withdrew from active participation in De Stijl. In the best-known and, in many ways, the most influential of his early buildings, the housing project for workers at The Hook of Holland, 1924–27 (fig. 398), he employed wrap-around, curved corners on his facades and solidly expressed brickwork in a manner that suggested a direct

397. ROBERT VAN'T HOFF. Huis ter Heide, Utrecht, The Netherlands. 1916

398. J. J. P. OUD. Workers' Housing Estate, Hook of Holland. 1924–27

line of influence from Berlage, despite the rectangularity and openness of the fenestration and the flat roofs. The workers' houses had an importance beyond their stylistic influence as an early example of enlightened planning for well-designed, low-cost housing. In the facade design of the Café de Unie, Rotterdam, 1925 (fig. 399), a less serious work, Oud almost literally translated a Mondrian painting into architectural terms, at the same time illustrating the possibilities of Mondrian's style for industrial, poster, and typographic design. Oud lived until 1963 and, in his later, monumental buildings, was once more absorbed into the international style of which he was a somewhat reluctant pioneer.

Van't Hoff was a more adventurous spirit, at least in his theories. He was the first member of De Stijl to discover Sant'Elia (see p. 217), about whose unfulfilled architectural projects he wrote in *De Stijl*. The other two leading architects associated with De Stijl (aside from Van Doesburg himself, who not only was active as an architectural designer and a color consultant but wrote architectural criticism under various names) were Rietveld and Van Eesteren. Both rose to prominence after the end of World War I, so that their achievements belong to the period of the international spread of De Stijl. Rietveld was not only an architect, but a furniture designer as well, whose early chairs and desks have become classics. In a sideboard of 1919 (fig. 400) he was able to compose his interpenetrating planes and lines in a classic ver-

tical-horizontal form, but the result is closer in feeling to Wright than to Mondrian. This is also true of much of Rietveld's earlier architecture, as may be seen in the model of the Schröder house in Utrecht, 1923–24 (colorplate 98), in which the cube of the structure is broken up by detached interlocking planes of rectangular slabs joined by unadorned piping, giving the whole the appearance of a piece of constructivist sculpture. However, the design is not simply a De Stijl mannerism, for the large corner and row windows give ample interior light; cantilevered roofs shelter the interior from the sun; and the rooms of the house are thus light, airy, and cool. Until his death in 1964, Rietveld remained one of the masters of Dutch architecture, receiving many major commissions, of which the last was the Van Gogh Museum in Amsterdam, begun in 1967.

Van Eesteren collaborated with Van Doesburg in a number of architectural designs during the 1920s, including a project for a house that was one of the most monumental efforts in De Stijl domestic architecture attempted to that date. This palatial edifice (see fig. 401), in contrast with Rietveld's approach, emphasized the pristine rectangular masses of the building, coordinated as a series of wings spreading out from a central core defined by the strong vertical accent of the chimney pier in the Wrightian mode. In the central mass they opened up the interior space with cantilevered terraces that anticipated Wright's house in Bear Run, 1936 (see fig. 706).

401. VAN EESTEREN
and VAN DOESBURG.
Project for Rosenberg House.
1923

# THE INTERNATIONAL STYLE IN ARCHITECTURE

During the 1920s the architectural pioneers of the first modern generation—Wright in the United States, Perret in France, Loos in Austria, and Behrens in Germany—continued to consolidate their positions, although not at the same rate of progress or recognition.

Between 1915 and 1922, Wright, as previously noted, was occupied principally with the Imperial Hotel in Tokyo—now, regrettably, destroyed. At the same time he was building houses in California—notably the Millard house, 1923 (fig. 402)—with a new, massive, rectangular outline resulting from his experimentation with poured concrete. In the Millard house he used precast patterned concrete blocks. Built on an inclined plot, this house was organized as a compact vertical cube. Its sharp contrast with the horizontality of the earlier prairie houses demonstrates Wrights unfailing ability to adapt his design to new situations and materials.

In the next decade Wright had no important commissions. His progress must be charted through such projects as his 1929 design for a skyscraper, St. Mark's Tower, New York, and such visionary essays into city planning as the project for Broadacre City, 1931–35.

The Tower, finally built in 1953 as the Price Tower, Bartlesville, Oklahoma (fig. 403), was, for its time, a daring concept: a cruciform "airplane propeller" structural unit sheathed in a glass shell and supporting cantilevered floors. Boldly protruding terraces and soaring utility pylons gave the skyscraper the stylistic signature of its author.

In France, Perret completed his concrete-and-glass masterpiece, the church at Le Raincy, between 1922 and 1923 (see fig. 255), after which there came a long *détente* of solid industrial building, experimental in its use of ferroconcrete but conventional in design. Loos, in Vienna, lived only to 1933, and most of his completed architectural works during the 1920s continued to be houses of relatively modest proportions. His career as an architect was rather strange for a man now recognized as a major pioneer of modern building. A large percentage of his works consisted of interior design—the reconstruction and decoration of the interiors and facades of existing shops or restaurants, or the redecoration of apartments. The spare rectangularity of the garden facade of his Steiner house, 1910, anticipated De Stijl and interna-

*below left:* 402. FRANK LLOYD WRIGHT. Millard House, Pasadena, California. 1923

*below right:* 403. FRANK LLOYD WRIGHT. Price Tower, Bartlesville, Oklahoma. 1953

404. WALTER GROPIUS and ADOLF MEYER. Fagus Shoe Factory, Alfeld-an-der-Leine, Germany. 1911–16

tic importance (although sharp issue was taken with those who contended that function was all).

The first principle of the new architecture of steel or ferroconcrete was elimination of the bearing wall. The outside wall became a skin of glass, metal, or masonry constituting an enclosure rather than a support. Thus, one could speak of an architecture of volume rather than of mass. Window and door openings could be enlarged indefinitely and distributed freely to serve both function —activity, access, or light—and design of exterior or interior. The regular distribution of structural supports led to rectangular regularity of design but not to the balanced axial symmetry of classical architecture.

The next principle was avoidance of applied decoration: the creation of style through the proportioning and distribution of solid and void. The elimination of strong contrasts of color on both interiors and exteriors was presented as a characteristic, although the influence of Mondrian and Van Doesburg on certain Dutch architects was noted. The international style resulted in new concepts of spatial organization, particularly a free flow of interior space, as opposed to the stringing together of static symmetrical boxes that had been previously necessitated by interior bearing walls. Finally, the international style lent itself admirably to urban planning, low-cost mass housing, and garden cities—to any form of large-scale building involving inexpensive, standardized units of construction.

405. WALTER GROPIUS and ADOLF MEYER. Model Factory at the Werkbund Exhibition, Cologne. 1914

tional style architecture. In the early 1920s Behrens moved into an expressionist phase in his Höchst Dye Works, 1920–25. His influence pervaded the architecture of the post-war era, for among those who had worked with him as students or assistants were Walter Gropius, 1907–10, Le Corbusier, 1910–11, and Mies van der Rohe, 1908–11.

The term international style for the wave of new experiment in architecture that gained momentum during the 1920s was given prominence by an exhibition of advanced tendencies held at the Museum of Modern Art, New York, in 1932. Communication among architects had been re-established so rapidly after World War I and stylistic diffusion had spread so wide that it had become difficult to speak of national styles. Rather, there were now centers of experimentation upon which architects and artists converged from everywhere. The catalogue by Henry-Russell Hitchcock and Philip Johnson accompanying the exhibition attempted to define the characteristics of the style. The authors emphasized the importance of structural steel and ferroconcrete, whose characteristic properties led to novel forms and thus to the first style based on a new structural system since the Romanesque and Gothic architecture of the twelfth and thirteenth centuries. Function was asserted to be of fundamental stylis-

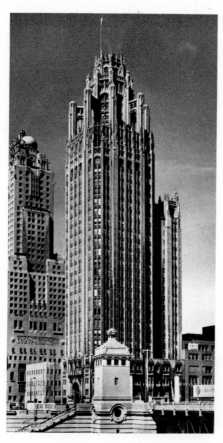

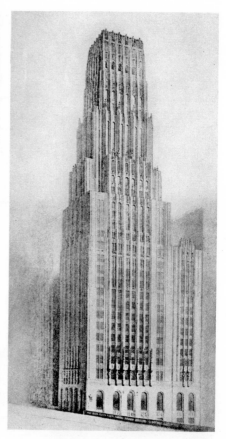

406. WALTER GROPIUS and
ADOLF MEYER. Design for
the Chicago Tribune Tower. 1922

407. RAYMOND HOOD.
Chicago Tribune Tower.
1922

408. ELIEL SAARINEN.
Design for the Chicago
Tribune Tower. 1922

Unquestionably the experiments of the pioneers of modern architecture in the use of new materials and in the stripping away of accretions of classical, Gothic, or Renaissance tradition resulted in various common denominators that may be classified as a common style. However, the individual stamp of the pioneers is recognizable even in their most comparable architecture. Wright, it must be stressed, influenced but never considered himself a participant in the international style. In fact, he was in violent opposition to many of its ideas and exponents.

## WALTER GROPIUS (b. 1883) TO 1930

Among the architects who assumed positions of leadership in Europe after World War I, Gropius, as director of the Bauhaus, exercised the greatest direct influence on the younger generation. After spending two years in the office of Behrens, he joined forces with Adolf Meyer (1881–1929) to build, in 1911, a factory for the Fagus Shoe Company at Alfeld-an-der-Leine (fig. 404). Deriving from Behrens' turbine shop and not really involving any radically new structural system, the Fagus building still represents a sensational innovation in its utilization of complete glass sheathing even at the corners. In effect, Gropius here had invented the curtain wall that has created so much of the form of subsequent large-scale

twentieth-century architecture. As a result of the success of this building, Gropius and Meyer were commissioned to build a model factory and office building for the 1914 Werkbund exhibition in Cologne (fig. 405). What is interesting about this structure is the manner in which the architects harmonized a variety of materials and structural forms. They combined massive brickwork with open glass sheathing, the latter most effectively used to define the exterior spiral staircases at the corners. Broadly horizontal overhanging roofs recall Frank Lloyd Wright; and the entire building reveals the range of architectural forms of which the new style was capable at its inception.

In 1919, after the interruption of the war years, Gropius took up his duties as director of the Weimar Schools of Arts and Crafts, a position he had inherited from Henry van de Velde in 1915 but had been unable to assume because of the war. These schools he combined under the name of the Bauhaus. During the years that he was director of the Bauhaus, Gropius continued his own architectural practice in collaboration with Meyer until Meyer's death. One of the projects, unfulfilled, was the design for the Chicago Tribune Tower, in 1922 (fig. 406). The competition for this tower, entered by architects from every part of the world, was a turning point in the warfare between the traditional and modern approaches to architecture. Although the traditionalists won the battle with the Gothic cathedral designed by the

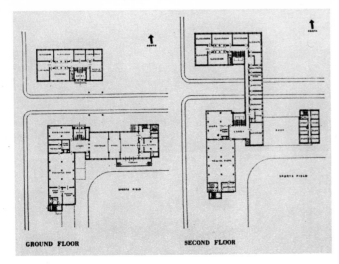

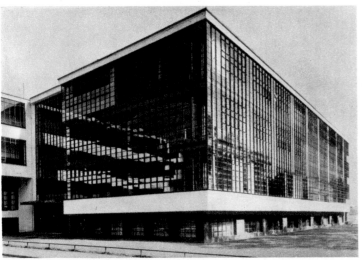

409. WALTER GROPIUS. Plan of the Bauhaus,
Dessau, Germany. 1925–26

410. WALTER GROPIUS. Workshop Wing, Bauhaus,
Dessau, Germany. 1925–26

411. WALTER GROPIUS. Siemensstadt Housing Project,
Berlin. 1929–30

American architect Raymond Hood (fig. 407; Saarinen's second-prize winner was also basically conservative, fig. 408), the wide publicity dramatized the conflict. The design of Gropius and Meyer, in the spare rectangularity of its forms, its emphasis on skeletal structure, and its wide tripartite windows, was actually building on the original skyscraper designs of Sullivan and the Chicago school, and at the same time looking forward to the skyscraper of the mid-twentieth century.

The most important architectural achievement of Walter Gropius while he was at the Bauhaus (1919–28) was the design for the new Bauhaus buildings (figs. 409, 410) at Dessau, where the school moved in 1925. These buildings, finished in 1926, may be said to define for large-scale building the nature and characteristics of the international style. They involved a complex of classrooms, studios, workshops, library, and living quarters for faculty and students. The workshops consisted of a glass box rising four stories and presenting the curtain wall, the glass sheath or skin, freely suspended on the structural-steel elements. The form of the workshop wing suggests the uninterrupted spaces of its interior. On the other hand, in the dormitory wing, the balconies and smaller window units contrasting with clear expanses of wall surface imply the broken-up interiors of individual apartments.

The plan of the Bauhaus is roughly cruciform (or, ironically in view of the Bauhaus' fate, a truncated swastika) with administrative offices concentrated in the broad, uninterrupted ferroconcrete span of the bridge linking workshops with classrooms and library. In every way the architect sought for the most efficient organization of interior space. At the same time he was sensitive to the abstract organization of the rectangular exterior —the relation of windows to walls, concrete to glass, verticals to horizontals, lights to darks. The Bauhaus combined functional organization and structure with a Mondrian design in three dimensions. Not only were the Bauhaus buildings revolutionary in the efficient planning for a complex series of activities, in the application of abstract principles of design on the basis of the interaction of verticals and horizontals; they also, as Siegfried Giedion has stressed, embodied a new concept of architectural space. The flat roof of the Bauhaus and the long, uninterrupted planes of white walls and continuous window voids create a lightness that opens up the space of the structure. Seen from above, the buildings seem to float. The glass areas integrate the interior and exterior worlds in a simultaneous and continuously shifting vision that Giedion relates to analytical cubism, and sees as the reflection of an attitude toward architectural space involving also the element of time.

Gropius left the Bauhaus in 1928 to devote his full time to architectural practice. Until he was forced by the Nazis' rise to power to leave Germany in 1934—first for England and then, in 1937, for the United States—most of his building was in the realm of low-cost or middle-cost housing. This area has always been close to Gropius' heart, since he is deeply interested in the social as well as the aesthetic implications of housing and city planning. He was a pioneer in the development of tall-slab apartment houses widely spaced among garden areas to give

maximum light and air as well as garden surroundings. He already demonstrated in the Dammerstock housing project near Karlsruhe, 1927–28, and in the Siemensstadt project, 1929–30 (fig. 411) that such planned communities could have the amenities of suburban living while providing quarters for a large urban population. Such designs have since been the basis for a large part of planned-housing developments everywhere.

## ELIEL SAARINEN *(1873–1950)*

The historic and prophetic nature of the Chicago Tribune Tower competition was largely overlooked, even by the critics of Hood's design, for whom the most effective solution was that of the second-prize winner, Eliel Saarinen. The leading Finnish architect of the early twentieth century, Saarinen belonged chronologically with the first generation of architectural pioneers. His design for the Tribune Tower is as rooted in the Middle Ages as that of Howells and Hood, but conveys a general impression of being modern (fig. 408). At a moment when American builders were turning away from outright revival styles but were not yet prepared to accept radical solutions, Saarinen's qualified modernism had great appeal and influence. He moved permanently to the United States in 1923, and his American fame for the next twenty years rivaled and frequently surpassed that of Frank Lloyd Wright. His latest works, after 1937, were done in collaboration with his son Eero, who was to become one of the most creative American architects of the mid-century. These revealed acceptance of the international style, unquestionably as a result of the son's influence. One of the most successful results of this partnership was the small but beautifuly realized Tabernacle Church of Christ, Columbus, Indiana (fig. 412), of 1941–42. Although the sense of tradition remains, and a sense of craftsmanship in the brickwork as well, the church, in its sensitive and expressive lighting, well-proportioned walls, and clearly ordered interior space, draws on the ideas of younger European architects.

## LE CORBUSIER *(1887–1965)* TO 1930

Among the second generation of architectural pioneers who rose to prominence during the 1920s, the name Le Corbusier, the architectural pseudonym of the Swiss Charles-Edouard Jeanneret, belongs at the highest level. Le Corbusier was a searching and intense spirit, a passionate but frustrated painter, a brilliant critic, and an effective propagandist for his own architectural ideas. He learned the properties of ferroconcrete with Perret in Paris, worked for a period with Behrens in Berlin, studied the tradition of the Vienna Workshops, and traveled widely. Although he never became a painter of the first rank, his interest in and knowledge of cubism and its offshoots affected his attitude toward architectural space and structure. Le Corbusier's principal exploration throughout much of his career was the problem of the house—first the problem of minimal housing, to which he applied his famous phrase, "a machine for living." His aims were to create structures using to the limit the properties of ferroconcrete, its lightness and strength, struc-

tures in which the plan would achieve the utmost in freedom and flexibility, in the interpenetration of inner and outer space. A drawing of 1914 (fig. 413) states the problem and his solution. This is simply a perspective drawing of a structure consisting of six slender pillars standing on a broad, flat base and supporting two other floors or areas that may be interpreted as an upper floor and a flat roof. The stories are connected by a free-standing, minimal staircase. The ground floor is raised on six blocks, suggestive of his later use of stilts or piers.

This drawing is of importance in establishing at this early date Le Corbusier's philosophy of building. With these few . . . anything he wanted. . . . glass sheaths can sim- . . . rtitions can be distrib-

EN. Interior,
us, Indiana. 1941–42

413. LE CORBUSIER. Perspective drawing
for Domino Housing Project. 1914

414. LE CORBUSIER. Weissenhof Housing Project, Stuttgart, Germany. 1927

uted and shaped in any manner the architect desires. The entire structure can be repeated indefinitely either vertically or horizontally, with any number of variations. Le Corbusier did not, of course, invent the system of ferroconcrete screen-wall construction. (As previously mentioned, Behrens and Gropius had already constructed buildings involving the principle.) What he did was to state in the most elementary terms the principle on which a great part of twentieth-century architecture was to be based. Here in effect was the equation of the international style. Le Corbusier's five points for contemporary construction were: (1) the pillar, to be left free to rise through the open space of the house; (2) the functional independence of skeleton and wall, not only of outer walls but also of inner partitions; (3) the free plan—

composing interior space with non-bearing interior walls to create free flow of space and also interpenetration of inner and outer space; (4) the free facade—the completely flexible and variable wall, which is merely a non-supporting skin or sheath; (5) the roof garden—the development of the flat roof as an additional living area.

Le Corbusier's principles, both structural and aesthetic, first became evident in his projects for houses built in 1919–22. On the one hand, the feeling for the rectangular outline of the house—the box whose interior he would carve out at will—was essentially an aesthetic bias, related to De Stijl abstract painting and his own purist painting (see p. 198). On the other hand, Le Corbusier was perhaps the most fanatical of the early modern masters of architecture in his insistence that a house was a machine for living, just as an airplane was a machine for flying; and that its technical requirements must be studied in exactly the same way.

The possibilities of Le Corbusier's doctrine are particularly apparent in the Weissenhof housing project of the Werkbund exhibition in Stuttgart in 1927 (fig. 414). This project brought together the talents of several innovators, including not only Le Corbusier but also Gropius and Mies van der Rohe. The smaller of the two houses by Le Corbusier was a tall rectangular block of four levels. Structurally, it is a series of regularly placed, lightly proportioned piers which rise through all levels and on which the house is suspended. Each level is planned in relation to its efficient living function but, more important, each is different in character. The living room, or atelier, rises through the second and third stories (with a balcony for sleeping) to create a change of scale not only within the house but through the windows to outside nature, nature that also penetrates underneath the house between the piers on which it stands, and over it in the roof terraces. So many of the original ideas of the pioneers—the two-story living room, the roof garden, the window walls, the free-flowing transition from interior to exterior—have gone into the language of twentieth-

415. LE CORBUSIER. Villa Savoye, Poissy, France. 1928–30

century architecture that it is now almost impossible to realize how revolutionary they were when first presented in the 1920s and even before.

The masterpiece among Le Corbusier's early houses was the Villa Savoye at Poissy, near Paris, built between 1928 and 1930 (figs. 415, 416). The house is almost a square in plan, with the upper living area supported on delicate piers. The enclosed ground level has a curved-glass end wall containing garage and service functions, set well under the suspended second story. In the main living area on the second level the architect has demonstrated brilliantly his aim of integrating inside and outside space. The rooms open on a terrace, which is protected by half walls or windbreaks above horizontal openings that continue the line of the strip windows. The appearance of the house, with the suspended rectangular block accented by the cylindrical staircase towers, does have the quality of a beautiful ship or machine of the future. In section the horizontal elements are tied together by the ramps, which move in and out of doors. The integration of verticals and horizontals and of inner and outer space is so complete and so complex that it is almost impossible to realize the effect in a single photograph or even a series of photographs. Unfortunately the Savoye house was ruined during World War II and has remained in a state of tragic devastation until recently, when efforts have been made to restore it as one of the first monuments of modern architecture in France.

Le Corbusier, like Wright, had few major commissions during the 1920s, but he continually advanced his ideas and his reputation through his writings and through his visionary urban-planning projects. In 1922 he drew up a plan for a contemporary city of three million inhabitants, involving rows of isolated skyscrapers connected by vast highways and set in the midst of parks. This was still a theoretical concept, inspired by the utopian cities of Sant'Elia and Garnier but entailing practical solutions to urban planning that anticipated the slab housing of Gropius and subsequent city planners. His realization of the variety of problems involved in the modern city went far

417. LE CORBUSIER. Swiss Dormitory, Cité Universitaire, Paris. 1930–32

beyond that of his models and he made his suggested solutions even more specific in his so-termed Voisin plans for Paris, 1922, 1925. In these the emphasis was always on the control of indefinite outward expansion of the city through the concentration of residential areas in isolated skyscrapers, set within parks but made easily accessible to one another by various classified systems of transportation.

The competition for the League of Nations buildings in 1927 had particular significance for the history of modern architecture. Despite the fact that the final award was made to a pseudo-modern, essentially academic design, the entry of Le Corbusier and Pierre Jeanneret (his cousin, with whom he was in partnership) was so obviously superior in its organization of facilities, its adaptation to the restricted site, and its clarity and beauty that it broke the last power of the old Beaux-Arts tradition—its strangle hold on governmental buildings. This was the first time a completely contemporary solution for such a governmental complex had been presented, combining monumentality with traditionless design and efficient planning. Le Corbusier's project marked the beginning of the end of a tradition. Although it was never built, some elements of it were finally introduced into the United Nations complex in New York, though not entirely to the architect's satisfaction.

The fame of this project led to major commissions during the early 1930s, notable among them, the Swiss dormitory in the Cité Universitaire, Paris, 1930–32 (fig. 417), and the Centrosoyus (now the Ministry of Light

416. LE CORBUSIER. Interior, Villa Savoye, Poissy, France. 1928–30

*above and below right:* 418. MIES VAN DER ROHE. Elevation and Plan for Brick Country-House. 1923

Industries) in Moscow, 1929–35, which incorporated some elements of the League of Nations design. Le Corbusier's writings, also, have been tremendously influential in modern world architecture. His trenchant book *Vers Une Architecture* (1923) was immediately translated into English and other languages, and has since become a standard treatise. In it he announced firmly that engineers, not architects, were carrying on basic traditions; that an American grain elevator whose massive simplicity was a direct consequence of its function was architecture in the finest sense. He extolled the beauty of the ocean liner, the airplane, the automobile, the turbine engine, bridge construction and dock machinery, all products of the engineer, whose designs had to reflect functions and could not be embellished with non-essential decoration. While there was nothing radically new in these ideas (Louis Sullivan had insisted much earlier that "form follows function"), Le Corbusier dramatized the problems of modern architecture through brilliant comparisons and biting criticisms and, in effect, spread the word to a new generation.

### MIES VAN DER ROHE *(b. 1886)* TO 1930

Mies van der Rohe's contribution lies in the refinement of the basic forms of the international style, rather than in the development of its formal and engineering possibilities; he gave architectural expression to the concepts of De Stijl and particularly of Mondrian.

The earliest major influences on Mies were his father, a master mason from whom he initially gained his respect for craftsmanship; then Peter Behrens, in whose atelier he worked for three years; and Frank Lloyd Wright, the 1910 exhibition of whose works in Berlin was a disturbing but exhilarating experience. From Wright he gained his appreciation for the open, flowing plan and for the predominant horizontality of his earlier buildings. Mies was affected not only by Behrens' famous turbine factory, but even more by Gropius' 1911 Fagus factory, with its complete statement of the glass curtain wall. Gropius had been in Behrens' office between 1907 and 1910, and the association between Gropius and Mies that began there continued.

Mies's style remained almost conventionally neo-classical until after World War I. Then, after the long wartime interruption, he plunged into the varied and hectic experimentation that characterized the Berlin school. After 1919 most of the new ideas fermenting in the arts during the war began to converge on Berlin, which became one of the world capitals for art and architecture. These ideas included the German tradition of expressionism, Russian suprematism and constructivism, Dutch De Stijl, and international dadaism. Contact was re-established with French cubists and Italian futurists. The Bauhaus school created by Gropius at Weimar in 1919 was in continuous and close contact with Berlin.

In 1919 and 1921 Mies completed two designs for skyscrapers, which, although never built, established the basis of his reputation. One was triangular in plan, the second a free-form plan of undulating curves. In these he proposed the boldest use yet envisaged of an all-glass sheathing suspended on a central core including elevators and other utilities (see fig. 270). No such daring design for a skyscraper or, for that matter, for any other monumental building, was to be erected for thirty or forty years. The emphasis in these was on the formal and expressive qualities of the glass sheath, particularly its property of reflection; there was no real indication of either the structural system or the disposition of interior

space. The projects still belonged in the realm of visionary architecture, but they were prophetic of a solution of the skyscraper that made even Gropius' advanced design for the Tribune Tower seem somewhat dated. Wright's design for St. Mark's Tower in 1929 was actually more completely realized.

Mies's other unrealized projects of the early 1920s included a concrete office building with continuous ribbon windows set back from concrete-strip parapets, and two designs for country houses, the first (1923) in brick and the second (1924) in concrete. The brick country-house design brought together Wright's open plan with long walls integrating inside and outside space, and a classical arrangement of rectangular brick wall masses and window voids exemplifying the principles of De Stijl architecture. The plan of this house (fig. 418), as drawn with the utmost economy and elegance, is, in Mondrian's sense, a pure plastic abstraction.

It was the 1927 Deutscher Werkbund exhibition at Stuttgart that gave Mies his first major opportunity in large-scale planning. The feature of this exhibition was the Weissenhof housing development, the direction of which was given to him. Planned housing had become one of the central architectural issues in Germany during the 1920s, and young architects from other countries were invited to submit designs. It was here that Le Corbusier built his two houses on piers. Oud participated

419. MIES VAN DER ROHE. Barcelona Chair. 1929.
Leather and chrome-plated steel, height 29½″.
The Museum of Modern Art, New York.
Gift of Knoll Associates, Inc.

from Holland; the veteran Behrens, Gropius, and many others from Germany. Mies himself designed an apartment house whose principal innovations, structurally, were its use of steel for domestic architecture and, visually, the bold cantilevers of the roof elements. The architects, differing in their approaches, were unanimous in their concern for the efficient organization of the interiors of their houses and apartments, down to carefully planned kitchens and new designs in furniture. The Weissenhof settlement was also, in its uniform flat roofs and its use of white stucco and strip windows, a symbol of the hold that the international style in architecture had taken throughout Europe.

The last two works executed by Mies in Europe, before the rise of Nazism limited his activity and then forced his migration to the United States, were the German pavilion for the Barcelona Exposition in 1929 and the Tugendhat house at Brno, Czechoslovakia, 1930. The Barcelona pavilion, destroyed at the end of the exposition, has become one of the classics of Mies's career and of the international style. Here was the most complete statement to this date of all the qualities of refinement, simplification, and elegance of scale and proportion that Mies above all others has brought to modern architecture. It exemplified his famous phrase "less is more." In this building he contrasted the richness of highly polished marble wall slabs with the chrome-sheathed slender columns supporting the broad, overhanging flat roof. The marble and glass interior walls stood free, serving simply to define space. In contrast to the earlier brick country-house, the architect put limits on the space of pavilion and court by enclosing them in end walls. This definition of free-flowing interior space within a total rectangle was to become a signature for Mies in his later career. The pavilion was furnished with chairs, stools, and glass tables designed only by Mies, which themselves have become classics (fig. 419). In the Barcelona pavilion Mies demonstrated that the international style had come of age, had come to a maturity that permitted comparison with the great styles of the past.

In the Tugendhat house (fig. 420) the architect had an even better opportunity to demonstrate the totality of his design, down to every element of furniture and fixtures, with no expense spared. Dramatically situated on the side of a hill, the house is entered from above. Again the total form of the house and terraces is held within a rectangular outline. Slender, polished-steel columns stand free of the walls and carry the weight of the roof and floor. The curving staircase and a curving interior wall that defines the dining area add variety to the open interior space. Walls of marble, onyx, and ebony, curtains of beige or black silk or of white velvet, the Mies van der Rohe chairs and tables, symmetrically placed, all add to a total effect of almost overpowering perfection. In contrast to the richness and flexibility of the living quarters on the first floor, the bedrooms above are austerely enclosed rectangles that accent privacy.

Mies became director of the Bauhaus in 1930 but had little opportunity to advance its program. After moving from Dessau to Berlin in that year, the school suffered increasing pressure from the Nazis until it was finally closed in 1933. In 1937, with less and less opportunity to

420. MIES VAN DER ROHE. Tugendhat House, Brno, Czechoslovakia. 1930

practice, Mies left for the United States, where in the last thirty years he has been able to fulfill, in a number of great projects, the genius already apparent in the relatively few buildings he actually built in Europe.

## The Bauhaus, 1919–33

As has already been suggested, one of the most remarkable phenomenons of the 1920s was the school Das Staatliche Bauhaus, formed by Walter Gropius in 1919 from the two Ducal schools of arts and crafts in Weimar. As was the case with the English arts-and-crafts and Deutsche Werkbund traditions, Gropius was convinced of the need for unity of architect, artist, and craftsman. The program of Gropius was a new departure in its insistence not that the architect, the painter, or the sculptor should work with the craftsman, but that they should first of all be craftsmen. The idea of learning by doing, of developing an aesthetic on the basis of sound craftsmanship, was revolutionary.

The core of Bauhaus teaching was a foundation course designed to liberate the student from his past experiences and prejudices. This course, initially developed by the Swiss painter Johannes Itten, introduced the student to materials and techniques through elementary but fundamental practical experiments. A substantial part of the attack was on the classical traditions which still dominated the academies; it included practical experience but also investigation of non-Western philosophies and mystical religions. The approach to materials itself frequently became a sort of mystique. During the first years of the Bauhaus there was very little emphasis on the machine or on art in its relation to industrial society. However,

the important aspect of the curriculum was that it was never static, that it remained in a continual state of change and development. As Mies van der Rohe said at a dinner for Gropius in 1953: "The Bauhaus was not an institution with a clear program—it was an idea, and Gropius formulated this idea with great precision . . . . that it was an idea I think is the cause of this enormous influence the Bauhaus had on every progressive school around the globe. You cannot do that with organization, you cannot do that with propaganda. Only an idea spreads so far. . . ."

Around the idea was formed one of the most remarkable art faculties in history. Vasily Kandinsky, Paul Klee, Lyonel Feininger, Georg Muche, Oskar Schlemmer were among those who taught painting, graphic arts, and stage design. Pottery was taught by Gerhard Marcks, who was also a sculptor and graphic artist. When Johannes Itten left in 1923, the foundation course was given by Laszlo Moholy-Nagy, painter, photographer, theater and graphic designer and, through his writings and teaching, the most influential figure after Gropius in developing and spreading the Bauhaus idea. When the Bauhaus moved from Weimar to Dessau, several former students joined the faculty—the architects and designers Marcel Breuer and Herbert Bayer, and the painter and designer Joseph Albers, who reorganized the foundation course.

Of the artist-teachers, Kandinsky, Klee, and Feininger were to become recognized as masters of twentieth-century painting. Gerhard Marcks, after living in obscurity during the Nazi years, emerged after World War II as a leading German figurative sculptor. Moholy-Nagy, through his books *The New Vision* and *Vision in Motion* and his directorship of the New Bauhaus, founded in Chicago in 1937 (now the Institute of Design of the Illinois Institute of Technology), greatly influenced the teaching of design in this country. Joseph Albers, a teacher at Black Mountain College in North Carolina (1933–50) and subsequently at Yale University, had a comparable influence. Marcel Breuer, principally active at the Bauhaus as a furniture designer, ultimately joined Gropius in 1937 on the faculty of Harvard University and practiced architecture with him. After leaving this partnership in 1941, Breuer's reputation has steadily grown to a position of world renown.

The Bauhaus during the 1920s spread its ideas through the publication of remarkable documents by staff members and by other pioneers of cubism and abstraction (see Bibliography, "Bauhaus Books"). Thus it became the center during the 1920s for the propagation and development of new international experiments, especially the international school of architecture, and geometric abstraction in painting and sculpture. For a time, some currents of dadaism touched the Bauhaus, but its influence was never strong there, nor was that of German expressionism in painting, or German or Dutch expressionism in architecture. The first proclamation of the Bauhaus declared: "Architects, painters, and sculptors must recognize anew the composite character of a building as an entity. . . . Art is not a 'profession.' There is no essential difference between the artist and the craftsman. The artist is an exalted craftsman. . . . Together let us conceive and create the new building of

the future, which will embrace architecture and sculpture and painting in one unity and which will rise one day toward heaven from the hands of a million workers like the crystal symbol of a new faith."

This initial statement reflected some of the socialism then current in Germany and throughout much of Europe. Suspicion of this political attitude caused antagonism toward the school among the more conservative elements in Weimar, an antagonism that finally in 1925 drove the Bauhaus from that city to its new home in Dessau.

The Bauhaus in its first few years was necessarily tentative and experimental in applying the "idea" of Walter Gropius. By 1923, however, this idea had been clarified and tested into a more specific program. Gropius reiterated the principle of "a universal unity in which all opposing forces exist in a state of absolute balance." The emphasis on form as the embodiment of ideas, or of the inner self or inner compulsion, shows the influence of Kandinsky and "the spiritual in art." Gropius stipulated "a thorough practical, manual training in workshops actively engaged in production, coupled with sound theoretical instruction in the laws of design." This statement accordingly put more emphasis on the training of industrial designers than had the initial proclamation—an obvious result of the intervening experience of the Bauhaus teachers.

The underlying theory was established in terms that reflected Klee's ideas as well as those of Kandinsky; theosophical and Neo-platonic ideas may be noted, and awareness of the new mathematics and physics. It thus combined attitudes that had been in the air for years, not too logically integrated, perhaps, but nevertheless profoundly felt and destined to have world-wide influence.

The Bauhaus curriculum was divided into two broad areas: crafts and form problems. Each course had a "form" teacher and a "craft" teacher. This division was necessary because a faculty could not be found during the first four years that was capable of integrating the theory and practice of painting, sculpture, architecture, design, and crafts—although Klee taught textile design and Marcks pottery. With the move to Dessau, however, and the addition of Bauhaus-trained staff members, the various parts of the program were brought into closer proximity; the integration of arts and crafts became realized, particularly by Moholy-Nagy and Albers, and subsequently continued by their activities in the United States.

The emphasis of the 1923 curriculum was on training designers for industry. In Dessau the accent on architecture—which Gropius always considered the mother of the arts—was substantially increased, although the architecture students were expected to complete their training in engineering schools. He said: "We want to create a clear, organic architecture, whose inner logic will be radiant and naked, unencumbered by lying facades and trickeries; we want an architecture adapted to our world of machines, radios and fast motor cars, an architecture whose function is clearly recognizable in the relation of its form."

Despite the high talents of the painting faculty, few painters of distinction emerged. Since the history of the

Bauhaus has been written principally by architects, areas of discontent among the painters and sculptors were perhaps glossed over. The greatest practical achievements were probably in interior, product, and graphic design. During his years at the Bauhaus, Marcel Breuer created many furniture designs that have become classics, including the first tubular steel chair (fig. 421). In ceramic and metal design a new vocabulary of simple, functional shapes was established. The courses in display and typographic design under Bayer, Moholy-Nagy, Tschichold, and others revolutionized these fields. Bauhaus designs have passed so completely into the visual language of the twentieth century that many have become clichés, and it is now difficult to realize how revolutionary they were on first appearance. Certain designs, such as Breuer's tubular chair and his basic table and cabinet designs, Gropius' designs for standard unit furniture, and designs by other faculty members or students for stacking chairs, stools, dinnerware, lighting fixtures, textiles, display and typography, were so basic that they still continue in use.

Moholy-Nagy's experiments in abstract film and photography inaugurated a new era in these mediums, just as his light modulators—constructions involving space, light, and movement—(see fig. 502) were pioneer efforts whose potentials are being realized only now.

Gropius had early been interested in theater architecture, although only his City Theater at Jena, 1923, was actually built. However, his designs for Erwin Piscator for the Total Theater, 1929, entirely flexible in the combination of the proscenium and arena stage, still influence theater design.

421. MARCEL BREUER. Armchair. 1925.
Canvas and chrome-plated steel, height 28".
The Museum of Modern Art, New York.
Gift of Herbert Bayer

# FROM EXPRESSIONISM TO FANTASY IN PAINTING

Expressionism, like romanticism or classicism, is a term that has been applied to tendencies recurring in the arts since antiquity. Herwarth Walden, poet, critic, musician, and the founder of the avant-garde periodical *Der Sturm,* drew the distinction between new, revolutionary tendencies and the impressionism that formed their immediate background and frequently was thought of as their principal enemy. What he called expressionism, however, included cubism, futurism, and even abstraction. In 1912, Walden opened a gallery in Berlin for avant-garde art, the Sturm Galerie, where he exhibited Kandinsky and Der Blaue Reiter, Die Brücke and the Italian futurists, Braque, Derain, Vlaminck, Auguste

422. EGON SCHIELE. *Self-Portrait I.* 1909. 43½ x 14⅛″. Private collection, Turin

Herbin, and others grouped as French expressionists. Also shown were Ensor, Klee, and Delaunay. In 1913 came the climax of the Sturm Galerie's exhibitions, the First German Autumn Salon including 360 works: Henri Rousseau's room had twenty paintings, and almost the entire international range of experimental painting and sculpture at that moment was shown. Although during and after the war the various activities of Der Sturm lost their impetus, Berlin, between 1910 and 1914, was a rallying point for most of the new European ideas and revolutionary movements, largely through the leadership of Herwarth Walden.

Modern expressionism in Germany, Austria, and the Scandinavian countries was an offshoot of romanticism and, as previously noted, had its roots in late nineteenth-century symbolism and post-impressionism. Its essence was the expression of inner meaning through outer form. This outer form ranged from any kind of expressive realism to the abstract expressionism of Kandinsky. Italian futurism was an expressionist form of cubism; the new objectivity (Neue Sachlichkeit) of Otto Dix and George Grosz toward the end of World War I developed from expressionism; and even the new fantasy, dadaism, and surrealism came out of nineteenth-century romanticism—specifically, from symbolism—by way of expressionism. To understand the various directions in which expressionism moved during and after World War I, we may look at a few artists who were associated in some degree with expressionism, but had each his different interpretation: the Austrians Gustav Klimt, Egon Schiele, and Oskar Kokoschka, the American-German Lyonel Feininger, and the Swiss Paul Klee.

## GUSTAV KLIMT((1862–1918),

### EGON SCHIELE (1890–1918)

Klimt has been mentioned already as the leading painter of the art nouveau movement. He also occupies a special place in the story of Austrian expressionism, particularly through his relations with the younger expressionist Egon Schiele. Klimt was an established decorative and mural painter, working in a highly symbolic vein until the mid-1890s. In 1897, he joined a group of younger artists in the formation of the Association of Austrian Painters, Secession (in the sense of secession from the academy). From this point forward he was active in the exhibitions and publications of the Vienna Secession, created major scandals with his erotic, symbolic murals for the University of Vienna, and in the first

423. GUSTAV KLIMT. *Woman with a Black Feather Hat.*
1910. 31¼ x 24¾".
Collection Viktor Fogarassy, Graz, Austria

posed arm to the delicate face crowned by the mass of red hair on which the blue-black feather hat is suspended. Schiele's *Self-Portrait* has little grace and elegance, although many of the elements are similar. Here one is faced with a stark and angry actuality—an inner tension and conflict.

Further comparisons of paintings by Klimt and Schiele are valuable in illustrating both the continuity and the change between nineteenth-century symbolism and early twentieth-century expressionism. Klimt's painting *Death and Life* (also entitled *Death and Love*), 1908 and 1911 (colorplate 99), is heavy with symbolism presented in terms of the richest and most colorful patterns. On the right are figures symbolizing mankind—the lovers, the mother and child, the young girls and the old woman—all integrated into a flat mosaic design, all with closed eyes or bowed heads, awaiting their fate. On the left is the skull's-head image of Death, whose body is an equally flat area of textile decoration with crosses and circles. Nothing could better reveal both the decorative richness of forms and the essentially literary content of the symbolic aspect in art nouveau painting. The theme of Death and Life or Love may be traced in Germanic art from Dürer in the fifteenth century to Arnold Böcklin in the nineteenth.

Another version, by Schiele, painted in 1911 is *The Self-Seer II* (*Death and the Man*, colorplate 100).

decade of the twentieth century worked on the great art nouveau mural project for the Palais Stoclet in Brussels (see fig. 115).

Egon Schiele, born twenty-eight years after Klimt, lived a short and tragic life, dying in the influenza epidemic of 1918. He was a precocious draftsman and, despite opposition from his uncle (who was his guardian after his father died insane), studied at the Vienna Academy of Art. His principal encouragement came from Gustav Klimt, aged forty-five when they met in 1907, and at his height as a painter and leader of the avant-garde in Vienna. The two artists remained close, for the rest of their lives, but there were obviously strong conflicts between them. Although Schiele was briefly influenced by Klimt, much of his developed style was a specific reaction against the older man.

In the *Self-Portrait I,* 1909 (fig. 422), Schiele retains some of Klimt's art nouveau pattern in the drapery, but the intense portrayal, with its narrowed gaze and angular, emaciated figure, differs from even the most direct and least embellished of Klimt's portraits. Klimt's *Black Feather Hat* (fig. 423), painted the next year, clearly shows the older artist's ability to combine linear style with delicate, impressionist color. The portrayal is sharp and perceptive, but what first appeals to us is the elegant, decorative flow of line up the fur boa and gracefully

424. EGON SCHIELE. *The Painter Paris von Gütersloh.*
1918. 55½ x 43½". The Minneapolis Institute
of Arts. Gift of the P. D. McMillan Land Company

425. EGON SCHIELE. *Girl in Black Stockings.* 1911.
Gouache and pencil, 21½ x 14½".
Collection Christian M. Nebehay, Vienna

426. OSKAR KOKOSCHKA. *Portrait of Adolf Loos.* 1909.
29⅛ x 35⅞". Staatliche Museen, Berlin

This work is comparable in subject, but the approach could not be more different. The man (possibly a self-portrait), rigidly frontalized in the center of the painting, stares out at the spectator. His face is a horrible and bloody mask of ultimate fear. The figure of Death hovers behind, a ghostly presence folding the man in his arms in what might almost be an embrace. The paint is built up in jagged brush strokes on figures emerging from a background of harsh and dissonant tones of ocher, red, and green.

The revealing contrasts could be extended to almost every subject the two artists essayed—since both painted portraits, landscapes, and figures, as well as symbolic compositions. In Schiele's portraiture, other than his self-portraits, there persisted the same intensity of characterization, achieved by his use of harsh, brittle line against a broken field of dissonant colors integrating figure and abstract environment (*The Painter Paris von Gütersloh,* 1918, fig. 424). Klimt was a superb draftsman, particularly of female nudes drawn with a loving line that brought out every erotic implication. On the other hand, the female nudes of Schiele, drawn with even greater power, often combine erotic attraction with revulsion (fig. 425).

## OSKAR KOKOSCHKA *(b. 1886)*

Living a brief life of poverty and hardship and isolation in Vienna, a life interrupted by the war and curtailed at the age of twenty-eight, Schiele's remarkable, tortured art seems limited in comparison with that of Oskar Kokoschka, also a product of Vienna but a man who soon moved out into the larger world of modern art to become one of the international figures of twentieth-century expressionism. Between 1905 and 1908 Kokoschka was caught up in Viennese art nouveau, and his series of lithographs entitled *Dreaming Boys* suggests the influence of Klimt and Aubrey Beardsley. Before he went to Berlin at the invitation of Herwarth Walden in 1910, Kokoschka was already instinctively an expressionist. Particularly in his portraits his passionate search was for the exposure of an inner sensibility—which may have belonged more to himself than to the sitter. His very first portraits, such as the double portrait of the art historians Hans Tietze and his wife Erica Tietze-Konrat, 1909 (colorplate 101), and of the Viennese architect, Adolf Loos, 1909 (fig. 426), are among his masterpieces of portraiture. The broken color in the Tietze portrait unifies the figures with the free abstract background; the delicate interplay of the hands suggests intellectual and spiritual communion. The figure of Loos projects from its dark background; and the tension in the contemplative face is caught up in the sensitive, nervously clasped hands. The romantic basis of his early painting appears in *The Bride of the Wind,* 1914 (colorplate 102), an apotheosis of his love affair with Anna Mahler, in which the lovers, composed with flickering, light-saturated brush strokes, are swept through a dream landscape of night-filled, cold blue mountains and valleys lit only by the gleam of a shadowed moon.

Seriously wounded in World War I, Kokoschka produced little for several years, but his ideas and even his

style were undergoing constant change. The *Self-Portrait,* 1917 (fig. 427), is one of a series that he produced throughout his life, portraits that give us a running commentary on the artist's appearance and, more important, on his attempts at self-interpretation. In this painting he is still using a dark-blue, indeterminate background from which the figure, built of writhing coils of paint squeezed from the tube or modeled with the palette knife, projects in relief. The gaunt but heavy-boned peasant's face stares out at the spectator through wide, contemplative eyes whose impact is hypnotic.

In 1924 Kokoschka abruptly set out on travels. During this interval—some seven years—he explored the problem of landscape, combining free, arbitrary, and brilliant impressionist or fauve color with a traditional perspective-space organization that went back to the beginnings of Flemish landscape (*View of the Thames,* 1925–26; colorplate 103). The Thames landscape, which he painted several times, is typical of his approach at this time in the high vantage point, the bold use of linear perspective in the bridges, the yellows, blues, and reds flickering over and unifying the picture surface and, as they describe the rushing buses and cars in the foreground, recording the dynamism of the great city. Kokoschka's expressionism has always been personal. Throughout his long life he has exemplified the spirit of modern expressionism—the power of emotion, the anguish, the joy, the deeply felt sensitiveness to the inner qualities of man and nature.

In 1933, as a result of financial difficulties, the painter returned from his long travels. He went first to Vienna and then, in 1934, to Prague, where he remained for four years. During this period his works in public collections in Germany were confiscated by the Nazis as examples of "degenerate art."

In 1938, London became his home, although whenever possible he continued his restless traveling. After 1953 he lived principally in Switzerland. At all times his work maintained its freedom, its freshness and boldness. Colors are more violent, characterizations forceful, at times to the point of caricature. The long vista of his work makes it clear, however, that consistency of approach unifies his different experiments. Although he never deserted figuration, his later paintings have a kinship to aspects of abstract expressionism. This is only a coincidental relationship suggesting a common origin, however. Throughout his life Kokoschka has remained spiritually contemporary and an expressionist in his personal idiom.

## LYONEL FEININGER *(1871–1956)*

Although Lyonel Feininger was born an American of German-American parents, as a painter he belongs within the European orbit. The son of distinguished musicians, he was early destined for a musical career. But already, before he was ten, he was drawing his impressions of the buildings, boats, and elevated trains of New York City. He went to Germany in 1887 to study music, but soon turned to painting. In Berlin between 1893 and 1905 he earned his living as an illustrator and caricaturist for German and American periodicals, developing a brittle, angular style of figure drawing related to aspects of art

427. OSKAR KOKOSCHKA. *Self-Portrait.* 1917. 31⅛ x 24¾". Von der Heydt Museum, Wuppertal, Germany

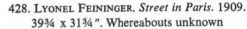

428. LYONEL FEININGER. *Street in Paris.* 1909. 39¾ x 31¾". Whereabouts unknown

nouveau, but revealing a personal sense of slightly mad satire. Two years in Paris, 1906–08, brought him in touch with the early pioneers of modern French painting. *Street in Paris,* 1909 (fig. 428), demonstrates the style of his illustrations, as well as a concern for composing and controlling picture space through areas of architecture. The jagged, nervous, attenuated, or truncated figures loom in the foreground and disappear in a rapid perspective diminution; the buildings and trees have a nervous dynamism of their own. The effect is that of people and even of buildings rushing madly in all directions, intent on purposeless activities.

By 1912–13 the artist had arrived at his own version of cubism, particularly the form of cubism with which Marc was experimenting at the same moment. Feininger was invited to exhibit with Der Blaue Reiter in 1913. Thus, not surprisingly, he and Marc shared the sources of orphism and futurism, which particularly appealed to the romantic expressive sensibilities of both. Whereas Marc translated his beloved animals into luminous cubist planes, Feininger continued with his favorite themes of architecture, boats, and the sea. In his *Harbor Mole,* 1913 (colorplate 104), he recomposed the scene into a scintillating interplay of color facets, geometric in outline but given a sense of rapid color change by the transparent, delicately graded color areas. In this work Feininger stated in a most accomplished manner the approach he was to continue, with variations, throughout the rest of his long life. It was an approach of strong, straight-line structure played against sensuous and softly luminous color. The interplay between taut linear structure and romantic color, with space constantly shifting between abstraction and representation, created effects of dynamic tension to carry the paintings beyond their decorative surface into a romantic-expressive mood. Another effect peculiar to Feininger among the European expressionists —although also to be seen in works of the American painter John Marin—is a reduction of scale in which objects almost always seem diminished by distance.

In 1919 Feininger was invited to join the staff of the Bauhaus, with which he remained associated until its dissolution in 1933. His own painting continued steadily in the direction he had chosen, sometimes emerging in shattered architectural structures, sometimes in serene and light-filled structures full of poetic suggestion. Back in the United States in 1937, he was affected by the new and exciting environment, and began to recapture the brittle, broken quality of line of his first drawings and paintings.

Feininger was essentially a painter of the city, of architecture massed parallel to the picture plane—but he had a second and obsessive love for the sea and ships. These he painted all his life, first for the subject, then increasingly for the challenge of bringing a scene of empty space, of sky and water meeting on the horizon under the control of the picture plane. It was a challenge that had intrigued painters of the modern movement at least from the time of Courbet.

## PAUL KLEE *(1879–1940)*

Paul Klee was one of the most varied, complex, and brilliant talents in the twentieth century. His stylistic development is difficult to trace even after 1914, since the artist, from this moment of maturity, was continually re-examining themes and forms in his efforts to come closer to essences.

Klee was born in Switzerland, the son of a musician and, like Feininger, initially inclined toward music; but having decided on the career of painting, he went to Munich to study, in 1898. During the years 1903–06 he produced a number of etchings (*Virgin in a Tree,* 1903; *Perseus, The Triumph of Wit over Misfortune,* 1904; *Two Men Meet, Each Supposing the Other to Be*

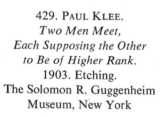

429. PAUL KLEE.
*Two Men Meet,*
*Each Supposing the Other*
*to Be of Higher Rank.*
1903. Etching.
The Solomon R. Guggenheim
Museum, New York

of *Higher Rank,* 1903, fig. 429), which in their precise, hard technique suggested the German graphic tradition of the Renaissance, in their mannered linearism the atmosphere of art nouveau, and in their mad fantasy a personal vision reflecting the influence of the expressionist printmaker Alfred Kubin (see p. 175). These were also among the first of Klee's works in which the title became an integral part.

Klee traveled extensively in Italy and France between 1901 and 1905 and probably saw works of Matisse. Between 1908 and 1910 he became aware of Cézanne, Van Gogh, and the beginnings of the modern movement in painting. In 1911 he had a one-man exhibition at the Thannhauser Gallery in Munich and in the same year met the Blaue Reiter painters Kandinsky, Marc, Macke, Jawlensky, and Gabriele Münter. Over the next few years he participated in the Blaue Reiter exhibitions, wrote for *Der Sturm* and, in Paris again in 1912, met Delaunay and saw further paintings by Picasso, Braque, and Henri Rousseau. Of importance was a trip he took with Macke in 1914, to Tunis and other parts of North Africa.

He was affected, like Delacroix and other romantics before him, by the brilliance of the sunshine and the color and clarity of the atmosphere. To catch the quality of the scene Klee, like Macke, turned to watercolor and a form of semi-abstract color pattern based on cubism (*Hammamet with the Mosque,* 1914; colorplate 105).

Between 1916 and 1918 Klee served in the German army. In 1920, Gropius invited him to join the staff of the Bauhaus at Weimar, and he remained affiliated with the school from 1921 to 1931. Becoming a teacher forced him to examine the tenets of his own painting, something that he did in publications of the greatest significance for modern art and particularly for those aspects concerned with expression of personal fantasy (see Bibliography). He sought to clarify the process of creation as an intuitive act arising from the peculiar spirit of the artist but affected by all his experiences, remembered consciously or not, including the images, materials, and forms with which he had worked. The art of Klee, as differentiated from that of Mondrian or even of Kandinsky in his later phase, was always rooted in nature. He observed and drew from nature every waking moment. His great storehouse of naturalistic observations, however, was only the raw material on which his vision could draw at the moment of revelation. He was like Mondrian and Kandinsky in his mystical sense of an inner content beneath surface nature.

Also like Mondrian and Kandinsky, Klee was concerned in his teachings and his painting with the geometric elements of the work of art—the point, the line, the plane, the solid. To him, however, these elements had a primary basis in nature and growth. It was the process of change from one to the other that fascinated him. To him the painting continually grew and changed in time as well as in space. In the same way color was not simply relationships, harmonious or otherwise, nor even a means of establishing space in the picture. Color was energy. It was emotion that established the mood of the painting within which the line established the action.

Klee was only rarely a pure abstractionist, and then principally in his Bauhaus years, when he was close to

430. PAUL KLEE. *Dance, Monster, to My Soft Song!* 1922. Mixed mediums on gauze mounted on paper, 17¾ x 12⅞″. The Solomon R. Guggenheim Museum, New York

Kandinsky and the traditions of Russian suprematism and constructivism and Dutch De Stijl. His paintings have a pulsating energy that seems organic rather than geometric. But they were never based on immediately observed nature except in his early works and sketchbook notations. He began to draw like a child, letting the pencil or brush lead him until the image began to emerge. As it did, of course, his conscious experience and skills came back into play in order to carry the first intuitive image to a satisfactory conclusion. At that conclusion some other association, recollection, or immediate inspiration would result in the title which then became part of the total work.

Klee thus was a romantic, a mystic. He saw the painting, or rather the creative act, as a magical experience in which the artist was enabled in moments of illumination to combine an inner vision with an outer experience of the world, in the visible rendering of a truth that was not "truth to man or nature" but was itself parallel to and capable of illuminating the essence of man or nature. The "microcosm" of his art, paralleling the "macrocosm" of nature, derives from Oriental ideas. Klee's art obviously grew out of the traditions of romanticism and specifically of symbolism, but he departed from both these traditions in that his inner truth, his inner vision, was revealed not

431. PAUL KLEE. *Around the Fish*. 1926.
18⅜ x 25⅛". The Museum of Modern Art, New York.
Abby Aldrich Rockefeller Fund

432. PAUL KLEE. *Ad Parnassum*. 1932. Casein and oil
on canvas, 39⅜ x 49⅝". Kunstmuseum, Bern

only in the subject, the color, and the shapes as defined entities, but even more in the process of creation that the spectator inevitably had to retrace step by step on the canvas. Klee was a "primitive of a new sensibility," as Cézanne before him had described himself as a primitive of a new vision.

Klee's teaching established much of the iconography of his paintings. As he used arrows to indicate lines of force for his students, these arrows began to creep into his works. Color charts, perspective renderings, graphs, rapidly rendered heads, plant forms, linear patterns, pointillist patterns, checkerboards, scattered or combined

elements of all descriptions, used to prove a point, became part of that reservoir of subconscious visual experience which the artist then would transform into a magical idea.

In the paintings between 1914 and 1918, one can observe experiments with cubist structure and an occasional excursion into a literary fantasy. In 1918 personal fantasy took over in forms that seem to have roots in the art of children, primitives, or madmen. His formal and expressive concepts were largely established before 1920. *Dance, Monster, to My Soft Song!*, 1922 (fig. 430), shows a vast, mad-eyed, purple-nosed head on an infinitesimal body, a child's drawing integrated with the most sophisticated gradations of yellow ocher and umber. This is the essence of one aspect of Klee's work—the childlike image that is in fact a subtle blending of the primitive line mask with the delicate color atmosphere of the ground. Childlike figure- and object-drawings are scattered or floating in an ambiguous space composed of delicate and subtle harmonies of color and light that add mystery and strangeness to the concept. The combination of naïve and sophisticated rendition creates a shock effect of incompatible elements that yet are a single and total visual experience.

In Klee's work as differentiated from that of more formally organized fantasists—dadaists and surrealists—the effects were visual or pictorial forms, not intellectual or literary concepts imposed on pictorial means. Although these seemingly elementary exercises of the *Pedagogical Sketchbook* (see Bibliography) reveal him to have been a master of picture construction and thoughtful planning, even in his works that are most abstract, most concerned with the relationships of lines and color planes and picture space, the final result can rarely be thought of as a geometric abstraction in the sense of Mondrian or Van Doesburg. The designations of "abstract" or "representational" cease to have any application. Klee's world is so personal and individual, so completely a part of—yet so completely divorced from—either normal human experience or existing ideas of abstract picture structure, whether geometric or abstract expressionist, that it exists independently of these, yet still encompasses them.

In *Red Balloon*, 1922 (colorplate 106), the colors are confined within the linear contours but still blend imperceptibly with the drifting, changing color of the whole. The red shapes at the upper left and right are confined by lines only toward the center. Toward the edges of the painting the reds change and flow into the delicate, grayed washes of the ground. The rest of the geometric structure, the total or partial squares and rectangles of yellow and green and umber, float in an indefinable space, impossible to fix or locate exactly. Even the blue-green shape at the bottom, defined at the right by an angled line that suggests a momentary recession into depth, only helps to complicate the spatial ambiguity. The central red circle alone—the "red balloon"—seems to hold as a mysterious focus about which everything else slowly gravitates in a perpetual state of change.

This, then, is an abstraction that is not an abstraction. It is a work of fantasy created out of abstract elements. Klee experimented with his personal forms of geometric abstraction most frequently during his Bauhaus years in

the upper left grows on a long stem from a container that might be a machine and is startled to be met head-on by a red arrow attached to the fish by a thin line. A full and a crescent moon, a red dot, a green cross, and an exclamation point are scattered throughout the black sky—or ocean depth—in which all these disparate signs and objects float. In this and related works he came closest to the efforts of the surrealists, who claimed him as a pioneer.

The range of Klee's experiments was so varied that it touched at one moment or another on almost every aspect of twentieth-century painting. During the early 1930s he explored a form of pointillism (deriving from Picasso's synthetic cubism rather than from Seurat): all-over patterns of brightly colored dots sometimes loosely formed into different colored triangles and controlled by a few strong lines to create an architectural image (*Ad Parnassum,* 1932, fig. 432). After he left the Bauhaus and despite the long illness that led to his death in 1940, his genius spread out in continually richer and more varied forms.

Figures, faces (sometimes only great peering eyes), fantastic landscapes, architectural structures—sometimes menacing—continued to be produced during the 1930s (*Arab Song,* 1932, fig. 433; *Revolution of the Viaduct,* 1937, fig. 434). Perhaps the principal characteristic of the last works was an expression, monumental for Klee, in which he used bold and free black linear patterns against his colored field. In some of the last works, con-

433. PAUL KLEE. *Arab Song.* 1932. Oil on burlap, 36 x 25¼". The Phillips Collection, Washington, D.C.

the 1920s, an obvious reflection of the constructivist atmosphere with which he was surrounded. *In the Current Six Thresholds,* 1929 (colorplate 107), is a non-objective arrangement of vertical-horizontal rectangles, in which gradations of deep color are contained within precisely ruled lines. Yet the total effect—as is usual with Klee—is organic rather than geometric. The forms seem produced by growth, and the sense of change is present throughout. Most of Klee's paintings were in combinations of ink and watercolor, mediums appropriate to the effects of fluidity that he sought, but this particular work is in a combination of oil and tempera, mediums he used to obtain effects of particular richness or density.

During the 1920s Klee produced a series of black pictures in which he used the oil medium, sometimes combined with watercolor. Some of these were dark underwater scenes in which fish swam through the depths of the ocean surrounded by exotic plants, abstract shapes, and sometimes strange little human figures. This theme, embodying an arrangement of irrelevant objects, some mathematical, some organic, is presented as a sort of surrealist still life in *Around the Fish,* 1926 (fig. 431), in which the precisely delineated fish on the oval purple platter is surrounded by objects, some machine forms, some organic, some emblematic. A schematic head on

434. PAUL KLEE. *Revolution of the Viaduct.* 1937. Oil on panel, 23⅝ x 19⅝". Kunsthalle, Hamburg

sisting only of a few brushed lines suggesting a figure or a snake, he drew close to some of the organic-surrealist paintings of Joan Miró. However, as always when one detects a relationship that may be an influence between Klee and another artist, it is difficult to tell who influenced whom (*La Belle Jardinière*, 1939, colorplate 108).

The art of Paul Klee introduces into the study of modern painting and sculpture, and even of architecture, the range of tendencies having to do with the exploration of the fantastic. His was a unique genius, but he was not in any sense working in isolation, for a large number of artists, both as individuals and as organized groups—dadaists, metaphysical painters, and surrealists—were concerned with themes of fantasy, rooted in new theories of the subconscious, in revolt against the insanity of war or, sometimes, simply in revolt against the predominance of abstract, formal elements in the experimental art of the twentieth century (*Battle Scene from the Comic Opera, "The Seafarer,"* 1923, colorplate 109; *A Leaf from the Book of Cities,* 1928, fig. 435).

## KANDINSKY AFTER 1921

Vasily Kandinsky returned to Germany from Russia in 1921, and in 1922 joined the faculty of the Bauhaus. In the previous years, under the influence of Russian suprematism and constructivism, his painting had turned gradually from free abstraction to a form of geometric abstraction. This change can be traced in three paintings of 1919, 1920, and 1923. *In Gray, No. 222,* 1919 (fig. 436), is almost totally free and non-geometric. *White Line, No. 232,* 1920 (see colorplate 94), shows some regular shapes, straight lines, and curving shapes with

*above:* 435. PAUL KLEE.
*A Leaf from the Book of Cities.*
1928. Engraving on chalk-
covered paper on wood,
17 x 12⅝".
Kunstmuseum, Basel

*right:* 436. VASILY KANDINSKY.
*In Gray, No. 222.* 1919.
50¾ x 69½". Collection
Mme. Nina Kandinsky,
Neuilly-sur-Seine, France

sharply defined edges. Then, in *Accented Corners, No. 247,* 1923 (fig. 437), regular, hard-edged shapes have taken over.

This is not to say that Kandinsky after 1921 deserted the expressionist basis of his earlier style. His mystical-theosophical ideas persisted. Even during his most rigidly geometric period his paintings were dynamic in structure, with triangles, circles, and lines flashing in and out of one another in unstable diagonals. He continued to use variegated color areas as contrasts with the geometry of the line. At times the mood becomes quiet: in *Several Circles, No. 323,* 1926 (see colorplate 95), the transparent color circles float serenely across one another in a gray-black space.

In correspondence with his biographer, Will Grohmann, during this period, Kandinsky emphasized his passion for the expressive power of abstract motifs, but he still thought of his painting as romantic: "The purpose, the content of art is Romanticism, and it is our fault if we understand the concept exclusively in terms of its temporary manifestations . . . . the circle which I have been using to such a large extent in my recent work can often be described only as a Romantic circle. And the coming Romanticism is a piece of ice in which a flame burns."

Kandinsky was a most influential member of the Bauhaus faculty, and not only because he was a great artist, a pioneer of modern abstraction, and a talented teacher bringing first-hand knowledge of the Russian revolution in abstract art. He was also capable of formulating his visual and theoretical concepts with precision and clarity. In 1926 he published as a Bauhaus Book his *Point and Line to Plane* (see Bibliography), his textbook for a course in composition. As compared with Paul Klee's *Pedagogical Sketchbook* of the previous year, Kandinsky's attempts a more absolute definition of the elements of a work of art and their relations one to another and to the whole. The spiritual or romantic basis of his art is evident here; and his correspondence of the time reveals his combination of the pragmatic and the mystical.

Kandinsky's association with the Bauhaus continued until it was closed in 1933. He painted prolifically, creating works filled with subject implications and form conflicts, but always staying within the abstract means. Toward the end of the Bauhaus years the lyrical, coloristic aspect of Kandinsky's painting began to re-emerge and to supersede the architectonic approach. In *Between the Light, No. 559*, 1931 (colorplate 110), the shapes are still geometric; they are stratified in an even more vertical and horizontal manner than before. The color is soft and muted however; precise shapes are surrounded by a diffused nimbus of light and color, so that the total effect is quiet and romantic. Some shapes suggest Egyptian or American Indian hieroglyphs, conveying a feeling of the exotic. Kandinsky was now aware of the surrealist activities of the 1920s; and one senses in this, and in works created after he moved to France in 1933, qualities akin to abstract surrealism. The color shapes take on their own life and play or do battle like micro-organisms or space monsters.

By late 1933 Kandinsky was in Paris, his home until his death. He was soon involved in the Abstraction-Création group of abstract artists, and became friendly with

437. VASILY KANDINSKY. *Accented Corners, No. 247.* 1923. Oil on burlap, 51¼ x 51¼". The Solomon R. Guggenheim Museum, New York

Miró, Arp, and Pevsner. This last period was for him extraordinarily rich both in quantity of work and in the enlargement of his ideas and his forms. In general he continued toward freer, more biomorphic shapes and colors and, at times he created textures more brilliant and varied than any since his abstract expressionist works. The edges of his shapes remained sharp, but the shapes seem to have emerged from microscopic fantasy. In *Composition IX, No. 626,* 1936 (colorplate 111), he established a mathematical color base by sectioning the two ends with identical triangles, one inverted and the other upright. The parallelogram shape between the two triangles is subdivided into four smaller identical parallelograms. On this rigidly defined but vividly coloristic ground he scattered a wild assortment of dancing little shapes: circles, checkerboard squares, long, narrow rectangles, and amoeba-like figures. This device of playing little free forms against a large geometric pattern intrigued him during these years. Sometimes the ground was an alternation of a few large identical vertical rectangles, sometimes a black-and-white checkerboard, but the contrast of freedom and control came from his lifelong concentration on the relations between intuitive expression and calculated abstract form.

This personal abstract fantasy was the principal departure of his later years. At times he scattered his little free forms haphazardly over a unified color ground; at other times he returned to a design of the fewest possible elements, as if to purify his means. Kandinsky's last paintings represent the flowering of one of the most remarkable and influential talents in modern art.

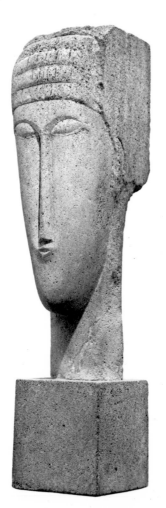

438. AMEDEO MODIGLIANI. *The Cellist.* 1909.
29 x 23½″. Private collection, Paris

## AMEDEO MODIGLIANI *(1884–1920)*

Modigliani was born of well-to-do parents in Leghorn, Italy. His training as an artist was often interrupted by illness, but he managed to get to Paris by 1906. Although he was essentially a painter, in 1909, influenced by Brancusi, he began to experiment with sculpture. His life was tragically short. For fourteen years he worked in Paris, riddled with tuberculosis, drugs, and alcohol, but drawing and painting obsessively.

Modigliani was not really an artist of the twentieth century, despite his connections with the School of Paris. He would have been at home in the Florence of Uccello or Botticelli. He utilized post-impressionist delimitation of picture space and cubist restriction of color; within these limits he was concerned with portraits, nudes, occasional studies of children, and sculptured heads or figures of Africa, archaic Greece, or the Early Middle Ages.

His career was so abbreviated that it is almost impossible to speak of a stylistic development, although one can observe a gradual transition from a nabi formula, in which the figure is securely integrated in the space of an interior, toward a pattern of linear or sculptural detachment. *The Cellist,* 1909 (fig. 438), was in the 1910 Salon des Indépendants and brought the artist some recognition. It was not a revolutionary subject or concept however. It was inspired by the Cézanne exhibition of 1907, which had been an overpowering experience for him. Despite this, Cézanne's concept of a figure balanced within its spatial environment was not congenial to Mo-

*right:* 439. AMEDEO MODIGLIANI.
*Head.* c. 1912.
Limestone, height 25″.
The Solomon R. Guggenheim
Museum, New York

*far right:*
440. AMEDEO MODIGLIANI.
*Caryatid.* ç. 1914.
Limestone, height 36¼″.
The Museum of Modern Art,
New York
Mrs. Simon Guggenheim Fund

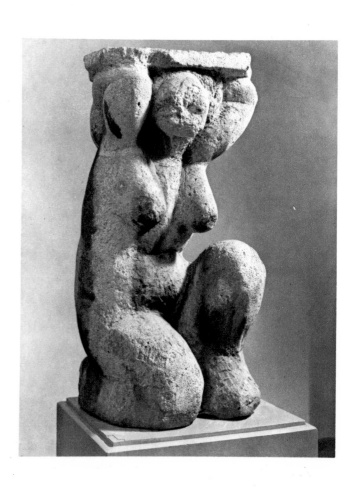

digliani. His experiments with sculpture over the next few years confirmed his passion for rendering the figure as sculptural relief and later as expressive contour drawing detached with beautiful lucidity from its background. The sculptural sources that appealed to Modigliani, aside from Brancusi, were archaic Greek kouroi and those African masks in which emphasis was on linear elongation of the features (*Head,* c. 1912; fig. 439). Sometimes he would turn to flat-topped, horizontally designed heads derived from the early medieval art of France or Spain, or to caryatids, treated with a crude blockiness of masses and surface that suggests late antique classical forms (*Caryatid,* c. 1914; fig. 440).

Modigliani was one of the master portraitists of twentieth-century painting. Although all of his portraits are given a family resemblance by his personal, elegant elongation or his use of forms deriving from primitive and archaic art, his friends, among whom were notable artists and critics of the early twentieth century, are characterized with a sensitive perception that accurately records their personalities, their eccentricities and foibles. *Bride and Groom,* 1915–16 (fig. 441), portrays an unidentified couple. One is tempted to see a French view of the upper-middle-class English. The two subjects seem arrogant and oblivious, with the primitivist technique of blank eyes and profile nose in full face contributing to the characterization.

Character analysis from works of art is a dangerous game, particularly when the sitter is anonymous and we have no corroborative documentation. We are on safer

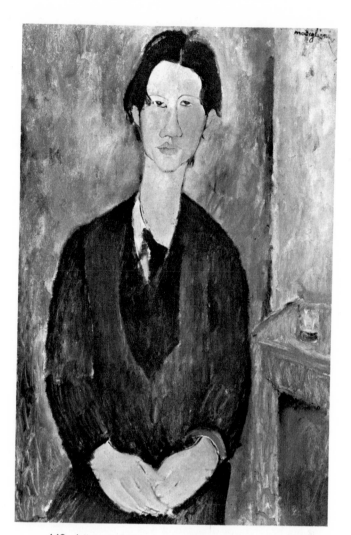

442. AMEDEO MODIGLIANI. *Chaim Soutine.* 1917.
36⅛ x 23½".
National Gallery of Art, Washington, D.C.
Chester Dale Collection

ground when we examine Modigliani's many portraits of well-known personalities. In this gallery, Picasso, seen in a sketch, is heavy-eyed and sensual. Max Jacob, poet and intellectual catalyst, has bland and cryptic eyes, yet gives off an aura of sharp intelligence and of sartorial elegance. Jacques Lipchitz is the debonair bohemian, vastly different from the latter-day patriarch. Jean Cocteau is a wraith, an intelligence already in process of burning out its corporeal shell. Chaim Soutine, 1917 (fig. 442), is a Russian peasant whose broad, flat nose, thick lips, and Slavic cheekbones seem to accentuate the almost cruel perception behind the half-closed eyes.

Aside from these well-known figures, Modigliani's portraits extend over the range of his friends and acquaintances, not only celebrities but anonymous boys, girls, and children—anyone who would pose for him without a fee. The same is true of his paintings of the nude, although he probably had sometimes to depend on professional models. His depictions of the nude or partially draped female are among the most beautiful and sensuous in the whole of art. The figure is normally set

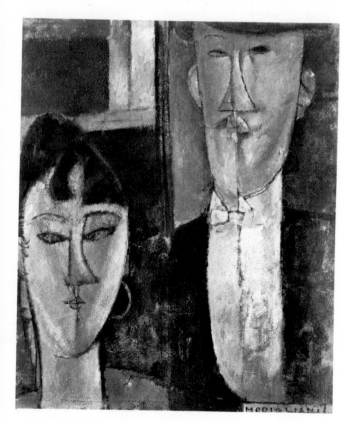

441. AMEDEO MODIGLIANI. *Bride and Groom.* 1915–16.
21¾ x 18¼". The Museum of Modern Art, New York.
Gift of Frederic Clay Bartlett

within a narrow depth of colored space. The artist is fond of the contrast of draped white sheets against a deep Venetian red. One feels a greater kinship of Modigliani's reclining, somnolent, or suddenly awakened nudes (*Nude,* 1917, colorplate 112) to Giorgione's *Sleeping Venus* (see fig. 15) than to Manet's assertive and arrogant *Olympia* (see fig. 16) or Renoir's light-dappled milkmaids (see colorplate 6). The figure is outlined with a flowing but precise line; the full and sensuous volumes are modeled with almost imperceptible gradations of flesh tones. The torso is often extremely elongated, but there is no visual sense of grotesque distortion. We are concerned only with elegant harmony in a pose of such idyllic composure that the twentieth-century nude recalls the reclining Venus of the Renaissance.

## CHAIM SOUTINE *(1894–1943)*

Chaim Soutine, a Russian, was a friend of both Marc Chagall and Modigliani, and of Jules Pascin as well. Soutine, Modigliani, Pascin, and Maurice Utrillo are often associated with one another, not because of any stylistic or even broadly aesthetic similarities, but because of the personal behavior, character, and even tragedy that gained them the sobriquet of *les peintres maudits.* Modigliani, after a life of dissipation, died in 1920 at the age of thirty-six from drugs, alcohol, and tuberculosis. Pascin, more successful financially during his lifetime, led a frenetically gay life during the 1920s that resulted in a gradual physical deterioration and finally in suicide in 1930. Utrillo, an alcoholic from childhood, was in and out of hospitals during much of his life, but ended his days as a respectable, honored, and well-to-do bourgeois.

Soutine differed from the other artists of this group in that his problem of dissipation was complicated by a will to self-destruction. Born into a poor Russian-Jewish family, he somehow developed a passion for painting and drawing, managed to attend some classes in Minsk and Vilna, and, through the help of a patron, went to Paris in 1911. He studied at the Ecole des Beaux-Arts, but it was through the artists whom he met at an old tenement on the Rue de Dantzig known as La Ruche that he began to find his way. These artists included Chagall and Lipchitz, through whom he met Modigliani. The tenement was on the left bank of the Seine and the artists were then ignorant of the Montmartre (right bank) activities of Picasso and Braque.

Soutine constantly destroyed or reworked his paintings, so that it is almost impossible to trace his development from an early to a mature style. He had an affection for some artists, like Bonnard, who represented an offshoot of impressionism, and he expressed admiration for Rouault. But his own paintings have an affinity (without direct influence) with German expressionism, particularly the works of Emil Nolde. This is a similarity of spirit, not specifically of style. Soutine belonged to the line of Van Gogh, even though he resented the implication. In one sense he was right to resent it: although Van Gogh painted man and nature in terms of an inner torment, it was a torment disciplined by brush strokes as precise and architectural as those of neo-impressionism. The essence of Soutine's expressionism lies in the intui-

443. CHAIM SOUTINE. *Gnarled Trees.*
c. 1921. 38 x 25".
Collection Mr. and Mrs. Ralph F. Colin, New York

tive power, the seemingly uncontrolled but immensely descriptive brush gesture. In this quality he is closer than any artist of the early twentieth century to the abstract expressionists of the 1950s. The old masters for whom he expressed enthusiasm—El Greco and the later Rembrandt—helped him to express in paint his peculiar way of seeing, but ultimately both the vision and the expression were his own. Like Van Gogh, Soutine was a tormented soul, given to violent excesses of temperament.

The first liberation of Soutine's expressive powers came in 1919, when, through the help of his friend and dealer, Leopold Zborowski (who had helped Modigliani), he was able to spend three years in a town in the Pyrenees called Ceret. The mountain landscape inspired him to a frenzy of free, expressionist brush paintings (for example, *Gnarled Trees,* c. 1921, fig. 443) that transcended in violence anything produced by the fauves or the German expressionists. In these works, trees, houses, and mountains are ripped apart as though by a literally earth-shattering cataclysm. Soutine painted furiously during this period, and seems himself to have been torn apart. But the result was his first success. After his return

*above:* Colorplate 99.
GUSTAV KLIMT.
*Death and Life.*
1908 and 1911.
Oil on canvas,
70⅛ x 78″. Collection
Frau Marietta Preleuthner,
Vienna

*right:* Colorplate 100.
EGON SCHIELE.
*The Self Seer II*
*(Death and the Man).*
1911. Oil on canvas,
31⅝ x 31½″.
Collection Dr. Rudolf Leopold,
Vienna

Colorplate 101.
OSKAR KOKOSCHKA.
*Hans Tietze and*
*Erica Tietze-Conrat.*
1909. Oil on canvas,
30⅛ x 53⅝ ".
The Museum of Modern Art,
New York. Abby Aldrich
Rockefeller Fund

Colorplate 102.
OSKAR KOKOSCHKA.
*The Bride of the Wind.*
1914. Oil on canvas,
71¼ x 86⅝ ".
Kunstmuseum, Basel

266

left: Colorplate 103.
OSKAR KOKOSCHKA.
*View of the Thames.* 1925–26.
Oil on canvas, 35⅜ x 51¼".
The Albright-Knox Art Gallery,
Buffalo, New York

below: Colorplate 104.
LYONEL FEININGER.
*Harbor Mole.* 1913.
Oil on canvas,
31¾ x 39¾". Collection
Mr. and Mrs. John Drew,
Pittsburgh

*above left:* Colorplate 105.
PAUL KLEE. *Hammamet with the Mosque.* 1914.
Watercolor on paper,
8⅛ x 7½". Collection
Heinz Berggruen, Paris

*above right:* Colorplate 106.
PAUL KLEE. *Red Balloon.*
1922. Oil on chalk-primed
muslin, mounted on board,
11½ x 12¼".
The Solomon R. Guggenheim
Museum, New York

*right:* Colorplate 107.
PAUL KLEE. *In the Current
Six Thresholds.* 1929.
Tempera and oil on canvas,
17 x 17". The Solomon R.
Guggenheim Museum, New York

left: Colorplate 108. PAUL KLEE.
*La Belle Jardinière.* 1939.
Tempera and oil on canvas,
37⅜ x 27⅝ ". Paul Klee Collection,
Kunstmuseum, Bern

below: Colorplate 109. PAUL KLEE.
*Battle Scene from the Comic Opera,*
*"The Seafarer".* 1923. Colored sheet,
watercolor and oil drawing, 15 x 20¼ ".
Collection Frau T. Dürst-Haass,
Muttenz, Switzerland

*right:* Colorplate 110.
VASILY KANDINSKY.
*Between the Light, No. 559.*
1931. Oil on cardboard,
27⅝ x 31½".
Private collection, Italy

*below:* Colorplate 111.
VASILY KANDINSKY.
*Composition IX, No. 626.*
1936. Oil on canvas,
47⅞ x 76¾".
Musée National d'Art Moderne,
Paris

*above:* Colorplate 112. AMEDEO MODIGLIANI.
*Nude.* 1917. Oil on canvas, 28¾ x 45¾".
The Solomon R. Guggenheim Museum, New York

*left:* Colorplate 113. CHAIM SOUTINE.
*Woman in Red.* c. 1922. Oil on canvas, 25 x 21".
Collection Dr. and Mrs. Harry Bakwin, New York

Colorplate 114. CHAIM SOUTINE.
*Side of Beef*. c. 1925.
Oil on canvas, 55¼ x 42⅜".
The Albright-Knox Art Gallery,
Buffalo, New York

Colorplate 115. MAURICE UTRILLO.
*Rooftops of Montmagny*. 1906–07.
Oil on canvas, 65 x 54".
Musée National d'Art Moderne, Paris

Colorplate 116. HENRI ROUSSEAU.
*Carnival Evening.* 1886. Oil on canvas, 46 x 35¼".
The Philadelphia Museum of Art. The Louis E. Stern Collection

273

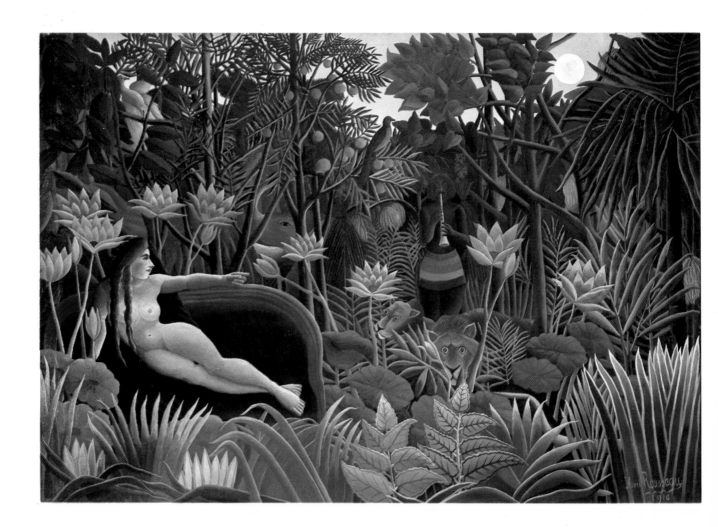

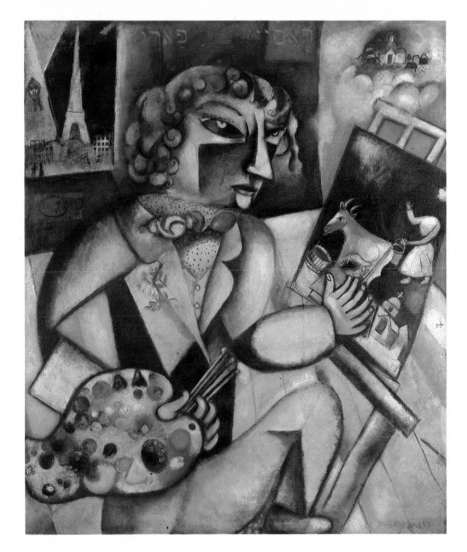

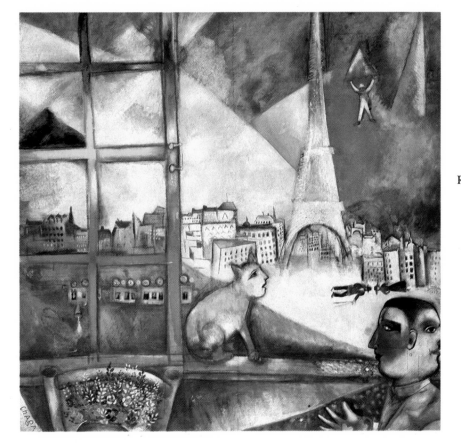

opposite:
Colorplate 117.
HENRI ROUSSEAU.
*The Sleeping Gypsy.*
1897. Oil on canvas,
51 x 79″. The Museum
of Modern Art,
New York. Gift of
Mrs. Simon Guggenheim

Colorplate 119.
MARC CHAGALL.
*Self-Portrait with
Seven Fingers.* 1912.
Oil on canvas,
49⅝ x 42⅛″.
Stedelijk Museum,
Amsterdam

opposite:
Colorplate 118.
HENRI ROUSSEAU.
*The Dream.* 1910.
Oil on canvas,
6′ 9″ x 11′ 4″.
The Museum of
Modern Art, New York.
Mrs. Simon Guggenheim
Fund

Colorplate 120.
MARC CHAGALL.
*Paris Through
the Window.* 1913.
Oil on canvas,
52⅜ x 54¾″.
The Solomon
R. Guggenheim Museum,
New York

275

Colorplate 121. MARC CHAGALL.
*The Green Violinist.* 1918.
Oil on canvas, 77¾ x 42¾".
The Solomon R. Guggenheim Museum,
New York

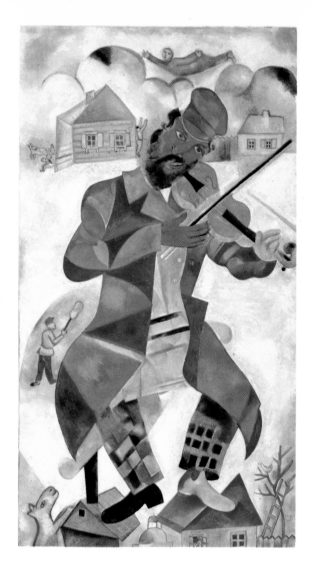

Colorplate 122.
MARC CHAGALL. *Birthday.*
1915–23. Oil on canvas,
31⅞ x 39⅜". The Solomon
R. Guggenheim Museum,
New York

to Paris, a large number of his canvases were bought by the American collector Albert C. Barnes.

In his portraits and figure paintings of the 1920s there was frequently an accent on a predominant color—red, blue, or white—around which the concept was built. In *Woman in Red,* c. 1922 (colorplate 113), the sitter is posed diagonally across an armchair over which her voluminous red dress flows. The red of the dress permeates her face and hands, is picked up in her necklace and in the red-brown tonality of the ground. Only the blue of the hat stands out against it. The hands are distorted as though from arthritis, and the face has the frozen, twisted grin of a paralytic. As in many of Soutine's portraits, the first impression is of a cruel caricature. Then, suddenly, one becomes aware of something disturbing, pathetic, sometimes frightening, something that pertains to the artist rather than to the sitter.

Soutine, like many indigent artists, had painted still lifes of fish or fowl from the beginning of his career, because the model could be painted and then eaten. However, his still lifes were different—the fowl scrawny and cadaverous, the fish repulsively goggle-eyed and gapemouthed. Before him perhaps only Courbet (whom Soutine admired) and Manet, influenced by Courbet, had painted fish so blatantly and repulsively dead. His passion for Rembrandt was commemorated in a number of extraordinary paintings that were free adaptations of Rembrandt's. In *Side of Beef,* c. 1925 (colorplate 114), Soutine transcended Rembrandt's *Butchered Ox,* in the Louvre, in gruesome, bloody impact. The story of the painting is well known—of the pathetic girl model daily fetching blood from the butcher's shop to refurbish the rapidly decaying carcass while nauseated neighbors

screamed for the police. But it is a curious fact that, once the initial shock has passed, we can appreciate the artist's passion for the sheer loveliness of the vermilion carcass shot through with yellow against the azure blue of the ground. In this and in many paintings Soutine demonstrates how close are the extremes of ugliness and beauty; how death and dissolution can involve resurrection.

## JULES PASCIN *(1885–1930)*

In the gaiety and easy hedonism of his life, Jules Pascin seems to represent an absolute contrast to the tortured Soutine. Yet it was he who committed suicide, at the age of forty-five, on the opening day of a major exhibition of his paintings. Pascin worked first in Vienna and Berlin and early demonstrated the talent of illustrator and caricaturist by which he always earned a respectable living. He was in Paris by the end of 1905, but before 1914 his reputation was greater in Germany than in France. He made drawings for the satirical journal *Simplicissimus* and exhibited at the 1911 Berlin Secession and the Independents exhibition in Cologne in 1912. In 1913, he also exhibited twelve works in the Armory Show in New York.

Pascin was acquainted with German expressionism, particularly Die Brücke, before World War I, and some of his earliest surviving paintings suggest Erich Heckel. By 1912 or 1913 he had settled on a style of figure painting in which his elegant draftsmanship was reinforced by delicate, atmospheric color tones in an effect of romantic mood that, in his mature works, could range from the nostalgia and innocence of childhood to the erotic

444. JULES PASCIN.
*Socrates and His Disciples Mocked by Courtesans.* c. 1921. Oil on paper, 61¼ x 86". The Museum of Modern Art, New York. Given anonymously in memory of the artist

fantasies of his studies of prostitutes (*Socrates and His Disciples Mocked by Courtesans,* c. 1921, fig. 444; *Nude with Green Hat,* c. 1925, fig. 445). The artist early established a personal manner, a successful and accomplished formula with many levels of appeal; he only occasionally saw any need to modify it. He did, from time to time, produce perceptive portraits, usually of his wife or his friends. In occasional figure studies he demonstrated a brutal power of expressive drawing indicative of abilities far beyond his pleasant, titillating norm (*Back View of Venus,* 1924–25; fig. 446). But the pleasures of leading a gay life seemed preferable until his health—and possibly also his vision of himself—deteriorated and he killed himself in 1930.

Pascin has a continuing reputation, for the erotic charm of his paintings has a never-dying appeal. He directly influenced the development of the modern movement in the United States, to which he came in 1914 and remained until 1920. Although New York was his base, he traveled through the South, the West, and the Caribbean. At this time, his gregarious and friendly nature brought him in touch with young artists who had been leading the American realist revolt. On a second stay in the United States in 1927–28 he became friendly with the younger American painters associated with forms of social or romantic realism. Pascin naturally held considerable interest for younger American artists trying to find a new direction. Since his actual style did not represent a radical departure from their own experiments, ex-

446. JULES PASCIN. *Back View of Venus.* 1924–25. 31⅞ x 26¾ ″. Musée National d'Art Moderne, Paris

cept perhaps in its technical sophistication (his interest in watercolor was a bond), his influence on these American painters was substantial.

## MAURICE UTRILLO (*1885–1955*)

The life and art of Maurice Utrillo provide perhaps the greatest paradox among the *peintres maudits.* He was the illegitimate son of Suzanne Valadon (1865–1938), a famous model for Renoir, Degas, and Toulouse-Lautrec, who later became an accomplished painter herself. Utrillo began to drink as a child, was expelled from school, dismissed from a position in a bank, and by the age of eighteen was in a sanatorium for alcoholics.

Somehow, during Utrillo's chaotic adolescence—probably through his mother's influence—he became interested in painting. He was self-trained, like his mother, but his art was hardly, if at all, influenced by her. Although his painting was technically quite accomplished and one can recognize stylistic influences from the impressionists or their successors, he was closer to the purposely naïve type of painting then developing from the recognition of Rousseau's genius. His obsessive concentration on an extremely limited subject matter and painstaking reproduction of it—the familiar scenes of Montmartre painted almost street by street—reflects the attitudes of the naïve and the primitive. (The word "primitive," in this context, is used to signify a non-academic, often self-taught, folk-art vision, rather than non-European tribal or exotic character.)

445. JULES PASCIN. *Nude with Green Hat.* c. 1925. 36¼ x 30¼ ″. Cincinnati Art Museum. Virginia Helm Irwin Bequest

The first paintings that still survive are of the suburb of Montmagny (colorplate 115) where he grew up, and of Montmartre after he moved there; painted approximately between 1903 and 1909, they tend to coarse brush texture and sober color. He then passed into an impressionist phase reminiscent of late paintings by Pissarro. About 1910, he began to reproduce the chalky white buildings of Montmartre. On occasional trips away from Paris he painted churches and village scenes that were variations on his basic theme (fig. 447). His favorite scenes recur over and over again, his memory refreshed from postcards. After 1919 his color brightened and figures occur more frequently. From 1930 until his death in 1955, Utrillo, now decorated with the Legion of Honor, lived at Le Vésinet outside Paris, where his wife watched over him carefully, and he divided his time between painting and religious devotions. During these twenty-five years of rectitude, he did little but repeat his earlier paintings.

Utrillo's case is curious; he was able to nourish a small but consistent talent for over fifty years. The talent was exaggerated by his association with great figures and movements of modern painting. Through his mother he was even linked with the impressionists and post-impressionists of the late nineteenth century. In the 1930s and 1940s the collectors and museums wishing to include the early twentieth-century School of Paris found in Utrillo an artist who seemed to have been a pioneer, yet whose paintings looked respectable among old masters, impressionists, or modern academic realists or romantics (fig. 448).

This is not to say that the best of his paintings lack quality. They are quiet, austere, and well composed. The clear white facades accented by the dark rectangles of shuttered windows or store fronts, lend a quality of classic simplicity. The empty streets, so often under a winter or late autumn sky with a few bare trees, breathe a gentle melancholy and nostalgia. But when one compares his work with what was happening in the first decades of the twentieth century, Utrillo's conservatism becomes apparent. His simplification of an architectural theme is a mild form of twentieth-century semi-abstraction—perhaps it is truer to say that, in spirit, these are really nineteenth-century paintings.

# PIONEERS OF FANTASY

The paintings of Paul Klee and some of Kandinsky's later paintings introduced aspects of a second major trend in modern art (the first being the exploration of form). This was the exploration of the irrational and the fantastic in naïve painting, primitivism, dadaism, and surrealism. These movements are descendants of nineteenth-century romanticism and symbolism. Behind them stretch a thousand years or more of individuals and movements concerned with some sort of personal, eccentric, unorthodox, mystical, or supernatural expression. Christian art from the fourth to the sixteenth centuries is a concentrated examination of the fantastic in its supernatural aspects, as believing Christian artists tried to describe the indescribable punishments of sinners and the ecstasies of the blessed. Sporadic efforts at this kind of art continued through the eighteenth century, culminating in William Blake's mystic visions and Francisco Goya's macabre and powerful nightmares describing a world gone rotten.

As romanticism grew and spread in the nineteenth century, fantasy appeared in many forms in painting, sculpture, and architecture. In the latter part of the century, Gustave Moreau, Rodolphe Bresdin, and Odilon Redon created separate dream worlds, but only Redon emerged as a master of the first rank. The principal transition from nineteenth-century romanticism to twentieth-century fantasy was provided by Redon, James Ensor, and Henri Rousseau.

## HENRI ROUSSEAU *(1844–1910)*

Until 1885, when he retired from his post of inspector at a toll station, Rousseau was an untrained Sunday painter. In 1886 he began to paint full time, and to exhibit regularly at the Salon des Indépendants. He drew and painted throughout his life—still lifes and landscapes that remind us of work by amateur or folk artists produced in every part of Europe and the Americas. His fresh directness came primarily from the limitations of his untrained vision. It is questionable whether he can really be classified as a naïve or primitive after 1885. Once his full energies were turned to painting, he seems to have developed a native ability into a sophisticated technique, and to have noted the differences between his approach and that of the salon artists.

Rousseau was a fascinating mixture of naïveté, innocence, and wisdom, seemingly humorless. He combined a strange imagination with a way of seeing that was magical, sharp, and direct. His first painting exhibited in the Salon des Indépendants, *Carnival Evening,* 1886 (colorplate 116), the work that marks his debut as a full-

time painter, is a masterpiece. The design includes deep space with all elements treated frontally and flatly. The black silhouettes of trees and house are drawn in painstaking detail—the accretive approach used by the archaic artist. Color throughout is low-keyed, as befits a night scene, but the lighted distant mountains between the dark sky and the even darker foreground of trees create a sense of weird white moonlight. The two tiny figures in harlequin costumes in the foreground glow with an inner light. Despite the painstakingly worked surface and the naïveté of his drawing, the artist not only fills his painting with poetry but achieves a structure that, for him, is extremely sophisticated for its date of 1886. The picture plane controls the design and the organization of depth to a degree that is prophetic of a major concern of art even in the 1960s.

449. HENRI ROUSSEAU. *Myself: Portrait Landscape.* 1890. 57½ x 44½″. National Gallery, Prague

By 1890 Rousseau had exhibited some twenty paintings at the Salon des Indépendants. Although consistently ridiculed by the public and the critics, they increasingly excited the interest of serious artists. Redon had already recognized something unique in Rousseau's work; during the 1890s his admirers included Degas, Toulouse-Lautrec, and even Renoir. His self-portrait entitled *Myself: Portrait Landscape,* 1890 (fig. 449), extols the great exposition in Paris, 1889, and shows the Eiffel Tower, a balloon, a flag-decked ship, and an iron bridge over the Seine (Pont des Arts). In the foreground stands the majestic figure of the bearded artist, dressed in black and crowned with a black beret. His brush is in his right hand, and his palette, inscribed with the names of his past and present wives, is in his left. His image of himself as a master of modern painting is nowhere more apparent.

With painstaking care and deliberation, Rousseau continually painted and drew scenes of Paris, still lifes, portraits of his friends and neighbors, and details of plants, leaves, and animals. His romantic passion for far-off jungles filled with strange terror and beauty first appeared in developed form in *Storm in the Jungle,* 1891 (fig. 450), and then recurred in a series of his best-known canvases. His exotic paintings of North Africa, like *The Sleeping Gypsy,* 1897 (colorplate 117), were part of the tradition of such scenes, long since become clichés in the hands of academicians. To the end of his life Rousseau continued his childlike admiration for the salon painters, particularly for the technical finish of their works. *The Sleeping Gypsy* is one of the most entrancing and magical paintings in modern art. By this time he could create mood through a few elements, broadly conceived but meticulously rendered. The composition has a curiously abstract quality (the mandolin and bottle foretell cubist studio props), but the mood is overpoweringly strange and eerie—a vast and lonely landscape framing a mysterious scene. In this work, as in others, Rousseau expressed qualities of strangeness that were unvoiced, inexpressible rather than apparent, anticipating the standard vocabulary of the surrealists. He seems also to have felt that he owed it to his position as an artist of stature to try his hand at the great allegorical "machines" that still filled the exhibitions of the academic salons, paintings extolling Liberty, Progress, or the Glory of France. His *Liberty Inviting the Artists to Exhibit at the 22nd Salon des Indépendants,* 1906 (fig. 451) is sheer delight. Under the plane trees and gay flags, two lines of artists with their canvases converge behind a heraldic lion; behind them (actually above them in the stratified space of archaic painting) are two converging lines of carts (the *charettes* in which artists brought their paintings to exhibitions). Behind the plane trees are the glass windows of the exhibition hall, and a solid mass of artists carrying their paintings in hand. In the wide blue sky flies the figure of Liberty, flapping her wings and triumphantly blowing her trumpet.

The last series of Rousseau's paintings, and the climax of his vision, are scenes of the jungle: in these the little leaves he picked up, and the animals and plants he observed in the Paris Zoo and Botanical Garden, were transformed into scenes of tropical mystery. The setting

450. HENRI ROUSSEAU. *Storm in the Jungle.* 1891. 50½ x 63½". Collection Mr. and Mrs. Henry Clifford, Radnor, Pennsylvania

451. HENRI ROUSSEAU. *Liberty Inviting the Artists to Exhibit at the 22nd Salon des Indépendants.* 1906. 68¾ x 47". On loan to the Museum of Modern Art, New York, from a private collection, Switzerland

in each is a mass of broad-leaved jungle foliage, gorgeous orchids, exotic fruits, and apprehensive, anachronistic animals peering out of the underbrush. The climax of such scenes is *The Dream,* 1910 (colorplate 118), Rousseau's last great work, painted in the year of his death. It is a fantasy that the surrealists undoubtedly envied: in the midst of a wildly abundant jungle, with its peering lions, brilliant birds, shadowy bison, pale moon, and dark-skinned flute player, a luscious, if malformed, nude rests on a splendid Victorian sofa. Rousseau's charmingly simple explanation of this improbable creation— that the lady on the couch dreamed herself transported to the midst of the jungle—explains the work at an elementary level. The conception is perfect, too entrancing to need any explanation other than its existence.

During his later years, Rousseau became something of a celebrity for the new generation of artists and critics. He held regular musical soirées at his studio. Picasso, in 1908, after discovering a portrait of a woman by Rousseau at Père Soulié's junk shop, purchased it for five francs and gave a large party for him in his studio, a party that has gone down in the history of early modern painting. Among those present were Gertrude Stein, the American poet and pioneer patroness of the new artists, Guillaume Apollinaire, already mentioned as the chief apologist for cubism and other modern experiments, the painter Marie Laurencin, the critic Max Jacob, and other artists, critics, and collectors. The party was half a joke on the innocent old *douanier,* who took himself so seriously as an artist, but more an affectionate tribute to a naïve man recognized to be more genius than naïve. The apotheosis of Henri Rousseau as painter and prophet came in the last decade of his life. Rousseau, despite the early date of his birth, belongs next to Picasso, Braque, Matisse, and the other painters who constituted the first generation of twentieth-century art.

## MARC CHAGALL (b. 1889)

Marc Chagall's birth was almost half a century after Rousseau's, yet he made an impact on the world of art within two or three years of Rousseau's last and most influential paintings. Chagall was born in Vitebsk, Russia, of a large and poor Jewish family. From his background he acquired a wonderful repertoire of Russian-Jewish folk tales and a deep and sentimental attachment to the Jewish religion and traditions. There was also inbred in him a fairytale sense of fantasy. Out of these elements emerged his personal and poetic painting. Chagall attended various art schools in St. Petersburg but derived little benefit until he enrolled in an experimental school directed by the theater designer Léon Bakst, who was influenced by the new ideas emanating from France. Chagall then could not rest until he departed for Paris in 1910.

In Paris, Chagall entered the orbit of Apollinaire and the leaders of the new cubism, as well as that of Modigliani, Soutine, and Jules Pascin. Chagall's Russian paintings had largely been intimate genre scenes, often brightened by elements of Russian or Jewish folklore. Bakst's school caused him to make bold efforts using fauve color and constricted space. His intoxication with Paris opened a floodgate of experiments in fauve color and cubist space, and above all of subjects filled with lyric fantasy. Within two years of his arrival, Chagall was producing mature and weirdly poetic paintings.

*Homage to Apollinaire,* 1911–12 (fig. 452), which seems something of a sport among his early efforts, already shows his utilization of cubist space. Although the work belongs in the early cubist tradition, specifically that of Delaunay, nothing about it is recognizably derivative. The organization of color shapes within the circular and spiral scheme is cubist in origin but individual in presentation—shapes cut across the double figure of Adam and Eve, integrating them with the rotating ground. Adam and Eve, their two bodies emerging from one pair of legs to symbolize the union and opposition of male and female, derive from medieval representations of the Fall of Man. The numbers on the left arc of the outer circle introduce the notion of time.

The symbolism of *Homage to Apollinaire* has been variously interpreted. The theme of lovers irrevocably joined continues throughout Chagall's work and his life, but it is a mistake to interpret literally Chagall's symbolic vocabulary. His knowledge of Jewish and Christian themes is extensive, as is his knowledge of ancient mythology and his native Russian folklore, but he is not concerned with scholarly development. *Homage to Apollinaire* is probably as close as he ever came to a scholarly approach, but its poetic charm and mystery are the result of unexpected juxtapositions dredged up from the artist's unconscious memory.

In his *Self-Portrait with Seven Fingers,* 1912 (colorplate 119), Chagall recapitulated his worlds—the Paris he

452. MARC CHAGALL. *Hommage to Apollinaire.* 1911–12. Stedelijk van Abbe-Museum, Eindhoven, The Netherlands

triangular kite. The suggested studio interior with its carefully drawn chair and flowers, and even its Janus-faced poet, seems closer to everyday experience than to the Paris of the poet's dream. The window with its frame of red, yellow, blue, and green, and its human-headed cat acting as a domesticated Cerberus, becomes a partition between the two cities. The sky composed in large geometric areas, and the animated buildings, particularly the somewhat tilted Eiffel Tower, suggest Delaunay's dynamic method imposed upon a dream of gentle nostalgia.

In 1914, Herwarth Walden, previously mentioned, arranged an exhibition of Chagall's work in Berlin. It had a great impact on the German expressionists, one that extended well beyond World War I. The outbreak of war caught Chagall in Russia, where he then stayed until 1922. After the Russian revolution, like Malevich and other avant-garde artists, he served for a time as a commissar of fine arts and formed a free art academy. Perhaps his most fruitful work was for the Yiddish theater in Moscow, painting murals and designing settings and costumes. This opportunity to work on a large scale in the theater has continued to fascinate him and to inspire some of his most striking paintings (*The Green Violinist*, 1918, colorplate 121).

In Russia, Chagall seems to have been drawn back to his Jewish heritage, expressed now with a deep sense of its pathos and dignity (*The Praying Jew*, 1914; fig. 453).

453. MARC CHAGALL. *The Praying Jew*. 1914.
46 x 35". The Art Institute of Chicago.
The Joseph Winterbotham Collection

lived in seen through the window, and a vision of Vitebsk that floated out of his memory. The peasant scene on the easel shows a cow and milkmaid hovering above a Russian Orthodox church. The studio is contracted as a room by Van Gogh might be, with a sour yellow floor and crimson walls. The artist, with his great eyes and long curly hair, is the least representational part of the picture: the face and body are broken up with cubist planes and modeled volumes; the palette is a pattern of color; the seven fingers of his left hand contribute a Jewish ritualistic symbolism. Despite his rapid assimilation of fauvism and cubism, the essence of Chagall's art is a vision of naïve simplicity, akin to that of Rousseau but imbued with his own poetic exuberance and sentiment.

During the next years in Paris, the painter continued to utilize the new forms in expressing his personal fantasy. *Paris Through the Window*, 1913 (colorplate 120), is like an expansion of the Paris detail in the *Self-Portrait*. Paris is now the entire picture. The double-faced Janus figure in the lower right corner (in appearance more like Apollinaire than Chagall himself), with two profiles in contrasting light and shadow, suggests a double nature for the painting—the romantic Paris of actuality, and Paris transformed in the poet's dreams with trains floating upside down, pedestrians promenading parallel to the sidewalks, and an aviator supported by a

454. MARC CHAGALL. *Double Portrait with Wineglass*.
1917–18. 91¾ x 53½". Musée National d'Art Moderne, Paris

The monumentality, somber color, abstraction, and sadness that this painting represents are in extreme contrast to a contemporary series of paintings made after his reunion with his beloved Bella, who became his wife in 1915. His feeling for her is commemorated in a group of paintings of lovers. In *Birthday,* 1915–23 (colorplate 122), Chagall floats ecstatically through the air and, with delicious absurdity, twists his head for a kiss, as Bella

455. ARNOLD BÖCKLIN. *Odysseus and Calypso.* 1883. Tempera on mahogany, 42⅞ x 59″. Kunstmuseum, Basel

456. MAX KLINGER. *Paraphrase on the Finding of a Glove.* Plate 2 from *A Glove.* 1881. Etching. The Museum of Modern Art, New York

pauses in her household chores. In *Double Portrait with Wineglass,* 1917–18 (fig. 454), Chagall rides on his beloved's shoulders, his hand over her right eye, more tipsy with joy than with wine, while angels hover overhead and Bella's uncovered eye looks out with delight.

Back in Paris in 1923, Chagall became increasingly active in the graphic arts, especially for the dealer Ambroise Vollard. He created illustrations in series for Gogol's *Dead Souls,* La Fontaine's *Fables,* and the Bible. In 1941, with the advent of World War II, Chagall moved to the United States, where Bella died in 1944. A painting of 1943, *Between Darkness and Light,* shows the shadowed blue face of the painter before the snowy vision of his native village, receiving the kiss of his ghostlike beloved. Sad and withdrawn, this painting seems a premonition of her death.

Chagall continued to move from project to project with undiminished energy and enthusiasm. In 1945 he designed sets and costumes for Stravinsky's *Firebird.* In 1947 he was given retrospective exhibitions at the museums of modern art in New York and Paris. He continued to make color lithographs, produced sculptures and ceramics, designed a ceiling for the Paris Opéra, 1963, and murals for the Metropolitan Opera at Lincoln Center, New York, 1966. Chagall's love of rich, translucent color, particularly the primaries blue, red, and yellow, made stained glass a medium natural for him; his most impressive windows are those he designed for the Synagogue of the Hadassah Medical Center in Jerusalem.

# The Metaphysical School

### GIORGIO DE CHIRICO *(b. 1888)*

Giorgio de Chirico links nineteenth-century romantic fantasy with twentieth-century movements in the irrational, dadaism, and surrealism. Born in Greece of Italian parents, De Chirico learned drawing in Athens. After the death of his father, a railroad architect, the family moved to Munich where the artistic leanings of the elder son Giorgio (then seventeen), and the musical leanings of the younger son Alberto, could be advanced. There De Chirico was exposed to the art of the late nineteenth-century German-Swiss romantic, Arnold Böcklin (1827–1901), and of Max Klinger (1857–1920), who carried the romantic tradition into the twentieth century. Although he quickly outgrew Böcklin, he retained certain images throughout his "metaphysical" period, particularly Böcklin's black, shadow figure of Odysseus with his back to the spectator in *Odysseus and Calypso,* 1883 (fig. 455). What impressed De Chirico in the work of the older romantic was Böcklin's ability to impart "surprise," to make real and comprehensible the improbable or fantastic, by juxtaposing it with normal everyday experience. While in Munich, De Chirico was also affected by the philosophical writings of Nietzsche and Schopenhauer. His concept of a painting as a symbolic vision was partly based on Nietzsche, even down to the particular

form taken by this dream: a deserted Italian city square
—perhaps Turin, where Nietzsche spent some late years
—deep in an autumn afternoon when the air is un-
naturally clear and the shadows long. Too, Nietzsche's
insistence on the lyric significance behind the surface ap-
pearance of mundane objects led De Chirico to his meta-
physical examination of still life.

Other sources for De Chirico's personal dream world
may be found in ideas then fermenting in Germany. Max
Klinger's strange etching, *Paraphrase on the Finding of a
Glove,* 1881 (fig. 456), from a series illustrating fetish-
ism that antedates the published theories of Freud, was
later specifically used by De Chirico; Klinger also in-
fluenced the expressionist exponent of fantasy, Alfred
Kubin (see p. 175), a graphic artist of considerable
power. Kubin's drawing, *Vision of Italy,* c. 1904–05 (fig.
457), a lonely piazza dominated by a statue of winged
Pegasus, may have intrigued De Chirico.

While De Chirico was in Germany, from 1905 to
1909, art nouveau was still a force and the German ex-
pressionists were beginning to make themselves known.
Ideal or mystical philosophies and pseudo-philosophies
were everywhere gaining currency among artists and
writers, and modern theosophy was an international cult.
We have already seen the theosophical bases of Kandin-
sky's approach to abstraction; and mystical concepts of
an inner reality beyond surface appearance affected art-
ists as divergent as Mondrian and Klee.

Psychoanalysis, with its study of the subconscious, the
symbolism of dreams, and the importance of instinct and
emotion in human behavior, also had great importance
for artists seeking new modes of expression. These artists
were rarely profound students of philosophy or psychol-
ogy; they assimilated, generally, a popularization of ideas
in the air and, like everyone else, sometimes misunder-
stood or misapplied them. But many individual artists
seized upon such current ideas, and though these might
ultimately be proved invalid or to have been grasped only
vaguely by the artist, they became the basis of works of
art through the artist's peculiar and intense perception.
De Chirico constantly referred to the metaphysical con-
tent of his paintings, using the term loosely or inaccu-
rately to cover various effects of strangeness, surprise, and
shock. One may ask to what extent was De Chirico's in-
dividual fantasy a direct result of the influences to which
he was exposed during the Munich years. This question,
of course, could be asked about any artist whose works
represent a departure, and may often be pointless or
unanswerable. It does have relevance, however, to De
Chirico's development, since his earliest paintings, be-
tween 1910 and 1915, were so distinct from those by
other artists around him and so influential in the develop-
ment of fantasy, particularly the ideas of the surrealists.
It is also important to consider the personality of De
Chirico himself—a notably strange and complicated one.
Thus it is very likely that even if he had been exposed to
quite different influences, he would still have formed
some comparable expression.

In 1910 he moved to Florence, where he probably
finished two pictures departing from Böcklin's style, if not
his spirit, and established the subject, the iconography,
and the mood of loneliness, strangeness, and melancholy

457. ALFRED KUBIN. *Vision of Italy.* c. 1904–05.
Colored drawing. Whereabouts unknown

458. GIORGIO DE CHIRICO. *The Enigma of an Autumn
Afternoon.* 1910. 14 x 18″. Whereabouts unknown

that he was to make his own. These paintings are *The
Enigma of an Autumn Afternoon* (fig. 458), now disap-
peared, and *The Enigma of the Oracle.* The subject (or
setting) is the piazza of an Italian city, with Renaissance
facades, a sculptural monument—here classical, but nine-
teenth-century in the later works. In many of these paint-

ings, the statue—based on the statue of Dante in the Piazza Santa Croce in Florence but transformed into a headless "classical" sculpture—turns its shrouded back to the spectator in a manner reminiscent of Böcklin's *Odysseus and Calypso*. In *Enigma of an Autumn Afternoon*, the square is empty of human beings save for two shrouded figures; the blank architectural facades, the long shadow cast by the statue, and the empty sky all contribute to the dream atmosphere. Even the dark curtains in the porticoes of the church create an uneasy sense of something hidden. At this time, when analytical cubism was reaching its climax in France and spreading through Europe, De Chirico's space is uncompromisingly that of Renaissance perspective, even though his main masses of architecture are parallel to the picture plane. Seemingly indifferent to the pictorial-spatial revolutions of the previous fifty years, his perspective space has the architectural clarity of fifteenth-century Italian art. But De Chirico's perspective space is one basis of the creation of his deserted world of dreams. In using perspective as an expressive rather than a merely descriptive device, to express effects of mystery, loneliness, or fear, the artist's

459. GIORGIO DE CHIRICO. *The Nostalgia of the Infinite.*
c. 1913–14. 53¼ x 25½".
The Museum of Modern Art, New York

revolution was as significant for the surrealists as cubism for the abstractionists.

James Thrall Soby quotes an unpublished article of 1912 by De Chirico, describing the genesis of this painting: "One clear autumnal afternoon I was sitting on a bench in the middle of the Piazza Santa Croce in Florence. It was of course not the first time I had seen this square. I had just come out of a long and painful intestinal illness, and I was in a nearly morbid state of sensitivity. . . . I had the strange impression that I was looking at [the piazza] for the first time, and the composition of my picture came to my mind's eye. . . . The moment is an enigma to me, for it is inexplicable. And I like also to call the work which sprang from it an enigma."

In 1911 De Chirico went to Paris, where he remained until 1915, when he was recalled to military service in Italy. He seems to have been more affected by old masters in the Louvre, such as Poussin and Claude, than by the cubists' experiments. Even the vociferous activities of the Italian futurists, which he must have noticed, did not touch him. But his slightly later interiors and still lifes include forms inspired by cubism, making it obvious that he observed the ferment around him and pursued his own aims deliberately. In 1913 he met Guillaume Apollinaire, who championed the young Italian, acquired some of his paintings, and had his symbolic portrait painted by him.

De Chirico's approach to art, during his early and most important phase—up to 1920—was to examine a theme as though to wring from it its central mystery. In 1912 and 1913 he painted a group of works incorporating a Hellenistic sculpture of a reclining Ariadne, of which *The Soothsayer's Recompense* (see colorplate 123), one of the finest, presents classical facades parallel to the picture plane, but the large clock and the train moving along the horizon are nineteenth-century elements having an anachronistic affinity with the architecture. Such anomalies are commonplace in Italian cities: a palazzo may become a nineteenth-century railway station suggesting the melancholy of departure (a title he used), a melancholy saturating the shadowed square in which deserted Ariadne mourns her departed Theseus. At times, the strange, sad loneliness of De Chirico's squares take on the dimension of fear, of isolation in a vast, empty space. In *The Nostalgia of the Infinite*, c. 1913–14 (fig. 459)—many of De Chirico's titles were coined later, by the poet and critic André Breton and the surrealists—two minute figures are isolated at the foot of a great square tower. The deep shadow of a colonnaded building lies across the front; the area where the two figures stand is brilliantly lit, as though they were trapped in a cosmic spotlight; at the right is a portentous, unidentified shadow. In this work De Chirico established much of the vocabulary to which the surrealists later responded—the inexplicable juxtapositions contrasting vastness and the infinitesimal, brilliant light and deep shadow (frequently inconsistent with the light source), and empty spaces filled with unknown threat. The off-key greens, deep browns and ochers, with dark gray shadows, are flat and opaque, but further tensions arise from the underlying luminescence.

Another masterpiece of this period is *The Melancholy*

*and Mystery of a Street,* 1914 (colorplate 124), perhaps De Chirico's finest example of deep perspective used for emotional effect. On the right an arcaded building in deep browns and grays casts a shadow filling the foreground; a lower white arcade on the left sweeps back toward infinity; the sky is dark and threatening. Into the brightly lit space between the buildings emerges a shadowy little girl rolling her hoop, a wraithlike figure drawn inexorably toward a looming black shadow of a figure behind the dark building. In the shadowed foreground is again an anachronism, an empty old-fashioned freight car whose open doors add another disturbing element of the commonplace. The scene may be described matter-of-factly: an Italian city square with shadows lengthening in a late autumn afternoon; an arcade of shops closed for the day; railway tracks in the lower left corner; the shadow of a heroic nineteenth-century statue; a little girl hurrying home. But from these familiar components the artist creates a mood of frightening strangeness.

Another painting of 1914 is in its way even more disturbing: *The Child's Brain* (fig. 460). Exceptionally for this period, it is a figure study with architecture in the background. This work has lent itself to Freudian interpretation in the light of De Chirico's close relationship with his mother. The surrealists seized on *The Child's Brain* with delight as a classic example of Freudian psychology in painting. In 1950 André Breton, still surrealism's spokesman, published the painting with the eyes retouched so that they look out on the spectator: curiously, the opened eyes take away much of the figure's menace.

During 1914 and 1915 De Chirico began to paint constricted architectural settings in which objects have a greater place. All objects are painted with a hard insistence on their three-dimensional reality that makes us see them as object-ideas transcending our visual or tactile experience of them. De Chirico was to explore the metaphysical reality of objects over the next few years.

A related interest began in 1914 and lasted for several years, that of mannequins, suggesting the articulated wooden figures used in drawing classes, dressmakers' dummies, or Renaissance lay figures and anatomical charts. Mannequins as the protagonists in De Chirico's pictorial dramas may have been inspired by his brother's play about "a man without voice, without eyes or face," but the faceless mannequin also develops logically from the headless draped figure or the anonymous frock-coated statue in the square, its back to the spectator. One of the finest of the series is *The Seer,* 1915 (fig. 461). Whatever the origin of De Chirico's mannequin iconography, the entire aura of the paintings in this series recalls Renaissance architectural perspectives of the fifteenth and sixteenth centuries, made dramatic by extreme foreshortenings and close-ups. When the artist refers specifically to Renaissance classicism, however, it is to the High and Late Renaissance of Michelangelo, Raphael, and their followers.

In Ferrara, from 1915 to 1919, De Chirico summed up his explorations of the previous years in a fully developed mature style. Their haunting, dreamlike fusion of reality and unreality earned them the appellation "metaphysical"; and when De Chirico met the artists Carlo Carrà and Filippo de Pisis in the army hospital in Fer-

460. GIORGIO DE CHIRICO. *The Child's Brain.* 1914. 32 x 25½". Breton Collection, Paris

461. GIORGIO DE CHIRICO. *The Seer.* 1915. 35¼ x 27⅜". James Thrall Soby Collection, New Canaan, Connecticut

462. GIORGIO DE CHIRICO. *The Disquieting Muses.*
1916. 38⅛ x 26".
Gianni Mattioli Foundation, Milan

looming construction of elements from the studio and drafting table, crowned by a blank mannequin head.

In *The Disquieting Muses,* 1916 (fig. 462), the artist combines other images and remembrances. The muses are classical, draped figures: the left figure with columnar drapery, its back to the spectator, has the head of a dressmaker's dummy; the center figure is seated with arms folded, her dummy's head placed neatly on the ground beside her; a more orthodox classical statue is seen dimly in the shadowed middle distance. All rest on a platform that terminates with the red facade of the Castello Estense of Ferrara and a factory building. Particularly disquieting in this painting is the curious ease and naturalness of the muses. Though made up of such disparate elements they yet seem to be sentient beings, at home in their environment.

The *Grand Metaphysical Interior,* 1917 (fig. 463), illustrates other aspects of De Chirico's Ferrarese period. Here he develops sharp and brilliant color and, in certain details, precisely defined textural surface. The interior is constricted by tilted gray planes; a realistic landscape painting and a framed relief of suspended objects are both set on a construction of armatures and mathematical instruments. This is a superb example of the artist's concern for the metaphysical reality of objects, illustrated particularly in the two suspended rolls of Italian

463. GIORGIO DE CHIRICO. *Grand Metaphysical Interior.* 1917.
37 x 27". James Thrall Soby Collection, New Canaan, Connecticut

rara, they formed the association known as the *scuola metafisica,* the metaphysical school.

De Chirico's key paintings of his Ferrarese sojourn—*The Great Metaphysician, The Disquieting Muses,* and *Grand Metaphysical Interior*—were the climax of the artist's visions of loneliness and nostalgia, his fear of the unknown, his premonitions of the future, and the reality beyond physical reality. De Chirico saw himself as an oracle. As in the case of certain visionary saints, the question has often been raised, somewhat unromantically, whether his visionary powers might have come from his disordered health, and his later academic classicism attributed, conversely, to his subsequent physical improvement in the 1920s.

*The Great Metaphysician,* 1917 (colorplate 125), combines the architectural space of the empty city square and the developed mannequin figure. The deep square is sealed in with low classical buildings. The sky occupies half of the canvas, becoming light toward the horizon. The buildings to right and left are abstract silhouettes extending geometric shadows over the brown area of the square: only the rear buildings and the foreground monument are brightly lit. This monument on a low base is a

464. GIORGIO DE CHIRICO. *The Sacred Fish*. 1919.
29½ x 24⅜″. The Museum of Modern Art, New York.
Acquired through the Lillie P. Bliss Bequest

posed by Marinetti, and practiced for a time by Carrà as well as by Severini, specifically influenced poets and artists among the dadaists and surrealists. Its recent influence on the pop artists is comparable to that of Russolo's noise organ on electronic music.

The directions of Carrà's paintings and collages after 1912 indicate his search for a new content and for forms more plastic and less fragmented than those of futurism. By 1916 he adapted ideas of Early Renaissance masters and the modern master of naïve expression, Henri Rousseau. Then De Chirico provided his answer; and Carrà's works immediately reflected it. He painted pictures in 1917 that are almost pastiches of De Chirico's, but in *The Drunken Gentleman* (fig. 465), dated 1916 but certainly painted in 1917, he developed an individual approach; the objects—sculptured head, bottle, glass, etc.—are modeled with clear simplicity in muted color gradations of gray and white, given strength and solidity by the heavy impasto of the paint. Out of elementary still-life props he creates his own metaphysical reality.

In 1918 Carrà published *Pittura Metafisica,* a book enunciating its philosophy. De Chirico, feeling justifiably that he was not given adequate credit, became embittered, and ended both their friendship and the metaphysical school as a formal movement. The metaphysical

bread; but the prosaic literalness of the landscape painting is a premonition of the coming change in De Chirico's work.

*The Sacred Fish,* 1919 (fig. 464), a strange and somber conception, is executed with an oily brush. The fish are placed in the suggestion of a cross on the trapezoidal altar; to the left is a candle decorated with a starfish; in the foreground is a puzzle box of brightly colored triangles, one of those mathematical props that haunt the paintings of this period. The space of the painting is almost uniformly in shadow, with a variety of vertical shapes dividing the space like stage flats. The painting has overtones of some obscene ritual of black magic; and this made the work appeal strongly to the surrealists.

## CARLO CARRA

It seems fateful that Carlo Carrà, of all the Italian futurists, was sent to Ferrara for military service; here he met De Chirico in 1917. Carrà had been replacing the coloristic fluidity of his futurist paintings with a more disciplined style akin to analytical cubism. He then introduced a modeled nude in some paintings, as a gesture to his growing admiration for Giotto and Early Renaissance painters. In the first war years he applied Marinetti's concept of free words to collages with propagandistic intent (see p. 229 and Carrà's *Patriotic Celebration, Free Word Painting,* see colorplate 92). The form pro-

465. CARLO CARRA. *The Drunken Gentlemen*.
1917. 23⅝ x 17½″.
Collection Carlo Frua de Angeli, Milan

school had never been a school, a movement, or even a style in the sense that cubism might be so considered. In addition to De Chirico and Carrà, the artists principally associated with it were De Chirico's younger brother who was known as Alberto Savinio (he became a serious painter at a later date), Filippo de Pisis, and briefly, Mario Sironi; the only other great name was Giorgio Morandi, because for a short time he used some of its subject matter. His genius, to be discussed later, lay elsewhere.

The essence of the metaphysical school was in the conviction of a few artists, notably De Chirico and Carrà, that the answer to the dilemma of modern art lay in the plastic reshaping of Renaissance visual reality, principally linear perspective. The metaphysical painters retained the forms of Renaissance reality, perspective space, recognizable environment, and sculptural figures and objects, and by various juxtapositions producing surprise and shock created an atmosphere of strangeness, sometimes even of fear and horror. In their search for a new content, the metaphysical painters took the first deliberate step for those who have since been exploring possibilities for expression in the intuitive and the irrational.

After 1920, just as De Chirico began to be recognized as a forerunner of new movements in many parts of Europe and the United States, he suddenly turned against the direction of his own painting; after a time of indecision, years in which he made exact copies of his metaphysical paintings on commission, he settled on an academic classicism that he has since continued to pursue. He did not actually repudiate his own early works, for he took pride in his reputation and became jealously possessive of his achievements. The end of World War I, however, was for him the end of a road. He was by no means alone in his abandonment of experiment or in his attempt to rejoin the mainstream of Renaissance painting. The end of the war saw many artists deserting fauve or cubist or abstract directions, some temporarily, others permanently.

466. GIORGIO MORANDI. *Landscape*. 1933. Etching.
Private collection, New York

## GIORGIO MORANDI *(1890–1964)*

Although the legacy of the metaphysical school was principally utilized by the Paris surrealists, one Italian painter of genius quietly and unobtrusively perpetuated the ideas of De Chirico and Carrà. This was Giorgio Morandi, whose reputation has gradually increased until he is now recognized as the most important Italian painter since De Chirico.

De Chirico had enunciated his metaphysical philosophy: "Every serious work of art contains two different lonelinesses. The first might be called plastic loneliness . . . the double life of a still life, not as a pictorial subject but in its supersensory aspect. . . . The second loneliness is that of lines and signals; it is a metaphysical loneliness for which no logical training exists, visually or psychically." This statement has particular reference to the still lifes and interiors with mannequins that De Chirico painted when he was associated with Carrà. In quite a different manner it is pertinent to the quiet but magical still lifes and landscapes painted and etched by Morandi.

Born in Bologna, Morandi lived there his entire life, teaching etching at the Academy of Fine Arts and producing small paintings of landscapes and bottles. His first paintings, between 1911 and 1914, were principally landscapes, evidently influenced by Cézanne. From 1914 to 1916 he experimented cautiously with cubist still life and some studies of attenuated figures in the manner of Modigliani. In these early works his personal point of view is already clear, as well as the muted, close-keyed color and rich texture that he maintained throughout his life. In 1916 he began a series of still lifes, in which all elements are simplified in an effect of almost total abstraction; yet the objects stand forth with near human presence within the abstract space.

The influence of the metaphysical school was strongest between 1918 and 1919. A typical still life of 1918 consists of the head of a dressmaker's dummy, two upright bottles, a folded paper, and a sliced end of bread, all arranged meticulously on a circular table that seems to float unsupported in space. The colors are harsh gray-greens and low-keyed ochers, accented by one gray-white bottle. Morandi's relationship to De Chirico and Carrà is clear, yet this work is an individual combination of precise realism and abstraction, with its isolation and "loneliness" of the inanimate objects. His association with the metaphysical school did not last as a separate phase beyond 1920, but for the rest of his life it clarified his ideas about his art. It was to be a search for the metaphysical reality of the commonplace. Collecting his beloved bottles and pots from junk shops, he insisted on their actuality; but he transformed them, in a manner like yet unlike Cézanne, into the actuality of a painting (colorplate 126).

Morandi was a most talented and sensitive graphic artist. His etchings, as traditional and subtle as Dürer's engravings, reiterated the course of his paintings. Using a pattern of meticulous crosshatching, he emphasized the sculptural mass of the objects in still lifes of the 1920s and, with variety of line, he created an uncanny effect of color variation. Interestingly, Morandi's etched landscapes frequently have more power and authority than do his painted landscapes (fig. 466).

# PART FIFTEEN

# DADA

## Zurich Dada, 1916–19

During World War I, searches for a new fantastic subject matter and content began to come into focus. Zurich, in neutral Switzerland, was the first important center in which arose an art, a literature, and even a music of the fantastic and the absurd. On this city in 1915 converged a number of young men, almost all in their twenties, exiles from the war that was sweeping over Europe. These included the German writers Hugo Ball and Richard Huelsenbeck, the Rumanian poet Tristan Tzara, the Rumanian painter and sculptor Marcel Janco, the Alsatian painter, sculptor, and poet Jean (Hans) Arp, and the German painter Hans Richter, who became a noted experimental film maker. Many other poets and artists were associated with Zurich dada, but these were the leaders whose demonstrations, readings of poetry, noise concerts, art exhibitions, and writings attacked the traditions and preconceptions of Western art and literature. Thrown together in Zurich, these young men (and women, such as the Swiss painter and designer Sophie Taeuber, later Sophie Taeuber-Arp) expressed their reactions to the spreading hysteria and madness of a world at war, in forms that were intended as only negative, anarchic, and destructive. From the very beginning, however, the dadaists showed a seriousness of purpose and a search for new vision and content that went beyond any frivolous desire to outrage the bourgeoisie. This is not to deny that in the manifestations of dada there was a central force of mad humor. This wildly imaginative humor is one of its lasting delights—whether manifested in free word-association poetry readings drowned in the din of noise machines, in mad theatrical or cabaret performances, in nonsense lectures, or in paintings produced by chance or intuition uncontrolled by reason. Nevertheless, it had a serious intent: the Zurich dadaists were making a critical re-examination of the traditions, premises, rules, logical bases, even the concepts of order, coherence, and beauty that had guided the creation of the arts throughout history.

Hugo Ball, a philosopher and mystic as well as a poet, was the first actor in the dada drama. In the spring of 1916, he founded the Cabaret Voltaire, in Zurich, as a meeting place for these free spirits and a stage from which existing values could be attacked. Interestingly enough, across the street from the Cabaret Voltaire lived Lenin, who with other quiet, studious Russians was planning a world revolution.

The name "dada" was coined in 1916 to describe the movement then emerging from the seeming chaos of the Cabaret Voltaire: its origin is still doubtful. The popular version advanced by Huelsenbeck is that a French-German dictionary opened at random produced the word "dada," meaning a child's rocking horse or hobby horse. Richter remembers the "da, da, da da," (yes, yes) in the Rumanian conversation of Tzara and Janco. "Dada" in French also means a hobby, event, or obsession. Other possible sources are in dialects of Italian and Kru African. Whatever its origin, the name dada is the central, mocking symbol of this attack on established movements, whether traditional or experimental, that characterized early twentieth-century art. The dadaists used many of the formulas of futurism in the propagation of their ideas—the free words of Marinetti, whether spoken or written; the noise-music effects of Russolo to drown out the poets; the numerous manifestoes. But their intent was opposite to that of the futurists, who extolled the machine world and saw in mechanization, revolution, and war the rational and logical means, however brutal, to the solution of human problems.

The dadaists felt that reason and logic had led to the disaster of world war, and that the only way to salvation was through political anarchy, the natural emotions, the intuitive, and the irrational. Their outlook in one respect was a return to Kandinsky's inner necessity, the spiritual in art; but dada, at least at its inception, was negative and pessimistic.

Zurich dada was primarily a literary manifestation, whose ideological roots were in the poetry of Arthur Rimbaud, in the theater of Alfred Jarry, and in the critical ideas of Max Jacob and Guillaume Apollinaire. In painting and sculpture, until Picabia arrived, the only real innovations were the free-form reliefs and collages "arranged according to the laws of chance," by Jean Arp. With few exceptions, the paintings and sculptures of other artists associated with Zurich dada broke little new ground. In abstract and expressionist film—principally through the experiments of Hans Richter and Viking Eggeling—and in photography and typographic design the Zurich dadaists did make important innovations.

Hugo Ball introduced abstract poetry with his poem *O Gadji Beri Bimba* in July 1916; and in June 1917 he presented an entire evening of abstract poetry that almost caused a full-blown riot. His thesis, that conventional language had no more place in poetry than the outworn human image in painting, produced a chant of more or less melodic syllables without meaning: "zimzim urallala zimzim zanzibar zimlalla zam. . . ." The frenzied reactions of the audience did not prevent the experiment from affecting the subsequent course of poetry. But one cannot evaluate Zurich dada by a tally of its concrete achievements or stylistic influences. Dada's importance was as a state of mind, not as a style or movement.

The Zurich dadaists were violently opposed to any organized program in the arts, or any movement that might express the common stylistic denominator of a coherent group; three factors nevertheless shaped their creative efforts. These were *bruitism* (noise-music, from *le bruit*—noise—as in *le concert bruitiste*), simultaneity, and chance. Bruitism came from the futurists, and simultaneity from the cubists via the futurists, although the da-

daists thought these principles to be negative, destructive forces. Chance, of course, exists to some degree in any act of artistic creation; in the past the artist normally attempted to control or to direct it, but it now became an overriding principle. All three, despite the artists' avowed negativism, soon became the basis for their positive and revolutionary approach to the creative act, an approach still found in poetry, music, drama, and painting.

With the end of the war Zurich dada was drawing to an end. The first enthusiasms were fading; its participants were scattering; but its world-wide impact was only beginning. The Spanish painter Francis Picabia arrived in 1918, bringing contact with similar developments in New York and Barcelona. Picabia, together with Marcel Duchamp and Man Ray, had contributed to a dada atmosphere in New York around Alfred Stieglitz's Gallery 291 and his periodical, *291*. With the help of the collector Walter Arensberg, Picabia had begun to publish his own journal of protest against everything, which he called *391*. After a journey to Barcelona, where he found many like-minded expatriates, including Marie Laurencin, Picabia visited Zurich, drawn by the spreading reputation of the originators of dada. Returning to Paris at the end of the war, he became a link between the postwar dadaists of Germany and France.

## JEAN (HANS) ARP *(1887–1966)* TO 1920

The one major artist to emerge from Zurich dada was the Alsatian Jean or Hans Arp. Arp was born in Strasbourg, then a German city but subsequently recovered by France. He studied painting and poetry, and in Paris in 1904 he discovered modern painting, which he then pursued in studies at the Weimar School of Art, and the Académie Julian in Paris. He also wrote poetry of great originality and distinction throughout his life. The disparity between his formal training and the paintings he found valid brought uncertainty, and he spent the years 1908–10 in reflection in various small villages of Switzerland. The Swiss landscape seems to have made a lasting impression on him: the abstraction to which he eventually turned was based on nature and living organic shapes.

In Switzerland Arp met Paul Klee; and after his return to Germany he was drawn into the orbit of Kandinsky and the Blaue Reiter painters. In 1912 he exhibited in Herwarth Walden's first Autumn Salon and by 1914, back in Paris, he belonged to the circle of Picasso, Modigliani, Apollinaire, Max Jacob, and Delaunay.

Arp took an unusually long time finding his own direction. Since he destroyed most of his pre-1915 paintings, the path of his struggle is difficult if not impossible to trace. He experimented with geometric abstraction based on cubism; by 1915, in Zurich, he was producing, as fast as his fingers could work, drawings and collages whose shapes suggest leaves and insect or animal life but which were actually abstractions. With Sophie Taeuber, (1889–1943), whom he met in 1915 and later married, he produced textile designs. Assisted by her, he further clarified his ideas: "These pictures are Realities in themselves, without meaning or cerebral intention. We . . . allowed the elementary and spontaneous to react in full freedom. Since the disposition of planes, and the propor-

tions and colors of these planes seemed to depend purely on chance, I declared that these works, like nature, were ordered according to the laws of chance, chance being for me merely a limited part of an unfathomable *raison d'être,* of an order inaccessible in its totality. . . ." Also emerging at this time was the artist's conviction of the metaphysical reality of objects and of life itself—some common denominator belonging to both the lowest and the highest forms of animals and plants. It may have been his passion to express his reality in the most concrete terms possible, as an organic abstraction (or, as he preferred to say, an organic *concretion*) that led him from painting to collage and then to relief and sculpture in the round.

In 1916–17 Arp produced some collages of torn, rectangular pieces of colored papers scattered in a vaguely rectangular arrangement on a paper ground. The story is told of their origin that Arp had torn up a drawing that displeased him and dropped the pieces on the floor, then suddenly saw in the arrangement of the fallen scraps the solution of the problems with which he had been struggling. Regardless of the truth in this anecdote the artist experimented with collages created in this manner, just as Tzara created poems from words cut out of newspapers, shaken and scattered on a table.

During the same period Arp devised a type of relief consisting of thin layers of wood shapes suggesting

467. JEAN ARP. *Torso, Navel.* 1920. Wood, 26 x 17 x 4".
Collection Mme. Arp-Hagenbach, Meudon, France

Colorplate 123.
GIORGIO DE CHIRICO.
*The Soothsayer's Recompense.*
1913. Oil on canvas, 53½ x 71″.
The Philadelphia Museum of Art.
Louise and Walter Arensberg
Collection

Colorplate 124.
GIORGIO DE CHIRICO.
*The Melancholy and Mystery
of a Street*. 1914. Oil on canvas,
34¼ x 28⅛″. Private collection

293

*right:* Colorplate 125. GIORGIO DE CHIRICO.
*The Great Metaphysician.* 1917. Oil on canvas,
41⅛ x 27½". The Museum of Modern Art,
New York. The Philip L. Goodwin Collection

*below:* Colorplate 126. GIORGIO MORANDI.
*Still Life.* 1960. Oil on canvas, 10 x 11¾".
Private collection, New York

Colorplate 127. JEAN ARP. *Fleur Marteau.*
1916. Oil on wood, 24⅜ x 19⅝".
Collection François Arp, Paris

Colorplate 128. JEAN ARP.
*Mountain Table Anchors Navel.* 1925.
Oil on cardboard with cut-outs, 29⅝ x 23½".
The Museum of Modern Art, New York

Colorplate 129. MARCEL DUCHAMP. *The Bride*.
1912. Oil on canvas, 35¼ x 21¾".
The Philadelphia Museum of Art.
Louise and Walter Arensberg Collection

Colorplate 130. MARCEL DUCHAMP.
*The Passage of the Virgin to the Bride*.
1912. Oil on canvas, 23⅜ x 21¼".
The Museum of Modern Art, New York

left: Colorplate 131.
MARCEL DUCHAMP.
*The Bride Stripped Bare
by Her Bachelors, Even
(The Large Glass).* 1915–23.
Oil, lead wire, foil, dust,
and varnish on glass,
8′ 11″ x 5′ 7″.
The Philadelphia Museum
of Art. Bequest of
Katherine S. Dreier

below: Colorplate 132.
MARCEL DUCHAMP. *Tu m'*.
1918. Oil and graphite
on canvas, with brush,
safety pins, nut and bolt,
27½″ x 10′ 2¾″.
Yale University Art Gallery,
New Haven, Connecticut.
Bequest of Katherine S. Dreier

*above left:* Colorplate 133. KURT SCHWITTERS.
*Picture with Light Center.* 1919.
Collage of paper with oil on cardboard, 33¼ x 25⅞″.
The Museum of Modern Art, New York

*above right:* Colorplate 134. MAX ERNST.
*The Elephant of the Celebes.* 1921.
Oil on canvas, 49¼ x 42⅛″.
Collection Roland Penrose, London

left: Colorplate 135. GEORGE GROSZ.
*Dedication to Oskar Panizza.* 1917–18.
Oil on canvas, 55⅛ x 43¼ ".
Staatsgalerie, Stuttgart

below: Colorplate 136. MAX BECKMANN. *Departure.* 1932–33.
Triptych, oil on canvas, side panels each 84¾ x 39¼ ",
center panel 84¾ x 45⅜ ".
The Museum of Modern Art, New York

Colorplate 137. JOSEF ALBERS.
*Homage to the Square: Apparition.*
1959. Oil on board, 47½ x 47½″.
The Solomon R. Guggenheim Museum,
New York

Colorplate 138. WILLI BAUMEISTER.
*Drumbeat.* 1942. Oil on cardboard,
20⅞ x 18⅛″. Collection
Felicitas-Karg Baumeister,
Stuttgart

300

468. JEAN ARP. *Aquatic.* 1953. Marble,
height 13″. Walker Art Center, Minneapolis

plants, exotic vegetables, crustaceans, or swarming amoebae, brightly painted, with strong implications of life, growth, and metamorphosis. A particular shape might suggest a specific object and thus give the relief its name (*Fleur Marteau,* colorplate 127). Although the origin of the shapes was initially intuitive (a line doodled on a piece of paper, a contour cut quickly through a thin piece of wood), the shape was rarely rectilinear and only occasionally loosely circular. The contour lines were organic in the sense of suggesting the irregularity of a living organism. Despite Arp's deliberate avoidance of rational processes in drawing or cutting, his unguided but highly experienced hand inevitably repeated directions that formed certain recognizable shapes that could be only his. A viola shape suggested a female torso; its uninterrupted surface needed some accent; this was provided by a cut-out circle that became a navel. For a period in the 1920s any circle became for Arp a navel, whatever its context (*Torso, Navel,* 1920, fig. 467; *Mountain Table Anchors Navel,* 1925, colorplate 128).

Although Arp participated less actively than some dada colleagues in the group's performances, he contributed drawings and poems to the dada publications between 1916 and 1919, while perfecting his own abstract organic fantasy. In his works he normally referred to the organic, whether something seen under the microscope or a human head or torso. In his later, freestanding sculptures in marble or bronze, the suggestion of head or torso became more frequent and explicit. When asked in 1956 about a piece entitled *Aquatic,* 1953 (fig. 468)—which, reclining, suggests some form of sea life, and standing on end, a particularly sensuous female torso—he commented, "In one aspect or another, my sculptures are always torsos." In the same way that De Chirico is the forerunner of the wing of surrealism that uses realistic techniques and recognizable images, Arp is the forerunner of the other wing that uses abstract organic shapes and arbitrary, non-descriptive color to create a world of fantasy beyond the visible world. The only recognizable influence on him is Brancusi, but his descendants are Joan Miró, Alexander Calder, and a subsequent generation of painters and sculptors.

# New York Dada, 1915–20

New York dada during World War I largely resulted from the accident that Marcel Duchamp and Francis Picabia both had come to New York and found a congenial environment in the avant-garde gallery of Alfred Stieglitz (1864–1946). Born in the United States, Stieglitz studied in Berlin, where he discovered his first enthusiasm, photography. He became a pioneer of photography as a fine art. With another notable photographer, Edward Steichen (b. 1879), he founded the Little Gallery of the Photo-Secession at 291 Fifth Avenue, and published a journal, *Camera Work.* Exhibitions and articles were devoted to all the arts, emphasizing the new European trends. By 1913 the gallery (later renamed 291) and the periodical had introduced the American public to such European masters as Toulouse-Lautrec, Henri Rousseau, Matisse, and Picasso; in the next few years Stieglitz showed Braque, Brancusi, Picabia, and African sculpture.

In 1915, assisted by Duchamp and Picabia, Stieglitz founded another periodical, *291,* to present the anti-art ideas of these artists. Thus, chronologically earlier than the dada movement in Zurich, comparable ideas were fermenting independently in a small cohesive group in New York. Aside from the two Europeans, the most important figures in the group were the young American artists Man Ray and Morton Schamberg, and the collector Walter Arensberg. The artist of greatest stature and influence was Marcel Duchamp, who really created New York dada.

## MARCEL DUCHAMP AFTER 1911

Duchamp's career as a painter was almost over when he arrived in New York in 1915. In the preceding three years he had gradually withdrawn from the professional art world for reasons never satisfactorily explained. In part it was due to disillusionment with the direction that cubism was taking toward decorative formalism; and in part with a much larger question in his mind concerning the fundamental validity of art.

Duchamp's disillusionment and questioning were first expressed in such paintings as *Nude Descending a Staircase No. 2* (see p. 210, colorplate 82), which use cubist faceting and simultaneity for expressive rather than formal purposes. In *Yvonne and Magdeleine Torn in Tatters,* 1911 (fig. 469), the portraits of his two younger sisters are fragmented and reassembled in different scales and views. The fragmentation derives from cubism, but the fragments are realistic details, some modeled in relief, varied in color, curvilinear and atmospheric in pattern, with elements fading in and out of one another. In

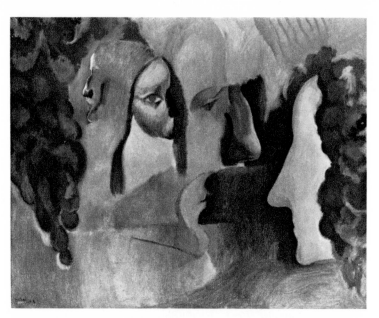

469. MARCEL DUCHAMP. *Yvonne and Magdeleine Torn in Tatters.* 1911. 23½ x 28¾". The Philadelphia Museum of Art. Louise and Walter Arensberg Collection

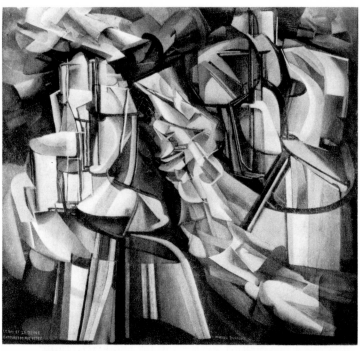

470. MARCEL DUCHAMP. *The King and Queen Traversed by Swift Nudes.* 1912. 45¼ x 50½". The Philadelphia Museum of Art. Louise and Walter Arensberg Collection

his intention was at the opposite extreme to theirs. Their dynamism, their "machine aesthetic," was an optimistic, humorless exaltation of the new world of the machine, of speed, flight, and efficiency, with progress measured in these terms. Duchamp, though he used some of their devices, expressed disillusionment through satirical humor. His sources, as with so much of dada and surrealism, were works of literature rather than art. The dedicated humorlessness of much early modern painting and sculpture may have contributed to Duchamp's rejection of it.

Alfred Jarry's drama *Ubu Roi,* although it had only two performances at its first presentation in 1896 and was not revived until 1908, had become known as the most outrageous indictment of bourgeois vulgarity in all of French theater. *Ubu Roi* became the dadaists' symbol and model for their program to destroy traditional standards of taste and beauty. Apollinaire, an admirer of Jarry, was close to Duchamp. Together with Picabia they attended in 1911 a performance of *Impressions of Africa* by Raymond Roussel, in which fantastic adventures are narrated with wild humor and ironic solemnity anticipating Duchamp's own mature "ready-mades." Of particular interest to the two artists was Roussel's notion of a painting machine to render all man-made forms of representational art obsolete.

During 1912 Duchamp, like Picabia, turned to the painting of machines of his own devising. First came the several variants on *The King and Queen Traversed by Swift Nudes* (fig. 470). The King and Queen are totemistic, machine figures derived from chessmen. Insofar as the figures can be identified within the luminous, sculptural elements from which they are constructed, they combine royal dignity with stylized caricature appropriate to their origin in chessmen or playing cards. The "swift nudes" around them act as divisive elements that yet seem to join them together. The figures are not only mechanized but are machines in operation, pumping some form of sexual energy from one to another.

The artist pursued his fantasies of sex machines in a series of paintings and drawings on which he worked during 1912–13, including *Virgin, Passage of the Virgin to the Bride, Bride,* and the initial drawing for the great painting on glass, *The Bride Stripped Bare by Her Bachelors, Even* (1915–23). The nature of these works, which climaxed and virtually terminated Duchamp's career as a painter, is that of a machine organism, and suggests anatomical diagrams of the respiratory, circulatory, digestive, or reproductive systems of higher mammals. *The Virgin* is a relatively simple organic system, the *Bride* (colorplate 129), more complicated and developed. The *Passage* (colorplate 130) transposes the forms of the *Virgin* to those of the *Bride,* and in it the artist most completely and successfully translates mysterious internal forces into a total pictorial harmony.

In these paintings Duchamp was seeking to reinstate human content in cubism, to translate legendary themes into the bold forms of modern biology and engineering. Such an intent, in so subtle and ironic a mind, could only be satiric. The *Virgin* and the *Bride,* symbols of inviolable purity and sanctified consummation, are presented as elaborate systems of anatomical plumbing. Thus, it would seem, the artist restores traditional subject in

effect, these shifting images are not so much cubist as the distortions of reality perceived in a hall of mirrors. This painting predicts Duchamp's subsequent attitudes more accurately than does the *Nude.*

The Paris exhibition of the futurists in February, 1912, helped Duchamp to clarify his attitudes, although

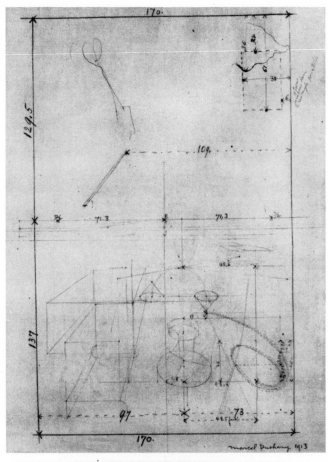

471. MARCEL DUCHAMP.
*The Bride Stripped Bare by Her Bachelors, Even.*
1913. Pencil sketch.
Collection Jeanne Reynal, New York

the Salon d'Automne, which was dominated by a cubism that, in the estimation of the little group, had become academic. This was the famous Salon de la Section d'Or, held on the Rue La Boétie in October 1912.

In this Salon named by Duchamp's brother Jacques Villon, were actually assembled all aspects of cubism, with the notable exceptions of Picasso and Braque, but cubism interpreted more freely than the jury of the Salon d'Automne permitted. Many offshoots of cubism were also admitted, including experiments toward abstraction and fantasy. Duchamp showed *Nude Descending a Staircase* (withdrawn from the previous Salon d'Automne), *Portrait of Chess Players,* a watercolor of *The King and Queen Traversed by Swift Nudes,* and still another watercolor. This was the first Paris showing of a number of his important paintings, and the last for forty years.

During this same year the so-called Armory Show was being organized in New York; and the American painters Walt Kuhn and Arthur B. Davies and the painter-critic Walter Pach were then in Paris selecting works by French artists. Four paintings by Duchamp were chosen: *Nude Descending a Staircase, Sad Young Man in a Train, Portrait of Chess Players,* and *The King and Queen Traversed by Swift Nudes.* When the Armory Show opened in February 1913, Duchamp's paintings, and most particularly the *Nude,* became the *succès de*

order to destroy it. If this is true, however, an ambiguity exists: the paintings, particularly the more developed *Bride* and *The Passage of the Virgin to the Bride,* have a mystery that takes them out of the realm of satire. *The Passage* in particular is a brilliant abstract construction, its closely keyed colors delicately graded and contrasted in light and shadow. Duchamp seems almost trapped by his own abilities. Doubting the traditional validity of painting and sculpture as legitimate modes of contemporary expression, and determined to undermine and destroy cubism, he nevertheless created pictures having demonstrable value, harmony, and symbolism within the existing vocabulary of art. Perhaps his recognition of this fact led him to abandon painting at the age of twenty-five. In his first sketches and diagrams for *The Bride Stripped Bare by Her Bachelors, Even* (fig. 471 and colorplate 131), he was already exploring the possibility of an aesthetic based on mathematical relationships.

On a short vacation trip in the fall of 1912 Duchamp, Picabia, Gabrielle Buffet, and Apollinaire discussed the state of art and the possibilities for new directions and forms in terms of every sort of paradox. As an immediate result, an exhibition was organized as a secession from

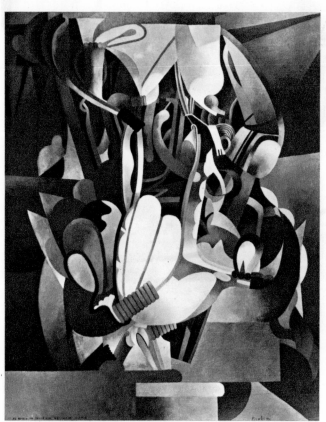

472. FRANCIS PICABIA. *I See Again in Memory My Dear Udnie.* 1913. 98½ x 78¼". The Museum of Modern Art, New York. Hillman Periodicals Fund

*scandale* of the exhibition. Despite the attacks in the press, all four of Duchamp's paintings were sold and he suddenly found himself internationally notorious. Picabia, represented in the show by *I See Again in Memory My Dear Udnie* (fig. 472) and *I Too Have Lived in America* (the title inspired perhaps by Poussin's *Et in Arcadia Ego*), visited the exhibition and returned full of enthusiasm for the vitality and hospitality of the new land.

Duchamp was meanwhile proceeding with his experiments toward a form of art or non-art based on everyday subject matter with a new significance determined by the artist, and with internal relationships proceeding from a relativistic mathematics and physics of his own devising. Although he had almost ceased to paint, he worked intermittently toward a climactic object intended to sum up the ideas and forms he had introduced in his *Virgin* and *Bride*. For this project he made, between 1913 and 1915, the drawings, designs, and mathematical calculations for *Bachelor Machine* and *Chocolate Grinder* (fig. 473), later to become the male elements accompanying the bride in *Bride Stripped Bare by Her Bachelors, Even* (also called *The Large Glass*).

In 1913, at a single stroke, the artist fathered two of the major innovations of twentieth-century sculpture: the mobile—sculpture that physically moves—and the ready-made, or found object—sculpture made from or in-cluding existing objects, usually commonplace, here an old bicycle wheel mounted on an ordinary kitchen stool. It is always possible to argue that both concepts existed earlier, but Duchamp's introduction of them at this particular moment led to their being developed in subsequent movements—dada, surrealism, kinetic sculpture, junk sculpture, and pop art. Duchamp experimented briefly with mechanical motion in his *Rotative Plaques* (fig. 474) of the 1920s and his *Roto-reliefs* of the 1930s. Toward the end of World War I the Russian constructivists introduced actual motion in sculpture; but neither they nor Duchamp followed up its immense possibilities.

In the ready-mades, Duchamp found forms that of their nature raised questions concerning historic values in art. He has described the various stages of his discovery and, as quoted in Richter, *Dada* (see Bibliography), Duchamp tells that in 1913 he mounted a bicycle wheel on the top of a kitchen stool and watched it turn; bought a cheap reproduction of a winter evening landscape, in which he inserted one red and one yellow dot at the horizon and gave it the title *Pharmacy;* bought a snow shovel in 1915 and wrote on it *"in advance of the broken arm."* About then he used the term "ready-made" to designate this form of manifestation. The choice of these ready-mades was never dictated by aesthetic delectation; it "was based on a reaction of *visual indifference* with a total absence of good or bad taste . . . in fact a complete

*above:* 473. MARCEL DUCHAMP. *Chocolate Grinder, No. 1.* 1913. 24¾ x 25⅝". The Philadelphia Museum of Art. Louise and Walter Arensberg Collection

*right:* 474. MARCEL DUCHAMP. *Rotative Plaques.* 1920. Glass, metal and wood, 73 x 48 x 40". Yale University Art Gallery, New Haven, Connecticut. Gift of the Société Anonyme

anaesthesia." The short sentence occasionally inscribed on the ready-made was important: it was not intended as a title, but "to carry the mind of the spectator toward other regions, more verbal." Sometimes he added graphic details which, in order to satisfy his craving for word-play, he called *"ready-made aided."* Then, "wanting to expose the basic antinomy between art and 'ready-mades' I imagined a *reciprocal ready-made*: use a Rembrandt as an ironing board!" Because the ready-made could be repeated indiscriminately, he decided to make only a small number yearly: "for the spectator even more than for the artist, *art is a habit-forming drug* and I wanted to protect my ready-made against such *contamination.*" He stressed that it was in the very nature of the ready-made to lack uniqueness; nearly every ready-made existing today is not an original in the conventional sense. Then, to complete this vicious circle he remarked: "Since the tubes of paint used by an artist are manufactured and ready-made products we must conclude that all paintings in the world are *ready-mades aided.*"

One glimpses in the foregoing the complex process of Duchamp's thought—the delight in paradox, the play of visual against verbal, and the penchant for alliteration and double and triple meanings. Over the years he has produced replicas of originals of replicas of ready-mades; documents such as *Valise* and *Green Box,* summarizing his life's work; and statements, interviews, and exhibitions that becloud the picture even further. And, despite his anti-aesthetic attitude, ready-mades, as he warned, did finally become works of art and have taken on a perverse beauty of their own. Younger artists have continued to make ready-mades or found objects, and the question of whether they are works of art at all is argued to the present time. Duchamp was clear on the matter: the conception, the "discovery," was what made a work of art, not the uniqueness of the object. In New York he began serious work on his *Large Glass.* To the 1917 exhibition of the New York Society of Independent Artists he submitted a porcelain urinal entitled *Fountain* and signed *R. Mutt* (fig. 475). When this entry was rejected, he resigned from the association. The *Fountain* was the most notorious of all Duchamp's ready-mades except, perhaps, for his "ready-made aided," executed after his return to France in 1919, of a photograph of Leonardo da Vinci's *Mona Lisa* to which he added a mustache and goatee and the caption, *L.H.O.O.Q.* (phonetically, *elle a chaud au cul*; fig. 476). *Mona Lisa's Mustache* has become part of the language of artistic nihilism.

In 1918, he made *Tu m'* (colorplate 132), for Katherine Dreier, a daring collector and leading spirit in American avant-garde art. It includes cast shadows, drawn in pencil, of a bicycle wheel, corkscrew, and hatrack; a pyramid of color samples; a *trompe l'oeil* tear in the canvas "fastened" by three real safety pins; a sign-painter's hand, as well as chance shapes and geometrically derived shapes. Much of op art is directly traceable to this work.

*The Bride Stripped Bare by Her Bachelors, Even,* or *The Large Glass,* was completed in 1923, as far as it could be completed—the summation of the artist's dreams of a machine-age; the mathematically derived

475. MARCEL DUCHAMP. *Fountain* and *Bottle Rack.* 1917. ( at the Installation Exhibition, Stockholm, 1963)

476. MARCEL DUCHAMP. *L.H.O.O.Q.* 1919. Reproduction of Leonardo's *Mona Lisa* with mustache and beard added in pencil, 7½ x 5". Collection Mrs. Mary Sisler, New York

love goddess, below whom swarm her bachelors, mere drones or empty malic molds being infused with the sperm gas or fluid constantly ground forth by the rollers of the chocolate machine. *Large Glass* can only be explained as a complex love machine full of sexual overtones that terminate in a curious pattern of sterility and frustration. Duchamp's machines were never intended to have a rational or logical solution, and his own exegeses add to the dimensions of the problem. After New York dust had fallen on certain sections for over a year, he had it photographed by Man Ray, then he cleaned everything but a section of the cones, to which he cemented the dust with a fixative. The final touch came when the *Glass* was broken while in transit and was thereby webbed with a network of cracks. Duchamp is reported to have commented with satisfaction, "Now it is complete." Since the cracks provide an unexpected transition between the Bride and her Bachelors, aesthetically he may have right (and this he would deplore).

# *German Dada, 1918–23*

In 1917 Richard Huelsenbeck had returned to Berlin from Zurich. Disillusion and criticism were rampant. The war was exhausting and endless; restrictions were severe; and the outcome was increasingly in doubt. The atmosphere was conducive to the spread of dada. Huelsenbeck joined a small group including the brothers Wieland and Johann Herzfelde (who changed his name to John Heartfield as a pro-American gesture), the painters Raoul Hausmann, George Grosz and, later, Johannes Baader. Huelsenbeck opened the dada campaign early in 1918 with speeches and manifestoes attacking all phases of the artistic status quo, including expressionism, cubism, and futurism. A Club Dada was formed, to which Kurt Schwitters, later the chief ornament of German dada, was refused membership. After the war came a period of political chaos, which was not ended by the formation of the German Republic. Berlin dada quickly took on a left-wing, communist direction, although the political sophistication of its members was not great. The Herzfelde brothers' journal, *Neue Jugend,* and their publishing house, Malik-Verlag, utilized dada techniques for political propaganda. George Grosz made for it many savage social and political drawings and paintings. One of the publications financed by the Herzfelde brothers was *Everyman His Own Football*: although it was quickly banned, its title became a rallying cry for German revolutionists.

Berlin dada did not produce many artists or poets of the stature of George Grosz or even of Raoul Hausmann. The Zurich dada experiments in noise-music and in abstract phonetic poetry were further explored. Hausmann, who traced the history of such efforts with German thoroughness, claimed the invention of a form of optophonetic poem, involving "respiratory and auditive combinations, firmly tied to a unit of duration," expressed in typography by "letters of varying sizes and thicknesses

which thus took on the character of musical notations."

In the visual arts a major invention or discovery was photomontage for dada effect. This was created by cutting up and pasting together, in new and startling contexts, photographs of individuals and events, posters, book jackets, and a variety of type faces—anything to achieve shock. Both Hausmann and Grosz claimed to have originated dada photomontage. The technique, of course, derived from cubist collage or *papier collé,* except that, in the dada version, subject was paramount. Even this form has antecedents in futurist collages. However, photomontage proved to be an ideal form for dadaists and subsequently for surrealists, and was expanded to heights of fantasy.

## KURT SCHWITTERS *(1887–1948)*

Somewhat apart from the Berlin dadaists was the Hanoverian artist Kurt Schwitters. Although not admitted to Club Dada, he was the purest exponent of the dada spirit to emerge from Germany, if not from the entire movement. Schwitters completed his formal training at the Academy in Dresden and painted portraits for a living. Denied access to Berlin dada, Schwitters established his own variant in Hanover under the designation

477. KURT SCHWITTERS. *Okola.* 1926. Collage,
6¾ x 5⅛". Formerly Collection G. David Thompson

478. KURT SCHWITTERS.
Hanover Merzbau. 1925 (destroyed)

Rohe, and Van Doesburg (fig. 478). The *Merzbau* grew throughout the 1920s with successive accretions of every kind of material until it filled the room. Having then no place to go but up, he continued the construction with implacable logic into the second story. When he was driven from Germany by the Nazis and his original *Merzbau* was destroyed, Schwitters started another one in Norway. The Nazi invasion forced him to England, where he began again for the third time. After his death in 1948, the third *Merzbau* was rescued and preserved in the University of Newcastle.

Early in the 1920s the De Stijl artist Van Doesburg had become friendly with Schwitters and they collaborated on a number of publications, and made a dada tour of Holland. Schwitters more and more became attracted to the geometric abstractionists and constructivists, for despite the fantasy and rubbish materials in his works, they demonstrated relationships and proportions that are almost as subtle as Mondrian's. Schwitter's stature as an artist continues to grow with the passage of time.

## MAX ERNST *(b. 1891)* TO 1921

Jean Arp moved to Cologne in 1919 and, with the young German artist Max Ernst, collaborated to form another wing of dada. The two had met in Cologne in 1914, but Ernst then served in the German army. At the end of the war, he discovered Zurich dada and the paintings of De Chirico and Klee. Ernst's own paintings, until he moved to Paris in 1921, were rooted in a Late Gothic fantasy drawn from Dürer, Grünewald, and Bosch. He was also fascinated by German romanticism in the macabre forms of Max Klinger and Arnold Böcklin. This

*Merz,* a word derived from Com*merz*bank. He was a talented poet, impressive in his readings, deadly serious about his efforts in painting, collage, and construction. These always involved a degree of dead-pan humor delightful to those who knew him, but shattering to strange audiences. His collages were made of rubbish picked up from the street—cigarette wrappers, tickets, newspapers, string, boards, wire screens, whatever caught his fancy. The works (*merzbilden*) he created were seriously studied as cubist structures, but different in essence from cubist, futurist, dada, expressionist, or propagandist collages. Miraculously, he was able to transform the rubbish, the detritus of his surroundings, into strange and wonderful beauty (fig. 477 and colorplate 133).

Schwitters introduced himself to Raoul Hausmann in a Berlin café in 1918 by saying, "I am a painter and I nail my pictures together." This description applies to all his relief constructions, since he drew no hard and fast line between them and *papiers collés,* but most specifically to his series of great constructions that he called *Schwitters Column* or *Merzbau.* He began the first one in his house in Hanover as an abstract plaster sculpture with apertures dedicated to his dadaist and constructivist friends and containing objects commemorating them: Mondrian, Gabo, Arp, Lissitzky, Malevich, Richter, Mies van der

479. MAX ERNST. *Here Everything is Still Floating.*
1920. Pasted photoengravings, 4⅛ x 4⅞".
The Museum of Modern Art, New York

480. MAX ERNST. *The gramineous bicycle garnished with bells the dappled fire damps and the echinoderms bending the spine to look for caresses.* 1920–21. Anatomical chart altered with gouache, 29¼ x 39¼". The Museum of Modern Art, New York

anized monster whose trunk-tail-pipe-line sports a cow-skull-head above an immaculate white collar. Sinister tusks protrude from the non-visible end. A headless classical torso beckons to the beast with an elegantly gloved hand. *The Elephant of the Celebes* is not intended for rational explanation even as a symbolic presentation. Its images are unrelated, some (the elephant) threatening, others (the beckoning torso) less explicable. Like the early paintings of De Chirico by which it was profoundly influenced, it suggests a nightmare; its appeal is to the level of perception below consciousness.

## Paris Dada, 1919–22

When Arp and Ernst left Cologne in 1921 and Baargeld abandoned painting, dada was terminated in that city; it ended at the same time in Berlin. Duchamp and Man Ray put a period point to New York dada with the single issue of a periodical *New York Dada*. The original Zurich dadaists had long since scattered. Thus dada as an organized movement was dead, except in Paris. Duchamp had largely given up creative activity (unless his very existence might be so described) apart from occasional motion experiments, the completion of his *Large Glass,* and participation in commemorative exhibitions and publications. In Germany, only Kurt Schwitters continued, a one-man dada movement.

By 1918 writers in Paris, including Louis Aragon, André Breton, and Georges Ribemont-Dessaignes were contributing to the Zurich periodical *Dada,* and shortly Tristan Tzara began writing for Breton and Aragon's journal *Littérature*. Picabia, after visiting the dadaists in Zurich, published No. IX of *391* in Paris and, in 1919, Tzara himself also arrived there. Thus, by the end of the war a dada movement was growing in the French capital, but it had primarily a literary nature. While in painting and sculpture, dada was largely an imported product, in poetry and theater it was in a tradition of the irrational and absurd that extended from Baudelaire, Rimbaud, and Mallarmé to Alfred Jarry, K.-X. Roussel, Apollinaire, and Cocteau. Paris dada in the hands of the literary men consisted of frequent manifestoes, demonstrations, periodicals, events, and happenings more violent and hysterical than any before. The artists Arp, Ernst, and Picabia took a less active part in the demonstrations, although Picabia contributed his own manifestoes. The original impetus and enthusiasm seemed to be lacking, however, and divisive factions arose, led principally by Tzara and by Breton. The early dadaists, like the bolsheviks of the Russian revolution, sought to maintain a constant state of revolution, even anarchy, but new forces led by Breton sought a more constructive revolutionary scheme based on dada. In its original form dada expired in the wild confusion of the congress of Paris called in 1922 by the dadaists. The former dadaists, including Picabia, who followed Breton, were joined by powerful new voices, among them Cocteau and Ezra Pound. By 1924 this group was consolidated under the name "surrealism."

"gothic quality" (in the widest sense) has remained the most consistent characteristic of Ernst's fantasies. In 1919–20 he produced collages and photomontages that demonstrated a genius for suggesting the metamorphosis or double identity of objects, a topic later central to surrealist iconography. In *Here Everything Is Still Floating,* 1920 (fig. 479), an anatomical drawing of a beetle becomes, upside-down, a steamboat floating through the depths of the sea. This was actually a collaborative effort, with Arp providing the name. From time to time Ernst, Arp, and a young painter-poet, J. T. Baargeld, collaborated on collages entitled *Fatagagas,* short for *Fabrication des Tableaux garantis gazometriques.* Through their magazine, *Die Schammade,* they had contacts with the French poets and critics André Breton, Paul Eluard, and Louis Aragon.

While convalescing from an illness, Ernst discovered the possibilities of using engravings from nineteenth-century magazines as the basis for transformation in collage; he came upon another new world in biological drawings of micro-organisms (fig. 480). Thus, single-handed, he created much of the surrealist vocabulary. Despite the close friendship between Ernst and Arp, their approaches to painting, collage, and sculpture were different. Arp's was toward abstract, organic surrealism in which figures or other objects may be suggested but are rarely explicit. Ernst, following the example of De Chirico and fortified by his own "gothic" imagination, became a principal founder of the wing of surrealism that utilized magic realism—that is, precisely delineated, recognizable objects, distorted and transformed, but nevertheless presented with a ruthless realism that throws into shocking relief their newly acquired fantasy. *The Elephant of the Celebes,* 1921 (colorplate 134), is a mech-

# GERMAN PAINTING IN THE 1920s AND 1930s

## The New Objectivity

In Germany the end of World War I brought a period of chaotic struggle between the extreme left and the extreme right. The social-democrat government could control neither the still powerful military, nor the rampant inflation. Experimental artists and writers were generally on the left wing, hopeful that from chaos would emerge a more equable society. Immediately following the social-democrat revolution of 1918, some of the leaders of German expressionism formed the November Group and were soon joined by dadaists. In 1919 the Workers' Council for Art was organized. It sought more state support, more commissions from industry, and the reorganization of art schools. These artists included many of the original expressionists, such architects as Walter Gropius and Erich Mendelsohn, and leading poets, musicians, and critics. Many of the aims of the November Group and the Workers' Council were incorporated into the program of the Weimar Bauhaus.

In their exhibitions the November Group re-established contact with France and other countries, and antagonisms among the various new alignments were submerged for a time in behalf of a common front. The expressionists were exhibited, as well as representatives of cubism, abstraction, constructivism, and dada; the new architects showed projects for city planning and large-scale housing. Societies similar to the November Group sprang up in many parts of Germany, and their manifestoes read like a curious blend of socialist idealism and revivalist religion.

The common front of socialist idealism did not last long. The workers whom the artists extolled and to whom they appealed were even more suspicious of the new art forms than was the capitalist bourgeoisie. It was naturally from the latter that new patrons of art emerged. By 1924 German politics was shifting inevitably to the right; and the artists' utopianism was in many cases turning into disillusionment and cynicism. There now emerged a form of social realism in painting to which the name the new objectivity was given. The Bauhaus, since 1919 at Weimar, had tried to apply the ideas of the November Group and the Workers' Council toward a new relationship between artist and society; in 1925 it was forced by the rising tide of conservative opposition to move to Dessau. Its faculty members still clung to post-war expressionist and socialist ideas, although by 1925 their program mostly concerned the training of artists, craftsmen, and designers for an industrial, capitalist society.

### GEORGE GROSZ (1893–1959)

The principal painters associated with the new objectivity were George Grosz, Otto Dix, and Max Beckmann —three artists whose style touched briefly at certain points but who had essentially different motivations. Grosz studied from 1912 to 1914 at the Royal Arts and Crafts School in Berlin, partially supporting himself with drawings of the shady side of Berlin night life. These caustic works prepared him for his later violent statements of disgust with post-war Germany and mankind generally. In 1913 he visited Paris and, despite later disclaimers, was obviously affected by cubism and its offshoots, particularly by Delaunay and Italian futurism. After two years in the army (1914–16), he resumed his caricatures while convalescing in Berlin; they reveal an embittered personality, now fortified by observations of autocracy, corruption, and the horrors of a world at war. Recalled to the army in 1917, he ended his military career in an asylum on whose personnel and administration he made devastating comment.

After the war Grosz was drawn into Berlin dada and its overriding left-wing bias. He made stage designs, and collaborated on periodicals, but continued his own work of political or social satire. Only occasionally did he move into fantasy, and then with loathing for this world rather than nostalgia for a world of dreams. The *Dedication to Oskar Panizza*, 1917–18 (colorplate 135), is his most futurist work. Inspired by Carrà's *Funeral of the Anarchist Galli* (colorplate 85), it shows a funeral turned into a riot. The painting is flooded with a blood or fire red. The buildings lean crazily; an insane mob is packed around the paraded coffin on which Death sits triumphantly, swigging at a bottle; the faces are horrible masks; humanity is swept into a hell of its own making. Yet the artist controls the chaos with a geometry of the buildings and the planes into which he segments the crowd.

The same geometry, based on a futurist variation of cubism, is evident in *The Little Murderer*, 1918 (fig. 481). It is a scene of sex and violence, themes that fascinated Grosz on both personal and social levels. The drawing *Fit for Active Service (K.V.)*, 1918 (fig. 482),

481. GEORGE GROSZ. *The Little Murderer.*
1918. 26 x 26".
Collection Mr. and Mrs. Richard L. Feigen, New York

483. GEORGE GROSZ. *Republican Automatons.* 1920.
Watercolor, 23⅝ x 18⅝", The Museum of Modern Art,
New York. Advisory Committee Fund

482. GEORGE GROSZ. *Fit for Active Service (K. V.)* 1918.
Pen, brush, and india ink, 14⅝ x 13¼".
The Museum of Modern Art, New York.
A. Conger Goodyear Fund

484. GEORGE GROSZ. *The Engineer Heartfield.*
1920. Watercolor and collage, 16½ x 12".
The Museum of Modern Art, New York.
Gift of A. Conger Goodyear

485. GEORGE GROSZ.
*A Piece of My World II.*
c. 1938. 39⅜ x 55⅛".
Estate of George Grosz,
Princeton, New Jersey

shows his sense of the macabre and hatred of the bureaucracy, with a fat complacent doctor pronouncing his "O.K." of a desiccated cadaver before arrogant Prussian-type officers and stupid enlisted men. The spare economy of the draftsmanship in this work as well as a certain cubist contraction of space are also evident in a number of paintings of the same period. *Republican Automatons,* 1920 (fig. 483), applies the style and motifs of De Chirico and the metaphysical school to political satire: empty-headed, blank-faced, and mutilated automatons parade loyally through the streets of a mechanistic metropolis on their way to vote as they are told. *The Engineer Heartfield,* 1920 (fig. 484), is a more personal document, revealing a more or less sinister engineer, with his mechanical heart, in the empty corner of a room defined by three planes. A collage element, a clipping from a newspaper, serves as a window in the background. In these two works Grosz comes closest to the spirit of the fantasy of the dadaists and surrealists. But he expressed his most passionate convictions in drawings and paintings that continue the expressionist tradition in savagely denouncing a decaying Germany of brutal profiteers and obscene prostitutes, of limitless gluttony and sensuality beside abject poverty, disease, and death. Rarely has an artist been motivated so completely by hatred. His normal style was of spare and brittle drawing combined with a fluid watercolor. In the mid-1920s he briefly used precise realism in portraiture, close to the new objectivity of Otto Dix.

Grosz was frequently in trouble with the authorities, but it was Nazism that caused him to flee. In the United States during the 1930s his personality was quite transformed. Although he occasionally caricatured American types, these were relatively mild, even affectionate. America for him was a dream come true and he painted the skyscrapers of New York or the dunes of Provincetown in a sentimental haze. His pervading sensuality was expressed in warm portrayals of Rubens-like nudes.

The growth of Nazism rekindled his power of brutal commentary, and World War II caused him to paint a series expressing bitter hatred and at times deep personal disillusionment (*A Piece of My World II,* c. 1938; fig. 485). In the later works sheer repulsion replaces the passionate conviction of his earlier statements. A highly complicated person with changing and at times confused motivations despite his intense emotional and intellectual responses, Grosz lost in his promised land something that he never regained.

## OTTO DIX *(b. 1891)*

The artist whose works most clearly defined the nature of the new objectivity was Otto Dix. Born of working-class parents, he was a proletarian by upbringing as well as by theoretical conviction. His war paintings were gruesome descriptions of indescribable horrors, rooted in the German Gothic tradition of Grünewald (*Trench Warfare,* 1922–23; fig. 486). Like Grosz, he was exposed to influences from cubism to dada, but from the beginning he was concerned with uncompromising realism. In his portraits of his parents (for example, fig. 487, 1921), there is an accumulation of miniature detail that goes beyond nineteenth-century realism to the German tradition of the Late Middle Ages. Although the figures are within a constricted space, Dix ignores all the plastic experiments of modern painting. This is a symptom of the post-war reaction against abstraction, a reaction most marked in Germany but also evident in most of Europe and in America. Even the pioneers of fauvism and cubism were involved in it. However, the super realism of

486. Otto Dix.
*Trench Warfare.*
1922–23
(destroyed 1943–45)

*above:* 487. Otto Dix. *Parents of the Artist.* 1921.
39¾ x 45¼". Kunstmuseum, Basel

*right:* 488. Otto Dix. *Dr. Mayer-Hermann.* 1926. Oil on wood, 58¾ x 39". The Museum of Modern Art, New York. Gift of Philip C. Johnson

Dix was not simply a return to the past. In his *Dr. Mayer-Hermann,* 1926 (fig. 488), the doctor's massive figure is seated frontally, framed by the vaguely menacing machines of his profession. Although the painting includes nothing bizarre or extraneous, the overpowering confrontation gives a sense of the unreal. For this type of super realism—as distinct from surrealism—there was coined the term magic realism: a mode of representation that takes on an aura of the fantastic because commonplace objects are presented with unexpectedly exaggerated and detailed forthrightness. Dix remained in Germany during the Nazi regime, although forbidden to exhibit. After the war he turned to a form of mystical, religious expression.

## MAX BECKMANN *(1884–1950)*

Beckmann was the principal artist associated with the new objectivity, but could only briefly be called a precise realist in the sense of Dix. Born of substantial parents in Leipzig, he was steeped in the Early Renaissance painters of Germany and The Netherlands, and the great seventeenth-century Dutch painters. After studies at the Weimar academy and a brief visit to Paris, he settled in 1903 in Berlin, then a ferment of German impressionism and art nouveau. Influenced by Delacroix and by the German academic tradition, he painted large religious and classical machines, and versions of contemporary disasters such as the sinking of the Titanic, 1912, done in the mode of Géricault's *Raft of the Medusa.* By 1913, Beckmann was a well-known academician. His service in World War I had a sobering effect, turning him toward a search for internal reality. *Self-Portrait with Red Scarf,* 1917 (fig. 489), shows Beckmann as haunted and anxious. Now the influence of Munch began to loom large. Beckmann's struggle is apparent in a big, unfinished *Resurrection,* on which he painted sporadically between 1916 and 1918. Here he attempted to join his more intense and immediate vision of the war years to his pre-war academic formulas. This work, though unsuccessful, liberated him from his academic past. In two pendant paintings of 1917, *The Descent from the Cross* (fig. 490) and *Christ and the Woman Taken in Adultery* (fig. 491), he found a personal expression, rooted in Grünewald, Bosch, and Bruegel, although the jagged shapes and delimited space also owed much to cubism. Out of this mating of Late Gothic, cubism, and German expressionism emerged Beckmann's next style.

Although he was not politically oriented, Beckmann responded to the violence and cruelty of the end of the war. *The Night,* 1918–19 (fig. 492), is a drama of torture and brutality, symptomatic of the lawlessness of the time and prophetic of the legalized sadism of the 1930s. Painted in pale, emotionally repulsive colors, the figures are twisted and distorted within a compressed space, as in late medieval representations of the tortures of the damned (here, the innocent). The horror is heightened by the explicit and accurate details.

These works, which impart symbolic content through harsh examination of external appearance, are close to and even anticipate the new objectivity of Grosz and Dix. Beckmann's attitude, growing out of expressionism but adding precise though distorted reality, was defined as

489. MAX BECKMANN.
*Self-Portrait with Red Scarf.* 1917.
31½ x 23⅝″. Staatsgalerie, Stuttgart

490. MAX BECKMANN. *The Descent from the Cross.*
1917. 59½ x 50¾″. The Museum of Modern Art,
New York. Curt Valentin Bequest

magic realism in 1923 by G. F. Hartlaub, director of the Kunsthalle in Mannheim, and documented in an exhibition at that museum in 1925. The term magic realism was also proposed by the critic Franz Roh.

In the later 1920s Beckmann was moving from success to success. When the Nazis came to power in 1933 he was stripped of his position and designated a "degenerate artist." In 1937 he moved to Amsterdam. In 1947, after years of hiding from the Nazis, Beckmann accepted a teaching position at Washington University, St. Louis, Missouri, and migrated to the United States, where he spent the rest of his life.

Throughout the 1930s and 1940s Beckmann continued to develop his ideas of coloristic richness, monumentality, and complexity of subject. The enriched color came from visits to Paris and contacts with French masters, particularly Matisse and Picasso. However, his emphasis on literary subjects having heavy symbolic content reflected his Germanic personality. The first climax of his new, monumental-symbolic approach was the large triptych, *Departure*, 1932–33 (colorplate 136). Alfred Barr described it as "an allegory of the triumphal voyage of the modern spirit through and beyond the agony of the modern world." The right wing shows frustration, indecision, and man's self-torture; in the left wing, sadistic mutilation, man's torture of others. Beckmann said of this triptych in 1937: "On the right wing you can see yourself trying to find your way in the darkness, lighting the hall and staircase with a miserable lamp dragging along tied to you as part of yourself, the corpse of your memories, of your wrongs, of your failures, the murder everyone

commits at some time of his life—you can never free yourself of your past, you have to carry the corpse while Life plays the drum." Also, despite his disavowal of political interests, the left hand panel must refer to the rise of dictatorship that was already driving liberal artists, writers, and thinkers underground.

The darkness and suffering in the wings are resolved in the brilliant sunlight colors of the central panel, where the king, the mother, and the child set forth, guided by the veiled boatman. Again, Beckmann: "The King and Queen have freed themselves of the tortures of life— they have overcome them. The Queen carries the greatest treasure—Freedom—as her child in her lap. Freedom is the one thing that matters—it is the departure, the new start."

It is important to emphasize the fact that Beckmann's allegories and symbols were not a literal iconography to be read by anyone given the key. The spectator had to participate actively; and the allusions could mean something different to each viewer. *Blindman's Buff*, 1945 (fig. 493), is a complicated allegorical triptych, vivid in color, filled with classical allusions, sexual symbolism, and contrasting attitudes of repose and gay debauchery. It may reflect the uninhibited relaxation after World War II. In the central panel perform a classical lyre player and a flute player together with a savage beating a drum; a woman is embraced by a dinner-jacketed man with a horse-head mask (the artist?). The wings are filled with a leering, whispering, gossiping crowd of spectators, who surround the principal figures: on the left the kneeling girl in blue, and the blindfolded young man on the right

*below left:* 491. MAX BECKMANN. *Christ and the Woman Taken in Adultery.* 1917. 58¾ x 49⅞".
City Art Museum of St. Louis, Missouri

*below right:* 492. MAX BECKMANN. *The Night.* 1918–19. 52⅜ x 60¼". Kunstsammlung Nordrhein-Westfalen, Düsseldorf

493. MAX BECKMANN. *Blindman's Buff*. 1945. Triptych, side panels each 42½ x 74½″, middle panel 90 x 80″. The Minneapolis Institute of Arts. Gift of Mr. and Mrs. Donald Winston

—both contemplative and detached, like the donors in a late medieval triptych. Both have lighted candles, Beckmann's favorite phallic symbol. *Blindman's Buff* may be read as a victory bacchanal, a condemnation of contemporary mores, or simply as a dispassionate observation on whatever is evil or good in the world.

Beckmann, Grosz, and Dix were the three most notable artists associated with the new objectivity; each of them can be so described only for a relatively brief period during the 1920s. Other artists were more marginally involved. Carl Hofer (1878–1955) was a romantic idealist at the beginning of the century but, after captivity in World War I and post-war suffering, he developed a spare and dry style, indicative of personal disillusionment (*Three Clowns,* 1922; fig. 494).

## Constructivism and Abstraction

### GABO AFTER 1920

Naum Gabo lived in Germany from 1922 to 1932, perfecting his constructivist sculpture and contributing importantly though indirectly to Moholy-Nagy's ideas on light, space, and movement at the Bauhaus. In 1920 Gabo designed a motor-propelled kinetic construction consisting of a single vibrating rod (fig. 495). He pursued experiments in motion, but for some reason did not take them to their logical conclusions. However, he intensively explored the possibilities of new materials, particularly of plastics, for the creation of monumental designs (fig. 496), searching for a form of architectural expression through constructed sculpture. About the *Col-*

494. CARL HOFER. *Three Clowns*. 1922. 50¾ x 40½″. Wallraf-Richartz Museum, Cologne

*umn,* 1923 (fig. 497), he said: "My works of this time, up to 1924 . . . are all in the search for an image which would fuse the sculptural element with the architectural element into one unit. I consider this Column the culmi-

*above left:* 495. NAUM GABO. *Kinetic Construction.* 1920. Metal rod vibrating by means of a motor, height 18″ without base. The Tate Gallery, London

*above right:* 496. NAUM GABO. *Space Construction C.* 1922. Plastic, 39 x 40″. Whereabouts unknown

nation of that search." Gabo was too far ahead of his time. However, his vision of the inevitable marriage of international style in architecture with open, constructed sculpture has been fulfilled by a generation of followers.

During the 1920s in Germany, Gabo was advancing construction in plastics in new directions and dimensions: a stage set for Diaghilev's 1926 ballet, *La Chatte*; his designs for the projected Palace of the Soviets, 1931 (fig. 498)—a daring, winged structure of reinforced concrete. The artist has occasionally returned to carving in stone —works that are essentially mass, to counterpoint, refresh, and clarify his thoughts on sculpture as limitless and illimitable space. In 1932 Gabo left Germany for Paris where he was active in the Abstraction-Création group organized to combat surrealism. His next move was to England for the years 1936–46. He has lived in the United States since 1946.

Gabo's principal innovation of the 1940s was a construction using webs of taut plastic strings on frames of interlocking plastic sheets (fig. 499). In these he attained transparent delicacy and weightlessness unprecedented in sculpture. But he has had only one major architectural-sculptural commission, a monument for the Bijenkorf department store in Rotterdam, 1954–57 (figs. 500, 500a). Although he has completed few other architectural constructions of any scale he has continued to make constructivist designs for both formal and expressive ar-

497. NAUM GABO. *Column.* 1923. Plastic, wood, and metal, height 41″. The Solomon R. Guggenheim Museum, New York

498. NAUM GABO.
Project for the Palace of the Soviets. 1931.
Drawing. Owned by U.S.S.R.

499. NAUM GABO. *Linear Construction, Variation*. 1942–43.
Plastic and nylon thread, 24½ x 24½″.
The Phillips Collection, Washington, D.C.

*above left:* 500. NAUM GABO. Construction for the Bijenkorf department store, Rotterdam. 1954–57.
Steel, bronze wire, freestone substructure, height 85′.

*above center:* 500a. NAUM GABO. Interior detail of construction for Bijenkorf store

*above right:* 501. NAUM GABO. *Construction Suspended in Space*. 1951. Aluminum baked black, plastic, gold wire,
bronze mesh, and steel wire, height 15′. The Baltimore Museum of Art. Saidie A. May Collection

chitecture. In his larger constructions Gabo recently has reintroduced steel frames to define the interplay of the contours with greater strength. The essence of his mature sculptures is to encompass, define, and enclose space so completely that they cannot be comprehended in a photograph. The *Construction Suspended in Space,* 1951 (fig. 501), is a fifteen-foot-high, rich composition of aluminum, stainless steel, phosphor bronze, rolled gold wire, and plastic; suspended in a stair well, it can be studied from every angle. As the spectator moves, it changes character and proportion while maintaining total harmony with every step one takes.

Gabo's constructions affected abstract sculpture in Germany during the 1920s, and also contributed to experimental stage design, to architecture, and to the pedagogical systems at the Bauhaus, particularly of Moholy-Nagy.

## LASZLO MOHOLY-NAGY *(1895–1946)*

Moholy-Nagy was an important educator and propagandist for abstract art, constructivism, functional design, and architecture. A Hungarian trained in law, he was wounded on the Russian front and became interested in painting during the long convalescence. In 1921 he met the Russian abstractionist El Lissitzky, in Düsseldorf (see p. 221), and through him was immediately attracted to abstract art.

502. LASZLO MOHOLY-NAGY. *Light-Space Modulator.*
1922–30. Metal and plastic, height 59½".
Busch-Reisinger Museum, Harvard University,
Cambridge, Massachusetts

Laszlo Moholy-Nagy met Walter Gropius in 1922 at the Russian constructivist exhibition in Berlin, and so impressed him that Gropius made him a professor in the Weimar Bauhaus. Until 1928 he was a principal theoretician in applying the Bauhaus concept of art to industry and architecture. He left the Bauhaus, to reside in Amsterdam and London, painting, writing, and experimenting in all mediums. In 1937 he founded the New Bauhaus in Chicago; this became the Institute of Design and is now a part of the Illinois Institute of Technology. His two principal books, *The New Vision* and *Vision in Motion,* are major documents of the Bauhaus method. His stylistic autobiography, *Abstract of an Artist* (English edition of *The New Vision,* see Bibliography), is one of the clearest statements of the modern artist's search for a place in technology and industry. He was first a relatively representational painter, then discovered meaning in drawings by Rembrandt and Van Gogh that for him transcended surface appearance. Through the symbolists and expressionists, he became aware of intuition as a forceful plastic means. Experimentation followed, and Moholy-Nagy went through the entire course of modern achievement. By 1921 his interests began to focus on elements that dominated his creative expression for the rest of his life—light, space, and motion. He explored transparent and malleable materials, the possibilities of abstract photography and the cinema.

Moholy-Nagy pioneered in the creation of light-and-motion machines built from reflecting metals and transparent plastics: these he named light modulators (fig. 502). During the 1920s he was one of the chief progenitors of the mechanized kinetic sculpture that has proliferated since 1950. Moholy-Nagy also worked with abstract modeled or constructed sculpture, light paintings, and graphic and product design. His own achievements were so many and so varied that they are not adequately appreciated even today. But his teaching of the implications of abstract painting and sculpture for industrial design, graphic design, architecture, and the total environment of man have affected an entire generation of artists, architects, designers, and consumers everywhere.

## JOSEF ALBERS *(b. 1888)*

After Johannes Itten left the Bauhaus, the foundation course was given by Josef Albers and Moholy-Nagy, each teaching in accordance with his own ideas. Albers, after studying widely in Germany, entered the Bauhaus as a student and, in addition to his work in the foundation course, taught furniture design, drawing, and calligraphy. He remained with the Bauhaus until the Nazis closed it in 1933 and then migrated to the United States. Through his work, teaching, and lecturing at Black Mountain College in North Carolina, Harvard, Yale, and many other colleges, art schools, and museums, Albers was the first to bring Bauhaus ideas to the United States, and since 1933 has been a major influence in the training of artists, architects, and designers in this country.

It is possible that Albers' early apprenticeship in a stained-glass workshop inspired his lifelong interest in problems of light and color within geometric frames. In his glass paintings of the 1920s (fig. 503) one can ob-

serve the transition from free-form compositions of glass fragments to a rigid rectangular pattern in which the relations of each color strip to all the others are meticulously calculated. The transparency of glass also led him to the investigation of perspective illusions in which geometric shapes reverse themselves. The approach can be summarized in terms of a painting, first created as a glass painting in 1931 and then re-created in tempera about 1935. It is a painting on a black ground, of straight, white lines enclosing areas of white, and light and dark gray (fig. 504). In his book *Despite Straight Lines* (see Bibliography), he describes precisely the many mutations of surface, vertical, and in-depth visual movement stimulated by these figures.

This and subsequent exercises in optics and perception were rooted in cubist concepts of simultaneity and fragmentation of vision, as well as the explorations of Van Doesburg, Mondrian, Malevich, and others into the questions of non-perspective pictorial space. Specifically influential were the Proun paintings of Lissitzky, in which the artist attempted the reintegration of perspective spatial illusion with the approaches of the cubists and abstractionists.

During the 1950s and 1960s Albers settled on the formula that he has entitled *Homage to the Square* (colorplate 137), in which he has explored endlessly the relationships of color-squares confined within squares. The calculated interaction of color and of straight lines, and their intimate relationships, has become the central pursuit of the artist. By confining himself to these elements over the last forty years, he has made notable contributions to the study of perception, both in how we see and in how to understand what we see. His scientific theories and his rational approach manifested in his teaching and his writing have obscured the fact that, in the process of his studies, he has created a body of works of art important for their influence on geometric abstractionists and optical painters, and in themselves works of beauty and value.

The importance of Albers' experiments, however, lay in the statement, in the clearest and simplest terms, of the

problem "how do we see the third dimension when created as an illusion by the artist in terms of lines, flat shapes and colors on a two-dimensional surface?" Albers has followed this approach to painting, perception, illusion, and the interaction of pictorial elements during his entire career.

OSKAR SCHLEMMER *(1888–1943),*

RUDOLF BELLING *(b. 1886),*

FREDERICK KIESLER *(1896–1966),*

HERBERT BAYER *(b. 1900),*

WILLI BAUMEISTER *(1889–1955)*

In the early 1920s there arose in Germany a school of machine painters and sculptors whose art both extolled the machine as a hope for the future and pointed out the danger that men might be turned into robots in a soulless machine society.

The paintings of Oskar Schlemmer, who taught theater design, sculpture, and mural painting at the Bauhaus from 1920 to 1929, were related to the classical proto-surrealism of De Chirico, Carrà and the metaphysical school, Léger's machine cubism, the purism of Ozenfant and Jeanneret, and the machinism of Belling. He synthesized from these sources a personal and strangely moving world of architectural, perspective space, populated by mannequin figures isolated in a state of permanent hypnosis. Schlemmer also has affinity with the great Italian muralists of the fifteenth century, particularly with Piero della Francesca and his impersonal, sculpturally simplified figures and mathematically precise perspective space. In *Figures Resting in Space (Room of Rest),* 1925 (fig. 505), he used the checkerboard floor of Early Renaissance perspective paintings diminishing to a white, rectangular opening at the back of the room. Two figures rest in the middle distance. Out of the foreground looms the back of a stiff, robot figure extending from floor to above the visible ceiling line. His legs are cut off by the mass of a head that is just entering the picture. The mechanical figures seen from the back in extreme close-up, the empty rectangle of the room in shadow but opening into the white emptiness of the space beyond, lend a sense of mystery that suggests the playing out of some disquieting drama. In *Group of Fourteen in Imaginary Architecture,* 1930 (fig. 506), the influence of the theater is evident, as it often is in Schlemmer's work. His turning back to the classicism of the Renaissance was not

*above:*
505. OSKAR SCHLEMMER.
*Figures Resting in Space
(Room of Rest).* 1925
43¼ x 33⅜".
Marlborough Gallery,
London

*right:*
506. OSKAR SCHLEMMER.
*Group of Fourteen
in Imaginary Architecture.*
1930. Oil and tempera
on canvas, 35⅞ x 47¼".
Wallraf-Richartz Museum,
Cologne

507. OSKAR SCHLEMMER. *Abstract Figure.*
1962 (after plaster original, 1921). Bronze, 42⅛ x 26⅜".
Collection Frau Tut Schlemmer, Stuttgart

508. RUDOLF BELLING. *Head.* 1923. Bronze, height 15".
The Museum of Modern Art, New York

509. FREDERICK KIESLER. Model for City in Space. 1925

a personal reaction against abstraction since he was always a figurative painter. In his sculpture, principally the reliefs that project his paintings into the third dimension, he moved closer to abstraction, but with a figure always evident or implied. His sculpture belonged in the decorative, mechanistic tradition of Archipenko, and only rarely, as in *Abstract Figure,* 1921 (fig. 507), achieved distinction of its own.

A principal exponent of the "machine" doctrine was the sculptor Rudolf Belling, one of the founders of the November Group. He was influenced by Archipenko, who lived in Germany in the early 1920s, but after attempting cubist sculptures, created works in which the head or figure was translated into machine forms. The mechanistic approach, in his hands, took on an expressive rather than abstract quality, pointing to a world in which man had become a machine (*Head,* fig. 508). This fascination with the ultimate implications of a machine society manifested itself in different mediums, notably in the play *R.U.R.,* produced in Berlin in 1923, in which the sets were designed by the Austrian Frederick Kiesler, a member of De Stijl who in 1925 designed a visionary City in Space (fig. 509) for the Austrian exhibition of the International Exhibition of Decorative Arts in Paris. Kiesler moved to the United States in 1926, where he

continued to develop as one of the visionaries of architecture, sculpture, and theater design.

Herbert Bayer, who was principally responsible for the Bauhaus workshops in typography and graphic de-

sign, managed to survive in Berlin, under the Nazis, as a commercial artist and designer until 1938, when he was able to move to the United States. Since that time he has pursued a successful career in New York and later from his home in Aspen, Colorado, as graphic designer and architect, while continuing his own painting.

Baumeister, like Schlemmer, was a pupil of Adolf Hoelzel at the Stuttgart Academy and a friend of the Swiss painter Otto Meyer-Amden (1884–1933), whose mystical ideas on mathematical symbols influenced both younger artists. Baumeister was one of the few German painters of any significance before World War II to explore the possibilities of free abstraction. He was first affected by cubism and purism, although he added a textural element by building up his surfaces sculpturally with sand and plaster. Gradually, free forms appeared among his machine forms, and by the early 1930s the forms, suggestive of figures, had taken on organic shape, influenced by the surrealist paintings of Joan Miró and at times of Paul Klee (for instance, *Stone Garden I,* 1939; fig. 510). During the Nazi regime he continued to paint in secret, advancing his own ideas toward freer abstraction—ideograms with elusive suggestions of figures. These signs came from the artist's imagination, but were based on the art of primitive peoples (*Drumbeat,* 1942; colorplate 138).

Unlike Schlemmer whose misfortune it was to remain in Germany during the Nazi dictatorship and to die in obscurity in 1943; and unlike Belling who migrated to Turkey in 1933 and sank into academic oblivion, Baumeister became one of the heroes of the post-war generation of German artists. Although his works belong in the world of abstract, organic surrealism, he was able to maintain an individual, magical expression even while painting under the greatest difficulties (fig. 511).

*above:* 510. WILLI BAUMEISTER.
*Stone Garden I.* 1939.
39⅜ x 31⅞ ".
Collection Felicitas-Karg Baumeister,
Stuttgart

*right:* 511. WILLI BAUMEISTER.
*Homage to Jerome Bosch.* 1953.
Oil on composition board, 43¼ x 59".
Collection Felicitas-Karg Baumeister,
Stuttgart

# PART SEVENTEEN

# PAINTING IN PARIS
# IN THE 1920s AND 1930s

At the end of World War I, Paris resumed its position as the world capital of the arts. Although many artists served in the French army, activity in the arts had continued in Paris during the war, partly because several older masters were still active, partly because foreign artists from neutral nations, such as Picasso and Juan Gris, were not called into the army. Braque, Léger, Metzinger, and Derain served in the war and came back to Paris. Braque was severely wounded in 1915 and did not resume painting until 1917. Duchamp-Villon and the sculptor Gaudier-Brzeska (who returned from England) were killed. The critic Guillaume Apollinaire died in 1918 of influenza and complications from a serious wound.

## PICASSO—THE EARLY POST-WAR YEARS

The career of Picasso during World War I exemplifies much that was happening during these years. After the years of discovery and experiment in analytical cubism, collage, and the beginning of synthetic cubism (1908–14), there was a pause during which the artist used cubism for decorative or fantastic-expressionist ends (see *Green Still Life,* colorplate 45, and *Glass of Absinthe,* fig. 220). Then, suddenly, in 1914–15 he began a series of realistic portrait drawings in a sensitive, even exquisite linear technique that recalls his long-time admiration for the drawings of Ingres (*Vollard,* 1915, fig. 512). The war years and the early 1920s saw a return to forms of realism on the part of other French painters—Derain, Vlaminck, Dufy—originally associated with fauvism or cubism.

The return to nature is understandable as a reaction against new styles and movements that had been pursued assiduously for five to ten years. This pattern has repeated itself at intervals during the twentieth century, and is observable at all periods in the history of art. In Picasso's case, however, the realistic drawings and, subsequently, realistic paintings, constituted not a reaction against cubism, but a sort of catharsis enabling him to re-examine its nature. In any event, he pursued cubist experiments side by side with realistic and classical drawings and paintings in the early 1920s.

In 1917 Picasso agreed, somewhat reluctantly because of his hatred for travel or disruption of his routine, to go to Rome with Jean Cocteau to design curtains, sets, and costumes for a new ballet, *Parade,* being prepared for Diaghilev's Russian Ballet Company (fig. 513). This brought the artist back into the world of the theater

512. PABLO PICASSO. *Ambroise Vollard.* 1915. Pencil on paper, 18⅜ x 12 9/16". The Metropolitan Museum of Art, New York. Elisha Whittelsey Collection, 1947

which, with the circus, had been an early love and had provided him with subject matter for his blue period. *Parade* was a notable example of Diaghilev's genius for bringing together the greatest experimental talents of the day. Aside from Cocteau, who wrote the book, and Picasso, the music was composed by Erik Satie and the choreography by Léonid Massine. The ballet was a satire on the world of the theater, with a theme of symbolic conflict between the delicate humanity and harmony of the music and the dancers, on the one hand, and the over-

513. PABLO PICASSO. Study for the Curtain for *Parade,*
Montrouge. 1916–17. Pencil, 7⅞ x 10⅞ ".
Whereabouts unknown

515. PABLO PICASSO. *The Bathers.* 1918.
Pencil on paper, 9½ x 12¼ ". Fogg Art Museum,
Harvard University, Cambridge, Massachusetts.
Bequest of Meta and Paul J. Sachs

514. PABLO PICASSO. *Portrait of Igor Stravinsky.* 1920.
Pencil, 24¼ x 18¾ ". Private collection, U.S.A.

516. PABLO PICASSO. *Sleeping Peasants.* 1919.
Gouache, 12¼ x 19¼ ". The Museum of Modern Art,
New York. Abby Aldrich Rockefeller Fund

517. PABLO PICASSO. *The Race.* 1922.
Tempera on wood, 12⅞ x 16¼ ". Collection the Artist

powering force of the mechanist-cubist managers and
the deafening noise of the sound effects, on the other. Its
mixture of reality and fantasy led Apollinaire in his pro-
gram notes to refer to its "sur-réalism," one of the first
recorded uses of this term to describe an art form. *Pa-
rade* involved elements of shock that the dadaists were
then exploiting in Zurich, and the contrasts of the com-

monplace and fantastic such as De Chirico had introduced into his paintings.

Picasso's early love of the characters from the Italian comedy and its descendant, the French circus, was renewed; Pierrots, Harlequins, and musicians again became a central theme. The world of the theater and music took on for him a fresh aspect that resulted in a number of brilliant portraits (*Stravinsky,* fig. 514), and figure drawings, particularly compositions of nudes done in delicately economical outlines (*Bathers,* 1918, fig. 515).

During the early post-war period Picasso experimented with different attitudes toward cubism and representation. In the latter, the most purely classical style was manifested before 1923 in drawings that have the quality of white-ground Greek vase paintings of the fifth century B.C. Already by 1920 such drawings embodied a specifically Greek or Roman subject matter which he continued to explore thereafter. During the same year he also began to produce paintings, frequently on a large scale, in which his concept of classic is in a different and monumental vein. This phase first manifested itself in 1919 in a small colored drawing of *Sleeping Peasants* (fig. 516), a tightly integrated composition of two massive figures in repose. He pursued this manner for the next three or four years in painting and continued it in sculpture in the early 1930s. It is as though the years of working with flat, tilted cubist planes had built up a need to go to the extreme of sculptural mass. The faces are simplified in the heavy, coarse manner of Roman rather than Greek sculpture, and when Picasso placed the figures before a landscape, he simplified the background to frontalized accents that tend to close rather than open the space. Thus the effect of high sculptural relief is maintained throughout. Normally the figures exhibit classic repose, but occasionally Picasso puts them into violent if lumbering activity that lends a quality of fantasy, as in *The Race,* 1922 (fig. 517). The colors of these paintings, in accordance with their classic origins, are light and bright—light blues and reds, with raw pink flesh tones. We should recall that crude, massive figure compositions were not new in Picasso's career: during his period of primitive and proto-cubist works, 1906–08, he produced a number of comparable massive and primitively powerful paintings (see fig. 196).

By 1923 the Greco-Roman phase was over. Picasso continued to paint for two or three more years in a classic vein, but now with a lyrical classicism close to the spirit of Athens in the fifth century B.C. One of the outstanding works of this phase is *The Pipes of Pan,* 1923 (fig. 518). The two youths are presented as massive yet graceful athletes, absorbed in their own remote and magical world under the spell of primitive music. In other works of the same period an even more delicate and lyrical quality is evident, taking us back to Picasso's first classic, rose period. It is possible that the deep and tender sentiment pervading these paintings (for instance, *Woman with the Blue Veil,* 1923, fig. 519) was the consequence of his feelings for his young son, Paul, whose childhood he was then recording in some of the most delightful paintings of children of the twentieth century. By 1925 this second classic phase was over in the figure paintings, to recur in the next decades from time

518. PABLO PICASSO. *The Pipes of Pan.* 1923. 80½ x 68½". Collection the Artist

519. PABLO PICASSO. *Woman with the Blue Veil.* 1923. 39½ x 32". Los Angeles County Museum of Art. Mr. and Mrs. George Gard de Sylva Collection

to time. Classic motifs continued to appear in still lifes; and the type of classic line drawing he had developed during the war (again it should be emphasized, the revival of a drawing style of his rose period) has continued in his work in one form or another. The specific classical subject taken from Greek or Roman mythology has also

520. PABLO PICASSO. *Nessus and Deianira*. 1920.
Pencil, 8¼ x 10¼". The Museum of Modern Art, New York.
Acquired through the Lillie P. Bliss Bequest

continued without interruption in the drawings and prints. Belonging to this second classic phase is the *Nessus and Deianira,* 1920 (fig. 520), a portrayal of the rape of Deianira, wife of Herakles, by the centaur, Nessus. The subject so intrigued the artist that he made versions in pencil, silverpoint, watercolor, and etching. The representational line drawings also revived his interest in the graphic arts, particularly etching and lithography. He produced prints at the beginning of his career, and some during the earlier cubist phase and the war years; from the early 1920s printmaking has become a major phase of his production, to the point where he must be regarded as one of the great printmakers of the century.

In the early 1920s Picasso also produced a few strange and almost inexplicable figure pieces of which the most curious is *By the Sea,* 1920 (misdated 1923, fig. 521). The subject and the light, simple colors, are of the classic type—three nudes, reclining or gamboling at the sea shore. Here, however, the artist has used grotesque distortions, particularly of the running and standing figures, that predict the next, or surrealist, stage of his work.

The incredible aspect of Picasso's art during this ten-year period (1915–25) is that he was also producing major cubist paintings. After the decorative enrichment of the cubist paintings around 1914–15, including pointillist color and elaborate, applied textures (*Vive la France,* 1914, fig. 522), the artist moved back, in his cubist paintings of 1916–18, to a greater austerity of more simplified flat patterns, frequently based on the figure (*Harlequin with Violin,* 1918, fig. 523). Simulta-

521. PABLO PICASSO.
*By the Sea.* 1920.
Oil on wood, 31⅞ x 39⅜".
Whereabouts unknown

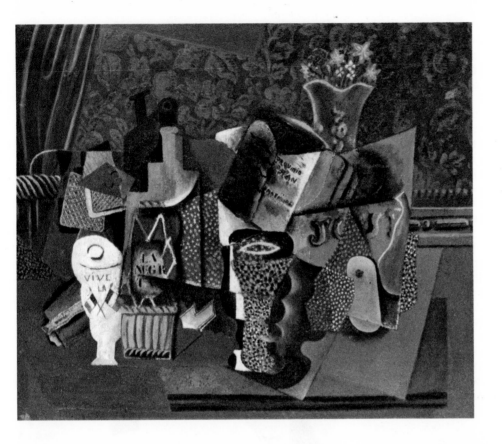

neously, he made realistic versions of this subject, a favorite with him (*Pierrot*, 1918, fig. 524). From compositions involving figures, there gradually evolved the two versions of the *Three Musicians*, 1921, both masterworks of the cubist tradition (colorplates 139 and 140). The three figures are seated in a row, frontal against an enclosing back wall, and fixed by the restricted foreground. There are many differences in the two versions, that at Philadelphia being generally more intricate and varied in forms and colors, that in New York simple and more somber. They are a superb summation of the cubist tradition up to this point, but they also embody something new. The three masked, mysterious figures are not merely organizations of flat-color shapes arranged to create a bold but harmonious unity; they are presences, suggestive not so much of gay musicians from the Italian comedy, as of some menacing tribunal whose role as musicians is a deception and a mockery. Probably the figures could be read in other ways, but the significant point is their emergence as definite personalities. At this point cubism takes on an expressionist or fantastic quality, one that adds to it a new dimension and changes its nature.

The other direction in which Picasso took cubism involved sacrifice of the purity of its analytical phase, for the sake of new explorations of pictorial space. In 1919 he made a series of studies of a still life on a table before an open window (for instance, fig. 525), in which the problem seemed to be the enlargement of the cubist vocabulary through the reintroduction of perspective depth, the heightening of color, and the use of curvilinear shapes. The result was, between 1924 and 1926, a series

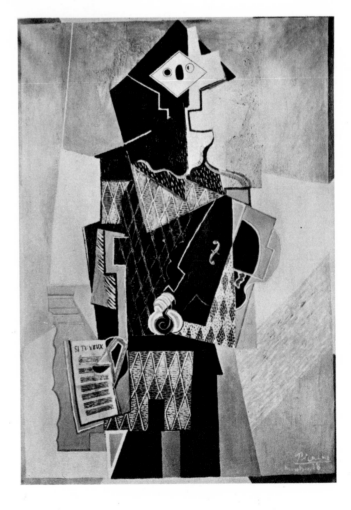

of the most colorful and spatially intricate still lifes in the history of cubism. The *Mandolin and Guitar,* 1924 (colorplate 141), illustrates the artist's superb control over the entire repertory of cubist and perspective space. The center of the painting is occupied by the characteristic cubist still life—the mandolin and guitar twisting and turning on the table, encompassed in mandorlas of abstract color-shapes: vivid reds, blues, purples, yellows, and ochers against more subdued but still rich earth colors; the tablecloth is vari-colored and patterned; the corner of the room with the open window is a complex of tilted wall planes and receding perspective lines creating a considerable illusion of depth which, however, seems constantly to be turning back upon itself, shifting and changing into flat planes of color. By violating every canon of earlier, analytical cubism, Picasso has accelerated the process of spatial metamorphosis to the point where the commanding element is the dynamism of the total space of the painting. Space here, in a most tangible manner, but a manner entirely different from that of the surrealists, becomes literally expressive.

It is interesting to recall the extent to which the subject of the open window, often with a table, still life, or figure before it, had also been a favorite of Matisse. Through this subject, in fact, one may follow his progress from fauve color to cubist simplification and back to oriental, coloristic, and curvilinear pattern at war's end. Perhaps

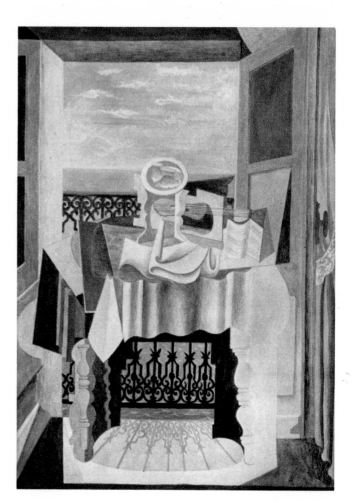

525. PABLO PICASSO. *Table in Front of a Window.* 1919. Gouache, 13¾ x 9¾". Private collection

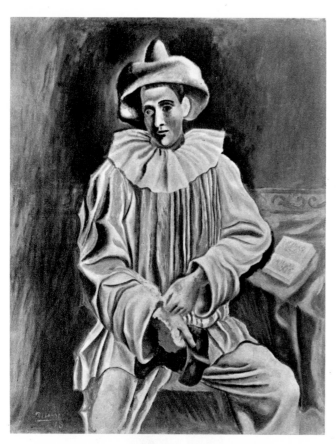

524. PABLO PICASSO. *Pierrot.* 1918. 36½ x 28¾". The Museum of Modern Art, New York. Sam A. Lewisohn Bequest

the most abstract painting ever made by Matisse was *The Open Window, Collioure,* 1914 (see colorplate 25): a work of flat planes of color, four arranged in vertical rectangles, blue, black, gray, and green; a horizontal, dark gray rectangle at the bottom establishing the base line; and a diagonal joining with the vertical plane of light gray to give with minimal means all the painting's indication of perspective depth. The stark, abstract, austere painting illustrates Matisse's exploration of cubist geometry just before the war and during its early years. (At this same period Picasso and Braque were bringing their cubist paintings to an extreme point of rococo decoration.)

Matisse, after his brief and personal exploration of cubism, returned, toward the end of the war, to his intimate portrayal of the corner of the studio. His palette was brilliant, his line decorative, with the architectural structure strengthened as a result of his cubist experiments, but not essentially different from the approach he had formed on the tradition of Cézanne and the impressionists. Because of certain points of relationship between Matisse's works like *Still Life in the Studio, Nice,* 1923 (colorplate 142), and Picasso's contemporary paintings of similar subjects, it is possible to believe that Picasso may have been looking at Matisse; yet his approach was entirely different, based as it was on cubism.

Picasso, in some cubist still lifes of the mid-1920s, introduced classical busts as motifs suggesting the artist's simultaneous exploration of classic monumentality and idealism. Sometimes, as in *The Studio,* 1925 (colorplate 143), the bust implies a different form of expression, a quality of mystery analogous to De Chirico's use of classical motifs. At this moment the surrealists were emerging as an organized group; and Picasso himself was soon to begin exploring the realm of fantasy.

## BRAQUE—THE POST-WAR YEARS

Braque and Picasso parted company in 1914, never to regain the intimacy of the formative years of cubism. After his war service and the slow recovery from a serious wound, Braque returned to Paris in the fall of 1917. The scene had changed during his years of absence. Picasso was in Italy, and other pioneers of cubism or fauvism were widely scattered. However, Juan Gris was still in Paris, painting in a manner that impressed Braque and inspired him in his efforts to find his own way once more. His first paintings in 1917–18 were conceived in broad, unified planes of color with stippled planes for accents. The linear structure was simplified in a geometry sug-

527. GEORGES BRAQUE. *Red and Blue Guitar.* 1930. 50¾ x 28¾". Private collection, New York

526. GEORGES BRAQUE. *Woman with Mandolin.* 1917. 36¼ x 25⅝". Collection Jean Masurel, Roubaix, France

gesting Gris' approach (*Woman with Mandolin,* 1917, fig. 526). By 1918–19, a new and personal approach to synthetic cubism began to be apparent in a series of paintings, of which *Café-Bar,* 1919 (colorplate 144), is a document for Braque's style for the next twenty years. As such it deserves close examination. The painting is tall and relatively narrow, a shape which Braque had liked during his first essays in cubism (see colorplate 43) and which he now began to utilize on a more monumental scale. The subject is a still life of guitar, pipe, journal, and miscellaneous objects piled vertically on a small, marble-topped pedestal table of the type whose French name is *guéridon.* This table was used many times in subsequent paintings, to which its name has been attached. It is placed as it might be on the sidewalk before a Paris café, with the diamond-shaped tiles of the pavement indicated at the base and the *Café-Bar* at the

top, presumably painted on the window of the café. The variously suggested elements of the environment are held together by a pattern of horizontal green rectangles patterned with orange-yellow dots, placed like an architectural framework parallel to the picture plane. Compared with his pre-war cubist paintings, this has more sense of illusionist depth and actual environment, although closed in comparison with Picasso's window paintings of the same year. Also, although the colors are rich, and

528. GEORGES BRAQUE. *Nude*. c. 1924. Pencil and chalk on paper, 15 x 26". The Philadelphia Museum of Art. The Louis E. Stern Collection

Braque's feeling for texture is more than ever apparent, the total effect recalls, more than Picasso's, the subdued tonality that both artists worked with during their early collaboration. This is perhaps the key to the difference between their maturities. Whereas the approach of Picasso was experimental and varied, that of Braque was conservative and intensive, continuing the first lessons of cubism. Even when he made his most radical departures into his own form of classical figure painting during the 1920s, the color remained predominantly the grays, greens, browns, and ochers of analytical cubism. From time to time, throughout his subsequent career, he tried his hand at high-keyed and positive color, but when he did, one sensed a certain graying of the reds and yellows that softened their impact and integrated them into a tonal harmony (*Red and Blue Guitar,* 1930, fig. 527). The principal characteristic of Braque's style emerging about 1919 was that of a textural sensuousness in which the angular geometry of earlier cubism began to diffuse into an over-all fluid pattern of organic shapes.

This style manifested itself in the early 1920s in figure paintings in which the artist seems to have deserted cubism as completely as Picasso did in his classic figure paintings. The difference again lay in the painterliness of Braque's paintings and drawings, as compared with Picasso's Ingres-like contour drawings and the sculptural massiveness of his classic paintings. In *Nude Woman with Basket of Fruit,* 1926 (colorplate 145), the figure flows through the limited space of the picture in a sheer delight of sensual femininity. The composition is a close

*above left:* 529. GEORGES BRAQUE. *Still Life: Le Jour.* 1929. 45 x 58". National Gallery, Washington, D.C. Chester Dale Collection

*above right:* 530. GEORGES BRAQUE. *Figure.* 1920. Plaster, height 7¾". Collection Dr. and Mrs. Philip D. Wiedel

*above left:* 531. GEORGES BRAQUE. *Cliffs and Fishing Boat.* 1929. 13 x 18". Private collection, New York

*above right:* 532. GEORGES BRAQUE. *Herakles.* 1932. Engraved plaster, 10⅝ x 8¼". Private collection, Basel

blend of halftones defined by the loose, flowing contours of the figure. In these paintings and figure drawings of the 1920s the artist effected his personal escape from the rigidity of his earlier cubism and prepared the way for his enriched approach to cubist design of the later 1920s and 1930s (*Nude,* c. 1924, fig. 528; *Still Life: Le Jour,* 1929, fig. 529).

During the early 1920s Braque also began to make small sculptures that reflected his interest in classic figures, frequently involving a degree of cubist geometry (fig. 530). In the late 1920s, inspired by summers in Normandy, he returned sporadically to a kind of pointillist landscape, lower in key but reminiscent of some of his earliest fauve efforts (*Cliffs and Fishing Boat,* 1929, fig. 531). The most dramatic variation on his steady, introspective progress occurred in the early 1930s when, under the influence of Greek vase painting, he created a series of line drawings and engravings with continuous contours (*Herakles,* 1932, engraved plaster, fig. 532). This flat, linear style also penetrated to his newly austere paintings of the period: scenes of artist and model or simply figures in the studio (*Painter and Model,* 1939, colorplate 146; *Woman with a Mandolin,* 1937, fig. 533). These works exhibit some of the most varied effects of Braque's entire career. The colors are subdued but rich and sensuous; still lifes (colorplate 147), and the shadowed interiors occupied by somber figures, are shot through with passages of luscious color, and filled with a mystery of loneliness. In his late maturity, Braque, without sacrificing any of the restraint or control that had marked his career, added an element of romantic enrichment to culminate and enlarge upon his lifetime of intensive contemplation.

533. GEORGES BRAQUE. *Woman with a Mandolin.* 1937. 51¼ x 38¼". The Museum of Modern Art, New York. Mrs. Simon Guggenheim Fund

# SURREALISM

In 1917 Apollinaire referred to his own drama *Les Mamelles de Tiresias,* and also to the ballet *Parade* produced by Diaghilev, as surrealist. The term was commonly used thereafter by André Breton, Paul Eluard, and other contributors to the Paris journal *Littérature.* The concept of a literary and art movement to be formally designated surrealism, however, did not emerge until dada had breathed its last in Paris.

In the first years after World War I, French writers had been trying to formulate an aesthetic of the non-rational stemming from Arthur Rimbaud, Comte de Lautréamont, Alfred Jarry, and Apollinaire; they sought their answer in the dadaists, then converging on Paris. Breton joined Tzara, Picabia, and Duchamp in publishing the February 1919 edition of *Bulletin Dada,* and other dada journals and manifestations from 1920 to 1922. During the same period there were exhibitions of Picabia and Max Ernst, the latter with an introduction by André Breton. By 1922, Breton was growing disillusioned with dada on the curious but perhaps legitimate basis that it was becoming institutionalized and academic. He opposed the large dada exhibition held at the Galerie Montaigne, and led the revolt that broke up the dada congress of Paris. But together with Philippe Soupault, he explored the possibilities of automatic writing in his surrealist texts called *The Magnetic Fields,* 1922 (some automatic writing had already been done about three years earlier).

After 1922 Breton assumed the principal editorship of *Littérature,* and gradually augmented his original band of writers with artists whose work and attitudes were closest to his own: Picabia, who contributed poems, aphorisms, and cover designs; Man Ray, who was experimenting with abstract photographs that he called "rayograms"; and Max Ernst. Artists and writers continued to explore automatic writing, the poetry of the magical, and the world of dreams and the Freudian subconscious. The group met Breton regularly at his or Paul Eluard's home, or at some favorite café; they discussed the meaning for the contemporary artist of Lautréamont, Rimbaud, or Jarry, or the significance of the marvelous, the irrational, and the accidental in painting and poetry. From these meetings emerged Breton's *Manifesto of Surrealism* in 1924, containing this definition:

SURREALISM, *noun, masc., pure psychic automatism by which it is intended to express, either verbally or in writing, the true function of thought. Thought dictated in the absence of all control exerted by reason, and outside all aesthetic or moral preoccupations.*

ENCYCL. Philos. *Surrealism is based on the belief in the superior reality of certain forms of association heretofore neglected, in the omnipotence of the dream, and in the disinterested play of thought. It leads to the permanent destruction of all other psychic mechanisms and to its substitution for them in the solution of the principal problems of life.*

This definition emphasizes words rather than plastic images, literature rather than painting or sculpture. The movement was dominated by poets and literary critics who felt themselves the heirs of Rimbaud, Lautréamont, and Jarry. Breton, in addition, was a serious student and disciple of Freud, from whose teachings he derived the surrealist position concerning the central significance, to poet and artist, of dreams and the subconscious. He conceived of the sur-real condition as a moment of revelation in which are resolved the contradictions and oppositions of dreams and realities. In the second manifesto of surrealism, 1930, he said: "There is a certain point for the mind from which life and death, the real and the imaginary, the past and the future, the communicable and the incommunicable, the high and the low cease being perceived as contradictions."

The element of chance, of randomness and coincidence in the formation of a work of art, or more important, of an artist, had for years been explored by the dadaists. Now it was made the basis for intensive study. Implicit in the surrealist program was the need for revolt—revolt against institutions and philosophies, against the older statesmen, philosophers, poets, and artists who had led the younger generation into the dreadful carnage of World War I. The surrealists and dadaists were all in their twenties; and, to understand the ferocity of their antagonisms, their recent experience of four years of total war must be kept in mind. This experience made the surrealists attach much importance to the poet's isolation, his alienation from society and even from nature.

Two nineteenth-century poets were major symbols and prophets for the surrealists. Isidore Ducasse (1846–1880), who assumed the name Comte de Lautréamont, and Arthur Rimbaud (1854–1891) were violent and outspoken critics of established nineteenth-century poets and of the forms and concepts of nineteenth-century poetry. Unknown to each other, both lived almost in isolation, wandered from place to place, and both died young; yet they wrote great poetry while still adolescents, tearing at the foundations of romantic poetry: they had irresistible appeal to the surrealists.

Lautréamont's poem *Les Chants de Maldoror* presents the archetypal hero of the surrealists: man, dual in nature, drawn equally by the spiritual force of God and the animal ferocity of beasts of prey. Like Baudelaire's *Dandy,* he possesses superior intelligence and sensitivity

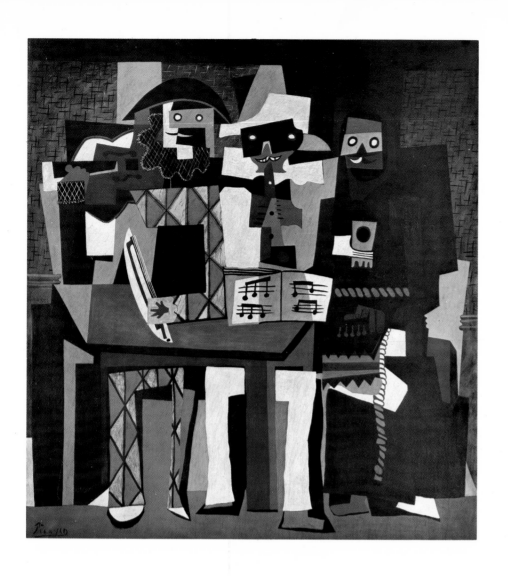

Colorplate 139. PABLO PICASSO.
*Three Musicians*. 1921.
Oil on canvas, 81¼ x 75¼".
The Philadelphia Museum of Art.
A. E. Gallatin Collection

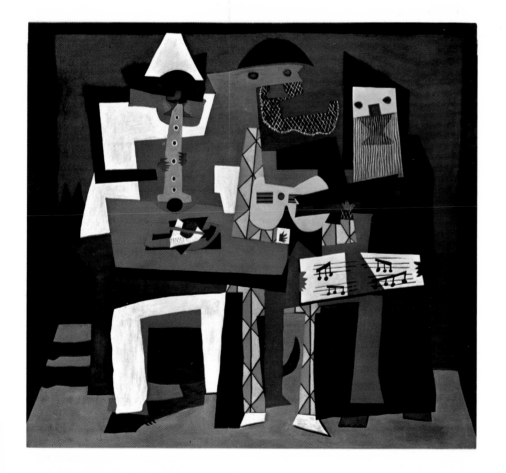

Colorplate 140. PABLO PICASSO.
*Three Musicians*. 1921.
Oil on canvas, 79 x 87¾".
The Museum of Modern Art, New York.
Mrs. Simon Guggenheim Fund

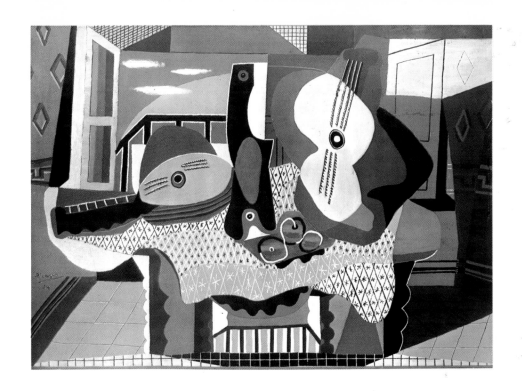

Colorplate 141.
PABLO PICASSO.
*Mandolin and Guitar*. 1924.
Oil with sand on canvas,
56⅛ x 79¾″. The Solomon
R. Guggenheim Museum,
New York

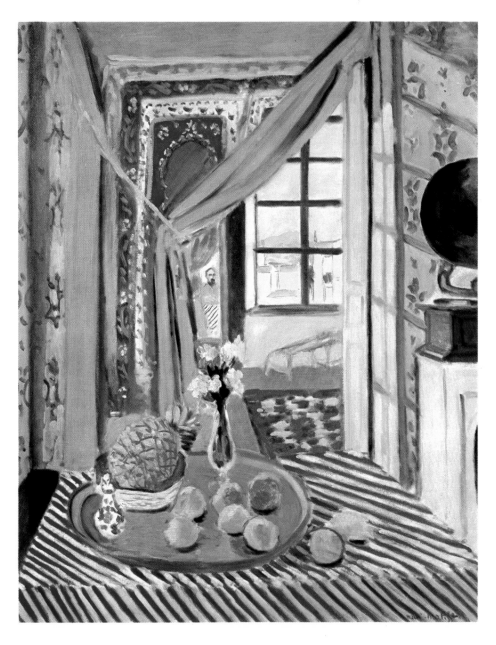

Colorplate 142.
HENRI MATISSE.
*Still Life in the Studio, Nice.*
1923. Oil on canvas,
39¾ x 32″. Collection
Mrs. Albert D. Lasker,
New York

left: Colorplate 143. PABLO PICASSO.
*The Studio.* 1925. Oil on canvas, 38⅝ x 51⅝".
Collection James Johnson Sweeney

*below left:* Colorplate 144.
GEORGES BRAQUE. *Café-Bar.* 1919.
Oil on canvas, 63¼ x 31⅞".
Kunstmuseum, Basel

*below right:* Colorplate 145. GEORGES BRAQUE.
*Nude Woman with Basket of Fruit.* 1926.
Oil on canvas, 63¾ x 29¼".
National Gallery of Art, Washington, D.C.
Chester Dale Collection

Colorplate 148. JOAN MIRO. *Montroig (The Olive Grove)*.
1919. Oil on canvas, 28⅜ x 35⅜".
Collection Mr. and Mrs. Leigh B. Block, Chicago

Colorplate 149. JOAN MIRO. *Catalan Landscape
(The Hunter)*. 1923–24. Oil on canvas, 25½ x 39½".
The Museum of Modern Art, New York

*opposite:* Colorplate 150. JOAN MIRO.
*The Harlequin's Carnival*. 1924–25. Oil on canvas, 26 x 36⅝".
The Albright-Knox Art Gallery, Buffalo, New York

opposite left: Colorplate 146. GEORGES BRAQUE. *Painter and Model*. 1939. Oil on canvas, 51 x 69″. Walter P. Chrysler Museum, Provincetown, Massachusetts

left: Colorplate 147. GEORGES BRAQUE. *Vase, Palette, and Skull*. 1939. Oil and sand on canvas, 36 x 36″. Collection Mr. and Mrs. David Lloyd Kreeger, Washington, D.C.

above: Colorplate 151. JOAN MIRO.
*Dog Barking at the Moon.* 1926.
Oil on canvas, 28¾ x 36¼″.
The Philadelphia Museum of Art.
A. E. Gallatin Colection

right: Colorplate 152. JOAN MIRO.
*Dutch Interior II.* 1928.
Oil on canvas, 36¼ x 28⅜″.
Collection Peggy Guggenheim, Venice

left: Colorplate 153. JOAN MIRO. *Painting.* 1933.
Oil on canvas, 68⅛ x 76¾".
The Museum of Modern Art, New York.
Gift of Advisory Committee

below: Colorplate 154. JOAN MIRO. *Nursery Decoration.*
1938. Oil on canvas, 2′ 7½″ x 10′ 6″. Collection
Mr. and Mrs. Richard K. Weil,
St. Louis, Missouri

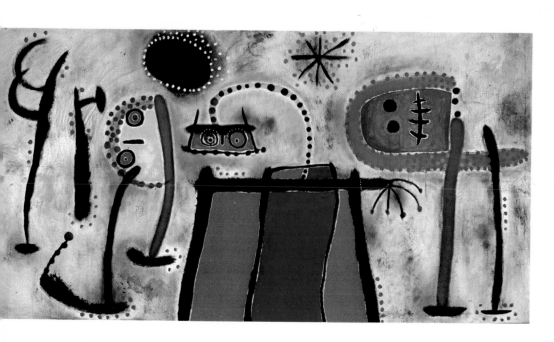

Colorplate 155.
JOAN MIRO. *Painting.* 1953.
Oil on canvas, 6′ 6¾″ x 12′ 4¾″.
The Solomon R. Guggenheim
Museum, New York

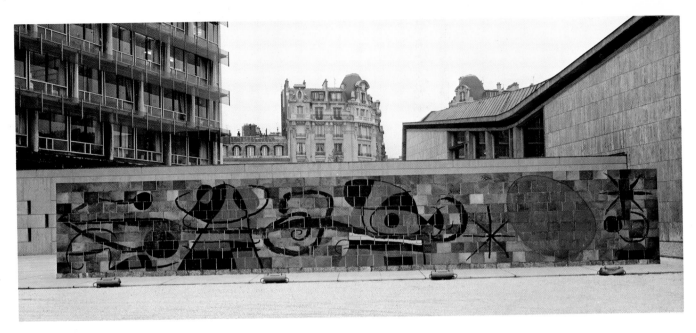

Colorplate 156. JOAN MIRO and JOSE ARTIGAS. *Wall of the Sun (Day)*. 1955–58.
Ceramic mural, 9′ 10″ x 49′. UNESCO, Paris

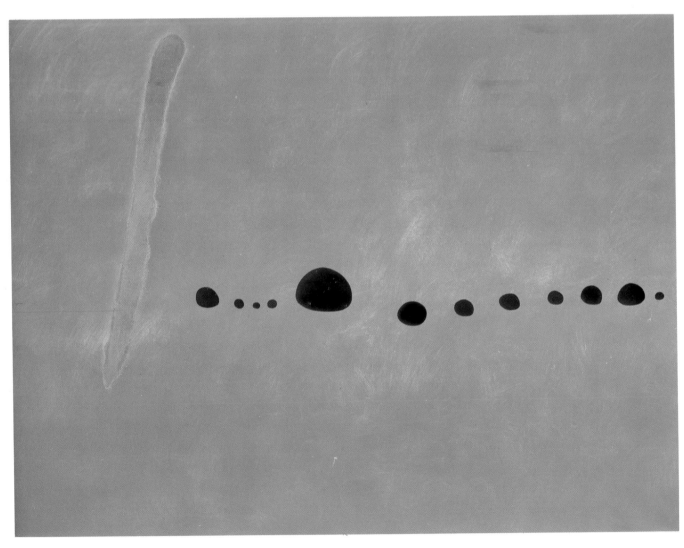

Colorplate 157. JOAN MIRO. *Blue II*. 1961. Oil on canvas, 8′ 10¼″ x 11′ 7¾″.
Pierre Matisse Gallery, New York

that he controls by coldness—the hero who lives apart from the world while living in it. Lautréamont parallels Baudelaire's image of the poet who is also priest and warrior; who creates through knowing and through killing. The work of art must be a work of destruction as well as of creation. The idea of revolt permeates Lautréamont's poetry: revolt against tradition, against the family, against society, and against God Himself.

The ideas of Rimbaud at seventeen years of age seemed, even more than those of Lautréamont, to define for the surrealists the nature of the poet and poetry. Rimbaud's intensive reading in Oriental and Greek mystical religions had fixed the poet, in his mind, as one possessed of divine madness, like Prometheus, the thief of the sacred flame. The poet, like the Christian mystic, must attain the visionary state through rigid discipline—but here a discipline of alienation, monstrosities of love, suffering, and madness. Like the surrealists later, Rimbaud was concerned with the implications of dreams, the subconscious (then still undefined), automatism, and chance. Words took on a magical significance, not as description or communication, but as mysterious invocations. Poetry was a voyage into the unknown.

The ideas advanced in Breton's manifestoes had belonged to the art and literature of revolt for some fifty years, but now they were codified explicitly. A dogma of surrealist principles was formulated and, almost at once, schisms and heresies appeared. Fortunately for the vitality of surrealist painting and sculpture, few of its exponents practiced the word according to Breton with scrupulous literalness. In fact, the major surrealist painters have little stylistic similarity, aside from seeking new subject matter or a new departure from traditional content. Since individualism and isolation were at the core of the movement, the artists sought, above all, to be individuals. Many established artists—like Picasso or De Chirico, for instance—who were assimilated by the surrealists (officially or otherwise) had, of course, been individuals long before the surrealist manifesto of 1924.

The first group exhibition of surrealist artists was in 1925 at the Galerie Pierre; it included Arp, De Chirico, Ernst, Klee, Man Ray, Masson, Miró, Picasso, and Pierre Roy. In that year Yves Tanguy joined the group. A surrealist gallery was opened in 1927 with an exhibition of these artists joined by Marcel Duchamp and Picabia. Except for René Magritte, who joined later that year, and Salvador Dali, who did not visit Paris until 1928, this was the roster of the first surrealist generation.

In the mid-1920s, De Chirico had abandoned his early metaphysical paintings (except for making copies of them) in favor of an academic classicism. Paul Klee, at the Bauhaus, was producing his most magical fantasies. Picasso, after balancing classicism against synthetic cubism for several years, was experimenting with fantasy by the evocation of monsters. Marcel Duchamp, back in Paris after leaving the *Large Glass* (see colorplate 131) unfinished—or perhaps finished through the shattering of the glass in transit—had ceased to produce art but not to participate in its eccentric manifestations. He continued to explore motion in his *Rotative Plaques* (see fig. 474). Man Ray, in Paris since 1921, still painted but was turning to photography and cinema, mediums in which he

was a pioneer experimentalist. Duchamp made in 1924 what may be called a surrealist film, *Anemic Cinema* (a typical Duchamp anagram), in Man Ray's studio; and Man Ray produced *Starfish*, with a script by Robert Desnos, in 1928. The influence of surrealism on the cinema can here only be suggested. The film had already been used by George Méliès to explore the fantastic in his *Hydrothérapie fantastique* in 1900. The first great example was Robert Wiene's *Cabinet of Doctor Caligari*, 1919; René Clair experimented with the surrealist film in *Entr'acte*, 1924; *Le Chien andalou*, 1929, by Salvador Dali and Luis Bunuel, and *Blood of a Poet*, 1931, by Jean Cocteau, have become classics of the surrealist film.

## PICABIA AFTER 1914

Picabia was born in Paris of wealthy Cuban and French parents, and acquired a reputation as the playboy of dada and surrealism. Between 1908 and 1911 he moved from impressionism to cubism. He joined the Section d'Or briefly and then experimented with the orphism of Delaunay and with futurism. In New York in 1915 he collaborated with Marcel Duchamp in the American version of proto-dada. Returning to Europe in 1916 he founded his journal, *391*, in Barcelona, and published it intermittently in New York, Zurich, and Paris until 1924.

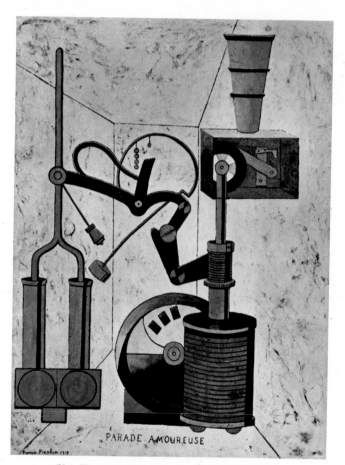

534. FRANCIS PICABIA. *Amorous Procession.* 1917. Oil on cardboard, 38¼ x 29⅛". Collection Morton G. Neumann, Chicago

535. FRANCIS PICABIA. *Child Carburetor.*
c. 1915–18. Mixed mediums on wood, 49¾ x 37⅞".
The Solomon R. Guggenheim Museum, New York

After meeting the Zurich dadaists in 1918, he was active in the dada group in Paris. Always in revolt, he then reverted to representational art and, after the emergence of surrealism, painted academic nudes; with the end of World War II, he resumed abstract painting. Picabia's artistic qualities tend to be obscured by his personality—exuberant and wealthy, with a concomitant magnificence of gesture, he loved controversy, wished to be in the forefront of every battle, and had a cultivated sense of the ridiculous. More than any of the dadaists and surrealists except Duchamp and Arp he introduced sheer nonsense into these sometimes overly serious explorations of the irrational, and enthusiasm into every kind of experiment or manifestation (figs. 534, 535).

### ARP AFTER 1920

Jean Arp went to Paris with Max Ernst in 1922, and was active in Paris dada during its brief life; he exhibited in the International Dada Exhibition, 1922, at the Galerie Montaigne, and contributed poems and drawings to dada periodicals. When official surrealism emerged in 1924 he was an active participant. At the same time, he remained in close contact with German and Dutch abstractionists and constructivists. He contributed to Theo van Doesburg's *De Stijl*, and with El Lissitzky edited *The Isms of Art*. After 1925 he and Sophie Taeuber-Arp made their home in Meudon outside of Paris.

During the 1920s Arp's favorite material was wood, which he made into painted reliefs. He also produced paintings, some on cardboard with cut-out designs making a sort of reverse collage. He had experimented with geometric abstractions between 1915 and 1920, occasionally collaborating with Sophie Taeuber (see p. 292). These abstractions were close to the contemporaneous works by Mondrian and Van Doesburg, although Arp has said that he knew nothing of their abstract paintings before 1919, and that he learned about constructed paintings principally from Sophie Taeuber-Arp, a fine painter who pioneered in geometric abstraction. Arp, however, abandoned geometric shapes by 1920 and already held the fixed conviction that "art is a fruit that grows in man, like a fruit on a plant, or a child in its mother's womb." Yet he never questioned the right of other artists to follow the path of geometry and, in fact, remained a close friend of Van Doesburg and a fervent propagandist for the paintings of Sophie Taeuber-Arp.

With the collaboration of these two artists, Arp deco-

536. JEAN ARP. *Rising Navel and Two Heads.*
1927–28. Mural, oil on plaster.
Café L'Aubette, Strasbourg (destroyed 1940)

537. JEAN ARP. *Navel-Sun.* 1927–28. Mural, oil on plaster.
Café L'Aubette, Strasbourg (destroyed 1940)

538. JEAN ARP. *Objects Arranged According to the Laws of Chance or Navels.* 1930. Varnished wood relief, 10⅜ x 11⅛". The Museum of Modern Art, New York

that the casually placed relief elements and the dropped loops of string have magically assumed forms unique to the artist's personal style; Arp, it would appear, may have given the laws of chance some assistance. He had a precedent for this: in 1913 Marcel Duchamp had carried out an experiment in chance that resulted in *Three Standard Stoppages* (fig. 540) and was later applied to *Large Glass.* According to the original description, "A straight horizontal thread one metre in length falls from a height of one metre onto a horizontal plane while twisting at will and gives a new form to the unit of length. . . . Three canvases were put on long stretchers and painted prussian blue. Each thread was dropped on a canvas and varnish was dripped onto the thread to bond it to the canvas. . . . The canvases were later cut from the stretchers and glued down onto strips of plate glass. When the decision was taken to use these curves in the *Large Glass* itself, and a method developed to make this integration, three wooden rulers were cut from draftsmen's straight-edges to be used as templates. The box made to house the equipment (looking like the cases made for croquet sets) completed the work in 1914."

Duchamp's *Three Standard Stoppages* is thus a remarkable document in the history of chance as a control-

539. JEAN ARP. *Squares Arranged According to the Laws of Chance.* 1916–17. Collage of colored papers, 19⅛ x 13⅝" The Museum of Modern Art, New York

rated ten rooms of the Café L'Aubette, in his native city, Strasbourg. His murals for the café (now destroyed) were the boldest, freest, and most simplified examples of his organic abstraction. They utilized his favorite motifs: the navel and mushroom-shaped heads, sometimes sporting a mustache and round-dot eyes. Despite the connotations of the titles—*Rising Navel and Two Heads* (fig. 536) and *Navel-Sun* (fig. 537)—these murals were among the most important abstractions of the organic or biomorphic type by any artist up to this time. *Rising Navel and Two Heads* was simply three flat, horizontal, scalloped bands of color, with two color shapes suggesting flat mushrooms floating across the center band. *Navel-Sun* was a loosely circular white shape with a dark center, floating on a large dark rectangle whose edge, undulating slightly, separates it from a narrow band above. There are no parallels for these paintings until the so-termed color-field painters of the 1950s and 1960s.

Of particular interest among Arp's reliefs and collages during the 1920s were those entitled or subtitled *Arranged According to the Laws of Chance* (fig. 538). These continued the 1916–17 experiment in *Squares Arranged According to the Laws of Chance* (fig. 539), although, now, most of the forms were organic rather than geometric. In the same vein, he produced string reliefs —loops of string dropped accidentally on a piece of paper and seemingly fixed there. It should be emphasized

540. MARCEL DUCHAMP. *Three Standard Stoppages.* 1913–14.
Left: three threads on glass panels, each 49½ x 7¼";
right: three wooden strips repeating the curves of the threads,
average length 44¼". The Museum of Modern Art,
New York. Katherine S. Dreier Bequest

541. JEAN ARP. *Head with Three Annoying Objects.*
1930. Brone, 14⅛ x 10¼ x 7½".
Succession Arp

ling factor in the creation of something that might still be considered a work of art. The lines traced by the three threads are not only rhythmic in themselves but, taken together, constitute a total harmony. A young painter recently attempted to duplicate this experiment, but the result was always a snarled and knotted mess no matter what thickness of thread or string or rope he used. A devout admirer of Duchamp, he was at first disillusioned by the suspicion that the threads had been arranged rather than dropped. Then he realized that the idea of the experiment—not the action itself—had intrigued Duchamp, and that what was commemorated in the final work of art was the idea.

Arp, independently of Duchamp, may also have guided his chance disposition of elements in some degree. However, the creation of a work of art lies in the motivation of the artist: the important element is the choice of chance, not chance itself. This principle was recently formulated by the composer Morton Feldman, when pressed on the place of choice or chance in his compositions. His answer was, succinctly: "Choice, of course. I choose chance."

Arp's great step forward in sculpture occurred at the beginning of the 1930s when he began to work completely in the round, to model clay and plaster for transference into bronze or marble. From the first his freestanding sculptures offered a unique imagery and concept of sculpture, and influenced major sculptors of the next generation—among them Alexander Calder, Henry Moore, and Barbara Hepworth. Arp shared Brancusi's devotion to mass rather than space as the fundamental element of sculpture. He thus stands at the opposite pole from the constructivists Gabo and Pevsner. In developing the ideas of his painted reliefs, he had introduced seemingly haphazard detached forms that hovered around the matrix like satellites. Thus *Head with Three Annoying Objects,* 1930 (fig. 541), includes a large biomorphic mass on which rest the three objects variously identified as a mustache, a mandolin, and a fly. It had been Arp's custom for the previous ten years to name the objects in his reliefs and collages after the fact, in accordance with the suggested association. This habit of applying titles to completed works was intended to inspire associations or to baffle and infuriate the spectator; it was introduced by the dadaists and developed by the surrealists. Also, Arp's sculptural creations, consisting of several elements which could be displaced and adjusted by the spectator, not only influenced Moore and Hepworth, but continue to influence younger sculptors today.

*To Be Lost in the Woods,* 1932 (fig. 542), one of Arp's earliest bronzes and a work of interesting complexity, includes a base which becomes part of the total design. The base is a pedestal form, an upper and a lower square block joined by two loosely cylindrical and conical shapes. On the upper block rest three organic forms, the two smaller nesting within the larger. This small structure, less than thirty inches in height, embodies forms and ideas that Arp was to explore over the rest of his career. The idea of the base as an integral part of the sculpture came from Brancusi, although the latter normally shaped bases in archaic forms of rough-hewn wood in order to heighten their contrast with the polished finish

more real, he asked, more concrete than the fundamental forms and colors of non-representational or non-objective art? Although Van Doesburg's term did not gain universal recognition, Arp used it faithfully and, as human concretions, it has gained a specific, descriptive connotation for his sculptures in the round. He himself said: "Concretion signifies the natural process of condensation, hardening, coagulating, thickening, growing together. Concretion designates the solidification of a mass. Concretion designates curdling, the curdling of the earth and the heavenly bodies. Concretion designates solidification, the mass of the stone, the plant, the animal, the man. Concretion is something that has grown."

This statement could be interpreted as a manifesto in opposition to the constructivist assertion of the primacy of space in sculpture. More pertinent, however, is its emphasis on sculpture as a process of growth, making tangible the life processes of the universe, from the microscopic to the macrocosmic. Thus a human concretion was not only an abstraction based on human forms but a distillation in sculpture of life itself.

The art of Jean Arp took many different forms between 1930 and 1966, the year of the artist's death. Abstract (or concrete) forms suggesting gnomes, sirens, snakes, chimeras, clouds, leaves, owls, crystals, shells, buds that were clustered breasts, a cobra-centaur, starfish, seeds and fruit, wineskins, and flowers emerged continually, spaced with forms suggesting such notions as growth, metamorphosis, dreams, and silence. *Torso,* 1953 (fig. 544), and *Aquatic,* 1953 (see fig. 468), represent his most explicit figurative sculpture. In this last

of marble or bronze. In Arp's sculpture both base and surmounting organic shapes are of bronze, so that the whole is one vari-shaped but unitary structure. The cylindrical or vase shapes of the base recur as late as 1947, and the concept of free forms resting on a receptacle shape reappears then as well as throughout the intervening years.

The most interesting part of *To Be Lost in the Woods* is the cluster of three interlocked organic shapes at the top. The artist here introduces sculptural forms in the round that, although abstract, nevertheless are reminiscent of identifiable portions of human anatomy. In the hands of Arp's followers, the biomorphic sculptural form developed into a major tradition in twentieth-century art. The forms were derived from those in *Head with Three Annoying Objects,* but are now generalized into humanoid abstractions.

To these shapes Arp applied the name "human concretion," a title that had a double significance for him (fig. 543). In 1930 Theo van Doesburg had proposed the name "concrete art" as a more accurate description for abstract art. He contended that the term "abstract" implied a taking away from, a diminution of, natural forms and therefore a degree of denigration. What could be

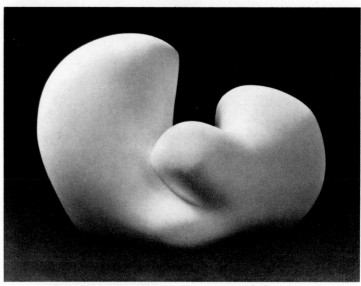

543. JEAN ARP. *Human Concretion.* 1949.
Cast stone (after original plaster of 1935), height 19½″.
The Museum of Modern Art, New York.
Gift of the Advisory Committee

544. JEAN ARP. *Torso*. 1953. Marble, height 32½".
Smith College Museum of Art, Northampton, Massachusetts.
Gift of Mr. and Mrs. Ralph F. Colin, 1956

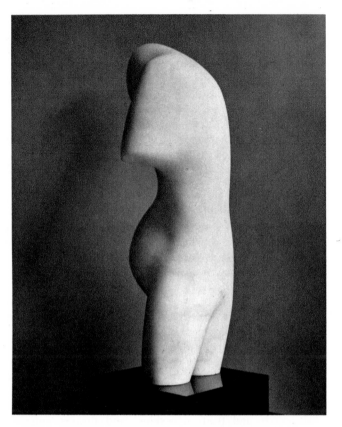

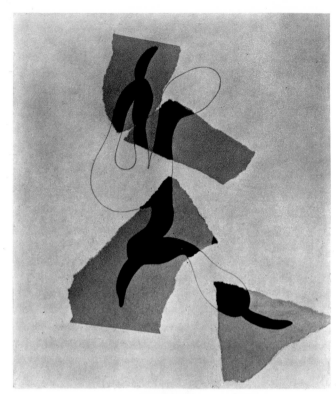

546. JEAN ARP. *Composition*. 1937.
Collage of torn paper, india ink wash, and pencil, 11¾ x 9".
The Philadelphia Museum of Art. A. E. Gallatin Collection

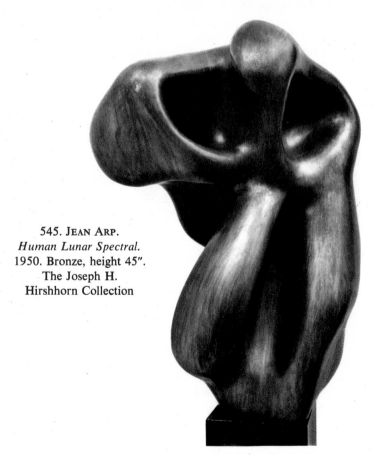

545. JEAN ARP.
*Human Lunar Spectral.*
1950. Bronze, height 45".
The Joseph H.
Hirshhorn Collection

work, the suggestion of metamorphosis is particularly striking. The artist tells us it may be displayed horizontally or vertically: vertically it is a female nude, horizontally, a finny monster. Since Arp's work is rarely over lifesize, *Human Lunar Spectral,* 1950 (fig. 545), is one of his more monumental pieces. It is also one of his strangest, combining human organisms, the valleys of the moon, and a presence that changes in various lights from man to moon to ghost. In this complex work are combined multiple suggested subjects with spatial organization in the round.

While developing his freestanding sculpture Arp continued to make reliefs and collages: besides painted reliefs, he experimented with natural woods, stone, and bronze, in regular, loosely geometric, or free forms. His collages of the 1930s (fig. 546) were a catharsis from the immaculateness of the sculptures. The change in his approach to collages was described by Arp: "The search for an unattainable perfection, the delusions that a work could be completely finished, became a torment. I cut the papers for my collages with extreme precision and smoothed them down with a special sandpaper. . . . The tiniest crack in a bit of paper often led me to destroy a whole collage. . . . The word 'perfection' means not only the fullness of life but also its end, its completion, its finish; the word 'accident' implies not only chance, fortuitous combination, but also what happens to us, what befalls us. . . . I began to tear my papers instead of cutting them neatly with scissors. I tore up drawings and carelessly smeared paste over and under them. If the ink

dissolved and ran, I was delighted. . . . I had accepted the transience, the dribbling away, the brevity, the impermanence, the fading, the withering, the spookishness of our existence. . . . These torn pictures, these *papiers déchirés* brought me closer to a faith other than earthly. . . ." Many of these torn-paper collages found their way to the United States and offered a link between organic surrealism and American abstract expressionism.

## MAX ERNST AFTER 1920

The career of Max Ernst as a painter and sculptor, interrupted by four years in the German army, may be said really to have begun when he moved to Paris in 1922. *The Elephant of the Celebes* (see fig. 134) was the chief painting of his pre-Paris period, although Ernst had produced other works of considerable interest, including paintings and drawings of machine monsters such as *Two Ambiguous Figures,* 1919 (fig. 547), inspired by Picabia. Aside from these, his dada collages were of first importance.

Historically, one of his most notable paintings was the group portrait of Paris dadaists, incipient surrealists, and earlier artists, set in a lunar landscape (*The Rendezvous of the Friends*, 1922, fig. 548). The identities are given in the picture caption, but we may note here that Ernst transforms De Chirico into a classical herm because of his recent defection to classicism; Raphael Sanzio peers out of the background; and Ernst himself sits on Dostoevsky's knee.

The manner of *The Elephant of the Celebes*, derived principally from De Chirico's early style, continues in *Pietà or Revolution by Night,* 1923 (fig. 549), presenting a kneeling bourgeois, bowler-hatted and heavily mustached, who holds in his arms a youthful figure with a classical head not unlike Ernst's own. The middle-aged

547. MAX ERNST. *Two Ambiguous Figures.* 1919. Collage with gouache and pencil, 9½ x 6½". Succession Arp

548. MAX ERNST. *The Rendezvous of the Friends.* 1922. 50⅜ x 76⅜". Collection Dr. Lydia Bau, Hamburg. *Standing, from left:* Philippe Soupault, Jean Arp, Max Morise, Raphael Sanzio, Paul Eluard, Louis Aragon, André Breton, Baargeld, Giorgio de Chirico, Gala Eluard, Robert Desnos. *Seated, from left:* René Crevel, Max Ernst, Feodor Dostoevsky, Théodore Fraenkel, Jean Paulhan, Benjamin Péret

above: 549. MAX ERNST. *Pietà or Revolution by Night.*
1923. 45⅝ x 35". Collection Sir Roland Penrose, London

below: 550. MAX ERNST.
*Two Children Are Threatened by a Nightingale.* 1924.
Oil on wood with wood construction, 18 x 13".
The Museum of Modern Art, New York

below right: 551. MAX ERNST. *The Horde.*
1927. 44⅞ x 57½". Stedelijk Museum, Amsterdam

bourgeois is reminiscent of the father figure in De Chirico's painting *The Child's Brain* (see fig. 460), which might almost be an illustration of some Freudian text on parental domination.

The last painting in this series, the artist tells us, was *Two Children Are Threatened by a Nightingale,* 1924 (fig. 550), a dream landscape with small figures, executed in unbelievably garish color. The fantasy is given peculiar emphasis by the elements in actual relief—the house on the right and the open gate on the left. Even the heavy, traditional frame introduces an oppressive note. Contrary to Ernst's usual sequence, the title of this painting came first. In his biographical summary, speaking in the third person, he noted: " . . . He never imposes a title on a painting. He waits until a title imposes itself. Here, however, the title existed *before* the picture was painted. A few days before, he had written a prose poem which began: *à la tombée de la nuit, à la lisière de la ville, deux enfants sont menacés par un rossignol . . . .* He did not attempt to illustrate this poem, but that is the way it happened."

In 1925, Ernst began to make drawings that he termed *frottage,* or rubbing, in which he used the child's technique of placing a piece of paper on a textured surface and rubbing over it with a pencil. The resulting image was largely a consequence of the laws of chance; the transposed textures were then reorganized in new contexts, and new and unforeseen associations were aroused. Not only did frottage provide the technical basis for a series of unorthodox drawings; it also intensified Ernst's perception of the textures in his environment—wood, cloth, leaves, plaster, and wallpaper. This perception caused his paintings of the late 1920s and the 1930s to take on an expressionist appearance, one that recalls his devotion to Late Gothic art and to the lush fantasies of nineteenth-century romantics such as Böcklin or Moreau (*The Horde,* 1927, fig. 551; and *Europe After the Rain,* 1940–42, fig. 552). This was to be Ernst's most consist-

ent direction for some twenty years, although concurrently he also explored a dozen other avenues that ranged from dissolving, curvilinear figure groups reminiscent of Picasso to isolated, precisely modeled birds in the manner of Magritte. His passion for birds, docile or menacing, was stated in particularly gruesome symbolism in *Surrealism and Painting,* 1942 (fig. 553), showing a monstrous beast made of smoothly rounded sections of human anatomy, serpents, and birds' heads. The monster is daintily making an abstract drawing. Possibly the work reflects something of the continuing warfare between surrealism and abstraction. The interest in geometry, which Ernst satirized in this and other paintings, has nevertheless reappeared in his work of the 1950s and 1960s; he explores minute crystalline structures and vast constellations in space to create a universe simultaneously visible in microscope and telescope (*Mundus Est Fabula,* 1959, fig. 554).

Though Max Ernst has had unquestionable significance in the general course of twentieth-century painting since World War I, and despite his undeniably great talents, he remains an eclectic. His brilliant adaptations are haunted by reminiscences of the art he has admired and artists he has worked with. These include Late Gothic artists and nineteenth-century romantics as well as De Chirico, Picasso, Picabia, Klee, Magritte, Tanguy, Dali,

554. MAX ERNST. *Mundus Est Fabula.* 1959. 51¼ x 64".
The Museum of Modern Art, New York. Gift of the Artist

555. MAX ERNST. *Soliloquy.* 1965. Collage on
plywood, 45⅝ x 39⅜". Collection the Artist

and the younger surrealist Matta Echaurren. Certain of
Ernst's recent assemblages suggest an elegant assimila-
tion of his earliest collages to current pop art. Some of
these influences were reciprocal in the close-knit world
of the surrealists; and it must be noted that no one en-
compasses so completely the whole of surrealism—with
the exception of the abstract-organic wing of Arp and
Miró. Within Ernst's considerable achievement as a
painter, it is the early collages and photomontages that
today seem most fresh and individual (fig. 555). Since
the early 1930s, Ernst has increasingly turned to sculp-
ture, which will be discussed later.

## JOAN MIRO *(b. 1893)*

A Catalan born at Montroig near Barcelona, Joan
Miró is one of the greatest talents of surrealism and a
master of twentieth-century painting. Although he lived
for many years in Paris, he has constantly returned to his
native country. In art schools in Barcelona he was intro-
duced to French romantic and realist art and then to the
impressionists and post-impressionists. His first indepen-
dent paintings, 1916–18, show that Cézanne and Van
Gogh affected him most. In *Portrait of E. C. Ricart,*
1917 (fig. 556), a heavy linear, coloristic pattern of
head and pajama coat are used to modify a Van Gogh
portrait. The lines and colors suggest influences from the
fauves and perhaps Chagall. The figure has an overpow-
ering presence, made even stronger by the delicate Japa-
nese print pasted on the canvas (Van Gogh had *painted*
a Japanese print on *his* portrait).

Miró was also painting landscapes of his beloved Cat-
alonia, interpreted either with extremely delicate color

and linear movement, or in a cubist vein. The con-
temporary artists whom Miró was beginning to admire
were Matisse and a fellow Spaniard, Picasso. *Montroig
(The Olive Grove),* 1919 (colorplate 148), is organized
in a frontalized, geometric pattern derived from cubism,
and also recalls the naïve vision of Rousseau, whom
Miró admired. From Matisse he learned how large areas
of color and pattern could flatten and control his picture
plane. *Nude with Mirror,* 1919 (fig. 557), combines
cubist faceting, flat-color areas, and geometric pattern
with a sculptural figure: the result is both serious and
ludicrous. It is a combination that pervades Miró's art—
scenes of wild humor and fantasy presented in a deadpan
manner as seemingly humorless and attentively detailed
as Rousseau's.

Miró had become acquainted with the works of the
leading avant-garde artists of Paris through reproductions
and exhibitions in Barcelona. On his first visit to Paris,
in 1919, he was warmly received by Picasso, met the
leaders of French art and, perhaps through Picasso, be-
came utterly fascinated with Rousseau's painting. The
crowning work of this period of geometric, primitive
realism is *The Farm,* 1921–22, a fascinating conglomera-
tion of meticulous details arranged with mathematical
precision, yet with the final effect of a magical world.

Spending winters in Paris and summers in Montroig,
the artist continued until 1924 to paint in this vein of
geometric, primitive realism. In a group of paintings of
1923–24, he moved into the realm of fantasy, formulat-
ing his vocabulary of the marvelous—almost a new lan-
guage of twentieth-century art. Miró had admired Pica-
bia's machine fantasies in Barcelona in 1917; during his
first Paris years he had naturally been drawn to the da-

daists; Klee's work enchanted him; and he was particularly friendly with Breton and the other poets who soon launched the surrealist revolution. Although these factors of environment may explain Miró's desire to enter the world of fantasy and delight; and although a natural inclination to fantasy was evident in his earlier works; these do not yet explain his authoritative creation of this unique world at one stroke. *Catalan Landscape (The Hunter),* 1923–24 (colorplate 149), begun before the surrealist manifesto was published, is one of the first examples of Miró's wonderful world. It is difficult to explain so sudden a transition, and the individuality of the fanciful new style. Among the dadaists the only analogy was Jean Arp's biomorphic abstractions. The relationship of Miró and Arp is close, however, and is based largely on their common love of organic shapes and their somewhat similar humor. At a more distant remove one is sometimes reminded of Hieronymus Bosch.

The fantasy in *Catalan Landscape* is remote but vivid: in the landscape, two planes of yellow and orange meet in a curving line; hunter and quarry are rendered in geometric lines and shapes; scattered over the ground are weird objects, some recognizable, some suggesting marine or microscopic life. *Harlequin's Carnival,* 1924–25 (colorplate 150), one of the first surrealist pictures, takes place within the suggested confines of a room; the perspective

557. JOAN MIRO. *Nude with Mirror.*
1919. 44 x 40".
Collection Mr. and Mrs. Pierre Matisse, New York

556. JOAN MIRO. *Portrait of E. C. Ricart.*
1917. Oil and pasted paper on canvas,
32¼ x 25⅞". Mrs. Florene May Schoenborn
and Samuel Marx Collection, New York

558. JOAN MIRO. *Person Throwing a Stone at a Bird.* 1926.
29 x 36¼". The Museum of Modern Art, New York

of the window opening on the night gives an odd inversion of space. A wild party rages inside; only the human being is lugubrious, an elegantly mustached man with a long-stemmed pipe, staring sadly at the spectator. Surrounding him is every sort of animal, beastie, or organism, all having a fine time. There is no specific symbolism; a brilliant, fantastic imagination has been given full rein. Certain favorite motifs recur in a number of paintings—

the ladder with the ubiquitous ear, the eye, the man with the pipe, the arrow-bird—but the salient points of Miró's art are not iconographical or structural. One element is fantastic humor, of which he, Klee, Arp and, slightly later, Alexander Calder are the modern masters. The other salient point is the vividness of Miró's unreal

world. His organisms and animals, even his inanimate objects, have an eager vitality that makes them more real to us than the crowds we pass daily.

Miró's career has been so prolific, so consistent yet so diversified, that it is difficult to trace in a general account. In the mid-1920s he explored different aspects of his new world, from the complexity of *Harlequin's Carnival* to the magic simplicity of *Dog Barking at the Moon*, 1926 (colorplate 151), and *Person Throwing a Stone at a Bird*, 1926 (fig. 558). In 1928 he visited Holland; inspired by the Dutch little masters, he produced a series entitled Dutch Interiors, that exemplify the metamorphosis from reality to fantasy. Starting from Jan Steen's (1626–1679) painting, *The Cat's Dancing Lesson* (fig. 559), Miró transformed it into *Dutch Interior II,* 1928 (colorplate 152), a vivid phantasmagoria of amorphous shapes floating in ambiguous space. Most of Steen's original figures and objects have been retained, and it is fascinating to see how they have been interpreted. The figure peering in the window has become a sort of ghostly emanation. The enclosure of Miró's group within the roughly oval ribbons of color which end in an arrowhead and a little monster, seems to have been inspired by Steen's tightly knit figure composition.

In the late 1920s and early 1930s Miró began to experiment with collage and assemblage, and to create the monster figures which he continued for another decade. Most impressive was the group of large paintings of 1933, his most abstract up to then. A number were based on collage elements, realistic details torn from newspapers and pasted on cardboard. The motifs—tools, furniture, dishes, and glassware—suggested to him abstract-organic shapes, sometimes with implied faces or figures. The predominantly abstract intent of these paintings is indicated by their neutral titles. *Painting,* 1933 (colorplate 153), is most completely non-figurative, and most impressive in its shadowed color, soft greens, blues, and graded tones of brown. On this background of atmospheric color float abstract-organic shapes, predominantly black; one is outlined in white, two have white areas, one a vivid red, others are merely black outlines. In contrast with Miró's paintings of the 1920s this work has serenity and mystery, and its color shapes are perhaps closest to those of Arp.

After this quiet and abstract interval, Miró continued his savage paintings; *Nursery Decoration,* 1938 (colorplate 154), is the largest. Although violent—black and red monsters on a ground predominantly brilliant blue—the beasts are not particularly alarming. One feels the artist's affection for even the fiercest creatures of his imagination. More disturbing is *Still Life with Old Shoe,* 1937 (fig. 560), displaying the deep reaction of this non-political artist against the fascists in the Spanish civil war. Picasso painted his great denunciation, *Guernica,* for the Spanish Pavilion at the Paris exposition that year. The imagery of *Still Life with Old Shoe* is explicit—the old shoe, the gin bottle, the fork plunged into the apple, the loaf of bread whose cut end becomes a skull—all disposed in an indeterminate space—with revolting color and black and sinister shapes. Again, this is not specific symbolism: the work reflects Miró's revulsion for events in his beloved Spain, and he expresses it in objects, col-

559. JAN STEEN. *The Cat's Dancing Lesson.* 17th century. Oil on panel, 23⅞ x 23¼". Rijksmuseum, Amsterdam

560. JOAN MIRO. *Still Life with Old Shoe.* 1937. 32 x 46". Collection James Thrall Soby, New Canaan, Connecticut

561. JOAN MIRO. *Self-Portrait*. 1937–38.
Pencil, crayon, and oil on canvas, 57½ x 38¼".
Collection James Thrall Soby, New Canaan, Connecticut

and was better known than almost any contemporary European master except Picasso and Matisse. As the leader of the organic-abstract wing of surrealism, he had an incalculable impact on younger American painters, then seeking their way out of the morass of social realism and regionalism (see p. 428).

By the end of World War II, Miró was working on a large scale, with passages of heavy paint or luminous, atmospheric color. *Painting*, 1953 (colorplate 155), is bold in shapes, patterns, and colors. On the varied ground the artist constructed objects, signs, and figures with rough, heavy brush strokes and intense color. He also began to work with the ceramist José Artigas, creating pottery, ceramic sculpture, and finally ceramic-tile murals of great strength. Miró's most recent monumental commission up to the present consists of two ceramic murals for UNESCO Headquarters entitled *Night* and *Day* (colorplate 156). The scale of the walls and the rough surface of the ceramic tiles inspired deep colors and simple, monumental shapes. Miró and Artigas organized the design on the walls with scrupulous care in relation to the architecture of the buildings. Miró said, "I sought a brutal expression in the large wall, a more poetic one in the smaller. Within each composition I sought at the same time a contrast by opposing to the black, ferocious and dynamic drawing, calm colored forms, flat or in squares." The artists looked back to the prehistoric paintings at Altamira in Spain, to the stone walls of Spanish Romanesque churches, Spanish Romanesque paintings, and to details of Gaudí's Park Güell in Barcelona. Other notable ceramic mural commissions have followed, including the ceramic wall for Harvard University (1960), which duplicated and replaced an earlier painting; and a ceramic mural for the Guggen-

562. JOAN MIRO. *The Poetess*. 1940.
Gouache on paper, 15 x 18".
Collection Mr. and Mrs. Ralph F. Colin, New York

ors, and shapes that convey decay, disease, and death. From this time comes Miró's self-portrait, a drawing in which his staring eyes and pursed lips reflect his obsession with the macabre (fig. 561). The harsh draftsmanship and hypnotic frontality mark a reversion to his early style.

With the outbreak of World War II, Miró settled permanently in Palma de Mallorca. The isolation of the war years and the need for contemplation and revaluation led him to read mystical literature and to listen to the music of Mozart and Bach. Until 1942 he worked on the small gouaches entitled Constellations, which are among his most intricate and lyrical compositions. These works recapture the delicate beauty and gaiety of his paintings of the 1920s, but the artist was now concerned with ideas of flight and transformation as he contemplated the migration of birds, the seasonal renewal of butterfly hordes, the flow of constellations and galaxies (*The Poetess*, 1940, fig. 562). These Constellations were shown at the Pierre Matisse Gallery, New York, in 1945 and affected the emerging American abstract expressionist painters. Miró had been shown in New York regularly from 1930,

563. JOAN MIRO. *The Red Disk*. 1960. 64⅛ x 51⅝″.
Collection Victor K. Kiam, New York

heim Museum (1967). In Miró's work of the 1960s the
freshness is in no way diminished. *The Red Disk,* 1960
(fig. 563), shows his interest in the American abstract
expressionists who earlier were influenced by him; but
the sense of subject continues: it suggests a cosmic ex-
plosion of planets or suns. The mural-sized painting *Blue
II,* 1961 (colorplate 157), is an almost pure example
of color-field painting—a great blue ground with a row
of brightly colored oval shapes creeping across micro-
organisms in an emulsion.

## Surrealism in the 1930s

From its inception, surrealism in painting took two di-
rections. The first, represented by Miró, André Masson
and later, Matta, is sometimes called organic surreal-
ism, or emblematic, biomorphic, or even absolute sur-
realism. In this tendency automatism, "dictation of
thought without control of the mind," is predominant,
and the results are generally close to abstraction, al-
though some degree of imagery is normally present. The
origins of this wing were in the experiments in chance
and automatism carried on by the dadaists and, earlier,
by certain futurists; the effects, particularly those sought
by Masson, were close to and influenced by the auto-
matic writing of surrealist poets.

The other direction in surrealist painting is associated
with Pierre Roy, Salvador Dali, Yves Tanguy, René Ma-
gritte, and Paul Delvaux. It presents, in meticulous de-
tail, recognizable scenes and objects which are taken out
of natural context, distorted and combined in fantastic
ways as they might be in dreams; its sources are in the

art of Henri Rousseau, Chagall, Ensor, De Chirico, and
nineteenth-century romantics. This wing, called super-
realism or naturalistic surrealism, attempts to use the
images of the subconscious, defined by Freud as uncon-
trolled by conscious reason (although Dali, in his para-
noiac-critical method, claims to have control over his
subconscious). Freud's theories of the subconscious and
of the significance of dreams were, of course, fundamen-
tal to all aspects of surrealism.

No hard-and-fast line can be drawn between the two
wings. Artists such as Max Ernst, Kurt Seligmann, and
Victor Brauner attempted all variations of surrealist ex-
periment at different times. Even Masson turned to a nat-
uralistic form of surrealism in the late 1930s. Picasso, as
might be expected, created a surrealist style of his own.
The division between the two wings is apparent, but no
precise classification is necessary for such artists as Pi-
casso, Miró, and Arp.

Out of the organic surrealism of Miró and Masson,
and the concepts of automatism and intuitive painting,
have emerged many creative directions of abstract
expressionism and other abstract styles in the later twen-
tieth century. Out of the naturalistic surrealism, aside
from variations on the same theme in the styles of a
number of younger exponents, have come certain forms
of magic (or precise) realism (see p. 368), on the one
hand, and romantic fantasy, on the other. But to the pop-
ular imagination it was the naturalistic surrealism asso-

564. PABLO PICASSO. *Minotaure*
(design for a magazine cover). 1933.
Pencil drawing with pasted papers and cloth tacked on wood,
19⅛ x 16⅛″. Private collection, New York

ciated with Dali, Tanguy, Roy, and others of that group that signified surrealism, even though it has had less influence historically than the organic surrealism of Miró, Masson, and Matta.

It should be remembered that surrealism was a revolutionary movement not only in literature and art, but also in politics. The periodical founded by Breton in 1925 as the voice of surrealism was named *La Révolution Surréaliste,* and it maintained a steady communist line during the 1920s. The dadaists at the end of the war were anarchists; and many future surrealists joined them. Feeling that governmental systems guided by tradition and reason had led mankind into the bloodiest holocaust in history, they insisted that non-government was better, that the irrational was preferable to the rational in art, and in all of life and civilization. The Russian revolution and the spread of communism provided a channel for surrealist protests during the 1920s. Louis Aragon, and later, Paul Eluard joined the communist party; Breton, after exposure to the reactionary bias of Soviet communism or Stalinism in art and literature, took a position closer to Trotskyism in the late 1930s. Writers were more active than painters in revolutionary propaganda, although Picasso in the 1930s became a communist in bitter protest against the fascism of Franco, and has maintained this position. Although schisms were occurring among the original surrealists by 1930, new artists and poets were joining and surrealism was spreading throughout the world. Salvador Dali joined in 1929, the sculptor Alberto Giacometti in 1931, Victor Brauner in 1932, Wolfgang Paalen in 1935. Other artists included Paul Delvaux, Henry Moore, Hans Bellmer, Oskar Dominguez, Kurt Seligmann, Roland Penrose, and Matta Echaurren. The list of writers was considerably longer. Surrealist groups and exhibitions were organized in England, Czechoslovakia, Belgium, Egypt, Denmark, Japan, Holland, Rumania, and Hungary. Despite this substantial expansion, internecine warfare resulted in continual resignations, dismissals, and reconciliations. Also, artists such as Picasso were adopted by the surrealists without joining officially.

During the 1930s the major publication of the surrealists was the lavish journal *Minotaure,* founded in 1933 by Albert Skira and E. Tériade. Although emphasizing the role of the surrealists, the editors drew into their orbit any of the established masters of modern art and letters who they felt had made contributions. These included artists as diverse as Matisse, Kandinsky, Laurens, and Derain. Picasso made the cover design for the first issue, a collage having in its center a classical drawing of a minotaur holding a short sword (fig. 564). His association with the journal may have fostered his interest in the beast.

## ANDRE MASSON *(b. 1896)*

Among the first surrealist artists, André Masson was the most passionate revolutionary, a man of violent convictions who had been deeply scarred, spiritually even more than physically, by his war experiences. Wounded almost to the point of death, he was long hospitalized. After partially recovering, his rages against the insanity

565. ANDRE MASSON. *Wreath.* 1925.
36¼ x 29½". Private collection, Paris

of man and society led to his confinement for a while in a mental hospital. Masson was by nature an anarchist, his convictions fortified by his experiences; his belief that the rational must be dominated by the irrational did not come by any rational process.

His paintings of the early 1920s were influenced by cubism, particularly that of Juan Gris, and he kept the structure and space of cubism in his early experiments with automatism and expressionist fantasies, as in *Wreath,* 1925 (fig. 565). In that year he was regularly contributing automatic drawings to *La Révolution Surréaliste;* these works directly express his emotions and contain various images having to do with the sadism of man and the brutality of all living things, down to fishes and insects. Scenes of massacres abound (*Battle of Fishes,* 1927, fig. 566). Accompanying this bitter pessimism is a passionate hope, through painting, to be able to find and express the mysterious unity of the universe hinted at in primitive myths and religions.

In the late 1930s, after living principally in Spain for two years, Masson temporarily turned to the other, naturalistic, wing of surrealism; he painted monstrous, recognizable figures in a manner influenced by Picasso and possibly Dali (*Labyrinth,* 1938, fig. 567). With the coming of World War II, he moved to the United States and exhibited regularly in New York, exercising influence on some of the younger American painters. In New York he reverted to a somewhat automatist, expressionist approach in works such as *Pasiphaë,* 1943 (colorplate

right:
566. ANDRE MASSON.
*Battle of Fishes.* 1927.
Oil, sand, and pencil
on canvas, 14¼ x 28¾".
The Museum of Modern Art,
New York

below:
567. ANDRE MASSON.
*The Labyrinth.* 1938.
47¼ x 24".
Galerie Louise Leiris,
Paris

158). Masson, after his return to France in 1945, sought tranquility in a new approach to expressionism. In the 1960s he turned to an abstract surrealism or expressionism that suggests a reverse influence from abstract expressionism.

Despite the violence and integrity of his emotional response and his historical significance in linking European surrealism and American abstract expressionism, Masson must be considered a talented eclectic whose major personal contribution was made in the 1920s.

### YVES TANGUY *(1900–1955)*

Tanguy had literary interests and close associations with the surrealist writers Jacques Prévert and Marcel Duhamel in Paris after 1922, but he was instinctively drawn to painting as his personal means of expression. With his friend Prévert he discovered the writings of Lautréamont and other prophets of surrealism. At the same time, despite a complete lack of training, he was making sketches for his own amusement and in 1923, inspired by a De Chirico painting in the window of the dealer Paul Guillaume, he began to paint in earnest. Until 1926 he painted assiduously in a naïve manner, and then just as assiduously destroyed the canvases. After meeting André Breton, he began contributing to *La Révolution Surréaliste* and was adopted into the surrealist movement. Suddenly, in *The Storm*, 1926 (fig. 568), a personal manner emerged, having the mystery of ocean depths, a luminescent darkness in which float manifestations of primordial life. Tanguy's subsequent progress was incredible, in both technique and fantastic imagination. *Mama, Papa Is Wounded!*, 1927 (colorplate 159), was the masterpiece of this first stage and exhibited all the obsessions that were to haunt him for the rest of his career. The first of these was an infinite perspective depth, rendered simply by graded color and a sharp horizon line—a space which combines vast emptiness and intimate enclosure where ambiguous little organic shapes are floating, isolated but at home. The fantasy of

this untrained artist so perfectly expressed the surrealist credo that he himself almost seems a product of Breton's imagination.

The submarine, or subterranean, atmosphere of these first surrealist paintings continued until 1930, in works filled with a romantic atmosphere of the hidden worlds of the microscope. After making a visit to Africa in 1930 and 1931, where he saw brilliant light and color, Tanguy began to define his forms precisely and expose them to a cruel sunlight. The space in his paintings during the 1930s became vast; earth merges imperceptibly with sky at an indefinable distance. *The Furniture of Time,* 1939 (fig. 569), offers no points of reference for measuring the space in which the curious objects drift aimlessly and uneasily. The objects are hard, mineral, or bonelike, yet they seem animated by some vestigial life from a destroyed universe. It is as though the artist had some premonition of the fears that would later haunt the world in the first and perhaps the last age of the atomic bomb.

Having arrived at his particular vision, Tanguy's art changed only in degree, not in kind. After moving to the United States in 1939 and settling in Woodbury, Connecticut, with his wife, the American surrealist painter Kay Sage, he continued to evoke his barren, destroyed universe. In *Slowly Toward the North,* 1942 (fig. 570), the world darkens, but the objects loom larger, joined now by geometric constructions that suggest a new birth of machines. In *Indefinite Divisibility,* 1942 (fig.

569. YVES TANGUY. *The Furniture of Time.*
1939. 45¾ x 35″.
Collection James Thrall Soby, New Canaan, Connecticut

570. YVES TANGUY. *Slowly Toward the North.* 1942.
42 x 36″. The Museum of Modern Art, New York.
Gift of Philip C. Johnson

568. YVES TANGUY. *The Storm.* 1926.
32 x 25¾″. The Philadelphia Museum of Art.
Louise and Walter Arensberg Collection

571. YVES TANGUY. *Indefinite Divisibility.*
1942. 40 x 35".
The Albright-Knox Art Gallery, Buffalo, New York

571), the bone objects themselves form complex structures, as though building their own skeletons. The space continues to be indefinite, permeated with a curious gray light. The long black shadows seem thrown by some newborn sun. In his last painting, *Multiplication of the Arcs*, 1954 (colorplate 160), the objects fill the ground area back to a newly established horizon line. Some form of life—animal? vegetable? mineral?—seems to have reconquered the devastated cosmos.

There is a hypnotic pattern about Tanguy's paintings; once he had established his image in 1926, he varied it only after careful deliberation. He had only one real image: a desolate universe in which some primitive life struggles to survive. This limitation produced one of the most pertinent and prophetic concepts in modern art.

### SALVADOR DALI (b. 1904)

The artist who above all others symbolizes surrealism in the mind of the general public is the Spaniard Salvador Dali. Not only his paintings, but his writings, his utterances, his actions, his appearance, his mustache, his genius for publicity—with all of these he has made the word surrealism a common noun in all languages, denoting an art that is irrational, erotic, insane—and fashionable. Dali's life itself has itself been so completely surrealist that his integrity and his pictorial accomplishment have been questioned, most bitterly by other surrealists. The primary evidence must be the paintings themselves, and no one can deny the immense

talent, the power of imagination, or the intense conviction that they display.

Dali was born at Figueras, near Barcelona; like Picasso, Miró and, before them, Gaudí, he is a product of the Catalan environment. A substantial part of the iconography of Dali, real or imagined, is obviously taken from scenes of his childhood and adolescence. The landscape of these early years is constantly in his paintings, which are marked by the violence of his temperament—ecstatic, filled with fantasy, terror, and megalomania. Barcelona at the end of World War I was influenced by Italian and French art, and Dali encountered, successively, impressionism, pointillism, and futurism, before he went to the Academy of Fine Arts, Madrid, in 1921. He followed the normal academic training, developing a highly significant passion for nineteenth-century academicians and romantics such as Jean Millet, Arnold Böcklin, and particularly the meticulous narrative painter Ernest Meissonier. His discoveries in modern painting during the early 1920s were De Chirico, Carrà, and the Italian metaphysical school, whose works were reproduced in the periodical *Valori Plastici*. More important for his development was the discovery of Freud, whose writings on dreams and the subconscious seemed to answer the torments and erotic fantasies he had suffered since childhood. His friendship with the Spanish poet Federico García Lorca, who frequently expressed his dreams and fantasies through drawings of exquisite, romantic sensibility, may have led Dali to the opposite extreme of attempting to create, through precise *trompe-l'oeil* technique, a dream world more tangibly real than observed nature. Between 1925 and 1927 he explored several styles: the cubism of Picasso and Juan Gris, the neo-classicism of Picasso, and a precise realism derived from Vermeer.

In 1928 he visited Paris and met the surrealists; in 1929 he moved there, to become an official member of the group; in that same year he married Gala Eluard, formerly the wife of the surrealist writer Paul Eluard. He had by now formulated the theoretical basis of his painting, described as paranoiac-critical: the creation of a visionary reality from elements of visions, dreams, memories, and psychological or pathological distortions.

Out of his academic training and his admiration for such masters as Vermeer and Meissonier, he developed an incredibly precise miniature technique, accompanying with a particularly disagreeable, discordant, but luminous color derived from the romantic realists and tinted photographs (he has referred to his paintings as "hand-painted photographs"). He frequently used familiar objects as a point of departure—Millet's sentimental painting *The Angelus,* watches, insects, pianos, telephones, old prints or photographs—many having fetishist significance. He declared his primary images to be blood, decay, and excrement. From the commonplace object he set up a chain of metamorphoses gradually or suddenly dissolving and transforming the object into a nightmare image, given conviction by the hard realistic technique. In collaboration with Luis Bunuel, Dali turned to the cinema and produced two documents in the history of film fantasy, *Un Chien andalou*, 1928, and *L'Age d'or*, 1930. The cinema medium had infinite possibilities for the surrealists, in the creation of dissolves, metamor-

phoses, and double and quadruple images, and Dali made brilliant use of these.

In his first fantastic paintings he discarded all the influences of cubism, classicism, or impressionism and introduced the microscopic realism of his developed style. In paintings like *Blood Is Sweeter Than Honey,* 1927, characteristic images and symbols appear: the decaying donkey with a hovering horde of flies; unlimited perspective space accented by ranks of drawing pins; the mutilated statue or corpse; the fetal shape; the double image (the donkey has a ghostly *doppelgänger*). His style matured with amazing rapidity, and only about two years later, in 1929, he produced *Illumined Pleasures* (fig. 572) and *Accommodations of Desire* (colorplate 161). They were created after he joined the Paris surrealists and had been exposed to ideas of Ernst, Miró, and Tanguy. In the first of these paintings De Chirico's influence is evident: the picture within a picture, the looming shadows, the architecture. The vast space defined by the horizon may come from Tanguy, and the insert picture of cyclists riding endlessly nowhere is probably based on a photomontage by Ernst. The total effect, however, is unique in the pervasive, manic violence. *Accommodations of Desire* is a more individual work, with its repeated variations of the snarling lion's head in process of continuous transformation. It exemplifies the artist's determination to create a super-reality by ruthless objectification of the dream; and to paint like a madman—not in an occasional state of receptive somnambulism, but in a continuous frenzy of induced paranoia. In his book, *La Femme visible* (1930), Dali wrote, "I believe the moment is at hand when, by a paranoiac and active advance of the mind, it will be possible (simultaneously with automatism and other passive states) to systematize confusion and thus to help discredit completely the world of reality." By 1930 Dali had left De Chirico's generalized dream world for his own world of violence, blood, and

decay. He sought to create in his art a specific documentation of Freudian theories applied to his own inner world. He started a painting with the first image that came into his mind and went on from one association to the next, multiplying images of persecution of megalomania like a true paranoiac. He defined his paranoiac-critical method as a "spontaneous method of irrational knowledge based upon the interpretative-critical association of delirious phenomena."

Dali shared the surrealist antagonism to formalist art, from neo-impressionism to cubism and abstraction. *The Persistence of Memory,* 1931 (fig. 573), is a denial of every twentieth-century experiment in abstract organization. Its miniature technique goes back to the Flemish art of the fifteenth century; its sour greens and yellows, on the other hand, are reminiscent of nineteenth-century

chromo-lithographs. The space is as infinite as Tanguy's, but rendered with hard objectivity. The picture's fame comes largely from the presentation of recognizable objects in an unusual context, with unnatural attributes. The limp watches, in fact, have become a popular visual synonym for surrealist fantasy.

Dali's painting during the 1930s vacillated between an outrageous fantasy and a strange atmosphere of quiet achieved less obviously. *Gala and the Angelus of Millet Immediately Preceding the Arrival of the Conic Anamorphoses,* 1933 (colorplate 162), exemplifies the first aspect: in the back of a brilliantly lighted room is Gala, grinning broadly, as though snapped by an amateur photographer; in the front sits an enigmatic male. Over the open doorway is a print of Millet's *Angelus,* a sexual fetish for Dali. Around the open door a monstrous comic figure emerges from the shadow, wearing a lobster on his head. There is no rational explanation for the juxtaposition of familiar and phantasmagoric, but the nightmare is undeniable.

In another portrait of Gala, 1935 (fig. 574), nothing is distorted or overtly fantastic, yet the impact is greater. Gala sits in the immediate foreground with her back to the spectator, a somewhat matronly figure in a figured jacket; she also sits, a mirror image, facing herself, against the opposite wall. Behind her head is another version of Millet's *Angelus.* The two Galas sit on different seats, and there is no mirror. Dali has produced this

575. SALVADOR DALI. *The Crucifixion.* 1951. 80⅝ x 45⅝". Glasgow Art Gallery and Museum

574. SALVADOR DALI. *Portrait of Gala.* 1935. Oil on wood, 12¾ x 10½". The Museum of Modern Art, New York. Gift of Abby Aldrich Rockefeller

strangely moving painting by very simple means. The mirror image as an instrument of fantasy has intrigued other artists: it occurs in Van Eyck's portrait of Arnolfini and his wife in the fifteenth century, in Italian mannerist portraits by Parmigianino in the sixteenth, and in works by Vermeer (*The Artist in His Studio*) and Velázquez *(Las Meninas)* in the seventeenth. Baroque and Rococo stage designers were also fascinated by the visual implications of mirror images, and in the twentieth century, Picasso used the theme in his surrealist works of the 1920s, producing a masterpiece in 1932 with *Girl Before a Mirror* (see colorplate 170). Dali's version probably owes most to those of his idol, Vermeer—either *The Artist in His Studio* or, even closer, *The Letter.*

Another favorite theme, the double or hidden image, may be analyzed in Dali's *Inventions of the Monsters,* 1937 (colorplate 163). Starting from the lower left corner we have a series of joined profiles, including those of

Dali and Gala, leading to a sort of altar of Venus in the middle distance. In the empty space beyond there is another familiar symbol, the burning giraffe, and to the left a somewhat repulsive group bending in devotion and presenting massive buttocks to the spectator. The obsession with every form of sexual symbolism may be noted here and in other paintings of the 1930s (*Soft Construction with Boiled Beans: Premonition of Civil War,* 1936).

In 1941 came a transition in Dali's career: he announced his determination to "become classic," to return to the High Renaissance of Raphael. When he had met Sigmund Freud in London in 1938, shortly before the psychoanalyst's death, Freud commented, "What interests me in your art is not the unconscious but the conscious." Whether this remark was satiric or serious, it is pertinent in evaluating Dali's induced paranoia. In the late 1930s, the artist was moving away from surrealism toward both a Renaissance ideal classicism and the developing neo-romanticism of Christian Bérard, Eugène Berman, and Pavel Tchelitchew. Dali had already been expelled from the surrealist party in 1934 by André Breton (who spent much time expelling heretics and welcoming new converts).

In 1940 Dali moved to the United States. His notoriety and fashionable acceptance reached their height with designs for the theater, fashionable shops, periodicals, jewelry, and *objets d'art.* Since 1950 his principal works have been devoted to Christian religious art exalting the mystery of Christ and the Mass. Large examples now hang in the Glasgow Art Gallery and Museum (*The Crucifixion,* 1951, fig. 575), the National Gallery of Art, Washington, D. C. (*The Last Supper,* 1955), and New York's Metropolitan Museum of Art. Their contribution to the history of Christian art is open to question.

Despite the controversy surrounding Dali there remains the original contention: that he is an artist of immense talent and imagination. In translating the subjective world of dreams into objective and disturbing images, he made a serious contribution to surrealism and to the art of the twentieth century.

## RENE MAGRITTE *(1898–1967)*

In contrast to Dali, René Magritte has been called the invisible man among the surrealists. George Melly in the script for a BBC film on Magritte, wrote: "He is a secret agent; his object is to bring into disrepute the whole apparatus of bourgeois reality. Like all saboteurs, he avoids detection by dressing and behaving like everybody else" (see Bibliography). Thanks perhaps to his anonymity, his works have had gradual but overwhelming impact, like a glacial flow.

After years of sporadic study at the Brussels Academy of Fine Arts, Magritte, like Tanguy, was shocked into realizing his destiny when in 1922 he saw a reproduction of De Chirico's painting *The Song of Love,* done in 1914; in 1926 he emerged as an individual artist with a style based on that of De Chirico. In that year Magritte, with *The Menaced Assassin* (fig. 576), summarized the elements he was to use in a lifetime of paintings, their shock based equally on the strange, the erotic, and the or-

576. RENE MAGRITTE.
*The Menaced Assassin.*
1926. 59¼ x 77"
The Museum of Modern Art,
New York.
Kay Sage Tanguy Fund

577. RENE MARGITTE. *Man with Newspaper.*
1928. 45½ x 32". The Tate Gallery, London

*above:* 578. RENE MAGRITTE.
*The Treachery (or Perfidy) of Images.* 1928–29
23¼ x 31½". Private collection, New York

*right:* 579. RENE MAGRITTE. *The False Mirror.* 1928.
21¼ x 31⅞". The Museum of Modern Art, New York

dinary. The barren perspective space is derived from De Chirico and from the flimsy unreal stage sets of early cinema melodramas. The action partakes of these scenes; its horror is clearly synthetic and, in a strange reversal, so becomes more horrible. The murdered girl is a department-store mannequin whose nude body yields real blood; the assassin, listening soulfully to the gramophone, is a clothes model whose painted wax face is identical with those of the watchers at the back window and the detectives lurking in front. And Magritte himself is, simultaneously, the anonymous, unseen man in the bowler hat, the assassin, the saboteur, the watcher, the secret agent.

In that same year, 1926, Magritte joined other Belgian writers, musicians, and artists in an informal group comparable to the Paris surrealists. He then moved to a Paris suburb and participated for the next three years in surrealist affairs. Wearying of the frenetic, polemical atmosphere of Paris, he returned to Brussels in 1930 and lived there quietly for the rest of his life. Because he withdrew from the art centers of the world, Magritte's paintings did not receive the attention they deserve. With important exhibitions in Europe and the United States since World War II, climaxed by the retrospective at New York's Museum of Modern Art in 1965, his unique contribution to surrealism and the history of fantasy is now recognized.

Magritte's style of precise, magic realism changed little —except for temporary excursions into other manners —after 1926; and because he frequently returned to earlier subjects, it is difficult to establish the chronology of his undated works. *Man with Newspaper,* 1927 (fig. 577), shows four identical views of the window corner in a modest café—identical, that is, except that the man appears only in the first; in the other three he has vanished. That is all, yet the sense of melodrama is acute. Again one is reminded of the silent motion picture of the early 1920s, the four views suggesting four frames of the film. The setting has the insubstantial, barren look of early cinemas, and the next event in the drama might be the disappearance of the room itself. Magritte was fascinated by the unreality of early efforts in film realism; as a boy, he had delighted in "Fantomas," penny thriller mysteries. Drawing on these sources, he extracted their essence

580. RENE MAGRITTE. *The Promenades of Euclid.* 1955.
63½ x 51½". Alexander Iolas Gallery, New York

in front of a window. Through the window is a land-scape; the scene on the painted canvas exactly replaces that segment which it reproduces, carrying the problem of nature-illusion-painting into a fourth dimension. *The Promenades of Euclid,* 1955 (fig. 580), depicts a city-scape with a great avenue in abrupt perspective; the avenue becomes, visually, a triangle that reiterates the coni-cal shape of the adjacent tower. Thus the promenade becomes Euclidean. The Gothic tower recalls Magritte's Flemish antecedents in painting, the Van Eycks and Ro-gier van der Weyden, who also painted views through a window. But here it is the illusion and the illusion of a semblance—the painted picture as part of a painted pic-ture—that is so fascinating.

Magritte has explored aspects of the gruesome that sometimes verge on the revolting. The succinctly titled *Portrait* (fig. 581) is a still life of a succulent slice of ham accompanied by wine bottle, glass, knife, and fork, all drawn with the utmost precision. The table on which they rest is a vertical rectangle of dark gray. Out of the center of the slice of ham stares a human eye. It is diffi-cult to explain why this rather obvious juxtaposition

in his fantasies of the commonplace. To this offshoot of surrealism the name magic realism is given. Magic real-ism, which flourished in Europe and America in the 1930s and 1940s, is the precise, realistic presentation of an ordinary scene with no strange or monstrous distor-tion: the magic arises from the fantastic juxtaposition of elements or events that do not normally belong together. De Chirico's paintings might better be described as magic realist than surrealist; other surrealists have used devices of magic realism, but Magritte (with Pierre Roy) is the major master of the approach.

The perfect symbol (except that Magritte disliked at-tributions of specific symbolism) for his approach is the painting entitled *The Treachery (or Perfidy) of Images,* 1928–29 (fig. 578). It portrays a briar pipe so meticu-lously that it might serve as a tobacconist's trademark. Beneath, rendered with comparable precision, is the leg-end *Ceci n'est pas une pipe* (This is not a pipe). This de-lightful work confounds pictorial reality. A similar idea is embodied in *The False Mirror,* of 1928 (fig. 579): the eye as a false mirror when it views the white clouds and blue sky of nature. This might be another statement of the artist's faith; *The False Mirror* introduces the illu-sionistic theme of the landscape that is a painting, not na-ture. The problem of real space versus spatial illusion is as old as painting itself, but here it is imaginatively treated. Magritte's studies include many variations of the theme: the simplest shows an easel with a painted canvas

581. RENE MAGRITTE. *Portrait.* 1935.
28⅞ x 19⅞". The Museum of Modern Art, New York.
Gift of Mrs. Yves Tanguy

582. RENE MAGRITTE.
*The Castle of the Pyrenees.* 1959.
78⅝ x 55⅛″. Collection Harry Torczyner,
New York

should be so shocking. One is reminded of the little man in an early film who, served with a plate containing two fried eggs, screamed: "Take them away! They're staring at me!"

Much of Magritte's iconography was established early in the 1930s, but his variations have been infinitely ingenious. The horn and the chair hover as ghostly images over a seascape of 1928 (*Threatening Weather*). In *The Ladder of Fire,* 1933, flames leap from a pile of paper, a chair, and a tuba in a room. Fire is an important part in many paintings; so are birds, and great rocks that may float in the air (*The Castle of the Pyrenees,* 1959, fig. 582), or within a room, blocking the view into the landscape or seascape (*The Invisible World,* 1953–54). The claustrophobic effect of these works becomes explicit in paintings of a rose or an apple suddenly grown as in *Alice in Wonderland* to mammoth proportions and threatening to burst the walls (*The Listening Chamber,* 1953, fig. 583). The erotic element persists, as does the segmented nude, the segments neatly framed, or stacked like receptacles (*Delusions of Grandeur,* 1961, fig. 584). The classical tradition continues in macabre but somehow amusing variants (fig. 585) on David's *Madame Récamier* and Manet's *Balcony,* 1949, with elegant coffins substituted for the figures.

In certain pictures of the 1950s, Magritte calcified all the parts—figures, interiors, landscapes, objects—into a single rock texture. The basic forms and themes, however, continued the fantasy of the commonplace through the 1960s. A midnight street scene is surmounted with the blue sky and floating clouds of noon; jockeys race

583. RENE MAGRITTE. *The Listening Chamber.* 1953.
31½ x 39⅜″. Private collection, New York

584. RENE MAGRITTE. *Delusions of Grandeur.* 1961.
39⅜ x 31⅞″. Galerie Alexander Iolas, Paris

*left:*
585. RENE MAGRITTE.
*Perspective:*
*Madame Récamier of David.*
1951. 24½ x 32⅛"
Private collection

*below:*
586. HANS BELLMER. *Doll.*
1937. Wood, metal,
and papier-mâché.
Private collection

over cars and through rooms; or an elegant horsewoman passing through a forest is segmented by the trees. But Magritte's world always contains the unobtrusive, invisible man in bowler hat and black topcoat, singly and in groups, as in *Golconda,* 1953, where a swarm descends over the city.

HANS BELLMER *(b. 1902),*

VICTOR BRAUNER *(1903–1966),*

OSKAR DOMINGUEZ *(1906–1957),*

MERET OPPENHEIM *(b. 1913),*

WOLFGANG PAALEN *(1907–1959),*

KURT SELIGMANN *(1901–1962)*

Only brief mention can be made of the second wave of surrealists. Hans Bellmer came to Paris from Berlin with an assemblage called a *Doll* (fig. 586), a dismembered female mannequin whose separate parts were articulated and could be made to move and contort into erotic or painful postures. The sadism of this work recurs in drawings by Bellmer, a talented graphic artist with a gothic imagination. Victor Brauner, a Rumanian and a friend of Brancusi in Paris, achieved something of a sensation even among the surrealists when in 1934 he exhibited his paintings on the metamorphoses of Monsieur K.—*Force of Concentration of M.K.,* 1934, and *The Strange Case of Monsieur K.,* 1933. Monsieur K., a spiritual descendant of Alfred Jarry's Père Ubu, is presented as the personification of bestiality, in a constant state of transformation from one obscene role to another. Brauner's personal imagery evolved during and after the

war, in a tradition derived from ancient or primitive art, Egyptian or Pre-Columbian. From the modeled figures of his earlier style he had, since the war, moved to a system of flat pattern, although occasionally he reverted in paintings involving battles of monsters. A fascinating though not entirely characteristic painting is *The Meeting at 2 bis Rue Perrel,* 1946, in which one (or two?) phantasmagoric monsters, consisting of male and female bodies,

587. OSCAR DOMINGUEZ. *Peregrinations of Georges Hugnet.*
1935. Object, painted wood with manufactured toys,
15⅝ x 12½". Collection Georges Hugnet, Paris

588. OSCAR DOMINGUEZ. *Decalcomania.* 1936. Ink,
14⅛ x 11½". The Museum of Modern Art, New York

589. OSCAR DOMINGUEZ. *The Clown.* 1956.
31⅞ x 23⅝". Collection R. A. Augustinci, Paris

590. MERET OPPENHEIM. *Object.* 1936.
Fur-covered cup, 4⅜" diameter; saucer, 9⅜" diameter;
spoon 8" long. The Museum of Modern Art, New York

# Neo-Romanticism

Neo-romanticism and magic realism are two of the most clearly definable reactions related to surrealism in the 1930s. It is not quite correct to call these tendencies offsprings of surrealism, since they paralleled its development; in a larger sense, they were part of the manifold reaction against cubism and abstraction. It is difficult, however, to conceive of their ultimate concentration on effects of mystery and fantasy without the climate of surrealism.

Neo-romanticism involved four key figures: Christian Bérard (1902–1949); the brothers Eugène Berman (b. 1899) and Léonid Berman (b. 1896), who painted under the name of Léonid; and Pavel Tchelitchew (1898–1957). The Bermans and Tchelitchew were Russian by birth and lived for a period in the United States during and after the war. Bérard and Eugène Berman achieved distinction as theater designers, particularly for the Ballet Russe de Monte-Carlo. Berman and the other neo-romantics, in reaction both to abstraction and surrealism, sought lyrical qualities and the return to man, his emotions, and his immediate environment. Berman, in particular, has been fascinated continually by a ro-

591. KURT SELIGMANN. *Star Eater*. 1947.
46 x 35″. Collection Mrs. Ruth White, New York

three pairs of arms, and one huge head with great staring eyes, rests in an Henri Rousseau landscape, complete with ghostly moon and dark piper. Brauner pursued his own path, producing works of haunting fantasy.

Oskar Dominguez, a Spaniard, was noted for his assemblages of found objects. *Peregrinations of Georges Hugnet*, 1935 (fig. 587), is a construction from a toy bicycle and a toy pony. As Alfred H. Barr, Jr. notes, "M. Hugnet, the Surrealist poet, earned his living for a time by delivering (on a bicycle) the prizes used in slot machines." Dominguez also contributed to the surrealists the technique known as decalcomania: inks or watercolor paints are transferred from one sheet of paper to another under pressure (*Decalcomania*, 1936, fig. 588). The technique appealed to the surrealists (particularly Max Ernst, who experimented in liquid oil paints) for its startling automatic effects. Dominguez' last painting, *The Clown*, 1956 (fig. 589), executed the year before his suicide, illustrates his intricate and combined techniques and a sense of the ridiculous that survived to the end.

Meret Oppenheim attained fame with his *Object*, 1936 (fig. 590), a cup, plate, and spoon covered with fur. The "fur-lined tea cup" has become a synonym for all the vagaries of surrealism. Wolfgang Paalen, an Austrian who spent his last years in Mexico, and Kurt Seligmann, a Swiss who spent his in the United States, were both gifted with dark, gothic imaginations frequently manifested in strange, lunar landscapes (fig. 591).

592. EUGENE BERMAN. *Muse of the Western World*. 1942. 50⅞ x 37¾″. The Metropolitan Museum of Art, New York. George A. Hearn Fund, 1943

mantic image of Italy and its past (fig. 592). Léonid early was attracted to seascapes, particularly shore scenes when the tide was out; these became vast areas of sand and sky rendered in precise draftsmanship and neutral colors (fig. 593). Bérard's double self-portrait, *On the Beach*, 1933 (fig. 594), using these same empty spaces of sea and sky for a background to a photographic self-portrait, is turned into fantasy by the second head peering across its own arm. No distortions or fantastic images are used, yet this work becomes surrealist through the inexplicable second self. Tchelitchew in the same way translates reality into fantasy: familiar objects create an unfamiliar illusion (*Still Life Clown*, fig. 595). In his monumental painting *Hide-and-Seek (Cache-cache)*, 1940–42 (colorplate 164), he deserted romantic realism in a weird dissection of inner anatomies.

595. PAVEL TCHELITCHEW. *Still Life Clown*. 1930. 39½ x 25⅝". The Art Institute of Chicago

593. LEONID BERMAN. *Mussel Gatherers at High Tide*. 1937. 21¼ x 32". Collection James Thrall Soby, New Canaan, Connecticut

# Magic Realism

The line between surrealism and what is variously called magic realism, precise realism, or sharp-focus realism is even more difficult to draw than that between surrealism and neo-romanticism. In general, the magic realists, deriving directly from De Chirico, create mystery and the marvelous through juxtapositions that are disturbing even when it is difficult to see exactly why. The magic realists, even though they may not indulge in Freudian dream images, are interested in translating everyday experience into strangeness (see also p. 363 and, for another type of magic realism, pp. 313–314).

### PIERRE ROY (1880–1950)

Pierre Roy, one of the original surrealists, later disowned by them, may be considered an immediate father of magic realism. *Daylight Saving*, 1929, is a straight *trompe-l'oeil* painting, but *Metric System*, c. 1933 (col-

594. CHRISTIAN BERARD. *On the Beach (Double Self-Portrait)*. 1933. 31⅞ x 46". The Museum of Modern Art, New York. Gift of James Thrall Soby

596. PIERRE ROY. *Danger on the Stairs.* 1927 or 1928.
36 x 23⅝". The Museum of Modern Art, New York.
Gift of Abby Aldrich Rockefeller

597. PAUL DELVAUX. *Venus Asleep.* 1944.
68 x 78⅜". The Tate Gallery, London

598. PAUL DELVAUX. *Night Train.* 1947.
Oil on wood, 60 x 82¾".
Collection Mr. and Mrs. Allen Guiberson, Dallas, Texas

orplate 165), adds a dimension of mystery to the rigid
geometry of the laboratory with its dissonant walls, its
ancient scientific apparatus, and the large door opening
on the night landscape where a solitary figure is
crouched. *Danger on the Stairs,* 1927 or 1928 (fig. 596),
is an even more overt example of fantastic dissociation,
but nonetheless effective for that. It is melodramatically
obvious, but the precise rendering, the elimination of all
extraneous elements, and the inexplicability of the event,
make it frightening.

## PAUL DELVAUX *(b. 1897)*

Paul Delvaux, who, like Magritte, has spent most of
his life in Brussels, came to surrealism slowly. Since
1935 he has painted his dream of fair women, usually
nude but occasionally clothed in chaste, Victorian dress;
they are like sleepwalkers in a dream world of classical
temples, Renaissance perspective, or Victorian architec-
ture. Occasionally lovers appear, but normally the males
are shabbily dressed scholars, intent on personal prob-
lems and strangely oblivious of the women. *Entrance to*

*the City,* 1940 (colorplate 166), gives the basic formula:
a spacious landscape; nude girls wandering about, each
lost in her own dreams; clothed male figures, with here a
partly disrobed young man studying a large plan; here
also are a pair of embracing female lovers and a bowl-
er-hatted gentleman (reminiscent of Magritte) reading his
newspaper while walking. The chief source seems to be
fifteenth-century perspective painting; even the feeling of
withdrawal in the figures suggests the influence of Piero
della Francesca, translated into Delvaux's peculiar per-
sonal fantasy. In *Venus Asleep,* 1944 (fig. 597), he

places his scene in what might be a Greek agora or temple precinct, mysteriously lit by a dark crescent moon. The sleeping Venus reclines on a neo-classical couch, attended by the skeleton figure of death in conversation with an elegantly dressed, corseted, and bustled lady in a plumed hat. Around the oblivious trio, nude mourners

599. BALTHUS. *The Street*. 1933. 76 x 94¼".
Collection James Thrall Soby, New Canaan, Connecticut

wail to the gods. The general effect might have been derived from Giulio Romano or some other Mannerist follower of Raphael. In *Night Train*, 1947 (fig. 598), the scene is a Victorian hotel (or bordello) decorated in shades of blue and purple. One nude stands in the foreground reflected in the background mirror, under which reclines a second nude. The hostess, modestly clothed, sits behind the desk. The large door opens on a railroad yard. The theme of the railroad station, particularly seen at night, appears frequently in Delvaux's work, inspired by De Chirico's *Melancholy of Departure*.

Delvaux is not a major original master of fantasy, but his dream world is nevertheless compelling. It is meticulously rendered, richly and sensitively colored, and filled with a nostalgic sadness that transforms even his erotic nudes into something elusive and unreal.

## BALTHUS *(b. 1908)*

Of the painters who have used precise realism to create an atmosphere of the marvelous, the most fascinating today is Balthus Klossowski of Rola, known as Balthus. Born of a distinguished Polish family, his father both an art historian and painter, and his mother a painter, he grew up in the environment of the nabis and the former fauves, among them Bonnard and Derain, as well as of the poet Rainer Maria Rilke. Like Delvaux he was drawn to the Renaissance. In his first major painting, *The Street*, 1933 (fig. 599), he established the mood of detachment and impersonality that has pervaded his works. The colors are cool and neutral. The figures are each intent on his own business, oblivious to all that goes

*left:* 600. BALTHUS. *Portrait of André Derain.* 1936. Oil on wood, 44⅜ x 28½". The Museum of Modern Art, New York. Lillie P. Bliss Bequest

*above:* 601. BALTHUS. *The Living Room.* 1942. 44 x 57". Collection Mr. and Mrs. John Hay Whitney, New York

on around him. Although Balthus has expressed his indebtedness to Courbet and Bonnard, one is reminded again of the frescoes of Piero della Francesca and the impersonal illusions of Seurat. Balthus has executed some of the finest modern portraits. That of *Derain,* 1936, is a frightening statement of the painter as an arrogant, overpowering individual, looming out of the foreground in Napoleonic pose while the exhausted model dozes in the background (fig. 600).

In the late thirties Balthus embarked on the theme that has obsessed him since: the child girl verging on adolescence, awakening to sexual consciousness and languid dreams of whose significance she is only beginning to become aware (fig. 601).

## Picasso After 1925

Picasso transformed a classical figure study, *By the Sea,* 1920, into a fantasy by grotesquely distorting the figures (see fig. 521). This was one of the few such experiments among his classical works; but *The Three Musicians,* 1921 (see colorplates 139 and 140), and the curvilinear cubist paintings of 1923–25 show that the artist was exploring aspects of fantasy in other ways. He was well aware of the Paris dadaists, knew Breton, and had been adopted by the surrealists. He contributed some abstract drawings to the second number of *La Révolution Surréaliste* (January 15, 1925); in the fourth number, July 15, 1925, Breton, the editor, included an account of *Les Demoiselles d'Avignon,* reproduced collages by Picasso and his new painting, *Three Dancers* or *The Dance,* 1925 (colorplate 167). From 1923 to 1925 come some of the artist's most classically lyrical drawings of dancers (fig. 602), but the new painting was a startling departure from these. In a room that combines cubist space with a suggestion of perspective depth like Picasso's other great cubist paintings of this period, three weird figures perform an ecstatic dance. The figures to the right are jagged and angular; the figure to the left is curvilinear and abandoned. Picasso uses every device in the cubist figure vocabulary—simultaneous views, full face and profile, hidden or shadow profiles, faceting, interpenetration—to create a fantastic image. This painting is almost as important a milestone in Picasso's development as the *Demoiselles d'Avignon* of 1907.

In the late 1920s and the 1930s Picasso followed *Three Dancers* with an outburst of fantasy in painting and sculpture so rich that it cannot be tabulated, much less classified. The sculpturesque classical paintings were transformed into a series of metamorphic organisms derived from his various Bathers on the Beach. These organisms led him to return to sculpture, which he had neglected since 1914. In 1928 he made sketches for sculptural monuments that were assemblages of bonelike figures. These "bone figures" continued into the 1930s and still recur at intervals. An early masterpiece is *Seated Bather,* 1930 (colorplate 168), which is part skeleton, part petrified woman, and all monster, taking her ease in the Mediterranean sun. Pencil drawings published in 1933 in *Minotaure* (see Bibliography), the lavish surrealist journal of the 1930s, illustrate the artist's fertile imagination in creating figure sculptures that are partly living organisms and partly machines. *Girls with a*

604. PABLO PICASSO. *Woman Dressing Her Hair.*
1940. 51¼ x 38⅛".
Collection Mrs. Bertram Smith, New York

606. PABLO PICASSO. *Construction in Wire.*
1928–29. Iron wire, height 19⅝".
Collection the Artist

605. PABLO PICASSO. *Painter with a Model Knitting.*
Illustration for Balzac's *Le Chef-d'oeuvre inconnu,* Paris, 1931.
1927. Etching. The Museum of Modern Art, New York.
Gift of Henry Church

*Toy Boat,* 1937 (fig. 603), combines sculptural structure with curvilinear, pneumatic effects. There is a curious humanity about all these monsters: *Seated Bather* has the nonchalance of a bathing beauty, and these two girls concentrate on their boat like children (although they do not appear particularly childlike). The head that peers over the distant horizon is less menacing than interested

in their play. Perhaps the most gruesome of this entire gallery of monsters is *Woman Dressing Her Hair,* 1940 (fig. 604), a figure who nevertheless preens herself with delicately feminine gestures.

Picasso's accomplishment since 1925 can perhaps best be summarized by particular themes. One is the Artist in His Studio, a favorite subject with the cubists because it permitted familiar, easily accessible scenes and objects to be examined. Picasso returned to the theme in the 1920s, not to reconstitute plastic reality but rather to re-examine the nature of reality itself. His interest may have been aroused by a commission from Ambroise Vollard to provide drawings for an edition of Balzac's *Le Chef-d'oeuvre inconnu (The Unknown Masterpiece),* published in 1931 (*Painter with a Model Knitting,* 1927, fig. 605). This story concerns a deranged painter who spent ten years painting the portrait of a woman and ended with a mass of incomprehensible scribbles. Picasso's interpretation may show his disbelief in absolute abstraction, although he also included a number of line-and-dot drawings (1926) that are more abstract than anything he did before or since. Not long after, he was also designing abstract constructions of metal rods in which the figure is still implicit (fig. 606). He returned to the subject of the painter and his model in a richly coloristic work (colorplate 169), which introduces a note of fantasy: reality and illusion are reversed and painter and model become surrealist ciphers, but the portrait on the artist's canvas is a classical profile. Since then Picasso has returned to the theme time after time.

Colorplate 158.
ANDRE MASSON.
*Pasiphaë.* 1943.
Oil and tempera
on canvas, 39¾ x 50″.
Private collection,
Glencoe, Illinois

*left:* Colorplate 159. YVES TANGUY.
*Mama, Papa Is Wounded!* 1927.
Oil on canvas, 36¼ x 28¾″.
The Museum of Modern Art, New York

*above:* Colorplate 160. YVES TANGUY.
*Multiplication of the Arcs.* 1954. Oil on canvas,
40 x 60″. The Museum of Modern Art, New York.
Mrs. Simon Guggenheim Fund

Colorplate 161. SALVADOR DALI.
*Accommodations of Desire*. 1929.
Oil on panel, 8⅝ x 13¾".
Collection Mr. and Mrs. Julien Levy,
Bridgewater, Connecticut

Colorplate 162. SALVADOR DALI.
*Gala and the Angelus of Millet
Immediately Preceding the Arrival
of the Conic Anamorphoses*. 1933.
Oil and canvas, 9⅜ x 7⅜".
Collection Henry P. McIlhenny,
Philadelphia

*above:* Colorplate 163.
SALVADOR DALI.
*Inventions of the Monsters.* 1937.
Oil on canvas, 20⅛ x 30⅞".
The Art Institute of Chicago.
Joseph Winterbotham Collection

*left:* Colorplate 164.
PAVEL TCHELITCHEW.
*Hide-and-Seek (Cache-cache).*
1940–42. Oil on canvas,
78½ x 84¾". The Museum
of Modern Art, New York.
Mrs. Simon Guggenheim Fund

375

Colorplate 165. PIERRE ROY. *Metric System.*
c. 1933. Oil on canvas, 57½ x 39".
The Philadelphia Museum of Art.
Louise and Walter Arensberg Collection

Colorplate 166. PAUL DELVAUX. *Entrance to the City.*
1940. Oil on canvas, 63 x 70⅞".
Collection Mme. Robert Giron, Brussels

Colorplate 167. PABLO PICASSO.
*Three Dancers (The Dance).* 1925.
Oil on canvas, 84⅝ x 56¼".
The Tate Gallery, London

left: Colorplate 168. PABLO PICASSO.
*Seated Bather*. 1930. Oil on canvas, 63⅞ x 51⅛".
The Museum of Modern Art, New York.
Mrs. Simon Guggenheim Fund

below: Colorplate 169. PABLO PICASSO.
*The Painter and His Model*. 1928. Oil on canvas,
51⅛ x 64¼". The Museum of Modern Art, New York.
Sidney and Harriet Janis Collection

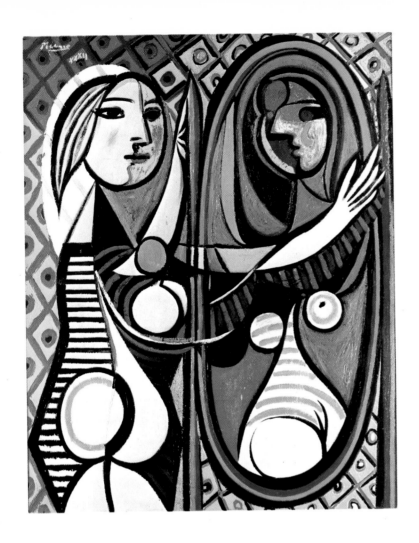

Colorplate 170. PABLO PICASSO.
*Girl Before a Mirror*. 1932.
Oil on canvas, 63¾ x 51¼".
The Museum of Modern Art, New York.
Gift of Mrs. Simon Guggenheim

Colorplate 171.
PABLO PICASSO.
*Crucifixion*. 1930.
Oil on wood, 20⅛ x 26".
Collection the Artist

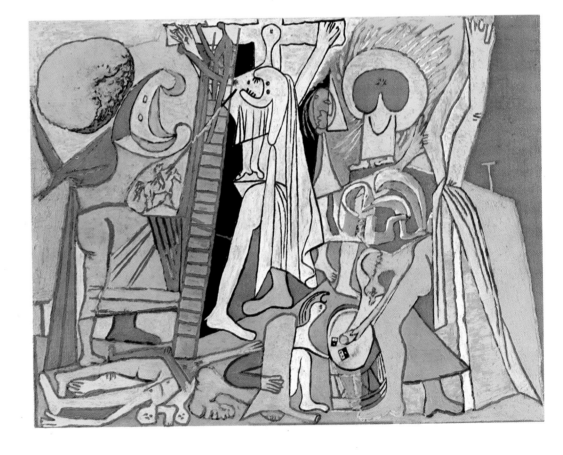

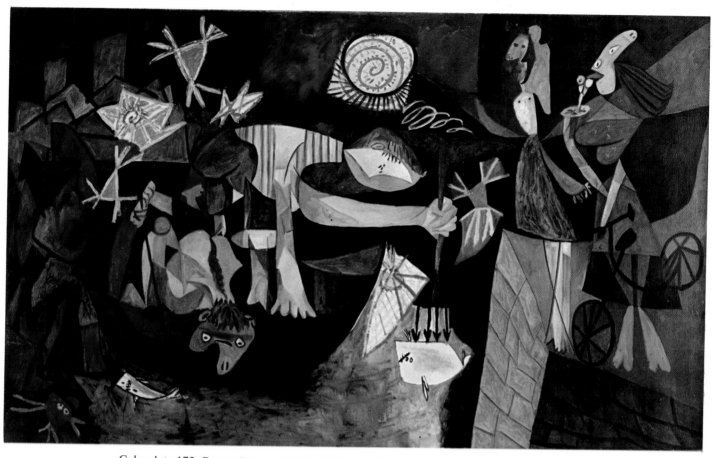

Colorplate 172. PABLO PICASSO. *Night Fishing at Antibes.* 1939. Oil on canvas, 6′ 9″ x 11′ 4″.
The Museum of Modern Art, New York. Mrs. Simon Guggenheim Fund

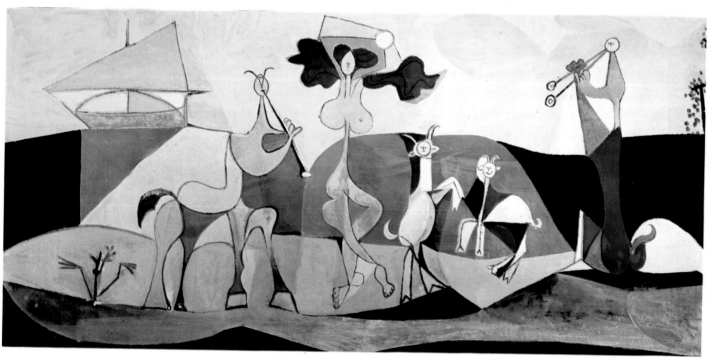

Colorplate 173. PABLO PICASSO. *La Joie de vivre.* 1946.
Oil on canvas, 47¼ x 98½″. Musée Grimaldi, Antibes, France

Colorplate 174. Pablo Picasso.
*Women of Algiers*. 1955. Oil on canvas, 44⅞ x 57½".
Collection Mr. and Mrs. Victor W. Ganz, New York

*above right:* Colorplate 175.
Alberto Giacometti.
*Portrait of David Sylvester*.
1960. Oil on canvas, 45¾ x 35".
Collection Mr. and Mrs.
Joseph Pulitzer, Jr.,
St. Louis, Missouri

*right:* Colorplate 176.
Alexander Calder.
*The Orange Panel*. 1943.
Mobile, oil on wood,
sheet metal, wire, and motor,
36 x 48". Collection
Mrs. H. Gates Lloyd,
Haverford, Pennsylvania

Colorplate 177. ALEXANDER CALDER. *Four Elements*. 1962.
Standing mobile, sheet metal and motor, height 30′. Moderna Museet, Stockholm

Colorplate 178. Auguste Herbin. *Composition*. 1939. Oil on canvas,
18½ x 43¼″. Collection Pierre Peissi, Paris

Colorplate 179. Jean Helion. *Composition*. 1934. Oil on canvas,
56⅝ x 78¾″. The Solomon R. Guggenheim Museum, New York

*left:* Colorplate 180.
PIET MONDRIAN. *Tableau II.*
1921–25. Oil on canvas,
29½ x 25⅝″.
Collection Max Bill, Zurich

*below left:* Colorplate 181.
PIET MONDRIAN. *Composition
with Red, Yellow, and Blue.*
1921. Oil on canvas,
31½ x 19¾″.
Gemeente Museum, The Hague,
The Netherlands

*below right:* Colorplate 182.
PIET MONDRIAN. *Composition
with Red, Blue, and Yellow.*
1930. Oil on canvas,
20 x 20″. Collection
Mr. and Mrs. Armand P. Bartos,
New York

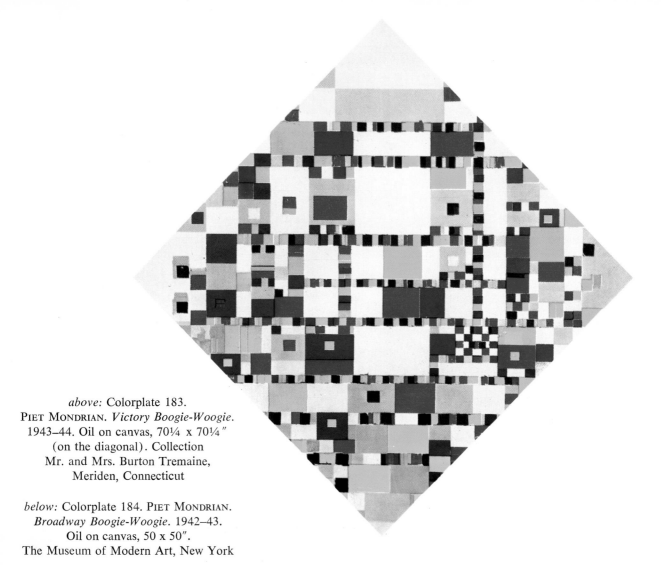

above: Colorplate 183.
PIET MONDRIAN. *Victory Boogie-Woogie.*
1943–44. Oil on canvas, 70¼ x 70¼″
(on the diagonal). Collection
Mr. and Mrs. Burton Tremaine,
Meriden, Connecticut

below: Colorplate 184. PIET MONDRIAN.
*Broadway Boogie-Woogie.* 1942–43.
Oil on canvas, 50 x 50″.
The Museum of Modern Art, New York

384

In two key paintings of the 1930s—*Girl Before a Mirror*, 1932 (colorplate 170), and *Interior with Girl Drawing*, 1935 (fig. 607)—the artist plays further variations on this theme. Both have brilliant color and both assimilate classical repose with fantasy and cubist space, through which the early 1930s became one of the great periods of Picasso's career. Such moments of summation alternate with cycles of fertile and varied experiment. The magical *Girl Before a Mirror* brings together Picasso's total experience of curvilinear cubism and classical idealism. The painting is powerful in color patterns and linear rhythms, but above all it is a work of poetry: the maiden, rapt in contemplation of her mirror image, sees not merely a reversed reflection but a mystery and a prophecy. This lyrical work revives the poetry of the blue and rose periods and of his period of classical idealism; it adds a dimension of strangeness to the exotic Odalisques that Matisse painted, and anticipates Braque's haunting studio scenes.

Picasso's major painting of the 1930s and one of the major paintings of the twentieth century is *Guernica*, 1937 (fig. 608). This work was inspired by the Spanish civil war—specifically, the bombing and destruction of the Basque town of Guernica by German bombers in the service of Spanish fascists. Picasso was deeply involved in the conflict from the beginning, and in a sense had been unconsciously preparing for this statement since the end of the 1920s. Some of its forms first appear in the *Three Dancers* of 1925. Around 1930 he made a number of studies for scenes of the Passion of Christ; the small, brilliant *Crucifixion*, 1930 (colorplate 171), was the most resolved, and has a tortured agony that looks back to the Isenheim Altarpiece and forward to the *Guernica*. In a series of engravings of The Sculptor's Studio, 1933 (later combined in the Vollard suite), the figure of the

minotaur, the bull-man monster of ancient Crete, first appeared. In later plates the minotaur was the main protagonist. During 1933 and 1934 Picasso also painted bullfights of particular savagery. These works reflected conflicts in the artist's personal life, and produced the climax of graphic work, the *Minotauromachy* of 1935 (fig. 609). It presents a number of figures reminiscent of Picasso's life and his Spanish past, particularly his recollections of Goya: the women in the window, the Christlike figure on the ladder, the little girl holding flowers and candle, the screaming horse carrying the dead woman with bared breasts, the minotaur groping his way blindly.

607. PABLO PICASSO. *Interior with Girl Drawing*. 1935.
51⅛ x 76⅝". Private collection, New York

608. PABLO PICASSO. *Guernica*. 1937. 11′ 6″ x 25′ 8″.
On extended loan to the Museum of Modern Art, New York, from the Artist

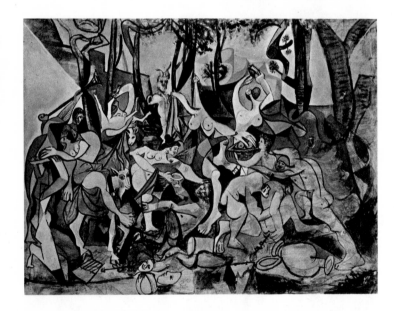

The minotaur's place in Picasso's iconography is ambiguous: he may be a symbol of insensate, brute force, or a symbol of Spain, or sometimes his role is that of the artist himself. Not even in so representational a work as this, however, and even less in the *Guernica,* can we look for specific, literary symbolism. Picasso is transmitting feelings of terror and pity in a generalized sense, not a literal documentation of these emotions.

The artist was active on the side of the loyalists in the Spanish civil war. In January 1937, he created an etching composed of a number of episodes accompanied by a poem, *The Dream and Lie of Franco.* Franco is shown as a turnip-headed monster, and the bull the symbol of resurgent Spain. In May and June 1937, Picasso painted his great canvas, *Guernica,* for the Spanish Pavilion of the Paris World's Fair. It is a huge painting in black, white, and gray, a scene of terror and devastation; to express this the artist drew on the experience of his entire life. Although he used motifs such as the screaming horse or agonized figures derived from his surrealist distortions of the 1920s, the structure is based on the cubist grid. It is the most powerfully expressionist application of cubism ever created.

Probably a hundred sketches and related drawings or paintings surround the *Guernica.* Its impact on the artist himself may be seen in innumerable works during the next decades. Even in the brief period of relaxation before the outbreak of World War II, many of Picasso's paintings have a quality of deep disturbance, and he attained only rarely the lyrical mood of *Night Fishing at Antibes,* 1939 (colorplate 172). Although the artist was not molested by the Germans during the occupation of France, his paintings and sculptures reveal his bitterness. The theme of the skull is frequent; colors are dark and dissonant, distortions extreme and obsessive. Only in paintings of his family do his humor and sentiment sporadically revive.

The liberation of Paris brought paintings of untrammeled gaiety. Picasso's *Bacchanale,* August 1944 (fig. 610), adapted from Poussin, is an orgy of celebration. Even more delightful is *La Joie de vivre,* 1946 (colorplate 173), a work that takes us back to Matisse's composition of 1905–06. Picasso's, too, is conceived in flat-color planes and curving outlines; serious centaurs pipe and frisky goats gambol around the dancing nymph who

trips over her feet, while her abundant hair and lavish breasts flap in the breeze. This is, in fact, a superb satire of the tradition of pastoral painting, to which Picasso was so devoted.

His work since the end of the war shows no halt in his amazing energy, in the form of a stream of paintings, sculptures, ceramics, and prints. His latest works may seem to have less relevance to contemporary tendencies than previously, but they have an astonishing freshness that puts his juniors to shame. His adaptation of works by the old masters illustrates a mood of reflection on himself and his relation to the art of the past: During the 1950s and 1960s he produced many free variants of works by Poussin, Lucas Cranach, Velázquez, Delacroix (colorplate 174)—all brilliant in color, organization, and conception.

# Fantasy in Sculpture and Assemblage

A strain of fantasy is present in twentieth-century sculpture from its beginnings. This was almost assured by the mere fact that sculptors, except for the abstract constructivists, continued to use the human head and figure as their basic subjects. Thus, an element of human semblance remained in some degree present, no matter how much the heads and figures were transformed by every sort of simplification, distortion, stylization, or cubist manipulation. Picasso was capable of introducing human fantasy, even into non-figurative sculpture, such as the famous *Glass of Absinthe,* 1914 (see fig. 220). Seen from one side the glass opens up in a huge mouth with protruding tongue reaching for the lump of sugar on the spoon above. This is a direct ancestor of all the "object sculptures" with which the dadaists began to play and which have reached their apotheosis in contemporary pop art.

Fantasy became explicit in modern sculpture with Boccioni's *Mother (Anti-Graceful,* see fig. 374), and even more so in his weird window sculptures such as *Fusion of a Head and a Window,* 1911, now destroyed. Here was a prototype for subsequent experiments in sculpture as environment. The next step, even more significant, was Marcel Duchamp's invention of the ready-made (see p. 304). Probably not even Duchamp could envisage the impact his ready-mades were to have on definitions and traditions.

Among the Zurich dadaists, 1916–19, the only contributions to a sculpture of fantasy were certain reliefs by Arp; later, he developed his organic-figurative fantasies into freestanding works. Sophie Taeuber-Arp made a wooden *Dada Head* (fig. 611) in 1920, perhaps inspired by Raoul Hausmann's *Mechanical Head,* 1919–20 (fig. 612), in which a variety of miscellaneous objects—a metal collapsing cup, a tape measure, labels, a pocketbook—are attached to a mannequin's head. The masterpieces of dada sculpture or assemblage are Kurt Schwit-

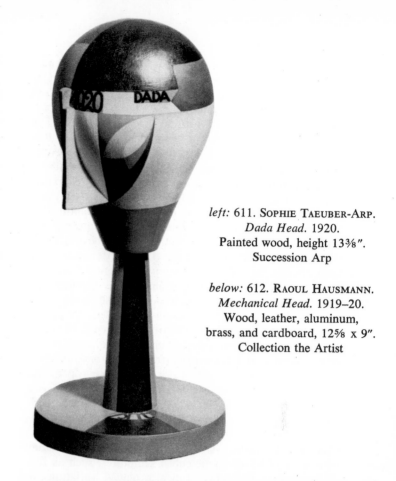

*left:* 611. SOPHIE TAEUBER-ARP. *Dada Head.* 1920. Painted wood, height 13⅜". Succession Arp

*below:* 612. RAOUL HAUSMANN. *Mechanical Head.* 1919–20. Wood, leather, aluminum, brass, and cardboard, 12⅝ x 9". Collection the Artist

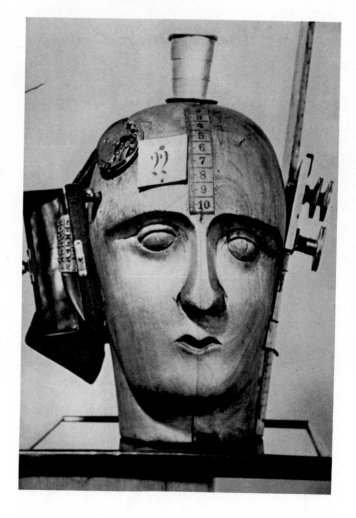

ters' three *Merzbau* (see fig. 478). It is difficult to know whether these should be described as sculpture or architecture. Probably the contemporary term "environment" is appropriate since they are entities into which the spectator can walk and of which he becomes a part. The *Merzbau*, involving different sets and secret grottoes that the artist manipulated for his friends, were also ancestors of the happenings of today.

Although the Paris surrealists during the 1920s experimented with forms of collage and assemblage, Arp made their only major contribution to fantasy in sculpture before the revival of Picasso's interest in sculpture and the emergence of Julio Gonzalez and Alberto Giacometti. Of the cubist sculptors only Jacques Lipchitz seems to have been affected by the surrealist environment (if not the doctrine), but the exception is important. Lipchitz had steadily explored the possibilities of cubism from 1914 into the 1920s, passing from abstract forms to figures and reliefs of increasing complexity, and then in the early 1920s to monumental cubist figures. In the same period he produced straightforward portraits again and, in 1926, played variations on cubist forms in little openwork sculptures modeled in wax for casting in bronze. These are of interest intrinsically and historically in that, although cast rather than worked in direct metal, they anticipate the openwork figure constructions of both Picasso and Gonzalez. Also, during the mid-1920s, along with some of his climactic cubist sculptures, such as *Joie de vivre* (see fig. 333), Lipchitz played variations in figures whose individual personalities asserted themselves over the cubist forms (*Reclining Nude with Guitar*, 1928, see fig. 334). He also made sketches that were to be formulated in the great *Figure*, 1926–30 (see fig. 335), a primitive totem whose hypnotic, staring presence marks the transition of Lipchitz to a new phase of expressionist subject. It was no accident that this should have happened exactly at the moment when surrealist fantasy was reaching its first peak.

## THE SCULPTURE OF PICASSO AFTER 1928

About 1928 Picasso's surrealist bone paintings revived his interest in sculpture, which, except for a few sporadic assemblages, he had abandoned since 1914. The result was first a modeled metamorphic monster cast in bronze, seemingly in process of eating its own tail. Then, about 1930, with the technical help of his old friend Julio Gonzalez, a skilled metalworker, he produced welded iron constructions that, together with similar constructions produced at the same time by Gonzalez himself, marked the emergence of direct-metal sculpture as a major, modern medium. Picasso's *Woman in the Garden,* 1929–30 (fig. 613), a large and free construction involving plant forms and an exuberant figure made up of curving lines and organic-shaped planes, is one of the most intricate, charming—and monumental—works of direct-metal sculpture produced to that date. The artist also made wood carvings of elongated figures, later cast in bronze, that have a certain affinity to the later, characteristic figures of Giacometti. Other metal constructions made by Picasso during 1931 revive the artist's old passion for African art.

Carried away by enthusiasm, Picasso modeled in clay or plaster until by 1933 his studio at Boisgeloup was filled: massive heads of women, reflecting his contemporaneous curvilinear style in painting and looking back in some degree to his Greco-Roman style; torsos transformed into anthropomorphic monsters; surprisingly representational animals—a cock and a heifer; figures assembled from found objects organized with humor and delight. At times the humor becomes wild satire, as in *Bust of a Warrior,* 1933 (fig. 614). Of the found-object sculptures perhaps the most renowned is the *Bull's Head,* 1943 (fig. 615), which consists of an old bicycle seat and handlebars—a wonderful confirmation of Duchamp's assertion that for the artist it is only the idea that matters. During the war Picasso created, in plaster for bronze, a shepherd holding a lamb, one of his most moving conceptions (fig. 616). Picasso was obviously thinking of the Early Christian figure of the Good Shepherd, Christ the protector of the oppressed, a figure that may be traced back to classical pagan religions as well as to the Old Testament. His depression over the war was also

613. PABLO PICASSO. *Woman in the Garden.* 1929–30. Bronze after welded iron, height 82¾". Collection the Artist

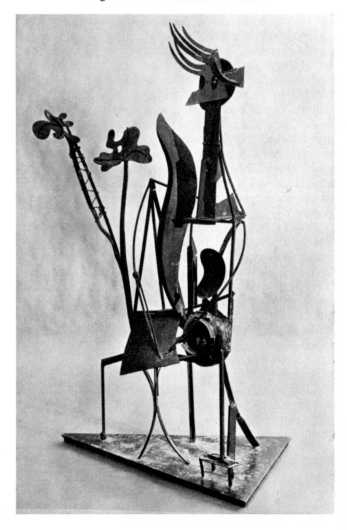

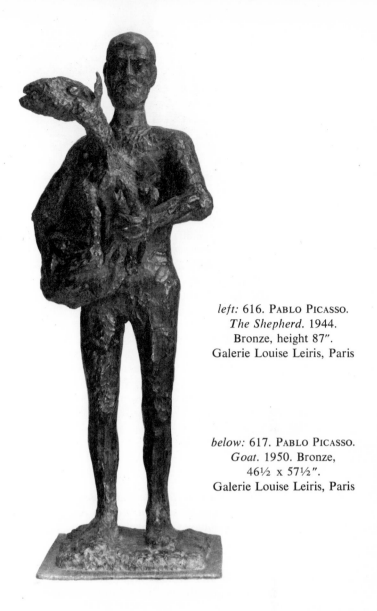

*left:* 616. PABLO PICASSO.
*The Shepherd.* 1944.
Bronze, height 87".
Galerie Louise Leiris, Paris

614. PABLO PICASSO. *Bust of a Warrior.* 1933.
Bronze, height 47¼". Galerie Louise Leiris, Paris

*below:* 617. PABLO PICASSO.
*Goat.* 1950. Bronze,
46½ x 57½".
Galerie Louise Leiris, Paris

615. PABLO PICASSO. *Bull's Head.* 1943.
Bronze, height 16⅛". Galerie Louise Leiris, Paris

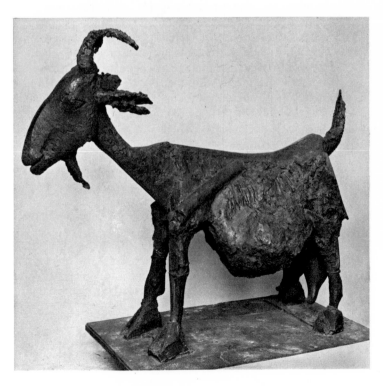

618. PABLO PICASSO. *Baboon and Young.* 1951.
Bronze, height 21″. The Museum of Modern Art, New York.
Mrs. Simon Guggenheim Fund

619. PABLO PICASSO. *The Bathers.* 1956–57.
Bronze, height of tallest figure 8′ 8½″.
Galerie Louise Leiris, Paris

reflected in the brutal bronze *Skull,* 1944. This image also occurred frequently in the paintings of the same year.

With the end of the war his spirit lightened. The tempo of production in painting, sculpture, and graphic art accelerated. A new interest, ceramics, appeared. In 1950 he made a bronze figure of a pregnant woman, a bursting fertility symbol. His delight in the portrayal of animals continued with the *Goat,* 1950 (fig. 617), a marvelously dissolute-looking animal, and the *Baboon and Young,* 1951 (fig. 618), also bronze. The baboon's head is a toy automobile, and the whole figure was derived from this chance resemblance. During the later 1950s and the 1960s his principal sculptural activities were cutting out works from sheet-metal, assembling flat stick figures from wooden planks, and then casting them in bronze (fig. 619). The figures recall some small paintings of about 1928, in which flat, cut-out bathers gambol on a beach.

The sculpture of Picasso since the 1920s has had a special pertinence to contemporary sculpture, not only in its exploration of the techniques of direct metal and the use of the found object, but particularly in the expanding application of fantastic subject.

## JULIO GONZALEZ (1876–1942)

Gonzalez, another son of Barcelona, had been trained

in metalwork by his father, a goldsmith, but for many years he practiced as a painter. In Paris by 1900, he came to know Picasso, Brancusi, and Despiau; but after the death of his brother Jean in 1908, he dropped out of the art world for about twenty years. Then, at the end of the 1920s Picasso asked him for technical help in constructed sculpture, his new interest. Gonzalez had for some years been experimenting with relief sculpture, cut or incised from flat sheets of metal, and had made cubist figures and masks in the spirit of analytical cubism (*Mask of Roberta in the Sun,* 1927, fig. 620; and *Don Quixote,* 1929, fig. 621); the openwork construction of the latter had no precedents in figure sculpture except the transparencies on which Lipchitz had been working for three or four years. It may be said that Gonzalez began a new age of iron for sculpture. By 1931 Gonzalez was working in direct, welded iron, with a completely open, linear construction in which the solids were merely contours defining the voids. The difference between these constructions and the earlier ones of Gabo and the Russian constructivists lies not only in the technique—which was to have such far-reaching effects on younger sculptors —but in the fact that Gonzalez was always involved in the figure (*Woman Combing Her Hair,* c. 1931–33, fig. 622; *Woman with a Mirror,* 1936–37, fig. 623; *Cactus Man I,* 1939–40, fig. 624). Shining through the fantasy of the elegant forms of the first two is a delicate sense of humanity. *Cactus Man* is, as the name implies, a bristly and

622. JULIO GONZALEZ.
*Woman Combing Her Hair.*
c. 1931–33. Iron, height 59".
Moderna Museet, Stockholm

623. JULIO GONZALEZ.
*Woman with a Mirror.*
1936–37. Iron, height 82".
Collection Roberta Gonzalez, Paris

624. JULIO GONZALEZ.
*Cactus Man I.* 1939–40.
Bronze, height 26".
Collection Hans Hartung, Paris

625. JULIO GONZALEZ. *Montserrat.*
1936–37. Wrought and welded iron,
65 x 18½". Stedelijk Museum, Amsterdam

the cubist sculptures of Lipchitz and Laurens and, more important, of primitive and prehistoric art. Giacometti's *Spoon Woman (Femme cuiller),* 1926–27 (fig. 626), is a frontalized, surrealist-primitive totem, with a spiritual if not a stylistic affinity to the work of Brancusi. It is the first attempt of a young sculptor to create form that is completely abstract yet has the presence of a figure. In *The Couple,* 1926 (fig. 627), the anthropomorphic transformation was made more overt in the two figures. Presented first as sexual symbols, there is a definite personal interaction between them, even a touch of humor in the play of hands and the single great ogling eye of the male.

At the end of the 1920s, Giacometti was drawn into the orbit of the Paris surrealists. For the next few years he made works that reflected their ideas, and until 1935 he exhibited with Miró and Arp at the Galerie Pierre. The sculptures he produced during these years, considered as expressions of fantasy, are among the master-

aggressive individual, suggesting a new authority in the artist's work, which death cut short at this point.

Side by side with these openwork, direct-metal constructions, Gonzalez continued to produce naturalistic heads and figures, for instance, the large wrought-iron and welded *Montserrat,* 1936–37 (fig. 625), a heroic figure of a Spanish peasant woman, symbol of the resistance of the Spanish people against fascism.

## ALBERTO GIACOMETTI *(1901–1966)*

If Gonzalez was the pioneer of the new iron age, Alberto Giacometti was the creator of a new image of man. Son of a Swiss impressionist painter, he was drawing by the age of nine, painting by twelve, and made his first bust of his brother Diego when he was thirteen. After studies in Geneva and a long stay with his father in Italy, where he saturated himself in Italo-Byzantine art and the paintings of Cimabue and Giotto, and became acquainted with the futurists, he moved to Paris in 1922. Here he studied with Bourdelle for three years and then set up a studio with Diego, an accomplished technician who continued to be his assistant and model to the end of his life. The first independent sculptures reflected awareness of

626. ALBERTO GIACOMETTI. *Spoon Woman (Femme cuiller).*
1926–27. Bronze, height 57".
The Solomon R. Guggenheim Museum, New York

627. ALBERTO GIACOMETTI. *The Couple (Man and Woman).*
1926. Bronze, height 23½".
Collection Mrs. Barnett Malbin, Birmingham, Michigan

pieces of surrealist sculpture: *Disagreeable Object,* 1931, a tusk shape with an eye and lesser tusks, which emphatically fulfills its title; a mechanical mobile of a *Hand Caught by a Finger (Main prise),* 1932, a sadistic machine that recalls Bellmer's *Doll.* (Alexander Calder, the American father of the mobile, had made his first hand-cranked version of a mobile in 1929 and gave his first exhibition of hand and mechanical mobiles in Paris in 1932.) Even more gruesome was *Woman with Her Throat Cut (Femme égorgée),* 1932 (fig. 628), a bronze construction of a dismembered female corpse with a family resemblance to Picasso's 1929 *Seated Bather* (see colorplate 168).

Of greatest significance in terms of the artist's subsequent directions are certain experiments in open-space construction. *Suspended Ball,* 1930–31, is simply that—in an open cage made of thin metal rods defining a cube of space, a wooden ball is suspended on a wire and touches a crescent shape of wood in unstable balance on the wooden floor. This is, thus, an open-space construction of geometrical shapes with implied movement (the pendulum ball) and curious relationships. Another space experiment with even more direct implications for Giacometti's later studies of walking figures in a lonely city square is *No More Play,* 1933. This might be described as a sort of cosmic chess game. The chessboard is a smooth marble slab with geometrically exact moon cra-

ters. In two of these stand isolated little figures of bronze. Rectangular trapdoors in the center open to reveal cryptic contents. These space sculptures were climaxed by *The Palace at 4 A.M.,* 1932–33 (fig. 629), a structure of wooden rods defining the outlines of a house. At the left a woman in an old-fashioned long dress stands before three tall rectangular panels. She seems to look toward a raised panel on which is fixed a long, oval spoon shape with a ball on it. To the right, within a rectangular cage, is suspended a spinal column, and in the center of the edifice hangs a narrow panel of glass. Above, floating in a rectangle that might be a window, is a sort of pterodactyl

628. ALBERTO GIACOMETTI. *Woman with Her Throat Cut (Femme egorgée).* 1932. Bronze, height 34½".
The Museum of Modern Art, New York

629. ALBERTO GIACOMETTI. *The Palace at 4 A.M.*
1932–33. Wood, glass, wire, and string, 25 x 28¼ x 15¾".
The Museum of Modern Art, New York

—"the skeleton birds that flutter with cries of joy at four o'clock." This strange edifice was the product of a period in the artist's life that haunted him and about which he has written movingly: " . . . when for six whole months hour after hour was passed in the company of a woman who, concentrating all life in herself, magically transformed my every moment." Whatever the associations and reminiscences involved, *The Palace at 4 A.M.* was primarily significant for its wonderful, haunting quality of mystery arising from the artist's sense of the loneliness of modern man. It was this perhaps that he saw with such frightening clarity whenever he tried to draw a figure or paint a portrait, and it was this sense of loneliness that he felt so incapable of rendering. Yet he rendered it with incomparable conviction. This despite the fact that he always denied any desire to comment on the condition of man, to evoke the feeling of alienation.

His intent, ever since he returned to the study of the figure in 1935, was, as it had been when he was a student, to render the object and the space that contained it as exactly as his eye saw them. Since an object seen close became for him a meaningless confusion of details, he increased the distance between himself and the object until

632. ALBERTO GIACOMETTI. *Monumental Head.*
1960. Bronze, height 37½".
The Joseph H. Hirshhorn Collection

*left:* 630. ALBERTO GIACOMETTI. *Invisible Objects (Hands Holding the Void).* 1934–35. Plaster, height 61½".
Yale University Art Gallery, New Haven, Connecticut

*right:* 631. ALBERTO GIACOMETTI. *Head of a Man on a Rod.*
1947. Bronze, height 21¾".
Collection William N. Eisendrath, Jr., St. Louis, Missouri

it began to come into focus and he could perceive it as a totality within its own definable space. This establishment of the correct visual distance was only a first step. There were still details to be stripped away in the sculptures and the isolated figures of his paintings. The effect, whether he sought it or not, is an overpowering sense of aloneness, although one may also read in the figures a quality of integrity rather than of alienation, something that enables them to survive like characters in a play of Samuel Beckett, even in a void, in an ultimate situation. In attempting to interpret Giacometti's later figure sculpture, it is important to remember *The Palace at 4 A.M.*

The need to attempt what he felt to be impossible, "to render what the eye really sees," led Giacometti to abandon his surrealist sculpture and to begin the most intensive possible examination of a limited subject—the figure and portrait head—first with a professional model and later with his brother Diego or his wife Annette as models. A transitional work is *Invisible Objects (Hands*

*Holding the Void),* 1934–35 (fig. 630), an elongated figure, half sitting on a chair structure that provides an environment. The mask face and the very concept— "hands holding the void"—mark this as a fantasy figure with surrealist overtones. That the concept should be in the form of a single, vertical, attenuated figure is significant for Giacometti's later work.

Almost at once he began to realize the magnitude of the quest he was undertaking. From 1935 to 1940 he worked all day from a model but, as he said, "nothing was as I had imagined." He then decided to make a new start: "I began to work from memory. . . . But wanting to create from memory what I had seen, to my terror the sculptures became smaller and smaller, they had a likeness only when they were small, yet their dimensions revolted me, and tirelessly I began again, only to end several months later at the same point. A large figure seemed to me false and a small one equally unbearable, and then often they became so tiny that with one touch of my knife they disappeared into dust. But head and figures seemed to me to have a bit of truth only when small. All this changed a little in 1945 through drawing. This led me to want to make larger figures, but then to my surprise, they achieved a likeness only when tall and slender. . . ."

When he returned to Paris from Switzerland after the war, his ten-year struggle, during which he finished few works, had been resolved. Although every painting and sculpture was an agony of working and reworking, Giacometti was able, in the last twenty years of his life, to produce a body of sculptures and paintings that mark him as one of the masters of twentieth-century art.

The *Head of a Man on a Rod,* 1947 (fig. 631), of which he did several versions, is really two profiles pressed together, scarred and pitted in effects that are both a horrible laceration of the flesh and the translation of the face into a rugged, rocky landscape. Giacometti had early developed (perhaps from his studies of ancient sculpture) a passion for color in sculpture; and one of the most striking aspects of the latter works is the patinas he has used in the bronze.

Giacometti's favorite models continued to be his brother Diego, his mother, and his wife Annette. Diego is the subject of dozens of sculptures and paintings, ranging from relatively representational works to grotesque, attenuated, and pitted masks, but always alive and clearly recognizable (fig. 632). The single spindly figure appeared in a hundred variants on the artist's basic theme: standing rigid; walking like an Egyptian deity; mounted on a chariot suggesting an Etruscan bronze (fig. 633); in groups, and in environments evoking the isolation of the individual (figs. 634 and 634a). In the 1950s Giacometti

633. ALBERTO GIACOMETTI. *Chariot.* 1950. Bronze, height 57". The Museum of Modern Art, New York

634. ALBERTO GIACOMETTI. Detail of *Walking Quickly Under the Rain.* 1949. Bronze, length 32". Collection Mr. and Mrs. Gordon Bunshaft, New York

634a. ALBERTO GIACOMETTI. *Composition with Seven Figures and One Head.* 1950. Bronze, height 22". The Reader's Digest Collection

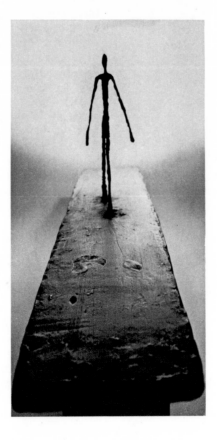
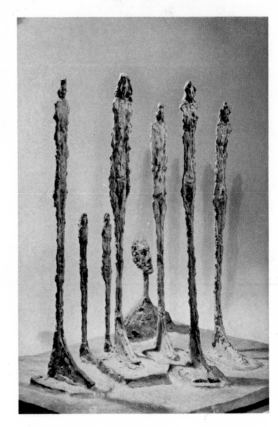

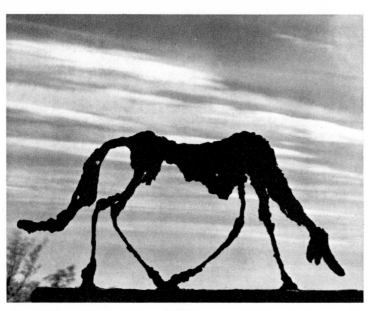

635. ALBERTO GIACOMETTI. *Dog.* 1956.
Bronze, height 17½". The Joseph H. Hirshhorn Collection

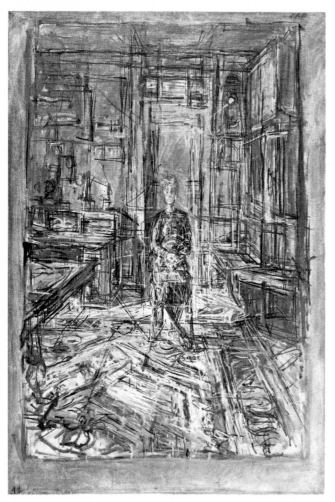

636. ALBERTO GIACOMETTI. *The Artist's Mother.* 1950.
34⅝ x 23½". The Museum of Modern Art, New York.
Acquired through the Lillie P. Bliss Bequest

occasionally varied his theme, as in the wonderful study of the starving dog (fig. 635), in whom he saw himself ("It's me. One day I saw myself in the street just like that. I was the dog.").

From the 1940s Giacometti also drew and painted with furious though consistently frustrated energy. He sought to pin down the space, the environment occupied by the figure, that could only be suggested in the sculptures. In their subordination of color and emphasis on the action of line, the paintings have the appearance of drawings or even engravings. The impact in the paintings (although related) comes largely from Giacometti's technique of elimination or erasure. In *The Artist's Mother,* 1950 (fig. 636), the figure is almost completely assimilated into the network of linear details of the bourgeois living room. These details are nowhere explicit, but still they obtrude in an atmosphere that becomes oppressive, while the old woman sits isolated in their midst. In a later portrait, of the critic *David Sylvester,* 1960 (colorplate 175), the elimination of environmental details is carried to the point where the figure remains alone in a void, surrounded by the aura of a destroyed world.

## THE SCULPTURE OF MAX ERNST

Ernst was drawn to sculpture in 1934 through his friendship with Giacometti, at the moment when the latter was leaving surrealism for his own new vision of reality. Since that time Ernst has increasingly concerned himself with sculpture, and his productivity in this medium has almost matched that in painting and collage. His first works were modified, egg-shaped boulders whose surfaces he carved with abstract patterns in the manner of Arp. From this the artist went on to several sculptures worked in plaster for casting in bronze. *Oedipus II,* 1934 (fig. 637), is a military-looking figure with phallic overtones. It is based on casts of wooden pails assembled in precarious balance, recalling the artist's 1920 collage *The Hat Makes the Man;* but the big-nosed visage certainly owes something to Picasso's sculpture of the early 1930s. Other sculptures resulting from this first enthusiasm in 1934–35 were a *Bird Head* reminiscent of a type of Gabon reliquary, metal-covered figures; and *Lunar Asparagus* (fig. 638), two enormously elongated-plant figures who maintain a certain shy personal interrelationship. In 1944, in the United States, Ernst created a series of frontalized figures reminiscent of African sculpture, Picasso, and even, at times, Duchamp (fig. 639).

## ALEXANDER CALDER *(b. 1898)*

The two other major sculptors who emerged from the environment of surrealism in the 1930s were the American Alexander Calder and the Englishman Henry Moore (who is treated below). Calder, born in Philadelphia, was the son and grandson of sculptors. After studying engineering he was gradually drawn into the field of art, principally as an illustrator. In 1926 he went to Paris where he first attracted the attention of avant-garde artists and writers with his *Circus,* a full-fledged, activated environment, and his portraits and caricatures constructed from wire. There followed his wire sculpture

637. MAX ERNST.
*Oedipus II*. 1934.
Bronze, height 24⅜″.
Private collection, New York

638. MAX ERNST.
*Lunar Asparagus*. 1935.
Plaster, height 65¼″. The Museum
of Modern Art, New York

639. MAX ERNST. *The King Playing with the Queen*.
1954. Bronze (cast from original plaster of 1944),
height 38½″. The Museum of Modern Art, New York.
Gift of Mr. and Mrs. John de Menil

*Fishbowl with Crank,* 1929, which has been described as a hand-operated mobile; and early drawings and wire constructions of marked technical ingenuity and playful humor (*Romulus and Remus,* 1928, fig. 640).

In 1930 Calder came under the influence of Mondrian and of the constructivists—specifically Gabo. He began to experiment with abstract painting and, more significant, abstract wire constructions that illustrated an immediate mastery of constructed space sculpture (*Universe,* 1931, fig. 641). These early abstract sculptures had a predominantly austere, geometric form, although the suggestion of subject—constellations, universes—was rarely absent.

Calder's first group of hand and motor mobiles was exhibited in 1932 at the Galerie Vignon, where they were so christened by Marcel Duchamp. When Arp

640. ALEXANDER CALDER. *Romulus and Remus*. 1928. Wire sculpture,
2′ 7″ x 9′ 4″. The Solomon R. Guggenheim Museum, New York

*above left:* 641. ALEXANDER CALDER. *Universe.* 1931. Wire and wood, height 36". Collection the Artist

*above right:* 642. ALEXANDER CALDER. *The White Frame.* 1934.
Mobile, wood, wires, ropes, sheet, and motor, 7½ x 9'. Moderna Museet, Stockholm

heard the name "mobile," he asked, "What were those things you did last year—stabiles?" Thus was born the word, which technically might apply to any sculpture that does not move, but which has become specifically associated with Calder. During the 1930s the artist created motorized mobiles, both as reliefs, with the moving parts on a plane of wooden boards or within a rectangular frame; and freestanding, with elements moving in three-dimensional space. Of the first type, one of the earliest on a large scale is *The White Frame,* 1934 (fig. 642). In this, a few elements are set against a plain, flat background: a large, suspended disk at the right, a spiral wire at the left, and between them, suspended on wires, a white ring and two small balls, one red and one black. Put into motion, the large disk swings back and forth as a pendulum, the spiral rotates rapidly to create a multiple spiral effect, and the ring and balls spin. Whereas *The White Frame* still (with the exception of the spiral) reflects Mondrian and geometric abstraction, *The Orange Panel,* 1943 (colorplate 176), reveals a major change of the late 1930s: Calder now uses free forms and scatters them loosely over intensely colored ground, reflecting both Miró and Arp, his good friends. From this point onward, Calder's production moved easily between geometric or neo-plastic forms and those associated with organic surrealism.

The characteristic works of the 1930s and 1940s—those on which the image of the artist has been created—are the wind mobiles, either standing or hanging, made of plates of metal or other materials suspended on strings or wires, in a state of delicate balance. The earliest wind mobiles were relatively simple structures in which a variety of objects, pieces of glass, wood, or free-form metal moved slowly in the breeze. A far greater variety of motion was possible than in the mechnically driven mobiles. For one thing, the element of chance played an important role. Motion varied from slow, stately rotation to a rapid staccato beat. In the more complex examples shapes rotated, soared, changed tempo and, in certain instances, emitted alarming sounds. By the end of the 1930s Calder's wind mobiles had become extremely sophisticated and could be made to loop and swirl up and down as well as around or back and forth. One of the largest hanging mobiles of the 1930s is *Lobster Trap and Fish Tail,* 1939 (fig. 643). Although it is quite abstract in its forms, the subject association is strong. The torpedo-shaped element at top could be a lobster cautiously approaching the trap, represented by a delicate wire cage balancing at one end of a bent rod. Dangling from the other end is a cluster of fan-shaped metal plates suggestive of a school of fish. The delicacy of the elements somewhat disguises the actual size, some nine-and-a-half feet in diameter.

From the late 1940s dates a growing interest in monumental forms, and in the transformation of the mobile to a great architectural-sculptural wind machine whose powerful but precisely balanced metal rods, tipped with large, flat, organically shaped disks, encompass and define large areas of architectural space. In 1957 a giant mobile was commissioned for Idlewild (now Kennedy) Airport in New York. The completed structure, with its very large leaf blades painted red and black with orange

643. ALEXANDER CALDER. *Lobster Trap and Fish Tail*. 1939. Mobile, steel wire and sheet aluminum, height c. 8½', diameter c. 9½'. The Museum of Modern Art, New York. Gift of the Advisory Committee

644. ALEXANDER CALDER. *Acoustical Ceiling*. 1952. Aula Magna, University City, Caracas, Venezuela

accents, now hangs in the enormous hall of the International Arrivals Building. This combination of mobile and architecture demonstrates the possibilities of the mobile form, conceived and executed on this scale, for really grand expression. Actually Calder's major commission to date for a hanging construction (although not a mobile) is the acoustical ceiling for an auditorium in University City, Caracas, Venezuela, 1952 (fig. 644). The entire ceiling is broken up with gigantic, brightly colored free shapes which seem to float in mid-air, and which define and enhance the architectural space of the interior. Also, astonishingly, the shapes function as far as the acoustical properties of the hall are concerned.

Since the mobile, powered by currents of air, could function better outdoors than indoors, the artist began early to explore the possibilities for outdoor mobiles. These could best be resolved in terms of some form of standing structure and, intrigued by the possibility of developing such structures, Calder undertook new experiments. One of the earliest was *Red Petals*, 1942 (fig. 645), a graceful, naturalistic form, in every detail suggestive of some exotic plant or tree. The base is a tripod of triangular leaf forms which grow into a tall, curving stem, nine feet high, from whose tip extend the delicate tendrils of wires balancing leaf or flower shapes. The importance of this work lies not only in its large scale and its biomorphic beauty, but in its statement of the standing mobile as an organic whole, interrelating stabile and mobile forms. Calder, in the late 1950s and 1960s, created many large, standing mobile units which rotate in limited but impressive movement over a generally pyramidal

645. ALEXANDER CALDER. *Red Petals*. 1942. Standing mobile, painted iron, height 9' 2". Collection Arts Club of Chicago

base, essentially neutral in form. One example is *The Spiral* (fig. 646), created for the UNESCO building in Paris in 1958.

His most impressive achievement of the 1960s, however, is found in his great stabiles—a term really belonging to Calder—but even in his work it has particular application only to his large-scale metal-plate constructions, normally painted black. Calder had begun his career as a sculptor of carved wooden animals or wire

structures. In the 1940s he made a number of Constellations inspired by the painted Constellations of Miró: fantastic, free-form, highly finished wooden shapes joined by webs of wire. Although nothing actually moves, these bizarre stabiles of witty and monstrous animal or plant life sometimes suggest violent activity.

A second form of the early large-scale stabile is very different in its somewhat geometric character, although it is also intended to be some strange monster. *Black Beast*, 1940 (fig. 647), is four large cut-out plates intersecting at extreme angles, shaped to create an open structure. With voids below as well as above, the structure is joined only at a narrow waist. There are suggestions of heads and legs attached to torsos; viewed from different angles, the animal changes to a group of animals or to animals and human figures. Despite such connotations, the whole has a strongly architectural effect. This suggestion of sculpture becoming an architectural environment is what makes *Black Beast* an important prototype for another major group of the later stabiles.

The most monumental expression of such an architectural environment is the *Teodelapio,* 1962, designed for the sculpture exhibition at Spoleto, Italy. This is sixty feet high, and one can drive a car through it. From the same year is the thirty-foot-high construction (colorplate 177), now in front of the Modern Museum in Stockholm. It was made after a model for an unrealized commission to make a motorized mobile for the New York World's Fair of 1938. As the title indicates, it is made of four elements: a great black bastion with a pointed table-

*above left*: 648. ALEXANDER CALDER. Detail of *Hello Girls!* 1964. Standing mobile, painted metal, height 12' 4".
Los Angeles County Museum of Art. Art Museum Council Fund.

*above right*: 649. ALEXANDER CALDER. *Guillotine for Eight.* 1963. Stabile, sheet metal, height 21' 11". Perls Gallery, New York.
*Ghost.* 1964. Mobile, metal, c. 24 x 35'. Collection Mr. and Mrs. Leonard H. Horwich, Chicago.
The Solomon R. Guggenheim Museum Retrospective Exhibition, 1964–65

top that rocks back and forth on its base; an orange-and-black figure motif with outflung, curved arms, that whirls round and round; a tall, black-and-white pole with an orange disk at the end of a slowly revolving arm set at right angles; and a column of diminishing half-circles, painted orange and yellow. All four units have separate motors, making the shapes leap and lunge and spin in interactions often reminiscent of a dada manifestation.

Although fountains would seem to be an inevitable development of the mobile concept, the artist has had very few commissions for them. The most important is the fountain for the Los Angeles County Museum, 1964, consisting of a group of standing mobiles on simple, high, triangular bases. The two arms high in the air, as though in a gesture of gay greeting, gave the structure its name—*Hello Girls!* (fig. 648). Jets of water striking the blades whirl the mobiles.

Other important architectural constructions of the 1960s are: *Guillotine for Eight,* 1963 (fig. 649), which, with the large white mobile *Ghost,* hovering overhead, constituted the central focus of the Guggenheim Museum retrospective of the artist in 1964–65; *Slender Ribs,* 1954, a stabile placed spectacularly at the edge of the ocean, on the grounds of Louisiana Museum in Denmark; the large, 1965 stabile *Guichet* at Lincoln Center in New York; *La Grande Voile,* designed to the space in front of a building at the Massachusetts Institute of Technology in Cambridge, Massachusetts. For the 1967 World's Fair in Montreal, Canada, the artist created his most monumental stabile to date (fig. 650).

650. ALEXANDER CALDER. *Man.* 1967. Stabile,
stainless steel, height 94'. EXPO 67, Montreal, Canada

# ABSTRACTION IN THE 1930s: SCHOOL OF PARIS

Paris during the twentieth century has drawn artists from every part of the world. Hence, the School of Paris is international rather than specifically French, and, during the 1920s in France, abstract painting and sculpture were largely imported products, forced to struggle for survival against the influences of the older masters of modern art as well as the sensation created by the surrealists. Although Picasso, Braque, and even Matisse had come close to abstraction before and during World War I, they did not take the final steps; and in the next decades they pursued their individual paths. Of the cubists, Delaunay, one of the pioneers of abstraction, during the 1920s was principally interested in cubist figuration, although after 1930 he returned to abstraction in painting and sculpture; Léger painted a number of quite abstract mural designs during the 1920s. The purism of Ozenfant and Jeanneret during its short life continued to cling to the object. The influence of Dutch De Stijl and Russian constructivism and suprematism was more apparent in Germany than in France during the 1920s, partly because of the Bauhaus and partly because France has been less receptive to imported influences in modern art. When the De Stijl artists held an exhibition in 1923 at the gallery of Léonce Rosenberg, it aroused little general interest. Mondrian, then living in Paris, could sell nothing, and secretly painted flower pictures to earn a living.

In 1925 a large exhibition of contemporary art was organized in Paris by a Polish painter, Poznanski, at the hall of the Antique Dealers Syndicate. Among those included were Arp, Baumeister, Brancusi, the pioneer American abstractionist Patrick Henry Bruce (1880–1937), Robert and Sonia Delaunay, Van Doesburg, César Domela, Goncharova, Gris, Klee, Larionov, Léger, Louis Marcoussis, Miró, Moholy-Nagy, Mondrian, Ben Nicholson, Ozenfant, Enrico Prampolini, Victor Servranckz, Vantongerloo, Jacques Villon, and Friedrich Vordemberge-Gildewart. The purpose of the exhibition was stated as "not to show examples of every tendency in contemporary painting, but to take stock, as completely as circumstances permit, of what is going on in *non-imitative plastic art,* the possibility of which was first conceived of by the cubist movement." There are obvious omissions, such as the Czech Kupka, one of the first abstract painters in Paris; nevertheless, it was a surprisingly comprehensive showing of abstract tendencies. In the face of the rising tides of representation and surrealism, however, it did not attract wide attention.

The next major event in the history of abstraction in Paris did not come until 1930, when the artist-critic Michel Seuphor and the Uruguayan painter Joaquin Torres-Garcia founded the group and periodical entitled *Cercle et Carré* (Circle and Square). The first exhibition, held in April 1930, on the ground floor of the building in which Picasso lived, included Arp (always *persona grata* with both surrealists and abstractionists), Baumeister, Jean Gorin (a new French disciple of Mondrian), Kandinsky, Le Corbusier, Léger, Mondrian, Ozenfant, Pevsner, Prampolini, Russolo, Schwitters, the American futurist Joseph Stella, Sophie Taeuber-Arp, Torres-Garcia, Vordemberge-Gildewart, and Vantongerloo. Also shown, according to Seuphor, but not in the catalogue, were Otto Freundlich from Germany, Jean Xceron from the United States, Moholy-Nagy, Hans Richter, and Raoul Hausmann.

The periodical and the exhibition, although short-lived, had a considerable impact. Their impetus and their mailing lists were taken over by Vantongerloo and Auguste Herbin, upon the formation in 1931 of a comparable group, Abstraction-Création, with a periodical of the same name. Herbin had pursued a long, slow path toward abstraction from about 1906 to the end of the 1920s. During the early 1920s he returned to representation, but by 1927 he had again become completely abstract. Abstraction-Création, both in its exhibitions and its publications, was a force for abstract art until 1936. After World War II it was succeeded by the Salon des Réalités Nouvelles, which carried on the battle for abstract art, in particular for the tradition of Mondrian and constructivism.

In the early 1930s the rise of nazism in Germany brought more of the older masters of abstraction to Paris. Gabo moved there from Berlin in 1932, rejoining his brother Pevsner, who had lived in Paris during the 1920s. Kandinsky came in 1933, followed by many younger abstractionists.

The mixture of artists from Russia, Holland, Germany, and France itself, as well as from other countries, resulted in a gradual breaking down of distinctions. By the mid-1930s, despite the general coolness of the French to geometric abstraction, Abstraction-Création on occasion had as many as four hundred members—from suprematism, constructivism, De Stijl, and their many offshoots. With the exception of Mondrian, who adhered rigidly to his basic principles, most abstractionists took from each source whatever they needed. Even

Van Doesburg's elementarism (see p. 238), with its departure from the vertical-horizontal axis in favor of the diagonal, owed much to suprematism, as did a large proportion of Kandinsky's paintings of the 1920s and 1930s.

Of the newer converts to geometric abstraction, César Domela, born in Amsterdam in 1900, joined the De Stijl group in Paris in 1924, and attempted during the 1920s to combine the austere, open forms with which Mondrian was then working with the tilted planes of the later Van Doesburg (fig. 651). From this he passed to relief constructions embodying forms of these artists and, later, some of Kandinsky's, in combinations of glass and metal. This interest in painting-relief has continued since, but he has deserted the straight line for linear arabesques derivative from art nouveau.

Friedrich Vordemberge-Gildewart (b. 1899) was German, a member of both the Sturm and De Stijl. In Germany he was affected by El Lissitzky, but out of the various sources of De Stijl, suprematism, and constructivism he was able to develop a personal and consistent style in both painting and relief construction, a style of simplicity and clarity that has nevertheless enlarged the vocabulary of abstraction (fig. 652).

Otto Freundlich (1878–1943) belonged to an older generation. He exhibited with the cubists and turned to abstraction after World War I. During the 1930s he painted in a warm, atmospheric manner, organizing his canvas in small irregular rectangles of color, each of which built up to larger units (fig. 653). Works of singular individuality resulted, which, although totally abstract, were reminiscent of cubist paintings by Juan Gris or some cubist-inspired works by Franz Marc. Freundlich died in a concentration camp in Poland in 1943.

Auguste Herbin (1882–1960), Jean Gorin (b. 1899), and Jean Hélion (b. 1904) were the three French painters to emerge from the abstract environment during the 1930s. Herbin, as noted, had grown up in the atmosphere of early cubism, but from the beginning was interested in pursuing his own researches on color and its interrelationships, based on the color theory of Goethe. By the end of World War I his abstract paintings were startling in the impact of their colors and geometric shapes.

653. OTTO FREUNDLICH. *The Unity of Life and Death.*
1936–38. 47⅛ x 35½". Collection Mrs. Barnett Malbin,
Birmingham, Michigan

654. AUGUSTE HERBIN. *Rain*. 1953. 45⅝ x 35".
Galerie Denise René, Paris

655. JEAN GORIN. *Composition No. 8*. 1964. Painted wood,
25⅝ x 25⅝". Collection F. Graindorge, Liège, Belgium

In the 1920s he turned briefly to representation, applying his ideas about color and abstract shapes to landscape and figure. About 1927 he went back to abstraction and has followed this path since, in a manner that seems to have particular pertinence for younger hard-edge painters, pop artists, or sculptors. Although *Composition, 1939* (colorplate 178), owes something to Delaunay's paintings of the 1930s, the dynamics of his color shapes are entirely his own. In a typical post-war painting, *Rain, 1953* (fig. 654), the forms assume a hypnotic presence, through the flat, intense color and the frankly mathematical shapes. When they are studied, the color relations form optical illusions. In fact, Herbin is an important pioneer in retinal or optical painting. He has written effectively of his theories of color, its relations, and its psychological impact.

Neither of the other two French members of the abstract community in Paris have arrived at so individual a form of expression, but both are artists of distinction. Hélion, after developing a personal, abstract style influenced both by Mondrian and the machine forms of Léger, returned to representational painting. *Composition, 1934* (colorplate 179), illustrates the lyrical, graded colors, and the flat or modeled shapes, floating on a color ground, that give his abstract paintings romantic-expressive overtones. Jean Gorin, in his paintings and reliefs, has remained a faithful follower of Mondrian, although in late works he has introduced circular and di-

agonal shapes. He managed to perpetuate—more precisely, perhaps, than any of Mondrian's followers—the sense of spacing, of vertical-horizontal relations of lines and color rectangles (fig. 655).

## ANTON PEVSNER AFTER 1923

Pevsner left Russia in 1923, after his younger brother Naum Gabo had moved to Berlin, and in 1924 settled in Paris. About 1925 he began to work seriously in abstract constructed sculpture, apparently with the advice and encouragement of his brother. There is some confusion about the part played by Pevsner in the founding of Russian constructivism. (It is sometimes difficult to trace the origins of art movements or the development of individual artists, partly because artists become art-history-minded and concern themselves with questions of chronological priority. For the documentation of the rise of abstract art in Russia during World War I and the Russian revolution, there are further complications owing to the isolation, general confusion, and lack of adequate contemporary publications.)

Considering Pevsner's late start (he was forty years old in 1925), his subsequent development into one of the major constructivists is all the more remarkable. Since the *Portrait of Marcel Duchamp* (fig. 656) was commissioned by the Société Anonyme in 1926, we may accept the work—an open plastic construction based on Gabo —as a starting point for the artist's sculpture. By the end

of the 1920s Pevsner had abandoned construction in plastics (with a few exceptions) in favor of direct-metal abstractions in bronze or copper. He established his own identity as a sculptor not only in his choice of different materials but, more important, in the individual style of construction that he formulated over the next twenty years. *Construction in Space,* 1929 (fig. 657), is a crisp, dynamic machine form, engineered in the most accomplished fashion. Despite this precision, Pevsner has categorically denied, quite correctly, any mathematical basis in the organization of his mature works.

In such a piece as *Projection into Space,* 1938–39 (fig. 658), he perfected his technique and his sculptural conceptions. The work is polished bronze, not cast but hammered out to machine precision. Faithful to the Realistic Manifesto (see p. 224), he has taken space as his primary means of expression, complete three-dimensional space articulated as tangibly as Bernini in the seventeenth century articulated his figures to express the space that surrounded them. Gabo was drawn to transparent plastic materials by his desire to make of space the paramount sculptural medium defined only in a minimal sense by lines or imperceptible planes. Pevsner was at-

657. ANTON PEVSNER. *Construction in Space.* 1929. Burnt sheet brass and glass, height 27⅛". Kunstmuseum, Basel. E. Hoffmann Collection

656. ANTON PEVSNER. *Portrait of Marcel Duchamp.* 1926. Celluloid on copper, 37 x 25¾". Yale University Art Gallery, New Haven, Connecticut. Société Anonyme Collection

658. ANTON PEVSNER. *Projection into Space.* 1938–39. Bronze and oxidized copper, 21½ x 15¾ x 19¾". Collection Frau M. Sacher-Stehlin, Pratteln, Switzerland

of thin reeds spinning in space. For some reason, the tight, linear construction seems to accelerate the tempo of the spiraling motion; the illusion is perhaps accentuated by the horizontal elements flying out at right angles from the compressed waist of the hourglass construction. By the mid-1940s, Pevsner was sufficiently in control of his bronze structures to revert to a frontalized, totemistic form with perspective recessions moving back from an invisible picture plane in a tour de force of reality imitating illusion (*Oval Fresco,* 1945, fig. 660).

Pevsner's bronze constructions, in which he wrapped planes of metal in rhythmic spirals around definable depth, lent themselves to monumental scale, and he was able to carry out several large architectural commissions. The most dramatic was at the University of Caracas, Venezuela (where Alexander Calder's acoustical ceiling is also to be found), the *Dynamic Projection in the 30th Degree,* 1950–51 (fig. 661), which is over eight feet high. This is a sweeping diagonal form that combines solidity of shape with the freedom of a vast pennant held rigid by the force of a tornado wind. Until his death in 1962, Pevsner was the major exponent of abstract constructed sculpture working in Paris. Although he seemed isolated during these years, just as Brancusi also seemed isolated in Paris, his influence was slowly spreading through the world.

659. ANTON PEVSNER. *Developable Column.* 1942. Brass and oxidized bronze, height 20¾". The Museum of Modern Art, New York

tracted by the relations between tangible space and tangible planes and lines, in materials sufficiently dense to define both the enclosed and the surrounding space. In this sense he was a more traditional sculptor, carrying on the concepts of space definition first fully stated in Hellenistic sculpture and then in that of the Baroque. However, there are differences. *Projection into Space* is a group of abstract, spiraling shapes whose rotating effect is accentuated by the radiating lines on the curving planes. It is a work whose structure carries the eye of the spectator around the perimeter and almost forces him to walk around it and view it from different points of view. As against a Hellenistic or Baroque sculpture it is a series of curving planes that not only define surrounding space but, more important, enclose space as the walls of a building enclose architectural space. The other important feature here and in much of Pevsner's subsequent sculpture is the dynamism of the spiraling planes, the illusion of movement in a static design. This quality probably derives from such futurist sculptures as Boccioni's *Bottle Unfolding in Space,* but here is given increased dynamism by the elimination of the subject, the bottle; we are left with the spiraling movement as an abstract but concrete fact.

In subsequent works (*Developable Column,* 1942, fig. 659) the artist massed his linear ridges so closely that the entire structure seems to be composed of a tight mass

660. ANTON PEVSNER. *Oval Fresco.* 1945. Bronze and oxidized tin, 31½ x 18¼". Whereabouts unknown

661. ANTON PEVSNER.
*Dynamic Projection
in the 30th Degree.*
1950–51. Bronze, height over 96".
Aula Magna, University City,
Caracas, Venezuela
(Carlos Raúl
Villanueva, architect)

## MONDRIAN AFTER 1920

Mondrian lived in Paris between 1919 and 1938 and, although he did not take the initiative in the organization of Cercle et Carré or Abstraction-Création, his presence and participation were of the greatest significance for the growth and spread of abstraction. As already noted, he had resigned from De Stijl in 1925 after Van Doesburg introduced the diagonal as part of its vocabulary. Painting and writing on his theories, he fully formulated his ideas during the 1920s.

In 1919 Mondrian had found his solution to the problem with which he had been struggling for several years —how to express universals through a dynamic balance of vertical and horizontal structure, with primary hues of color disposed in rectangular areas. He was disturbed by the fact that up to this point, in most of his severely geometric paintings—including the floating color-plane compositions and the so-termed grid or checkerboard paintings—the shapes of red, blue, or yellow seemed visually to function as foreground forms against a white and gray background, and thus to interfere with total unity. The solution, he found, lay in making the structure independent of color, with heavy lines (which he never thought of as lines in the sense of edges) moving through the rectangles of color. By this device he was able to gain a mastery over color and space that he did not exhaust in the next twenty years.

The perfected formula is seen in *Tableau II,* 1921–25 (colorplate 180). Here is the familiar palette of red,

blue, yellow, black, and two shades of gray. The total structure is emphatic, not simply containing the color rectangles but functioning as a counterpoint to them. Both red and gray areas are divided into larger and smaller rectangles. The black rectangles, since they are transpositions of lines to planes, act as further unifying elements between line and color. Mondrian is careful to leave the edges of the painting open: along the top and in the lower left corner he does not bring the verticals quite to the edge, with the consequence that the grays at these points surround the end of the lines. Only in the lower right does the black come to the edge, and this is actually a black area through which the line moves slightly to the left of the edge. In all other parts a color, principally gray, but red and yellow at upper left, forms the outer boundary. The result that Mondrian sought—an absolute but dynamic balance of vertical and horizontal structure, using primary hues and black and white—is thus achieved. Everything in the painting holds its place visually. By some curious visual phenomenon, caused by the structure and the subtle disposition of color areas, the grays are as assertive as the reds or yellows; they advance as well as recede. The painting is not in any sense of the word flat. Everything is held firmly in place, but under great tension.

During 1921 the artist played a dozen different variations on his solution, as though testing its validity. Then, late in 1921, he attempted a still more open and austere composition; now the predominant colors were white, light gray, or light blue, with primary hues used only as

small accents. The linear structure, although sometimes heavy in its elements, was also held to a minimum. In *Composition with Red, Yellow, and Blue,* 1921 (colorplate 181), the heavy black lines define one major gray-white square surrounded by smaller rectangles of the same gray-white, and of light blue, red, yellow, and deep blue. The two largest areas, the central square and the top right rectangle, are the same off-white—although divided by a black line—and this makes them visually a single dominant unit, holding the small accents of brilliant hues effectively in their subordinate places.

The open composition with emphasis on large white or light-gray areas predominated in Mondrian's production during the 1920s, and in fact for the rest of his life At the end of the 1920s he did reverse the process in a number of paintings in which the structure of the lines is comparably simple, but the dominating color areas are one or another of the primaries at maximum intensity. *Composition with Red, Blue, and Yellow,* 1930 (colorplate 182), is a square canvas with a large color square of red, upper right, joined point to point by intersecting black lines with a small square of comparably intense blue, lower left. Surrounding them, equally defined by heavy black lines, are rectangles of off-white. In the lower right corner is one small rectangle of yellow. The curious fact about this painting is again that the white areas, combined with the subordinate blue and yellow, effectively control and balance the great red square. It is as though Mondrian, in command of all the elements of abstract painting, now feels confident that he can keep even the most assertive colors under absolute control.

Once having satisfied himself of this fact, he returned to an intensive examination of the open composition in which color was subordinated to a subtle variation on vertical-horizontal linear patterns on a neutral white or off-white ground, with minimal accents of positive color. This approach he followed during the 1930s in a refinement of his elements and relations. *Composition in White, Black, and Red,* 1936 (fig. 662), is almost totally a structure of vertical and horizontal black lines on a white ground, with a small black rectangle in the upper left corner and a long red strip at the bottom. The lines, however, represent intricate proportions, both in the rectangles they define and in their own thickness and distribution. In the right lower corner horizontal lines, varied subtly in width, create a grid in which the white spaces seem to expand and contract in a visual ambiguity.

In further variations the artist turned from canvases of square or almost square shape to the diamond shape—the square turned on edge. This shape inspired some of his most austere designs, in which his desire to violate the frame, to express a sense of incompleteness, was given tangible expression. *Composition with Yellow Lines,* 1933 (fig. 663), is prophetic in its use of primary yellow lines rather than black, and represents an ultimate simplification in its design of four lines, delicately adjusted in width, and cutting across the angles of the diamond. Mondrian's fascination with the incomplete within the complete, the tension of lines cut off by the edge of the canvas that seek to continue on to an invisible point of juncture outside the canvas, is nowhere better expressed than here. The desire of the lines to rejoin and complete themselves, to recover the square, is almost painful. The fascination of the painting also lies in another direction —the abandonment of black—a premonition of the *Victory Boogie-Woogie* of 1943–44 (colorplate 183).

In 1938, with the approach of war, Mondrian left Paris for London; after two years he moved to New York, where he spent his final four years. Manhattan became the last great love of his life, perhaps because of the neo-plastic effect created by skyscrapers rising from the narrow canyons of the streets and the rigid grid of its plan. The major new stimulus to the artist was that of lights at night, when the skyscrapers were transformed into a brilliant pattern of light and shadow, blinking and changing. Mondrian also loved the tempo, the dynamism, of the city; the dance halls, the jazz bands, the excitement of movement and change. He felt driven to translate it into his seemingly austere patterns of rectangular linear structures and color shapes. When we look at his impressions of New York, we must recall that he was originally and temperamentally a landscapist. He had spent twenty-three years—1888–1911—studying the Dutch landscape or still lifes associated with that landscape. For the next five years his developing abstractions were still rooted in landscape. He was extremely sensitive to his surroundings and the experience of New York, which held a romantic attraction, proved to be overwhelming.

The impact of the city is most evident in *Broadway Boogie-Woogie,* 1942–43 (colorplate 184). Here the artist returned to the square canvas but departed radically from the formula which had occupied him for over twenty years. There is still the rectangular grid; but the black,

662. PIET MONDRIAN. *Composition in White, Black and Red.* 1936. 40¼ x 41". The Museum of Modern Art, New York. Gift of the Advisory Committee

663. PIET MONDRIAN.
*Composition with Yellow Lines.*
1933. 52⅜ (on the diagonal).
Gemeente Museum, The Hague, The Netherlands

linear structure balanced against color areas is gone. In fact, the process is reversed: the grid itself is the color, with the lines consisting of little squares or rectangles of red, yellow, and blue. The ground is a single plane of off-white, and against it vibrate the varicolored lines and scattered areas of red, yellow, and blue. One can "read" the night facades of office buildings with blinking window lights.

In evaluating the course of geometric abstraction from its beginnings, about 1911, to the present time, an understanding of the part played by Piet Mondrian is of paramount importance. He was the principal figure in the founding of geometric abstraction during World War I; the ideas of De Stijl and their logical development were primarily his achievement. Mondrian's influence extended not only to abstract painting and sculpture but to the forms of the international style in architecture as well. Through the teachings of the Bauhaus in Germany and its offshoots in the United States, his theories were spread throughout the Western world. During the 1920s and 1930s in Paris it was probably the presence and

inspiration of Mondrian more than that of any other single person that enabled abstraction to survive and gradually to gain strength—in the face of the revolution of surrealism and the counterrevolution of representation, economic depression, threats of dictatorship, and war.

In the United States he was a legendary figure inspiring not only the geometric abstractionists, who had been carrying on a minority battle against social realism and regionalism, but also a number of younger artists who were to create a major revolution in American art. The emerging abstract expressionists of the early 1940s almost without exception had the greatest respect and even reverence for Mondrian, even though their painting took directions that would seem diametrically opposed to everything he believed in. And, finally, when one examines recent tendencies in American abstract painting—hard-edge abstraction, optical painting, or color-field painting—in almost every case a line may be traced to Mondrian. His impact on the course of twentieth-century art may even have transcended that of Picasso, Braque, or Matisse.

# PART TWENTY

# PAINTING AND SCULPTURE IN THE UNITED STATES TO 1945

With the so-called Armory Show, early in 1913, the provincialism of American art, for the first time, became apparent. Although substantially outnumbered by Americans, the European artists constituted a revelation to the public and particularly to American artists and collectors. Despite the expatriates—Whistler, Cassatt, Sargent; despite the introduction of French impressionism to the United States; and despite the fact that many American artists at the end of the last century studied in Italy, Germany, or France, the first modern American revolution in painting was not away from, but toward, realism; not toward experiment with form, only toward new pictorial subject matter. This anomaly is explained in part by the fact that the academic spirit had become anathema to young painters around 1900. The ash can school (or the eight: Robert Henri, George Luks, John Sloan, William Glackens, Everett Shinn, Maurice Prendergast, Arthur B. Davies, and Ernest Lawson) defied the proprieties of academic art, some turning to realistic representations of urban life, others to impressionism.

The tradition of realism and impressionism represented by the eight remained a force in American painting until World War II. In fact, social and regional realism dominated the American scene during the 1930s although, at the same time, European modernism was beginning to have an impact. This impact was a natural consequence of the fact that American artists continued to visit and study in Europe. The most important single factor, aside from the Armory Show, in the birth of the modern spirit, was Alfred Stieglitz who, in his small gallery at 291 Fifth Avenue, showed many European pioneers and championed American experimentalists (see p. 301).

Stieglitz, one of the great photographers of the twentieth century, expanded his program in 1907 to include painting and sculpture, and in 1908 a large exhibition was held of Rodin's drawings. Over the next ten years Stieglitz, assisted by another great photographer, Edward Steichen, showed Matisse, Toulouse-Lautrec, Rousseau, Picasso, Brancusi, Severini, and Picabia, as well as African primitive art. Among the Americans shown were Max Weber, John Marin, Georgia O'Keeffe, Stanton Macdonald-Wright, Arthur Dove, Marsden Hartley, Alfred Maurer, and the sculptor Elie Nadelman. These constituted the American pioneers of international modernism. Most of them had worked in Europe—principally Paris—before 1914, and were familiar with the exhibitions at the Salon des Indépendants and the Salon

d'Automne. Weber and Patrick Henry Bruce, among other Americans, studied with Matisse as early as 1907–08. Lyonel Feininger, as already noted, was associated with the modern movement in Germany from its inception.

## Pioneers of American Modernism

ALFRED H. MAURER *(1868–1932),*

MAX WEBER *(1881–1961),*

MARSDEN HARTLEY *(1877–1943)*

The American pioneers of modernism practiced styles ranging from fauve expressionism to cubism and abstraction. Alfred H. Maurer concentrated on expressionist portraits and cubist studies of heads.

Max Weber absorbed the lessons of the fauves and cubists almost from the beginning of his career and then, as with a number of American pioneers, turned to a form of romantic expression. *Chinese Restaurant,* 1915 (colorplate 185), was his most ambitious excursion into cubism, but the optical insistence on the checkerboard pattern relates it as well to the American tradition of *trompe-l'oeil.* Toward the end of World War I the artist abandoned cubism for a form of linear expression related to Chagall and Soutine.

Marsden Hartley discovered the Blaue Reiter in Berlin in 1912. The German flag series, painted about 1914, were his most effective abstractions, deriving from cubism or the orphist abstractions of Delaunay but different in impact. It is not correct to refer to these as abstractions, since Hartley used the colors and images of the German flag literally, though broken up and reorganized, to symbolize the aggressive war spirit he found in Germany in 1914 (*Portrait of a German Officer,* 1914, colorplate 186). His flag series influenced experimental American painters from Stuart Davis to Jasper Johns.

## JOHN MARIN *(1870–1953)*

The other artists whom Stieglitz continued to exhibit and promote—John Marin, Arthur Dove, and Georgia

O'Keeffe—were all very different from Hartley, Maurer, Weber and from one another. Taken together, these six painters personify the different ways in which modern art was first brought to the United States, and its advances and retreats during the first forty years of the century.

John Marin, one of the chief American masters of watercolor painting, was in Europe between 1905 and 1911. Perhaps his greatest single source was the late watercolors of Cézanne; cubist structure was the controlling force throughout Marin's life, particularly the dynamic cubism of Delaunay and the futurists. Early paintings of New York commemorate the tempo of the city, just as Delaunay's Eiffel Tower paintings reflected that of Paris. In summers, the artist painted the Maine coast. *Maine Islands*, 1922 (fig. 664), summarizes his approaches to nature and abstraction, to perspective and cubist space, and to the expression of materials. During the 1920s and 1930s Marin carried his interpretations of New York closer to a form of expressive abstraction, although again the subject is always clearly there. In *Lower Manhattan (Composition Derived from Top of the Woolworth Building)*, 1922 (colorplate 187), we have an explosion of buildings whose destructive agent seems to be the black sun with its yellow star center.

## ARTHUR G. DOVE *(1880–1946)*

Dove abandoned a career as an illustrator to go to Paris in 1907 and become a painter. His paintings of 1910, to which he gave the name abstractions, have some residue of subject matter—suggestions of buildings or landscapes—but they are nevertheless as close to a non-objective image as were the paintings of the same time, by Kandinsky, whose work Dove knew. In his two years of study, Dove seems to have absorbed remarkably the entire course of modern European art.

He soon felt the need to return to a greater degree of representation, but throughout his life he was concerned with the spiritual forces of nature rather than its external forms. Like many American artists, he was affected by the emergence of European surrealism during the 1920s, but his fantasy belonged more with the American romanticism of Albert P. Ryder or the symbolism of Odilon Redon. During the 1930s his sense of fantasy was at its height, with landscapes transformed into monsters, or his favorite image, the sun or moon, transformed into a great Cyclops' eye (*Ferry Boat Wreck—Oyster Bay,* 1931, fig. 665). His paintings did not change until the 1940s, when he experimented with geometric abstraction.

Even in his most abstract works, such as *That Red One,* 1944 (colorplate 188), the sense of organic nature and of his personal fantasy remains, with the geometric

above: 664. JOHN MARIN.
*Maine Islands.* 1922.
Watercolor, 16¾ x 20".
The Phillips Collection,
Washington, D.C.

left: 665. ARTHUR G. DOVE.
*Ferry Boat Wreck—Oyster Bay.*
1931. 18 x 30".
The Whitney Museum
of American Art, New York.
Gift of Mr. and Mrs. Roy R.
Neuberger (and purchase)

shapes transforming themselves into a black, dead sun in a cosmic spacescape.

An aspect of Dove's achievement now in process of re-evaluation is his collages, produced principally during the 1920s. He was aware of the evolution of cubist collage, but his own efforts have more in common with nineteenth-century American folk art and *trompe-l'oeil*

666. ARTHUR G. DOVE. *Goin' Fishin'*. 1925. Collage, 19½ x 24″. The Phillips Collection, Washington, D.C.

667. GEORGIA O'KEEFFE. *Black Iris*. 1926. 36 x 29⅞″. The Metropolitan Museum of Art, New York. The Alfred Stieglitz Collection, 1949

paintings, and the collages and assemblages of the dadaists. He knew of the activities of the New York dadaists Marcel Duchamp, Man Ray, and Picabia during World War I. His own collages range from landscapes made up literally of their natural ingredients—sand, shells, twigs, and leaves—in a folk-art assemblage, to satiric *papiers-collés*. *Goin' Fishin'*, 1925 (fig. 666), an assemblage of fragmented fishing poles and denim shirt sleeves, is a work that seems more in an American tradition extending from the nineteenth century and is related to the fascinating constructions, much later, of Joseph Cornell, and the giant shirts and soft constructions of Claes Oldenburg.

## GEORGIA O'KEEFFE *(b. 1887)*

Georgia O'Keeffe differs from most of the other American pioneers of modernism in that her training was entirely native, and it is difficult to describe any specific, direct influence from European modernism. From the beginning, her imagery, whether the subject was New York skyscrapers, enormously enlarged details of flowers, bleached cow skulls or pelvises, Western barns or adobe churches, involved a precision of linear presentation that somehow turned the work into an abstraction (*Black Iris*, 1926, fig. 667). Such sharp-focus, close-up details may also reveal the influence of the expanding art of photography as practiced by Stieglitz.

## STANTON MACDONALD-WRIGHT *(b. 1890),*
## MORGAN RUSSELL *(1886–1953),*
## PATRICK HENRY BRUCE *(1880–1937),*
## JOSEPH STELLA *(1877–1946)*

Among the American painters most closely associated with French cubism and Delaunay's orphism were Stanton Macdonald-Wright and Morgan Russell. Both were in Paris before 1910 and both were interested in the color theories of Chevreul and Von Helmholtz. Their two-man movement they entitled synchromism. The abstract paintings, or synchromies, that resulted were close to the orphism of Delaunay and Kupka and probably were inspired by them, despite intense rivalry and vehement assertions of originality on the part of the Americans. For a few years, synchromism did produce a number of individual abstractions in which the properties and relations of pure color were explored. *Abstraction on Spectrum (Organization, 5)*, 1914 (colorplate 189), by Macdonald-Wright, may owe much to Delaunay's disks, but it has a freshness, even an aggressive expressiveness, that adds separate dimensions. Morgan Russell's most monumental work, *Synchromy in Orange: To Form* (fig. 668), illustrates his denser, less lyrical handling of color, but the same concern with structure built on planes of color. The synchromists showed in Munich and at the Galerie Bernheim-Jeune in Paris during 1913, and in New York in 1914.

Another American associated with synchromism and orphism was Patrick Henry Bruce, who worked with Matisse and Delaunay. Bruce was obsessed with creating

668. MORGAN RUSSELL. *Synchromy in Orange: To Form.*
1913–14. 11′ 3″ x 10′ 3″. The Albright-Knox Art Gallery,
Buffalo, New York. Gift of Seymour H. Knox

669. PATRICK HENRY BRUCE. *Painting.* c. 1930.
35 x 45¾″. The Whitney Museum of American Art, New York

works that "by reason of their structural qualities, could be looked at from four sides." In *Composition III,* 1916–17 (colorplate 190), one can observe his characteristic manner of laying on paint in flat, matte color areas of black, red, yellow, violet, and blue, in building such a structure. During the 1920s and 1930s, the sculptural or architectural concept became more explicit in his paintings as he placed three-dimensional geometric shapes within a limited though clearly stated extension into space (*Painting,* c. 1930, fig. 669). The three-dimensional geometric objects, created out of flat, hardedge area combinations, are designed as shapes to emphasize multiple views. Other American painters, Morton Schamberg, Andrew Dasburg, and Thomas Hart Benton, tried their hands at forms of synchromist painting but, by the end of World War I, the movement had largely ceased to exist and most of the artists involved, with the exception of Bruce and Russell, were returning to figuration.

Of the artists who brought specific aspects of European modernism to the United States, perhaps the most talented was Joseph Stella. Born in Italy, he came to the United States in 1902; between 1909 and 1912 he was in France and Italy. In Italian futurism he found his specific inspiration and for a number of years produced works that, in their linear dynamism and coloristic brilliance, compare favorably with those of Boccioni or Severini. To the Italian futurists the United States of the early twentieth century was a romantic ideal—a world of exploding energy, new frontiers, expanding industry, and unlimited opportunity. Stella brought this romantic enthusiasm to his interpretations of New York. His masterpieces are his

670. JOSEPH STELLA. *Brooklyn Bridge.* 1917–18.
84 x 76″. Yale University Art Gallery, New Haven,
Connecticut. Gift of the Société Anonyme

several versions of the Brooklyn Bridge, that beautiful construction that had become a symbol of New York. The earliest version, 1917–18 (fig. 670), is the most explicitly futurist in the dynamism of its geometric linear pattern, the luminosity of its color, its kaleidoscopic mingling of shifting views. The effect may also reflect the influence of the cinema, then reaching its first maturity.

# The Armory Show

The event of first significance to the modern art movement in the United States was the International Exhibition of Modern Art, held in New York at the Armory of the 69th regiment, between February 17 and March 15, 1913. The exhibition was a sensation, and while the lay press covered it extensively (and at first with praise), the show was savagely attacked by critics and American artists. Matisse was singled out for abuse, as were the cubists; Duchamp's *Nude Descending the Staircase* enjoyed a *succès de scandale,* identified as "an explosion in a shingle factory."

As a result of the controversy, an estimated 75,000 people attended the exhibition. In Chicago, where the European section and approximately half the American section were shown at the Art Institute, nearly 200,000 visitors crowded the galleries. Here the students of the Art Institute's school, egged on by their faculty, burned Matisse and Brancusi in effigy. In Boston, where some 250 examples of the European section were shown at Copley Hall, the reaction was more tepid.

By any standard the Armory Show was a remarkable achievement. Although many of the American artists exhibited have disappeared into limbo, a high percentage of those who are regarded as the pioneers of modernism were included. The European section was extraordinarily complete. Only the Italian futurists were not included, perhaps because they insisted on being shown as a group. German expressionism was slighted, with the exception of Kandinsky, Kirchner, and one or two others. French progressive painting and sculpture, on the other hand, was not only comprehensive but excellent in quality.

The full impact was not absorbed for another thirty years, but almost immediately there were evidences of change in American art and collecting. New galleries dealing in modern painting and sculpture began to appear. Although communications were soon to be interrupted by World War I, more American artists than ever were inspired to go to Europe for study. American museums began to buy and to show modern French masters.

Despite the unquestionable impact of the Armory Show on American artists, it is difficult to detect immediate, direct influences from the European art exhibited. One problem was that the exhibition was a panorama of all modern art for a century, with emphasis on the older masters Cézanne, Odilon Redon, Rousseau, Gauguin, and Van Gogh. Cubism, then the dominant new style in France, received less attention than fauvism, which had already passed into history. Cubism was then changing from its analytical to its synthetic stage, and one can find virtually no evidence of analytical cubism among Americans; yet, almost all the Americans associated with cubism, orphism, or futurism had studied in Europe before the Armory Show. Marcel Duchamp's presence in the United States was originally a result of World War I, but was specifically inspired by his success at the Armory Show. Together with Francis Picabia and the young American painter, Man Ray, he became, as noted, the center of the New York wing of international dada, and Duchamp has continued to be an important force in American art since then. Probably because of his association with Duchamp and Picabia during the war years Man Ray, alone, developed in New York a form of synthetic cubism of considerable originality and authenticity (*The Rope Dancer Accompanies Herself with Her Shadows,* 1916, fig. 671).

671. MAN RAY.
*The Rope Dancer Accompanies Herself with Her Shadows.*
1916. 52 x 73⅜".
The Museum of Modern Art, New York. Gift of G. David Thompson

414

# The Precisionists

The most significant manifestation of a new spirit in American art during the 1920s was the movement to which the name precisionism has been given. It has also been labeled cubist-realism or cubo-realism; and the precisionists are sometimes unhappily known as immaculates. All these labels refer to an art that is realistic at base, but controlled in one way or another by geometric simplification that stems from cubism. The approach of the precisionists has already been suggested in the discussion of Georgia O'Keeffe who, with Charles Sheeler, was the central figure in its formulation. Precisionism, as seen in the works of these artists, and of Charles Demuth, Ralston Crawford, and Niles Spencer, is basically a precise and frequently photographically realistic art stripped of detail to the point that it becomes abstract in its impact.

The painting of O'Keeffe until the late 1920s was largely concerned with organic subjects: flowers or plant forms in extreme close-up. She also produced occasional and sometimes romantic interpretations of architectural themes. Sheeler and Demuth favored architectural landscape; Sheeler, machine forms as well. Machine forms, given dada or surrealist overtones, were also favorite subjects of Morton Schamberg, who was probably the closest to the circle of Marcel Duchamp. Some of the precisionists met regularly with members of New York dada at the collector Walter Arensberg's apartment for all-night discussions on the state of art and the world.

## CHARLES SHEELER (*1883–1965*)

*Church Street "El"*, 1922 (fig. 672), by Sheeler is, in its severity and elimination of details, closer to geometric abstraction than to cubist painting. There is really no distortion of the architecture, no shifting or multiple views as in cubism. There is simply a high degree of selection of those details—arbitrary patterns of light and shadow and flat color which transform themselves into abstract patterns. Sheeler employed this manner in paintings of factory scenes or machine close-ups—admiring symbols of the expanding world of industry, and the identical attitude is found in studies of his own living room.

## CHARLES DEMUTH (*1883–1935*)

Charles Demuth, a Pennsylvanian, was the third major figure of the first generation precisionists. His developed works were the closest to French cubism. His first mature works were illustrations for books, as well as imaginative studies of dancers, acrobats, and flower or plant forms, free and organic in treatment, seemingly at the other extreme from a precisionist style. In a number of landscapes executed in watercolor in Bermuda in 1917, using interpenetrating and shifting planes and suggestions of multiple views, he began his experiments with abstract lines of force, comparable to those used by Italian futurists or by Lyonel Feininger (*Bermuda No. 2—The Schooner*, 1917, fig. 673). In his late works Demuth ex-

672. CHARLES SHEELER. *Church Street "El"*. 1922. 16 x 18½". Collection Mrs. Earle Horter, Phildelphia

673. CHARLES DEMUTH. *Bermuda No. 2—The Schooner.* 1917. Watercolor, 10 x 13⅞". The Metropolitan Museum of Art, New York. The Alfred Stieglitz Collection, 1949

panded his exploration of the abstract or symbolic implications of the American scene in ways that have influenced younger artists since. He became interested in the advertising signs on buildings and along highways, not as blemishes on the American landscape but as images with a certain abstract beauty of their own (fig. 674). In this period he also produced a series of poster portraits made up of images and words and lettering associated with friends. *I Saw the Figure 5 in Gold*, 1928 (colorplate 191), is a tribute to the poet William Carlos Williams and, in fact, is based on Williams' poem *The Great Figure*, to which the painter may also have contributed: Among the rain/and lights/I saw the figure 5/ in gold/on a red/firetruck/moving/tense/unheeded/to gong clangs/siren howls/and wheels rumbling/through the dark city.

674. CHARLES DEMUTH. *Buildings, Lancaster.* 1930.
Oil on composition board, 24 x 20". The Whitney Museum
of American Art, New York. Anonymous Gift

675. MORTON L. SCHAMBERG. *Machine.* 1916. 30⅛ x 22¾".
Yale University Art Gallery, New Haven, Connecticut.
Collection of the Société Anonyme.
Bequest of Katherine S. Dreier

The numerous references to Williams in the painting
are explicit. The golden 5s radiate from the center in a
futurist dynamic; buildings tilt in space, and rays of col-
or-light sweep across the middle distance and fore-
ground, tying together perspective recession and picture
plane. Demuth, despite his short career, may have been
the most talented and comprehensive in approach of the
painters associated with precisionism, and he anticipated
and influenced still another generation of magic realists
and pop artists. Stuart Davis, the major American artist
to emerge during the 1920s, has admitted with gratitude
his debt to Demuth. Today, Robert Indiana and Jasper
Johns have painted their variants on the theme of 5 as
tributes to him.

## MORTON L. SCHAMBERG (*1882–1918*)

One of the most interesting, and today still under-
valued, of the talents associated with the precisionist atti-
tude, was Morton L. Schamberg, whose career was ended
in the influenza epidemic of 1918. Schamberg was con-
cerned with a machine iconography (fig. 675) related to
that of Marcel Duchamp and Francis Picabia (see figs.
471, 472). Although he was close to Duchamp and New
York dada, his machine world did not seem to have fan-
tastic or satirical overtones. There was, rather, an admi-
ration for the beauty and precision of machines compara-
ble to Sheeler's. An exception is the sculpture *God,* c.
1918 (fig. 676), made up of an inverted plumbing trap,
and remarkably prophetic of assemblage and junk art of
four decades later.

676. MORTON L. SCHAMBERG. *God.* c. 1918. Miter box
and plumbing trap, height 10½". The Philadelphia
Museum of Art. Louise and Walter Arensberg Collection

above: Colorplate 185. MAX WEBER.
*Chinese Restaurant.* 1915.
Oil on canvas, 40 x 48″.
The Whitney Museum of American Art,
New York

*right:* Colorplate 186. MARSDEN HARTLEY.
*Portrait of a German Officer.* 1914.
Oil on canvas, 68¼ x 41⅜″.
The Metropolitan Museum of Art, New York.
The Alfred Stieglitz Collection, 1949

*above opposite:* Colorplate 187. JOHN MARIN. *Lower Manhattan (Composition Derived from Top of the Woolworth Building).* 1922. Watercolor, 21⅝ x 26⅞″. The Museum of Modern Art, New York. Acquired through the Lillie P. Bliss Bequest

*below opposite:* Colorplate 188. ARTHUR G. DOVE. *That Red One.* 1944. Oil on canvas, 27 x 36″. William H. Lane Foundation, Leominster, Massachusetts

*above:* Colorplate 189. STANTON MACDONALD-WRIGHT. *Abstraction on Spectrum (Organization, 5).* 1914. Oil on canvas, 30 x 24″. © Des Moines Art Center, Iowa. Nathan Emory Coffin Memorial Collection

*left:* Colorplate 190. PATRICK HENRY BRUCE. *Composition III.* 1916–17. Oil on canvas, 63¼ x 38″. Yale University Art Gallery, New Haven, Connecticut. Collection Société Anonyme

419

above: Colorplate 191. CHARLES DEMUTH.
*I Saw the Figure 5 in Gold*. 1928.
Oil on composition board, 36 x 29¾".
The Metropolitan Museum of Art, New York.
The Alfred Stieglitz Collection, 1949

right: Colorplate 192. STUART DAVIS.
*Rapt at Rappaport's.*
1952. Oil on canvas, 52 x 40".
The Joseph H. Hirshhorn Collection

420

Colorplate 193. STUART DAVIS. *Colonial Cubism.* 1954. Oil on Canvas, 45 x 60″.
Walker Art Center, Minneapolis

*above*: Colorplate 194. STUART DAVIS.
*Blips and Ifs*. 1963-64.
Oil on canvas, 71 x 53″.
Amon Carter Museum, Fort Worth, Texas

*right*: Colorplate 195. NILES SPENCER.
*In Fairmont*. 1951.
Oil on canvas, 65½ x 41½″.
The Museum of Modern Art, New York.
Edward Joseph Gallagher Collection

*above*: Colorplate 196.
EDWARD HOPPER.
*Early Sunday Morning.* 1930.
Oil on canvas, 35 x 60″.
The Whitney Museum of American Art,
New York

*right*: Colorplate 197.
ABRAHAM RATTNER.
*Song of Esther.* 1958.
Oil on composition board, 60 x 48″.
The Whitney Museum of American Art,
New York

Colorplate 198. MILTON AVERY. *Swimmers and Sunbathers*. 1945. Oil on canvas, 28 x 48⅛″.
The Metropolitan Museum of Art, New York. Gift of Mr. and Mrs. Roy R. Neuberger, 1951

Colorplate 199. FRANK LLOYD WRIGHT. Taliesin West, Phoenix, Arizona. Begun 1938

## STUART DAVIS (1894–1964)

Stuart Davis is the most significant American painter to emerge between the two world wars. His professional career encompassed virtually the entire span of modern art in the United States. While still a student, he exhibited five watercolors in the 1913 Armory Show and was overwhelmed by the experience of the show. His collages and paintings of the early 1920s are explorations of the everyday scene, executed in a manner which became his own but which still is a transition between nineteenth-century American *trompe-l'oeil* and pop art of the 1960s (fig. 677).

In his Eggbeater series of 1927–28 he attempted to rid himself of the last illusionistic vestiges of nature, painting an eggbeater, an electric fan, and a rubber glove again and again until they had ceased to exist in his eyes and mind except as color, line, and shape relations (fig. 678). These abstract works were followed by a series of relatively literal cityscapes, a product of his visit to Paris in 1928–29. The dialogue between reality and abstraction continued throughout the 1930s with works such as *House and Street* (fig. 679), one of the earliest examples of a divided composition in which the shift of point of

678. STUART DAVIS. *Egg Beater #1 (Abstraction)*. 1927. 27 x 38¼ ". The Phillips Collection, Washington, D.C.

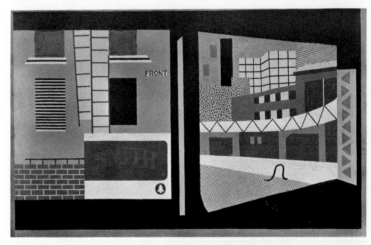

679. STUART DAVIS. *House and Street*. 1931. 26 x 42¼ " The Whitney Museum of American Art, New York

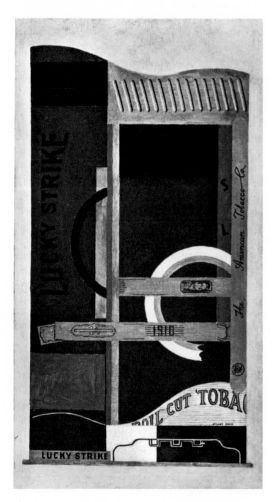

677. STUART DAVIS. *Lucky Strike*. 1921. 33¼ x 18".
The Museum of Modern Art, New York

view between right and left side suggests the frames of motion picture film, with a consequent linking of simultaneous and consecutive vision. He continued the interplay of clearly defined, if fragmented, objects with geometric abstract organization; his color became more brilliant and he intensified the tempo, the sense of movement, the gaiety, and rhythmic beat of his works through an increasing complication of smaller, more irregular, and more contrasted color shapes.

The climax of these experiments may be seen in two works of the 1940s, *Report from Rockport*, 1940, and *The Mellow Pad*, 1945–51. *Report from Rockport* (fig. 680), although more abstract than most paintings of the 1930s, includes recognizable bits such as buildings and gas pumps. There is a strong suggestion of depth, achieved by linear perspective as well as by color, but major color areas reaffirm the picture surface. This surface twists and vibrates with jagged, abstract color

shapes and lines, elements that put the scene into violent and fantastic movement translating the jazz tempo of America into abstract color harmonies and dissonances.

During the later 1940s Davis produced a series of small paintings which eliminate all representational or associative elements except the series titles Pad or Max, or the full picture title, and employ abstract elements ranging from the most severely puristic vertical-horizontal geometry to the strongly expressionistic. In *The Mellow Pad* (fig. 681), on which the artist worked intermittently between 1945 and 1951, he developed these abstract sketches into a monumental composition, his most intricate and important achievement of the 1940s.

Fascinated by the abstract and symbolic significance of words incorporated into his paintings, he was inevitably

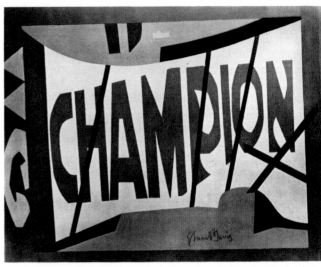

682. STUART DAVIS. *Little Giant Still Life.* 1950. 33 x 43″. Virginia Museum of Fine Arts, Richmond

680. STUART DAVIS. *Report from Rockport.* 1940. 24 x 30″. Collection Mr. and Mrs. Milton Lowenthal, New York

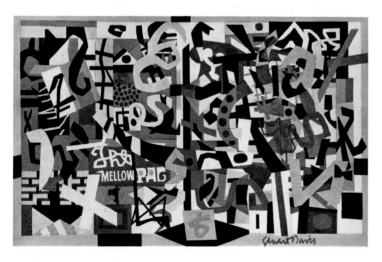

681. STUART DAVIS. *The Mellow Pad.* 1945–51. 26 x 42″. Collection Mr. and Mrs. Milton Lowenthal, New York

led, in the 1950s, to canvases such as *Little Giant Still Life,* in which the word became the entire painting (fig. 682). This work, together with subsequent variations on the theme, constituted a new and major passage in the artist's exploration of the nature of subject, of the painted surface, and of words as elements of painting.

In the painting *Rapt at Rappaport's,* 1952 (colorplate 192), the alliterative and slangy title once more invades the actual painting, the staccato letters flashing across the lower part like a news bulletin. Large color shapes of red, blue, and black are suspended against a unified ground color, in this case, green; the larger shapes are flatly arranged, and the whole painting tends toward the over-all pattern that Davis explored in a number of works during the 1950s. The surface is livened with a series of characteristic invented shapes, the torn S or 8 ribbon, the floating white circles or rectangles, the X and star fragment, that act as directional thrusts. The cross, rectangle, and square, established in a precise geometrical relation to one another, reaffirm the total picture rectangle as well as the degree in which depth is here achieved by relations of flat, overlapping color planes.

There are few if any modern artists who have used titles of paintings in as imaginative and yet as structural a manner as did Stuart Davis. He added another dimension to abstract paintings in his use of letters, words, phrases, and the mood or tempo of the painting.

*Colonial Cubism,* 1954 (colorplate 193), is one of the largest, simplest, and most powerful organizations ever achieved by Davis. The colors are limited; the architectural structure of interlocking planes pull and push against one another, resulting in enormous tension. Aside from a few irregular circular shapes and the brittle calligraphy of the signature, all areas have a sharp, rectilinear regularity. With the exception of the artist's signature, all lettering, words, or phrases have been eliminated. It is a work in which Davis was obviously rethinking some of the tenets of cubism. But a comparison of this painting with any cubist work of Picasso, Léger, or any other Eu-

ropean cubist, will reveal how completely Davis created his own world from cubist elements. *Blips and Ifs*, 1963–64 (colorplate 194), the last completed work, provides in a climactic sense a summary of his attitudes toward form and subject. One of the largest of his later paintings, it has the character of an enlarged detail from a slightly earlier work, *Standard Brand,* 1961. Here we can see the artist's final investigation of words and abstract forms and symbols dominating the picture space. The fragmentation of the words heightens their non-associative abstract reality. Color shapes and rhythmic ribboned movements are simplified to a grandiose scale in which the compression of all elements reinforces the explosive tension.

Stuart Davis is almost the only American painter of the twentieth century whose works have transcended every change in style, movement, or fashion. Even during the 1950s he continued to have the respect and admiration of the most experimental new artists. With the emergence of pop art and other attempts at a re-exploration of subject, his paintings have taken on a new significance in the history of modern American art.

# NILES SPENCER (1893–1952),
# RALSTON CRAWFORD (b. 1906)

In Spencer's early work there is apparent an individual

684. RALSTON CRAWFORD. *Tour of Inspection, Bikini.* 1946. 24 x 34″. Collection Mr. and Mrs. Myron A. Minskoff, New York

683. RALSTON CRAWFORD. *Whitestone Bridge.* 1939. 40 x 32″. The Memorial Art Gallery of the University of Rochester, New York. Marion Stratton Gould Fund, 1951

application of precisionism: a sense of mood, romantic or melancholy, in the manner of De Chirico. Through the 1930s his paintings became at times more specifically representational, but the depth of mood persisted; yet the abstract structure is strong and clear. In the manner of Picasso's synthetic cubism of the 1920s, Spencer's later works combine Renaissance perspective space and modern cubist space to create a tightly interlocked construction of urban images. A powerful canvas, *In Fairmont,* 1951 (colorplate 195), painted shortly before Spencer's death, gives the spectator a worm's-eye view of factory structures densely massed in the foreground and composed of large planes of somber colors. The effect is massive and forceful, all the more disturbing because of the absence of all traces of human existence.

The artist who most effectively carried the precisionist tradition forward to the present day is Ralston Crawford. With *Overseas Highway,* 1939, and *Whitestone Bridge,* 1939 (fig. 683), an individual approach became evident, involving an extreme form of linear perspective combined with flat, two-dimensional color areas. During World War II Crawford served in the Air Force and in 1946 was assigned to cover the atomic explosion at Bikini. In *Tour of Inspection, Bikini,* 1946 (fig. 684), jagged, torn shapes vibrate on an enclosing ground of yellow-and-blue stabilizing areas, which hold them in suspension. Nervous black lines moving over the surface increase the tempo, and at the same time help to establish scale. Although based on specific visual impressions such as the brilliant blue of sky and sea, the blinding light of the explosion, twisted cables and metal fragments, this is not really a subject painting. It is rather a reaction to the sense of destruction, the awesome power and even beauty of the explosion itself. Later, he returned to a cooler palette, predominantly blue and white, and a structure of suspended geometric shapes. Almost without exception Crawford's paintings are based on observation or

impression of an actual scene: emotional reactions translated into symbols.

# The 1930s:
# Realism, Social Realism,
# and Regionalism

The 1930s in the United States was a decade of depression, reaction, and isolation in politics and art. The realists, who had been the first revolutionaries, had now replaced the Academy as the guardians of conservatism and were fighting a rear-guard battle against modernism. The second wave of realists put greater emphasis on the Americanism of their works, whether these were bitter attacks on the American political and economic system that had produced the sufferings of the great depression, or chauvinistic praise of the virtues of an actually declining agrarian America. Art reflected the spirit of isolationism that dominated so much of American thought and action after World War I. It became socially conscious, nationalist, and regionalist.

From the point of view of the art produced, the 1930s may seem a bleak and reactionary time in the United States. The crucial event of this decade—indeed, a catalyst transcending even the Armory Show—was the establishment, by the United States government, of a Federal Art Project. It enabled many of the major American painters to survive: and a large percentage of the younger artists who created a new art in America after World War II might never have had a chance to emerge had it not been for the Project.

The decade, however, marked a détente in modern art in America. Although there were many artists of talent, and many interesting directions in American art, most of

*above*: 685. BEN SHAHN.
*The Passion of Sacco and Vanzetti.*
1931–32. Tempera on canvas,
84½ x 48″. The Whitney Museum
of American Art, New York.
Gift of Edith and Milton Lowenthal

*right*: 686. EDWARD HOPPER.
*Nighthawks.* 1942. 33¼ x 60⅛″.
The Art Institute of Chicago.
Friends of American Art
Collection

these lie outside the scope of this book. In this category may be included the so-termed American scene painters, the social realists, the regionalists. Whatever their qualities and virtues may be, their work, offering little that was new or experimental, is not in its essence germane to the evolution of modern art. Nevertheless, a few artists must be briefly mentioned, since either they or their work influenced younger artists who have advanced modern art.

BEN SHAHN *(b. 1898),*

EDWARD HOPPER *(1882–1967),*

IVAN LE LORRAINE ALBRIGHT *(b. 1897)*

Of the artists associated with social realism the major figure is Ben Shahn, whose work has its roots in expressionism, naïve art, and the cubist dislocation of planes. Shahn gained recognition in the early 1930s through his paintings on the notorious case of Sacco and Vanzetti. These were bitter denunciations of the American legal system which had condemned the two anarchists to death (fig. 685).

Although he had made several long visits to France between 1906 and 1910, at the exact moment of the fauve explosion and the beginnings of cubism, Edward Hopper, seemingly unaffected by either of them, early began to state his basic romantic-realist themes of isolated houses and lonely individuals in "one night cheap hotels." Hopper's subject, his attitude to it, and his style were established in the 1920s and varied little thereafter. One of his

finest works was *Early Sunday Morning*, painted in 1930 (colorplate 196). The row of buildings, with their shops below and dreary apartments above, fill the canvas from end to end, reiterating and closing in the surface, except for the narrow rectangle of blue sky and the foreground of deserted street. It is, thus, organized in a purely plastic, vertical-horizontal manner. The form and the appearance are, nevertheless, only attributes of a mood as lonely as a De Chirico Italian piazza transformed into an American provincial town.

Much of the effect of Hopper's paintings is derived from his sensitivity to light—the light of early morning or of twilight; the dreary light filtered into the hotel room or office; or the garish light of the lunch counter isolated within the surrounding darkness (fig. 686).

A very different kind of expressionist or realist-expressionist is Ivan Albright, who has lived his entire life in Chicago. Albright is one of the most individual and curious talents to emerge from the American scene. He has devoted his career to a form of microscopic realism in still lifes and figures that become intense and repulsive but definitely effective studies in the horrible disintegration of man and his environment (fig. 687). Since 1941, although he has executed other individual works, Albright has been working continuously on one painting, entitled *Poor Room —There is No time, No end, No today, No yesterday, No tomorrow, only the forever and forever and forever without end* (begun 1941, fig. 688). Seen through a broken casement, the clutter of dilapidated objects becomes a Victorian study in decadence. Albright is a painter who cannot be classified or attached to any movement,

689. DIEGO RIVERA. *Jacques Lipchitz (Portrait of a Young Man).* 1914. 25⅝ x 21⅝ ". The Museum of Modern Art, New York. Gift of T. Catesby Jones

690. JOSE OROZCO. *Modern Migration of the Spirit.* Mural, fourteenth panel. 1932–34. Baker Library, Dartmouth College, Hanover, New Hampshire. Trustees of Dartmouth College

691. DAVID SIQUEIROS. *Echo of a Scream.* 1937. Duco on wood, 48 x 36″. The Museum of Modern Art, New York. Gift of Edward M. M. Warburg

except in a general way to that of magic realism. In this particular painting and the actual environment out of which he has created it and which is physically a part of it, he anticipates ideas explored by the new realists and others concerned with the problem of the work of art, the happening, or the environment.

## The Mexicans

DIEGO RIVERA *(1886–1957),*

JOSE CLEMENTE OROZCO *(1883–1949),*

DAVID ALFARO SIQUEIROS *(b. 1898)*

Particularly influential to American painters (although not necessarily in the direction of modernism) were the Mexican muralists Rivera and Orozco. Rivera had studied and lived in Europe between 1909 and 1921, and had been associated with cubism (fig. 689). During the 1920s he received important commissions for monumental fres-

coes from the Mexican government. This was the period when he turned against the modern movement in an attempt to create a national Mexican style reflecting both the history of Mexico and the socialist spirit of the Mexican revolution.

Orozco, who received his training in Mexico City, and who was perhaps even more strongly influenced than Rivera by Mexican Indian traditions, also had important fresco commissions in the United States during the 1930s, notably at Dartmouth College in Hanover, New Hampshire. Here, in the Baker Library, between 1932 and 1934, he created a panorama of the history of the Americas, beginning with the story of Quetzalcoatl, continuing with the coming of the Spaniards, the Catholic Church, and concluding with the self-destruction of the machine age climaxed in a great Byzantine figure of a flayed Christ in process of destroying his own cross (fig. 690).

The third of the Mexican triumvirate of muralists, David Siqueiros, was less immediately influential on United States mural painters, since he was less well-known. *Echo of a Scream*, 1937 (fig. 691), illustrates his vigorous pictorial attack. The sole survivor of the three, Siqueiros has recently emerged from prison, where he was sent for political activities, to embark on the most ambitious fresco project of his life in Mexico City.

The Mexican muralists struck a common chord with American artists, partially because they represented a living tradition of fresco painting and partially because theirs was an art of social protest with an obvious appeal to the American left wing.

# Toward Abstract Art

During the 1930s modernism, particularly cubism and abstraction, seemed to have been driven underground, although the Federal Art Project did support many of the more experimental artists. Thus the seeds were sown that resulted, after the war, in a transformation of the United States from the position of a provincial follower to that of a full partner in the creation of new art and architecture.

When American artists under the Project began to receive commissions for murals they generally had little experience in the techniques and few immediate guidelines. Some turned back to the Renaissance for inspiration. A few, such as Arshile Gorky, Willem de Kooning, Philip Guston, and James Brooks, used the opportunity to explore aspects of cubism or abstraction on a large scale. The significant wall paintings produced by the Project were, with the exception of those by Stuart Davis, from the hands of artists still relatively unknown: Gorky, Guston, Brooks, and Burgoyne Diller.

In the 1930s, in sculpture as in painting, despite the predominance of the academicians and the isolation of the progressive artists, a number of sculptors were emerging, some of whom were destined to change the face of American sculpture at the end of World War II. Alexander Calder was an established artist-sculptor during the

1930s, but in a European rather than an American context (see p. 396). Internationally he was the best-known American sculptor before the war, and still is. His influence grew continuously, although it has been most apparent in American constructivist sculpture since 1945.

Other sculptors who emerged during the 1930s but whose principal achievements have taken place since 1945 were Reuben Nakian, Joseph Cornell, Seymour Lipton, Raoul Hague, David Smith, and Theodore Roszak. These, together with certain others, were the sculptors who created the new American sculpture of the 1950s. Among them, David Smith today exercises an influence that is world-wide.

A number of other events and developments of the 1920s and 1930s also suggested the path to the future. In 1920 Katherine Dreier, painter and collector, advised by Marcel Duchamp, had organized the Société Anonyme for the purpose of buying and exhibiting examples of the most advanced European and American art. The Société not only held exhibitions but arranged lectures and symposiums. A. E. Gallatin, another painter-collector, in 1927 put his personal collection of modern art on display at New York University under the name of The Gallery of Living Art. It remained on exhibition for fifteen years. (This collection, now at the Philadelphia Museum together with the even more important one of Walter C. Arensberg, includes examples by Brancusi, Braque, Cézanne, Kandinsky, Klee, Léger, Matisse, Miró, Mondrian, and many others.) The Gallery of Living Art became, in effect, the first museum with a permanent collection of exclusively modern art to be established in New York City, or perhaps anywhere in the world. It was followed by the creation of the Museum of Modern Art in 1929, which climaxed its initial series of exhibitions by modern masters with the historic shows of "Cubism and Abstract Art" and "Fantastic Art, Dada, Surrealism," both in 1936. In 1935 the Whitney Museum held its first exhibition of American abstract art and, in 1936, the American Abstract Artists group was organized.

During the 1930s a few progressive European artists began to visit or migrate to the United States. Léger made three visits before settling at the outbreak of World War II. Not only Duchamp, but Jean Hélion, Ozenfant, Moholy-Nagy, Josef Albers, and Hans Hofmann were all living in the United States before 1940. The last four were particularly influential as teachers. The group as a whole represented the first influx of the European artists who spent the war years in the United States and who helped to transform the face of American art. Conversely, younger American painters continued to visit and study in Paris during the 1930s. During the late 1930s and 1940s the American Abstract Artists group held annual exhibitions dedicated to the promotion of every form of abstraction, but with particular emphasis on geometric abstraction related to those then being propagated in Paris by the Cercle et Carré and Abstraction-Création groups. With the exception of Stuart Davis, most of the artists of the group came to maturity after World War II. Their emergence during the 1930s and the gradual re-establishment of close contacts with the European modernists were of great importance for the subsequent course of modern American art.

ARTHUR B. CARLES *(1882–1952),*

ABRAHAM RATTNER *(b. 1895),*

MILTON AVERY *(1893–1965),*

LOREN MACIVER *(b. 1909),*

MORRIS GRAVES *(b. 1910)*

A few painters must be mentioned at this point, for their work, while not distinctively avant-garde, nevertheless contributed to the powerful forward surge of American art after World War II. Arthur B. Carles belongs properly among the pioneers of American painting active in the first decades of the twentieth century. Early paintings suggest influences from Cézanne, the fauves and, at times, the cubists. In the mid-1920s he began working abstractly, in an extremely free and expressionist manner related to Picasso's most coloristic paintings of the period, but, in the explosion of color and shapes, more suggestive of the early works of Jackson Pollock.

Abraham Rattner, most of whose training was in France, is an expressionist close to both the French and German schools, with reminiscences of Rouault in his religious paintings. A late painting entitled *Song of Esther,* 1958 (colorplate 197), is suggestive of Picasso's later *Artist in the Studio* series, although the free handling of the heavily textured color also reflects the abstract expressionism then dominant in the United States.

Avery, like Carles, somewhat isolated from developments around him, was one of the few American masters of figure painting during the 1930s and 1940s. Avery characteristically worked in broad, simplified planes of color deriving from Matisse but involving a personal poetry. In his later years he turned more to landscape which, although always recognizable, became more and more abstract in organization (*Swimmers and Sunbathers,* 1945, colorplate 198). He was not only a distinguished painter but a major link between the color paintings and collages of Matisse and the American color-field painters of the 1950s and 1960s, such as Mark Rothko, Adolph Gottlieb, and Helen Frankenthaler.

The fantasy of Loren MacIver and Morris Graves belongs in a lyrical vein. Loren MacIver has lived and painted in New York City all her life. In earlier works such as *Hopscotch,* 1940 (fig. 692), she observed a small detail of cracked and broken sidewalk with the chalked numbers of the game at the right, but transformed this detail into a free abstraction, lyrical in color and large in feeling. With prosaic elements she creates a world of poetic fantasy with definite affinities to the lyrical wing of abstract expressionism.

Morris Graves is a native of the Pacific Northwest. His mysterious and delicately drawn little paintings of birds have a spiritual affinity to the works of Paul Klee. Graves has been much influenced by Oriental religion and philosophy, particularly Zen Buddhism, and has saturated himself in the mythology of the Northwest Indians. The *Blind Bird,* 1940 (fig. 693), is a strange and seemingly pathetic little creature, but hypnotic in its effect. Graves has said, "I paint to rest from the phenomenon of the external world . . . and to make notations of its essences with which to verify the inner eye." In his own way, he is carry-

692. LOREN MACIVER. *Hopscotch.* 1940. 27 x 35⅞".
The Museum of Modern Art, New York

693. MORRIS GRAVES. *Blind Bird.* 1940. Gouache,
30⅛ x 27". The Museum of Modern Art, New York

ing on that search for the inner reality, the inner spirit, to which Kandinsky and Klee devoted their lives.

# Sculpture

American sculpture during the first forty years of the twentieth century lagged far behind painting in quantity,

*left:* 694. GASTON LACHAISE. *Standing Woman (Elevation).* 1912–27. Bronze, height 70″. The Albright-Knox Art Gallery, Buffalo, New York

*below:* 695. GASTON LACHAISE. *Floating Figure.* 1935. Bronze (after original of 1927), height 51¾″. The Museum of Modern Art, New York. Given anonymously in memory of the Artist

quality, and originality. During this period the academicians predominated; recent developments in modern sculpture such as cubism or constructivism were hardly visible. Archipenko, who had lived in the United States since 1923 and who had taught at various universities, finally opened his own school in New York City in 1939; and Alexander Calder, Theodore Roszak, Isamu Noguchi, and Herbert Ferber were at work. There were, of course, sculptors of considerable ability in the roster of academicians, but as late as 1948 there was little that was new or experimental.

GASTON LACHAISE *(1882–1935),*

ELIE NADELMAN *(1882–1946),*

SAUL BAIZERMAN *(1889–1957),*

ISAMU NOGUCHI *(b. 1904)*

Among the first generation of modern American sculptors two of the most interesting were Europeans, trained in Europe, who migrated to the United States early in their careers. These were Gaston Lachaise and Elie Nadelman. Lachaise was born in Paris and trained at the Ecole des Beaux-Arts. By 1910 he had begun to experiment with the image that was to obsess him during the rest of his career, that of a female nude with enormous breasts and thighs and delicately tapering arms and legs. This form derives from Maillol, but in Lachaise's versions is given a range of expression from pneumatic

696. GASTON LACHAISE. *Torso.* 1928. Bronze, 9½ x 8 x 3⅞″. Collection The Lachaise Foundation

697. ELIE NADELMAN. *Man in the Open Air*. c. 1915.
Bronze, height 54½″. The Museum of Modern Art,
New York. Gift of William S. Paley

699. JOHN STORRS. *Forms in Space #1*. 1926. Combination
of metals, height 21″. The Downtown Gallery, New York

698. MAX WEBER. *Spiral Rhythm*. 1915. Bronze,
height 24″. The Joseph H. Hirshhorn Collection

700. SAUL BAIZERMAN. *Silence*. 1936. Hammered copper,
height 14½″. John Rood Sculpture Collection,
University Gallery, University of Minnesota, Minneapolis

701. SAUL BAIZERMAN. *Nike*. 1949–52. Hammered copper, height 66″. Walker Art Center, Minneapolis

702. SAUL BAIZERMAN. *Old Courtesan*. 1947–52.
Copper, height 38¼″.
The Solomon R. Guggenheim Museum, New York

elegance to a gross power that transcends that of the pre-historic female fertility figures (figs. 694, 695, 696).

Elie Nadelman received his European academic training at the Academy in Warsaw. Around 1909 in Paris he was making serious studies of the problems of reducing the human figure to almost abstract curvilinear patterns. After his move to the United States in 1914, his sculpture increasingly took on a quality that might be described as a form of sophisticated primitivism. *Man in the Open Air*, c. 1915 (fig. 697), illustrates the simplification of surfaces and linear outlines together with the witty and amusing commentary on contemporary life that mark these works.

Curiously, the most accomplished modern sculpture produced by an American early in the century was by the painter Max Weber. Along with his experiments in cubist painting, Weber made a number of cubist sculptures of distinction (for example, fig. 698). Since, by 1920, Weber was turning away from cubism toward a personal form of expression, his cubist sculptures remained isolated experiments that had no immediate influence.

Another American sculptor working in an original cubist style during the early decades of the century was John Storrs, whose work was not recognized, and largely forgotten until its recent rediscovery (fig. 699).

The most original of the American pioneer sculptors associated with the traditional wing was Saul Baizerman, born in Vitebsk, Russia. He began to experiment with a technique of hammered copper from which he developed a personal, expressive figure style. The figures were beaten out of large sheets of copper worked from the back, which was left completely open. Thus, they might seem to take on the characteristics of high relief sculpture. To Baizerman, however, the hollowed-out space of the backs was as important as the projecting volumes of the fronts; his works were to be seen as both positive and negative volumes. Baizerman's portrait heads frequently achieve a quality of repose and withdrawal comparable to the Praxitelean approach as well as to that of Late Gothic Madonnas (fig. 700). In his figures, the tradition of Maillol was uppermost (*Nike*, 1949–52, fig. 701), although at

703. JOHN FLANNAGAN. *New One*. 1935. Granite, height 6½ x 11½″. The Minneapolis Institute of Arts. The Ethel Morrison Van Derlip Fund

704. ISAMU NOGUCHI. *Monument to Heroes.*
1943. Bone, paper, wood, and string, height 28″.
Collection the Artist

705. ISAMU NOGUCHI. *Euripides.* 1966.
Marble, height 90″.
Collection the Artist

times he varied his formula, with the surface tormented into jagged peaks and valleys that represented his own interpretation of Rodin (fig. 702).

The American sculptural tradition during the first forty years of the century was primarily a tradition of carving, including a number of talented artists such as Chaim Gross and Hugo Robus, who also worked extensively in bronze. John Flannagan (1895–1942) was a unique native talent. Despite an expressed antipathy to the new sculpture in Europe he nevertheless followed that sculpture closely. He worked best on a small scale; and his most successful evocations were small animals and newborn children (fig. 703).

Isamu Noguchi, born in 1904 in Los Angeles of a Japanese father and an American mother, has had an even more international background. He lived in Japan from the age of two to fourteen, was apprenticed for a while to the American academic-realist sculptor Gutzon Borglum, but by 1927 was in Paris working as Brancusi's assistant and becoming acquainted with all the new developments in painting and sculpture. Major influences in Paris included not only Brancusi, but Giacometti and Calder, as well as Miró, and Picasso in his surrealist phase (figs. 704, 705). During the 1930s Noguchi was the most advanced American sculptor working in the United States (with the exception of Calder, who commuted). Since he tended to isolate himself, exhibiting little and earning his living through furniture and product design, Noguchi's position and achievements were not generally recognized until after World War II.

# PART TWENTY-ONE

# ARCHITECTURE SINCE 1930

The early achievements of modern architecture—really a series of isolated experiments in the first third of the century, have too often been transformed into academic clichés. This is particularly true of the international style, with its ferroconcrete or its glass or metal sheathing suspended on a steel framework. Everywhere in the world one now sees buildings, large or small, which are practically indistinguishable from one another—large-scale imitations of surface appearance. In architecture, even more than in painting and sculpture, the creation of new ideas has become difficult partly because of the fertility of the pioneers, and partly because of the pattern of patronage. Whereas there has been a great expansion in governmental, industrial, and domestic building since 1945, there has not been a comparable expansion in urban planning, housing projects, or other areas with problems different from those explored earlier. The younger architect of the later twentieth century has had unparalleled opportunities to work in a contemporary mode but, paradoxically, few opportunities to present solutions for the most pressing architectural problems of his era—town and city planning, large-scale low-cost housing, slum clearance, urban congestion, and transportation. Notwithstanding these limitations, an astounding number of talented architects came to maturity since the 1930s. At the same time the great innovators lived on, with increasing activity and recognition, far into the century.

In architecture as in all the other arts and sciences the United States benefited from the fact that Nazi repression drove many of the artists, architects, and scientists out of Germany. Walter Gropius left Germany in 1934 for England, staying there for three years. He collaborated with Maxwell Fry in the design of Impington College in Cambridgeshire, 1936 (see fig. 738). In 1937 he went to the United States, to become Professor and then Chairman of the Department of Architecture at Harvard University. Marcel Breuer also had come to America in 1937, to join Gropius at Harvard; they were in partnership until 1941 when Breuer entered practice on his own.

Moholy-Nagy had been invited to Chicago, also in 1937, to form a New Bauhaus. In the same year, Josef Albers arrived in America to teach design and painting, first at Black Mountain College and then at Yale University. In 1938, Mies van der Rohe, who had arrived in the United States the year before, was invited to the Illinois Institute of Technology (then the Armour Institute). José Luis Sert (b. 1902) migrated to the United States in 1939 and since 1958 has been Dean of the Harvard Graduate School of Design.

At that time, American schools of architecture in general were still following the academic Beaux-Arts tradition. It is largely as a result of Gropius' and Mies's efforts, as well as those of a few other distinguished emigrants, that architectural schools were transformed over the next twenty years and American architecture entered into a new age of modern experiment. In the same way, Moholy-Nagy, Albers, and others affected the industrial, product, and graphic design of the United States.

By 1930 many of the ideas of twentieth-century architecture had been stated in one form or another, with the exception of new concepts still developing in the field of engineering. The 1930s saw a degree of retrogression, particularly in communist or fascist countries such as Russia and Germany. In those countries and, to a lesser degree, in Italy, an overblown academic style took the place of modern experiment. Such a style was also used for Italian governmental buildings (but free experiment, particularly in engineering, was not entirely discouraged). Even in France, despite the achievements of Corbusier, official buildings such as the Museum of Modern Art in Paris, 1937, frequently reverted to a form of neo-classicism. In contrast, during this period and since, Finland and the Scandinavian countries—Sweden, Norway, and Denmark—made notable contributions to modern design in architecture, furniture, crafts, and industrial products.

## The Later Styles of the Pioneers

### FRANK LLOYD WRIGHT AFTER 1930

Despite the depression, Wright began to secure important commissions and also to make a contribution in the field of low-cost individual housing (the Usonian houses), as well as in city planning. During the period c. 1931–35, when commissions were few, he developed his plan for Broadacre City, an integrated and self-sufficient community of detached housing with built-in industries. Like most such schemes Broadacre City was never realized, but it did enable Wright to clarify his ideas on city planning, further developing the idea of the garden town, with detached houses within ample natural surroundings.

His most important realized structures of the 1930s were the Kaufmann House, Falling Water, at Bear Run,

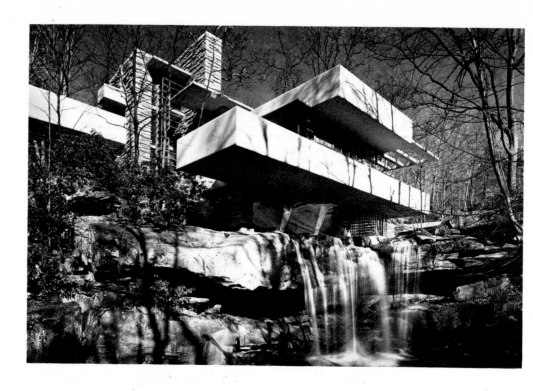

*right*: 706.
FRANK LLOYD WRIGHT.
Kaufmann House, Bear Run,
Pennsylvania. 1936

*below*: 707.
FRANK LLOYD WRIGHT.
Interior, Kaufmann
House. 1936

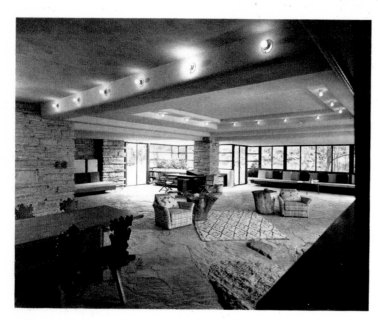

choring the suspended horizontals (fig. 706). The central mass consists of rough, local stone courses contrasting with the beige-colored concrete. The building is particularly effective in its contrast of solid and voids: the interior is literally the welcoming cave in the middle of the woods (fig. 707). The plan combines openness, efficient flow, and containment of individual areas, with the integration of exterior and interior.

The Johnson Administration Building, started in the same year as the Kaufmann House, inaugurated a new phase in Wright's style. In this building, which resembles a gigantic and beautiful machine, Wright began to use dominant curvilinear elements (fig. 708). The building is brick, with no windows except the translucent but not transparent bands of window wrapped around the tower (fig. 709). Natural lighting is achieved in other areas through skylights and tubular glass strips. Thus the effect of the building is one of self-containment, a turning inward upon itself. The interior is a forest of slender columns tapering to the base (fig. 710) like those at the Palace of Minos in Crete. The columns terminate at the top in broad, shallow capitals which repeat the circular motif throughout. Encouraged by a sympathetic patron, Wright was able to design all details including desks and office chairs.

The Johnson Building may have been a gesture of defiance toward the rectangularity of the spreading international style. In any event, it illustrated once again Wright's inexhaustible fertility, and led to many buildings embodying the principle of the circle. But Wright did not desert the rectangle or the triangle: Taliesin West, the home that he began to build for himself in 1938 near Phoenix, Arizona, and which, characteristically, was still in process of building and rebuilding until his death in 1959, is in plan and elevation a series of interlocked triangles. The architect's most dramatic assimilation of a

Pennsylvania, 1936, and the Administration Building of the S. C. Johnson and Son Company, Racine, Wisconsin, 1936–39, 1950. The Kaufmann House, built over a waterfall, is one of Wright's most stunning conceptions. In the use of ferroconcrete for the cantilevered terraces, it has an affinity to the international style. It is a basic Wright conception, however, combining features of the original prairie houses and the California houses built of pre-cast concrete blocks. The adaptation to a specific and dramatic site exemplifies one of Wright's greatest abilities: to use all the implications of a site, no matter how difficult it might seem. In the Kaufmann House we still have a central, vertical mass of utilities and chimneys an-

*above:* 708. FRANK LLOYD WRIGHT. Administration Building,
S. C. Johnson and Son Company, Racine, Wisconsin. 1936–39, 1950

*right:* 709. FRANK LLOYD WRIGHT. Laboratory Tower,
S. C. Johnson and Son Company. 1936–39, 1950

building into a natural environment, it becomes an outgrowth of the desert and mountain landscape (colorplate 199). Other buildings involving the triangle or pyramid are the Unitarian Church in Madison, Wisconsin, 1947, and Beth Sholom Synagogue in Elkins Park, Pennsylvania, 1959, the latter reminiscent of a Sumerian ziggurat.

Wright completed a number of buildings involving the circle, such as the second Jacobs' House in Madison, Wisconsin, 1948, the David Wright House in Phoenix, Arizona, 1952, and the Morris Gift Shop, San Francisco, 1948–49. The climax of these experiments was The Solomon R. Guggenheim Museum, New York. First conceived in 1943, it was not actually completed until 1959, after Wright's death. The Guggenheim Museum has been more discussed than any other twentieth-century building. It is the only building the leading American architect was ever commissioned to do in New York City and it was many years before he could obtain the necessary building permits for so revolutionary a structure. It consists of two parts: the main exhibition hall and a small administration building, both circular in shape (fig. 711). The gallery proper is a continuous spiral ramp around an open, central well. The building radiates outward toward the top, each ramp becoming deeper than the one below; the ramps are suspended on huge pylons. A skylight dome on ribs provides natural, general lighting, while continuous strip-lighting around the ramps provides additional light. Permanent projecting fins divide the ramps into equal bays. The interior of the Guggenheim Museum is one of the great architectural spaces of the twentieth century, inviting comparison with the interior of St. Peter's or the Roman Pantheon. As a museum it involves easy and efficient circulation, in contrast to the traditional museum with its galleries consisting of a series of interconnected box-like rooms. The architect also introduced two new aspects of viewing. The division of the

710. FRANK LLOYD WRIGHT. Interior, Administration
Building, S. C. Johnson and Son Company. 1936–39, 1950

ramps into bays, in which not more than three or four paintings are hung, allows the spectator, stepping into the bay, an intimacy that focuses his attention on each individual work. Then, when he turns around and looks across the open central area, he is given a panorama that suggests interesting and frequently exciting comparisons (see fig. 649).

Originally, Wright planned a rectangular slab building behind the administration building to contain various service functions and studios. This addition was not built at

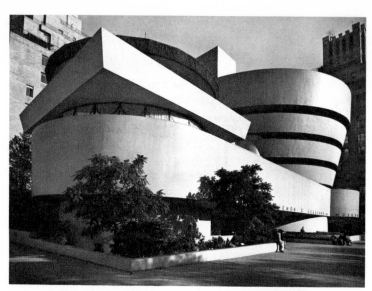

711. Frank Lloyd Wright. The Solomon R. Guggenheim Museum, New York. 1957–59

the time but, in a somewhat reduced form, has been carried out by the Wright firm. In the last years of his life Wright designed many projects involving the circle, such as the Opera and Auditorium for Baghdad, Iraq, 1957; and some of these projects have been carried out since his death by the Wright architectural firm.

## WALTER GROPIUS AFTER 1930

In America, Gropius soon put into effect his principles of collaboration and his ideas concerning the social responsibilities of the architect. In 1945, with some of his students, he formed The Architects' Collaborative (TAC) to design buildings in the United States and elsewhere. At Harvard he continued his design of school structures with the Harvard Graduate Center, 1949–50. Here he had the problem of placing a modern building within a traditional environment that extended from the eighteenth to the twentieth century. He made no compromises to tradition but used stone and other materials to enrich and give warmth and variety to his modern structure (fig. 712). He also commissioned artists such as Miró, Arp, and Albers to design murals, thus introducing to Harvard the Bauhaus concept of the integration of the arts. In his later years, with The Architects' Collaborative, Gropius moved again into full-scale architectural production; he created the American Embassy in Athens, buildings for Baghdad University and, in 1957, he returned to Germany to design an apartment building for the Berlin Interbau Exhibition. Perhaps the most ambitious of the later designs was the Boston Back Bay Center, 1953 (fig. 713), unhappily never constructed. This is a large-scale project involving office buildings, a convention hall, a shopping center, underground parking lot, and a motor hotel. Two slab structures are set in a T-form, raised on stilts above the intricate, landscaped pedestrian walks and driveways. The facades are richly textured; the entire complex is a superior example of recent American experiments in the creation of total, industrial,

*above:* 712.
Walter Gropius
and The Architects'
Collaborative.
Harvard Graduate Center,
Cambridge, Massachusetts.
1949–50

*right:* 713.
Walter Gropius.
Project for City Center
for Boston Back Bay.
1953

714. MIES VAN DER ROHE. Block plan for Illinois Institute of Technology, Chicago. 1940

mercantile, or cultural centers—social and environmental experiments with which Gropius himself had been concerned in Germany during the 1920s.

## MIES VAN DER ROHE AFTER 1930

Mies van der Rohe, having completed relatively few buildings before leaving Germany in 1937, was finally able to put his ideas into practice in the United States. In the skyscrapers he created, as well as in the new campus for the Illinois Institute of Technology, his solutions were so superb and the impact of the buildings so impressive that his influence on younger American architects has been incalculable. The plan of the Institute, as drawn by Mies in 1940, is characteristically a beautiful abstraction (fig. 714). Located in a deteriorating area on the south side of Chicago, the school complex is a model of efficient organization and urban planning. In fact, it became the inspiration for large-scale slum clearance in the area. The buildings, of steel construction, are organized

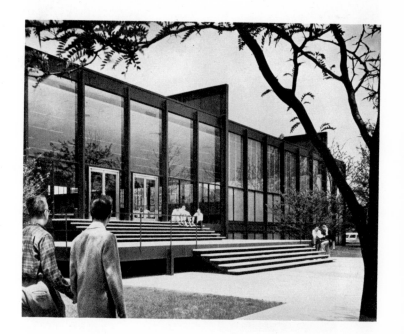

*above right*: 715. MIES VAN DER ROHE. S. R. Crown Hall, Illinois Institute of Technology, Chicago. 1952–56

*below*: 716. MIES VAN DER ROHE. Project for National Theatre, Mannheim, Germany. 1953

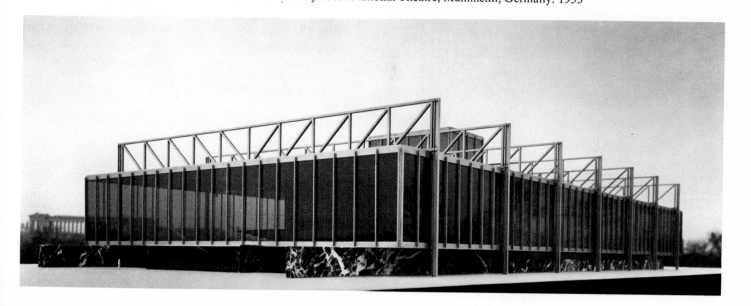

on a modular principle. Each in itself and all in their relations to one another exemplify Mies's sensitivity to every aspect of proportion and detail of construction (fig. 715).

After having envisioned (but not built) two of the

717. MIES VAN DER ROHE. Project for National Gallery, Berlin. 1962–68

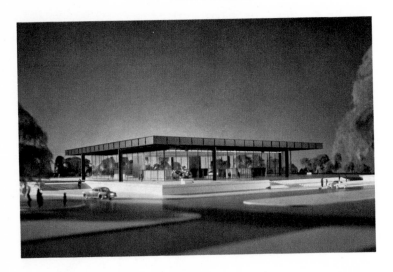

718. LE CORBUSIER, NIEMEYER, COSTA. Ministry of Education, Rio de Janeiro, Brazil. 1937–43

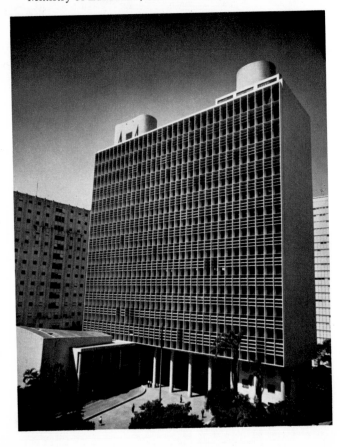

most advanced skyscraper designs, in 1919 and 1919–21, Mies was finally enabled to carry out some of his ideas in the apartments on Lake Shore Drive, Chicago, 1951 (see fig. 785), and in the Seagram Building, New York, 1956–57 (with Philip C. Johnson, see fig. 787). The Seagram Building and Mies's Federal Center in Chicago, 1964, represent the climax of a development in the United States that began with Sullivan and the Chicago school, was diverted during the age of eclecticism, and gradually came back to original principles. This development will be traced below.

In his later works such as the project for a national theater at Mannheim, Germany, 1953 (fig. 716), or the building for the department of architecture and design, Illinois Institute of Technology, 1956, or the National Gallery, Berlin, 1962–68 (fig. 717), Mies not only refined his modular system to a point of utmost simplicity but, using a suspended frame structure, he was able to realize his ideals of a complete and uninterrupted interior space to be divided or sub-divided at will.

## LE CORBUSIER AFTER 1930

In the 1930s Le Corbusier, having successfully completed the Swiss students' pavilion in Paris, 1932, was invited by the Brazilian government as consultant for the Ministry of Education building in Rio de Janeiro (fig. 718). The architectural team included Oscar Niemeyer, who was to become the chief modern architect of Brazil, Lúcio Costa, and several others; but the design of the building, as executed between 1937 and 1943, was primarily Corbusier's. It is a slab structure on stilts, the north side textured and given constantly changing variety by movable sun louvers.

The characteristics of Corbusier's later style were the exploration of free, organic forms and the statement of materials, principally his favorite ferroconcrete, in its raw original state as it emerged from the molds. The apartment building in Marseilles known as Unité d'Habitation, 1947–52 (fig. 719), on the one hand carries out the architect's town-planning ideas and, on the other hand, expresses the rough-surfaced concrete details as massive sculpture (fig. 720). The building is composed of small duplex apartments with a two-story living room, developing his 1927 Weissenhof housing schemes (see fig. 414). It includes shops, restaurant, and recreation areas, to constitute a self-contained community. Here Corbusier abandoned the original concept of concrete as a precisely surfaced machine material and presented it in its rough, primitive state. In doing so, he inaugurated a new style, almost a new age, in modern architecture, to which a name, the new brutalism, was later given. Possibly related to the French word, *brut* (uncut, rough, raw), but first associated with the Smithson family (see p. 451), the term has taken many forms, but involves fundamentally the idea of truth to materials and the blunt statement of their essence. Frank Lloyd Wright had preached this doctrine from the beginning of his career, and Mies van der Rohe in his own way has been as ruthlessly dedicated to the statement of glass and steel as Le Corbusier has been to the statement of concrete. The new brutalism, however, most characteristically mani-

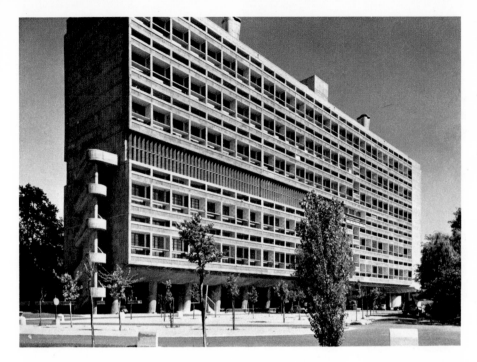

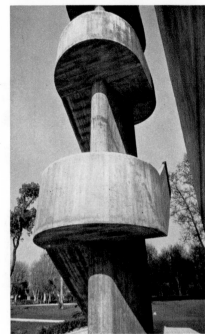

above: 719. LE CORBUSIER. Unité d'Habitation,
Marseilles, France. 1947–52

above right: 720. LE CORBUSIER. External Escape Stair,
Unité d'Habitation. 1947–52

right: 721. LE CORBUSIER. Notre Dame du Haut,
Ronchamp, France. 1950–54

below right: 722. LE CORBUSIER. Interior,
Notre Dame du Haut. 1950–54

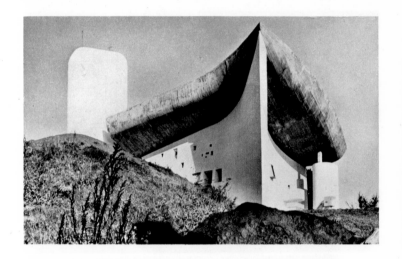

fests itself in concrete not only because of its texture but even more because of its innate sculptural properties.

During the 1930s and 1940s Corbusier continued his city-planning projects. In 1937 he proposed a scheme for the reconstitution of the center part of Paris on the right bank of the Seine. This was a further development of his so-called Voisin plan of 1925 with high-rise buildings of different shapes placed in wide-open spaces and connected by high-speed roadways.

The pilgrimage Chapel of Notre Dame du Haut at Ronchamp, France, 1950–54, built high on a hill, is the first climax of Corbusier's new sculptural style. It is molded of white concrete topped by the dark, floating mass of the roof and accented by the towers (inspired by Hadrian's villa), which serve as a geometric counterpoint to the main mass (fig. 721). The interior is lit by windows of varying sizes and shapes that open up from small apertures to create focused tunnels of light (fig. 722). This is one of the great religious structures of the twentieth century, in external forms and the mystery of its interior going back beyond Christianity to the prehistoric grave forms of megalithic times.

In contrast to Ronchamp is the monastery of La Tourette at Eveux near Lyons, 1957–60, a massive square of undressed concrete, with the austere cells of the monks arranged in a U around the central courtyard (figs. 723, 724). More than Ronchamp, where the concrete, though rough, is painted, La Tourette expresses the force of the

723. LE CORBUSIER. Monastery of La Tourette,
Eveux, France. 1957–60

724. LE CORBUSIER. Interior Court,
Monastery of La Tourette. 1957–60

725. LE CORBUSIER. Secretariat Building, Chandigarh,
India. 1958

raw material, as do the stark, massive, rectangular shapes.

In the 1950s Corbusier was finally given the opportunity to put into effect his lifelong ideas on total city planning in the design and construction of Chandigarh, a new capital for the Punjab in India, on which he worked into the 1960s. The city of Chandigarh is situated on a plain at the edge of hills; the capital buildings, comprising the Secretariat, the Assembly, and the High Court, are placed to the north in the foothills. The three buildings are arranged in an arc around a central area and are accompanied by terraces, gardens, and pools. Access roads to the city are largely concealed; changing vistas are achieved through ingeniously placed man-made mounds. The Secretariat, 1958 (fig. 725), carries on the slab principle transformed into a honeycomb by the open terraces and breezeways. The High Court, 1952–56, develops the principle of the massive, encompassing roof. The entrance area consists of ground-to-ceiling pylons intersected by access ramps. The Assembly building, 1959–62 (fig. 726), is the most impressive of the three, with its ceremonial entrance portico and upward-curving roof set on pylons, the whole reflected in the pool and approached by a causeway. The interior, designed for monumental effect, is another great modern architectural space.

Le Corbusier's achievement is embodied not only in the individual buildings, but in their subtle visual relationships to one another. The total complex, to be completed by another building designed as a Governor's residence or museum, constitutes a fitting climax to Corbusier's career.

726. LE CORBUSIER. Assembly Building, Chandigarh,
India. 1959–62

727. ALVAR AALTO. Finnish Pavilion
at the New York World's Fair. 1939

## Finland

### ALVAR AALTO (b. 1898),
### AARNE ERVI (b. 1910)

Notable for the importance of his contribution to the modern tradition is Alvar Aalto, the leading architect of Northern Europe. Aalto demonstrated his particular gifts dramatically in the Finnish Pavilion at the New York World's Fair, 1939 (fig. 727). This featured an inward-leaning, undulating wall that was both a literal instance of dynamic architecture and an excellently functional display space. The sense of movement as well as a sensitivity to different materials have characterized Aalto's architecture. The dynamism is apparent in the open flow of his house plans and particularly striking in the plan for a large dormitory at the Massachusetts Institute of Technology, 1947. The students' rooms are arranged along an S-curve that gives continually changing vistas and provides a large number of identical units. Both in plan and in elevation the architect plays the curves against rectangular and triangular accents which effectively lock and control them. Aalto's architecture is characterized by a warmth and humanity in his use of materials, individualizing particular buildings, and harmonizing with the human scale. Compared to that of Corbusier or Wright,

it is almost self-effacing. It seems to grow out of the site and out of particular, individual problems, whether those of factory, house, school, or town plan. Aalto is one of the leading designers of furniture, and is particularly effective in his development of bentwood chairs and tables.

One of his most successful houses is that built for the art dealer and collector, Louis Carré, appropriately known as the Maison Carré, between 1956 and 1958 at Bazoches, not far from Paris. The house is placed on a rise of ground, and the diagonal of the roof reiterates the landscape (fig. 728). The exterior is an integrated alternation of diagonals and planes. The materials are concrete with accents of stone and wood. Inside (fig. 729), the architect used light woods on curving ceilings and walls to create an effect of moving and integrated space. The house is completely furnished with Aalto furniture.

As the leading architect of Finland and Scandinavia, Aalto has had many opportunities to experiment with public buildings, churches, and town planning. Notable is

728. ALVAR AALTO. Maison Carré,
Bazoches-sur-Guyonne, France. 1956–58

729. ALVAR AALTO. Interior, Maison Carré. 1956–58

the House of Culture in Helsinki, 1955–58. Although this building is flawed by details such as the entry and its relation to the large adjoining office block, it represents on the exterior the architect's most exciting use of brick wrapped dramatically around the structure (fig. 730). Aalto, in some of his office buildings and larger housing developments, employs aspects of the international style cube and, for the latter, steel-skeleton construction; but his most personal expression is to be seen in structures such as the Town Hall at Säynätsalo, c. 1950–53 (figs. 731, 731a). This is a center for a small town including a council room, library, offices, shops, and homes. The brick structure with broken, tilted roof lines merges with the natural environment. Heavy timbers, beautifully detailed, are used for ceilings, to contrast with the brick walls inside and out. Although somewhat romantic in concept, this center illustrates the combination of effective planning and respect for the natural environment characteristic of Aalto and the best North-European architecture.

It is a curious fact that although Finland and the Scandinavian countries, generally progressive in government and social planning, and non-traditional in architecture, have produced relatively few experimental architects aside from Aalto, and few buildings of international distinction. There has been rather a good average of tasteful, comfortable, and well-planned buildings, not of striking distinction. The architecture of Aalto, however, does have international significance, both for its intrinsic merit and because it represents a dominant tendency of mid-century architecture: away from the strict emphasis on clarity of form developed by the international school, and toward enrichment of forms and materials.

The principal contributions of Finnish architects, perhaps of most North-European architects, has been in the area of housing and town planning, for which there was great need, with post-World War II rebuilding and expansion. Much shoddy and hastily built housing appeared, as it did elsewhere in the world. A number of well-planned garden cities did, however, emerge or are in plan. In Finland, the new town of Tapiola, near Helsinki, by Ervi, reflects ideas of the younger architects. Impressively situated in forest land, it was built by the Housing Foundation, unions, and welfare organizations (fig. 732). It is designed for twelve to eighteen thousand inhabitants, many commuting to central Helsinki to work. The town center includes a theater, church, tall office building, and shopping and recreation centers organized around a man-made pool. Houses and apartments of

730. ALVAR AALTO. House of Culture, Helsinki, Finland. 1955–58

731. ALVAR AALTO. Town Hall, Säynätsalo, Finland. c. 1950–53

731a. ALVAR AALTO. Plan of Town Hall, Säynätsalo

*left*: 732. AARNE ERVI.
Model of Community Center
for the Garden City of Tapiola,
Finland. 1955

*below*: 733.
ERIK GUNNAR ASPLUND.
Stockholm Exhibition.
1930

varying scale are scattered throughout the woods, permitting privacy and living space.

# Sweden

### ERIK GUNNAR ASPLUND *(1885–1940)*

The leading early modern architect of Sweden was Erik Gunnar Asplund, whose design for the Stockholm Exhibition in 1930 (fig. 733) was the first major break from the neo-classic tradition then still prevalent in Sweden. This steel-and-glass structure, although designed as temporary exhibition architecture, had a wide influence throughout Scandinavia because of its lightness, brightness, and clear statement of structure. Asplund's principal monument is the Forest Crematorium, Stockholm, 1940; situated on a hill partly created by the architect, it is a superb example of modern religious, though non-denominational architecture, integrated with a beautiful setting (fig. 734).

In Sweden as in Finland the most important post-war architectural contributions are the various housing schemes and planned communities. These include Vällingby in West Stockholm; Farsta, a planned community at the south of Stockholm; and housing schemes such as Orebro and Gröndal. Vällingby, designed by the Stockholm City Planning office (chief architect Sven Markelius), was begun in 1953 and planned as a suburb for twenty-five thousand inhabitants. It is a model of urban planning (fig. 735). Trees and park areas were preserved and expanded. Office buildings and homes embody a wide variety in scale and style. There is fast transportation to the center of Stockholm. Vällingby includes all business, cultural, and recreational facilities to serve not only its inhabitants but those of surrounding communities. Housing in the center of the town consists of a series of widely spaced high-rise buildings in the manner of

734. ERIK GUNNAR ASPLUND. Forest Crematorium,
Stockholm. 1940

735. SVEN MARKELIUS. Vällingby, Sweden. Begun 1953

*above:* 736. ARNE JACOBSEN. Bellavista Housing Development,
Klampenborg, Denmark. 1932–34

*right:* 737. ARNE JACOBSEN. Søholm Housing Project, Søholm, Denmark. 1950

*above*: 738. WALTER GROPIUS and MAXWELL FRY. Impington College, Cambridgeshire, England. 1936

*below*: 739. WALTER GROPIUS and MAXWELL FRY. Plan of Impington College. 1936

Corbusier's Voisin city plans. Toward the edges are smaller apartment buildings and individual houses for larger families and those who prefer more isolation.

# Denmark

### ARNE JACOBSEN (b. 1902)

In Denmark, as in Holland, since both are low-lying, flat maritime countries, the traditional material is brick, which is easily available and able to withstand the damp of the climate. The newer architecture has continued to use brick inside as well as outside; it also favors the traditional plan of buildings around courtyards. Arne Jacobsen was influenced by Le Corbusier and Mies van der Rohe, and his Bellavista Housing Estate near Copenhagen, 1932–34 (fig. 736), followed the general formulas of the international style, with whitewashed walls, ribbon windows, and staggered terraces. With the Søholm Housing Project, 1950, he reverted to a more traditional silhouette and material of yellow brick. The houses, some of which are placed on an incline, have both the sense of individuality and assimilation to the environment that mark the best Scandinavian architecture (fig. 737).

# Great Britain

After the important pioneer work of the late nineteenth century by Morris, Webb, Voysey, and Mackintosh, there was, as has been noted, little experimental ar-

chitecture in Great Britain during the first decades of the twentieth century. In the 1930s a new impetus was given by the arrival in Britain of the German architects Walter Gropius, Marcel Breuer, Erich Mendelsohn, and the Russian Serge Chermayeff. The impetus was interrupted by the devastation of World War II and, since the war, budgetary limitations have prevented large-scale architectural development. Although few great individual buildings have been erected in England in the twentieth century, progress has been made in two areas, town and country planning, and the design of schools and colleges. Walter Gropius, as noted, collaborated with the English architect Maxwell Fry in the design of Impington College, 1936 (figs. 738, 739), a structure involving a secondary, adult education school and community center that reflected some of the plans of the Dessau Bauhaus (see fig. 409).

740.
FREDERICK GIBBARD.
Harlow New Town,
England.
1947

741.
HUBERT BENNETT
and others.
Alton Estate,
Roehampton,
London.
1952–59

The wide-scale destruction occurring during World War II resulted in intensive research on the problems of town planning, although much of this was not subsequently put into practice and Great Britain, like most of Europe and America, suffered after the war from the disease of hastily-built mass housing. Nevertheless, in planned communities such as Harlow New Town, 1947 (chief architect Frederick Gibbard), and in the Alton Estate, Roehampton, 1952–59 (architects Hubert Bennett and others), prototypes were established: the former a design of houses with individual gardens (fig. 740), the latter a mixture of spaced, high-rise apartments with one- and two-story houses arranged over the contoured landscape (fig. 741). Roehampton, developed under the London County Council, is an outstanding example of low-cost housing, accommodating some ninety-five hundred persons. Tower apartments, rectangular slab blocks, and row houses are widely spaced amid extensive, landscaped surroundings. The influence of Corbusier is evident in the design and distribution of the buildings.

## ALISON SMITHSON (b. 1928), PETER SMITHSON (b. 1923)

Two of the most influential of the younger British architects are Alison and Peter Smithson. Their Secondary School at Hunstanton, Norfolk, 1954 (fig. 742), in its clear statement of structural geometry, is derived from Mies van der Rohe, but is original in plan. Administrative services are on the ground floors; classrooms, delegated to the second, are saturated with controlled, natural light. The Smithsons were probably responsible for the phrase, the new brutalism, which originated in 1954 and which has since become almost a cliché for the definition of new tendencies in architecture. The phrase (see p. 442) refers not only to the brutal statement of materials as practiced by Le Corbusier and a host of followers, but also to the uncompromising, if meticulous, assertion of structure practiced by Mies van der Rohe. It is in effect a return to basic principles of modern architecture, frequently lost sight of in the embellishments of the mid-century. In its origin it might be equated to the revolutions of Jackson Pollock and the American abstract expressionists, to Dubuffet and *l'art brut,* or to electronic noise-music. It is interesting that brutalist architecture, constituting an expressionist application of international style functionalism, should have been named in England. (It was in England, as well, that the term pop art was coined about 1955 or 1956, for one of the most widespread tendencies in modern painting.)

## France

With the exception of the titanic figure of Le Corbusier and earlier works by Auguste Perret, French architecture of the twentieth century has had few moments of inspiration. This is in part the result of the continuing academic system of training for architects, and the persist-

ing influence of a bureaucratic old guard. Some progress has been made recently in housing, and some of the best buildings have been churches. Perret's reconstruction of Le Havre after World War II, begun in 1947, is an uninspired example of modern classicism. Le Corbusier (born a Swiss) produced a number of masterpieces but his influence was greater outside of France than in it.

The most ambitious post-war structure erected in Paris was the UNESCO building (United Nations Educational Scientific and Cultural Organization) in the Place de Fontenoy (fig. 743). The architects were Marcel Breuer and Bernard Zehrfuss and the engineer Pier Luigi Nervi. The eight-story Secretariat building is Y-

742. ALISON and PETER SMITHSON. Secondary School, Hunstanton, Norfolk, England. 1954

743. BREUER, ZEHRFUSS, and NERVI. UNESCO Building, Paris. 1958

744.
MARCEL BREUER.
IBM-France
Research Center,
La Gaude Var,
France.
1960–62

745.
Interbau
Hansa-Viertel,
Berlin.
1957

shaped, adjoined to a fine conference hall, designed principally by Nervi. Although the total complex is excellently adapted to a difficult site, and although it is adorned by a large number of sculptures, paintings, and murals by leading artists such as Miró (see colorplate 156), Calder, Picasso, Noguchi, and Henry Moore, the total effect of the UNESCO building with the exception of the Conference Hall tends to be niggling and disappointing. Breuer developed the ideas and plan of the UNESCO building into his work on a research center for IBM-France (International Business Machines), at La Gaude Var, 1960–62. This is a huge structure of a comparable, double Y-plan, with windows set within deep, heavy, concrete frames, the whole on concrete supports (fig. 744). The effect of openness and airiness combined with massive, rugged detail. The enlargement of the elements results in greater sculptural cohesion than in the UNESCO building.

# Germany

As we have seen, Germany until 1930 was probably the world leader in the development of a new architecture. During the Nazi regime, 1933–45, German architecture declined from its position of world leadership to academic mediocrity. The destruction during World War II left the way open for a major rebuilding program. Unfortunately, a tradition of experiment and of progressive teaching and sympathetic patronage had also been destroyed by the Nazis. Thus, much of the recent building has been mediocre and, even in those structures where a conscious effort was made, inspiration and dedicated talent were lacking. Germany lost a generation of progressive architects and patrons.

Among the best buildings in post-war Germany are the new churches, theaters, and concert halls. The attempt to duplicate the famous 1927 Weissenhof estate (see fig. 414) on a more ambitious scale has been less successful, despite the fact that, following the earlier precedent, leading architects—Aalto, Le Corbusier, Gropius, Niemeyer, and others—were invited to participate. The new project, the so-called Interbau Hansa-Viertel, Berlin, 1957, embodies an informal grouping of tall and small residence structures in a landscaped park (fig. 745). Even with the talent that went into its design, it tends to a certain rigidity and lack of cohesion—possibly a result of the fact that many of the buildings are individual signatures of the participating architects.

Although the construction of very tall skyscrapers is still relatively limited in Germany, one of the most impressive to appear anywhere is the Phoenix-Rheinrohr building in Düsseldorf, 1957–60 (fig. 746), the architects of which were Helmut Hentrich and Hubert Petschnigg. Influenced by the uninterrupted high-rise slab buildings developed primarily in the United States, this twenty-two-story structure introduced a new sense of monumental scale by joining three slabs (two smaller units flanking on each side a larger unit) with connecting areas; the middle bay contains service functions, eleva-

746. HELMUT HENTRICH and HUBERT PETSCHNIGG. Phoenix-Rheinrohr Building, Düsseldorf, Germany. 1957–60

tors, washrooms, et cetera. The result is among the impressive, original, and efficient skyscrapers of recent times.

## HANS SCHAROUN (b. 1893)

Of the concert halls, the most ambitious is Hans Scharoun's Philharmonic Hall in Berlin, 1956–63 (figs. 747, 748, 749). Scharoun was one of the pioneer German modern architects who produced a number of experimental houses and housing projects during the 1920s and 1930s and was active in urban planning projects. He remained in Germany during the Nazi regime and the war, but was permitted to do little building. In the post-war period he has been an important link between the past and the present, responsible for the extensive Charlottenburg-Nord housing development in Berlin, 1955–61, and other housing projects, as well as the Berlin Philharmonic Hall. The Philharmonic stems from

*right*:
747. HANS SCHAROUN.
Philharmonic Hall,
Berlin. 1956–63

*below*:
748. HANS SCHAROUN.
Interior,
Philharmonic Hall

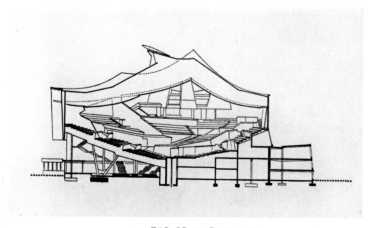

749. HANS SCHAROUN.
Section of Philharmonic Hall

Walter Gropius' concept of the Total Theater in which the audience surrounds the stage (see p. 251)—in this case the orchestra. The ideal, here attempted on a vast scale, is that of achieving intimacy between the audience and the players. This is a phase of the world-wide trend toward audience participation in theater, music, and happenings.

# Italy

Modern architecture made a somewhat belated arrival in Italy, perhaps because the sense of the past was so strong. No wonder that new or foreign experiments should have had difficulty in penetrating. The one outstanding architect produced by futurism was killed in World War I at the age of twenty-eight. This was Antonio Sant'Elia, whose visionary designs have been discussed (see p. 217). Had he lived, he might have accelerated the progress of modern architecture in Italy. As it was, his ideas faded with the fading of futurism and his influence was felt principally, through publications, on pioneers outside of Italy, importantly on Le Corbusier, and on the architects of De Stijl and the Bauhaus.

Although progressive architecture was not formally suppressed by Italian fascism as it was in Germany under the Nazis, the climate was not favorable for growth. The official governmental style looked back to showy monumentalism, of which the nineteenth-century monument to Victor Emmanuel II, in Rome, is the most distressing example. The Group of 7, younger architects, banded together in 1933 for a functional or rational architecture with a specifically Mediterranean accent. A few outstanding, though isolated, buildings resulted from Italian rationalism between the wars, notably Giuseppe Terragni's Casa del Popolo (House of the People, fig. 750), at Como, 1932–36, or Matté-Trucco's Fiat Works in

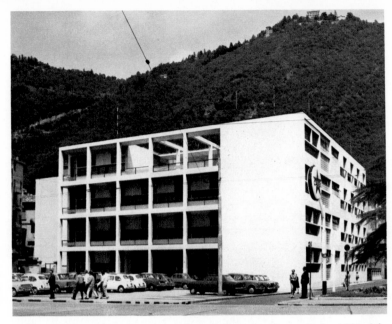

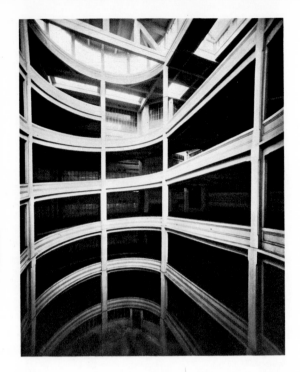

*above*: 750. GIUSEPPE TERRAGNI. Casa del Popolo, Como, Italy. 1932–36

*right*: 751: GIACOMO MATTE-TRUCCO. Heliclines to the Superelevated Car Testing Track, Fiat Lingotto Plant, Turin, Italy. 1927

Turin, 1927 (fig. 751). The latter includes a pioneer statement of a curving car ramp that anticipates some of the post-war Italian achievements in engineering. (Pier Luigi Nervi was at that moment also beginning his sensational career as an architectural engineer.)

Since the end of World War II, Italy has expanded its experiment in progressive architecture, moving into a position of European and even world leadership in many aspects of industry, product, and fashion design. One of the first outstanding post-war structures is the Main (Termini) Railroad Station in Rome (1948–50, Calini and Montuori, chief architects; figs. 752, 753). It is a good example of Italian engineering. Its cantilevered roof of unusual design permits the use of continuous glass walls between the supporting columns, and uninterrupted interior space. The architects have incorporated the ruins of the fourth-century B. C. Servian wall into the total design, as a dramatic contrast to the modern building.

Italian post-war architecture has been characterized generally by qualities of drama and excitement as well as by sound planning. Industrial firms, notably Olivetti, have commissioned buildings of remarkable quality that include progressive social planning. The Olivetti factory in Pozzuoli, near Naples, 1954 (Luigi Cosenza, architect), is a complex of industrial-administrative structures accompanied by a wide range of services for the employees—cafeteria, library, and recreation facilities. It is located on landscaped grounds with splendid views overlooking the Bay of Naples (fig. 754). New shops, apartment buildings, hotels, and churches, with a uniformly high average of design, have been built in every part of Italy since the war. A notable achievement has been the design of new art museums, particularly in Turin; and the modernization of installation and presentation techniques in older museums. Among churches, one of the most exciting in concept and imaginative use of materials is Enrico Castiglioni's project for a pilgrimage church, in Syracuse, 1957 (fig. 755). This involves a dynamic use of reinforced concrete in a roof that rests on freestanding supports. Here is an instance of

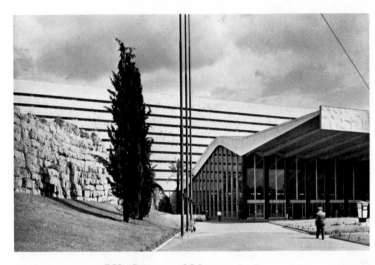

752. CALINI and MONTUORI.
Termini Station, Rome. 1948–50

753. CALINI and MONTUORI.
Interior, Termini Station

the search for new space concepts that represents perhaps the most important exploration of the young architects.

## PIER LUIGI NERVI *(b. 1891)*,
## GIO PONTI *(b. 1891)*

The great leader in this search is the engineer-architect Pier Luigi Nervi. Nervi is one of the great builders of all time, with a resounding ability to translate engineering structure into architectural forms of beauty. Chronologically he belongs with the pioneers of modern architecture, and his fundamental theses were stated in a number of important buildings executed during the 1930s. His preferred material is reinforced concrete, and his main contribution is his realization of its potentials in the creation of new shapes and dimensions of space. One of the most important commissions in his career was the design of an aircraft hangar in 1935, the first of a number of variants he built for the military from 1936 to 1941. These hangars, which involved uninterrupted roof spans, led him to a study of different ways to create such spans. He learned how to lighten and strengthen his materials, and to play aesthetic and structural variations in his designs.

Since 1945, Nervi has had unparalleled opportunities of putting his theories into practice. Because the im-

754. LUIGI COSENZA.
Olivetti Factory, Pozzuoli, Italy. 1954

755. ENRICO CASTIGLIONI.
Project for Pilgrimage Church, Syracuse, Italy. 1957

756. PIER LUIGI NERVI. Interior,
Exhibition Hall, Turin, Italy. 1948–49

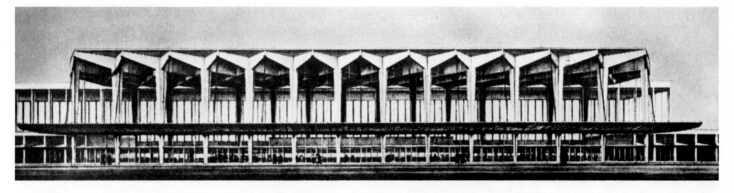

757. Pier Luigi Nervi. Project for Main Railway Station, Naples, Italy. 1954

mense exhibition building in Turin, 1948–49, had to be built rapidly, the architect developed a formula for small, prefabricated units which could be assembled easily on location (fig. 756). In his design project for the railroad station in Naples, 1954 (fig. 757), he created an open, rectangular hall hung on a system of concrete piers, and a network of diagonal roof elements that support the ceiling. Two of the dramatic applications of his experiments with ferroconcrete are the small and large sports palaces built originally for the Olympic Games in Rome, in 1960. The smaller, to hold four to five thousand spectators, was built in 1956–57, in collaboration with the architect Annibale Vitellozzi. The building is essentially a circular roof structure in which the enclosed shell roof, 197 feet in diameter, rests lightly on thirty-six Y-shaped concrete supports. The edge of the roof is scalloped, both to accentuate the points of support and to increase the feeling of lightness (fig. 758). A continuous window band between this scalloped edge and the outside wall provides uniform daylight and adds to the floating quality of the ceiling (fig. 759). On the interior, the ceiling, a honeycomb of radiating, interlaced curves, floats without apparent support. The large sports palace in Rome, built between 1958 and 1960, was designed for some sixteen thousand spectators. The dome is supported on diagonal posts which, with the abstract sculptural shapes of the staircases, reminds one of the structural system of Gaudí (fig. 760). In this case, the ceiling and supports are enclosed in a glass shell.

Nervi, during the 1950s and 1960s, collaborated with architects in Italy and other parts of the world. The Pirelli Tower in Milan (1956–59) is the design of Gio Ponti, the most distinguished of living Italian architects (with the exception of Nervi, who is better described as an engineer). Ponti developed slowly but consistently from neo-classical beginnings toward an elaborate modernism; he has been invited to design buildings in almost every part of the world. The Pirelli Tower (fig. 761), for which Nervi was the structural engineer, remains Ponti's masterpiece, and one of the most lucid and individual interpretations of the skyscraper yet achieved. Since, in contrast to most American skyscrapers, it is a separate building surounded by lower structures, designed to be seen from all sides, the architect was concerned with making it a total, harmonious unit. A boat-shaped plan,

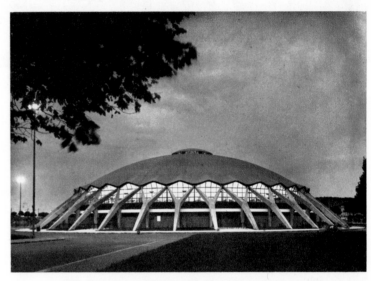

758. Pier Luigi Nervi and Annibale Vitellozzi. Sports Palace, Rome. 1956–57

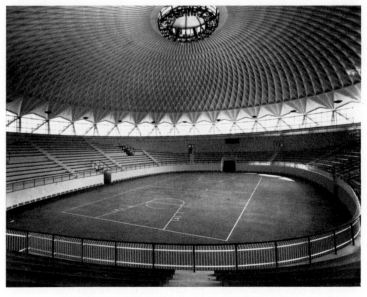

759. Pier Luigi Nervi and Annibale Vitellozzi. Interior, Sports Palace. 1956–57

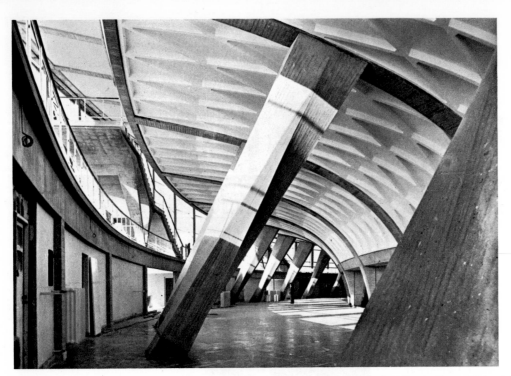

*above left*: 760. PIER LUIGI NERVI. Interior, Large Sports Palace, Rome. 1958–60

*above right*: 761. GIO PONTI, PIER LUIGI NERVI, and others. Pirelli Tower, Milan, Italy. 1956–59

rather than the customary rectangle slab, was used. It is unusual and impressive, departing from the tradition in that the entire building is carried on tapering piers. These result in enlargement of the spaces as the piers become lighter toward the top. The entire building, with the diagonal areas at the ends enclosed and framing the side walls of glass, has a sculptural quality, a sense of solidity and mass unusual in contemporary skyscraper design.

# Latin America

### OSCAR NIEMEYER *(b. 1907),*
### LUCIO COSTA *(b. 1902),*
### CARLOS RAUL VILLANUEVA *(b. 1900)*

The most spectacular example of the spread of the international style occurred in Latin America after 1940. Le Corbusier's participation in the design of the Ministry of Education and Health in Rio de Janeiro between 1937 and 1943 (see fig. 718) was the spark that ignited the younger Latin American architects, notably Oscar Niemeyer in Brazil. Corbusier's influence is apparent in most of the subsequent development of Brazilian architecture, but Niemeyer and the others added expressionist and baroque elements involving curving shapes, in plans and facades, together with lavish use of color that reflected the Latin American tradition. The scheme of Ibirapuéra Park in São Paulo, 1951–55 (fig. 762), illustrates the flowing organic organization at the opposite extreme to the straight geometry of the international style. Even in the main building, the Palace of Industries, 1953, a large rectangular structure, the interior is given dynamic force by the interlocking system of pedestrian ramps which break up and add vistas to the space. Niemeyer, in his church of Saint Francis at Pampulha, 1943, utilized concrete in the creation of a modern baroque structure of parabolic curves decorated in painted tiles (fig. 763) by Candido Portinari (the internationally best-known Brazilian painter, who fuses native, expressionist, and cubist influences in a powerful, socially-conscious, sophisticated style). Niemeyer's inventions in industrial and domestic building have ranged over all styles of modern architecture. The drama and vitality of his plans for Ibirapuéra led to his greatest commission, and one of the most dramatic commissions in the history of architecture: the design of an entire city at Brasilia, the proposed new capital of Brazil (fig. 764). The general plan of the city was laid out by Lúcio Costa, the dean of modern Brazilian architecture, but Niemeyer was entrusted with the principal public buildings. Brasilia is a utopian project possibly doomed to failure. The idea of building an entire city in the middle of a vast country, far removed from any of the principal centers of commerce and industry, represents the ultimate excursion into fantasy. At a time in the history of architecture, however, when only lip service is being given, and very little actual attention is being paid, to total concepts of urban planning, such a project is important, even in its deficiencies and failures.

During the last thirty or forty years, modern architecture has rapidly expanded in Latin America. Many, if not most, of the buildings erected are clichés of the international style, with the superficial appearance of modernism incorporated into traditional structures—typical of other countries where building expansion has taken place since 1945. In Latin America, nevertheless, individual

above: 762. OSCAR NIEMEYER.
Ibirapuéra Park, São Paolo,
Brazil. 1951–55

left: 763. OSCAR NIEMEYER.
Church of St. Francis,
Pampulha, Brazil. 1943

below left: 764.
OSCAR NIEMEYER.
Palace of the Dawn, Brasilia,
Brazil. 1959

below right: 765.
CARLOS RAUL VILLANUEVA.
Olympic Stadium, Caracas,
Venezuela. 1950–51

architects of talent or even genius have emerged, to contribute to the ideas and forms of progressive architecture. In Caracas, Venezuela, one of the most rapidly growing cities in Latin America, Carlos Raúl Villanueva has produced a number of outstanding buildings, particularly his Olympic Stadium, 1950–51 (fig. 765), and the buildings for University City, 1952 and later. The auditorium for University City, the Aula Magna, 1952–53, is an interior space whose lightness and airiness is enhanced by the ceiling designed by Alexander Calder and the acoustic specialist Robert Newman (see figs. 644, 661).

Mexico City was already adopting aspects of the international style in the mid-1920s, and this has become the official style of the country. It has been modified, particularly in the University City—under construction for thirty years—by the Mexican predilection for mural design. To be seen here are brilliantly colored decorative mosaic or tile treatments of exteriors, and huge commissioned frescoes by Rivera, Orozco, Siqueiros, and the other Mexican masters of mural painting (see p. 430).

## Canada and Australia

In Canada and Australia, vast and lightly populated countries, modern architecture in the 1950s and 1960s has accelerated at a pace unparalleled in their history. New buildings of all descriptions—skyscrapers, factories, housing projects, educational institutions, shopping centers, cultural centers, air terminals, and government buildings—have created a new architectural face for both of these countries. The City Hall in Toronto, built in 1965, architect Viljo Rewell, although a subject of controversy, is an original and exciting symbol of the new spirit in Canada (fig. 766). Scarborough College in Ontario, designed by the Australian-born architect John Andrews, is a dramatic new educational complex in Canada. Created in the tradition of Le Corbusier—massive structures of undressed concrete, monumental propor-

766. VILJO REWELL. City Hall, Toronto. 1965

*above*: 767. JOHN ANDREWS. Science and Humanities Wings, Scarborough College, Toronto. 1966

*right*: 768. ERICKSON and MASSEY. Simon Fraser University, South Burnaby, British Columbia. 1965

*left*: 769. Project for Arts Center, Melbourne, Australia

*below*: 770. HALL, TODD and LITTLETON. Sydney Opera House, Bennelong Point, Sydney Harbor, Australia. To be completed in 1972

tions, and noble vistas—this is a concept that would be notable in the modern architecture of any country (fig. 767). Architecturally, the other outstanding Canadian educational institution is Simon Fraser University, South Burnaby, British Columbia (fig. 768), by Erickson and Massey, 1965, a complex that combines modern classical space organization with the most advanced structural engineering.

In Australia, there is a comparable development of new architectural forms, from the slab skyscraper to the integrated educational institution and advanced experiments in housing and urban planning (fig. 769). The most spectacular modern structure is the Sydney Opera House on Bennelong Point, Sydney Harbor, scheduled to be completed in 1972 (fig. 770). Architects Hall, Todd, and Littleton succeeded the Danish Joern Utzon, who made the original design. This cultural center includes an opera hall, a theater, an exhibition area, a cinema, and a chamber music hall.

# Japan

### KENZO TANGE *(b. 1913)*

An independent style in modern Japanese architecture has been apparent only since the 1960s. Before, there was principally derivative commercial modern building, particularly in Tokyo, but little of any distinction or originality. The leader of the new Japanese architecture is Kenzo Tange. Like most of the younger Japanese architects, he is a disciple of Corbusier and particularly of Corbusier's later, brutalist style. Tokyo City Hall, 1952–57, is a rather thin and overly elegant version of Corbusier's Unité d'Habitation (see fig. 719), but with his Kagawa Prefecture Office, Takamatsu, 1955–58, Tange gained more authority in a combination of massive, direct concrete treatment with horizontally accentuated shapes reminiscent of traditional Japanese architecture (fig. 771). His Kurashiki City Hall, built in

771. KENZO TANGE. Kagawa Prefecture Office, Takamatsu, Japan. 1955–58

1958–60, is an even closer approximation, in its general effect, to Corbusier's La Tourette monastery, with Japanese architectural reminiscences. Perhaps his most striking achievement is the pair of gymnasiums he designed for the Olympic Games held in Tokyo in 1964 (figs. 772, 773). Both roofs are suspended from immense cables, and their structure is at once daring and graceful. Somewhat resembling seashells, the larger roof is hung from

*right*: 772.
KENZO TANGE.
Main Gymnasium,
Tokyo. 1964

*below*: 773.
KENZO TANGE.
Aerial view,
The National
Gymnasiums,
Tokyo. 1964

*below*: 774. TAKEO SATO. City Hall, Iwakuni, Japan. 1959

*right*: 775. KUNIO MAYEKAWA. Gakushuin University Library, Tokyo. 1961

*below right*: 776. KUNIO MAYEKAWA. Metropolitan Festival Hall, Tokyo. 1961

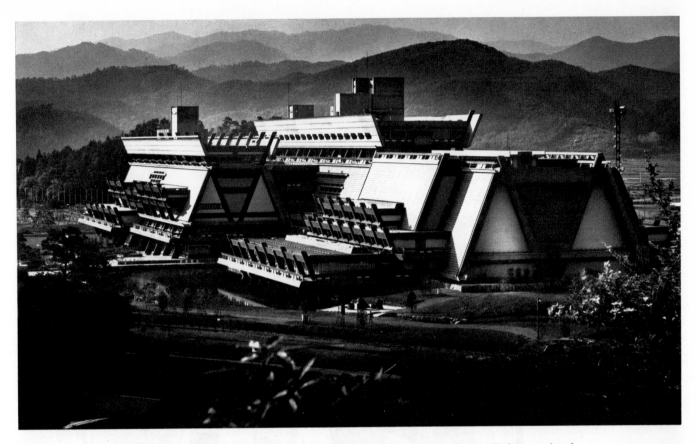

777. SACHIO OTANI. International Conference Building, Kyoto, Japan. To be completed

two concrete masts, while the smaller is ingeniously hung from a cable spiraling down from a single mast. The brutalism of the buildings themselves, with their rough surface textures, bold, sweeping curves, and frank structure gives the complex—set as it is on a huge platform of undressed stone blocks—a sense of enduring drama. Other Japanese architects who are following the late Corbusier line are Takeo Sato, whose City Hall in Iwakuni (fig. 774) is an even more literal transposition of a Japanese pagoda than Tange's Kagawa Prefecture Office, and Kunio Mayekawa, whose library of Gakushuin University in Tokyo combines exterior masses of interlocked, vertical towers and horizontal balconies with an interior that is chaste, immaculate, and light in proportions (fig. 775). Mayekawa's Metropolitan Festival Hall in Tokyo, 1961 (fig. 776), has, particularly in the upswept roof line, pointed if unassimilated relationships to Corbusier's government buildings in Chandigarh. Sachio Otani's still incomplete International Conference Building, Kyoto (fig. 777), is a massive building to house meeting and exhibition rooms, restaurants, administrative offices, shops, and recreation areas. Employing old trapezoidal and triangular design elements, it is one of the most spectacular attempts yet made to combine motifs and concepts of ancient Japanese building with modern structure on a vast scale.

Modern architecture in Japan, despite a long history of sporadic examples extending back to Frank Lloyd Wright's Imperial Hotel (see fig. 253), is actually only at its inception. Assimilating the overpowering Corbusier influence, the tradition of Japanese architecture—which for centuries embodied so many elements that today are

called modern—is helping to turn this influence into something indigenous.

## United States

In the early part of the twentieth century, modern architecture in the United States lost its original impetus. Almost all major building—industrial, commercial, governmental, or house architecture—between 1900 and 1940 was eclectic. Sullivan and Wright during these years had much more influence on the European pioneers than they did on Americans. In the 1930s a number of events and individuals pointed the way to a new era in modern design. The Museum of Modern Art in New York began a series of important exhibitions, the first of which, organized in 1932 by Henry-Russell Hitchcock and Philip Johnson, gave the international style its name. There followed exhibitions of the Chicago school (1935), Le Corbusier (1935), Aalto (1938), and the Bauhaus (1938). In this decade, also, a number of new skyscrapers were built that broke the eclecticism of the skyscraper form, and introduced aspects of the Chicago school, or principles of the Bauhaus and the international style.

Architects in the second half of the twentieth century have been able to develop new concepts of space, either through new structural systems, or through older systems such as ferroconcrete, used in new ways. Some of the areas in which architects have worked on an unprecedented scale, aside from the skyscraper and other urban

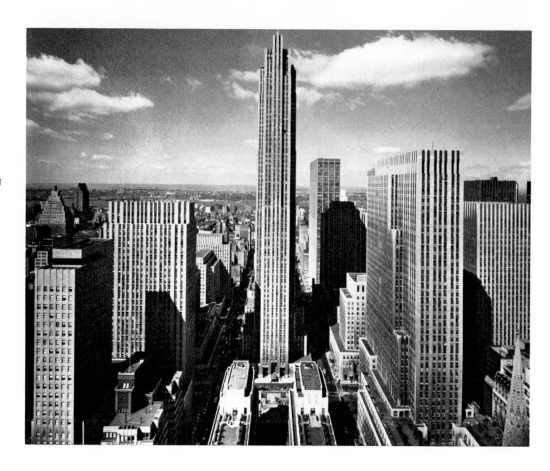

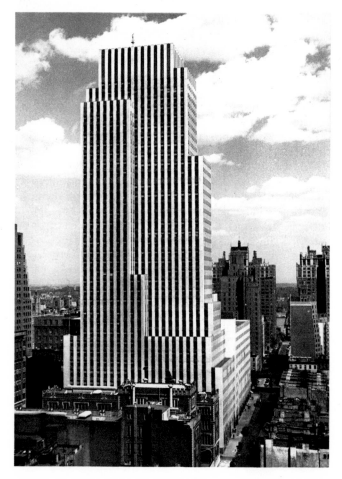

office buildings, are industrial plants and research centers; university campuses; religious structures; cultural centers including museums, theaters, and concert halls; and airports.

At this point, the structure of this book must change somewhat. The main headings have been given to generally broad treatments of movements, or tendencies, or other new developments. Following this, nationality has been the organizing principle (superficially, since as has been noted, it is the internationalization of our subject that is so conspicuous); and under nation, the division and emphasis has been—as it should be—upon individual creators, each with his own heading or in the company of one or two others. But obviously, in the section immediately following, and from then on, another arrangement must be used. Thus, architecture in the United States is divided by category (skyscrapers, houses, industrial complexes, et cetera), and some of the major creative talents and avant-garde spirits are placed within a running text under these headings. It would be too cumbersome to give them each their private cubicle—a repetitious sequence of name headings. In architecture, this segregation is less desirable not only because architects are often important under several headings, but also because major achievements are often the work of a group or even clusters of groups. In painting and sculpture, as we come closer to the time of writing, the artists shift from one category to another and, indeed, the categories themselves are not always capable of exact delineation. Half-a-century from now, it will no doubt be more possible to establish broad and solid categories of the great proliferation of the arts since World War II.

# SKYSCRAPERS

The most comprehensive complex of skyscraper buildings is Rockefeller Center in New York, begun in 1931 and still continuing. Although the original buildings have elements of Gothic detail, these are simplified to a relatively unobtrusive point, and have been eliminated in the newer buildings of the 1950s and 1960s (fig. 778). Rockefeller Center is of significance not only in marking a step toward a rational skyscraper design, but even more in its planning concept. Introduced here are large open areas for pedestrians between the office buildings; many recreational facilities; an elaborate cinema (Radio City Music Hall); radio and television studios; a theater, skating rink, and restaurants. Few, if any, office complexes in twentieth-century American architecture have improved on the total concept of Rockefeller Center. Its design is notable as an early example of the tendency to bring together large teams of architects and engineers to work cooperatively on a huge and complicated commission. The architects were Reinhard and Hofmeister, with the collaboration of Corbett, Harrison, MacMurray, Hood, and Fouilhoux. Although the introduction of this great mass of buildings into central Manhattan aggravated the problem of urban traffic congestion, Rockefeller Center did introduce an attitude of concern for the individual and his environment.

One of the architects collaborating on this scheme, Raymond Hood (1881–1934), almost singlehandedly charted the evolution of the skyscraper between 1920

781. GEORGE HOWE and WILLIAM LESCAZE. Philadelphia Savings Fund Society Building, Philadelphia. 1931–32

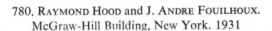

780. RAYMOND HOOD and J. ANDRE FOUILHOUX. McGraw-Hill Building, New York. 1931

and the early 1930s. His was the winning entry for the Chicago Tribune Tower, 1922 (see fig. 407), an extreme, although functionally effective, example of neo-Gothic design.

With John Mead Howells he designed the Daily News Building, 1930 (fig. 779), and with J. André Fouilhoux, the McGraw-Hill Building, 1931 (fig. 780), in New York. In both, the revivalist accretions of previous skyscrapers were stripped off. An interesting point of these two buildings is that the architects, realizing the peculiar design problem of the skyscraper—a tall building consisting of horizontal layers—designed the Daily News with an accent on the vertical and the McGraw-Hill Building with an accent on the horizontal.

A more revolutionary interpretation of the skyscraper than any of those noted is the Philadelphia Savings Fund Society (PSFS) Building, 1931–32 (fig. 781), by George Howe (1886–1955) and William Lescaze (b. 1896). The PSFS is the first, fully realized application of the international style to skyscraper design. Hood and Howells' Daily News Building still uses heavy masonry sheathing, into which the vertical window strips were set deeply. PSFS, using a much greater expanse of glass, ties vertical and horizontal accents together with a light but strong statement of the steel skeleton. The plan of indi-

782. Midtown Manhattan Skyline, looking North.

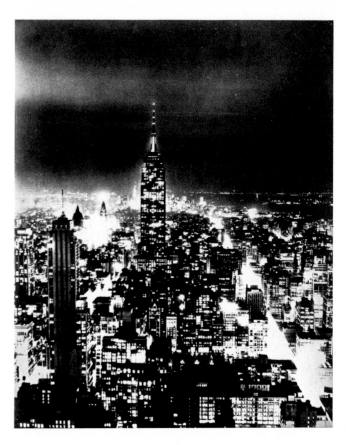

783. Midtown Manhattan Skyline at night, looking North.

784. WALLACE K. HARRISON and others.
United Nations Headquarters, New York. 1947–50

vidual floors is a T-shape and embodies a sound understanding of skyscraper planning in its effective segregation of service from office spaces.

Compared with this structure, the Chrysler Building, completed 1929, and the Empire State Building, 1930–32, familiar landmarks of the New York skyline, represent retrogression, both in their forms and functional design. This, unfortunately, is true of most skyscrapers erected in the United States between the 1930s and the 1960s. Although the New York skyline, particularly by night (figs. 782, 783), has a magical and exciting appearance, individual buildings are best examined at a distance. In New York, particularly, because of builders' desire to utilize every permissible inch of available space, there developed a peculiar kind of structure, with stories stepped back to conform (though barely) to the building codes. This "ziggurat" was perhaps the most characteristic design of the New York tall office building for twenty years after 1930. Only in the 1950s did architects and their patrons begin to realize the importance of open space for pedestrians and, as well, the public-relations value of a well-designed structure that could become a landmark. For reasons already noted—and especially the influence of international style and specifically Bauhaus-trained architects—there occurred a major renaissance and flowering of skyscraper design after the mid-century in the United States and, indeed, throughout the world.

The first American monument of this renaissance is the United Nations Building, 1947–50 and later, de-

signed by an international team of architects under the general direction of Wallace K. Harrison (fig. 784). The Secretariat Building introduced to the United States a concept of the skyscraper as a tall, rectangular slab, in this case with the sides sheathed in glass, and the ends in marble. Le Corbusier was principally responsible for the main forms of the Secretariat, but its simplified, purified structure embodies the Bauhaus tradition of Gropius and Mies van der Rohe as well.

The next and, in terms of its subsequent influence, even more important skyscraper was the twin apartment building in Chicago, designed by Mies van der Rohe in 1951 (fig. 785). Mies had been in Chicago since 1937, principally occupied with the new campus of the Illinois Institute of Technology. The skyscraper tradition of Louis Sullivan and the Chicago school inevitably had a fascination for him and drew him to a study of the skyscraper form. The basic problems involved—of steel structure, its expression, and its sheathing—were of particular interest. He had already explored these problems in his dramatic, though unbuilt, skyscraper designs in 1919 and 1919–21. The twin apartment buildings consist of two interrelated vertical blocks with the steel structure accenting the verticals. As is customary with Mies, the structures are built on a module.

The inspiration of Mies and of the United Nations Building led immediately to the first great office building of the 1950s, Lever House, 1951–52 (fig. 786), de-

786. SKIDMORE, OWINGS and MERRILL. Lever House, New York. 1951–52

signed by Skidmore, Owings and Merrill, and an outstanding example from this large industrial architectural firm. Lever House, intended—as is increasingly the case with the new skyscrapers—as a monument symbol for a world-wide corporation, is a tall, rectangular slab, occupying only a small part of a New York block. It is raised on pylons which support the first enclosed level— the principal public areas, which cover a large part of the plot—thus giving the total structure a vertical L-shape. The building is one of the first instances of the all-glass structure, with horizontal ribbon windows tinted a light green to reduce glare, alternating with opaque, dark green strips. Lever House remains one of the spectacular and satisfactory buildings in New York.

Across Park Avenue from Lever House is one of the masterpieces of skyscraper architecture, the Seagram Building, 1958 (figs. 787, 788). In it Mies van der Rohe and Philip Johnson were given an unparalleled opportunity to create a monument to modern industry, comparable to the Gothic cathedrals which were monuments to medieval religious belief. The building is a statement of the slab principle, isolated with absolute symmetry within a broad plaza lightened by balanced details of fountains. The larger skeleton structure is clearly apparent within the more delicate framing of window elements that sheath the building. The materials, metal bronze and

785. MIES VAN DER ROHE. Lake Shore Drive Apartments, Chicago. 1951

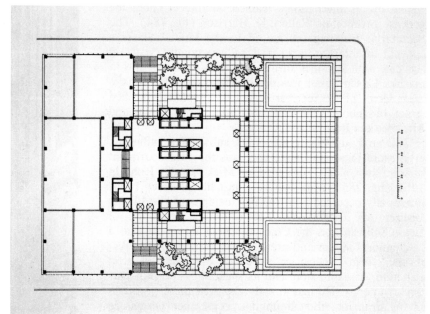

*left*: 787. MIES VAN DER ROHE and PHILIP JOHNSON. Seagram Building, New York. 1958

*above*: 788. MIES VAN DER ROHE and PHILIP JOHNSON. Plan of Seagram Building. 1957

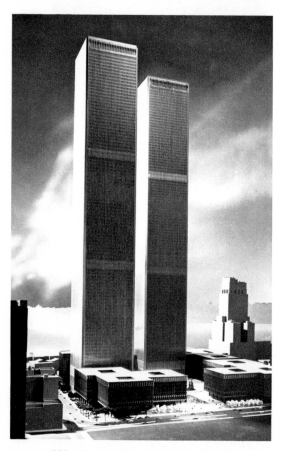

789. MINORU YAMASAKI. Project for World Trade Center, New York. Begun 1967

790. EERO SAARINEN. CBS Building, New York. 1962–64

791. BERNARD ZEHRFUSS. Model for a City-Planning Project, Paris

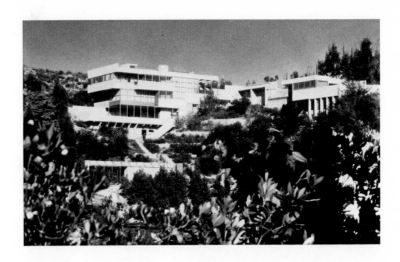

amber glass, lend the exterior an opaque solidity that
does not interfere with the total impression of light that
fills the interior. The building is perhaps the consummate
expression of Mies's emphasis on "the organic principle
of order as a means of achieving the successful relation-
ship of the parts to each other and to the whole." No
other building of modern times has had such influence on
subsequent skyscraper design.

The Miesian credo has been given its most monumen-
tal statement in the design for a projected World Trade
Center (fig. 789), built for the Port of New York Au-
thority. Designed by Minoru Yamasaki (b. 1912) and
Emery Roth & Sons, the twin towers of 110 stories will
be the tallest in the world. The Phoenix-Rheinrohr
Building in Düsseldorf, as noted (see p. 453), also plays
significant variations on Mies's theme, as do skyscrapers
in every part of the world. There are architects, however,
who escape the tradition of Mies: among them Eero
Saarinen (1910–1961), whose CBS Building, New York,
1962–64, reintroduces an uncompromising contrast of
massive vertical piers alternating with the recessed voids
of the windows (fig. 790); Gio Ponti in his Pirelli Build-
ing, in Milan (see fig. 761); and Bernard Zehrfuss (b.
1911) of the firm of Camelot, Mailly and Zehrfuss, in
his design for a skyscraper complex in a city-planning
project in Paris (fig. 791). In the latter, the concept of
the skyscraper as a cluster of connected, interrelated
buildings may represent a new direction.

## HOUSES

During the first half of the twentieth century, most ex-
periments in modern architecture were carried out in in-
dividual houses. This is understandable, since the cost of
building a skyscraper or a great industrial complex is so
exorbitant that it took half-a-century before patrons
dared to gamble on modern buildings. As noted, the ar-
chitecture of Frank Lloyd Wright during most of his life
consisted of individual houses. The first of the European
architects to come to the United States during the 1920s,
William Lescaze, Richard Neutra (b. 1892), and Ru-
dolph Schindler (1887–1953), devoted much of their ca-
reers to house architecture. Both Schindler and Neutra
worked for Wright and each built a house in California
for Dr. Richard Lovell, combining aspects of Wright's
house design with that of the international style. The
Neutra house in particular (fig. 792)—placed spectacu-
larly on a mountainside and, through its open terraced
construction, taking every advantage of the amenities of
landscape and climate—created a distinct style of South-
ern California architecture. It may even have had some
influence on Wright's Kaufmann House. Neutra's Kauf-
mann House near Palm Springs, California, 1947 (figs.
793, 794), illustrates his ability, comparable to Wright's,
to assimilate a modern structure into a picturesque des-
ert and mountain landscape.

Much of the early American architecture of Gropius
and Breuer consisted of houses following Bauhaus princi-

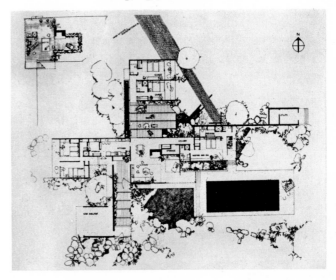

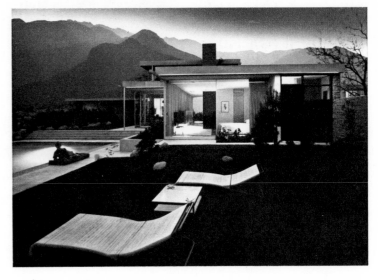

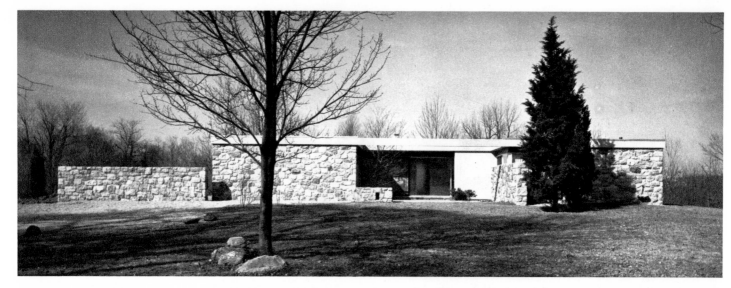

795. MARCEL BREUER. House II, New Canaan, Connecticut. 1951

*above:* 796.
MARCEL BREUER.
Interior, House II. 1951

*above right:* 797.
MARCEL BREUER.
Robinson House,
Williamstown,
Massachusetts. 1946–47

*right:* 798.
MIES VAN DER ROHE.
Farnsworth House, Plano,
Illinois. 1950

799. PHILIP JOHNSON.
Glass House, New Canaan,
Connecticut. 1949

ples. Breuer's own second house at New Canaan, Connecticut, 1951, illustrates his adaptability in the use of materials that blend with the local scene. In this case it is principally concrete and field stone with weathered wood beams used for the ceilings (figs. 795, 796). In other houses, such as the Robinson house in Williamstown, Massachusetts, 1946–47 (fig. 797), he also uses field stone in an expressive manner that anticipates the stone-and-concrete structures of his later career.

Mies van der Rohe has built no houses in the United States with the exception of the Farnsworth House in Illinois (fig. 798), but his tradition has been carried on, notably by Philip Johnson, whose own home in New Canaan, Connecticut, 1949 (figs. 799, 800), is a classic extension of the Miesian principles. The main house is a glass box which provides protection but destroys the boundaries between nature and enclosed space; the guest house is at the other extreme—a totally enclosed structure.

Of great potential significance are the visionary house designs which belong to a new stage of imaginary architecture in the larger sense. Outstanding is the Endless House, 1959, designed by Frederick Kiesler. As early as 1925 he conceived of a city in space built on a bridge structure, and an Endless Theater. From these, in 1934, he developed a space house, and after years of experiment, the so-termed Endless House (figs. 801, 802). In this he abandoned the rectangle and returned to egg shapes, freely modeled from plastic materials and involving a continuously flowing interior space. Kiesler's ideas have influenced younger expressionist architects such as John M. Johansen, who has devised a house utilizing sprayed concrete in which the curves of the interior also eliminate angles and moldings: floors, walls, and ceilings are unbroken surfaces (fig. 803). Such experiments represent an attempt not only to find new forms based on

800. PHILIP JOHNSON. Interior, Glass House. 1949

natural, organic principles but also to utilize new technical and industrial developments with the potential of cutting building costs. Among them is Paolo Soleri's house and studio, 1961, in Scottsdale, Arizona, literally a cave, the forerunner of which was the house in Cave Creek, Arizona, 1950 (fig. 804).

The Kiesler concept in a modified form has been utilized in the design of a house of the future molded from plastic and furnished with objects made of plastic (fig. 805). This design, by the architects Richard W. Hamilton and Marvin L. Goody, is one of many such experiments now being carried on in Europe and America. Few show prospects of large-scale development.

*above left*: 801.
FREDERICK KIESLER. Model
of Endless House. 1958–59

*left*: 802.
FREDERICK KIESLER. Plan
of Endless House. 1958–59

*above right*: 803.
JOHN M. JOHANSEN. Project
for Spray Form House. 1950s

*below left*: 804.
PAOLO SOLERI. House,
Cave Creek, Arizona. 1950

*below right*: 805. RICHARD W.
HAMILTON and MARVIN L. GOODY.
House of the Future. 1957

Prefabrication—in which individual units are mass-manufactured and then assembled—has been an unrealized dream of the twentieth century. There have been instances of successful, large-scale prefabrication such as Nervi's Turin Exhibition Hall (see fig. 756); some manufacturers in the United States offer partially prefabricated small houses. The architect-designer Charles Eames, in a number of California houses, including his own in Santa Monica, 1949, has developed practical forms of partial prefabrication, using structural modules consisting of light steel-skeleton cores covered with fitted plastic, stucco, or glass panels (fig. 806), as well as stock doors, windows, and accessories. The potentials of prefabrication for large-scale, low-cost housing are very great, but are continually retarded by many forces, including obsolete building codes and antiquated building methods.

## INDUSTRIAL COMPLEXES

One of the principal post-war trends has been the movement of industry away from the congestion of large cities, to the open spaces of the suburbs or smaller towns. This trend is a natural consequence of the enormous expansion of industrial building after World War II, the exorbitant costs of land and construction in cities, as well as the realization on the part of many companies, such as insurance firms and research centers, that it is not essential to have immediate contact with clients, since virtually all their business is carried on by correspondence or telephone. There has also been an increase of attention to the welfare of employees, a realization of the importance of an attractive natural environment, and awareness that employees can be housed more easily,

cheaply, and comfortably in smaller communities. One of the first large-scale post-war industrial complexes to be built was the Technical Center for General Motors in Warren, Michigan, 1951–57. The principal architect was Eero Saarinen, who was a spectacular talent among younger American architects. The Center (fig. 807), begun in collaboration with Eero's father (see p. 245), but essentialy the work of the younger man, is a large-scale, self-sufficient complex of buildings arranged within an attractive landscape around an artificial lake. Although the Research Center in its final form was much like Mies van der Rohe's plan for the Illinois Institute of Technology, and the design of the buildings follows the international style, its importance rests in the total planning concept and in the development of prefabricated units such as the sealed, enameled surface panels. The architect attempted to avoid a mechanical appearance of the buildings through the use of bright enamel color and the introduction of certain fanciful details such as the water tower, the dome of the Styling Auditorium, and the circular staircases. The fountains in the lake include the *Water Ballet* of Alexander Calder.

## COLLEGE AND UNIVERSITY CAMPUSES; RELIGIOUS STRUCTURES

Since 1945 there has been an expanding enrollment in colleges and universities everywhere, with consequent building programs ranging from the addition of a classroom or dormitory to the creation of whole new campuses. Too often this expansion has followed traditional college architecture, with some slight gestures to modernism. In a number of instances, however, enlightened ad-

808. JOSE LUIS SERT. Married Student Housing,
Harvard University, Cambridge, Massachusetts. 1964

ministrations have called on the talents of the most advanced architects. Thus, Harvard University, a campus of red-brick Georgian and Victorian structures, employed Gropius to build a new Graduate Center (see fig. 712), and José Luis Sert, now dean of architecture, to design the new apartments for married graduate students (fig. 808), as well as other structures. Harvard also has the distinction of having commissioned the only building by Corbusier in the United States (if we except his part in the design of the United Nations Buildings). This is the Carpenter Center for the Visual Arts (fig. 809), an outstanding example of Corbusier's late style, with its monumental shapes and rough concrete masses. It is not only a powerful instance of Corbusier's brutalism, but is an unusually efficient building—a fact in itself remarkable since it was erected without a clear understanding on the part of the University as to its actual purpose. Only one fact was really known: that it was primarily a building for exhibitions, studio activities in painting, sculpture, and design. Corbusier, with this meager program, designed the interiors, with excellent natural light, as large, handsome, uninterrupted spaces capable of subdivision. This, as it turned out, was all that was necessary.

The educational expansion, particularly of state universities, has provided the opportunity to create entire campuses as a unit. In terms of site, one of the most spectacular of these is the new Air Force Academy designed by Skidmore, Owings and Merrill between 1956 and 1962 (fig. 810). The Air Force Academy, built on a gigantic paved platform, is an interlocked series of rectangular courtyard buildings, appropriately accompanied by a huge stadium. Curiously, the focal point seems to be the Chapel, a structure of mechanized modern Gothic modular elements.

American college campuses are particularly susceptible to academic design systems. Administrators and architects alike tend to feel that the architecture of repositories of learning should symbolize the traditions being preserved. Yet one of the principal tendencies at mid-century has been, in effect, a new academy based on the international style. This is apparent in the work of many American architects, notably that of Edward D. Stone

*above*: 809. LE CORBUSIER.
Carpenter Center for
the Visual Arts, Harvard
University, Cambridge,
Massachusetts. 1963

*right*: 810.
SKIDMORE, OWINGS and
MERRILL.
Air Force Academy,
Colorado Springs,
Colorado. 1956–62

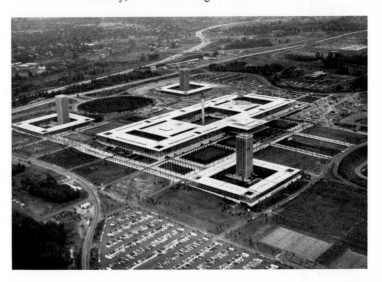

(b. 1902). (One of the first American proponents of the international style, Stone passed into a phase of monumental facade architecture, which might be described as a form of neo-classicism with oriental overtones; fig. 811.) His campus for the State University of New York, Albany (fig. 812), is a beautifully integrated, symmetrical composition of squares and rectangles. His sensitivity to proportional relationships and richness of textural detail makes him an outstanding instance of a mid-century tendency that implies the lapse of contemporary architecture from experiment into decoration and ornament. In the late phase of any architectural cycle, architects have always turned to the elaboration of detail and emphasis on visual effects, in an effort to find their own forms of personal expression.

In the planning of total campuses, university trustees and administrators have predictably turned to the architects who were sure to produce the most pleasing and spectacular effects. Frank Lloyd Wright was given an opportunity to design the campus of Florida Southern College at Lakeland, 1940–59, because both the college and the architect were insolvent and willing to take a chance. The tendency to take a chance is less apparent in the total campus planning today. In individual buildings, however, college campuses have seen some remarkable experiment. Marcel Breuer was given one of his first major American opportunities in the Abbey Church of St. John's, for the Benedictine College in Collegeville, Minnesota, 1953–63. His chief work to this date had been the UNESCO Building in Paris, in which his collaboration with Nervi undoubtedly affected his thinking about the use of concrete and engineering principles of construction. These he applied in the lecture hall for New York University Bronx campus, 1961, a dramatically cantilevered structure with windows of varying sizes punched in the mass of the roughly textured concrete (fig. 813). The Abbey Church at Collegeville (figs. 814, 815) features a detached bell tower, a great concrete slab set up on piers. This monumental gateway to the church is itself a splendid work of abstract sculpture. The interior of the church, influenced by Corbusier as well as

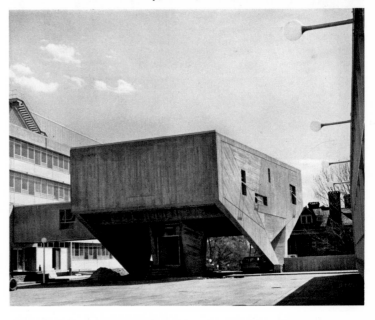

by Nervi, but evidencing an individual interpretation, is one of the most compelling religious structures in the United States.

Although he has actually built relatively few buildings, perhaps the most influential American architect of the mid-century is Louis I. Kahn (b. 1901). Born in Estonia and brought to Philadelphia in 1905, he received an architectural training in the Beaux-Arts tradition, at the University of Pennsylvania. There followed a year in Europe, where he was impressed both by the monuments of

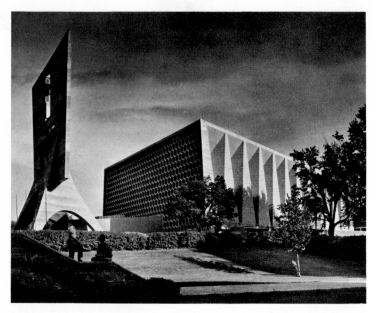

814. MARCEL BREUER and HAMILTON SMITH. St. John's Abbey and University, Collegeville, Minnesota. 1953–63

815. MARCEL BREUER and HAMILTON SMITH. Interior, St. John's Abbey Church. 1953–63

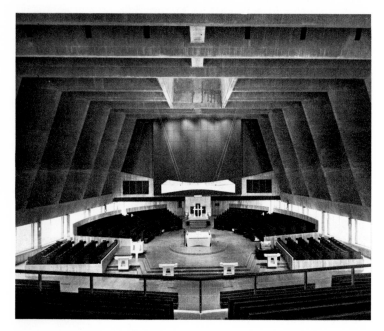

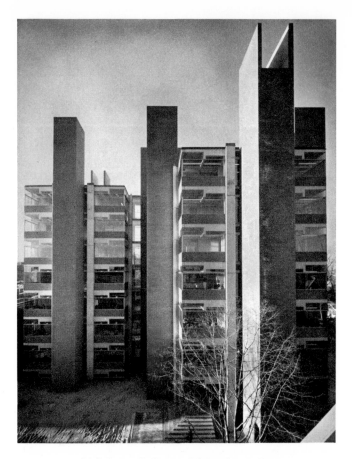

816. LOUIS I. KAHN. Richards Medical Research Building, University of Pennsylvania, Philadelphia. 1957–61

816a. LOUIS I. KAHN. Plan of Richards Medical Research Building

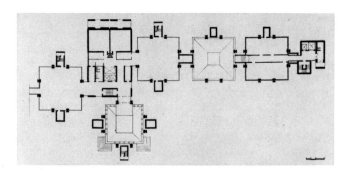

classical antiquity and by his discovery of Corbusier. For a number of years he taught at Yale University, where he designed the Yale Art Gallery, the university's first modern building and one of the first contemporary approaches to the problem of the art museum. After he returned to the University of Pennsylvania in 1957 to teach, Kahn designed for the University the Richards Medical Research Building (figs. 816, 816a), a structure comprising a series of interconnected enclosed squares —the laboratories—accented by groups of brick pylons that provide ducts for continual air circulation as well as for stair and elevator services and storage. Despite some functional limitations, the building is one of the most

imaginative, impressive, and fresh in vision of any designed in the mid-twentieth century. Almost immediately, its effect began to be seen in imitations and adaptations in both the United States and Europe. It is difficult to describe the impact of this building and of the rest of Kahn's architecture. It combines a simplicity and clarity of form that avoids all contemporary clichés, looks to the future, and yet is as traditional as the Parthenon or the walls of Babylon. Kahn is not only a designer concerned with mechanical and visual relationships of extraordinary subtlety and aesthetic quality, but he is a planner, both practical and visionary, on the scale of an individual building (fig. 817) or of an entire city. It may be that

his greatest influence, however, will be through his teaching and writings, although it is to be hoped that some inspired patrons will give him the opportunity to carry out his ideas as they deserve.

Of other campus buildings, among the most notable are those of Aalto at MIT, already discussed (see p. 445), and Paul Rudolph (b. 1918) at Yale University. Rudolph's architecture is symptomatic of the talented adaptation of the work of the pioneers, now the practice of leading architects of the younger generation. One of his most impressive structures is the parking garage in New Haven, a forceful adaptation of Corbusier's brutalism (fig. 818).

Rudolph's Art and Architecture Building for Yale University is an impressive and dramatic structure, illustrative of the new eclecticism (fig. 819). The exterior masses are reminiscent of early works by Frank Lloyd Wright, such as the Larkin Building (see fig. 251). The Married Student Housing at Yale (fig. 820), a complex of self-contained units on a limited, sloping plot, seems to reflect the influence of Kahn, Rudolph's predecessor at Yale, as well as some of the early French colonial housing developments in Algiers and Casablanca designed by Corbusier and others on the basis of native forms. This type of housing complex, with staggered, isolated units, is of particular interest to a number of younger architects.

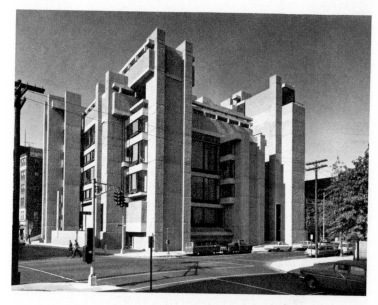

819. PAUL RUDOLPH. Art and Architecture Building, Yale University, New Haven, Connecticut. 1963

817. LOUIS I. KAHN. Project for Kimbell Museum, Fort Worth, Texas

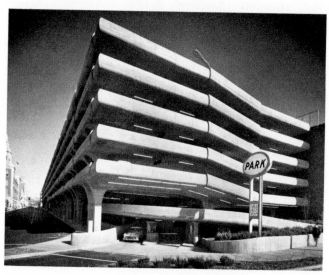

818. PAUL RUDOLPH. Parking Garage, New Haven, Connecticut. 1961

820. PAUL RUDOLPH. Married Student Housing, Yale University, New Haven, Connecticut. 1961

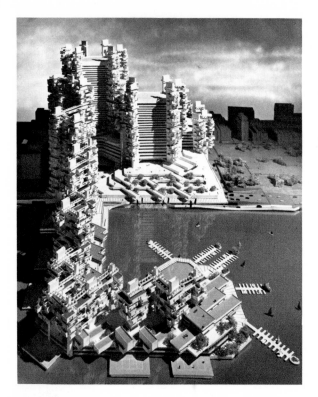

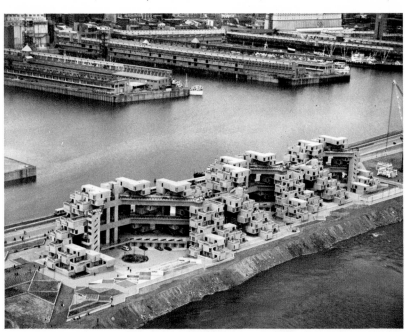

Rudolph's project for a graphic arts center in Manhattan (fig. 821) is a gigantic, visionary application of this way of building; but it has been given its most dramatic presentation in the so-called Habitat—prefabricated concrete structures designed by the Israeli architects Moshe Safdie, David Barott, and Boulva for the Montreal World's Fair, EXPO 67 (fig. 822).

## CULTURAL CENTERS, THEATERS, AND MUSEUMS

Another manifestation of the changing American scene after the mid-century has been the proliferation of cultural centers. The idea of the cultural center, usually a complex of buildings involving one or more theaters or concert halls, frequently combined with a museum or an exhibition hall for painting and sculpture, is an outgrowth of the community art centers that emerged during the 1930s under the Federal Art Project of the WPA. The Tyrone Guthrie Theater in Minneapolis, designed by Ralph Rapson and built in 1960–61 on property adjoining the Walker Art Center, interconnects with the Center so that the museum with its changing exhibitions can be integrated with the program of the theater. The theater has an arena stage, one of the most flexible American theater designs (fig. 823). The treatment of the facade and foyer areas owes something to newer German theaters such as the Municipal Theater at Gelsenkirchen, 1958–59 (fig. 824).

The most elaborate cultural center in the United States is Lincoln Center for the Performing Arts, New York, which opened in 1962 with a concert in Philharmonic Hall (architect, Max Abramowitz). The principal buildings surround a monumental plaza, the focus of which is a tall fountain designed by Philip Johnson (fig. 825).

They comprise, in addition to Philharmonic Hall, the New York State Theater (completed 1964; architect Philip Johnson, fig. 826), the Vivian Beaumont Theater (completed 1965; architect, Eero Saarinen), the Library-Museum of the Performing Arts (completed 1965; architects, Skidmore, Owings and Merrill), and the Metropolitan Opera House (completed 1966, architect, Wallace K. Harrison, fig. 827). A large subterranean garage underlies this group. Adjunct structures include a midtown branch of Fordham University and a new home for the Juilliard Conservatory of Music (begun in 1965; architects, Belluschi, Catalano, Westermann). A new building for the High School of Performing Arts is contemplated.

The buildings created by this grandiose assemblage of talent exemplify—Saarinen's flexible theater excepted—the new monumental classicism characteristic of public and official architecture in the 1960s. The project is unquestionably impressive, although many practical criticisms have been leveled against individual structures. The main difficulty, aside from problems of acoustics and sightlines, seems to lie in the impact of Lincoln Center's somewhat barren monumentality—its huge scale lacking in ornamental detail to establish a human reference. Rockefeller Center, that huge but less pretentious combination of commerce and recreation, appears rather intimate and comfortable by comparison.

A building which is not in itself literally a center of cultural activities but might be considered their parent is the new home of the Ford Foundation in New York City. Completed in 1967 (architect, Kevin Roche), this building deserves comment as a revival of an original concept seen in Wright's Larkin Building. It is a tall building designed as balconies around an open central space. The basic L-plan is brought to a square by a landscaped courtyard which provides a much needed area of vege-

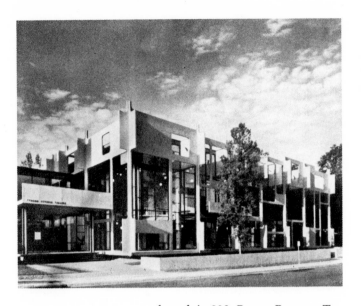

*above left:* 823. RALPH RAPSON. Tyrone Guthrie Theater, Minneapolis, 1960–61

*above right:* 824. RUHNAU, RAVE, and VON HAUSEN. Municipal Theater, Gelsenkirchen, Germany. 1958–59

*above left:* 825.
Lincoln Center. From left:
New York State Theater,
by PHILIP JOHNSON, 1964;
Metropolitan Opera House,
by WALLACE K. HARRISON, 1966;
Philharmonic Hall,
by MAX ABRAMOWITZ, 1962

*above right:* 826.
PHILIP JOHNSON. Auditorium,
New York State Theater. 1964

*left:* 827. Lincoln Center.
Left: Metropolitan Opera House.
Right: Vivian Beaumont Theater,
by EERO SAARINEN, 1965

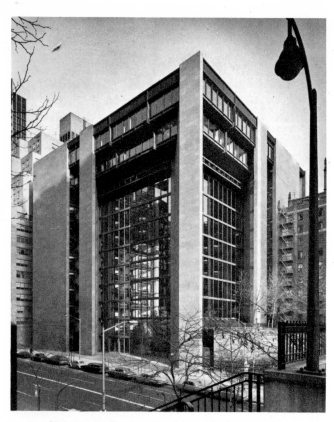

828. KEVIN ROCHE. Ford Foundation Building,
New York. 1967

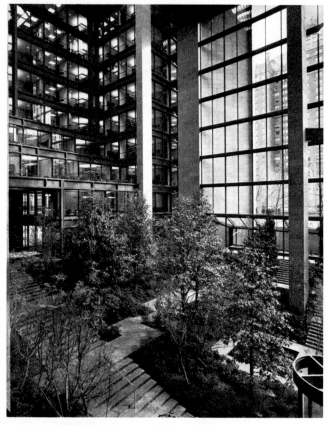

828a. KEVIN ROCHE. Interior Courtyard,
Ford Foundation Building.

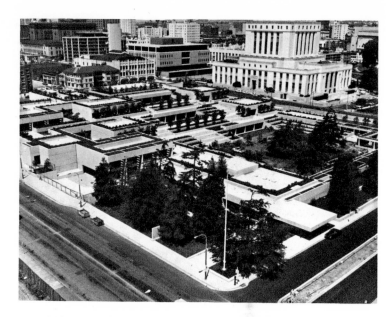

829. KEVIN ROCHE. Oakland Museum, Oakland, California.
To be completed 1969

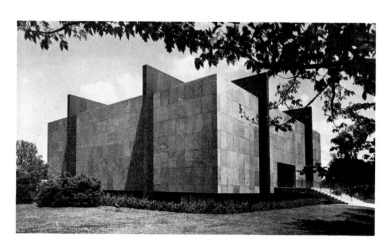

830. PHILIP JOHNSON. Munson-Williams-Proctor Institute,
Utica, New York. 1957

831. PHILIP JOHNSON. Interior, Munson-Williams-Proctor Institute

tation in Manhattan, for both working staff and passing spectators (figs. 828, 828a).

Roche, who carries on many of the Saarinen traditions, has also been commissioned to design the new Oakland Museum in California. One of the most comprehensive new museum designs of the twentieth century, this will include galleries for art history and natural sciences (fig. 829). Like the Ford Foundation headquarters, the essence of the plan is a combination of efficient interior space opening out on landscaped terraces and lawns.

The cultural center concept continues to spread to cities all over the United States. Edward Stone's Community Center for the Performing Arts in Washington, D. C., should be mentioned, and comparable though naturally less ambitious centers are envisioned in many other cities. Philip Johnson has designed several museums, such as the Munson-Williams-Proctor Institute in Utica, New York, 1957 (figs. 830, 831), and the Museum of Pre-Columbian art of Dumbarton Oaks, Washington, D. C., (fig. 832). Each in its own way is a self-contained unit, the former a completely enclosed building, with the exception of the skylight over the central well. It is a handsome structural system: an exposed, reinforced-concrete, copper-sheathed frame, from which the building is suspended. The Pre-Columbian wing of Dumbarton Oaks is a jewel box—eight circular galleries set in a square around a central circular lobby.

An art museum is actually a complicated design problem, involving basic questions of efficient circulation, adequate light—natural, artificial, or both—sufficient work and storage space and, in most cases, rooms for other events such as concerts, theatrical performances, and receptions. The design of I. M. Pei (b. 1917) for the Everson Museum of Art, Syracuse, New York, 1965 (figs. 833, 834), is a smaller building with a flexible solution created in impressive masses that may owe something to the inspiration of Kahn.

One of the most ambitious museum structures, the Museum of Modern Art in New York, in its building and rebuilding is almost a history of the international style in the United States. The original building was designed by Stone and Philip Goodwin in 1937, as the first American public building in the international style. The courtyard was the work of Philip Johnson. New additions by Johnson have more than tripled the size of the museum and have introduced many new experiments in flexible exhibition space and museum lighting. In the original international style formula, the museum was designed essentially as an interior space. Crowded into a mid-town New York street, the entrance front, with its varying facades is difficult to comprehend as a whole; the garden exterior is the principal and most effective view (fig. 835).

In New York, the two most impressive art museum buildings are by two older masters: Frank Lloyd Wright's Guggenheim Museum (see fig. 711) and the more recent Whitney Museum of American Art designed by Breuer. Breuer's building, illustrative of his later brutalism, is a development of the forms he used earlier for St. John's Monastery Church and for the auditorium of New York University. It is a stark and impressive building, in which heavy dark granite and concrete are used

832. PHILIP JOHNSON. Plan of Museum of Pre-Columbian Art, Dumbarton Oaks, Washington, D.C. 1963

833. I. M. PEI. Elevation of Everson Museum of Art, Syracuse, New York. 1965–68

834. I. M. PEI. Sketch of Interior, Everson Museum of Art. 1965–68

835. PHILIP JOHNSON. Sculpture Garden and
New Building, The Museum of Modern Art,
New York. 1964

*above*: 836. MARCEL BREUER. Whitney Museum of American
Art, New York. 1966

*below*: 837. MARCEL BREUER. Interior,
Whitney Museum of American Art

inside and out (fig. 836). The main galleries are simply huge, uninterrupted halls capable of being divided in any way, by movable yet solid partitions (fig. 837). It represents the utmost flexibility in installation space and artificial lighting. Natural daylight has been sacrificed, with the exception of shaped windows that are relief accents. Although in the original design of the Whitney the architect was forced to sacrifice work and storage space, provision is made for its expansion in future construction.

## URBAN PLANNING AND REHABILITATION; AIRPORTS

One of the unfulfilled dreams of modern architecture is the planning of cities. This, in fact, has been a dream of architects since antiquity, occasionally given partial fulfillment as in the new Hellenistic cities built after the conquest of Alexander the Great, the Roman forums, the Renaissance and Baroque piazzas, the Imperial Forbidden City of Peking, and Baron Haussmann's rebuilding of Paris in the nineteenth century. Le Corbusier, as indicated, was one of the visionaries of European planning in his designs for a new Paris. It was only at Chandigarh in India that he was able to realize some of his ideas. Brasilia is perhaps the most complete realization of a new city plan in the twentieth century.

Most American efforts at urban planning or slum reconstruction have been brave but partial attempts, continually frustrated by antiquated codes and political or economic opposition. One of the most successful efforts at rebuilding the center of an American city is that of Philadelphia, begun in the 1940s. This has involved the opening up of new highways and the coordinated design of public and commercial buildings, as well as slum clearance and, most important in a city like Philadelphia, the preservation of historic monuments. Although progress has been slow, and beset with many difficulties, the achievement of Philadelphia has been remarkable (figs. 838, 839). In San Francisco, with its magnificent harbor, a plan for the Golden Gateway involving a series of high-rise buildings combined with individual town houses, is in process (fig. 840). Mies van der Rohe has designed a superb urban renewal project for Lafayette Park, Detroit (fig. 841), of twenty-one-story buildings combined with one- and two-story row houses, set in a spacious park area. Other comparable rehabilitation pro-

grams are being carried out, but the dream of the ideal city is still far from realization. Great metropolises like New York or Chicago continue to fight day-to-day battles of human welfare, traffic congestion, and air pollution.

Many of the best opportunities for a kind of urban planning, with new structures, have been offered by the airports proliferating in the 1950s and 1960s. Unfortunately, very few of these opportunities have been adequately realized: the architecture is routine and the solutions of problems such as circulation are inadequate. New York's Kennedy Airport is a vast hodge-podge of miscellaneous architectural styles illustrating every cliché of modern architecture. A rare few individual buildings rise above the norm. One is Eero Saarinen's TWA terminal, 1962 (figs. 842, 843), with its striking airplane-

*above left*: 838. Independence Mall, Philadelphia, before reconstruction (1950)

*above right*: 839. Independence Mall, Philadelphia, after reconstruction (1967)

*left*: 840. Project for the Golden Gateway, San Francisco. 1960s

*right*: 841.
MIES VAN DER ROHE.
Project for Lafayette Park,
Detroit, Michigan

*below left*: 842.
EERO SAARINEN.
TWA Terminal, Kennedy
Airport, New York. 1962

*below right*: 843.
EERO SAARINEN.
Interior, TWA Terminal,
Kennedy Airport

844. EERO SAARINEN. Dulles Airport, Chantilly, Virginia. 1961–62

wing profile and interior spaces. Saarinen had a better opportunity to design a complete terminal at the Dulles Airport for Washington, D. C., 1961–62 (fig. 844). It is an exciting and unified design concept in the main building with its upturned floating roof, and in the adjoining related traffic tower. Saarinen here also resolved practical problems such as transporting passengers directly to the plane through mobile lounges.

## ARCHITECTURE AND ENGINEERING

To many students of modern architecture and particularly of urban design, the solutions for the future lie less in the hands of the architects than of the engineers. Architects themselves are closely following new engineering experiments, particularly such new principles of construction as those advanced by Conrad Wachsmann (b.

845. CONRAD WACHSMANN. Project for Hangar for U.S. Air Force. 1959

846. BUCKMINSTER FULLER. Dymaxion House. 1929

847. BUCKMINSTER FULLER. Dymaxion Car. 1933

1901) and Buckminster Fuller (b. 1895). Wachsmann is a pioneer of industrial, mass-produced, prefabricated buildings who, since 1950, has been a professor at the Illinois Institute of Technology in Chicago and director of its department of advanced building research. His primary concern is the development of universal modules from which structures capable of indefinite expansion can be built (fig. 845).

Buckminster Fuller is the universal man of modern engineering. As early as 1929 he designed a Dymaxion House (fig. 846), literally a machine for living that made Corbusier's concept seem metaphorical. In the early 1930s, he built a practical three-wheeled automobile which has been recognized as one of the few rational steps to solution of city traffic congestion—and has never been put into production (fig. 847). These and many other inventions led ultimately to his geodesic dome structures, which are equilibrium figures based on tetrahedrons, octohedrons, or icosahedrons. These domes, which can be created in almost any material and built to any dimensions, have been used for greenhouses, covers for industrial shops, and mobile, easily-assembled living units by the American army. Although Fuller's genius has been widely recognized for a generation, it is only in the second half of this century that he has been given an opportunity to demonstrate the tremendous flexibility, low cost, and ease of construction of his domes. The American Pavilion at EXPO 67 (fig. 848) was a triumphant vindication of this engineer-architect whose ideas of construction and design (fig. 849) threaten to make most modern architecture obsolete.

848. BUCKMINSTER FULLER. American Pavilion, EXPO 67, Montreal. 1967

849. BUCKMINSTER FULLER. Two-mile Hemispherical Dome for New York City. 1961

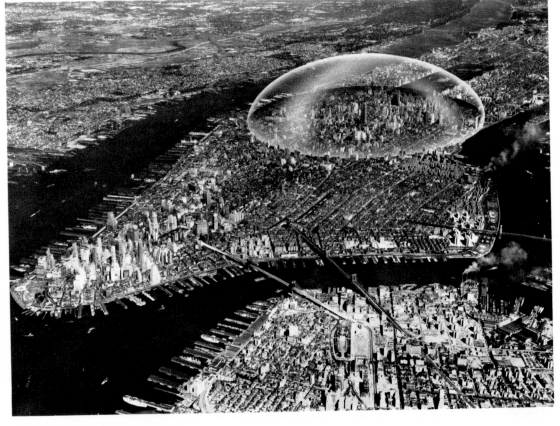

# PART TWENTY-TWO

# PAINTING AND SCULPTURE AT MID-CENTURY

Virtually all the important masters of painting and sculpture during the pre-war era were active into the 1950s and 1960s. Questions have been raised over their influence on the post-war generation but, as will be seen, certain pre-war masters were crucial to subsequent developments. The influence of Picasso on a number of artists who were to become leaders in abstract expressionism and other types of free abstraction was particularly important during the 1940s. The influence of Matisse was most significant for painters of the 1950s and 1960s concerned with color organization. Even more influential on the experimental wing of painting after mid-century were Mondrian, Kandinsky, Arp, Miró, Duchamp, Klee, and Schwitters. The influence of the sculptural pioneers is evident to the degree that the new sculpture has involved constructivism, the utilization of the found object, and figurative fantasy. Even the principles of light and motion in sculpture were laid down in the 1920s and 1930s by Gabo, Duchamp, Moholy-Nagy, Calder, and others.

A major characteristic of painting and sculpture after mid-century is internationalism. From the beginning, modern experimental art had cut across boundaries, but identifiable national statements persisted until World War II. Paris, of course, was a center where artists gathered from every part of Europe and the Americas. Despite the internationalism of Paris, the modern movement, as we have seen, in Germany and Austria took the particular form of expressionism, in Italy of futurism, in Russia and Holland of abstraction. After 1945, it is difficult to draw even such broad distinctions as these. Until 1960, the predominant tendencies everywhere—in Europe, North and South America, and even Japan—were abstract, whether geometric abstraction or some form of abstract expressionism. Influences were transmitted so rapidly from country to country that it has become impossible to pin down the origin of new developments. Artists are not only immediately aware of everything going on in the world through exhibitions and art publications, but they travel on a scale never equaled in previous history.

The essential achievement of painters and sculptors after mid-century may be summarized as the consolidation and expansion of ideas formulated by the pioneers. The one major breakthrough into new territory has been abstract expressionism. Cubism, fauvism, and dada were departures as radical and significant as perspective painting five hundred years before. Like perspective painting, the implications of which were so extensive that the eras of the High Renaissance and the Baroque were spent in working them out, the experimental art of the early twentieth century did not begin to exhaust the potentials of its new vocabularies. The young artists of the post-war world have enlarged these vocabularies enormously, rethought their implications, and applied them to new contexts.

The survey of recent trends in painting and sculpture will, for convenience, follow the same form as that on architecture. Artists and works will be discussed first under countries, although relations and cross-currents between countries will be pointed out. In defining painting and sculpture since 1945, the criterion has been the discussion of artists whose international reputation dates from the 1940s rather than earlier; thus, a number of artists are discussed here who were mature artists in the 1930s but whose reputation at that time was on a national rather than an international level. Also, as we draw closer to the present moment, the account becomes more summary, with the emphasis placed on works of art as illustrative of specific tendencies rather than on the careers of artists studied in any depth.

## Abstract Expressionism, Action Painting, and Abstract Imagists in the United States

Experimental American painting during the 1930s was chiefly associated with geometric abstraction. Most of the European painters and sculptors who came to the United States during the 1930s and 1940s were, as mentioned earlier, leaders of cubism or geometric abstraction. Mondrian, unquestionably the most important figure among the refugee artists, was already a symbol and an ideal for all those artists associated with the American Abstract Artists group. He immediately found many disciples.

Despite the appearance, in the flesh, of this prophet of geometric abstraction, the consummation of the first major wave of American abstraction was, paradoxically, the revolution of abstract expressionism—a movement or style largely divorced from the traditions of geometry.

Other European artists previously discussed, who came to New York as a result of the war, included surrealists representing the European avant-garde during the 1920s and 1930s.

The relations of the new movement—to be known as abstract expressionism—to surrealism, and particularly to the organic surrealism of Miró, Masson, and Matta, are obvious. In tracing its origins, however, one must also look to Kandinsky, Soutine, and the later style of Picasso. American pioneers, like Marin, Weber, Dove, Tobey, and Gorky, anticipated where they did not influence directly. From its origins in 1942 until its official recognition in the Museum of Modern Art 1951 exhibition, "Abstract Painting and Sculpture in America," abstract expressionism developed into the most powerful original movement in the history of American art. During this period, the artists involved were conscious of their participation in exciting, if loosely defined, phenomenons. A few critics, notably Clement Greenberg, championed the new movement; a few dealers, such as Betty Parsons, Charles Egan, and Samuel Kootz, began to present the artists. Recognition by major museums and by art journals—heavily committed even after the war to social realism, art-as-documentation, Latin American art, and finally, re-establishment of contact with European art—came more slowly.

Abstract expressionism was not so much a style as an idea (the abstract expressionists were diverse individuals who had little in common except what they were against). As already suggested, its roots are to be found in the efforts of a few individuals working in relative isolation during the 1930s and 1940s. The essence of abstract expressionism is the spontaneous assertion of the individual. It is impossible, therefore, to make comprehensive generalizations about the movement as a style. Any conclusion which can be drawn must be the cumulative effect of a study of individual artists who were engaged in the New York ferment during the 1940s and 1950s.

The history of abstract expressionism in the United States and in the world has yet to be written. There are still elements of obscurity and controversy concerning its origins. These encompass the whole expressive wing of modern art from Van Gogh and Gauguin through the fauves, German expressionists, dadaists, futurists, and surrealists. Impressionism, as well, played an important part. Also involved is the history of the acceptance of modern expressionist and abstract art in the United States. In 1942, immediately after America's entry into World War II, the dominant styles of painting were still social realism and regionalism. The war created a ferment that brought on the victory of abstract and expressionistic art and the creation of the first major original direction in the history of American painting.

The term, abstract expressionism, was first used, 1919, to describe certain paintings of Kandinsky, and used in the same context by Alfred Barr in 1929. The critic Robert Coates applied this term to a number of younger American painters in 1946, particularly to De Kooning, Jackson Pollock, and their followers. Harold Rosenberg coined the phrase, action painting. Other terms, including the more neutral New York school, have been used for the ferment occurring in American painting during the 1940s and 1950s. None of these terms, with the possible exception of the last, which is non-descriptive, is particularly satisfactory, because of the individualistic approach of the artists concerned.

As has been noted, in 1951 the Museum of Modern Art held a large exhibit entitled "Abstract Painting and Sculpture in America." During 1958–59 the Museum circulated another exhibition, "The New American Painting," to eight European countries. The first exhibition represented the introduction and official recognition of abstract expressionism by a major museum; the second might be considered an international apotheosis. At that moment, when the new American painting was being recognized on a world-wide scale, it was actually—at least in its most accepted form—in process of change and even decline. Although the greater number of younger painters concerned with abstract expressionism between 1950 and 1960 derived from the gestural brush paintings of De Kooning and, to a lesser extent, of Pollock, scarcely had this second generation emerged when their path seemed to have led to a dead end. For whatever reason—a change in fashion, critical pressure, or a general realization that the automatic intuitive gesture is too easily imitated—brush painting, with its accent on texture and gesture, was already in a decline by the end of the 1950s.

Although American abstract expressionism is as diverse as the artists involved, in a very broad sense two main tendencies may be noted. The first is that of brush painters, concerned in different ways with the gesture or action of the brush, the texture of the paint; and, on the other hand, the color-field painters, concerned with the statement of an abstract sign or image in terms of a large, unified color shape or area.

For convenience, then, artists of the New York school in the early 1950s may be separated into two large divisions, the action painters (Pollock, De Kooning, Tworkov, and Kline) and the painters who worked with large color fields or abstract images (Rothko, Newman, Still, Motherwell, Gottlieb, and Reinhardt). This division is arbitrary, since other categories—abstract impressionism, lyrical abstraction—may be formulated to include Guston, Brooks, and Marca-Relli. In the early part of the 1950s attention was focused on the action painters, and most of the second generation were drawn to De Kooning or Pollock.

At the same time, certain younger painters—in reputation or in years—were fascinated by the color experiments of Rothko, Still, Newman, and Motherwell, as well as by some of the less familiar or less understood paintings of Pollock. This led to painting as varied in individual manifestations as abstract expressionism was and, in general, involves openness of structure, anonymity of brush stroke, and accent on large and pure color fields. Many names have been given to this perhaps most significant tendency in American painting of the 1960s: post-painterly abstraction (by Clement Greenberg), color-field painting, chromatic abstraction, etc. It grew with an unobtrusive force that delayed its recognition as a major tendency until the early 1960s. Later in inception but much more emphatic in its original impact was the movement in painting and sculpture to which the name pop art has been given. Both movements will be discussed in later pages.

Colorplate 200.
ARSHILE GORKY. *The Liver
Is the Cock's Comb*. 1944.
Oil on canvas, 72 x 98″.
The Albright-Knox Art Gallery,
Buffalo, New York.
Gift of Seymour H. Knox

Colorplate 201. ARSHILE GORKY.
*The Betrothal II*. 1947.
Oil on canvas, 50¾ x 38″.
The Whitney Museum of American Art, New York

*right*: Colorplate 202. HANS HOFMANN. *The Gate.*
1960. Oil on canvas, 74⅝ x 48¼″.
The Solomon R. Guggenheim Museum, New York

*below*: Colorplate 203. MATTA. *Disasters of Mysticism.*
1942. Oil on canvas, 38¼ x 51¾″.
Collection James Thrall Soby, New Canaan, Connecticut

Colorplate 204. WILLEM DE KOONING. *Composition*. 1955. Oil on canvas, 79⅛ x 69⅛".
The Solomon R. Guggenheim Museum, New York

*above*: Colorplate 205.
JACKSON POLLOCK.
*Lavender Mist*. 1950.
Oil, enamel, and
aluminum paint on
canvas, 7′ 4″ x 9′ 11″.
Collection
Alfonso Ossorio,
East Hampton,
New York

*right*: Colorplate 206.
JACKSON POLLOCK.
*Ocean Greyness*.
1953. Oil on canvas,
57¾ x 90⅛″.
The Solomon R.
Guggenheim Museum,
New York

492

left: Colorplate 207. WILLIAM BAZIOTES.
*Dusk*. 1958. Oil on canvas, 60⅜ x 48¼".
The Solomon R. Guggenheim Museum, New York

below left: Colorplate 208. PHILIP GUSTON.
*Painting*. 1952. Oil on canvas, 48 x 50¾".
Collection Mrs. Albert H. Newman, Chicago

below right: Colorplate 209. PHILIP GUSTON.
*Duo*. 1961. Oil on canvas, 72¼ x 68".
The Solomon R. Guggenheim Museum, New York

Colorplate 210.
CONRAD MARCA-RELLI.
*The Blackboard*.
1961. Oil and
canvas collage,
7 x 10'.
Seattle Art Museum.
Eugene Fuller
Memorial Collection

Colorplate 211.
ADOLPH GOTTLIEB.
*Rolling*. 1961.
Oil on canvas,
72 x 90¼".
Collection Mr. and
Mrs. A. I. Sherr,
New York

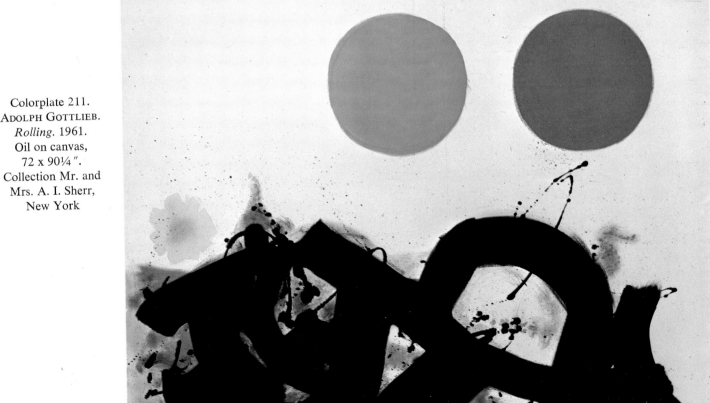

*above:* Colorplate 212. CLYFFORD STILL.
*Number 2.* 1949. Oil on canvas, 92 x 67″.
Collection Mr. and Mrs. Ben Heller, New York

*above right:* Colorplate 213. MARK ROTHKO.
*Orange and Yellow.* 1956. Oil on canvas, 91 x 71″.
The Albright-Knox Art Gallery, Buffalo, New York.
Gift of Seymour H. Knox

*right:* Colorplate 214. MARK ROTHKO.
*White and Greens in Blue.* 1957.
Oil on canvas, 8′ 4″ x 6′ 10″.
Private collection, New York

## ARSHILE GORKY (1904–1948)

Arshile Gorky illustrates most specifically the line between Picasso, European surrealism, and American abstract expressionism. Gorky was brought to the United States from his native Armenia in 1920 and almost from the beginning of his career as a painter was deeply influenced by European artists, particularly Cézanne and Picasso. He was also a friend of Stuart Davis, Willem de Kooning, and Frederick Kiesler. In his last decade or so, Gorky's paintings and drawings became freely expressionistic in an abstract sense. One of his climactic paintings is *The Liver Is the Cock's Comb,* 1944 (colorplate 200), a huge composition with characteristics of a wild and vast landscape, or of a microscopic detail of internal anatomy. At this point there seems to be no doubt that Gorky had moved from Picasso to the early free abstractions of Kandinsky—to which the term abstract expressionism was first applied (see p. 173). The surrealist sense of organic fantasy is, however, greater than in Kandinsky; this is particularly apparent in the drawings, where fantastic shapes become more explicit. At this point, then, the artist is bringing together aspects of Kandinsky's free abstraction, Miró's and Masson's organic surrealism and residues of Picasso (colorplate 201). Although the sense of subject is much stronger than will be the case in the abstract expressionist works of De Kooning and Pollock during the late 1940s and 1950s, the sources and the vocabulary have been clearly stated.

## HANS HOFMANN (1880–1966)

Of the European painters who strongly affected American avant-garde art in mid-century, one of the most remarkable was Hans Hofmann. He was a phenomenon in that his career literally encompassed two worlds and two generations. Born in Bavaria, he lived and studied in Paris between 1903 and 1914, during this time experiencing the range of new movements from neo-impressionism to fauvism and cubism. He was particularly close to Delaunay, whose ideas on color structure influenced him (as they did Kandinsky, Klee, and Marc) even more than did Picasso's and Braque's cubism. In 1915 he opened his first school in Munich and from this point, until the mid-1950s, his reputation was primarily that of a great teacher. In 1932 he moved to the United States to teach, first at the Art Students League, then at his own Hans Hofmann School of Fine Arts in New York and Provincetown, Massachusetts. Most of Hofmann's European paintings were destroyed in a studio fire and thus it is almost as though he first emerged as a full-fledged painter about 1940, at the age of sixty. Hofmann's greatest concern as a painter, as teacher, and as theoretician lay in his concepts of pictorial structure on architectonic principles rooted in early cubism. This did not prevent him from attempting the freest kinds of automatic painting. A number of such abstract expressionist works executed around 1940, although on a small scale, anticipated the action painting of Pollock (fig. 850).

During the last twenty-six years of his life, Hofmann painted with amazing fertility and variety, ranging in expression from a lyrical romanticism to precise geometry

(fig. 851; colorplate 202). Although his range was enormous, it was always, in his later years, within the abstract means. His influence on a generation of younger artists is incalculable.

850. HANS HOFMANN. *Spring.* 1940. Oil on wood, 11⅜ x 14⅜″. Collection Peter A. Rübel, Connecticut

851. HANS HOFMANN. *Summer Night's Bliss.* 1961. 84 x 78″. The Baltimore Museum of Art. Gift of the Artist

## SEBASTIAN ANTONIO MATTA ECHAURREN
(b. 1912)

When he migrated to the United States in 1939, Matta, a Chilean, was relatively little known despite his association with the surrealists in Paris. His one-man show at the Julien Levy Gallery in 1940 was so completely outside the experience of most American experimental artists that its impact was momentous. Although Matta was much younger than most of his expatriate European colleagues and less well known, his paintings marked a step of liberation, beyond even the most advanced of the European surrealists, and represented the step forward that American

852. MATTA. *Unthinkable*. 1957.
6′ 8″ x 9′ 10″. Alexander Iolas Gallery, New York

853. WILLEM DE KOONING. *Night Square*. 1950–51.
Oil on masonite, 30 x 40″.
Collection Mrs. Martha Jackson, New York

artists were seeking. Over the next few years, together with the American painter Robert Motherwell, he helped to bridge the gap between European surrealism and the American movement to be called abstract expressionism. Matta's painting at this point is exemplified in the *Disasters of Mysticism*, 1942 (colorplate 203). Although this has some roots in Masson and Tanguy, it is a lyrical excursion into fantasy, different from either; in its ambiguous flow, from brilliant flame-light into deepest shadow, it suggests the ever-changing universe of outer space. The concern with a kind of space fantasy obsessed Matta more and more in his later work, where paintings became machines dedicated to some incomprehensible battle of planets or robots (fig. 852). Although in the later paintings fantastic subject becomes more explicit, those executed between 1940 and 1944 were influential because of their expression of violent but indefinable conflicts through abstract means.

## WILLEM DE KOONING (b. 1904)

A central figure in the story of abstract expressionism is Willem de Kooning, even though he was not one of the first to emerge in the public eye during the 1940s. De Kooning, born in Rotterdam, Holland, came to the United States in 1926; soon he became a close friend of Gorky and a number of the artists who were to be associated with abstract expressionism. Although he did not exhibit until 1948, he was an underground force about whom the younger experimental painters were talking.

De Kooning was a figure painter and portraitist until 1940, one whose studies of individuals in an environment had an affinity to the paintings of Giacometti. When he began painting abstractions, the shapes were first suggestive of Picasso seen through Gorky. In the early 1940s, however, these curvilinear shapes—still with organic or biomorphic suggestions—were presented with a counterpoint of jagged, brittle lines that heightened the energy of the canvas. Some of the most successful are a group of black paintings with white drawing executed around 1950 (fig. 853). By 1950 the artist had also developed his personal aspect of abstract expressionism, distinct from Kandinsky, Gorky, Picasso, or anyone who had preceded him; and he emerged as one of the prophets of a new style, a new intensive mode of expression. At the same moment his nostalgia for the figure impelled him to begin his famous series of women paintings, overpowering, at times repellent, but hypnotic evocations of woman as sex symbol, fertility goddess—and in the tradition of Edvard Munch—blood-sucking vampire. His exploration of the women theme (fig. 854) still continues, with variations ranging from the threatening, to simple caricature, to the gently erotic. During the late 1950s, De Kooning returned for long periods to abstraction (*Composition*, 1955, colorplate 204), given in his hands an extraordinary dynamic force. These abstractions, while losing nothing of their expressive violence of brush stroke, later tend to larger gestures and an architectural structure somewhat related to the paintings of Franz Kline. From these, in the early 1960s, he turned back with an almost rhythmic alternation to a form of figure painting—the women once more, but executed with a delicacy transcending any he had done before (fig. 855).

854. WILLEM DE KOONING. *Woman VI.* 1953.
68½ x 58½". Museum of Art, Carnegie Institute,
Pittsburgh, Pennsylvania

855. WILLEM DE KOONING. *Reclining Figure in Marsh
Landscape.* 1967. Oil on paper, 18¼ x 23". Collection
Mr. and Mrs. Jay R. Braus, Larchmont, New York

856. JACKSON POLLOCK. *Night Ceremony.* 1944. 72 x 43".
Collection Mr. and Mrs. Bernard J. Reis, New York

## JACKSON POLLOCK *(1912–1956)*

Jackson Pollock has become the world-wide symbol of
the new American painting after World War II. Pollock
came from Cody, Wyoming, to study at the Art Students
League, New York, with Thomas Hart Benton, and a re-
lation can be seen between his abstract arabesques and
Benton's figurative patterns. His paintings of the mid-
1940s, usually involving some degree of actual or implied
figuration, were coarse and heavy (fig. 856), suggestive
of Picasso, Max Ernst, and, at times, Miró or Masson, but
filled with a nervous, brutal energy of their own. By 1947
—even earlier in drawings—the artist had begun to experi-
ment with over-all painting, a labyrinthine network of
lines, splatters, and paint drips from which emerged the
great drip paintings of the next few years (colorplate 205).
These paintings, generally executed on a large canvas laid
out on the floor, are the works most popularly associated
with the phrase, action painting.

It was never the intention of the critic Harold Rosen-
berg, in coining this phrase, to imply that action painting
was a kind of athletic exercise. Nor is it true that the furious
and seemingly haphazard scattering of the paint involved
a completely uncontrolled, intuitive act. There is no ques-
tion that, in the paintings of Pollock and many of the other
abstract expressionists, the element of intuition or the ac-
cidental plays a large and deliberate part; this is one of
the principal contributions of abstract expressionism.
However, nothing that an experienced and accomplished

857. JACKSON POLLOCK. *Echo*. 1951. Duco on canvas, 92 x 86¼". Collection Mr. and Mrs. Ben Heller, New York

artist does can be completely accidental. There is always involved the control of many years' practice and reflection. It is no accident that the drip paintings of Pollock executed between 1947 and 1951 have a common identity and personal presence.

Aside from their intrinsic quality, Pollock's drip paintings contributed other elements that changed the course of modern painting. There was, first, the concept of the over-all painting, the painting seemingly without beginning or end, extending to the very limits of the canvas and implying an extension even beyond. This, together with the large scale of the works, introduced another concept—that of wall painting different from the tradition of easel painting, even as it existed in cubism and geometric abstraction. This was the final break from the Renaissance idea of painting detached from spectator, to be looked at as a self-contained unit. The painting became an environment, an ensemble, which encompassed the spectator, surrounding him on all sides. The feeling of absorption or participation is heightened by the ambiguity of the picture space. The colors and lines, although never puncturing deep perspective holes in the surface, still create an illusion of continuous movement, a billowing, a surging back and forth, within a limited depth. In these ways, Pollock departed from the tradition of Renaissance and modern painting before him and, although he had no direct stylistic followers, he affected the course of experimental painting after him.

The last few years of Pollock's life were marked by doubts and indecisions. He explored problems of the figure in drawings and paintings (fig. 857), using black predominantly, and between 1953 and 1956 returned to tradi-

tional brush painting, heavy in impasto, and involving images reminiscent of paintings of the early 1940s (color-plate 206). Although these later works have suffered in critical opinion when compared to the drip paintings, some of the black paintings particularly suggest a new phase of the greatest importance, unfortunately terminated by his tragic death in 1956.

## MARK TOBEY (b. 1890)

Mark Tobey is the pioneer American modernist whose influence on abstract expressionism is seemingly most explicit but actually most ambiguous. About 1918 he was converted to the Bahai faith, which preaches the oneness of mankind, an indivisible reality that does not admit of multiplicity. In 1923 he began studying Chinese brush painting; and in 1934 he studied Zen Buddhism in China and Japan. Inevitably he was drawn by a profound inner compulsion, to a personal kind of abstract expression with strongly religious overtones.

In Chicago and New York he was entranced by the impact of the great city—the lights, the motion, the noise. This impact Tobey sought to express in a pattern of over-all line played against fields of varied color (*Broadway*, c. 1935, fig. 858). At this stage he was still using a form of

858. MARK TOBEY. *Broadway*. c. 1935. Tempera on masonite, 26 x 19¼". The Metropolitan Museum of Art, New York. Arthur H. Hearn Fund, 1942

859. MARK TOBEY. *Above the Earth.* 1953. Gouache on cardboard, 39¼ x 29¾″. The Art Institute of Chicago. Mr. and Mrs. Sigmund Kunstadter Collection

Renaissance perspective recession, although the line pattern tended to flatten this out.

Although Tobey had gradually become aware of the implications of cubism and of abstraction and fantasy, particularly as seen in Kandinsky, Mondrian, Klee, and Picasso, he had to work out his own abstract expression in terms of his religious convictions. These had to do not only with the Bahai doctrines and the Oriental concepts of union of spirit (theoretically comparable to the ideas of Mondrian and Kandinsky), but also with a passionate conviction concerning the significance of space, of the void, not as something empty like a vacuum, but as something filled or charged with energy, with forces invisible to the eye but infinitely important. His paintings were abstractions of nature, if this may be taken to imply cosmic as well as terrestrial natural forces. He abandoned Renaissance perspective and classical modeling in favor of a multiple vision analogous to, but different from, that of the cubists (*Above the Earth,* 1953, fig. 859).

There is certainly a superficial resemblance between Tobey's over-all paintings and Pollock's. Tobey composed paintings from linear arabesques and fluid color before Pollock's drip paintings. Both artists were interested in space as a void charged with particles of energy, but the forms and the effects of both are different. It is probable that Pollock saw Tobey's white-line paintings during the 1940s, but if he was influenced by them he made of them something uniquely his own.

BRADLEY WALKER TOMLIN *(1899–1953),*

WILLIAM BAZIOTES *(1912–1963),*

JACK TWORKOV *(b. 1900)*

Until the last five years of his life, Tomlin was one of the most sensitive and accomplished American cubists in a tradition stemming from Braque or Gris. Then, about 1948, he began to experiment with a form of free calligraphy, principally in black and white, deriving from his interest in Zen Buddhism and its manifestation in Japanese brush painting (*Tension by Moonlight,* 1948, fig. 860). From this moment of liberation, he returned during the last three or four years of his life to abstract geometry rooted in cubism, in its shifting, ambiguous space, but close to Mondrian in its delicate and rhythmic arrangement of rectangular patterns. As was the case with most of his experimenting contemporaries, he did not fit neatly into any specific category; he may be described simply as an artist who was working out a new and personal direction, based on some of the pioneers of European modernism.

Baziotes was even more closely associated with the origins of American abstract expressionism than was Tomlin, but is equally difficult to categorize as an expressionist. His origins were specifically in the abstract surrealism of Miró or Masson, seen at times through Gorky or, considerably earlier, through Odilon Redon. A friend of Motherwell and Matta since the early 1940s, Baziotes explored with them aspects of surrealist automatism, and was at the center of the new post-war developments in American art. His own painting remained remarkably consistent and personal from the beginning to the end of his career. It was characterized by shifting, fluid, luminous color into which were worked biomorphic shapes drawn with great

860. BRADLEY WALKER TOMLIN. *Tension by Moonlight.* 1948. 32 x 44″. Betty Parsons Gallery, New York

861. JACK TWORKOV. *Boon.* 1960. 76 x 59".
Private collection

sensitivity and always suggestive of some form of micro-
cosmic or marine life (*Dusk,* 1958, colorplate 207).

Of the brush-gesture painters after De Kooning, Jack
Tworkov is the most individual. Tworkov was influenced
by De Kooning at the end of the 1940s, but during the
1950s developed his poetical, personal style using off-key
colors. In the 1960s, he has moved to a form of free
geometry or color-field painting involving vertical, loosely-
contoured colored stripes (fig. 861).

## FRANZ KLINE *(1910–1962)*

Until 1950, Kline was a figurative painter or a painter of
figures and urban scenes tinged with social realism. Even
after he began to paint abstractly, he remained as fascinat-
ed with the details and tempo of contemporary America
as Stuart Davis. At the same time he was deeply im-
mersed in the tradition of Western painting, from Rem-
brandt to Goya. A passion for drawing manifested itself
during the 1940s, particularly in his habit of making little
black-and-white sketches, fragments in which he studied
single motifs or space relations. One day in 1949, looking
at some of these sketches enlarged through a projector, he
saw their implications as large-scale, free abstract images.
This was a revelation that from one moment to the next
changed him from a representational painter (who as early
as 1947 attempted occasional small exercises in abstrac-

862. FRANZ KLINE. *Nijinsky (Petrushka).* 1949.
33½ x 28". Collection Mr. and Mrs. I. David Orr,
Cedarhurst, New York

862a. FRANZ KLINE.
*Nijinsky (Petrushka).*
c. 1950. 46 x 35¼".
Collection Muriel Newman, Chicago

tion) to a full-fledged abstract expressionist (figs. 862, 862a). Using cheap, commercial paints and housepainter brushes, he attacked large pieces of canvas attached to the walls of his studio.

Although Kline in 1950 was well aware of the experiments of the pioneer abstract expressionists already mentioned, the impetus for his style seems to have come primarily from his own earlier sketches, suddenly seen in a new, magnified context. More significant, the works he began to produce about 1949–50 represented a form of expression entirely individual, one of the major contributions to abstract expressionism. Kline's first large-scale black-and-white abstractions are dated 1950. Among their unique qualities are the large, rugged, but controlled brush stroke; the powerful, architectural structure; and in the paint texture as well as in shaping of forms, an insistence on the equivalence of the whites that prevents the work from becoming simply a large-scale black drawing on a white ground. The titles of most of his works are the chance associations with something encountered in daily life.

Kline was a phenomenon in the rapidity with which he achieved a mastery of his new abstract-expressionist vocabulary. Even the first works have nothing tentative about them. By 1955 he was producing a series of masterpieces, monumental in scale and conception. *Mahoning*, 1956 (fig. 863), continues the architectural frame with a great Gothic structure of broken beams tied together in a seemingly crazy arrangement, suggestive of change and decay, that yet has something of the permanent and the immutable, as in the architecture of Gaudí. The balance of blacks and whites is such that concentrated study transforms the painting into a structure of white solids on black voids (fig. 864). It is no accident that Kline's painted structures have had their great impacts on constructivist sculptors of the 1960s. His introduction of color in the late 1950s is still

a matter of controversy. Unfortunately, he did not live long enough to demonstrate that color could add a new dimension to his work.

## PHILIP GUSTON (b. 1913)

Another wing of abstract expressionism is represented by Philip Guston, who has been variously referred to as an abstract impressionist or romantic expressionist. Guston was a successful figurative painter in the 1940s, with an individual form of fantasy related to surrealism and magic realism but independent of them. In 1947–48, he began to experiment with an abstract statement with reminiscences of buildings and urban landscapes. After many painful intervals of doubt and hesitation, there emerged in 1950 an abstract style which, over the next three or four years manifested itself as a freely textural, vertical-horizontal

866. James Brooks. *Octon.* 1961. 84 x 66″.
James A. Michener Foundation Collection,
Allentown Art Museum, Pennsylvania

composition loosely based on his admiration for Mondrian (*Painting*, 1952, colorplate 208).

Guston's development, in contrast with that of Kline and some of the other painters associated with the New York school, was a gradual but consistent progression from lyrical figuration to expressive geometry to free and brilliant coloration in the mid-1950s. The paintings of 1954–55 combine mass in the color shapes with atmospheric depth. At the same time, the tendency to concentrate centralized color masses within a light and fluid environment gave these masses a new subject implication. From this point forward the artist was thinking of color shapes—reds, blues, and greens intertwined with blacks—as personalities engaged in conflicts within the total space of the painting. Darkness, or at least a gray-black tonality, has increasingly dominated the works of the 1960s. The abstract color shapes, with their curious interchanges and conflicts, have taken on naturalistic, if undefinable associations (*Duo*, 1961, colorplate 209).

Guston's sense of subject, of figuration, is so strong that with merely a large black color shape in the scumbled tonality of the painting he can create the impact of a living personage.

## JAMES BROOKS (b. 1906)

It was in cubism, perhaps inspired by Brooks's long friendship with Bradley Walker Tomlin, that his first abstractions emerged. This was, however, a curvilinear, free version of cubism frequently composed within the tondo form (fig. 865). After producing a number of works suggestive of the current drip paintings by Pollock, he went

on to a phase of free but tense color structures in which the curvilinear cubist forms and a lyrical pattern are implicit. Since that time, the painting of Brooks has become more monumental in its color organization (*Octon*, 1961, fig. 866). Despite the intensity and brilliance of the color this work achieves a simplified structure through the dominance of the large, unified color shapes which tie together all the movement of the edges. Brooks exemplifies a group of artists associated, perhaps erroneously, with abstract expressionism (Esteban Vicente, Adja Yunkers, Cameron Booth, Georgio Cavallon, and others), who combine a delight in brilliant color with structure of the highest order achieved in deceptively immediate and direct painting.

## CONRAD MARCA-RELLI (b. 1913)

There is no more anomalous inclusion among abstract expressionists than Marca-Relli, a member of the New York school since the early 1950s: his painting was more figurative than abstract, more classical than expressionistic. There is definite expressive content in his works, but it is inextricably involved with integrated formal structure. He created figure studies freely composed of oil paint and canvas collage, owing something to the traditions of metaphysical painting, of Gorky, and De Kooning (fig.

868. CONRAD MARCA-RELLI. *RXL-4*. 1966. Aluminum, 57 x 54 x 4″. Marlborough-Gerson Gallery, New York

869. CONRAD MARCA-RELLI. *L-2-66*. 1966. Oil and canvas collage, 72 x 60″. Marlborough-Gerson Gallery, New York

867. CONRAD MARCA-RELLI. *Seated Figure Outdoors*. 1954. Oil and canvas collage, 20 x 15″. Collection Mr. and Mrs. Walter Bareiss, Greenwich, Connecticut

867). His principal concern in the 1950s remained, nevertheless, the control of the total picture space, which he sought to achieve through large-scale, almost explosive figure organizations rather than through architectural themes. In *The Joust,* 1959, earlier vestiges of figures have disappeared into organic color shapes, black, red, and white, which carry the sense of violent conflict. The battle theme, particularly inspired by Uccello's *Battle of San Romano*, is a dominant note in the paintings of this period.

For a few years at the end of the 1950s the tempo again became more quiet, sometimes lyrical, subdued but delicate and luminous in color—a new architecture rather than a conflict of personages or abstract color shapes. Figuration was finally interrupted by abstract constructions. This led to the paintings and relief sculptures of the mid-1960s, the most restrained and simplified of the artist's career (colorplate 210). A large aluminum relief sculpture, *RXL-4,* 1966 (fig. 868), consists of a group of interlocked shapes, dully but richly polished, held in a state of positive tension. Such constructions, and even more so the large black-and-white collages (fig. 869), have an Oriental quality, a sense of Japanese calligraphy seen in detail but greatly enlarged.

## ROBERT MOTHERWELL *(b. 1915)*

Robert Motherwell, the youngest of the artists originally associated with abstract expressionism, bridges both its tendencies, although most of his major paintings to date belong on the side of the abstract imagists. His early training was in art history, criticism, and philosophy. As a painter, he was largely self-trained with the exception of some formal study with the surrealist Kurt Seligmann. In 1941 he made the acquaintance of European artists then in New York, particularly the surrealists Max Ernst, Tanguy, Masson, and Matta. The aspects of surrealism that most

870. ROBERT MOTHERWELL. *Pancho Villa, Dead and Alive.*
1943. Gouache, oil, and cardboard collage,
28 x 35⅞ ". The Museum of Modern Art, New York

872. ROBERT MOTHERWELL. *In White with 4 Corners.*
1964. Cardboard collage, 30 x 22". Collection the Artist

871. ROBERT MOTHERWELL. *At Five in the Afternoon.*
1949. Casein on composition board,
15 x 20". Collection the Artist

873. ROBERT MOTHERWELL. *Indian Summer #2.* 1962–64.
Oil and acrylic on canvas, 66⅛ x 50⅛ ".
Collection the Artist

intrigued him were automatism, the concept of the intuitive, the irrational, and the accidental in the creation of a work of art. His first paintings represented an initial attempt to resolve the seeming contradictions between Mondrian (whom he had also met in New York) and the abstract surrealists.

In 1943 he began to experiment with collage, and one of the most important creations of this period is *Pancho Villa, Dead and Alive,* 1943 (fig. 870), a work in which the artist's individual directions in painting are first made manifest. It is a frontalized structure with the two doll-like images of Pancho Villa set within vertical rectangles; and the forms and images which were to become a signature for Motherwell, such as the ovoid shapes held in tension between vertical architectural elements, are explicitly stated here.

In 1949 he painted *At Five in the Afternoon* (fig. 871) after a poem by Lorca. This was the first in the series of paintings entitled Spanish Elegies, a title inspired by Motherwell's profound reaction to the Spanish revolution, which was expressed in over one hundred variants during the 1950s and 1960s. Although they constitute one aspect of his work, they nevertheless tell much about his attitude to the art of painting. They are almost uniformly black and white with occasional passages of ocher or gray and consist, in most part, of a few large, simple forms, vertical rec-

tangles holding loosely ovoid shapes in suspension. In the Elegies, Motherwell finally liberated himself from the tradition of the easel painting and formulated his mature concept of the painting as a mural, preserving the integrity of the picture plane, and capable of an indefinite lateral expansion.

Along with his mural-scale painting, Motherwell, in the late 1950s, developed his collages as a sort of counterpoint. Many of them, using postcards, posters, wine labels, or wrapping paper, received in his daily mail, constitute a visual day-by-day biography of the artist (*In White with 4 Corners,* 1964, fig. 872). His paintings of the late 1950s and 1960s range from the most painterly in terms of expressed brushwork to large, brilliant, hard-edge color structures. Motherwell's is a very personal art but one that has effectively bridged many of the gaps between early abstract expressionism and the color-field painting of the 1960s (*Indian Summer # 2,* 1962–64, fig. 873).

## ADOLPH GOTTLIEB (b. 1903)

Born in New York City, Gottlieb studied at the Art Students League with John Sloan and, through a visit to Europe in 1921–22, became aware of new European experiments in cubism and abstraction. A stay in Arizona during 1937 resulted in a number of curious magic-realist paintings of objects picked up from the desert arranged within rectangular compartments. These anticipated the Pictographs that represent the artist's most serious explorations during the next fifteen years: a grid arrangement filled with two-dimensional pictographs. These latter were unquestionably influenced by Torres-Garcia as well as Paul Klee, although gradually Gottlieb increased the scale and variety to a degree of monumentality beyond anything attempted by his predecessors.

During the 1950s the artist began to play variations on a theme that he entitled Imaginary Landscapes, consisting

874. ADOLPH GOTTLIEB. *The Frozen Sounds, Number 1.*
1951. 36 x 48". The Whitney Museum of American Art, New York.
Gift of Mr. and Mrs. Samuel M. Kootz

875. Adolph Gottlieb. *Orb*. 1964. 90 x 60".
Dallas Museum of Fine Arts

His exhibitions at the Betty Parsons Gallery—1947, 1950, and 1951—were of great influence in the establishment of the color-field or abstract-imagist wing of abstract expressionism. Since the late 1930s he had painted in a freely abstract manner involving large, flowing images executed in a heavy, even coarse, paint texture of over-all color, shifting and changing, opening and closing space, with no beginning or no end. By 1947 he was working on a huge scale, sometimes 8 x 10 feet, with immense color areas predominantly black or red or yellow in a constant state of fluid though turgid movement (colorplate 212). Over the next ten years Still persisted in his basic image, a predominant color varying in value and shot through with brilliant or somber accents breaking out from the ground.

## MARK ROTHKO *(b. 1903)*

Mark Rothko, Clyfford Still, Barnett Newman, and Ad Reinhardt, all extremely different as painters, have in common with Motherwell and Gottlieb the sense of an abstract image or symbol presented through color, line, and shape. Every abstract as well as realistic painter has an image which becomes the painting itself, but in these artists the

876. Mark Rothko. *Baptismal Scene*. 1945. Watercolor, 19⅞ x 14". The Whitney Museum of American Art, New York

of a foreground of heavily-textured paint with a sharply accented horizon line above which a group of astral presences—spheres, ovals, or rectangles—float in an empty sky (*The Frozen Sounds, Number 1*, 1951, fig. 874). The other principal development of the late 1950s and 1960s has been the series commonly called Bursts, a sort of cosmic landscape consisting generally of an upper circular or ovoid element suggestive of a burning sun, below which is a broken, exploding element, open and dynamic in contrast with the sun above (*Orb,* 1964, fig. 875). The artist has played infinite variations on these forms, and in recent works has combined aspects of the Bursts with the Imaginary Landscapes (*Rolling,* 1961, colorplate 211). Another recent tendency has involved an abstract landscape with a flatly painted rectangle as foreground, and loosely rectilinear shapes organized above, almost like a color chart.

## CLYFFORD STILL *(b. 1904)*

Clyfford Still is one of the first post-war instances of the American university artist-teacher. Between 1946 and 1950, he taught at the California School of Fine Arts in San Francisco, then (under its director Douglas MacAgy) one of the most progressive art schools in the world.

877. MARK ROTHKO. *No. 18*. 1948. 67¼ x 55⅞ ″.
Vassar College Art Gallery, Poughkeepsie, New York.
Gift of Mrs. John D. Rockefeller III

During the 1950s Rothko maintained his basic image of large, loose color rectangles floating in space, but played color and shape variations on them. Sometimes he changed the formula to a hollow rectangle or U-shape and, increasingly, at the end of the 1950s he began to move away from bright, sensuous color toward color that was deep and somber, even, by implication, tragic (colorplate 214). In the 1960s he pursued this more heroic vein both in individual wall paintings and in murals for Harvard University and a chapel at St. Thomas University in Houston, Texas. The latter series consists of a group of huge panels, almost uniform in their deep red-brown color, filling the entire space of available walls. These are designed to be completely homogeneous with the architecture and the changing light of the chapel interior, and thus represent a total architectural-pictorial experience in a sense analagous to that attempted by the religious muralists of the Baroque seventeenth century.

## BARNETT NEWMAN *(b. 1905)*

A principal characteristic of the so-called abstract imagists or color-field painters and their many followers is concentration on and continual reworking of a specific theme. Perhaps the most extreme examples of this tendency are to be found in the mature works of Barnett Newman and Ad Reinhardt. Newman in the mid-1940s was working in a pattern of loose vertical-horizontal geometry with a predominance of vertical lines or color areas, broken at the edges and alternating with circular or spheroid

878. BARNETT NEWMAN. *Stations of the Cross: Twelfth Station.* 1965. Acrylic polymer on canvas, 78 x 60″. Collection the Artist

sense of image, or of the painting as a mysterious presence, is capable of moving the emotions of the spectator, of developing complex associations from the simplest visual stimuli.

Mark Rothko had been painting since 1925 and exhibiting since 1929. His *Baptismal Scene*, 1945 (fig. 876), is a work reminiscent of organic abstract surrealism. By 1947 he had begun to formulate his mature style consisting of large floating color shapes with loose, undefined edges that gave them both a sense of movement and tangible depth (*No. 18*, 1948, fig. 877). Over the next few years these shapes were refined and simplified to the point where they consisted of color rectangles floating on a color ground (colorplate 213). The oil paint is thinly washed on with considerable tonal variation which adds to the effect of a constant cloudlike, visual shifting. In *No. 18,* 1952, the dominant earth colors, red-browns of varying densities combined with a central strip of yellow ocher, are suspended on a ground of light but intense blue, apparent around the edges and in a horizontal strip that seems to penetrate the surface below the central yellow. Now Rothko was painting on a huge scale, something that contributed to the effect of enclosing, encompassing color. This is a kind of painting which, by the sheer sensuousness of its color areas, by the dimensions, and by the sense of indefinite outward expansion without any central focus, is designed to absorb and engulf the spectator, to assimilate him into a total color experience.

shapes. By the end of the decade he had simplified his formula to a unified color field interrupted by a vertical line or, rather, a narrow, vertical contrasting color space (*The Word*, 1954, colorplate 215). Newman's paintings, with their rigid verticality, have inevitably been related to Mondrian. They are, however, very different in their impact—not only because of their much larger format, but because of the nature of the vertical line whose deliberately fragmented edges create the impression of an opening in the picture plane rather than a line on the surface. It is as though the predominant color field has been torn apart and we are given a glimpse into some sort of subsurface. There is thus established a tangible tension between the color surface and the "line" which seems to be a structural or spatial opening and closing (*Twelfth Station*, 1965, fig. 878).

### AD REINHARDT *(1913–1967)*

Ad Reinhardt, one of the pioneer American abstractionists, painted in a geometric, rectangular style since the late 1930s. He was one of the most brilliant and individual minds among post-war avant-garde American painters, a superb caricaturist and a student of Oriental art. After abstract experiments in the 1940s, with Mondrian geometry alternating with more freely composed allover patterns, in the early 1950s he began to simplify his palette to a single color. The first group of such paintings was in red, the next in blue, and the final group, on which he worked for the rest of his life, in black. One first observes these later paintings simply as a unitary field of red, blue, or black. With time, there begins to emerge a second, inner image—a smaller rectangle, square, or central cross consisting of a slightly different value or tone of the color (colorplate 216). His stated purpose was always elimination of all associations, all extraneous elements, the refinement of paintings to a single dominant experience. There is no question that these later works were powerful visual, expressionist, images, hypnotic in their effect.

# *Great Britain: Painting*

At this point we must retrace our steps briefly, to bring the development of modern art in Great Britain to its present position of importance in world art. British art, like American, had followed an essentially traditional course at the end of the 1800s and during the first decades of the 1900s. Like American art, it was insular and had no international impact—in the sense of influencing modern art in general—until the years just after World War II. Just as refugee modernists were to affect British art and architecture in the 1930s and 1940s (many proceeding to the United States where they had the same influence) so foreigners had, in the late nineteenth century, disturbed the course of British art.

Despite the French admiration for Constable and Turner, and despite the fact that Monet, Pissarro, Sisley, Manet, and Toulouse-Lautrec visited or lived for periods in London, the influence of impressionism and post-impressionism on British painting was belated and watered-down. The greatest single influence for new experiment was Whistler, who lived in London after 1859. He carried on a continual battle for the recognition in England of progressive French painting, and it was a result of his insistence that the late impressionist paintings of Monet, as well as works of Cézanne, were first exhibited by official art organizations. He also inspired young English artists like Walter Richard Sickert (1860–1942) to go to Paris and study the impressionists at first hand.

When we examine the works of the English pioneers, little genuine innovation can be found, although there are many individual works of quality. Philip Wilson Steer (1860–1943) was the most dedicated impressionist. Sickert, himself, after experimenting with impressionism, returned to a form of tonal, expressionist painting, closer to Courbet, Manet, and the nabis than to developed impressionism (*Ennui,* 1913–14, fig. 879). He became a leader among the young British painters, and his studio in Camden Town became the gathering place for progressive artists and critics who included Percy Wyndham Lewis, Lucien Pissarro (1863–1944, son of Camille Pissarro), and the critic Frank Rutter. In 1913 they merged into the London Group which continued for many years as a forum for experiment and discussion.

879. WALTER SICKERT. *Ennui.* 1913–14. 60 x 44¼ ". The Tate Gallery, London. Presented by C.A.S.I.

880. MATTHEW SMITH. *Fitzroy Street Nude No. 2.*
1916. 40 x 30″. Collection British Council, London

ented painter, writer, and polemicist Percy Wyndham Lewis (1882–1957). In the catalogue of the only exhibition of vorticism, at the Dore Gallery in 1915, Lewis described the movement: "By vorticism we mean (a) Activity as opposed to the tasteful Passivity of Picasso; (b) Significance as opposed to the dull and anecdotal character to which the Naturalist is condemned; (c) Essential Movement and Activity (such as the energy of a mind) as opposed to the imitative cinematography, the fuss and hysterics of the Futurists." At this time (1915) Lewis was reflecting the general reaction against the decorative phase of synthetic cubism. The attack on futurism also represented a reaction, since the ideas and the style of most of the vorticists were originally based on futurism as well as cubism.

Lewis passed through many phases during his mercurial career. Few of his early, vorticist paintings survive, and his achievement must be judged largely by works dating from the 1920s and 1930s. *Revolution,* c. 1917 (fig. 881), is a curious work, a sort of abstract city of the future in the process of disruption by rebellious computers. Later, he experimented with stylized, totemistic figures, and in the same period did portraits of Edith Sitwell, Ezra Pound, and other literary figures, giving them, through a suggestion of cubist structure, an appearance of modernism. The personification of the subjects is, nevertheless, precise and arresting.

Of crucial importance in the emergence of a new art in England were the exhibitions organized by the critic Roger Fry (1866–1934), at the Grafton Galleries. The first, November 1910–January 1911, included 150 works by Manet, Cézanne, Gauguin, Van Gogh, and the French symbolists. The second, October–December 1912, began with Cézanne and placed the emphasis on Matisse and the fauves, Picasso and the cubists, as well as a section for English artists, principally from the Camden Town group. Fry, himself, through his writings and personal prestige, remained a powerful voice for a new English art all his life, although he continued to prefer Cézanne and Matisse rather than the cubists and their followers.

Of his generation, the painter closest to European modernism and particularly to fauvism and expressionism was Matthew Smith (1879–1959), who studied with Matisse and spent much time in France over some thirty years. *Fitzroy Street Nude No. 2,* 1916 (fig. 880), is reminiscent of Van Gogh and Matisse in the spatial contraction and arbitrary color, with other relationships which are probably direct influences. Yet it is a work of individuality, closer to European modernism than most contemporary British works.

The final chapter in the story of modern English art before World War I was the emergence of the group who called themselves vorticists (from vortex) led by the tal-

881. PERCY WYNDHAM LEWIS. *Revolution.* c. 1917.
78 x 60″. The Tate Gallery, London

882. PAUL NASH. *Monster Field*. 1939. 30 x 40″.
Durban Art Gallery, South Africa

Other artists associated with vorticism were C. R. W. Nevinson, William Roberts, David Bomberg, Edward Wadsworth, and the sculptor Henri Gaudier-Brzeska. Of particular significance for vorticism was the association of the poet Ezra Pound, who gave the movement its name and, with Lewis, founded the periodical *Blast,* whose subtitle read *Review of the Great English Vortex.* With World War I, vorticism, not in itself a highly original artistic movement, was ended as an organized force. It produced few artists of ability or originality. For modern art in England, nevertheless, it was of great importance in marking the moment of complete involvement in the new experimental art of Europe.

Paul Nash (1889–1946) illustrates the dilemma of British artists who attempted to maintain a national identity while absorbing the lessons of European modernism. First affected by cubism (seen through Wyndham Lewis' vorticism) during World War I, he was caught up in abstract constructivism during the 1920s and then in surrealism during the 1930s. Nash was a principal founder in 1933 of the artists' association known as Unit I. His characteristic mature works combine surrealist qualities of strangeness and emptiness with romantic interpretations of the English landscape (fig. 882). In these he is close to the neo-romantics Eugène Berman and Léonid (see p. 367).

## STANLEY SPENCER *(1891–1959)*

The two English painters of greatest stature between the wars represent extremes of contrast. One, Stanley Spencer, went through life seemingly oblivious to everything in twentieth-century painting except for some aspects of surrealism or sharp-focus realism. In his earlier paintings with Christian themes he developed a curious, personal style in his drawing, reminiscent of early Italian or Flemish paintings, which enhanced his visionary effects. In the late 1920s Spencer received a large mural commission for the Oratory of All Souls, in Burghclere, Berkshire. For this he painted a series based on his war experiences, climaxed by the huge *Resurrection,* 1928–29 (fig. 883),

*above*: 883. STANLEY SPENCER. *Resurrection*.
1928–29. 21′ x 17′ 6″.
Sandham Memorial Chapel, Burghclere, England.
Property of the National Trust

*right*: 884. STANLEY SPENCER. *The Nursery*. 1936.
30⅛ x 36⅛″. The Museum of Modern Art, New York.
Gift of the Contemporary Art Society, London

*left:* 885. BEN NICHOLSON.
*Painted Relief.* 1939.
Painted synthetic material,
32⅞ x 45″.
The Museum of Modern Art,
New York.
Gift of H. S. Ede and the Artist

*below:* 886. BEN NICHOLSON.
*White Relief.* 1936.
Oil on carved board,
8 x 9¼″.
Collection Naum Gabo,
Middlebury, Connecticut

an endless panorama of the dead soldiers struggling from their graves amidst a forest of overturned crosses. While Spencer maintained his religious convictions throughout his life, in his later works he also turned to strange presentations of scenes with erotic overtones (*The Nursery,* 1936, fig. 883), sometimes suggestive of paintings by Balthus. Even these usually have religious implications in the sense of a modern morality play.

## BEN NICHOLSON *(b. 1894)*

The other outstanding English painter to emerge between the wars was Ben Nicholson, who is also a distinguished sculptor. Whereas Spencer might be considered narrowly English, Nicholson was the most internationally minded of his generation. He spent much of 1911–13 in France and Italy, where he encountered the new art. Acquaintance with Wyndham Lewis and the vorticists led him to experiment with forms of semi-abstraction as early as World War I. During the 1920s he practiced variants on the cubism of Braque and Picasso, with a general accent on balanced frontality comparable to paintings of the purists Ozenfant and Jeanneret. His association with the Abstraction-Création group in 1933 and his meeting with Mondrian about that time led him to complete geometric abstraction in the Mondrian tradition. This tradition, interpreted in a personal manner, has charted his subsequent career in both his paintings and his reliefs, but he has also continued to explore aspects of cubism, of purism, and even combinations of abstraction with literal details of landscape.

His art seems to stand apart from that of the Continental masters; his cubist works could never be confused

with those of any of the French cubists; his abstract painting and reliefs, while stemming from those of Mondrian, do not reveal their source in the sense that those of other followers, French, Dutch, or American, inevitably do. The difference is difficult to define; it may have something to do with Nicholson's continuing feeling for objective nature, his particular feeling for line, or perhaps some intangible in the English tradition.

Early works still in the purist phase reveal most of the characteristics of Nicholson's mature style. The color is subdued, matte, and delicately harmonious: a limited

887. BEN NICHOLSON. *Night Facade*. 1955.
Oil on pressed wood, 42½ x 45¾".
The Solomon R. Guggenheim Museum, New York

range of gray whites to grayed ochers, with a few accents of black and muted red, and rubbed pencil passages of dark gray. The surfaces look as though the finished oil painting had been gone over with an abrasive. All the elements of still life, table, bottle, and bowls, are frontalized and flattened. The effect is predominantly linear. The shapes are outlined with ruler and compass in fine and precise contour. Despite the undistorted definition of the objects, the impact is abstract. The use of the dominant color accents between the objects gives to these intervals a sense of abstract shape that controls the painting. Another curious visual effect has to do with modeling of the bottle and bowls. These are delicately modeled in a manner which should make them project slightly in the illusion of relief; but this does not happen, unless one concentrates on the separate objects. Perhaps because the same color values used to render the modeling of contours reappear as flat planes on the table top, the artist manages to achieve a definable solidity at the same time that everything is held tightly on the picture plane.

This is already a most sophisticated painting, and this sophistication, the control the artist has over his medium and all elements of composition, constitutes an outstanding characteristic of his art. In the 1930s Nicholson turned to a form of rigid, vertical-horizontal abstraction and, perhaps inspired by his wife, Barbara Hepworth, began to experiment with relief sculpture. As Nicholson may have turned to relief sculpture as a result of his wife's activities, so Hepworth may have been inspired to the use of regular, mathematical shapes and even the linear stretched string motifs as a result of Nicholson's abstractions.

*Painted Relief*, 1939 (fig. 885), is a meticulous adjustment of squares and rectangles in low but varying relief projections. The larger shapes are a uniform muted, sand

color; played against these are a square of dull ocher, a rectangle of red-brown and, top and bottom at the left, strips of pure white. The only lines are two finely etched circles, placed slightly off center in the major squares. The edges of the relief shapes also act as a precise, rectangular linear structure. In his white reliefs, produced principally during the 1930s and 1940s, all color and drawn line are eliminated. The total effect is achieved through the interaction of overlapping, interacting rectangles, with an occasional circle in sunken relief (*White Relief,* 1936, fig. 886). In these, the concepts of Mondrian would seem to be carried to a point of pure abstraction even beyond Mondrian himself.

In the same period Nicholson also produced paintings involving the same principles of strict rectangularity, using the primary colors with black, white, and grays, sometimes varying the values and intensities, and combining light, delicate blues with intense yellows. The artist has always drawn and painted from nature—landscapes, figures, and still lifes. The drawings have an Ingres-like delicacy and precision; as might be expected, architectural themes appeal particularly to Nicholson (*Night Facade*, 1955, fig. 887). Occasionally in the landscape paintings he has indulged in a form of personal fantasy in which one of his abstract structures is superimposed on a quite literal landscape. However, a recent work, *Saronikos,* 1966, of carved pavatex, a synthetic wood product, shows Nicholson's abiding dedication to pure abstraction (colorplate 217).

# Great Britain: Sculpture

## JACOB EPSTEIN *(1880–1959),*

## HENRI GAUDIER-BRZESKA *(1891–1915)*

Epstein, an American, settled in London in 1905 and became a highly controversial figure both for his portraits and for his architectural sculptures. He regularly roused the English public to fury. He was in touch with Picasso, Brancusi, and Modigliani before World War I and through them was introduced to primitive art, a powerful influence on his early work. One of his first mature sculptures, *The Rock Drill,* 1913 (fig. 888), is also one of his most individual and impressive. Recalling the forms of cubist sculpture (although antedating most), it is essentially an expressionist work, a mechanistic monster that anticipates some aspects of machine expressionism or surrealist sculpture.

Epstein's sculpture in general divided itself into two phases, the monumental carved figures, massive and brutal in their statement of the weight of the materials; and the expressionist works, principally portraits but also the late religious pieces, modeled in clay for bronze, with surfaces so exaggeratedly broken as to become mannered (*The Visitation,* 1926, fig. 889). The influence of Epstein on Moore is to be seen primarily in the carved figures Moore produced at the beginning of his career.

*above left:* 888. JACOB EPSTEIN. *The Rock Drill.* 1913.
Sculptured bronze, 27¾ x 23 x 17½ ". The Tate Gallery, London

*above right:* 889. JACOB EPSTEIN. *The Visitation.* 1926.
Bronze, height 65". The Joseph H. Hirshhorn Collection

*left:* 890. HENRI GAUDIER-BRZESKA. *Torso.* 1913. Marble, height 10".
Victoria and Albert Museum, London

*below:* 891. HENRI GAUDIER-BRZESKA. *Crouching Figure.* 1914.
Marble, height 8¾ ". Walker Art Center, Minneapolis

Gaudier-Brzeska was born in France and trained in France, Germany, and England. Between 1911 and 1915, when he was killed in World War I, he lived in London, like Epstein active in the vorticist circle around Wyndham Lewis. He had, thus, only about four years of mature sculptural expression. He was a friend of Ezra Pound and other literary figures who have created a legend concerning him which obscures the true picture. The relatively few works he left do indicate a great natural talent and an awareness of new experiment in sculpture, unparalleled in England at the moment (*Torso*, 1913, fig. 890; *Crouching Figure*, 1914, fig. 891).

892. HENRY MOORE. *Reclining Figure.*
1929. Hornton stone,
height 22½".
Leeds City Art Galleries, England

893. HENRY MOORE. *Interior-Exterior Reclining Figure.*
1951. Bronze, height 13½".
The Joseph H. Hirshhorn Collection

## HENRY MOORE (b. 1898)

Of English artists whose works had international implications for the modern movement before World War II, the most important is the sculptor Henry Moore. Even he did not begin to assume a genuinely international stature, in the sense of influencing as well as being influenced, before 1945. He was, however, a mature artist by the early 1930s, in touch with the main lines of surrealism and abstraction on the Continent, as well as all the new developments in sculpture, from Rodin through Brancusi to Picasso and Giacometti. More significant, by 1935 he had already made original statements and had arrived at many of the sculptural figurative concepts that he was to build on for the rest of his career.

Son of a coal miner, Moore studied at the Royal College of Art until 1925, receiving a sound, academic training which had little relevance to the twentieth century. The greatest immediate influence on him were the works of art he studied in English and European museums, particularly the classical, pre-classical, and non-Western art—African or Pre-Columbian—he saw in the British Museum. He was also attracted to English medieval church sculpture and to those masters of the Renaissance tradition—Masaccio, Michelangelo, to Rodin and Maillol—who had a particular feeling for the monumental. In English sculpture of the immediate past there was little on which he could draw, with the exception of the two highly disparate figures, Epstein and Gaudier-Brzeska. He was

894. HENRY MOORE. *Tube Shelter Perspective.* 1941.
Chalk, pen, and watercolor, 8½ x 6½".
Collection Mrs. Henry Moore, England

*above left:* 895. HENRY MOORE. *Madonna and Child.* 1943–44. Hornton stone, height 59″.
Church of St. Matthew, Northampton, England

*above right:* 896. HENRY MOORE. *The King and Queen.* 1952–53. Bronze, height 64½″. The Joseph H. Hirshhorn Collection

certainly aware of Gaudier in the early 1920s, and several figures seem to relate to those of the earlier sculptor.

Between 1926 and 1930 the dominant influence on Moore was Pre-Columbian art. *Reclining Figure,* 1929 (fig. 892), is one of the artist's first masterpieces in sculpture, a work that may owe its original inspiration to the Toltec sculpture of Chac-Mool, the Mexican Rain Spirit (with overtones of Maillol), but of a massive blockiness that stems from a passionate devotion to the principle of truth to materials. In this and other reclining figures, torsos, and mother-and-child groups of the late 1920s, Moore established basic themes on which he was to play variations for the rest of his life.

In the early 1930s the influence of surrealist sculpture, particularly that of Picasso, became evident. Moore began to explore other materials, particularly bronze, and his figures took on a fluidity and sense of transparent surface appropriate to the (to him) new material. Similar effects were achieved in carved wood in which he followed the wood grain meticulously. A characteristic of the figures of the 1930s is the opening up of voids, frequently to the point where the solids function as frames for the voids, but Moore put his personal stamp on the formula in his maintenance of classical humanity in his figures.

In the early 1930s, as well, Moore turned to abstract forms, and by opening up the masses and creating dispersed groups he studied various kinds of space relationships. This began a continuing concern with a sculpture of tensions between void and solid. These experiments were then translated back into the figures. The interest in spatial

897. HENRY MOORE. *Falling Warrior.* 1956–57. Bronze, length 52″. The Joseph H. Hirshhorn Collection

problems led Moore during the 1940s and 1950s to an ever greater use of bronze and other metals in which he could enlarge the voids of the figures. *Interior-Exterior Reclining Figure,* 1951 (fig. 893), is one of a series of intricate and subtle arrangements of interpenetrating solids and voids.

In World War II Moore made thousands of drawings of the underground air raid shelters in London (fig. 894). These inspired some of his most tender family groups and Christian religious works, as well as some of his most classic—in a literal Greek mode—restrained, and monu-

*above left:* 898. HENRY MOORE. *Glenkiln Cross.* 1955–56. Bronze, height 11'. The Joseph H. Hirshhorn Collection

*above right:* 899. HENRY MOORE. *Lincoln Center Reclining Figure.* 1963–65. Bronze, height 16'.
Lincoln Center for the Performing Arts, Inc., New York

mental draped figures (*Madonna and Child,* 1943–44, fig. 895). The early 1950s brought forth new experiments in attenuated, angular, bone figures. The figures in *The King and Queen,* 1952–53 (fig. 896), with masks for faces, and flattened out, leaflike bodies, maintain a sense of personality, of regal dignity. *Falling Warrior,* 1956–57 (fig. 897), is a macabre and tragic symbol of a world bent on destroying itself. In the mid-1950s Moore produced a large series of upright motifs of which the most notable is the *Glenkiln Cross,* 1955–56 (fig. 898), a gigantic and savage totem which links the Christian symbol, particularly the great, Early Christian Irish crosses, with the fertility columns of primitive mankind.

After mid-century Moore, acknowledged dean of English sculptors and a figure of world reputation, received many commissions for architectural sculpture. Museums and commercial or industrial firms are happy to acquire one of his later, monumental reclining figures; they seem to adapt and to enhance any architectural setting (*Lincoln Center Reclining Figure,* 1963–65, fig. 899). Generally, these latest works involve three directions, all in some degree based on earlier concepts of reclining or standing figures. The most impressive of these are probably the reclining rock, or mountain figures, vast in scale, craggy in effect, frequently broken in two or three parts so that the spectator can walk into them. At the other extreme is a type of reclining figure, smoothly contoured and reminiscent of the inside-outside figures of the 1930s (*Reclining Mother and Child,* 1960–61, fig. 900). Third is a form of shattered bone figure, usually standing, that develops ideas

900. HENRY MOORE. *Reclining Mother and Child.*
1960–61. Bronze, 33½ x 86½ x 54".
Walker Art Center, Minneapolis

of the earlier bone figures and warriors. Here the sense of death and destruction is strong. Most of the recent work is in bronze, now the artist's favorite material. The earlier insistence on truth to materials is no longer a factor, and bronze is given a range of effect, from the most jagged and rocky to the most finished and biomorphic. He has explored the full possibilities of sculptural forms and materials, but has always brought his explorations back to the problems of humanity.

# BARBARA HEPWORTH (b. 1903)

Barbara Hepworth, the other English sculptor of international stature before World War II, for a long time did not receive her merited recognition because of identification with Henry Moore. Like him, she worked abstractly during the 1930s, frequently placing separate shapes in tension or subtle relationships with one another. At that time she also explored the use of strings stretched across voids and, on occasion, lines, abstract or describing profile faces, etched into the stone (*Two Segments and Sphere*, fig. 901). The two artists remained in close touch, each affected by experiments the other initiated. Both were re-acting to the modern sculpture they discovered in Paris during the 1920s; but Moore was drawn more to the surrealist-figurative sculpture of Picasso, and Hepworth more to the abstract-organic sculpture of Brancusi or Jean Arp, and to the constructivism of Gabo.

In 1931, Hepworth married Ben Nicholson, and with him became a leader of the English abstract movement during the 1930s. In 1933, they were invited to become members of the Abstraction-Création group in Paris, and were active in the Unit One group which was attempting to establish a common front for modern art in England. After its dissolution they, together with Gabo, published *Circle* in 1937, as a program for abstract painting, constructivism, and modern architecture and design. This work introduced many of the ideas of the Bauhaus to England.

Nicholson and Hepworth were close to Herbert Read, the critic, then emerging as the leading advocate of modern art in England. When, during the 1930s, Gabo, Mondrian, Gropius, Moholy-Nagy, Breuer, and other European artists and architects moved to England, Hepworth and Nicholson were able to strengthen old friendships and form new ones among these pioneers of modernism.

The later 1930s produced some of Hepworth's most severely simplified sculptures, a number of them consisting of a single marble column, gently rounded or delicately indented to emphasize their organic, figurative source. Perfection of finish, making the marble glow with an inner life, is a fundamental quality of Hepworth's sculptures. Her wood sculptures of the 1940s are marked by the same

901. BARBARA HEPWORTH. *Two Segments and Sphere.* 1935–36. Marble, height 12″. L.H. Florsheim Foundation for Fine Arts, Chicago

902. BARBARA HEPWORTH. *Wave.* 1943–44. Plane wood with color and strings, length 18½″. Collection Mr. and Mrs. Ashley Havinden, England

903. BARBARA HEPWORTH. *Figure: Churinga.* 1952. Spanish mahogany, height 49″. Walker Art Center, Minneapolis. T. B. Walker Foundation Acquisition,1955

904. BARBARA HEPWORTH. *Group III (Evocation)*. 1952.
Serravezza marble, height 9".
Collection Margaret Gardner, England

emerged, sometimes in the interior void, as in *Churinga*, sometimes in massive abstract figures.

During the 1950s Hepworth's most interesting new experiment (related to her early group compositions and also to Giacometti's groups of walking figures) is the series of Groups in white marble, small in scale and magical in their impact (fig. 904). In these, external lighting effects become an important aspect of their total effect. Since the mid-1950s, the artist has moved in a new direction with a series of flat, thin forms intertwined in curving loops. These are usually modeled in metalized plaster and cast in metal. The bronze, biomorphic *Porthmeor: Sea Form*, 1958 (fig. 905), roughly textured and massive despite its openness of form, suggests some deep-sea crustacean or coral growth. Since 1960 Hepworth has received a number of commissions that have permitted her to work on a monumental scale. One of the most effective is *Meridian*, 1960 (fig. 906), for State House, Holborn, London—a great, openwork structure, a varied, expanding, and continuous ribbon, reminiscent of some vast plant form, combining monumentality with qualities of delicacy and grace.

905. BARBARA HEPWORTH. *Porthmeor: Sea Form*. 1958.
Bronze, height 30½".
The Joseph H. Hirshhorn Collection

906. BARBARA HEPWORTH. *Meridian*. 1960. Bronze, 15 x 10'.
Science Research Council, State House, Holborn, London

loving finish; the woods are beautiful and frequently exotic —mahogany, scented guarea, lagowood, or rosewood— worked to bring out their essential nature. Easier to work than stone, wood inspired her to an increasingly open type of composition, with voids penetrating the mass of the material. She also began at this time to use color, generally whites and blues in interior areas, to contrast with the natural wood of the exterior; and stretched strings to accent and define space across the voids (*Wave*, 1943–44, fig. 902; *Figure: Churinga*, 1952, fig. 903). For a period after World War II the sense of a naturalistic subject re-

# PART TWENTY-THREE

# ART SINCE MID-CENTURY

As has already been pointed out, in dealing with the art of the most recent past, an organization by national boundaries or classifications become almost irrelevant. Communications are so rapid, artists so mobile that one must acknowledge an international style that actually is world-wide. The variations of individual countries are possible to plot, but increasingly they seem to be unimportant. The organization of the last portions of this book, therefore, is in terms of broad categories, with comparative comments on artists who are widely dispersed throughout the world. In a world of tensions and hostilities, this international spirit among artists, this desire, this willingness to understand one another, is a hopeful sign.

## Figure and Fantasy

Since the early 1950s, despite the dominance of abstract expressionism in both the United States and Europe, there were recurring waves of insistence on a return to the figure, to a new naturalism or naturalistic fantasy. De Kooning and Pollock experimented with figuration at the beginning of the 1950s and De Kooning continued thereafter. The term, figuration, is ambiguous, since it can refer not only to the human (or animal) figure, rendered in some degree explicitly, but also to the implication of figures in abstract works. There was, however, in the late 1940s and the 1950s a deliberate and concerted attempt to reintroduce subject-matter figures, most frequently in a macabre effect. One may trace this tendency back to the dadaists, the surrealists, and specifically to Picasso in the 1920s and 1930s. Crucial to the new figuration are Alberto Giacometti (see p. 392) and Jean Dubuffet.

### FRANCE

The greatest French artist to emerge after World War II, Dubuffet was forty-three years old when, in 1944, he had his first one-man exhibition, at the Galerie René Drouin in Paris. After brief study at the Académie Julian in 1918, which he found uncongenial, he retired from the art world for some twenty-five years. He continued to draw and paint privately, but much of his time was taken up with music, the study of languages, experimental theater and puppetry. Of importance to the artist in finally discovering what it was he wanted to do was Hans Prinzhorn's book, *Bildnerei der Geisteskranken*, on the art of the insane. Here he found a brutal power of expression that seemed to

907. JEAN DUBUFFET. *Festival de Terre*. 1951.
35¾ x 48¼". Private collection, New York

him much more valid than the art of the museums or even the most experimental new art. The art of the insane and the art of children became the models on which he built his approach. The artist whose works attracted him most was Paul Klee, who had also used children's and psychopathic art as sources.

Since 1944 Dubuffet has been one of the most prolific painters in history, and has concurrently carried on an awe-inspiring program of writing on, cataloguing, and publishing his own development and his own works. The first of the new paintings were panoramic views of Paris and Parisians, the buses, the metro, the shops, the back streets. The colors are bright and gay, and the people are drawn in a childlike manner. Space is composed as in primitive or archaic painting, with depth indicated symbolically by stratification—the lowest stratum closest to the spectator (*View of Paris: The Life of Pleasure*, 1944, colorplate 218). It is at this stage that Dubuffet's paintings are closest in spirit to those of Klee.

Successively Dubuffet explored the variations of graffiti —images and messages, frequently obscene, scratched on walls; and the textural effects of Paris walls with their generations of superimposed posters. The scratched, mutilated surface, built up in combinations of paint, paper, and sand particularly appealed to him. *Festival de Terre*, 1951 (fig. 907), with its three figures who combine as-

908. JEAN DUBUFFET. *Volonté de puissance.* 1946.
45⅝ x 35". Whereabouts unknown

908. JEAN DUBUFFET. *Volonté de puissance.* 1946.
45⅝ x 35". Whereabouts unknown

occur in his working of the heavy ground. With modified techniques and materials his figures became more wildly mad, with sharply broken contours and smeared, bloody surfaces (*The Gypsy,* 1954, colorplate 219). It has always been Dubuffet's habit to work on a single theme or a few related themes for a period of a year or more. Thus the landscapes of the early 1950s were followed by a series of landscape-tables. The figures of the mid-1950s were accompanied by sculptured figures made of coal clinkers fixed with cement, or combinations of slag and tree roots, forming strange little figures, close in spirit to the painted figures of the period. It was at this same moment that Dubuffet became obsessed with the image of the cow, partially because the cow in the green pasture instilled a sense of pastoral wellbeing, and partially because the cow became for the artist a sort of clown or buffoon, ridiculous yet at the same time sympathetic (*La Vache,* 1954, fig. 910).

In Vence in 1955 the artist created a series of landscapes with figures in an India ink medium of imprint assemblage. The stay produced a variety of subjects, inspired by the local scene—gardens, carts, assemblages of butterfly wings, rough surfaces of old roads, studies of grasses and plants. In all of these Dubuffet was constantly experimenting with new techniques, frequently at first in

909. JEAN DUBUFFET. *Le Metafisyx (Corps de dame).*
1950. 44¾ x 35¼". Collection
Mr. and Mrs. Arnold Maremont, Winnetka, Illinois

pects of the psychopathic and the foetus floating insanely in a placenta-landscape, illustrates the most brutal aspect of his art.

Dubuffet's characteristic technique, which he used for some fifteen years after he had arrived at it about 1945, was based on a thick ground made of sand, earth, fixatives, and other mysterious elements into which the pigment was mixed. Figures were incised into this ground; the whole was scratched, scarred, worked in every way to give it a tangible, powerful reality. This reality of the painting as a physical object is of major importance in the attainment of the mysterious, primordial effect he was seeking. Out of ground or paste emerge monstrous figures that combine qualities of madness, with the power of prehistoric fertility images (*Volonté de puissance,* 1946, fig. 908; *Le Metafisyx: Corps de dame,* 1950, fig. 909). His landscapes are those of the moon or of a world in birth or in death; close-up views of geologic formations, barren of any vegetation, incapable of supporting any life. Works through the 1950s are predominantly in close-keyed browns, dull ochers and blacks, normally verging toward monochrome. All is darkness, but there is in them, however, magical light that glows within the paste, or pigment.

Independent of the American abstract expressionists, and anticipating many of them, Dubuffet worked in a largely intuitive manner, using every accident that might

*left:* 910. JEAN DUBUFFET. *La Vache.* 1954.
Ink on paper, 9 x 12″. Private collection, New York

*below:* 911. JEAN DUBUFFET. *Door with Couch-Grass.* 1957.
Oil on canvas with assemblage, 74⅜ x 57½″.
The Solomon R. Guggenheim Museum, New York

India ink or watercolor, later to be developed in oil. The works are some of the most profound and poetic fantasies of the imagination to be produced by a twentieth-century artist. One of the main sources of his inspiration has been the great collection he began in 1945, of *art brut:* art that is rough, raw, or even unadulterated. Numbering thousands of works in all mediums, the collection contains the art of the insane, the primitive, and the naïve. To the artist these works have an authenticity, an originality, a passion, even a frenzy, that is utterly lacking in the works of professional artists. It is this divine madness that he is continually seeking in his own works.

About 1957 Dubuffet made a number of paintings of doors. These developed out of assemblages based on walls with stains, and graffiti made up of oil painting fragments, cut up and pasted together in new relationships. He used novel and highly individual techniques to give "the impression of teeming matter, alive and sparkling . . . which could also evoke all kinds of indeterminate textures, and even galaxies and nebulae" (*Door with Couch-Grass,* 1957, fig. 911). At this time he also returned to studying the streets of Paris and, once again, the single figure or head—now magnificently bearded—obsessed him. In the views of Paris, color became more brilliant than at any previous period, and the urban activity was accelerated to a fury, as was the compartmentalization of the little city blocks hemmed within the narrow, twisted streets (*Business Prospers,* 1961, fig. 912).

Between 1962 and 1966 Dubuffet was occupied with what he refers to as the "Twenty-Third Period of My Works," to which he gave the coined name L'Hourloupe. These works represent one of the most radical departures in the artist's stylistic development and chronologically one of the most sustained. Some doodling with a red ballpoint pen while telephoning, in July, 1962, inspired him to create a small book of drawings with text. The drawings were in red and blue lines on a black ground, the lettering in white on black. Semi-automatic and self-contained, the drawings were free-form, abstract shapes, flowing and changing like amoebae, filled with suggestions of living organisms even at times of human figures.

912. JEAN DUBUFFET. *Business Prospers.* 1961.
65 x 86⅝″. The Museum of Modern Art, New York.
Mrs. Simon Guggenheim Fund

From this modest beginning the artist developed a vast repertoire of allover, color-shape paintings, some on a scale transcending anything he had ever done previously. In *Virtual Virtue,* 1963 (colorplate 220), dozens of little figures are engaged in frenzied physical embrace. They are drawn in undulating lines of red and blue with black and purple; the figures are white-bodied with blue tints. The total effect is that of a wild maze in which the figures are trapped and which is at the same time made up of the figures. Many variants on the linear-landscape-figure-object maze appeared during 1962 and 1963, with sporadic recurrence of individual *personnages.* Objects and utensils began to appear in the series regularly, from January 1964. These included typewriters, lamps, scales, fish-ing boats, wheelbarrows, and beds. At the end of 1964 objects ceased and people in landscapes recurred. Then, in February 1965, the themes became the tap, the washbasin, the open book, and the clock (*Legendary Figure of a Tap,* 1965, fig. 913). The climax of the entire series is *Nunc Stans,* 1965 (fig. 914), a gigantic color jigsaw puzzle of interlocked figures, faces, and objects. Despite the insistence on ordinary household utensils, these are invariably anthropomorphized, made into human organisms involved in fantastic and frenetic dances and embraces.

Jean Fautrier (b. 1898), one of the older artists who emerged after World War II, painted representationally through the 1930s, frequently figure studies reminiscent of early Rouault or of Pascin. During World War II he produced a series of small, strange paintings which he called Hostages: built-up masses of paint centralized on a neutral ground, resembling decayed human heads served on platters.

The paintings of Hostages, exhibited in 1945, *were* decapitated heads transformed into paint objects. These were followed by a series of Nudes, or Naked Torsos, whose hacked and mutilated shapes suddenly emerge as such from the heavy paste of clay, paint, glue, and other materials which are built up in a half-relief (colorplate 221). The artist's insistence on the painting as an object in itself with a tangible, physical existence, has particularly impressed a generation of younger artists, not only the so-called matter painters, but experimentalists of all shades. Aside from Dubuffet and Fautrier, the leading School of Paris exponent of matter painting is Philippe Hosiasson (b. 1898, Russia), who did not begin painting in a non-figurative manner until 1948. Hosiasson builds up his thick pastes, layer by layer, to create a barren, geologic landscape that is shot through with rich gleams of color. There is a certain relationship between his works and those of Emil Schumacher (b. 1912), the leading German exponent of matter painting.

Germaine Richier (1904–1959) was student and assistant of Bourdelle in the late 1920s. Since Bourdelle had been an assistant to Rodin, Richier thus inherited the main line of modern figurative sculpture. The earliest surviving sculpture of the late 1930s and early 1940s are sensitive portrait heads in the Rodin tradition. A squatting woman, entitled *Le Crapaud (The Toad),* 1942, suggests some of the macabre quality of later works. This is fully formulated in two figures, the male called *The Storm,* 1947–48, and the female, more devastating, *The Hurricane,* 1948–49 (fig. 915). These are monsters, powerful as gorillas, with

913. JEAN DUBUFFET. *Legendary Figure of a Tap.* 1965. Vinyl on canvas, 39⅜ x 31⅞".
Collection the Artist

914. JEAN DUBUFFET. *Nunc Stans.* 1965. Vinyl on canvas, 5' 4" x 27'. The Solomon R. Guggenheim Museum, New York

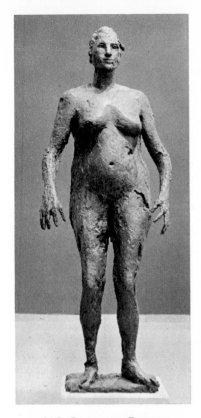

915. GERMAINE RICHIER.
*The Hurricane.* 1948–49. Bronze,
height 70⅛". Collection Dr. W. A.
Bechtler, Zollikon, Switzerland

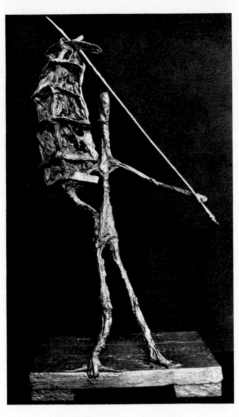

916. GERMAINE RICHIER.
*Don Quixote with the Windmill.* 1954.
Bronze, height 22½". University Gallery,
University of Minnesota, Minneapolis

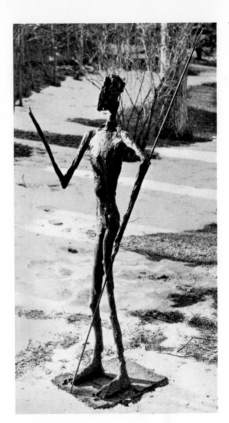

917. GERMAINE RICHIER.
*Don Quixote of the Forest.* 1950–51.
Bronze, height 93".
Walker Art Center, Minneapolis

pitted, torn, and lacerated flesh, that in a curious way are both threatening and pitiful, characteristics typical of Richier's race of monsters.

The theme of Don Quixote appealed to her and she produced several different versions: a small one in bronze doré, showing the emaciated, tragi-comic knight entangled in his windmill (fig. 916, 1954), and an over life-size example, *Don Quixote of the Forest,* 1950–51 (fig. 917). In the latter the knight's ineptitude and genuine dignity are beautifully suggested in the skeletal figure. The artist was obsessed with the natural world of growing things, as well as their inevitable decay. In this *Don Quixote* she cast the legs from tree boughs and the face from a rotting log. The attenuation of these figures owes something to Giacometti, but the tragic yet combative effect is quite different from Giacometti's sense of isolation.

Richier experimented with the bronze technique, using paper-thin plaster models, into the surface of which she pressed every sort of organic object. These experiments were first carried on in small works—fanciful chessmen or trees or plants (*The Tree,* 1956). Sometimes she placed her figures in front of a frame, the background of which is either worked in relief or, in some larger works, painted by a painter friend. Richier's passion for experiment as well as fantasy is carried to extremes in works like *The Horse with Six Heads,* 1953 (fig. 918). The bronze shell is a miracle of bronze casting, thin to the point of transparency, with the shredded surface everywhere torn open, like rotted flesh that has been picked over by vultures. In

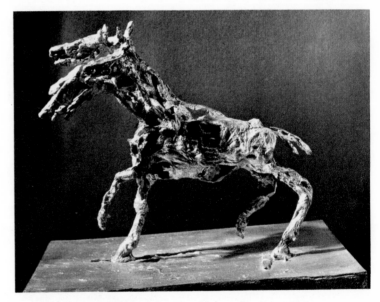

918. GERMAINE RICHIER. *The Horse with Six Heads.*
1953. Bronze, height 13⅜".
Richier Estate, courtesy Galerie Creuzevault, Paris

later works her violence of expression becomes excessive, close to the extreme forms of German expressionism. There are relations not only to Giacometti, but even more to Dubuffet's figures. In fact, the violence of her imagination may be traced to some of the later works of Rodin

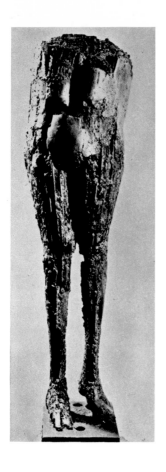

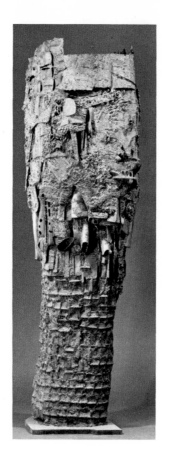

and Bourdelle, and is continued in other French or School of Paris sculptors, notably César and Ipousteguy.

Whereas Richier stretched the possible limits of bronze casting, César Baldaccini (César; b. 1921) creates comparable effects from the assemblage of old iron scraps and machine fragments. In this he belongs with the so-called junk sculptors who, using the detritus of machine civilization have, in recent years, made telling comments on that civilization. In his constructions, César, over long periods of time, has worked abstractly, but he returns continually to the figure, and the figure is implicit in many of the abstract works. His *Nude*, 1958 (fig. 919), is a pair of legs with lower torso, eroded and made more horrible by the sense of life that remains. *La Maison de Davotte*, 1960 (fig. 920), built up of fragments of rusted iron, is a huge structure, suggestive of an embalmed figure torso or a flattened head in which the primary expressive element is the gruesome texture of the surface. Here the decay of the materials conveys a larger message of decay, in which there is still a kind of order and beauty. During the 1960s the artist has made many assemblages of automobile bodies crushed under great pressure into massive blocks of varicolored materials, as they are in auto junkyards when the metal is processed for re-use (*The Yellow Buick*, 1959, fig. 921). At the same time, the study of the figure continues. *The Victory of Villetaneuse*, 1965 (fig. 922), is a welded assemblage, brazed and irregularly polished—an immense, gross, earth goddess, almost literally

*above left:* 919. CESAR. *Nude.* 1958. Bronze, height 26¾". The Joseph H. Hirshhorn Collection

*above right:* 920. CESAR. *La Maison de Davotte.* 1960. Iron, height 72". The Joseph H. Hirshhorn Collection

*right:* 921. CESAR. *The Yellow Buick.* 1959. Compressed automobile, 59½ x 30¾ x 24⅞". The Museum of Modern Art, New York. Gift of Mr. and Mrs. John Rewald

*far right:* 922. CESAR. *The Victory of Villetaneuse.* 1965. Iron, height 88½". Galerie Claude Bernard, Paris

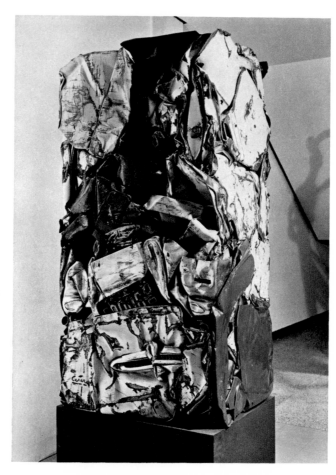

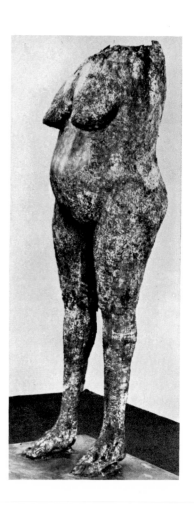

representational. Despite the constructed technique, the effect is close to traditional bronze and, in fact, a number of bronzes were cast from the original iron.

Jean-Robert Ipousteguy (b. 1920) left painting for sculpture about 1954. Since that time he has become one of the most impressive figurative expressionists. From initially abstract experiments using a variety of materials, he moved to a form of figure sculpture and to themes principally executed in bronze which, while intensely personal in their formulation, embody a strong sense of tradition. *David,* 1959 (fig. 923), is a massive, totemistic figure whose head is a threatening helmet. The technique, which Ipousteguy has made his own, employs extremely heavy bronze, carefully finished in a black or very dark patina, a smooth mass that is then shattered at many points. It is as though the impregnable material has been torn apart by some cosmic explosion. A recent work, *Alexander Before Ecbatana,* 1965 (fig. 924), illustrates the increasing complexity of spatial organization as well as the artist's deliberate use of the grand, academic, historical theme. The conqueror, Alexander, before the walls of Ecbatana, capital of the kingdom of the Medes, is an immense symbol of insatiable power. His triple face is enclosed in and emerges from a huge helmet structure that seems to have been literally ripped open. The city is presented symbolically by a landscape sculpture that is already completely subordinated to the conqueror. This is an effective and powerful work in organization and conception, but also of great interest in its revival of the grandiose history theme. Such a subject was a favorite with the official academic painters during the nineteenth cen-

tury and was even used frequently by so original a talent as Delacroix. In returning to the clichés of the academy it is as though Ipousteguy were attempting to prove that even the most tired themes could be given new significance, could serve as the basis for a new kind of expression in the later twentieth century.

## ITALY AND AUSTRIA

Italian painting between the wars lapsed into forms of realism with largely Renaissance, classical roots. De Chirico, as noted, after quarreling with the Paris surrealists, who had regarded him as a great pioneer, painted for the rest of his life in an eclectic, classical manner. Carrà also returned to the older tradition of landscapes, architectural in structure and romantic in mood, and to monumental figure studies. Only Morandi continued to maintain a high level of accomplishment in his limited but intensely sensitive and profound still lifes. The Novecento, formed in 1926, was an artists' organization that deliberately sought a return to nature, to traditional techniques and subjects. This included such painters as Arturo Tosi, Mario Sironi, and Felice Casorati, who have explored various past Italian traditions in paintings that have added little to the development of modern art.

Among the more interesting of the figure or subject painters are Antonio Donghi (b. 1897), who paints with a painstaking precision that combines a certain naïve vision with the meticulousness of fifteenth-century Flemish art; and the younger Renato Guttuso (b. 1922), who has built an expressionist art on the later works of Picasso. With

925. MARINO MARINI. *Dancer*. 1954. Bronze,
height 65½". The Joseph H. Hirshhorn Collection

the end of World War II and the end of Italian fascism,
painting moved into the orbit of international abstract ex-
pressionism and then of various forms of new experiment
in pop and optical art.

The main Italian contribution in figuration came in
sculpture, in the work of at least two men of talent, Marino
Marini (b. 1901) and Giacomo Manzù (b. 1908) and
numerous others of ability and originality. Marini was a
mature artist before the war, already experimenting with
his favorite subjects including the Horse-and-Rider theme.
At that time he made plump figures, with primitive model-
ing of the features on the textured surface of the head, and
paint worked into the gouges to add color and textural
variety. The figures of the 1950s became more angular,
sometimes elongated; the sketchy, naïve element, more
pronounced; the color, worked in an arbitrary series of
geometric areas, is frequently a dominant note (*Dancer*,
1954, fig. 925).

Marini is a brilliant portraitist. His portrait heads are
all characteristic Marini heads—surfaces grooved, slashed,

torn, and vari-colored; forms distorted; features exagger-
ated. Yet they catch in an uncanny degree the expression
and the personality of the sitter (*Curt Valentin*, fig. 926).

The Horse-and-Rider subject began to interest Marini
in the late 1930s, and during the war became for him a
symbol for suffering and homeless humanity. The versions
of the earlier 1940s are plump, sedate, and somewhat
reminiscent of Chinese carvings of peasants riding oxen
(*Horse and Rider*, 1949, fig. 927). As he continues with
the subject the action becomes more dramatic, the horse
and rider more angular and attenuated. The horse, with
elongated, widely stretched legs and upthrust head,
screams in agony, in a manner that recalls Picasso's
*Guernica* (see fig. 608). The rider, with outflung stumps
of arms, falls back in a violent gesture of absolute despair
(*Horse and Rider*, 1950–53, fig. 928). The next stage saw
the rider almost completely overthrown; and recently, in
*Composition of Elements*, 1964–65 (fig. 929), horse and
rider have been transformed into an abstract arrangement
of parts.

Giacomo Manzù was influenced by Medardo Rosso,
but his real loves were Donatello, Jacopo della Quercia,
and the Italian Renaissance. *Girl in Chair*, 1955 (fig.
930), is a completely traditional work which has, never-
theless, a lightness and vitality that make it contemporary.

926. MARINO MARINI. *Portrait of Curt Valentin*. 1953.
Bronze, height 9½". The Joseph H. Hirshhorn Collection

927. MARINO MARINI. *Horse and Rider*. 1949.
Bronze, height 71". Walker Art Center, Minneapolis

928. MARINO MARINI. *Horse and Rider*. 1950–53. Bronze,
height 81". The Joseph H. Hirshhorn Collection

929. MARINO MARINI. *Composition of Elements*. 1964–65. Bronze, 3' 3" x 9' 3" x 4' 5".
Collection Mr. and Mrs. Rudolph B. Schulhof, Kings Point, New York

*above left:* 930.
GIACOMO MANZU.
*Girl in Chair*. 1955.
Bronze, height 44¾".
The Joseph H. Hirshhorn
Collection

*above right:* 931.
GIACOMO MANZU.
*Standing Cardinal.*
1954. Bronze, height
66½". The Joseph H.
Hirshhorn Collection

*right:* 932.
GIACOMO MANZU. *Death
by Violence I*. 1962.
Bronze door panel,
39¾ x 28¼". St. Peter's
Cathedral, Rome

*far right:* 933.
FRITZ WOTRUBA.
*Figure with Raised Arms.*
1956–57. Bronze, height
70⅝". The Joseph H.
Hirshhorn Collection

The *Girl in Chair*, particularly, with the introduction of the prosaic chair, illustrates the close study of nature in which the artist's works are rooted, and also the poetry which he is able to instill into the subject. The chair has recurred in a number of independent versions of 1966, cast in bronze or, in one small version, in gold, with still-life elements of drapery, branches, or a lobster. This literal statement of commonplace objects simply as objects, without any mystical or symbolic overtones, brings Manzù close to some of the younger artists in Europe and America who prefer to call themselves object-makers.

The Cardinal series (*Standing Cardinal*, 1954, fig. 931), takes a conventional subject and creates from it a mood of withdrawal and mystery, at the same time utilizing the heavy robes for a simple and monumental sculptural volume. Manzù is one of the few living artists with a genuine feeling for Christian subject matter. He was close to Pope John XXIII, and has carried out a number of great religious commissions, notably the bronze door panels for St. Peter's Cathedral (fig. 932), and for the Salzburg Cathedral. Manzù as a sculptor is an anomaly: a Renaissance artist who has made his place in the contemporary world, a traditional sculptor who is never academic.

Among noteworthy European sculptors utilizing the figure who emerged in the post-war era is the Austrian Fritz Wotruba (b. 1907). Beginning in a literal classical vein, he gradually evolved a personal form of primitive image, with its roots in cubism or more specifically in abstraction. His monumental figures, roughly carved from a single block of stone, are literally made up of cubes or cylinder shapes seemingly assembled to suggest the main masses of a standing, seated, or reclining figure (*Figure with Raised Arms,* fig. 933). Hundertwasser (Friedrich Stowasser, b. 1928), a Viennese, is one of the contemporary European masters of figurative fantasy. He continues the Austrian art nouveau tradition of Klimt and Schiele with the addition of strong overtones from Paul Klee. His self-portrait, entitled *Maison née à Stockholm, morte à Paris und die Beweinung meiner selbst (House born in Stockholm)*, 1965 (colorplate 222), is a brilliant pastiche of art nouveau decoration surrounded by touches of expressionism and fantasy.

## GREAT BRITAIN

The most important figure painter in the British Isles since 1940 is the Irish-born Francis Bacon (b. 1910). About 1945 he made a series of studies on the theme of the Crucifixion, the climax of which was a *Magdalene*, 1945–46 (fig. 934)—a massively modeled figure inspired by Giotto, set within a room suggestive of an art gallery. The space of the room is defined by some perspective lines, but the color is a unified yellow-orange. The figure, partially draped, solid as a marble altar, is bent double. Over her head is a blue umbrella from which hangs a semi-transparent veil, and below this, partially obscured, is her head, like that of some weird animal, extended on a long neck, mouth wide open in a great wail or scream of grief. This work established many of the themes Bacon has

934. FRANCIS BACON. *The Magdalene*. 1945–46. 57¼ x 50¾ ". Bagshaw Art Gallery, Batley, England

935. Attributed to TITIAN. *Cardinal Filippo Archinto*. 46 x 26". John G. Johnson Collection, Philadelphia

developed over the years. His devotion to the monstrous, the deformed, or the diseased has been variously interpreted as a reaction to the plight of the world and humanity. The *Magdalene* also reveals his superb qualities as a pure painter and his obsessive sense of tradition, in this case

936. FRANCIS BACON. *Head of a Man—Study of Drawing by Van Gogh.* 1959. 26⅛ x 24⅛".
Collection Mr. and Mrs. Harry C. Cooper, Los Angeles

extending from Giotto in the fourteenth century, to the sixteenth-century High Renaissance.

Bacon uses paintings of the past as the basis of his works, but he tranforms these in terms of his own inward vision or torment. In the early 1950s he made a series of studies of a pope, after Velázquez' *Portrait of Pope Innocent X* in the Doria Gallery in Rome. (Lawrence Alloway has also pointed the relation of this series to a strange portrait of *Cardinal Filippo Archinto,* fig. 935, in which the Cardinal is partially hidden by a semi-transparent curtain.) The pope is usually shown seated in a large, unified surrounding space, the figure blurred as though seen through a veil; the perspective lines are suggestive of a glass box within which the figure is trapped. The mouth is usually open in a shout or a scream. In *Head Surrounded by Sides of Beef (Study After Velázquez),* 1954 (colorplate 223), two great, bloody sides of beef are placed heraldically above, on either side. This motif, deriving ultimately from Rembrandt seen through Soutine— with whom Bacon has many traits in common—first appeared in *Painting,* 1946. The exact meaning of the Pope series is deliberately obscured by the artist, but there can be no question of the disturbing, sometimes horrifying, impact. There can be no question either of the beauty of the painting and the grandness of the conception; in fact, the dignity, the spaciousness, the traditionalism of the concept and its execution throw into relief the disturbing qualities.

Another artist who has, understandably, fascinated Bacon is Vincent van Gogh. He made many variations on Van Gogh's *The Artist on the Road to Tarascon,* 1888 (now destroyed), and has done a great number of portraits that are extensions of Van Gogh's last self-portraits (fig. 936). In the portraits, using whirling brush strokes, he twists the face as it might be seen in an excessively dis-

937, 938, and 939. FRANCIS BACON. *Three Studies for a Crucifixion.* 1962.
Each panel 78 x 57". The Solomon R. Guggenheim Museum, New York

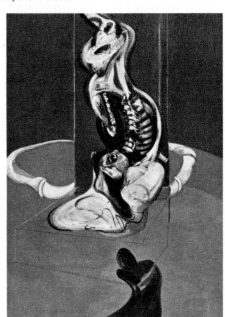

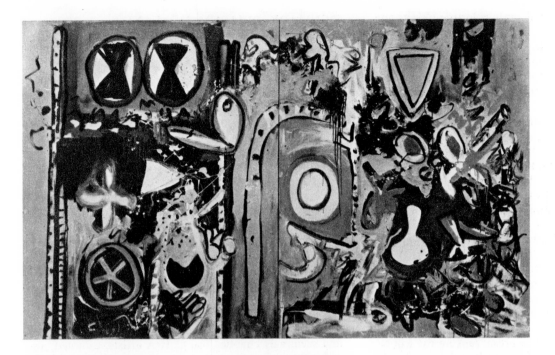

941. ALAN DAVIE.
*Golden Pig.* 1963.
Two panels, 6 x 10'.
Private collection

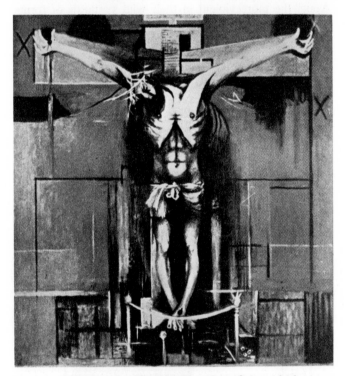

940. GRAHAM SUTHERLAND. *Crucifixion.* 1946.
Oil on hardboard, 96 x 90".
Church of St. Matthew, Northampton, England

torted mirror, while still maintaining an element of the recognizable. The effect is one of madness.

A climactic work of the early 1960s is the triptych *Three Studies for a Crucifixion,* 1962 (figs. 937, 938, 939). In it the artist summarizes motifs and forms developed during the 1950s: the figures in large space, the sides of beef, the nude on a bed in a room with curving walls and drawn shades. The figure is, however, a broken, bloodied cadaver that might have been beaten to death in a concentration camp.

Graham Sutherland (b. 1903) and James Alan Davie (b. 1920) are the two other leading British painters associated with forms of figuration or fantasy today. Beginning with meticulously representational paintings and etchings during the 1920s, Sutherland during the 1930s explored forms of symbolic landscape with reminiscences of Gauguin. In the 1940s these landscapes—trees and rock forms—were transformed into monstrous figures that suggest some of Picasso's expressionist-surrealist work of the 1930s (see p. 386). The war years led to a certain reversion in the representation of devastated, bombed-out buildings, and industrial scenes. By the end of World War II Sutherland had arrived at his characteristic jagged, thistle-like totems, frequently based quite literally on plant forms but transformed into menacing beasts or chimeras. A commission for the painting of a Crucifixion in St. Matthew's Church, Northampton, led him back to Grünewald's Isenheim Altarpiece. In Grünewald's torn, lacerated figures he found a natural affinity (fig. 940). In the 1950s and 1960s Sutherland has continued to play variations on his individual totems, sometimes in his handling of space and atmosphere coming close to contemporaneous works by Francis Bacon. Along with his expressionist works he has carried on a successful career as a portraitist, painting many of the great figures of his time in literal but penetrating interpretations.

Davie, born and educated in Scotland, taught in Edinburgh for a number of years after World War II. His earlier painting reveals the normal progression from a provincial form of post-impressionism, through various stages that inevitably include late works by Picasso, but also by American abstract expressionists and members of the CoBrA group. It is probably with these last, particularly Lucebert and Jorn, that his later paintings belong most specifically. These are characterized by a wild and seem-

ingly chaotic assembly of brilliantly coloristic objects and shapes, sometimes suggestive of Miro or Ernst, but combined with smeared and dripped paint which despite its roughness acts as the coordinating element (*Golden Pig,* 1963, fig. 941). In his most recent works Davie frequently works in broader, more unified color areas, using more explicit images.

The British figurative tradition in the post-war era has been carried on more in sculpture than in painting until the emergence of British pop art. Moore and Hepworth stand somewhat apart from the younger British sculptors. Reg Butler (b. 1917) developed from an abstract construction derived from Gonzalez to an expressive figure style that has more in common with Marini and the Italians than it has with Moore (*Girl,* 1954–56, fig. 942). Kenneth Armitage and Lynn Chadwick (see below), Bernard Meadows (b. 1915) and Elizabeth Frink (b. 1930) explore their separate, individual problems of expression in bronzes of violent action or macabre repose. Eduardo Paolozzi (b. 1924) was the principal British exponent of the junk sculpture or found-object school (*Saint Sebastian No. 2,* fig. 943). In recent years he has become a leader in the British school of pop art or object making (as will be shown). Out of the detritus of decayed machines he made marvelous monsters of ferocious vitality whose incredible agglomerative surfaces, reflecting in bronze the thousands of nuts, bolts, wires, and other machine parts, take on the pathetic beauty of a dying civilization.

## DENMARK, BELGIUM, HOLLAND

In Holland in 1948, Karel Appel (b. 1921), Cornelis Corneille (b. 1922), and George Constant (b. 1920), formed the Experimental Group, seeking new forms of elemental expression, as much opposed to Mondrian and De Stijl as to the academy. Through contacts with similar groups in Copenhagen and Brussels, this evolved into the international expressionist group, CoBrA (Copenhagen, Brussels, and Amsterdam), of which the Danish painter Asger Jorn and the Belgian Pierre Alechinsky are other notable members.

Most of the painters associated with the CoBrA group employed some sort of subject or figuration, usually derived from folk art, children's art, prehistoric, or primitive art. The most important unifying principle among these divergent artists was their doctrine of complete freedom of abstract expressive forms, with accent on brush gesture. In this they were allied to Dubuffet and Fautrier in France, for both of whom the artists of CoBrA had great respect, although the directions their free expression took were different, generally more violent, colorful, dynamic, and seemingly chaotic. The CoBrA artists, as noted, also differed widely among themselves, Asger Jorn and Karel Appel the more violent in their wild synthesis of forms and brilliant color, Pierre Alechinsky and Corneille in some degree more apparently controlled. Appel has consistently painted figures and portraits with linear and col-

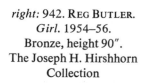

*right:* 942. REG BUTLER. *Girl.* 1954–56. Bronze, height 90″. The Joseph H. Hirshhorn Collection

*far right:* 943. EDUARDO PAOLOZZI. *Saint Sebastian No. 2.* 1957. Bronze, height 84¾″. The Solomon R. Guggenheim Museum, New York

*above left:* 944. KAREL APPEL. *Portrait of Willem Sandberg.* 1956. 51¼ x 31⅞ ".
Museum of Fine Arts, Boston. Tompkins Collection

*above right:* 945. ASGER JORN. *Green Ballet.* 1960. 57 x 78¾ ". The Solomon R. Guggenheim Museum, New York

oristic enthusiasm (*Portrait of Sandberg*, 1956, fig. 944; *Angry Landscape*, 1967, colorplate 224). The Dutch poet-painter Lucebert (b. 1924), another member of CoBrA, explores a kind of fantasy figuration with implications of folk tales and legend, and of children's art, often delightfully filled with humor (colorplate 225).

Of all the CoBrA painters with the exception, perhaps, of Appel, Jorn represents the most extreme reaction against concrete art's principles of order and harmony. Whereas Appel establishes a certain control through his representation of an explicit face or figure, Jorn's paintings at first glance have the impact of Ruskin's epithet concerning Whistler—a pot of paint flung in the face of the public. Using largely undiluted primary colors with blacks, whites, and greens, Jorn smears, slashes, and drips the paint in a seemingly uncontrolled frenzy. Yet the control, established in large, swinging, linear movements, and asymmetrically balanced color shapes, is still sufficient to bring a degree of order out of chaos while not diminishing the explosive fury of the abstract expression (*Green Ballet*, 1960, fig. 945). Pierre Alechinsky, by comparison, particularly in his earlier works of the 1950s, uses an all-over structure of tightly interwoven elements with a sense of order deriving from microcosmic organisms (*Ant Hill*,

946. PIERRE ALECHINSKY.
*Ant Hill.* 1954.
59½ x 93⅞ ".
The Solomon R. Guggenheim
Museum, New York

*above left:* 947. HORST ANTES. *Yellow Figure with Bird*. 1964–65. 39⅜ x 35¾".
Collection Charles and Peter Gimpel, London

*above right:* 948. RICHARD OELZE. *In a Church*. 1949–54. 31½ x 39½".
Private collection

*above left:* 949. JAN LEBENSTEIN. *Aquatic*. 1965. Private collection

*above right:* 950. ANTONIO SAURA. *Grande Crucifixion rouge et noire*. 1963. 76¾ x 96½". Galerie Stadler, Paris

1954, fig. 946). Paintings of the 1960s tend to be looser, closer to Jorn in shapes, though continuing to be more neutral in color and more suggestive of explicit figuration.

## GERMANY, POLAND, SPAIN

All over the world during the 1950s and 1960s individual artists have explored different aspects of expressionist figuration. Their motivation has been principally a reaction against abstract expressionism, but their productions are so varied that classification is difficult, if not impossible. In Germany, Horst Antes (b. 1936) has created crude, heavy, primitive figures deriving from Max Beckman (fig. 947). Richard Oelze (b. 1900) creates romantic-symbolist landscapes filled with atmosphere and populated by repulsive specters (fig. 948). Poland has produced a number of figurative or semi-figurative artists, working in the high impasto of matter painting, of whom Jan Lebenstein (b. 1930) is the most interesting (fig. 949). In Spain, a figurative, expressionist painter with some affinity to Appel, although he has characteristically painted more in monochrome, is the Spaniard Antonio Saura who, beginning as a surrealist, moved into the painting of overpowering heads and figures whose tragic expressions have specific social-realist implications (*Grande Crucifixion*, 1963, fig. 950). Very different in character, the Spaniard Eduardo Arroyo (b. 1931) has qualities in common with the surrealism of Magritte and the enlarged detail pop painting of an artist like James Rosenquist (*Nine Tomorrows from Waterloo,* 1965, fig. 951).

## UNITED STATES

During the 1950s, critics in the United States, faced with the overwhelming tide of abstract expressionist painting, frequently predicted the return to the figure or to some form of representation. In 1959 the Museum of Modern Art in New York held a large exhibition entitled "New Images of Man," which surveyed the current state of figure painting and sculpture in both Europe and America. Interestingly, the most impressive American figure painter shown was Willem de Kooning, whose Woman series, dated between 1950 and 1954 (see fig. 854) was outstanding in the show. In the later 1950s De Kooning returned principally to abstract expressionist painting, but during the 1960s he has, after an extended interval when he painted little, gone back once more to figurative painting. In the San Francisco Bay area of California, a group of painters who studied or taught at the California School of Fine Arts—where Clyfford Still and Mark Rothko had taught in the late 1940s—began to apply abstract expressionist brush painting to studies of figures in environments. These were David Park (1911–1960), Elmer Bischoff (b. 1916), and Richard Diebenkorn (b. 1922). Although their approaches were related, and their subjects were similar—figures grouped but seemingly isolated in a room or a landscape—Park was the most assertive of brush texture independent of the figures, Bischoff the most involved in a romantic-baroque sense of space and movement, as Diebenkorn was in the creation of a mood of quiet and isola-

951. EDUARDO ARROYO. *Nine Tomorrows from Waterloo.* 1965. Galerie André Schoeller, Paris

952. RICHARD DIEBENKORN. *Man and Woman in a Large Room.* 1957. 71 x 63″. The Joseph H. Hirshhorn Foundation

tion (*Man and Woman in a Large Room,* 1957, fig. 952). Diebenkorn worked abstractly before 1955, in broad areas of open color carefully structured in rectangular planes, a manner that owes much to Matisse. It may be that the abstract, coloristic harmony of his later figurative painting is still of more significance than the suggestion of obscure human relations that he has introduced.

953. JAN MULLER. *The Temptation of Saint Anthony.*
1957. 6′ 8″ x 10′ 1″.
Collection Mrs. Jan Muller, New York

Some American figurative painters, such as Rico Lebrun (1900–1964), have pursued paths of violent expressionism involving distorted, mutilated, or monstrous figures. Related but somewhat apart from these is Jan Muller (1922–1958) who did not come to the United States until 1941 and, although he studied at the Art Students League, his curious, visionary paintings seem to belong to an older tradition of German expressionism or even of German medieval painting (*The Temptation of Saint Anthony*, 1957, fig. 953).

## LATIN AMERICA

Expressionist figuration is particularly strong in Latin America, in character sometimes pushed to the point of gruesomeness. Jorge de la Vega (b. 1930, Argentina) has created some of the most repulsive, but in their own way amusing, monsters of our time. He composes them of everyday collage elements combined with brush gestures, thus suggesting aspects of earlier expressionism and contemporary pop art (fig. 954). Luis Felipe Noé (b. 1933, Argentina) has also been influenced by dadaism and pop art which, however, he exploits for expressionist purposes. *Charisma*, 1963 (fig. 955), has an interesting affinity to James Ensor's *Portrait of the Artist Surrounded by Masks* (see fig. 284). Noé has also experimented with multiple paintings in the forms of triptychs or polyptychs executed on hinged, joined doors, thus giving a personal variation to the theme of the shaped canvas. An older Argentinian who is in many ways the most contemporary is Antonio Berni (b. 1905). He was a Parisian surrealist and a social realist until the 1960s when he achieved a combination of expressionism and pop art, using collages of clippings from magazines, actual objects, and grotesque painted figures. Despite the use of pop art techniques, Berni continues to be involved in the analysis and criticism of social problems (fig. 956).

Closer to the magic realism of the early century is Fer-

nando Botero (b. 1932, Colombia) who transforms portraits by Rubens and Velázquez into inflated, peculiarly repulsive children painted with a precision which gives a startling and frightening actuality (*Rubens' Woman*, 1963, fig. 957).

In reviewing briefly the Latin American painters of figurative fantasy, somewhat older or more established masters must not be forgotten, even if some of them have more to do with the worlds of Paris and New York than of their native countries. Rufino Tamayo (b. 1899) has lived in Paris and New York but now spends most of his time in his home in Mexico City. He continues to paint his serene monumental figures in their rich reds and ochers, suggesting their Pre-Columbian ancestry (fig. 958), combining these with abstract topographical landscapes that have about them something of the nature of an archeological excavation.

David Alfaro Siqueiros, since his release from prison where he had served a term for political activities, has painted with undiminished energy. *Flowers*, 1962 (fig. 959), instills in the passive subject qualities of energy and violence suggesting the undaunted spirit of this eternal

954. JORGE DE LA VEGA. Detail of *The Four-Legged Table.*
1965. Mixed mediums. Galeria Bonino, Buenos Aires

955. LUIS FELIPE NOE. *Charisma*. 1963. Collage on canvas, 9′ ¾″ x 6′ 4¾″. The Solomon R. Guggenheim Museum, New York. Gift of Mr. and Mrs. Charles S. Gehrie

957. FERNANDO BOTERO. *Rubens' Woman*. 1963. 72 x 70″. The Solomon R. Guggenheim Museum, New York. Gift of the Neumann Foundation

956. ANTONIO BERNI. *The Great Illusion*. 1962. Private collection

958. RUFINO TAMAYO. *Woman in Gray*. 1959. 76¾ x 51″. The Solomon R. Guggenheim Museum, New York

*above left:* 959. DAVID ALFARO SIQUEIROS. *Flowers.* 1962. Acrylic on cedar, 18¼ x 15".
Collection Tomás Marentes, Mexico City

*above right:* 960. MATTA. *Vers L'Uni.* 1963. 6' 6¼" x 10' 2". Galerie Daniel Cordier, Paris

961. WILFREDO LAM. *Tropic of Capricorn.*
1961. 58⅛ x 85".
Collection Sonja Henie and Niels Onstad, Los Angeles

rebel. He has embarked on a mural project of heroic size and complexity for the auditorium in the Parque de Lama, in Mexico City. The several panels, each weighing about a ton, are modeled, incised, and painted, in a variety of mediums.

Matta Echaurren, after his spectacular exhibitions in New York in the early 1940s, explored for a number of years subjects related to science fiction and outer space (see fig. 852). Most recently he has combined these stark and dramatic drawings with the intensely varied and luminous color of his earlier works (fig. 960).

Wilfredo Lam (b. 1902, Cuba) has lived in Paris since the late 1930s, with the exception of the war years spent in the United States. He is one of the most original of the later converts to surrealism, owing a great deal to the surrealist paintings and sculptures of Picasso (fig. 961).

## Abstract Painting

### SCHOOL OF PARIS

In the ten years after the end of World War II, various forms of free or geometric abstraction dominated the painting of Europe and the United States, although, as noted in the development of Dubuffet and Giacometti, fantastic figuration was given a new impetus. The School of Paris was enriched by the continuing activity of the old masters and the return from the United States of Léger, Chagall, Max Ernst, Masson, Picabia, Hélion, and others, including Duchamp who, after 1945, commuted between Paris and New York.

The first group of painters to gain notice in terms of a program were those who called themselves Young Painters in the French Tradition, under which name they had exhibited together in 1941, during the German occupation. These were Jean Bazaine (b. 1904), Alfred Manessier (b. 1911), the Belgian Gustave Singier (b. 1909), Jean Le Moal (b. 1909), and Charles Lapicque (b. 1898). Most of these had studied with Roger Bissière (1888–1964), who was influenced by Klee and had worked and taught quietly for many years, influencing a generation of younger artists, but not himself gaining recognition until

the end of his life. Bissière employed an allover, generally rectangular linear pattern through which he played spots of impressionist color in the creation of a flickering, luminous surface (fig. 962).

The disciples of Bissière practice a variety of styles, but have in common traits of lyrical color and free but controlled structure that have affinities to fauve landscapes. Bazaine uses directional lines of forces, rooted in analytical cubism, combined with tonal grounds shot through with rich but subdued color (fig. 963). Manessier, on the other hand, employs a free geometry, with irregular, flowing shapes, organized in a clear pattern of flat color areas. The group as a whole does suggest the French tradition from impressionism through fauvism and cubism, and has even been categorized as abstract impressionist. They and a number of other artists associated with them, such as the Russians André Lanskoy (b. 1902), Serge Poliakoff (b. 1906), and Nicholas de Staël (1914–1955), constituted the dominant new direction in School of Paris painting after 1945.

Lanskoy came to abstraction in the 1930s through his studies of Klee and Kandinsky, although he did not completely free himself of the object until 1941. His gaily colored and closely structured paintings (which suggest analytical cubism at some remove) have their origins in close observation and love of natural landscape—as was the case with the fauves—and embody a comparable sensuous delight in brilliant, harmonious color (*Voyage to Arles*, 1953, fig. 964).

Poliakoff works in large, bold, but not intense colors, roughly textured and matte in surface, to create effects of crude, primitive force (*Composition*, 1950, fig. 965).

De Staël was born in Russia and grew up in Belgium, where he attended the Royal Academy of Fine Arts. In the 1940s he was painting abstractly (*Composition*, 1948, fig. 966), but as his work developed he became more and more concerned with the problem of nature versus abstraction; he seems increasingly to have been dissatisfied with

the non-objective aspect of his own works and desirous of finding solutions that would assert the subject while maintaining the abstract forms (colorplate 226). He experimented with many styles in landscape, still life, and figure, some atmospherical and mystical, some simplified to large planes of flat color accented by a few contrasting color spots. In the last year of his life he began painting quite literal scenes of boats and birds and ocean, in thin, pale colors reminiscent of the later landscapes of Marquet. In 1955 De Staël died by suicide, having reached an impasse, it seems (as in the case of Jackson Pollock), from which there was no exit.

Bram van Velde (b. 1895, Holland) is one of the most isolated and powerful of art informel painters. The sense of subject, usually in the form of large heads with great staring eyes, has continued in his work until the 1960s.

963. JEAN BAZAINE. *Marée basse*. 1955.
55¼ x 76¾". Galerie Maeght, Paris

962. ROGER BISSIERE. *Composition (331)*. 1957.
18 x 21½". Collection Otto Henkell, Wiesbaden, Germany

964. ANDRE LANSKOY. *Voyage to Arles*. 1953.
38⅜ x 51⅜". The Solomon R. Guggenheim Museum, New York

965. Serge Poliakoff. *Composition*. 1950.
Oil on wood, 51⅜ x 38¼".
The Solomon R. Guggenheim Museum, New York

966. Nicholas de Stael. *Composition*. 1948.
39¼ x 25½". The Art Institute of Chicago.
Gift of Mr. and Mrs. William Wood Prince

This, however, was less significant than his use of free abstract color-shapes accentuated with patterns of dripping paint. Van Velde is the European artist closest perhaps to aspects of American action painting, particularly that of his fellow Hollander, De Kooning. He provides an unconscious link between the Americans and the CoBrA group (fig. 967).

Despite the prevalence of the lyrical or abstract impressionist wing of free abstraction in Paris during the 1940s and 1950s, other artists were emerging dedicated to expressive brush gesture. These included Hans Hartung, Gérard Schneider, Pierre Soulages, and Georges Mathieu, constituting a group who, in their accent on the direct, the intuitive, the spontaneous, paralleled the American abstract expressionists. To these as well as to others such as Wols, Alechinsky, Van Velde, or Asger Jorn, who pursued free abstraction in quite different manners, the terms *l'art informel,* or *tachisme,* have been applied.

L'art informel (the last, a coined word) is a term devised by the French critic Michel Tapié. As used in European painting and as it has spread throughout the world, it is an extremely broad term roughly equivalent to American abstract expressionism and, specifically, to action painting. It represents the departure from the tradition of cubism and geometric abstraction in the creation of a new

form of expression. The emergence of this art from the generally decorative patterns of post-war French abstraction exactly paralleled in time, if not in forms, the origins of abstract expressionism in the United States. To European painters, far more than to the Americans, the problem was escape from the overpowering tradition of cubism. Art informel refers to intuitive, spontaneous, undisciplined art (but is not to be thought of as informal, in the sense of opposite to formal). In this art, for which Tapié coined another term, *un art autre*—another art, or way-out art— the essence is creation with no desire for, nor preconceptions of, control, geometric or otherwise. It is painting which begins with the brush and a blank canvas and may go anywhere. Thus, various other categories: *tachisme* (from the French word *tache*)—the use of the blot, the stain, the spot, or the drip; lyrical abstraction in its freely decorative phase; gesture painting—the insistence on the statement of the brush stroke; abstract calligraphy; matter painting—the assertion of the material of paint, fortified with sand, clay, or other materials; all these are different manifestations of l'art informel. The term, like abstract expressionism, is so broad and all-inclusive as to be almost meaningless, but its usefulness is the emphasis it places on opposition to all phases of disciplined, geometric, or concrete art.

Hans Hartung (b. 1904) is German by birth and train-
ing, and did not settle in Paris until 1935. His individual,
brittle, linear style may owe something to the earlier ab-
stract expressionism of Kandinsky, whom he met in 1925.
Hartung experimented with free abstract drawings and
watercolors as early as 1922, a fact that has added to the
controversy: who originated abstract expressionism? Dur-
ing the 1930s he explored personal variants on cubism and
on abstract surrealism related to that of Miró and Masson.
He also produced constructed sculpture in the tradition of
Gonzalez, and surrealist collages or assemblages. His prin-
cipal interest remained that of sensitive, generally brittle
linear structures played against delicate, luminous washes
of color. In the late 1940s he developed his mature style of
free linearism over total color fields (*T-50 Painting 8*,
1950, fig. 968). In the 1960s he moved to a more total
form of field painting in which light and shadow are
played over one another in chiaroscuro effects that might
almost be abstractions from late Rembrandts (colorplate
227).

Gérard Schneider (b. 1896, Switzerland) has lived in
Paris since 1916. At first he worked in a representational
but freely expressionist coloristic style, already suggestive
of his later abstractions. He then explored forms of geo-
metric abstraction, and since 1950 his paintings have been
characterized by large, sweeping and swirling, heavily tex-
tured paint passages, rich and sensuous in color, and fre-
quently moving over a unified color, or black ground.

Pierre Soulages (b. 1919, France) first came to Paris in
1938 but did not settle there until 1946. Almost immedi-
ately he began painting abstractions, structures based on
studies of tree forms. The architectural sense and the
closely-keyed color-range that characterize his abstract
style—this sense of physical, massive structure in which the
blacks stand forth like powerful presences—may have been
inspired originally by the prehistoric dolmens of his native

Auvergne, as it certainly was by the Romanesque sculp-
ture of the area. Soulages has consistently followed the
principle of the subdued palette, feeling that "the more lim-
ited the means, the stronger the expression." Within this
limited means—the great sweeping lines or color areas, usu-
ally black or dark color, heavy in impasto, applied with the
palette knife or large, housepainter's brushes—Soulages has
achieved an art of power and elegance, particularly notable
not only in the forms but in the penetrating, encompassing
light that unifies the painting (colorplate 228).

Wolfgang Schulze Wols (1913–1951), who lived prin-
cipally in France after 1932, developed an abstract style
after World War II with some analogies to that of Fau-
trier. He also built up his paint in a heavy central mass
varying from the monochromatic ground more in value
then in hue, but shot through with flashes of intense colors
that create the impact of magnified biological specimens or
half-healed wounds (fig. 969).

969. WOLFGANG SCHULZE WOLS. *Oil*. 1949.
Alexander Iolas Gallery

Zao-Wou-Ki (b. 1920, Peking) is another artist who uses shifting effects of light and shadow, but with an entirely different, more lyrical effect. Usually he employs a dominant, over-all color with an infinite variation of tones to create romantic, atmospheric effects of space changing and moving continually. Worked throughout this space are innumerable small, linear figurations, suggestive of and frequently derived from Chinese calligraphy (fig 970).

Georges Mathieu (b. 1921) has been described as the Salvador Dali of l'art informel. After World War II he moved toward a calligraphic style that owes something to Hartung. Mathieu's calligraphy, however, consists of sweeping patterns of lines squeezed directly from the tube in slashing impulsive gestures. To him, speed of execution is essential for intuitive spontaneity which, in turn, will lead to universality. Typically he turned to elaborate titles taken from battles or other events of French history. This is in line with his insistence that he is a traditional history painter working in an abstract means. He has a love of spectacle and performance; at times he has painted, dressed in armor, before an audience, attacking the canvas as though it were the Saracen and he were Roland. His critics have frequently raised the question as to who won the battle. It must be recognized, nevertheless, that Mathieu, like Dali, in spite of love of performance and paradox, is an artist of substantial abilities, one of the leading European exponents of brush gesture or action painting (colorplate 229).

An artist difficult to classify but one of great sensitivity is Maria Helena Vieira da Silva (b. 1908, Lisbon). Since the 1940s she has been obsessed with the interaction of perspective and non-perspective space in paintings that are literally based on architectural themes of the city. *The Invisible Stroller,* 1951 (fig. 971), is related to Picasso's synthetic cubist paintings of the 1920s in its fluctuations of

970. ZAO-WOU-KI. Untitled. 1965.
13½ x 12½'.
Private collection, New York

971. MARIA HELENA VIEIRA DA SILVA. *The Invisible Stroller.*
1951. 52 x 66". San Francisco Museum of Art.
Gift of Mr. and Mrs. Wellington S. Henderson

Colorplate 218. JEAN DUBUFFET. *View of Paris:*
*The Life of Pleasure.* 1944. Oil on canvas, 35 x 45¾″.
Collection Mr. and Mrs. David M. Solinger, New York

Colorplate 219. JEAN DUBUFFET.
*The Gypsy.* 1954. Oil on canvas,
36¼ x 29″. Hillman Periodicals, Inc.

Colorplate 220. JEAN DUBUFFET. *Virtual Virtue.* 1963. Oil on canvas, 37¾ x 50⅞″. Saidenberg Gallery, New York

*above:* Colorplate 221.
JEAN FAUTRIER. *Nude.* 1960.
Oil on canvas, 35 x 57½ ".
Collection de Montaigu, Paris

*right:* Colorplate 222.
HUNDERTWASSER. *Maison née à Stockholm,
morte à Paris
und die Beweinung meiner selbst
(House born in Stockholm).*
1965. Oil on canvas, 32 x 23⅔ ".
Collection J. J. Aberbach, New York

Colorplate 223. FRANCIS BACON. *Head Surrounded by Sides of Beef (Study After Velázquez).* 1954. Oil on canvas, 50⅞ x 48″.
The Art Institute of Chicago. Harriott A. Fox Fund

*above:* Colorplate 224.
KAREL APPEL. *Angry Landscape.* 1967.
Oil on canvas, 51¼ x 76¾".
Martha Jackson Gallery, New York

*right:* Colorplate 225.
LUCEBERT. *Child, Mother, Father.* 1962.
Oil on canvas, 39¼ x 31⅓".
Private collection,
New York

548

Colorplate 226. NICHOLAS DE STAEL.
*Untitled.* 1951. Oil on canvas, 63 x 29″.
Collection Mr. and Mrs. Lee A. Ault,
New York

Colorplate 227. HANS HARTUNG.
*Untitled.* 1963. Oil on canvas, 39⅜ x 31⅞″.
Private collection

right: Colorplate 228.
PIERRE SOULAGES. *Painting.* 1952.
Oil on canvas, 77⅜ x 51¼″.
The Solomon R. Guggenheim Museum,
New York

below: Colorplate 229.
GEORGES MATHIEU. *Painting.* 1953.
Oil on canvas, 6′6″ x 9′10″.
The Solomon R. Guggenheim Museum,
New York

Colorplate 230.
LUCIO FONTANA.
*Green Oval Concept.* 1963.
Oil on canvas, 70 x 48½ ″.
Galleria dell'Ariete,
Milan

Colorplate 231.
ANTONI TAPIES.
*Painting Collage.* 1964.
Collage on canvas, 14 x 22″.
Martha Jackson Gallery,
New York

551

*above:* Colorplate 232. LOUISE NEVELSON.
Left: *An American Tribute to the British People*.
1960–65. Wood painted gold, 10'2″ x 14'3″.
**The** Tate Gallery, London
Right: *Sun Garden, No. 1*. 1964.
Wood painted gold, 72 x 41″.
Collection Mr. and Mrs. Charles M. Diker

*right:* Colorplate 233.
ZOLTAN KEMENY. *Zephyr*. 1964.
Brass and colored polyester relief, 53 x 42½″
Collection Mme. Madeline Kemeny, Paris

*above left:* 972. JEAN-PAUL RIOPELLE. *Blue Night.* 1953. 44⅞ x 76¾″. The Solomon R. Guggenheim Museum, New York

*above right:* 973. ERNST WILHELM NAY. *Orbit.* 1963. 63¾ x 55⅛″.  M. Knoedler & Co., New York

Renaissance perspective and the cubist grid. From this point forward she has gradually flattened the perspective while retaining the rigid, rectangular, architectural structure. The view of the city, seen from eye level, has become the view from an airplane where, as one rises higher and higher, details begin to be blurred and colors melt into general tonalities.

To the artists already discussed under this category may be added the Canadians Paul-Emil Borduas (1905–1960), who was important in bringing aspects of French art informel to Canada; and Jean-Paul Riopelle (b. 1923). Riopelle has lived in Paris since the late 1940s and is married to the American abstract expressionist Joan Mitchell. Although deriving originally from Jackson Pollock, his painting is essentially a kind of controlled chance, an intricate mosaic of small, regular, strokes of jewel-like color, held together by directional lines of force (*Blue Night*, 1953, fig. 972).

## GERMANY

Art informel or free abstraction in Germany is largely the product of an older generation, since no younger generation of artists emerged during the Nazi regime. The new German art began to take form in the late 1950s and 1960s in the context of the new realism, pop, and optical painting. Willi Baumeister had been a figurative painter after World War I in a manner deriving from Léger; with the end of World War II and Nazi control he turned to a form of abstract surrealism that owes much to Miró (see p. 350). The other German leaders of the lyrical wing of free abstraction include Theodore Werner (b. 1886), Ernst Wilhelm Nay (b. 1902), and Fritz Winter (b. 1905). Werner characteristically uses an over-all ground of luminous color applied in thin washes. Over this he plays free linear patterns and floats long organic shapes, black or in contrasting colors, in a manner that again suggests Miró.

974. FRITZ WINTER. *March.* 1951. 47¼ x 59″. Collection Achille Cavellini, Brescia, Italy

Nay orchestrates bright colors on his canvas for relationships and total effects in which the musical analogy is striking, although it may be the music of Johann Strauss rather than Richard (fig. 973). Winter, from an earlier style in which semi-geometric structures were worked over light, tonal grounds, has moved to regular, loosely rectangular arrangements of subdued, poetic color shapes, arranged to form a mysterious architectural facade filling the entire area of the canvas (fig. 974).

Another older German painter, very different in style and temperament from those just discussed is Julius Bissier (b. 1893). Bissier was associated with the new objectivity

in the 1920s and most of his earlier works were destroyed in the 1930s. After World War II he entered upon a new phase of small, delicate, and haunting paintings in gouache or tempera, heightened by sensitive calligraphy. Sometimes he inserts childlike drawings of buildings or other representational elements that indicate his indebtedness to Klee. It is certainly true that Bissier preserves the spirit of Klee perhaps better than any other artist of the post-war period (*MQ,* 1959, fig. 975).

## ITALY

In Italy the first move toward a new art after World War II was the formation in 1947 of the Fronte Nuovo delle Arti (New Art Front) consisting of both abstractionists

975. JULIUS BISSIER. *MQ.* 1959. India ink, 15⅜ x 20½ ". Private collection

976. AFRO BASALDELLA. *For an Anniversary.* 1955. 59 x 78⅝ ". The Solomon R. Guggenheim Museum, New York. Gift of Mr. and Mrs. Joseph Pulitzer, Jr., 1958

and younger realists. Members included Renato Birolli, Giuseppe Santomaso, Renato Guttuso, Antonio Corpora, Pericle Fazzini, Giulio Turcato, Nino Franchina, Ennio Morlotti, Emilio Vedova, Giuseppe Pizzinato, and Leoncillo. This group lasted only until 1948 and was succeeded in 1952 by the Otto Pittori Italiani (Eight Italian Painters), a more consistent group of art informel abstractionists, consisting of Afro Basaldella, Mattia Moreni, Santomaso, Birolli, Corpora, Morlotti, Turcato, and Vedova. Their paintings have been described by the critic Lionello Venturi as abstract-concrete. In general they are comparable to the more lyrical abstractionists of the School of Paris.

Afro Basaldella (b. 1912), who uses the name Afro to distinguish himself from his brother, the sculptor Mirko, created during the 1950s an atmospheric world of light and shadows, with subdued, harmonious colors and shapes that are in a constant state of metamorphosis. In later works of the 1960s the color and shapes are sharply defined and jagged, in the spirit of American action painting (*For an Anniversary,* 1955, fig. 976). Birolli (1906–1959) combined a comparable atmospheric quality with vivid colors, for effects that were similar in their romantic lyricism. Corpora in the 1950s combined a general tonality of luminous color with an abstract linear figuration, built up or scratched into the heavy paint surface. Recently he has emphasized the reality of the painting as an abstract but physically existent object. *La Dolce Vita,* 1964, is a violet-red rectangle suspended within a ground of blue. This in turn contains two balanced rectangles opening up to a mysterious interior of small, vividly varied color-shapes. There is a certain relation to later works by Fautrier in the imagery of the object if not in the actual execution.

While these artists, although individual in their styles, may be described as belonging to international art informel lyricism, the real impact of post-war Italian art on a younger generation was made by individuals of entirely different approach. These include Lucio Fontana, Giuseppe Capogrossi, and Alberto Burri. Fontana was born in Argentina in 1899 and educated in Italy. In 1947 he moved permanently to Italy where he founded the movement he called spatialism, whose principles he has followed since that time in paintings, sculptures, and works that transcend the limits of both painting and sculpture. This, in fact, was the program of spatialism: to free art from past aesthetic preconceptions, to "abandon the acceptance of known forms in art and begin the development of an art based on the unity of time and space" (*The White Manifesto,* Buenos Aires, 1946). Fontana had been trained initially as a sculptor, a fact that contributed to his conviction that painting above all needed new spatial concepts.

By 1949, the artist had begun to perforate or slit the canvas, thus in effect destroying the actual picture plane that had been the point of departure during virtually the entire history of painting. During the 1950s he experimented with matter, building up his perforated surfaces with heavy paint, paste, and glues in which he incorporated pebbles, pieces of glass, canvas fragments, or ceramic shards. It was in 1958–59 that, feeling he was complicating and embellishing the works too much, he slashed a spoiled canvas, and realized that in this simple act he could achieve the integration of surface with depth that he was seeking.

As early as 1949, Fontana also created spatial environments with free forms and black light and, during the 1950s made large-scale architectural-spatial designs, in collaboration with the architect Luciano Baldessari. In his desire to break down categories of painting, sculpture, and even architecture, Fontana describes all his works as Concetti Spaziali (C. S.)—Spatial Concepts. In recent years he has multiplied his investigations, using sheet-metal burned with blow torches, ceramics, and lacquered wood combined with canvas. In these last, the detached, cut-out elements floating over the ground give a new and mysterious ambiguity to his spatial concepts (*Green Oval Concept*, 1963, colorplate 230; *Spatial Concept*, 1965, fig. 977).

Without arguing the eternal question of who did what first, Fontana, beginning a new career at the age of forty-eight (most of his early works were destroyed in World War II), has made significant contributions to many of the new directions of modern art—art as environment, light or optical art, painting as object, the shaped canvas, and above all the breaking down of the distinctions between painting and sculpture, and even architecture, as distinct and separate forms. He has had great influence on younger European artists, although he is less well-known in the United States.

Giuseppe Capogrossi (b. 1900) also found his personal direction rather late in his career. After having passed through various stages—figurative, expressionist, and abstract—about 1949 he arrived at an original image involving signs or emblems, variations on a basic hieroglyphic form (*Surface 210*, 1957, fig. 978). This is a heavily drawn semi-circle interpenetrated by lines to create a comb-like form. Using this simple but suggestive image, he creates a great variety of arrangements, frequently with the effect of excavated archeological sites viewed from above. Capogrossi is an individual painter with some relations to the ideographs of Torres-Garcia or Adolph Gottlieb, in spirit rather than in specifically stylistic character. His impact has not been as compelling as that of Fontana or Burri, but his image is an arresting one that may have had some direct influence on younger, systemic painters —artists who organize their canvases in terms of a prescribed and repeated system or pattern.

Alberto Burri (b. 1915) was a doctor by profession (as Capogrossi held a doctorate in law) and began painting when he was a prisoner of war in the United States. Presumably because of the lack of adequate materials, he used old sacks roughly sewn together and heavily splashed with paint. The results were often reminiscent of blood-stained bandages, torn and scarred—devastating commentaries on war's death and destruction. They have been related to Schwitters' collages, but their impact is much more brutal and even horrifying than anything Schwitters produced.

For a period in the mid-1950s Burri burned designs on thin wood panels like those used in orange crates. In them, as in the earlier works, there is a strange conflict between, on the one hand, the ephemeral material (which sometimes disintegrates visibly when moved from place to place), the sense of destruction and disintegration; and, on the other hand, the elegance and control with which the artist arranges his elements (fig. 979). Burri has also worked in metal and plastics, melting and re-forming these

977. LUCIO FONTANA. *Spatial Concept (White and White)*. 1965. Canvas and lacquered wood, 68⅞ x 68⅞ ″. Collection the Artist

978. GIUSEPPE CAPOGROSSI. *Surface 210*. 1957. 81⅜ x 62¾ ″. The Solomon R. Guggenheim Museum, New York

979. ALBERTO BURRI. *Wood and White, 1.* 1956. Combustion; oil, tempera, and wood on canvas, 34½ x 62⅝ ". The Solomon R. Guggenheim Museum, New York

with a blow torch to achieve results of vivid coloristic beauty combined with effects of disease and decay. His influence, like that of Fontana, has been widespread, particularly on those younger artists who raise questions concerning the nature and the transience of a work of art.

SPAIN

As has been discussed, the movements described in the United States as abstract expressionism and in Europe as art informel spread in one form or another to every part of the world. In Spain, a young group of artists began to emerge after 1946, of whom the most talented was Antoni Tàpies. Tàpies, in Barcelona in 1948, joined with other young artists and poets, including Modest Cuixart and Juan Edmundo Cirlo, in the formation of the group entitled Dau al Cet (Seven on the Die), a phrase taken from André Breton. They published a review for two or three years and, in general, followed the abstract surrealism of Miró and the fantasy of Klee. In Madrid in 1957 another group, called El Paso (The Step), was formed, including Antonio Saura, Luis Feito, Rafael Canogar, and Manolo Millarès.

Tàpies (b. 1923) has been one of the leading exponents of matter painting, building up large surfaces with combinations of somber paint, varnishes, sand, and powdered marble to create an effect of solid relief. His colors are generally subdued but rich, with surfaces worked in many ways—punctured, incised, modeled in relief. During the 1960s he characteristically turned to a coloristic pattern, still involving large-scale areas modulated in tone (colorplate 231). Recently, in combinations that suggest the paintings of Barnett Newman and some of the pop artists, he has combined contrasting stripes against color fields as well as specific objects.

Saura (b. 1930), as we have noted, maintains the image of face and figure presented in violent, slashing brush strokes with some affinity to Appel, although generally in a more muted palette (see fig. 950). Luis Feito (b. 1929) builds up the heavy, generally dark but luminous, masses of his centralized paint-and-sand matter against his flat, neutral ground, to give impact comparable to burned-out

volcanoes. With the exception of Tàpies and Saura, both of whom have lived outside of Spain for long periods of time and who belong to the larger international world, most of the new Spanish painters are important as illustrating the enormous spread of these art informel tendencies during the 1950s. The same may be said of painters in Yugoslavia, Poland, Czechoslovakia, Israel and, with a few notable exceptions, Scandinavia.

## Concrete Art

In 1930, as has been noted, Theo van Doesburg coined the word "concrete" as a substitute for abstract in its specific application to the geometric abstractions of Van Doesburg, Mondrian, and De Stijl. This was followed in 1931 by the Abstraction-Création group which, during the 1930s, sought to advance the principles of pure abstraction and of Mondrian's neo-plasticism. The concept of concrete art was revived in 1947 in the Salon des Réalités Nouvelles; the gallery of Denise René, opened in Paris in 1944, became an international center for the propagation of concrete art. Among the leaders outside of France were Josef Albers, who had gone to the United States in 1933 and whose influence there on the spread of geometric abstraction has been discussed. He exhibited regularly with the American Abstract Artists group as well as with Abstraction-Création in Paris.

Equally important for the spread of concrete art in Europe have been the Swiss, with Max Bill a leader in the perpetuation and specific definition of concrete art, a term he has applied to his own art since 1936. The term has the advantage over the term abstract, in that it applied to a particular phase of abstract art, the geometric tradition of Mondrian and Van Doesburg. It also serves as a rallying cry in its emphasis on the painting as an entity in itself, as something *concrete* rather than as something abstracted from (with the implication of derivation from) nature. Bill

980. MAX BILL. *Endless Loop.* 1947–49. Gilded copper, 9¾ x 29 x 8". The Joseph H. Hirshhorn Collection

981. RICHARD PAUL LOHSE. *Pure Elements Concentrated in Rhythmic Groups*. 1949–56. Private collection

defined concrete art as follows: "Concrete painting eliminates all naturalistic representation; it avails itself exclusively of the fundamental elements of painting, the color and form of the surface. Its essence is, then, the complete emancipation of every natural model; pure creation." This definition does not depart much from the original definitions of Mondrian and Van Doesburg; and post-war concrete art is essentially a continuation of their ideas and forms, as well as those of Arp, Gabo, and Pevsner. Its importance as an international movement lies in its expansion of the possibilities and forms. Many aspects of post-war constructivism, color-field painting, systemic painting, and optical art stem from the tradition of De Stijl and concrete art.

## SWITZERLAND

Max Bill (b. 1908, Switzerland) studied at the Dessau Bauhaus between 1927 and 1929 when Josef Albers was teaching there. Since that time he has developed into one of the most talented and varied exponents of Bauhaus ideas, as a painter, sculptor, architect, graphic and industrial designer, and writer. He was associated with Abstraction-Création in Paris, and organized exhibitions of concrete art in Switzerland. Unlike Pevsner, Bill has always been fascinated by the relations of mathematics and art. He insists that painting and sculpture have always had mathematical bases, whether these were arrived at consciously or unconsciously. By mathematics he is not referring to plane geometry or simple arithmetic, but to the relativistic mathematics of Einstein and nuclear physics. He also insists on the philosophical and even—in the spirit of Kandinsky and Malevich—the spiritual or ethical roots of modern art. He is referring primarily, of course, to con-

crete art, in whose forms he finds simplicity, clarity, and harmony, qualities symbolic of universal ideals.

In his paintings, Bill like Albers is constantly experimenting with color relationships, particularly the interaction of colors upon one another. Thus, recent works bear titles like *Four Color Pairs Around a White Center; Condensation from Violet to Yellow; Four Complementary Color Groups in a Blue Field*. In sculpture he frequently uses geometric shapes (*Endless Loop*, fig. 980). The form that has intrigued him the most and on which he has played many variations, is the endless helix or spiral that turns back upon itself with no beginning and no end.

Richard Paul Lohse (b. 1902) is like Max Bill in the mathematical basis of his painting. He seeks the simplest possible unit such as a small color square and then, using not more than five color hues but a great range of color values, he builds his units into larger and larger complexes through mathematically precise distribution of hues and values in exact and intellectually predetermined relationships. The result is a composition or color structure that spreads laterally and uniformly, with no single focus, to the edges of the canvas, and has the implication and the potential of spreading to infinity beyond the edges. Despite the rigidity of Lohse's system, the subtlety and richness of his colors, the shimmering quality deriving from their infinitely varied relationships, give to his works a lyrical, poetic feeling. His art is of importance as an immediate prototype for recent tendencies in systemic painting and optical art (*Pure Elements Concentrated in Rhythmic Groups*, 1949–56, fig. 981).

## ITALY

At the opposite pole from Bill but still within the definition of concrete art is the older painter Alberto Magnelli (b. 1888). Although he produced abstractions as early as 1915, Magnelli painted figuratively during the 1920s and early 1930s. He did not enter upon his later abstract (or concrete) style until after 1935, and gained little recognition for it until after World War II. Magnelli's

982. ALBERTO MAGNELLI. *Sonorous Border*. 1938. 38¼ x 57½ ". Galerie de France, Paris

works normally involve a dynamic interplay, tension, or even conflict of shapes. These are mainly geometric, but he does not hesitate to depart from absolutely regular forms if necessary. His colors are flat, matte, unmodulated, without luminosity and unrelated to colors in nature, thus strengthening the feeling of complete abstraction. There is, nevertheless, such sharp tension between the various forms and colors that they take on a kind of abstract personality, even at times an abstract surrealist quality (*Sonorous Border*, 1938, fig. 982).

## SCHOOL OF PARIS

Three of the Paris post-war leaders in concrete art are the Dane Richard Mortensen (b. 1910), Jean Dewasne, (b. 1921) and the Swede Olle Bäertling (b. 1911). Of even greater importance is Victor Vasarely, but his development is so inextricably tied to optical and kinetic art that he is best discussed in that context.

Mortensen, while maintaining the simplified color scheme—with variations—and the precise edges of the concrete art school, uses looser, less geometric shapes and thus anticipates the direction known as hard-edge painting, in which colors are flat and uniform and color shapes may take any form.

Dewasne, like Auguste Herbin and Jean Deyrolle (b. 1911), a former cubist, sought for Mondrian's purity in the elimination of association, but with greater intensification of color and variety of abstract shapes. Recent works by Dewasne use enamel paints on porcelain surfaces to create effects of mechanical purity and power, deriving from Léger but going beyond him in machine depersonalization (*La Demeure antipode,* 1965, fig. 983).

Although Olle Bäertling now lives in Stockholm, he has been sufficiently associated with the French *art concret* to be considered a member of the School of Paris. Bäertling is in a sense concerned with the same problems of austere geometry in both his paintings and sculptures. His paintings are principally immaculate triangles of color sometimes bounded by heavy black lines (fig. 984). His sculptures are simply line constructions, which, when seen against appropriate backgrounds, "fill in" with color and resemble his paintings.

# Abstract Sculpture and Construction

The terms abstraction and construction are obviously not mutually exclusive. Although a substantial amount of *abstract* sculpture continues to be cast in bronze or carved from stone, most recent abstract sculpture is *constructed* from metal, and figurative sculptors, pop artists, and assemblagists also utilize varieties of construction. The word, constructivism, as it grew from the early experiments of Tatlin, Gabo, Pevsner, Moholy-Nagy (see pp. 222 ff.),

*above:* 983. JEAN DEWASNE. *La Demeure antipode.* 1965. Enamel on masonite, 37⅞ x 50⅞ ". The Solomon R. Guggenheim Museum, New York. Gift of Herbert C. Bernard

*right:* 984. OLLE BAERTLING. *Ardiam.* 1963. 70 ¾ x 36". The Solomon R. Guggenheim Museum, New York. Gift of Professor Leif Sjoberg

*left:* 985. DAVID SMITH.
*The Royal Bird.* 1948.
Stainless steel,
21¾ x 59 x 9″.
Walker Art Center,
Minneapolis. T. B. Walker
Foundation Acquisition, 1952

*below:* 986. DAVID SMITH.
*Star Cage.* 1950.
Steel, height 44¾″.
John Rood Sculpture Collection,
University Gallery,
University of Minnesota,
Minneapolis

and others, has developed a specific connotation of abstraction, geometric or organic. A recent book on *Constructivism* by the motion-sculptor George Rickey uses the word in its widest possible sense to include not only abstract, constructed sculpture, but almost every form of abstract painting or sculpture with the exception of abstract expressionism and surrealism. Although this position can perhaps be justified, the term will be used here in its narrower sense.

## UNITED STATES

Constructed sculpture—as contrasted with sculpture cast in bronze or modeled in stone—and particularly direct-metal constructed sculpture, constituted a major direction after World War II. David Smith (1906–1965) was the most original sculptor of his generation in America. Since his death in an automobile accident his influence has become world-wide. Smith was born in Decatur, Illinois, and between 1927 and 1932 studied painting at the Art Students League, New York. About 1930, intrigued by reproductions of Picasso's welded-steel sculptures of 1928–29, he began to experiment with constructed sculpture.

During the 1930s and 1940s there was a surrealist quality in his sculptures, deriving from Picasso and Gonzalez (although this was alternated with geometric construction); and in the Medals of Dishonor, works of social commentary. With *The Royal Bird*, 1948 (fig. 985), the viciously aggressive skeleton of some royal bird of prey, Smith attained a climax of figurative expression at the moment he was beginning to move away from surrealism. The early 1950s were marked in his works by linearism, a drawing of space in steel. This was constructivist sculpture in the original sense of Gabo's Realistic Manifesto, in which the voids constituted the forms defined by the steel lines. Even when the sculptures were composed two-dimensionally, the natural setting, seen through the open spaces, introduced ever-changing suggestions of depth,

color, and movement (*Star Cage*, 1950, fig. 986). During the 1950s Smith also experimented with monolithic figure forms, on occasion producing a vertical-horizontal structure of rectangular, superimposed masses that is a startling anticipation of primary structures of the later 1960s.

Smith worked long and painfully in the perfection of his sculptural concepts. He was never trained formally as a sculptor and thus was able to avoid the academic intervals from which most American sculptors of the 1930s and 1940s suffered. He first learned to weld in an automobile plant in the summer of 1925, and in World War II he worked in a locomotive factory. Here he not only advanced his technical experience in handling metals, but the sheer scale of locomotives suggested possibilities for the monumental development of his direct-metal sculpture. After

*above:* 987. DAVID SMITH.
*Sentinel IV*. 1957.
Steel, painted black,
height 81¾". Private
collection, Connecticut

*above right:* 988. DAVID SMITH.
Left: *Cubi XVIII*. 1964.
Stainless steel, height 9′ 8″.
Museum of Fine Arts, Boston.
Anonymous donation.
Center: *Cubi XVII*. 1963.
Stainless steel, height 9′.
Dallas Museum of Fine Arts.
Right: *Cubi XIX*. 1964.
Stainless steel, height 9′ 5″.
The Tate Gallery, London

*right:* 989. REUBEN NAKIAN.
*Rape of Lucrece*. 1953–58.
Direct steel, height 12′.
Egan Gallery, New York

World War II his studio, on an up-state New York farm, was a complete machine shop, and during the 1950s and 1960s, his fields became populated with his sculptures, ever more monumental in scale and conception.

During much of his career Smith worked on series of related sculptures in unrelated styles. The different series were worked on concurrently or overlapping chronologically. In the 1950s the Agricola constructions (with obvious agrarian overtones) continued the open, linear approach; the Sentinels were usually monolithic, figurative sculptures, at times employing elements from farm machinery. This tendency to use found objects was accelerated as the decade advanced. In contrast with most of the junk sculptors who used found objects, Smith—who had begun using them early in his career—integrated them in the total structure so that their original function was subordinated in the totality of the new design, as in his Tank Totems and his Sentinels (*Sentinel IV,* fig. 987). In the early 1960s the artist became intrigued with the use of old machine wheels, to the point of creating a series of Wagons or Chariots. In 1962 he was invited by the Italian government and the composer-entrepreneur Gian-Carlo Menotti to spend time in Italy to create works for the Spoleto exhibition. His Zig series represented a literal excursion into cubism which also included the use of color. (Smith, originally a painter, was always convinced of the validity in the use of color as an integral part of sculpture.)

In the last, great series, with the generic name of Cubi, Smith—as the name suggests—was employing the cube and the cylinder, now worked in polished, then abraded, stainless steel, in the creation of great, architectural struc-

tures, as illustrated in fig. 988. Smith's relation to the subsequent development of primary structures or minimal art is most important. In one respect he differs from most of his sculptural descendants who, in a deliberate insistence on anonymity, in most cases design their structures and have them manufactured and painted by others—professional technicians. Smith made his own works, only rarely employing shop assistants. Even in the mechanistic Cubi series he constructed and finished the works himself. In these he exercised particular care in the polishing of the

*above:* 990. REUBEN NAKIAN. *Leda and the Swan.* 1960–61. Terra cotta. Egan Gallery, New York

*far left:* 991. THEODORE ROSZAK. *Rodeo.* 1967. Steel, height 20″. Collection the Artist

*left:* 992. SEYMOUR LIPTON. *Loom.* 1965. Nickel-silver on Monel metal, height 70″. Collection the Artist

surfaces to create effects of brilliant, allover calligraphy out of the highly reflecting, light-saturated surfaces.

One of the most impressive American sculptors after World War II is Reuben Nakian (b. 1897). It is something of a paradox to refer to him as a constructivist, since by passionate inclination he is a modeler whose favorite materials are terra cotta or plaster prepared as a base for bronze. Nakian, in contrast to David Smith, went through

993. HERBERT FERBER. *Environmental Sculpture*. 1967. Fiberglass and polyester resin. Voorhees Hall, Rutgers University, New Brunswick, New Jersey

an academic training. During the 1930s he was engaged in portrait sculpture. At the same time he was beginning to become acquainted with experimental artists—Davis, Gorky, and De Kooning. Gorky in particular was influential in introducing Nakian to the tradition of modern European art. In the late 1940s the artist started to work in terra cotta, creating free, expressionistic interpretations of themes from classical mythology. He worked on a small scale since, even by the 1950s, Nakian could not afford large-scale efforts in either terra cotta or bronze. In 1954 he began using a technique of thin coats of plaster spread over cloth and attached to elaborate but delicate metal armatures, a technique which is closer in effect to construction than to traditional bronze casting, and which is difficult to cast. It was nevertheless a technique that Nakian perfected over the next few years, and through which he made an individual contribution to sculpture. His first major success came in 1958—when he was sixty-one—with the creation of a number of steel-plate constructions, the largest and most impressive of which was the *Rape of Lucrece,* on which he had worked for five years (fig. 989). In these constructions he used large diagonal and curving plates mounted on a complex arrangement of metal pipes, to create a violent interplay of abstract shapes.

Returning to terra cotta in the 1960s he produced a large number of small groups and incised plaques dealing with erotic themes from Greek mythology—Leda and the Swan, or satyrs with compliant nymphs. These figurative compositions show the influence of Gaston Lachaise (see p. 433) but it is Lachaise translated into high (or low) comedy (fig. 990). The plaster constructions, many of which were later cast into bronze, represent the fulfillment of a life of experiment. Like his 1954 works, these are composed of large, thin sheets of plaster with glue, spread

*below left:* 994. MARK DI SUVERO. *Big Piece*. 1964. Wood and steel, height 14′. Private collection

*below right:* 995. LOUISE BOURGEOIS. *Labyrinthine Tower*. 1963. Plaster, height 24″. Private collection

996. Etienne Hajdu. *Field of Forces.* 1956. Copper, 74 x 74″. The Solomon R. Guggenheim Museum, New York

997. Etienne-Martin. *Anemone.* 1955. Elm, height 43½″. The Solomon R. Guggenheim Museum, New York

over wire mesh and arranged on armatures, sometimes exposed but increasingly concealed, in the later works. These continue the classical theme and, while the figure is normally implicit, it is metamorphosed into rocks or mountains: The gods and goddesses return to the earth or mountain that was their primitive habitat.

The other American sculptors identified with abstraction or construction in recent years are as varied as the potentialities of their mediums. Theodore Roszak (b. 1907), who was first a painter, became a geometric constructivist in the 1930s. A decade later he developed his free-form constructions of steel, brazed with bronze, brass, or nickel. These are romantic statements, frequently rooted in literary ideas, abstractions with naturalistic forms implicit—bone structures, birds, sea life, or plant forms. Although Roszak can achieve great power in certain works, his sculptures are usually characterized by a bold elegance in which spiky, aggressive shapes are combined with shapes of extreme delicacy. His surfaces are characterized by coloristic variety ranging from polished steel elements to areas that are burned and tortured into fantastic effects (fig. 991).

Seymour Lipton (b. 1903), using sheets of Monel metal, nickel-silver, or bronze, hammers these into large spatial volumes, suggestive at times of plant forms, at others of an architecture of fantasy (*Loom*, 1965, fig. 992). His works combine monumentality and repose with a sense of poetry and mystery. Spatially they combine a subtle interplay of exterior and interior forms that emphasize the nature of the material—thin sheets of hammered metal.

These sculptors represent only two of the many directions taken by abstract construction or direct-metal sculpture. The list and the directions could be expanded indefinitely. Herbert Ferber (b. 1906) has made significant explorations of sculpture as environment, even creating in 1960 an entire sculptural room into which the spectator enters (*Environmental Sculpture,* fig. 993). This trend to

sculpture-as-architecture increased dramatically during the 1960s among younger sculptors or sculptors more recently on the scene. Among them is Mark di Suvero (b. 1933), who uses sections of old wooden beams or structural steel building elements, T-beams, and I-beams, into open articulations that suggest a titan's pastime—or a bombed-out factory. The weathered or rusted steel is allowed to affirm its weight, but often a distorted beam is poised atop a fulcrum, responding to a slight push with deliberate movement. Old automobile tires, chairs, barrels, and other cast-off objects are incorporated into these massive constructions, which frequently invite the spectator to sit on or in them (fig. 994).

A sculptor almost impossible to classify in terms of contemporary trends, but nevertheless one of the most individual and imaginative on the American scene, is Louise Bourgeois (b. 1911, France). Beginning as a painter-engraver, she turned to carved sculpture in the later 1940s, creating isolated, elongated forms whose closest analogue is perhaps the sculptures of Giacometti, although there are few if any stylistic relationships. These alternated with clustered groups in which the abstract shapes painted black and white take on a strangely human, communal quality. During the 1960s she turned largely to plaster for bronze (fig. 995), a more flexible material in which she developed her fantasy still further in anthropomorphic fossila and inside-out shapes in which the hidden interior is at times a magical series of microscopic caves.

## SCHOOL OF PARIS

In the School of Paris, contemporary sculpture predominantly continues the traditions of modeling and carving. As we have noted, most of the outstanding sculptors in the post-war period were figurative—Picasso, Giacometti, Richier, Miró, Max Ernst, Ipousteguy, and César, who works between the figure and abstract junk sculpture. The

*right:* 998. ROBERT JACOBSEN.
*Jaser 2.* 1956.
Metal, height 28¾″.
Galerie de France, Paris

*far right:* 999. BERTO LARDERA.
*Ancient Deity No. 3.* 1958.
Stainless steel and iron.
Private collection

*below:* 1000.
PIOTR KOWALSKI. *Cube V.* 1967.
Steel and plaster, 35 x 35 x 35″.
Collection the Artist

influence of Arp has been considerable on such sculptors as Henri-Georges Adam, (b. 1904), Emile Gilioli (b. 1911) and André Bloc (b. 1896). Adam's *Large Nude,* 1948–49, although quite explicitly a figure, is characteristic of his and others' translations of Arp's forms into a kind of mannerism. Here they are combined with cubist elements which accentuate the mannered quality. Etienne Hajdu (b. 1907, Rumania) combines aspects of both Arp and Brancusi in the creation of exquisitely finished, decorative marbles, as well as hammered copper or brass pieces which are somewhat more rugged (fig. 996).

Etienne-Martin (b. 1913) is one of the most independent talents on the Paris scene. In his wood carvings he uses huge, gnarled tree-roots that he transforms into strange animal or plant forms while maintaining their essence (fig. 997). He is also a modeler of ability, creating plaster structures that are like ancient, ruined buildings or eroded cliffs. In the 1960s he turned to the use of

bronze in the creation of massive figures made of interlocking parts. Somewhat related to Etienne-Martin in his use of organic-vegetative forms seemingly in process of growth and change is Francis Stahly (b. 1911, Germany), whose carved or modeled sculptures characteristically flow across the ground, clinging close to it. This distinctive tendency—to create sculptures that move like plants or reptiles over the ground, rather than rise up like a monument—has appeared in many different aspects among young sculptors throughout the world.

At the other extreme from these earth-crawlers is the Argentine artist, Alicia Penalba (b. 1918), whose predominantly vertical works come out of cubism, and are abstract totems of dignity and power.

Anton Pevsner lived in Paris between 1923 and his death in 1962, and produced all his constructivist sculpture during this period. He became world-renowned, but unlike Arp, seems to have had virtually no influence on contemporary French sculpture. School of Paris sculptors dedicated to a constructivist tradition are Jean Gorin (b. 1899), who was first a painter, Nicholas Schöffer (b. 1912, Hungary), Berto Lardera (b. 1911, Italy), and Robert Jacobsen (b. 1912, Denmark), although the latter two have played many variations on the theme. Jacobsen uses a rough, welded-iron technique that combines power with clarity of form (fig. 998); Lardera, with large, thin, interpenetrating metal sheets, achieves an impelling effect of translucence in opaque materials (fig. 999). Nicolas Schöffer during the 1960s experimented with large-scale constructions involving light and motion on a vertical-horizontal, architectural framework, as described below.

The leading young constructivist to emerge in France in the 1960s is Piotr Kowalski (b. 1927, Poland). Kowalski is an excellent instance of the internationalism so dominant in the arts after the mid-century. Born in Poland, he lived for a period in Brazil, was educated (in architecture) at Harvard University in the United States, and since 1961. has lived in Paris. His constructions combine the austerity of the Swiss, Max Bill, with a use of organic plaster forms suggestive of the American, Peter

Agostino. Despite all this he has created an individual and striking image that is continually examining the problems of relating rigid geometric forms with the essentially formless (fig. 1000), pursuing the examination of construction in its relations to abstract or organic fantasy.

## GREAT BRITAIN

The chief exponents of abstract sculpture in Great Britain remain Ben Nicholson and Barbara Hepworth, with Nicholson close to the tradition of Mondrian and Hepworth close to that of Brancusi and Arp (see pp. 513 ff). Kenneth Martin (b. 1905) is a talented and tasteful, if somewhat eclectic abstract constructivist, at times owing something to Tatlin and Rodchenko, at other times to Zoltan Kemeny. *Screw Mobile,* 1956–59, is a spiral, wire-cage mobile suggestive of suspended, rotating structures by both Rodchenko and Vantongerloo in his later phase. A later work (or works), *Three Oscillations,* 1963–64 (fig. 1001), consists of spiraling assemblages of polished bronze stacked in rectangular layers like skyscrapers caught in an earthquake. Lynn Chadwick (b. 1914), while maintaining his figure formula, has become more geometrically abstract. *Winged Figures,* 1962 (fig. 1002), has much of the simplicity and monumentality of the new, minimal sculpture. Kenneth Armitage in the 1960s also turned to an essentially abstract image with some suggestions of figurative fantasy (*The Bed,* 1965, fig.1003). His use of synthetic materials such as polyester resins is symptomatic of the widespread explorations of such materials in the search for new impersonality in sculpture.

William Turnbull (b. 1922, Scotland) is one of the most talented of the younger British sculptors, with roots in Brancusi but playing his own variations on his source. In the last few years Turnbull has turned to a form of primary structure—vertical slabs of painted steel imbedded in steel bases (*3 X 1, Second Version,* 1966, fig. 1004). Although the elements here are machine-fabricated to the artist's specifications, the monumental impact is comparable to his earlier stone and bronze works.

Victor Pasmore (b. 1908) is the leading English constructivist in the tradition of Mondrian. Pasmore was a painter, first impressionist and then neo-plastic until 1951,

1002. Lynn Chadwick. *Winged Figures.* 1962. Painted iron, length 18′. Collection the Artist

1003. Kenneth Armitage. *The Bed.* 1965. Fiberglass and polyester resin, 48 x 35½ x 68½″. Collection the Artist

1004. William Turnbull. *3X1, Second Version.* 1966. Polychromed steel, 84½ x 31 x 93″. Collection the Artist

1001. Kenneth Martin. *Three Oscillations.* 1963–64. Brass, left to right 11 x 5″, 9 x 5″, 10½ x 5″. Collection the Artist

1005. VICTOR PASMORE. *Projective Construction in White, Black Silver, and Mahogany.* 1965. Wood, plastic, and aluminum, 48 x 48 x 14″. Marlborough Fine Art Ltd., London

1006. MATHAIS GOERITZ. Steel structure, height 14′ 9″, in patio of The Echo, Experimental Museum, Mexico City. 1952–53

1007. MATHIAS GOERITZ, LUIS BARRAGAN, and MARIO PANI. *The Square of the Five Towers.* 1957–58. Painted concrete. Satellite City, Mexico City, Mexico

when he came under the influence of Charles Biederman, a neo-plastic constructivist and theoretician of constructivism living in Red Wing, Minnesota. Biederman's book, *Art as the Evolution of Visual Knowledge,* advances his version of constructivism, named structuralism, and has had a remarkable impact on younger constructivists in England and in Canada (fig. 1005).

## MEXICO

The leading constructivist sculptor of Mexico is Mathias Goeritz (b. 1915, Germany). Since 1949 he created in

Mexico an impressive body of architectural-environmental abstract sculpture. This includes his experimental museum called The Echo (1952–53), entire rooms filled with massive, tilted, geometric structures through which the spectator walks (fig. 1006). Even more monumental are the *Five Towers* (1957–58), designed as the approach for a satellite city—vertical, triangular forms soaring to heights that range from one hundred and twenty to one hundred and eighty-five feet (fig. 1007). Goeritz's stark, powerful sculptures have undoubtedly influenced American as well as European sculptors in their approach to problems of large-scale environmental sculpture or primary structures.

# Return to the Object

At this point the related developments of assemblage, happenings, pop art, and *nouveau réalisme* must be discussed. The lines of demarcation between them are not sharp (sometimes they are not even meaningful); but in common these tendencies are concerned with the visible, tangible world—a world of objects and everyday events—as the basic material of their creative activities. Thus they are a powerful reaction to all forms of abstraction—even though often heavily dependent on the accomplishments of abstract art. After first outlining the movements themselves, a few of the main artists in each category will be discussed.

Two important exhibitions were held in New York late in 1961 and late in 1962. The earlier in date was The Museum of Modern Art's "The Art of Assemblage"; the other was the Sidney Janis Gallery's "New Realists." The Museum show, organized by William C. Seitz, was a history of the aspect of modern art that involves the accumulation of objects, from two-dimensional cubist *papiérs collés* and photographic montages, through every sort of dada and surrealist objects, to junk sculpture, and on to complete room environments. Seitz defined the assemblages in his exhibition: (1) "They are predominantly *assembled* rather than painted, drawn, modeled, or carved. (2) Entirely or in part, their constituent elements are pre-formed natural or manufactured materials, objects, or fragments not intended as art materials."

The New Realists' exhibition, the following year, 1962, included a number of the recognized British and American pop artists and also representatives of the French nouveau réalisme, and artists from Italy and Sweden working in related directions. Although the American pop artists had been emerging for several years, Janis' show was an official recognition of their arrival. At that moment the term, pop art, was not generally applied to them, and their relations to European nouveau réalisme were not clear. This exhibition made it apparent that these artists, all of whom were concerned with subject—in contradistinction to abstract expressionist or art informel artists—nevertheless were exploring it in strikingly individual ways. The Europeans seemed closer to the tradition of dada and surrealism, the British and Americans more involved in contemporary popular culture and representational, commercial images. For a number of years in the 1960s, different labels—neo-dadaists, factualists, popular realists, new realists, and pop artists—were applied indiscriminately. Pop art won the field, obviously because it is a catchy, slangy title which was immediately picked up by newspapers, periodicals, and television. As we have noted, even in the United States it continues to be used loosely, so that with the possible exceptions of Warhol, Rosenquist, Wesselmann, Lichtenstein, and Oldenburg, most artists associated with the movement must be examined individually to determine their exact involvement. Included would be a few British and West Coast American artists such as Richard Hamilton, Peter Blake, Peter Phillips, in England, and Wayne Thiebaud and Mel Ramos in California. The relations between pop art and the new realism is confused further by the fact that most of the American pop artists have had major European shows in recent years, and many of the Europeans are shown continually in New York and throughout the United States.

The movement known as *le nouveau réalisme* was founded in 1960 by the critic, Pierre Restany and the artist, Yves Klein. A manifesto was issued in Milan, and exhibitions of the group were held at Restany's Gallery J., in Paris, November–December 1960, and May 1961. The latter was labeled as "40 Degrees Above Dada," indicating a kinship with the earlier movement. Restany's statement that "the new realism registers the sociological reality without any controversial intention," indicates a desire for impersonal presentation of subject without expressionist or social-realist overtones. This aim is comparable to that of pop art, but the results were as different as the artists involved. These included Klein, Martial Raysse, Fernandez Arman, César Baldaccini, Jean Tinguely, Daniel Spoerri, Raymond Hains, Jacques de la Villeglé, and François Dufrêne. All of these with the exception of Klein were included in the assemblage exhibition, and most were naturally in the New York new realists show. The catalogue of the latter show quoted some excerpts from Pierre Restany: "In Europe, as well as in the United States, we are finding new directions in nature, for contemporary nature is mechanical, industrial and flooded with advertisements. . . . The reality of everyday life has now become the factory and the city. Born under the twin signs of standardization and efficiency, extroversion is the rule of the new world. . . ." Although this part of his statement seems applicable to pop art, the new realists, as noted, seemed to belong to the assemblagists of dada and surrealism, and will be discussed in this context.

## ASSEMBLAGE AND JUNK SCULPTURE

In a sense, much of this book has been tracing the history of assemblage, for among its precursors must be included cubist collage, Picasso's early still-life constructions, the futurists (notably Boccioni's constructions), the dadaists, the surrealists, and their descendants. Kurt Schwitters was the founder of the tradition of junk sculpture, which assumed an important place in sculptural experiment after World War II. Man Ray was closer to pop art and the new realists in his transformation of existing, manufactured objects, although his aim was always the paradox of surrealism. His *Indestructible Object*, consisting of a metronome to the swinging arm of which is attached a vivid photograph of a human eye, becomes in action literally hypnotic. The great name and the great influence for pop artists and the new realists is, of course, Marcel Duchamp. Even the word, assemblage, as well as many others, such as ready-made, or mobile, that have particular pertinence today, belong to him. His last oil painting, *Tu m'*, 1918 (see colorplate 132), is almost a dictionary of post-war tendencies in art, from pop, to op, to color-field painting, to programed or structured painting or sculpture.

An influential figure is the American, Joseph Cornell (b. 1903). A recluse, he is a man of culture; his interests, as indicated in his box constructions, range over much of the art and literature of the Western world. In the early 1930s

1008. Joseph Cornell. *Medici Slot Machine.*
1942. Construction, 13½ x 12 x 4¼".
Collection Mr. and Mrs. Bernard J. Reis, New York

1009. Joseph Cornell. *Pharmacy. 1943.*
Construction, 15¼ x 12 x 3⅛".
Collection Mrs. Marcel Duchamp, New York

he became acquainted with the Julien Levy Gallery, a center for the display of European surrealism. Here he met many of the surrealists, exiled in the United States as a result of Nazism and World War II. His first experiments with collage were inspired by works of Max Ernst, and soon Julien Levy was exhibiting his small constructions along with the European surrealists. By the mid-1930s Cornell had settled on his formula of a simple box, glass-fronted usually, in which he arranged objects, photographs, maps. With these he created a personal dream world related to surrealist assemblage, but also to Renaissance perspective paintings and to nineteenth-century American *trompe l'oeil* paintings—in the last case translated back into the three-dimensional objects which first inspired them.

Cornell's boxes are filled with associations—of home, family, childhood, of all the literature he has read and the art he has seen. The only proper analogy to them is Proust. His entire life seems to have been devoted to the remembrance of things past, a nostalgia for a lost childhood or a lost world. *Medici Slot Machine*, 1942, one of the early masterpieces, centered on a *Young Prince of the Este Family*—a portrait by Giovanni Battista Moroni (c. 1525–1578)—employs aspects of cubism, geometric abstraction, multiple images taken from the early cinema, as well as symbols suggesting relations between past and present

(fig. 1008). There is not in this or subsequent works an organized iconography capable of precise analysis. Everything is allusion or romantic reminiscence gathered together, as one idea or image suggested another, to create one of the most intimate and magical worlds in all modern art.

During the 1940s and 1950s Cornell played many variations on his world, sometimes with an unquestioned influence from Mondrian, creating three-dimensional neo-plastic constructions (*Multiple Cubes*, 1946–48); at other times, using mirror backgrounds, he anticipated the formulas of the optical artists of the 1960s (*Pharmacy*, 1943, fig. 1009). For thirty years or more he has been the most closely guarded yet public secret among American artists. It is indicative of his universal appeal that everyone who knows his work claims to have discovered him—this despite the fact that his exhibitions have received enthusiastic reviews in the press since the 1930s. Yet, like Magritte, he has remained the invisible man until recently, when his influence seems to be universal, the invisible man who is everywhere.

Another pioneer who made contributions of an entirely different kind to the art of environment was Frederick Kiesler, a great visionary architect (see p. 471). In an exhibition organized at the end of his life, he combined sculptural forms with colored panels and objects sugges-

tive of church furniture to create a somber and somehow menacing chapel dedicated to some sinister religion. Bone forms cast in bronze are placed before painted, lighted niches like relics to be worshiped. On a table altar stands another such relic, and hovering over this is a suspended table form whose downward-pointing legs pose a tangible threat. This group is appropriately named *The Last Judgment*. Although this exhibition or environment had to be placed in a gallery and the relationships between the parts established by dramatic lighting, ideally its setting should have been an architectural space designed by Kiesler himself. Although later dispersed, this work has few modern parallels in its combination of surrealist-expressionist atmosphere with constructivist forms (fig. 1010).

More properly in the tradition of assemblage is Louise Nevelson (b. 1900) whose characteristic works of the 1960s have been large wooden walls made of dozens of individual boxes that are filled with hundreds of carefully arranged found objects—usually sawed-up fragments of furniture or woodwork rescued from old, destroyed houses. These are then painted a uniform black or, in her later work, white, or gold, and despite their composition from junk, they achieve qualities of decayed elegance, reminiscent of the graceful old houses from which the elements were mined (*An American Tribute to the British People*, and *Sun Garden, No. 1*, colorplate 232). Recently Nevelson has turned to new materials—aluminum, epoxy, or clear lucite (*Transparent Sculpture VI*, 1967–68, fig. 1011)—frequently on a smaller scale and produced in multiple editions. She thus has joined the ranks of those artists concerned with optical and light effects. Despite the new immaculate precision, the effect of these works still has the altar-like quality of the wooden walls.

The development described as junk sculpture was widespread in Europe and the United States during the 1950s. Junk sculpture—a designation that most of the artists involved do not particularly care for—is that branch of assemblage which deliberately seeks out the junk, the cast-offs of urban civilization, and transforms it into a work of art either by selection, reorganization, or presentation without comment. Schwitters was the first great exemplar of this attitude, although the ultimate origin was in cubist collage and construction. Picking up every sort of rubbish from the streets, he would then lovingly transform these into collages or reliefs and, on a monumental scale, into his Merzbau (see p. 307). The use of found objects permeates dada and surrealism and is revived in the so-called combine paintings of Rauschenberg. Dubuffet's sculptures made from coke clinkers, and Burri's torn and bleeding burlap paintings are aspects of junk culture, as are the curious reliefs by the Englishman, John Latham, made of old, mutilated books. In France, César has been the principal exponent, first with his rusty figurative sculptures made of machine parts, and then with his huge junked automobiles compressed into cubes under titanic pressure. In England, Paolozzi produced junk machine-parts figures, but has since turned to an art of shiny, new, machine precision, more properly associated with pop art. In the United States, junk artists abound, perhaps because there is more junk. Automobile graveyards are a familiar part of the American scene, as are huge, smoking garbage dumps.

Richard Stankiewicz (b. 1922) is one of the first and most important of the post-war junk sculptors, working both at the level of surrealist figuration and also at that of abstract construction. An early work, *The Secretary*, is a delightful piece of fantasy in which the dilapidated typewriter is in fact the typist who is engaged in typing a letter on herself. On the other hand, *Untitled*, 1962 (fig. 1012), although made up of old, rusty pieces of machinery, is a pure abstract arrangement of parts, as precisely organized

1010. FREDERICK KIESLER. Environmental Sculpture Exhibition. Right: *The Last Judgment*. 1955–59, 1963. Bronze, aluminum, pewter, lucite, gold leaf, and stainless steel, 82 x 36 x 37″. Collection Mrs. Frederick Kiesler, New York

1011. LOUISE NEVELSON. *Transparent Sculpture VI*. 1967–68. Lucite, 19 x 20 x 8″. The Whitney Museum of American Art, New York

as a construction by Gabo. The junk has here been transformed by the artist's hand into a work of beauty in which even the rusted surfaces begin to take on new textural significance.

John Chamberlain (b. 1927) has used parts of junked automobile bodies, with their highly enameled, colored surfaces, to create abstract assemblages of considerable beauty (fig. 1013). More recently Chamberlain has turned to sculptures in soft synthetics such as urethane, to create abstract counterparts of Oldenburg's soft constructions.

Lee Bontecou (b. 1931) for a number of years has

worked with an obsessive image of face-vagina, frequently with frightening zipper teeth, made up of old pieces of welded steel and canvas (*Untitled*, 1964, fig. 1014). Recently she, also, has begun experimenting with more pristine forms and materials, in which bold, abstract color plays a large part. Peter Agostini (b. 1913), who earlier cast junk elements into aggressive bronze images bristling with protuberances has, during the 1960s, concentrated on plaster constructions that reverse all concepts of truth to materials. Sometimes these have the lightness of balloons extruding unwholesome living organisms, sometimes they are simple still lifes of bottles, fruit, eggs, and draperies,

set within a frame, all cast or molded in white plaster and all having an eerie, ghostlike reality (fig. 1015). In the use of plaster for the creation of a kind of sub-reality, there are points of analogy between Agostini and George Segal (b. 1924), and also the Belgian sculptor or object-maker, Paul van Hoeydonk (b. 1925), whose ghostlike mannequin figures, presented in white plaster in whole or in part, partake of the same shadowy reality (fig. 1016.)

One of the youngest and, in terms of her use of materials, most attractive of the assemblage artists is the German, Mary Bauermeister (b. 1934). She combines glass and colored marble balls with painted plaster grounds, sometimes worked with graffiti, to create works that are overwhelmingly decorative in their appeal. One is reminded of the bibelot shelves of Victorian England or even the *cabinets des amateurs* of the French eighteenth century (fig. 1017).

Switzerland has produced or fostered several of the most remarkable talents in modern sculpture. Arp gained his first impetus during an early sojourn there around 1909, and came to his first maturity during the dada period, 1917 to 1919. Giacometti was a Swiss, as are Max Bill, Jean Tinguely, Robert Müller, and Bernhard Luginbuhl. Zoltan Kemeny (1907–1965), although born in Rumania and trained in Budapest, Hungary, lived in Zurich, Switzerland after 1942. He was one of the most individual and fascinating sculptors, employing a form of assemblage involving scraps of every kind of metal, copper, iron, zinc, aluminum. Cutting these scraps into different shapes—small squares, cylinders, or long strips—he welded them together, principally in relief, to create magical images, sometimes growing plants, sometimes strange

cellular structures. Within the limitations of his technique Kemeny achieved an amazing range of effects. Color, created through selection of materials and through changes wrought by the intense flame of the welding torch, is of particular importance in the final result (colorplate 233).

Robert Müller (b. 1920) assembles cut sheets of metal, usually iron painted black, into intricate organic abstract shapes that evoke some sinister animal or menacing personage. Müller studied with Germaine Richier, who was in Switzerland between 1939 and 1945. Although his direct-metal abstract constructions are different from her

*above right:* 1016.
PAUL VAN HOEYDONCK. *Mouvement.*
1965. Celluloid, wood, and iron,
diameter 49¼".
Galerie Cogeime, Brussels

1017. MARY BAUERMEISTER.
*All Broken Up.* 1965–67.
Mixed mediums, 5' 7" x 9' 2".
Private collection, New York

*right*: 1018.
ROBERT MULLER. *Organ*.
1966. Iron, height 83″.
Stedelijk Museum,
Amsterdam

*far right*: 1019.
PABLO SERRANO. Portion of
*Man with a Door*. 1965.
Bronze. Galería Juana Mordó,
Madrid

*above left*: 1020. EDUARDO CHILLIDA. *Space Modulation IV*. 1966. Iron, height 22¾″.
Collection Aimé Maeght, Paris

*above right*: 1021. ANDREA CASCELLA. *Narcissus*. 1967. Black Belgian marble, height 36″.
Galeria dell'Ariete, Milan

figurative bronzes in technique and appearance, they do have similarities in the suggestions of monstrous forms. Müller's characteristic shapes combine curving, space-enclosing volumes with jagged outgrowths. Although frequently using scraps of metal for particular effect, he differs from the junk sculptors in the care with which he paints, polishes, and finishes these to eliminate all trace of the junkyard source. Since, like so many young sculptors he is strongly opposed to the use of bases, he composes his pieces to stand or lie on the ground (fig. 1018).

Spain has produced some of the great figures of twentieth-century sculpture, including Picasso, Miró, and Gonzalez. Of the next generation a leading figure is Pablo Serrano (b. 1910) who during the 1950s was a direct-metal constructivist, but in the 1960s has used bronze in the creation of horrifying abstract-organic creatures. *Man with a Door*, 1965 (fig. 1019), is less man than some beast from the depths of the sea, whose door-mouth opens wide to reveal a particularly repulsive interior made up of a large, roughly polished mineral.

The most talented Spanish sculptor of the younger generation is Eduardo Chillida (b. 1924). Working with iron—originally forged in open, linear shapes, but more recently in massive, monumental bars—he has created some of the most impressive pure constructivist abstractions of mid-century. Earlier works suggest the old tools from which they were forged, but later works (*Space Modulation* IV, 1966, fig. 1020) have a pure and powerful architectural abstraction with extremely subtle relations of the massive, tilted, rectangular shapes. Chillida is a sculptor in the direct line of the first constructivists and artists of De Stijl, and he is a worthy descendant.

In Italy, despite the strong figurative tradition represented by Marini, Manzù, and others, some of the most interesting post-war sculpture is found in abstraction and construction. Andrea Cascella (b. 1920) creates beautifully integrated constructions of marbles and other stones (*Narcissus*, 1967, fig. 1021). The brothers Pomodoro—Arnaldo (b. 1926) and Gio (b. 1930)—work principally in bronze. Although they have individual styles they complement each other in curious ways, even to their separate use of male and female sex imagery. Arnaldo uses a few simple, basic forms, tall columns, large spheres, and rectangular forms, either as reliefs or free-standing. Modeled in plaster and cast in bronze, the forms are smooth, highly polished areas, with jagged apertures filled with intricate detail. In the columns or spheres it is as though beautifully finished, intricate machines had been shattered by an explosion, revealing the complicated workings within. The rectangular sculptures look like giant computers displaying their fantastic machinery (fig. 1022). Hollowed-out dish-forms, elaborated with mathematical detail, become *Double Radar* (1965); the machine or, explicitly, computer iconography, is confirmed in the titles *The Mathematician's Table, Homage to the Cosmonaut,* and *The Table of Memory.*

Gio Pomodoro's own distinct style is related to his brother's in the emphasis on precision of technique. (Both brothers began as goldsmiths and decorators.) Whereas Arnaldo's approach is essentially mechanistic—even his columns and spheres are phallic only in a remotely symbolic sense—Gio's sculptures are intensely sensual. The sexuality

1022. ARNALDO POMODORO. Exhibition at the Venice Biennale, 1964: Left: *Estate of J. F. Kennedy.* 1963–64. Bronze. Center: *Sfera.* 1964. Bronze. Right: *3 Travellers Columns.* 1961–64. Bronze. Marlborough-Gerson Gallery, New York

derives not only from the overtly vaginal symbolism, but predominantly from the undulating, organic, light-reflecting surfaces of large sheets of bronze (fig. 1023). The concept of sculptural frontality evident in Gio's works owes a great deal to American abstract expressionist and color-field painters such as Pollock, Kline, and Newman. In some ways his sculptures might be called organic, sculptural versions of Newman's "line" paintings.

Frontality as a sculptural principle was first enunciated in Italian sculpture by Pietro Consagra (b. 1920) as early as 1947–48. During the 1950s he constructed his sculptures from laminated metals or joined, wooden planks on a free-standing quadrangular principle. His concern was to get away from the age-old concept of sculpture as a centralized totem. His boards or metal constructions were scarred, burned, welded, and riveted to create a two-dimensional sculptural landscape which, because it did exist in three dimensions, preserved a degree of sculptural mass (*Conversation Piece,* fig. 1024). In the 1960s he attempted to destroy even this degree of mass by working with thin, single iron or aluminum panels interpenetrated by space. These panels, now assuming curving, organic shapes, are painted in solid reds, blues, whites, et cetera, the colors which to the artist seemed the most natural for those shapes. In bringing sculpture closer to painting, Consagra represents a widespread movement in both painting and sculpture: the movement of Fontana's spatialism in painting, or David Smith's line drawings, or the concept of the shaped canvas. He is not, any more than any of the others involved, trying to create a synthesis of painting and sculpture, but is attempting to change the traditional formulas and to expand the frontiers of sculpture.

Hans Uhlmann (b. 1900) was the first German, aside from Oskar Schlemmer, to make constructions from rods and plates of iron or steel. Because of Nazi repression he did not really emerge as a major sculptor until after 1945. His constructions belong to the geometric tradition of Gabo, Pevsner, and Russian constructivism.

Other leading constructivists of Germany include Norbert Kricke (b. 1922) and Brigitte Meier-Denninghoff (b.

1023. GIO POMODORO. *Borromini Square II*. 1966.
Bronze, 78 x 78". Marlborough-Gerson Gallery, New York

1024. PIETRO CONSAGRA. *Conversation Piece*. 1958. Wood,
height 56". The Solomon R. Guggenheim Museum, New York

1923). Both of these artists use thin rods of steel, welded together. Kricke creates open, spiny constructions that suggest some mechanized cactus (fig. 1025). Meier-Denninghoff, composing her rods in sheaves, makes architectural structures, frequently in the form of tall, joined, inverted pyramids, or soaring, crenellated towers of medieval German castles.

## HAPPENINGS

The concept of the integration of the various arts and, more important, of the arts with life, is an integral aspect of the pop revolution. The leading spokesman for this attitude is Allen Kaprow (b. 1927), the creator of Happenings and environments. The first of these, entitled *18 Happenings in 6 Parts*, was held at the Reuben Gallery in 1959. The Reuben Gallery, in existence only during 1959 and 1960, was one of a group of struggling art galleries in downtown New York, important as experimental centers in which many of the leading younger artists of the 1960s first appeared. Among those who showed at the Reuben Gallery, aside from Kaprow, were Jim Dine, Claes Oldenburg, George Segal, and Lucas Samaras. Another indication of the internationalization of modern art is to be seen in this connection. The Japanese have made some claim to priority in Happenings, since the so-called Gutai Group, of Osaka, staged Happening-like performances as early as 1955, and from 1957 onward such performances were held in Tokyo as well as Osaka.

Happenings may have had their origins in the dada manifestations held during World War I. In a sense they might be traced to the improvisations of the *commedia dell' arte* of the eighteenth century. In the 1940s the composer John Cage was experimenting with musical forms that involved unplanned audience participation. Happenings have also been considered a development into action out of the principles of collage (fig. 1026). Kaprow has defined a happening as "an assemblage of events performed or perceived in more than one time and place. Its material environments may be constructed, taken over directly from what is available, or altered slightly; just as its activities may be invented or commonplace. A Happening, unlike a stage play, may occur at a supermarket, driving along a highway, under a pile of rags, and in a friend's kitchen, either at once or sequentially. If sequentially, time may extend to more than a year. The Happening is performed according to plan but without rehearsal, audience, or repetition. It is art but seems closer to life." He also defined an environment as "literally a surrounding to be entered into. . . ." Whatever its history and its exact characteristics (which must obviously vary extremely in each instance) the idea of the happening and the word itself in a few years have become parts of American folk culture. Many of the terms, images, and ideas of pop art found instant popular acceptance, if not always complete comprehension, on the part of the mass media, including television, films, newspapers, and magazines. Even television and newspaper advertisements, women's fashions, and product design were affected, resulting in a fascinating cycle in which forms and images taken from popular culture and translated into works of art were then retranslated into other objects of popular culture.

## BRITISH POP ART

Although pop art is normally thought of as an American phenomenon, it was actually born in England in the mid-1950s. The term was presumably coined by the English critic Lawrence Alloway but for a somewhat different context than its subsequent use. As Alloway himself pointed out, late in 1952 a group of young painters, sculptors, architects, and critics were meeting in London at the Institute of Contemporary Art. Called the Independent Group, those involved, aside from Alloway, were the architects Alison and Peter Smithson, the sculptor Paolozzi, the architectural historian Reyner Banham, the artist Richard Hamilton, and others. The discussions focused around popular culture and its implications—such things as western movies, space fiction, billboards, machines; in short, aspects of the contemporary scene considered to be anti-aesthetic. Out of these meetings emerged the term the new brutalism (see p. 451) and, in the works of Richard Hamilton, Paolozzi, and others, certain works which established much of the vocabulary and attitude of subsequent pop art.

One of the most fascinating is a small collage by Richard Hamilton entitled *Just What Is It That Makes Today's Homes So Different, So Appealing?* 1956 (fig. 1027). A photomural of this was used as a theme in an exhibition held at the Whitechapel Art Gallery in 1956 entitled "This is Tomorrow."

Hamilton (b. 1922) is a disciple of Marcel Duchamp, and it should be noted that Duchamp's philosophy of art or anti-art has been perhaps the major influence on pop artists. The other outstanding influence is, understandably, Kurt Schwitters. Hamilton's collage shows a "modern" apartment decorated with a haughty female nude and her mate, a muscle-man in a typical you-too-can-be-strong pose. The apartment is furnished with products of mass culture: television, tape recorder, an enlarged cover from a comic strip book, a Ford emblem, and an advertisement for a vacuum cleaner. Through the window can be seen a movie marquee featuring Al Jolson in *The Jazz Singer.*

The important point about Hamilton's, and subsequent pop artists', approach to popular culture or mass media is that their purpose is not satirical or in any way antagonistic. They are not expressionists such as George Grosz and the social realists of the 1930s who were attacking the ugliness and inequities of urban civilization. In simple terms, they are looking at the world in which we live, the great city, and examining the objects and images that surround us with an intensity and penetration which frequently make us conscious of them for the first time. Hamilton, a professional display artist, has made paintings and reliefs of automobiles (*Homage, Chrysler Corp.,* 1957), and kitchen interiors based on excerpts from different commercial advertisements.

Of the other English pop artists, Peter Blake (b. 1932) is perhaps the best-known. He takes the objects of popular idolatry such as Elvis Presley, the Beatles, or pin-up girls, and presents them with a seriousness and literalness that gives to them qualities of sympathetic sadness or humor (fig. 1028). His self-portrait as an Elvis admirer, complete with fan magazine and fan buttons, is a delightful and compelling work combining gentle humor and the nostalgia of unfulfilled dreams, with himself as the object.

Peter Phillips (b. 1931), like Blake and many of the younger experimenting English artists, is a product of the Royal College of Art, which in recent years has become one of the most progressive art schools in the world. His paintings, brilliant in color and aggressive in their organi-

1027. RICHARD HAMILTON. *Just What Is It That Makes Today's Homes So Different, So Appealing?* 1956. Collage, 10¼ x 9¾". Collection Mr. Edwin Janss, Jr., California

1028. PETER BLAKE. *On the Balcony.* 1955–57. 47¾ x 35¾". The Tate Gallery, London

*above left:* 1029. ALLEN JONES. *Green Dress.* 1964. 49⅞ x 38". Richard Feigen Gallery, New York

*above right:* 1030. R. B. KITAJ. *London by Night, Part 1.* 1964. 53 x 73". Marlborough Fine Art Ltd., London

zation of precisely represented machine objects, comes close in feeling to some of the contemporary American pop artists such as James Rosenquist or Tom Wesselmann (colorplate 234).

Other leaders of British pop are Joe Tilson (b. 1928), Allen Jones (b. 1937), Gerald Laing (b. 1936), and David Hockney (b. 1937). During the 1960s Allen Jones has been concerned with an erotic imagery—partial figures of girls with gartered stockings revealing long areas of thigh. The figure stands attenuated, to become a sort of phallic totem (*Green Dress,* 1964, fig. 1029).

An ambiguous but crucial figure in the development of English pop is the American R. B. Kitaj (b. 1932) who studied in the Royal College under the G.I. Bill and has since lived in England. Kitaj paints everyday scenes or modern historical events and personalities in simple, broad, flat color areas combined with strong linear emphasis. His paintings are fragmented images involving every kind of association and a sense of incompleteness that in itself has an impact of fantasy and grotesquerie. Although it is difficult to define his work narrowly within the tradition of pop art, his images have a great influence on the English pop artists (*London by Night, Part 1,* 1964, fig. 1030).

One sculptor was of particular importance in the development of British pop art during the 1950s. This is Eduardo Paolozzi (b. 1924). Originally influenced by Giacometti, Paolozzi, after 1954, became obsessed with the relations of technology to art and became a serious spokesman for pop culture. His sculptures, although cast in bronze, were essentially assemblages of machine parts translated into persuasively human or animal monsters. In the mid-1960s Paolozzi's many studies and experiments in the area of industrial society were climaxed by a series of his most effective sculptures to date. These are constructed principally of polished aluminum and vary from austere, simplified forms to elaborate machine constructions that take on a life of their own (fig. 1031).

## U.S. POP ART

Pop art in all its manifestations was given its greatest impetus in the United States during the 1960s. This was an art which had a natural appeal to American artists, living in the midst of the most blatant and pervasive industrial and commercial environment. Many of the images used by the British pop artists during the later 1950s derived from American motion pictures, popular idols, comic strips, or signboards. In the case of the English artists these were viewed at some remove, thus frequently being instilled with romantic, sentimental overtones. For the American pop artists, once they realized the tremendous possibilities of their everyday environment in the creation of new subject matter, the result was generally more bold, aggressive, even overpowering, than in the case of their European counterparts.

American pop art was first of all a major reaction against the abstract expressionism which had dominated painting in the United States during the later 1940s and 1950s. During the later 1950s, as we have already noted, there were many indications that American painting would return to a new kind of figuration, a new humanism. A number of talented artists emerged using as a theme the

1031. EDUARDO PAOLOZZI. *Medea.* 1964. Welded aluminum, 81 x 72 x 45". Robert Fraser Gallery, London

figure in a Renaissance environment. This, however, would only be a looking back, and something more positive was needed in the search for a new subject. American art had a long tradition of interest in immediate environment that extended to the *trompe l'oeil* paintings of the nineteenth century and was kept alive by many of the precisionist painters during the early twentieth century, most particularly by Stuart Davis. Marcel Duchamp's long residence in the United States and his anti-art program had a gradually increasing influence on younger artists during the 1950s. This was also true of Léger's machine cubism. Léger, during his American sojourn of the 1940s, became involved in an almost literal exaltation of the industrial scene. Duchamp, of course, led younger painters back to dada and most specifically to Kurt Schwitters, who has been perhaps the greatest influence on pop artists aside from Duchamp. In the latter 1950s, artists were becoming concerned with pop art and pop culture not only in England but in France, where the movement known as *le nouveau réalisme* was gaining strength.

There are many artists other than those mentioned who can be considered examples of proto-pop. Richard Lindner (b. 1901, Germany) came to the United States in 1941 and has gained a gradually increasing reputation during the 1950s and 1960s. His work is related to the machine cubism of Léger as well as that of Schlemmer. He created a curious and personal dream world of tightly corseted mannequins who at times seem to be caricatures of

*above left*: 1032. RICHARD LINDNER. *119th Division*. 1965. 80½ x 50½ ".
Walker Art Center, Minneapolis

*above right*: 1033. LARRY RIVERS. *Double Portrait of Birdie*. 1955. 70¾ x 82½ ".
The Whitney Museum of American Art, New York. Anonymous gift

erotic themes, with bright, flat, even harsh colors and every kind of dissociated image. He provides a specific link between certain aspects of early surrealism, machine cubism, and the mechanistic wing of American pop art (*119th Division*, 1965, fig 1032; and *Hello*, 1966, colorplate 235).

Larry Rivers (b. 1923) is a talented, brilliant eclectic whose paintings represent almost a history of American styles at mid-century. His literal, explicit studies of nudes painted in 1954–55 were one of the first major attacks on abstract expressionism (*Double Portrait of Birdie*, 1955, fig. 1033). In the same period he was experimenting with figure sculpture in the tradition of Rodin and Medardo Rosso. Since the mid-1950s, he has developed a characteristic image rooted in cubist (specifically early Duchamp) fragmentation and simultaneity. The re-examination of American history and of old master paintings seen in reproduction has particularly intrigued him (fig. 1034). Rivers cannot be described exactly as a pop artist, but he shares the concern for the everyday image while differing in the degree of expressionist commentary.

The most important painter in the establishment of American pop's vocabulary is Robert Rauschenberg (b. 1925). He studied at the Académie Julian in Paris and in the late 1940s at Black Mountain College, North Carolina,

1034. LARRY RIVERS. *Dutch Masters and Cigars III*. 1963
Oil and collage on canvas, 96 x 67⅜ ".
Private collection, New York

above left: 1035. ROBERT RAUSCHENBERG. *The Bed*. 1955. Construction, 74 x 31″. Collection Mr. and Mrs. Leo Castelli, New York

above right: 1036. ROBERT RAUSCHENBERG. *Monogram*. 1959. Construction, 48 x 72 x 72″. Leo Castelli Gallery, New York

below: 1037. ROBERT RAUSCHENBERG. *Retroactive II*. 1964. 84 x 60″. Private collection

with Josef Albers. Jasper Johns, another important pioneer of pop, was there at the same time. From Albers, Rauschenberg learned not so much a style as an attitude. Although he considers Albers the most important teacher he has ever had, even more important in his development was the presence at Black Mountain of the composer John Cage, perhaps the greatest single influence in the development of pop art as well as offshoots such as Happenings, environments, and innumerable experiments in music, theater, dance, and so-called mixed media productions.

In January 1955, in an exhibition at the Egan Gallery, Rauschenberg introduced what he called combine paintings, in which he bodily incorporated objects into the structure of the canvas. These at first were relatively modest collage elements—photographs, prints, or newspaper clippings such as might have been accumulated on the walls of his studio. There was one outstanding exception, *The Bed*, 1955 (fig. 1035), which included a pillow and quilt over which paint was splashed in an abstract expressionist manner. Rauschenberg came out of abstract expressionism and has never entirely departed from it. His most spectacular combine painting, *Monogram*, 1959, (fig. 1036), with a stuffed ram encompassed in an automobile tire, includes a painted and collage base in which free brush painting acts as a unifying element.

The combine paintings of Rauschenberg have their obvious origin in the collages and constructions of Schwitters and some of the other dadaists. His motivation and approach, however, are different not only in the great spatial expansion, but in the use of the topical, the specific association with which the artist at the same moment was

above left: 1038. JASPER JOHNS. *Flag.* 1954. Encaustic and collage on canvas, 42 x 60".
Collection Philip Johnson, New York

above right: 1039. JASPER JOHNS. *Target with Four Faces.* 1955.
Encaustic and collage on canvas with plaster casts, 30 x 26". The Museum of Modern Art, New York

1040. JASPER JOHNS. *Painted Bronze (Beer Cans).* 1960.
Painted bronze, 5½ x 8 x 4¾".
Collection Mr. and Mrs. Robert C. Scull, New York

concerned. It is this attempt to create a unity out of impermanent materials, topical events, and an expressive brush stroke that gives his paintings their particular qualities and raises numerous questions concerning the nature of subject and abstraction in the later twentieth century. During the 1960s he, like many other artists, has increasingly used silkscreen transfers to create a kaleidoscope of images deriving from the daily press and motion pictures even more than from the example of the dadaists. Fre-

quently his ideas and images have been taken over by younger pop artists; but his overriding concern with the creation of a total harmony out of the most disparate elements, and his actual concern for the subject makes him, rather than a pop artist, a painter not only in the tradition of abstract expressionism but of expressionism in its broader subject sense (*Retroactive II*, 1964, fig. 1037; and *Estate*, 1963, colorplate 236).

Jasper Johns (b. 1930) appeared on the New York scene in 1955 at the same moment as Rauschenberg, with personal images entirely different but equally revolutionary. These were, at first, paintings of targets and American flags executed in encaustic with the paint built up almost in relief (*Flag*, 1954, fig. 1038). The paintings are executed with such precision and neutrality as to become objects in themselves rather than reproductions of familiar objects. Johns's early paintings are of great importance in shaping contemporary art attitudes. In addition to targets and flags, he took the most familiar objects—numerals and number charts, color charts, maps of the United States—and then painted them, particularly in his earlier works, with an absolute objectivity, with, nevertheless, the occasional intrusion of mysterious, romantic elements such as the plaster cast faces in *Target With Four Faces*, 1955 (fig. 1039). The result, paradoxically, is that Johns's object—flag, target, number chart—ceases to be a reproduction of anything and takes on an identity of it own. This element of impersonality—the creation of a work of art which, even if it includes a recognizable subject, has no existence other than as an object in itself—became central to many of the painters and sculptors of the 1960s.

From the end of the 1950s, Johns's paintings became more free in the use of expressionist brush strokes and in

the interpolation of objects; they seem to draw closer to the combine paintings of Rauschenberg (*Field Painting*, 1964, colorplate 237). Johns has also produced a number of sculptures that have stated the pop art problem of the everyday object which, in Duchamp's phrase, becomes a work of art because the artist says it is. By taking a coffee can filled with paint brushes, or two beer cans, and casting them in bronze (fig. 1040), he immortalizes the commonplace. Again, the motivation of Johns is somewhat different from the pop artists' in that he continually seems to be concerned with the creation of a work of art, no matter what the subject may be.

However Rauschenberg and Johns should be classified —perhaps a not very important problem—they are both of major significance in the move away from abstract expressionism; in the exploration of new subjects involving the everyday image of America, in the creation of new or impressively revived ways of seeing; and in re-thinking the nature of art.

The artists most specifically associated with American pop art are Andy Warhol, Roy Lichtenstein, Tom Wesselmann, James Rosenquist, Claes Oldenburg, Robert Indiana, and Jim Dine. Dozens of other pop artists have emerged in every part of the United States as well as throughout the world, searching for relations or contrasts between art and reality. Of the Americans, some of the most interesting are from California, the supreme symbol

of popular culture, with its movies, super-highways, parking lots, giant hamburger stands. It is not surprising, therefore, that a major school of pop art should have emerged in Los Angeles. Edward Kienholz, Mel Ramos, Edward Ruscha, and Wayne Thiebaud illustrate the range of this school. Allan D'Arcangelo provides a link between pop art and the American precisionists. Among sculptors who are related to aspects of pop art, as differentiated from object-makers such as Oldenburg, the most important names are probably George Segal, Marisol, and Ernest Trova.

Jim Dine (b. 1936), like Rauschenberg and, later, Johns, is rooted in abstract expressionism, although he seems to treat it with a certain irony, combining brush gesture painting with objects out of Duchamp. These are not only physically present but frequently are reiterated in painted images or shadows, and then reiterated again through lettered titles, as though he is giving an elementary lesson with ironic overtones in the various dimensions of reality (figs. 1041, 1042).

Roy Lichtenstein (b. 1923) defines the basic premises of pop art (if anyone can) more precisely than any other American painter. He has taken as his primary subject the most banal comic strips or advertisements and has enlarged them faithfully in oil or acrylic paint, using limited, flat colors and hard, precise drawing. The result is a hard-edge subject painting that documents while it gently

1041. JIM DINE. *Hatchet with Two Palettes, State #2.*
1963. Oil on canvas with wood and metal, 72 x 54".
The Harry N. Abrams Family Collection, New York

1042. JIM DINE. *5 Toothbrushes on Black Ground.*
1962. Toothbrushes and oil on canvas, 48 x 36".
Sidney Janis Gallery, New York

*right:* 1043. ROY LICHTENSTEIN.
*Whaam.* 1963. Magna on two
canvas panels, 5′ 8″ x 13′ 4″.
The Tate Gallery, London

*below:* 1044. ROY LICHTENSTEIN.
*Big Painting.* 1965. Oil and
magna on canvas, 7′ 8″ x 10′ 9″.
Collection Mr. and Mrs.
Robert C. Scull, New York

parodies the familiar hero images of modern America. It
is to be noted that Lichtenstein deliberately selects the old-
fashioned comic strip, of violent action and sentimental
romance, rather than the new sophisticated strip (*Whaam,*
1963, fig. 1043). Using the comic strip technique, down
to the Ben Day printing dots, he has also made free adap-
tations of reproductions of paintings by Picasso and
Mondrian and, recently, has created landscapes and whip-
lash, abstract expressionist works with his quasi-mechani-
cal means (*Big Painting,* 1965, fig. 1044).

The paintings of Lichtenstein, as well as those of
Wesselmann, Rosenquist, and Warhol, share not only an
attachment to the everyday, commonplace, or vulgar
image of modern industrial America, but also the treat-
ment of this image in an impersonal, neutral manner.
They do not comment on the scene or attack it like social
realists, nor do they exalt it like ad men. They seem to
be saying simply that this is the world we live in, this is
the urban landscape, these are the symbols, the interiors,
the still lifes that make up our own lives. As opposed to
the junk sculptors, the assemblage artists who have cre-
ated their works from the rubbish, the garbage, the refuse
of modern industrial society, the pop artists deal princi-

pally with the new, the "store-bought," the idealized vul-
garity of advertising, of the supermarket, and of television
commercials.

Tom Wesselmann (b. 1931) is the artist of the tele-
vision commercial and of movie-magazine sex. Using
assemblage elements—real clocks, television sets, air con-
ditioners, with photomontage effects for window views,
plus sound effects—he creates an urban environment in
which the aggressive reality of actual objects or photo-
graphic images gives them a sense of unreality as com-
pared with the painted passages (fig. 1045). For a number
of years he has played variations on the theme of the Great
American Nude, a faceless American sex symbol, pristine
and pneumatic, but no more sensual than his supermarket
groceries are edible (*Great American Nude #57,* 1964,
fig. 1046).

James Rosenquist (b. 1933) for a period was a bill-
board painter, working high over New York's Times
Square. The experience of painting glamor girls with faces
thirty feet in diameter gave him an extreme close-up vision
of commercial art which he has translated into huge
paintings of fragmented reality put together under the
control of cubism. As compared with Lichtenstein and
even Wesselmann, he is devoted to the organization of the
total picture surface and, on occasion, to pictorial effects
that can only be described as expressionist. His most am-
bitious painting to date is *F-111,* 1965, ten feet high and
eighty-six feet long, capable of being organized into a
complete room, to surround the spectator. This work,
named after a new American fighter-bomber, is a series
of images of destruction combined with prosaic details of
happy, everyday American life—an impressive if some-
what confusing indictment of mechanized, or any kind of
warfare (fig. 1047).

The painter who more than any other stands for pop
art in the public imagination, through his paintings, ob-
jects, underground movies, and his personal life, is Andy
Warhol (b. 1930). Like several of the other pop artists,
Warhol was first a successful commercial artist. Initially,
as a pop artist, he drew attention through his concentra-
tion on standard brands and supermarket products—Coca-
Cola bottles, Campbell's soup cans, and Brillo cartons. His
most characteristic manner was repetition—endless rows
of Coca-Cola bottles, literally presented, and arranged as

*above right:* 1045. TOM WESSELMANN. *Interior No. 2*. 1964. Mixed mediums, including fan, clock, light, 60 x 48 x 60″. Private collection

*above right:* 1046. TOM WESSELMANN. *Great American Nude #57*. 1964. Collage, 48 x 60″. Private collection

1047. JAMES ROSENQUIST. Portion of *F-111*. 1965. Collection Mr. and Mrs. Robert C. Scull, New York

*above left:* 1048. ANDY WARHOL. *Marilyn Monroe.* 1962. Oil, acrylic, and silkscreen enamel on canvas, 20 x 16″.
Collection Jasper Johns, New York

*above right:* 1049. ANDY WARHOL. *Electric Chair.* 1965. Acrylic and silkscreen enamel on canvas, 22 x 28″.
Leo Castelli Gallery, New York

they might be on supermarket shelves or as they might pass in review on a television commercial. From this he turned to the examination of the contemporary American folk hero—Elvis Presley, the love goddess, Elizabeth Taylor, Marilyn Monroe. Using silkscreen processes for mechanical repetition he further emphasizes his desire to eliminate the personal signature of the artist, to depict the life and the images of our time without comment (*Green Coca-Cola Bottles*, 1962, colorplate 238; and *Marilyn Monroe*, 1962, fig. 1048).

For a period in the mid-1960s, Warhol utilized scenes of destruction or disaster taken from press photographs and presented with the same impersonality, suggesting that these also are aspects of the current scene to which familiarity breeds indifference. In these gruesome pictures of automobile wrecks the nature of the subject makes the attainment of a neutral attitude more difficult. *Electric Chair*, 1965 (fig. 1049), taken from an old photograph, shows the grim, barren death chamber with the empty chair in the center and the sign, SILENCE, on the wall. Presented by the artist either singly or in monotonous repetition, the scene becomes a chilling image, as much through the abstract austerity of its organization as through its associations.

In the later 1960s Warhol turned more and more to the making of films, so-termed underground movies. Using his principle of monotonous repetition, which gradually becomes hypnotic in its effect, he documents the world in which he lives. Although these films and even the process of making them contain strong elements of parody

of the commercial film world, they are a serious and sometimes important venture on the part of the artist. The story line, particularly as it deals with erotic themes, has gradually become stronger, and some of the films have become (for experimental movies) substantial financial successes. Warhol's turning to the films is also symptomatic of the synthesis of mediums that has entered into the work of pop artists: the term used is mixed media.

Claes Oldenburg (b. 1929), one of the most talented and intelligent artists associated with New York pop art, created his version of Happenings in his Ray Gun "Spex," described as a museum for pop events, which later developed into his Ray Gun theater. Then in 1961 he opened an actual store on 2nd Street in New York, filled with objects made of painted plaster and attractively priced for such amounts as $198.99. Many of these objects represented food—ice cream sundaes, sandwiches, or pieces of cake roughly modeled and garishly painted in serious parody of cheap restaurant staples. Later he, with his wife doing much of the sewing, began creating these delicacies in vinyl and canvas, stuffed with kapok; but now on a gigantic scale as they might appear in a surrealist nightmare. In his interest in paradox, Oldenburg is closer to the original dadaists or surrealists than most of the other pop artists.

The use of these materials led him ultimately to translation of hard or rigid objects, bathroom or kitchen fixtures, into soft and collapsing versions (*Soft Toilet*, 1966, fig 1050; and *Soft Giant Drum Set*, 1967, fig. 1051).These familiar, prosaic washstands, typewriters, engines, or radi-

Colorplate 234. PETER PHILLIPS.
*Custom Painting No. 3.* 1964–65.
Oil on canvas, 84 x 69″.
Collection Watson Powell, Des Moines, Iowa

Colorplate 235. RICHARD LINDNER. *Hello.*
1966. Oil on canvas, 70 x 60″.
Private collection, New York

Colorplate 236. ROBERT RAUSCHENBERG. *Estate*. 1963.
Oil on canvas, 96 x 70″. The Philadelphia Museum of Art

Colorplate 237. JASPER JOHNS.
*Field Painting.* 1964. Oil and canvas
on wood with objects, 72 x 36¾″.
Collection the Artist

Colorplate 238.
ANDY WARHOL.
*Green Coca-Cola Bottles.*
1962. Oil on canvas,
6′ 10″ x 8′ 9″.
Private collection,
New York

Colorplate 239.
GEORGE SEGAL. *The Diner.*
1964–66. Plaster, wood,
chrome, masonite, and
formica, 8′ 6″ x 9′ x 7″.
Walker Art Center,
Minneapolis

Colorplate 240. MARISOL.
*The Family*. 1961.
Mixed mediums, 82½ x 67″.
The Museum of Modern Art,
New York

Colorplate 241.
YVES KLEIN.
*Fire Painting*. 1961–62.
Flame burned into
asbestos with pigment,
43 x 30″.
Alexander Iolas Gallery,
New York

*left:* Colorplate 242. Burgoyne Diller.
*First Theme (Black Ground).* 1955–60.
Oil on canvas, 50 x 50″.
Galerie Chalette, New York

*below:* Colorplate 243. Anthony Caro.
*Midday.* 1960. Painted steel,
7′ 10″ x 12′ 6″ x 3′ 2″.
Collection Timothy and Paul Caro,
London

Colorplate 244. LARRY BELL. *Memories of Mike.*
1967. Vacuum-plated glass, 24¼″ cube.
Collection Mr. and Mrs. Arnold Glimcher, New York

Colorplate 245. VICTOR VASARELY. *Zebegen.*
1964. Gouache, 33⅛ x 31½″.
Collection the Artist

Colorplate 246. VICTOR VASARELY.
*Vonal-Ksz.* 1968. 78¾ x 78¾″.
Collection the Artist

left: Colorplate 247. KENNETH NOLAND.
*A Warm Sound in a Gray Field.* 1961.
Oil on canvas, 82½ x 81″.
Private collection, New York

*below:* Colorplate 248. LARRY POONS.
*Nixes Mate.* 1964.
Acrylic on canvas, 5′ 10″ x 9′ 4″.
Collection Mr. and Mrs. Robert C. Scull,
New York

Colorplate 249. JOHN FERREN.
*Maquette.* 1967. Construction.
Collection the Artist

Colorplate 250. GENE DAVIS.
*Moon Dog.* 1966.
Oil on canvas, 10 x 16′.
Private collection

*left:* Colorplate 251.
HELEN FRANKENTHALER.
*Interior Landscape.* 1964.
Acrylic on canvas, 8′ 8¾ ″ x 7′ 8¾ ″.
San Francisco Museum of Art.
Gift of the Women's Board

*below left:* Colorplate 252.
MORRIS LOUIS. *Kaf.* 1959–60.
Acrylic on canvas, 8′ 4″ x 12′.
Collection Kimiko and
John G. Powers, New York

*below right:* Colorplate 253.
MORRIS LOUIS. *Moving In.* 1961.
Acrylic on canvas, 87½ x 41½ ″.
André Emmerich Gallery, New York

593

above: Colorplate 254. ELLSWORTH KELLY.
*Blue, Green, Yellow, Orange, Red*. 1966.
Acrylic on canvas, five panels, each 60 x 48″.
The Solomon R. Guggenheim Museum, New York

right: Colorplate 255. KENNETH NOLAND. *Bridge*.
1964. Acrylic on canvas, 89 x 98″.
Collection Mrs. Harry Davidson, Toronto

below: Colorplate 256. KENNETH NOLAND.
*Graded Exposure*. 1967.
Acrylic on canvas, 7′ 4¾″ x 19′ 1″.
Collection Mrs. Samuel G. Rautbord, Chicago

above: Colorplate 257. JULES OLITSKI. *High a Yellow*. 1967. Acrylic on canvas, 7′ 8½″ x 12′ 6″.
The Whitney Museum of American Art, New York

below: Colorplate 258. FRANK STELLA. *Jasper's Dilemma*. 1962–63. Alkyd on canvas, 6′ 5″ x 12′ 10″.
Collection Alan Power, London

*left:* Colorplate 259. RICHARD SMITH. *Slices.* 1964.
Oil on canvas, 10′ 5″ x 8′ 4″.
Private collection, New York

*below:* Colorplate 260. CHARLES HINMAN. *Lode Star.* 1962.
Construction, canvas-wood frame, 60 x 86½ x 14″.
Private collection, New York

Colorplate 261. ISAAC ABRAMS.
*Untitled.* 1968. Oil on canvas, 40 x 40″.
Private collection, New York

*above left:* 1050. CLAES OLDENBURG. *Soft Toilet.* 1966 Vinyl, plexiglass, and kapok, 55 x 28 x 33″.
Collection Mr. and Mrs. Victor W. Ganz, New York

*above right:* 1051. CLAES OLDENBURG. *Soft Giant Drum Set.* 1967. Canvas, vinyl, and wood, 84 x 72 x 48″.
Collection Kimiko and John G. Powers, New York

ators, carefully rendered but collapsing in violation of their essential nature, become disturbing commentaries on the values of contemporary life. Oldenburg has also made many proposals for monuments: a colossal peeled banana for Times Square, a gigantic ironing board for the lower East Side of New York, a mammoth Teddy Bear for Central Park. The most dramatic of these, rendered with great seriousness by the artist in perspective and plan, is an enormous block of concrete, to be inscribed with the names of war heroes and placed at the intersection of two major thoroughfares, effectively blocking all traffic. Nevertheless, Oldenburg, for some curious reason, has not been commissioned to execute one of his mammoth monuments by the City of New York or any other patron of the arts.

Robert Indiana (born Robert Clark of Indiana, 1928), Allan D'Arcangelo (b. 1930), and Edward Ruscha (b. 1937) are descendants of the American precisionists. Indiana even painted a figure 5 (fig. 1052) in homage to Demuth (see colorplate 191). Like Stuart Davis he has been obsessed with word images, in his case attaining a stark simplicity that suggests the flashing words of neon signs (with distinctions)—EAT, LOVE, DIE. These are rendered in clashing colors and precise, hard-edge color shapes that relate him both to the optical (op) and color-field painters of the 1960s (*Die*, 1962, fig. 1053). Unlike most of pop art, which manifests little or no overt comment on society, Indiana's word-images are often bitter indictments, in code, of modern life, and sometimes even a devastating indictment of brutality, as in his Southern States series.

1052. ROBERT INDIANA. *The Demuth Five.* 1963.
68 x 68″ (on the diagonal).
Mr. and Mrs. Robert C. Scull, New York

1053. ROBERT INDIANA. *The Red Diamond Die.* 1962.
85 x 85″ (on the diagonal).
Walker Art Center, Minneapolis

1054. ALLAN D'ARCANGELO. *Full Moon.* 1963.
Acrylic on canvas, four panels, 61 x 64″.
Collection Kimiko and John G. Powers, New York

Allan D'Arcangelo (b. 1930) is even more explicitly a descendant of a precisionist like Ralston Crawford (see fig. 683). His theme is the highway, usually the super-highway with road signs appearing and disappearing as we drive across the nation (fig. 1054). Edward Ruscha (b. 1937) in the same way uses filling stations to symbolize the monotonous conformity of the American scene (fig. 1055). In contrast to these artists and yet committed to precise drawing, bold shapes, and flat, simple color is John Wesley (b. 1928); but his themes put him in a category of his own. In some strange way they recall the popular images of childhood reading and activities, and yet there is a definite feeling of art nouveau and *fin-de-siècle* eroti-

cism about them. Repetition is one of Wesley's main pictorial devices, and this is another link to some forms of pop art (fig. 1056).

Of the sculptors associated with pop art, the most impressive is George Segal (b. 1924). It should be noted again that distinctions of painting or sculpture cease to exist in the case of most pop artists. Most of those identified as painters have created sculpture; and those identified as sculptors, such as Oldenburg, protest the designation, preferring to be called object-makers. Segal was originally a painter, a student of Hans Hofmann, and began to turn to sculpture only in 1958. He was for a number of years closely associated with Allan Kaprow, a fact

1055. EDWARD RUSCHA.
*Standard Station, Amarillo,
Texas.* 1963. 5′ 5″ x 10′.
Collection Mr. and Mrs.
Dennis Hopper

*left:* 1056. JOHN WESLEY.
*Tea Tray with Five Maidens.* 1962. 64 x 84″.
Private collection, New York

*below:* 1057. GEORGE SEGAL. *The Movie House.*
1966–67. Mixed mediums, 8′ 6″ x 12′ 4″ x 12′ 9″.
Sidney Janis Gallery, New York

1058. ERNEST TROVA. *Study for Falling Man.* 1966.
Polished silicone, bronze, and enamel, 20 x 72 x 28″.
Private collection

that may have developed his interest in sculpture as a total environment. His figures are almost invariably cast in plaster from the human figure. The figure is then set in an actual environment—an elevator, a lunch counter, a movie ticket booth, or the interior of a bus. The props of the environment are purchased from junkyards. The figures, however, although modeled from life, are left rough and unfinished, ghostly wraiths of human beings existing in a tangible world. The result is an effect of loneliness and mystery, comparable at times to the paintings of Edward Hopper (*The Diner,* 1964–66, colorplate 239; and *The Movie House,* 1966–67, fig. 1057). Ernest Trova (b. 1927) has invented a disconcerting symbol of man in modern times. Anonymous, human yet machined, with machine appendages, this robot-man tumbles, stands at eternal attention, strides, or reclines. Whatever his stance, he seems to be in the process of turning into yet another machine of his own invention. The total effect of Trova's figures is to provide a glimpse into a frightening science-fiction future into which man has stumbled (fig. 1058). Marisol (Marisol Escobar, Venezuelan, b. 1930, in Paris) has created a world of her own from wood, plaster, paint, and unpredictable objects. The artist's own face and parts of her body are everywhere, but she does not ignore the "personalities" of our day, or the more humble folk (colorplate 240). Her works may perhaps be described as pop-assemblages, for she uses every technique of art to transform rough or "store-bought" materials into grimly satiric presences.

Using boxes and other receptacles in a manner derivative perhaps from Joseph Cornell, but with an entirely different emphasis, is Lucas Samaras (b. 1936, Greece). In his boxes, plaques, books, and table settings, prosaic elements are given qualities of menace by the inclusion of knives, razor blades, and thousands of ordinary but outward-pointing pins (fig. 1059). The objects are meticulously made, with a perverse beauty embodied in the threat that is involved. They cannot be classified as dada or pop art in the traditional sense; they are highly expressionist works that are actually disturbing in a most specific sense.

Samaras sees in everyday objects a combination of men-

ace and erotic love, and it is this sexual horror, yet attraction, that manifests itself in his work: Two chairs, one covered with pins and leaning back, the other painted and leaning forward, create the effect of a horrible sexual dance of the inanimate and commonplace. To touch one of his objects is to be mutilated; yet the impulse to touch it, the tactile attraction, can be powerful.

The quality of elegance apparent in these threatening objects has become explicit since 1965, in works of crys-

1059. LUCAS SAMARAS. *Box No. 3*. 1962–63. Mixed mediums. Collection Howard Lipman Foundation

1060. LUCAS SAMARAS. *Room No. 2*. 1966. Wood and mirrors, 8x10x8′. The Albright-Knox Art Gallery, Buffalo, New York

talline precision. This has led him to a form of construction in which mirrors multiply to infinity the image of a single chair (fig. 1060).

Edward Kienholz (b. 1927) has in common with Segal the creation of elaborate tableaux which are perhaps closer to assemblages than to pop art. He sometimes, as in his famous bar (fig. 1061), simply reproduces a familiar environment, but with fantastic accuracy of selective detail. Frequently, however, he embodies a mordant, even gruesome criticism of American life. His tableau, *The Wait*, 1965, showing the ancient woman, a dressed-up

skeleton enthroned among her life's belongings, is a three-dimensional projection of a social-realist painting of the 1930s. *The State Hospital*, 1964–66 (fig. 1062), is a construction of a cell with a mental patient and his self-image, modeled with revolting realism—the living dead. Strapped to their bunks, the two effigies of the same creature—one with goldfish swimming in his glass bowl head —make one of the most horrifying concepts created by any modern artist. Kienholz, who works in Los Angeles, should in fact be considered an expressionist sculptor concerned with the stupidity or the misery that is hidden just

1061. EDWARD KIENHOLZ. *The Beanery*. 1965. Mixed mediums, 7 x 22 x 6′. Dwan Gallery, New York

1062. EDWARD KIENHOLZ. *The State Hospital.* 1964–66.
Mixed mediums, 8 x 12 x 10'. Dwan Gallery, New York

1063. WAYNE THIEBAUD. *Cakes.* 1963.
60 x 72". Private collection, New York

behind the facade of modern, commercial civilization.

Two other California painters more directly in the stream of pop art are Wayne Thiebaud (b. 1920) and Mel Ramos (b. 1935), both of Sacramento. Their palettes are similar in their bright, commercial vulgarity. Thiebaud has specialized in still lifes of carefully arranged, meticulously depicted, harshly colored, and singularly perfect but unappetizing bakery goods (fig. 1063). Ramos took as his image the playmate or calendar nude of contemporary folklore. Displaying her ample charms and smiling a fetching, synthetic smile, she is gracefully posed on an oversized hamburger or piece of cheese (*Monterey Jackie*, 1965, fig. 1064). Ramos apotheosizes the original commercial art versions. His satire of both girlie magazines, and of aspects of American advertising, can only be described as deadpan.

## THE NEW REALISM

Of Pierre Restany's *le nouveau réalisme,* Yves Klein (1928–1962) was the seminal figure, one of the brilliant talents of the post-war period, whose early death arrested a potentially important development. He was a restless and imaginative innovator with a genuine, original fantasy that lends authenticity to his most outrageous displays. He and his followers have been described as attitude artists, a term that suggests their concern with the dramatization of ideas beyond the creation of individual works of art. In 1956 he held an exhibition of floating blue globes, thus anticipating Warhol's floating plastic pillows by some ten years. In 1958 he attracted thousands of people to an exhibition of nothingness, bare walls which were offered to the patrons to be paid for in pure gold. His blue anthropometrics of 1960 were nude models, covered with blue paint, who were rolled on canvases to create shadow-prints of their bodies. These were followed by his cosmogenies, in which he experimented with the effects of rain on canvas covered with wet blue paint. Then came the fire paintings, actual flame burned into asbestos with red, blue, and yellow pigment (colorplate 241), and the planetary reliefs

1064. MEL RAMOS. *Monterey Jackie.* 1965.
60 x 50". Collection Mr. and Mrs. Russ Soloman

of Mars, Venus, and the earth. His blue sponges may be described as found objects or, since they are painted his favorite ultramarine blue and attached to bases or to a wall, perhaps Duchamp's term, ready-made aided, is preferable. His monochrome paintings, in which he finally settled on the characteristic ultramarine, were extensions of his concept of the painting of nothingness. In this blue he saw the supreme "representation of the immaterial, the sovereign liberation of the spirit." In his passion for a

*above left:* 1065. ARMAN. *La Couleur de mon amour.* 1966. Polyester with embedded objects, 35 x 12″.
Sidney Janis Gallery, New York

*above right:* 1066. CHRISTO. Portion of *Strip-tease (empaquetage).* 1963. Private collection

1067. DANIEL SPOERRI. *Poem in Prose.* 1960.
Collage, 27⅛ x 21¼″. Galleria Schwarz, Milan

spiritual content comparable to that preached by Kandinsky, Mondrian, and Malevich, Klein was moving against the trend of his time, with its insistence on impersonality; on the painting or sculpture as an object; and on the object as an end in itself.

The other artists associated with the nouveau réalisme are all distinct individuals with interests that range from assemblage, to neo-dada, to motion sculpture, to forms of pop. Arman (born Augustin Fernandez, 1928) was a friend and in some degree a competitor with Klein. It was perhaps his desire to oppose a concept of fullness or completeness to Klein's nothingness that led him to his characteristic accumulations of reiterated objects—old sabres, eyeglasses and glass eyes, the broken little hands of cast-off dolls. Originally he was concerned with the tragic, expressionist quality of these sad, broken fragments, scattered haphazardly in a wooden box. Then he began to imbed them in plastic and, recently, to create clear plastic figures to act as containers for the objects. Thus, a transparent nude torso, dated 1966, contains a cluster of inverted paint tubes that pour brilliantly colored streamers of paint down into her belly and crotch. The figure is romantically entitled, *La Couleur de mon amour,* 1966 (fig. 1065).

Christo (born Christo Javachef, in Bulgaria, 1935) has a passion for packaging objects, anything from a bicycle, to a woman, to a skyscraper (fig. 1066). His *empaquetages* are again an art of attitude (deriving perhaps from some comparable efforts by Man Ray). These, and his later store fronts concealed by curtains, represent another commentary on contemporary industrial or product civilization, a return of objects and institutions to a form of

1068. MARTIAL RAYSSE. *Tableau dans le style français.*
1965. Assemblage on canvas, 85⅞ x 54⅜".
Collection Runquist

1069. MIMMO ROTELLA. *Untitled.*
1963. Décollage.
Galerie J, Paris

1070. OYVIND FAHLSTROM. *Dr. Schweitzer's Last Mission.* 1964–66. Variable environmental painting:
tempera on metal boxes; cut-out boards; magnetic cut-outs in metal and vinyl. Sidney Janis Gallery, New York

nothingness. Daniel Spoerri (a Swiss, born 1930), fastens ordinary dishes and other utensils to a chair and then attaches this to a wall, up-ended, as though it were a picture or relief. He is giving a slightly different application to the dada laws of chance and to the surrealist obsession with the fantasy of the commonplace. By taking the most ordinary objects as they might have been left after a meal, and exalting them as a work of art, he seeks a new shock of recognition, a new reality of objects—which seem to defy gravity (fig. 1067).

Martial Raysse (b. 1936) is closest of all the new realists to pop art, although he gives to his version a certain elegance and snobbism that suggests the beach at Nice rather than that at Coney Island. Using life-sized cut-outs of bathing beauties set in an actual environment of sand and sun umbrellas, he achieves startling simulations of elaborate advertisements for expensive watering places (fig. 1068). Something of the same feeling is seen in his own versions of old master paintings.

Others among the original members of the new realism, Jacques de Villeglé, François Dufresne, and Raymond Hains, have been identified with the technique known as décollage, actually practiced earlier by the Italian Mimmo Rotella (b. 1918). This, presumably the antithesis of collage, is the art of tearing or destroying posters to create new juxtapositions. There is nothing actually new in this,

except, perhaps its particular applications. Anyone who has lived in a large city is familiar with the layers upon layers of half-torn posters that decorate billboards and walls when these have not been renewed. It is possible that the original idea of collage originated with the torn and mutilated posters on Paris walls. The new aspect of décollage lay in its use of the slick images of modern advertising, for films or soapsuds, not in its pristine pop-art guise, but torn and tattered with one superimposed image intruding on another (fig. 1069). This becomes a sort of symbolic revolt against the commercial vulgarization that describes the urban landscape.

Carried several stages further, trends somewhat related to décollage are to be found in the collages of the Swedish artist Oyvind Fahlström (b. 1928), and the drawings of the Italian, Gianfranco Baruchello (b. 1924). Fahlström cuts up and reassembles black-and-white comic strips to create a dense and wildly confused but compelling world of elliptical associations. Fahlström has also moved, more recently, to large-scale patterns of dissociated images that comment on, criticize, or denounce contemporary values, aesthetic or political (*Dr. Schweitzer's Last Mission*, 1964–66, fig. 1070). Baruchello, at the other extreme, makes extremely sparse and widely-spaced drawings, combined with miniscule explanatory captions or paragraphs that explain nothing. The drawings, the cap-

*above:* 1071. GIANFRANCO BARUCHELLO. *Only Death, Sir.*
1964. Mixed mediums on aluminum, 39⅜ x 39⅜".
Galleria Schwarz, Milan

*right:* 1072. HERVE TELEMAQUE. *Piège.*
1964. 76¾ x 51⅛".
Galerie Mathias Fels, Paris

tions, the introduction to catalogues written by the artist, and even the catalogue titles in three languages fascinatingly confused, create the total image of a computer trying at one time to be an artist, critic, and scientist, and going insane in the process (*Only Death, Sir*, 1967, fig. 1071). Hervé Télémaque (1937, Haiti) is close to American pop art, and more specifically to Kitaj's Anglo-American version, in his use of fragmented images from contemporary journals and advertising. He isolates his often violently dramatized images of the current scene with large areas of black canvas. The drama of violence is heightened by the use of every form of unrelated image, suggesting both the early cinema and aspects of surrealism (fig. 1072).

Although it was characteristic of much art—whether it is pop, new realism, or the sculpture variously labeled primary, minimal, ABC, etc.—to avoid comment, to insist on its absolute objectivity in the early 1960s, the tendency to comment increased during the second half of the decade. This was the natural consequence of the tensions emerging from the war situation, from struggles for equal rights or self-determinism, and from the world-wide student revolts. Robert Indiana's blunt word-images have been mentioned, and James Rosenquist's huge painting, *F-111* was, as noted, a denunciation of war rather than a documentation of pop culture. Baruchello's machine iconography involves biting satire. The young Spanish artist Juan Genovés (b. 1930) turns the photograph image of the pop artists or the new realists into a frightening portrayal of war and mass destruction. In photographic flashes seen through the bombsight of a war plane or through the rifle-sight of an executioner, vast crowds flee hopelessly from inevitable mass murder; victims are led away, handcuffed, lined up against a wall to be shot; or, suddenly caught in a searchlight from which they cannot escape, they are simply obliterated (fig. 1073).

# *Other Directions in the 1960s*

## PRIMARY STRUCTURES, MINIMAL ART

Constructivism in the 1960s has gained a new impetus in the so-called primary structure, minimal art, or ABC art. Although no completely satisfactory name has been found for the sculptural movement represented by these artists, primary structure is probably preferable to minimal sculpture. Many of the sculptors involved object to the latter term for much the same reason that abstract painters objected to the term abstract, with its implication of some lessening or even denigration. In any event, primary structure represents a significant attitude in sculpture of the 1960s, even more in the United States than in England, but also in Japan, Germany, Australia, Canada, and other countries. It is related closely to a number of other significant tendencies of the decade: the sculpture that creates an architectural space or environment; the paintings involving the shaped canvas (here it is often difficult to draw the line); and the paintings involving mathematical systems as the bases of their organization. It also has relations to certain

1073. JUAN GENOVES. *Man Alone.* 1967.
47¼ x 41⅛". Collection Mr. and Mrs. Manuel Seff, New York

aspects of color-field painting which, in turn, overlaps with systemic painting. In almost all these different sculptural and pictorial experiments there is usually a strong geometric base, the use of intense, unmodulated industrial colors, and elemental shapes.

Primary structure is an obvious reaction to the romantic-fantastic figuration, the expressionist direct-metal abstraction, and even the classic geometry of sculpture in the 1950s. The immediate reaction of these primary structure sculptures is against the personal expression of the earlier abstract-expressionist painters or the direct-metal and junk sculptors. Thus, their outstanding quality is an industrial impersonality deriving from the fact that they are normally fabricated industrially, from plans made by the artist. Even more, it involves a questioning of the tradition of sculpture as an isolated object, on a pedestal, made of traditional materials of marble or bronze. The urge to impersonality, to the creation of a thing rather than a painting or a sculpture in the classic sense, originated in painting. Mondrian, of course, was a source; but one can trace a direct line from previous constructivists such as Mathias Goeritz, Max Bill, or Vantongerloo to these primary structure constructivists of the 1960s. The leading direct influences on the new sculptors and painters, however, were probably Ad Reinhardt and Barnett Newman. Among the sculptors it was unquestionably David Smith who has affected the new generation, even though Smith made his sculptures himself. Alexander Calder, in

his later monumental stabiles and mobiles, set the example for the utilization of skilled industrial workers in the manufacture of the final work on the basis of the artist's design. Burgoyne Diller (1906–1965), an American follower of Mondrian (colorplate 242), pioneered in American geometric abstraction in the 1930s; during the 1960s he made a number of projects in formica which were shop fabricated.

The primary structure sculptors normally work on a monumental scale which becomes more monumental when enclosed in an interior space. They place their objects on the floor, against the wall, or even suspended from the ceiling, to become integrated with the total environment even when they do not actually create that environment. Primary structure sculptors employ new, synthetic materials and, in general, use architectonic forms—although some employ organic shapes. Color and, on occasion, light, are used extensively and dramatically. The basis of the works is the depersonalization of art, the subordination of the individual artist's ego. This, as in recent systemic painting, is an understandable reaction against the personal gesture of abstract expressionism or action painting. Primary structure seems to represent an antithesis to the abstraction of the early century, as exemplified in Mondrian and Kandinsky, where the emphasis was always on the spiritual in art—the inner spirit or force represented by the non-objectivism of the external shapes. There are no intentional expressive, surrealist, or personally mystical overtones. Now the insistence is on the fact that the sculpture or the painting is simply an object. There is nothing more there than what the spectator sees. It must be evaluated objectively in terms of the perception and the sensitivity of the spectator. The curious fact involved in all this impersonality, this contemporary machine production, this standardization of forms, is that the statements of the individual artists are so distinct and stylistically recognizable. The complaint is frequently made that this new art is not only mechanical and soul-less (a criticism which the artists would approve), but that it represents the end, the *reductio ad absurdum* of the entire tradition of Western art. This may be so, but we must remember that the same accusation was leveled against Mondrian.

Among the younger artists associated with constructivism and minimal art, Anthony Caro (b. 1924) is one of the most impressive talents to emerge in England since World War II (*Midday,* 1960, colorplate 243). Like so many of the new English painters and sculptors, he is a product of the enlightened atmosphere of the Royal College schools. His large, powerful constructions, frequently assembled from industrial steel girders and painted bright colors, illustrate the heritage of David Smith. Philip King (b. 1934) and William Tucker (b. 1935) are other English exponents of the direction in sculpture known variously as primary structures or minimal sculpture. In *Brake,* 1966 (fig. 1074), King uses fiberglass and plastic in the creation of an austere and elegant structure consisting simply of five meticulously spaced slabs. This was fabricated by an industrial firm, in an edition of three, from the artist's full-scale model. In the same manner, William Tucker's *Four Part Sculpture,* 1966 (fig. 1075), made of fiberglass, was manufactured industrially to the artist's specifications and then painted by the artist. This consists merely of four large, immaculate cylinders placed horizontally side by side.

Primary structures spread even more widely in the United States than in England during the 1960s. American primary structures, particularly, owe something to David Smith's forms. Even closer as prototype or in concept is the work of Barnett Newman, particularly the few sculptures he produced, consisting of tall, vertical slabs of steel (fig. 1076) and the late, black paintings of Ad Reinhardt, with their insistence on impersonality and elimination of all extraneous elements.

*above:* 1074. PHILIP KING. *Brake.* 1966.
Fiberglass and plastic, 7 x 12 x 9'.
Rowan Gallery, London

*right:* 1075. WILLIAM TUCKER.
*Four Part Sculpture No. 1.* 1966.
Fiberglass, 18 x 72 x 90″. Collection the Artist

The constructions of Tony Smith (b. 1912) are perhaps too expressionist to fit the primary structure category, although he is now associated with it. His huge, heavy structures, preferably arched forms, either triangular or square, frequently turn back upon themselves to create dynamic tensions (figs. 1077, 1078). Donald Judd (b. 1928) carries the objective attitude to a point of mathematical precision. He repeats identical units, normally quadrangular, at identical intervals. These are made of galvanized iron or aluminum, occasionally with plexiglass. Although he sometimes paints the aluminum in strong colors, he at first used the galvanized iron in its original unpainted form, something that seemed to emphasize its neutrality (fig. 1079).

Judd is himself a critic and an articulate spokesman for the new sculpture. He vehemently insists that primary structures or minimal sculpture—most specifically his own —consitutes a direction essentially different from earlier constructivism or rectilinear abstract painting. The difference, as he sees it, lies in his search for an absolute unity or wholeness through repetition of identical units in absolute symmetry. Even Mondrian "composed," a picture by asymmetrical balance of differing color areas. Judd also insists on the non-environmental character of this sculpture. Despite its frequently monumental scale, it is detached from the spectator; he is not intended to enter into it and become a part of it. Although the principles of balanced symmetry and repetition are seen in many new sculptures and paintings, so narrow a definition would exclude many of the sculptors such as David Smith and Anthony Caro, who have certainly influenced this direction, as well as many younger artists after mid-century, who seek their own identity in the face of the enormous weight of earlier modern art. Their question frequently seems to be, "What can be done that has not been done before?"

Judd's works do, nevertheless, state the thesis of primary structures: they raise fundamental questions concerning the nature and even the validity of the work of art,

the nature of the aesthetic experience, the nature of space, and the nature of sculptural form. Can an absolutely mechanical arrangement of identical solids at identical intervals constitute a work of art? Since Judd's works of the 1960s grew continually in subtlety of proportion, even though arranged according to specific mathematical systems; since they have grown in coloristic richness and

*above left:* 1079. DONALD JUDD. *Untitled.* 1965. Galvanized iron, seven boxes,
each 9 x 40 x 31″ (9″ between each box). Collection Henry Geldzahler, New York

*above right:* 1080. RONALD BLADEN. *The X.* 1967. Painted wood to be made in metal,
22′ 8″ x 24′ 6″ x 12′ 6″. Fischbach Gallery, New York

1081. ROBERT MORRIS. *Untitled.* 1967.
Nine steel units, each 36 x 36 x 36″.
The Solomon R. Guggenheim Museum, New York

variety of elemental forms, the answer would seem to be yes.

Other primary structuralists, selected from the large number who emerged in the 1960s to illustrate the wide variety of approaches possible with elemental shapes, are Ronald Bladen (b. 1918), Robert Morris (b. 1931), and Robert Smithson (b. 1928). Bladen, a Canadian, uses monumental, architectural forms, frequently painted black, that loom up like great barriers in the space they occupy (*The X,* 1967, fig. 1080). Like Tony Smith, with whom he has a certain affinity, he makes his mock-ups in painted wood since the cost of executing these vast structures in metal would be exorbitant. The primary structuralists, with only a few exceptions, must await patrons for the final realization of their projects. Robert Morris, using a variety of related rectangular or triangular masses, composes an entire room into a unity of space. The work *Untitled,* 1967 (fig. 1081), each unit of which is large enough to be occupied by several persons, combines efficiency with environmental-space design, since the thin metal H-elements can be stacked together in a space little greater than a single one of them. Morris works extensively in fiberglass, shaped in geometric and at times curving, pneumatic forms. Robert Smithson has shown a preference for the indefinite repetition of staggered, ziggurat shapes in the creation of rhythmic effects of rapid continuity.

## MOTION AND LIGHT

Two directions explored sporadically since early in the twentieth century were given a great new impetus in the 1960s. These are motion and light used literally, rather than as painted or sculptured illusions. Duchamp's and Gabo's pioneer experiments in motion, and Moholy-Nagy's in motion and light, have already been noted. Before World War II (and since), Calder was the one artist who made a major art form of motion. Except for further explorations carried on by Moholy-Nagy and his students during the 1930s and 1940s, the use of light as a medium was limited to variations on "color organs," in which programed devices of one kind or another produced shifting patterns of colored lights. These originated in experiments carried on in 1922 at the Bauhaus by Ludwig Hirschfeld-Mack, and by the American Thomas Wilfred (1889–1968), inventor of the color organ and a brilliant, creative talent. The last years of the 1960s have seen a great revival in the use of light as an art form, and in the so-called mixed media, where the senses are assaulted by live action, sound, light, and motion pictures at the same time.

Gabo revived his interest in mechanical motion in the early 1940s, and about 1950 Nicholas Schöffer began using electric motors to activate his constructions. During the 1950s and 1960s the interest in light and motion suddenly snowballed through a series of exhibitions and the organization of a number of experimental groups. Although this has become a world-wide movement, the first great impetus came from Europe, particularly from France,

Germany, and Italy. Since 1955 a center for the presentation of kinetic and light art has been the Denis René Gallery in Paris, formerly the stronghold for the promotion of concrete art. In that year a large exhibition held there included kinetic works by Duchamp, Calder, Vasarely, Pol Bury, Jean Tinguely, Yaacov Agam, and Jesus Rafaël Soto. The first phase of the new movement was climaxed by the great exhibition held sequentially at the Stedelijk Museum in Amsterdam, the Louisiana Museum in Denmark, and the Moderna Museet in Stockholm. This was a vast and somewhat chaotic assembly of every aspect of the history of light and motion, actual or illusionistic, back to the origins of the automobile and to the American Eadweard Muybridge's photographic studies of the human and animal figures in motion. Although the exhibition did not draw any conclusions, it did illustrate dramatically that the previous few years had seen a tremendous acceleration of interest in these problems. The popular curiosity about this art is evidenced by the fact that the exhibitions were seen by well over one hundred thousand persons.

During the 1960s exhibitions of light and motion proliferated throughout the world, and the number of artists involved in different aspects increased spectacularly. A few outstanding examples will illustrate the range of possibilities already achieved.

It is interesting to note that Nicolas Schöffer, the principal inheritor of the space-motion-light tradition of Moholy-Nagy, should also be a Hungarian. After various explorations of expressionism and surrealism Schöffer, in 1950, turned to abstract-geometric construction in metal,

*below left:* 1082. NICOLAS SCHOFFER. *Prime Multiple with Lux 11.* 1960.
Copper-coated steel. Waddell Gallery, New York

*below right:* 1083. NICOLAS SCHOFFER. Artist before the Cybernetic Tower, La Boverie Park,
Liège, Belgium. 1961. Height 170′

in the tradition of Mondrian and neo-plasticism. He was soon drawn to cybernetics, the theory of systems and communications in their application to computers, and presently he turned to motion and light. Even the terminology he uses—spatiodynamics, luminodynamism, et cetera—suggests the desire for an integration of art with science and engineering, typical of the kinetic and light sculptors (fig. 1082). Schöffer, while retaining the rectilinear forms of his structures, has explored every aspect of motion and light, frequently on a monumental scale (fig. 1083). He has created light and motion settings for ballets and large-scale spectacles, and has even projected an entire cybernetic university city for thirty thousand students.

In the art of motion, Jean Tinguely (b. 1925, Switzerland), represents the opposite extreme to Schöffer. For Tinguely mechanized motion is the medium for the creation of sheer fantasy. He is Kurt Schwitters translated into movement. After preliminary efforts and the formulation of metamechanic reliefs and what he called metamatics, which permitted the use of chance in motion machines, he introduced painting machines in 1955. These he perfected in his 1959 metamatic painting machines, the most impressive of which was the "metamatic-automobile-odorante-et-sonore" for the first biennial of Paris; it produced some forty thousand abstract-expressionist paintings. His 1960 *Homage to New York*, created in the garden of New York's Museum of Modern Art, was a machine designed to destroy itself—which it finally did with the aid of the New York fire department. In Tinguely's machines, which are pure dada, one is inevitably reminded of the wonderful machines created for the comic strips by the cartoonist, Rube Goldberg (fig. 1084). Tinguely is a great master of the ludicrous, but he is also a poet and a serious theoretician. Two of his most suggestive statements are: "the only stable thing is movement" and "the machine allows me, above anything, to reach poetry."

Castro-Cid (b. 1937, Chile) creates macabre motorized constructions of robots that relate him to nouveau réalisme, as in his shadow figure of a human skeleton with a glass-enclosed robot figure whose arms are articulated strips of metal and whose head is a plastic dome containing the motor. Pol Bury (b. 1922, Belgium) is one of the most varied, prolific, and subtle of the kinetic artists. Using highly finished materials of wood and metal he makes motorized constructions in which rolling wooden balls, vibrating metal strips, crawling steel cubes move at so imperceptible a pace that the movement seems illusionary (fig. 1085). Somewhat related in their effect are Robert Breer's (b. 1926, U.S.A.) aluminum "tanks"—motorized forms that crawl over the floor at a pace of six inches per minute, periodically and uncannily changing direction in a manner that becomes menacing. Breer also produces crumbled sheets of mylax, his "rugs" that writhe and rustle in an alarming way.

Len Lye (b. 1901, New Zealand) is a pioneer experimental film maker as well as kinetic artist. His works, at the opposite extreme to those of Bury or Breer, are characterized by tremendous acceleration of movement, in vibrating rods or whirling metal strips with concomitant effect of screaming noise. (Noise is frequently an impor-

*above:* 1084. JEAN TINGUELY. *M. K. III.* 1964.
Kinetic sculpture, iron, 36¼ " x 82½ ".
The Museum of Fine Arts, Houston

*right:* 1085. POL BURY. Portion of *The Staircase.* 1965.
Wood with motor. The Solomon R. Guggenheim Museum, New York

*far left:* 1086. LEN LYE. *Fountain II.* 1963. Steel rods and base, height 89½ ". Howard Wise Gallery, New York

*left:* 1087. TAKIS. *Telemagnetic Musical.* 1966. Electromagnetic construction, 78 x 23½ ". Howard Wise Gallery, New York

tant accessory of kinetic sculpture. Tinguely has at times programed groups of old radios in complete disharmony. Calder at times introduced gongs into his wind mobiles.) Len Lye also creates delicately balanced, non-mechanized mobiles, tall groups of rods that vibrate gently of their own accord (fig. 1086). Takis (b. 1925, Greece) also uses rods, mechanized or in sensitive balance, to be set in motion by a touch of the hand. His principal contribution, however, is the utilization of electromagnets with which he can keep metal objects in a perpetual state of attraction and repulsion (fig. 1087). Davide Boriani (b. 1936, Italy), a founding member of the Gruppo T in Milan, also uses magnets but in a different manner. He places masses of iron filings within a glass-covered, compartmentalized container. Motivated by programed magnets, these iron filings crawl about their domicile like swarms of slow-moving insects.

Gyula Kosice (b. 1924, Hungary), now a citizen of Argentina, uses combinations of water power and light even in the design of large-scale murals such as that he did for the Embassy Center at Buenos Aires. Of the mobilists one of the most interesting to emerge since World War II is George Rickey (b. 1907, U.S.A.). Rickey composes long, tapering strips or leaf clusters of stainless steel in a state of balance so delicate that the slightest breeze or touch of the hand sets them into a slow, stately motion or a quivering vibration (fig. 1088). Gunter Haese (b. 1924, Germany) and Jesus Rafaël Soto (b. 1923, Venezuela) are not literally motion artists except insofar as their constructions, consisting of exquisitely arranged metal rods or metal blossoms on thin stems within a wire cage, are sensitive to the point that even a change in atmosphere will start an oscillation (figs. 1089, 1090).

1088. GEORGE RICKEY. *Four Lines Up.* 1967. Stainless steel, height 16'. Collection Mr. and Mrs. Robert H. Levi, Lutherville, Maryland

1089. GUNTHER HAESE. *Olymp.* 1967.
Brass and copper, 36⅝ x 29¾ x 23⅛".
The Solomon R. Guggenheim Museum, New York

The arts of light and motion proliferated a number of new artists' organizations and manifestoes during the late 1950s and 1960s. In 1955, in connection with the exhibition, "Movement," at the Denis René Gallery in Paris, Victor Vasarely, the pioneer of contemporary French optical paintings, issued his *Yellow Manifesto*, outlining his theories of perception and color. Bruno Munari (b. 1907), who was producing kinetic works in Italy as early as 1933, was also an important theoretician.

Very active in Spain, Equipo 57 (founded in 1957) is a group of artists who work as an anonymous team in the exploration of motion and vision. This anonymity, deriving from concepts of the social implications of art and also perhaps, from the examples of scientific or industrial research teams, was evident at the outset in the Group T in Milan, founded in 1959, Group N in Padua, founded in 1960, and the Group 0 (Zero) in Düsseldorf, Germany. In most cases the theoretical passion for anonymity soon dimmed and the artists began to emerge as separate individuals.

Group 0 (the 0 derives from the moment of blast-off in a space rocket countdown) was initiated in 1957 by Otto Piene (b. 1928) and Heinz Mack (b. 1931); Gunther Uecker (b. 1930) joined them in 1960. Piene, now resident in the United States, is one of the most fertile talents exploring the possibilities of light. In 1961 he created an entire light ballet that toured European museums. In

1090. JESUS RAFAEL SOTO. *Petite Double Face.* 1967.
Wood and metal, 23⅝ x 15".
Marlborough-Gerson Gallery, New York

1091. OTTO PIENE. *Electric Flower.* 1967.
Light bulbs, diameter 16".
Howard Wise Gallery, New York

1092. Julio Le Parc.
*Continuel Lumière Formes en Contorsion.* 1966.
Motorized aluminum and wood, 80 x 48½ x 8″.
Howard Wise Gallery, New York

1093. Richard Lippold. *Variation within a Sphere,
No. 10: the Sun.* 1953–56. Gold-filled wire,
c. 11 x 22 x 5½′. The Metropolitan Museum of Art,
New York. Fletcher Fund, 1956

1964–65 he was commissioned to design the lighting for the new City Opera House in Bonn. This consisted of an elaborate and intricate system of chandeliers for the foyer, and "milky ways"—complexes of thousands of individual bulbs—programed to change, go up and down in intensity in coordination with the stage lighting. This is a brilliant illustration of new possibilities for theater or institutional lighting, not only beautiful in its effects but also, apparently, highly efficient in its function (fig. 1091). Piene's commissions, as well as those of other light and motion artists, have important implications for the future in the collaboration of artists, architects, and light engineers.

The increasing collaboration of artists and scientists and engineers in the creation of musical or dance spectacles has already been referred to. A leading experimentalist in light and motion is the aeronautical engineer and geophysicist Frank Joseph Malina (b. 1912), who is a pioneer in American rocket research. Dr. Hans Jenny (b. 1904), a Swiss doctor and scientist, has carried on research in problems of vibration and periodicity that he has published under the title of *Cymatics* (Basel, 1967). He has also produced a film, *Vibrating World*, and exhibitions filled with images based on a wide variety of themes from natural phenomena, with implications for the new world of movement

in the arts. Gerald Oster (b. 1918), a chemist, has made intensive research into moiré patterns and their implications not only for science and industry, but also for optical, retinal, and illusionistic painting, and has become an influential figure in recent art.

Of the light experimentalists, the Argentinian Julio Le Parc (b. 1928) is one of the most imaginative, varied, and visually—even aesthetically—successful in his employment of every conceivable device of light, movement, and illusion. The award to him of the painting prize at the 1966 Venice Biennale was not only a recognition of his talents but also an official recognition of the new arts. Since 1958, Le Parc has lived in Paris where, in 1960, he was a founder of the Groupe de Recherche d'Art Visuel. With its home base at the Gallery Denis René, this group carries on research in light, perception, movement, and illusion. Le Parc is a major bridge between various overlapping but normally separate tendencies in the art of the 1960s: not only light and movement, but different forms of optical, illusionistic painting, and the directions to which the names, the new tendency, and programed art, have been given (fig. 1092).

In the United States, interest in light sculpture accelerated during the 1960s in many different forms. A pioneer,

1095. Preston McClanahan. *Star Tree*. 1966–67.
Plexi rods and fluorescent light, 62 x 96″.
Howard Wise Gallery, New York

although he did not actually use artificial illumination, in his constructions, is Richard Lippold (b. 1915). Also a talented industrial designer, he has produced a series of impressive architectural-sculptural structures since the 1940s. They are intricately composed of intensely polished gold wires and plaques whose brilliant surfaces shine with an iridescent luminescence, particularly when lighted artificially (fig. 1093).

Of the younger light artists, Dan Flavin (b. 1933) transforms light columns into austere relationships of forms in which the scale of the units and the spacing of the intervals, at times focused around a center accent, adapts the new technology to the equilateral balance of classical art (fig. 1094). Preston McLanahan (b. 1933) uses both reflected and projected light in the creation of delicate, plant-like forms in which the vibration of the elements adds the effect of organic life and growth (fig. 1095). Chryssa (b. 1933, Greece) bridges the gap between pop art and light sculpture. She first explored emblematic or serial relief sculpture composed of identical, rhythmically arranged elements of projection circles or rectangles; then in the early 1960s she made lead reliefs derived from newspaper printing forms. From this she passed to a kind of found-object sculpture in which she used fragments of neon signs. The love of industrial or commercial lettering, whether from newspapers or signs, is a persistent aspect of her works. In this she is recording the American scene in a manner analogous to the pop artists or to the earlier tradition of Stuart Davis and Charles Demuth. Soon the fascination with the possibilities of light, mainly neon tube light, took over completely, in the construction of elaborate light machines which, in some curious manner, maintain their qualities of contemporary American industrial objects (fig. 1096). Howard Jones (b. 1922) creates light and burnished-metal panels which, though flat, yield effects that suggest depth and space, as well as movement, often with exotic but indefinable visual "overtones" (fig. 1097). Generally, the flashing of the lights is programed; often it is at random. Recently, Jones has combined sound —either spectator-activated or programed—with his light panels.

1096. CHRYSSA. *Nonfunctioning Electrodes No. 1.*
1967. Neon, electrodes, clear and blue plexi,
26¼ x 30 x 32". Pace Gallery, New York

1097. HOWARD JONES. *Skylight Series.* 1968.
Brushed bronze and programed lights.
Howard Wise Gallery, New York

At the opposite extreme to these aggressive light interpretations of contemporary industrial America are the infinitely subtle glass boxes of Larry Bell (b. 1939). The glass cubes, resting on transparent glass bases, are coated on the inner surface, creating the most delicate effects of transparent light and color that seem to shift continually. Bell's is an art both romantically coloristic and classically austere, with affinities both to primary structures and optical or retinal painting (colorplate 244).

## OPTICAL PAINTING (OP ART)

More or less related tendencies in the painting of the 1960s may be grouped under the heading of optical (or retinal) painting. These involve a wide range of experiments, best defined in examination of the individual works. As has frequently been pointed out, the labels attached to modern monuments in art are rarely satisfactory, and are used for want of anything better. What is called optical painting overlaps at one end with light sculpture or construction (in its concern with illusion, perception, and the physical and psychological impact of color), and with light experiments on the spectator. At the other end, it impinges on some, though not by any means all, aspects of color-field painting in its use of brilliant unmodulated color.

Optical illusion, in one form or another, has intrigued painters from the beginnings of art in the cave paintings of

Altamira. Pompeian painting and Roman mosaics employed linear perspective rather for decorative, illusionistic effects than for the establishment of three-dimensional pictorial space. With the discovery, or rediscovery, of linear and atmospheric perspective in the fifteenth century, painters from Uccello to Crivelli delighted in the illusions of depth or shifting viewpoints permitted by the new technique. As we have noted at the beginning of this book, these experiments in perspective illusion attained fabulous dimensions in paintings of the Baroque and Rococo.

Theories of color and perception may be traced to the philosophers George Berkeley and David Hume in the eighteenth century, as well as to Goethe. In the nineteenth century, Delacroix was a pioneer in the exploration of color theory, and the impressionists and neo-impressionists carried experimentation in the perception of color to new limits. The influence of Chevreul, Von Helmholtz, Rood (and other writers on color and optics) on Seurat and the neo-impressionists, as well as later artists, has been discussed (see Part I).

There were elements of optical illusion in the paintings of Mondrian, Van Doesburg, and other painters of De Stijl, although this was not a central factor except in late Mondrian paintings (see colorplate 198). Moholy-Nagy and Albers introduced optical experiments into the curriculum of the Bauhaus, both in terms of color and perspective. Albers in his series Homage to the Square has made some of the most impressive twentieth-century contributions to the study of color relationships, as in his black-

what he calls kinetic plastics. To him, "Painting and sculpture become anachronistic terms: it is more exact to speak of a bi-, tri-, and multidimensional plastic art. We no longer have distinct manifestations of a creative sensibility, but the development of a single plastic sensibility in different spaces." Vasarely seeks the abandonment of painting as the individual gesture, the signature of the isolated artist. Art to him in a modern, technical society must have a social context. The work of art is the artist's original idea rather than the object consisting of paint on canvas. This idea, realized in terms of flat, geometric-abstract shapes mathematically organized, with standardized colors, flatly applied, is then capable of projection, re-creation, or multiplication into different forms—murals, books, tapestries, glass, mosaic, slides, films, or television. For the traditional concept of the work of art as a unique object produced by an isolated artist, he substitutes the concept of social art, produced by the artist in full command of modern industrial communications techniques, for a mass audience.

Implicit in Vasarely's own painting is the utilization of various devices to create illusions of movement and metamorphosis within the abstract organization. He has been a pioneer in the development of almost every form of

1098. VICTOR VASARELY. *Sorata-T.* 1953.
Triptych, engraved glass slabs, 6' 6" x 15'.
Private collection

and-white drawings and engravings he has advanced the entire field of perspective illusion (see colorplate 137). During the 1960s a new generation of painters and sculptors throughout the world turned to forms of art involving optical illusion or some other specific aspect of perception.

Victor Vasarely (b. 1908, Hungary) is the most influential master of the new optical art. Although his earlier paintings belonged in the general tradition of concrete art, since the 1940s he has devoted himself to optical art and theories of perception. He began with a serious study of the works and theories of Mondrian and Kandinsky, as well as the entire history of color theory, perception, and illusion. Since a large proportion of contemporary statements in optical art are observable in his works, they may be used to illustrate these statements generally. Vasarely's art theories, first presented in his 1955 *Yellow Manifesto*, involve the replacement of traditional easel painting by

1099. VICTOR VASARELY. *Vega.* 1957. Oil on canvas,
76¾ x 51⅛ ". Collection the Artist

1100. BRIDGET RILEY. *Drift 2*. 1966.
Emulsion on canvas, 91½ x 89½ ".
The Albright-Knox Art Gallery, Buffalo, New York

optical device for the creation of a new art of visual illusion. He divides his works into systematic categories in which he explores different aspects of art and illusion. His *photo-graphisms* are black-and-white line drawings or paintings. Some of these are made specifically for reproduction; in these he frequently covers the drawing with a transparent plastic sheet. The plastic sheet has the same design as the drawing but in a reverse, negative-positive relationship. When the two drawings—on paper and on plastic—are synchronized, the result is simply a denser version. As the plastic is drawn up and down over the paper, the design changes tangibly before our eyes. Here, literal movement creates the illusion. This and many other devices of Vasarely and other optical artists are refinements of processes long familiar in games of illusion or halls of mirrors.

In his Deep Kinetic Works the principle of the plastic drawings is translated into large-scale glass constructions. *Sorata-T.*, 1953, is a standing triptych, six-and-one-half by fifteen feet in dimension (fig. 1098). The three transparent glass screens may be placed at various angles to create different combinations of the linear patterns. Vasarely's art lends itself to monumental statements which he has been able to realize in murals, ceramic walls, and large-scale glass constructions. What he calls his Refractions involve glass or mirror effects with constantly changing images.

Since he is aware of the range of optical effects possible in black-and-white, a large proportion of Vasarely's works is limited to these colors. These he refers to simply as B N (*blanche noir*: white black). As the cubists and then the De Stijl painters limited their palettes in order to clarify their structural principles, so Vasarely and optical painters after him realized the importance of a comparable and

even more arbitrary color limitation in order to establish the vocabulary of illusion (fig. 1099).

It is, nevertheless, in color that the full range of possibilities for optical painting can be realized, and Vasarely is well aware of this. In the 1960s his color burst out with a variety and brilliance unparalleled in his career. Using small, standard color shapes—squares, triangles, diamonds, rectangles, circles, sometimes frontalized, sometimes tilted, in flat, brilliant colors against equally strong contrasting color-grounds—he sets up retinal vibrations that dazzle the eye and bewilder perception (colorplates 245, 246).

Of optical artists in the precise sense of being concerned with visual illusion, the British painter, Bridget Riley (b. 1931), is among the most effective. Employing largely black, white, and different values of gray, with repeated, serial units frontalized and tilted at various angles, she makes her picture plane weave and billow before our eyes. She employs variations in tone (which Vasarely rejects) to accentuate the illusion (*Drift 2*, 1966, fig. 1100). The American, Richard Anuskiewicz (b. 1930), a student of Josef Albers, normally uses straight lines and perspective devices to create startling emphases and inversions of illusionistic depth. In *Inflexion*, 1967 (fig. 1101) he skillfully reverses the direction of the radiating lines on each side of the square, thus making what at a quick glance looks like a traditional perspective box, suddenly begin to turn itself inside out.

The Israeli-born artist, Agam (Yaacov Gipstein, b. 1928), is identified with a form of optical painting or rather painted relief, in which the illusion is created by the movement of the spectator. *Double Metamorphosis II,*

1101. RICHARD ANUSKIEWICZ. *Inflexion*, 1967.
Liquitex on canvas, 60 x 60".
Sidney Janis Gallery, New York

silk, in which two identical patterns are applied in a slightly out-of-register relation. This creates a constant sense of movement and change, which is magnified when the material is in actual movement. The moiré principle is beautifully realized in the constructions of Soto (see fig. 1090). Comparable effects may be seen in the works of Karl Gerstner (b. 1930, Switzerland) and other artists working in three dimensions, using combinations of mirrors, lenses, and transparent plastics (fig. 1103). Pistoletto's mirror paintings in which the spectator finds himself, may also be classified as a form of optical art; as, in a quite different manner, may the aluminum constructions of Heinz Mack, the founder with Otto Piene, of the Zero group. Mack, working consistently on a serial principle (the constant repetition of standard elements), creates light-reflecting reliefs in which visual illusion is frequently incorporated (fig. 1104).

The interest in optical research has led to a number of new experiments on the part of artists who do not properly belong in this category. One of these is the employment of the circle as a central motif. In general, optical art employs a balanced, symmetrical composition as opposed, for instance, to the consistently asymmetrical approach of Mondrian and the De Stijl artists. Jasper Johns' Targets may have started the circle cycle. Kenneth Noland (b. 1924), a leader of the color-field painters, employed the circle in a number of his paintings of the early 1960s, sometimes with a deliberately illusionistic effect, achieved by blurring the contours. In *A Warm Sound in a Gray Field,* 1961 (colorplate 247), the outer circles seem to revolve slowly around the tiny spot of light at the exact center. Although Noland has moved away from circles, the Polish painter

1102. AGAM. *Double Metamorphosis II.* 1964. Oil on aluminum, eleven sections. 8' 10" x 13' 2¼".
The Museum of Modern Art, New York
Gift of Mr. and Mrs. George M. Jaffin

1964 (fig. 1102), one of the largest of these, is a grid with regular geometric color shapes painted over the projections. Seen straight on, the color shapes are frontalized; as one walks from one end to another, they shift into tilted, perspective shapes. The device used here is actually the reverse of that used by some Renaissance painters intrigued by the illusionistic possibilities of linear perspective. (Hans Holbein the Younger in his painting *The Ambassadors,* 1533, introduces in the foreground an exceedingly foreshortened skull—a *memento mori.* If one stands at the side of the picture and looks across it, the skull resumes its normal shape.) The interesting fact about Agam's relief paintings, beyond their technical virtuosity, is that each successive view composes effectively.

Among the many devices used by the optical painters and constructivists (as by light artists) to create illusion, one of the most common and even traditional is that known as moiré pattern. This derives from the French for watered

1103. KARL GERSTNER. *Lens Picture.* 1962–64.
Plastic lens and transparency
of concentric circles, 28 x 28".
Staempfli Gallery, New York

*far left:* 1104.
HEINZ MACK.
*Door of Paradise.* 1964.
Aluminum on wood,
80 x 40".
Howard Wise Gallery,
New York

*left:* 1105. TADASKY.
*Untitled.* 1965.
Acrylic, 68 x 68".
Fischbach Gallery,
New York

Wojciech Fangor (b. 1922) has independently continued to use them, with contours dissolved, in paintings that have the impact of sun or moon eclipses. Others who have used the circle with some illusionistic implications are the Japanese artists Tadasky (Tadasuke Kuwayama) (b. 1935, fig. 1105), Toshinobu Onosato (b. 1912), and Atsuko Tanaka (b. 1932); the Canadian, Terence Syverson (b. 1939); and the American, Alexander Liberman (b. 1912, Russia) among many others.

Optical painting has also inspired a movement toward allover painting in which a network or a mosaic of color strokes or dots covers the canvas and seems to expand beyond its limits. The Italian Piero Dorazio (b. 1927) covers the surface with semi-transparent bands of bright color that move in and out of one another in an intricate web (fig. 1106). The American Larry Poons (b. 1937) creates a seemingly haphazard but actually meticulously programed mosaic of small oval shapes that vibrate intensely over grounds of strong color (colorplate 248). The organization of Poons's color-shapes, which are worked out mathematically on graph paper, is another indication of the tendency to systems, or to what, in the 1960s, has been called systemic painting.

An offshoot of the wide diversification in the 1960s is the re-emergence of artists who in the period of abstract-expressionist dominance had pursued a minority direction, whether in a lyrical-romantic or a classic-geometric vein. Of the Americans, John Ferren (b. 1905) was a geometric abstractionist in the 1930s. Living in Paris from 1931 to 1938, he was closer to contemporary abstract movements than most Americans of his generation. Although associated with abstract expressionism in the late 1940s and 1950s, he maintained a kind of figuration, but was principally interested in the exploration of brilliant, varied color and the interaction of colors. Thus in the 1960s his paint-

1106. PIERO DORAZIO. *Where Is The Way Where Light Dwelleth.* 1966. 90¼ x 62½".
Marlborough-Gerson Gallery, New York

1107.
RICHARD POUSETTE-DART.
*Star Happenings.* 41 x 75".
Betty Parsons Gallery,
New York

1108. JIMMY ERNST. *Antiworlds (Homage to A. Vornesensky).*
1966. 50 x 65". Private collection

ings and his more recent color constructions suddenly fell into place with aspects of the new optics, systemic, and allover painting (colorplate 249). In a comparable manner, Richard Pousette-Dart (b. 1916), although he was associated with the first pioneers of abstract expressionism, always represented a minority, lyrical vein of the movement until recently, when his sparkling, microscopically detailed, allover paintings began to take on a new contemporary look (*Star Happenings,* fig. 1107). The same might also be said of Jimmy Ernst's curious, meticulous works which have always been an individual application of abstract surrealism, as in *Antiworlds (Homage to A. Vornesensky),* 1966 (fig. 1108). He was using perspectival devices for optical, illusionistic effect long before optical art had a name.

An artist who might be placed with the allover painters, or with the color-field painters (see below) is Gene Davis (b. 1920), another of that remarkable group of painters, including Morris Louis, Kenneth Noland, Howard Mehring, and Thomas Downing, who emerged from Washington, D.C. Davis might also be associated with the so-termed minimal artists because of his concentration on a single repeated image and principles of balanced frontality. Davis' image is the vertical color stripe, rigidly defined through the use of masking tape and presented in different paintings in a range of widths from narrow lines to color strips inches wide. He normally used uniform widths for the verticals in a given painting. Using highly saturated and varied colors, Davis arrives at effects of great color density, different from the openness of the color-field painters (colorplate 250).

## COLOR-FIELD PAINTING

A number of exhibitions held in the 1960s drew attention to certain changes that were occurring in American painting. During 1959 and 1960, French and Company, a gallery of traditional art, established a brief-lived program for contemporary art. The critic Clement Greenberg, acting as consultant, organized a series of one-man exhibitions including Barnett Newman, David Smith, Morris Louis, Kenneth Noland, Jules Olitski, and Friedel Dzubas —artists who were to be recognized as major forces in the color painting and primary structures of the 1960s.

In 1961, the Guggenheim Museum, New York, held an exhibition entitled "American Abstract Expressionists and Imagists," intended as a survey of the New York school at that date. Since its inception in the 1940s it has been apparent that the New York school was not simply a school of abstract expressionists or action painters, but included artists of many different directions. The exhibition pointed up the fact that, aside from the gestural or brush painters Pollock, De Kooning, Hofmann, Brooks, and others, there had always been another strain, to which the name, abstract imagists, was applied for convenience.

Through their extreme simplification of the canvas, these were painters concerned with creating a dominant, all-encompassing presence. This presence could be described as an image in the sense of an abstract symbol rather than a reflection or imitation of anything in nature. The paintings of Rothko, Newman, Gottlieb, Reinhardt, and frequently Motherwell and Still, all very different, had in common this sense of symbolic content achieved through large, flatly painted color areas, and dramatic statement of isolated and simplified elements. A comparable effect was achieved in the endless hypnotic squares of Josef Albers and, among younger artists, in the floating, free color-shapes of Raymond Parker, or the precisely delineated shape-tensions of Ellsworth Kelly and Leon Polk Smith.

These exhibitions illustrated the fact that many young artists were attempting to break away from what they felt to be the tyranny of abstract expressionism, particularly in its emphasis on the individual brush gesture. Some of these were seeking new directions within the formal control of geometry or hard-edge painting; others turned to expressionist figuration, or the re-exploration of dada or surrealism, pop art, optical art, or light and motion. Most suggestive was the apparent expansion of that direction then called abstract imagism, to which many other names have been applied, including post-painterly abstraction (by Clement Greenberg), and color-field painting. Still other names have been applied to various aspects of this direction during the 1960s—systemic painting (by Lawrence Alloway), or minimal painting.

These labels do not necessarily encompass all the same artists or all the directions involved—which range from forms of allover painting to almost blank canvases. The emphasis throughout, however, is on pure, abstract *painting,* in distinction to figuration, optical illusion, object-making, fantasy, light, motion, or any of the other tendencies away from the act of painting itself.

In the 1961 exhibition at the Guggenheim, the list of artists associated with these new forms included Nassos Daphnis, Friedel Dzubas, Helen Frankenthaler, Al Held, Ralph Humphrey, Alfred Jensen, Morris Louis, Kenneth Noland, Ludwig Sander, Leon Polk Smith, Theodore Stamos, Frank Stella, and Jack Youngerman. These and the others represented a wide variety of points of view. Some were then categorized as hard-edge painters, working in broad, flat, unmodulated color areas bounded by precisely delineated edges. The term "hard-edge" was first used by the California critic Jules Langsner, in 1959, and given its current definition by Lawrence Alloway in 1959–60. According to Alloway, hard-edge was defined in opposition to geometric art, in the following way: "The 'cone, cylinder, and sphere' of Cézanne-fame have persisted in much 20th-century painting. Even where these forms are not purely represented, abstract artists have tended toward a compilation of separable elements. Form has been treated as discrete entities" whereas "forms are few in hard-edge and the surface immaculate. . . . The whole picture becomes the unit; forms extend the length of the painting or are restricted to two or three tones. The result of this sparseness is that the spatial effect of figures on a field is avoided" (see Biblio.). The important distinction that is drawn here between hard-edge and the older geometric tradition is the search for a total unity in which there is no foreground or background, no "figures on a field." During the 1950s Ellsworth Kelly, Ad Reinhardt, Leon Smith, Alexander Liberman, Sidney Wolfson and Agnes Martin (most of them exhibiting at the Betty Parsons Gallery in New York) were the principal pioneers. Barnett Newman (also showing at Parsons) was a force in related but not identical space and color explorations.

In these and other painters who were working against the current of abstract expressionism in the late 1950s there was a general move (as Greenberg has pointed out) to openness of design and image—frequently the use of staining and raw canvas—and toward a clarity and freshness that differentiated them from the compression and brush expression of the action painters. Aside from the hard-edge painters, others such as Frankenthaler, Louis, Dzubas, and Stamos, were working more freely, although with an increasing subordination of brush gesture and paint texture. The directions and qualities suggested in the work of these artists—some already established masters, some just beginning to appear on the scene—were to be the dominant directions and qualities in abstract painting during the 1960s.

In 1963 the Jewish Museum, New York, presented an exhibition, "Toward a New Abstraction." Kenneth Noland was a featured painter at the United States pavilion of the Venice Biennale in 1964, and was given a one-man exhibition at the Jewish Museum in 1965. The Jewish Museum also defined the sculpture of primary structures in a large exhibition held in the spring of 1966. In 1964, Clement Greenberg organized an exhibition for the Los Angeles County Museum, which then traveled to the Walker Art Center, Minneapolis, and the Art Gallery, Toronto. This he entitled "Post Painterly Abstraction," using "painterly" in the sense of the German word *malerisch,* as used by the Swiss art historian Heinrich Wölfflin. In Greenberg's words, "Painterly (which Wölfflin applied to Baroque art to separate it from classical, High Renaissance art) means, among other things, the blurred, broken, loose definition of color and contour. The opposite of painterly is clear, unbroken, and sharp definition, which Wölfflin called 'linear'." Greenberg applied the term painterly to the abstract expressionism of Pollock, Hofmann, De Kooning, Kline, and their immediate followers who employed the apparent brush gesture—"the stroke left by the loaded brush or knife that frays out, when the stroke is long enough, into streaks, ripples, and specks of paint." Greenberg points out, further, "By contrast with the interweaving of light and dark gradations in the typical Abstract Expressionist picture, all the artists in this show move towards a physical openness of design, or towards linear clarity, or towards both. They continue, in this respect, a tendency that began well inside Painterly Abstraction itself, in the works of artists like Still, Newman, Rothko, Motherwell, Mathieu, the 1950–54 Kline, and even Pollock. A good part of the reaction against Abstract Expressionism is, as I've already suggested, a continuation of it. There is no question, in any case, of repudiating its best achievements." Among the qualities that Greenberg notes in the artists exhibited are (in some cases) the hard edge; in most cases, "the high keying, as well as lucidity, of their color . . . contrasts of pure hue rather than contrasts of light and dark . . . relatively anonymous execution."

The thirty-one artists in the exhibition included, among others, Gene Davis, Friedel Dzubas, Paul Feeley, John Ferren, Sam Francis, Helen Frankenthaler, Al Held, Alfred Jensen, Ellsworth Kelly, Alexander Liberman, Morris Louis, Kenneth Noland, Jules Olitski, Raymond Parker, Ludwig Sander, and Frank Stella. Canadian artists included Jack Bush and Kenneth Lochhead.

The next exhibition to document aspects of the new abstraction of the 1960s was entitled "Systemic Painting," 1966, organized by Lawrence Alloway for the Guggenheim Museum. This was somewhat more specialized than the other two, but it did overlap with both of them and suggest significant new directions in American abstract painting. It must always be kept in mind that these exhibitions (at least the latter two) occurred while pop art was dominating the American scene, closely following in many areas by optical painting, and light and motion.

The exhibition of systemic painting included among others: Paul Feeley, Ellsworth Kelly, Kenneth Noland, Neil Williams, Larry Zox, Frank Stella, Larry Poons, Al Held, Leon Smith, Jack Youngerman, and Nicholas Krushenick. Alloway draws attention to what he calls "one image art" in the works of many of these artists—the contemporary tendency to play continuous variations on a single theme: Noland paints circles, then chevrons; Feeley paints quatrefoils; Reinhardt paints crosses.

Alloway sees in this one image art the application of serial systems, and proposes the term "systemic." "The application of the term systemic to One Image painting is obvious, but, in fact, it is applied more widely here. It refers to paintings which consist of a single field of color, or to groups of such paintings. Paintings based on modules are included, with the grid either contained in a rectangle or expanding to take in parts of the surrounding space (Gourfain and Insley respectively). It refers to painters who work in a much freer manner, but who end up with either a wholistic area or a reduced number of colors (Held and Youngerman respectively). The field and the module (with its serial potential as an extendible grid) have in common a level of organization that precludes breaking the system. This organization does not function as the invisible servicing of the work of art, but is the visible skin. It is not, that is to say, an underlying composition, but a factual display. In all these works, the end-state of the painting is known prior to completion (unlike the theory of Abstract Expressionism). This does not exclude empirical modifications of work in progress, but it does focus them within a system. A system is an organized

right: 1109.
SAM FRANCIS.
*Red and Black*. 1954.
76⅞ x 38⅛".
The Solomon R.
Guggenheim Museum,
New York

far right: 1110.
SAM FRANCIS.
*Shining Back*. 1958.
79⅜ x 53⅛".
The Solomon R.
Guggenheim Museum,
New York

whole, the parts of which demonstrate some regularities. A system is not antithetical to the values suggested by such art work word-clusters as humanist, organic, and process. On the contrary, while the artist is engaged with it, a system is a process; trial and error, instead of being incorporated into the painting, occur off the canvas. The predictive power of the artist, minimized by the prestige of gestural painting, is strongly operative, from ideas and early sketches, to the ordering of exactly scaled and shaped stretchers and help by assistants."

Other labels such as "cool art" (by Irving Sandler) have been attached to these new tendencies, but enough have been cited to suggest the range of American abstract painting in the 1960s. Although certain common denominators are apparent, probably no single, encompassing term can be found to describe this painting any more satisfactory than abstract expressionism in the 1950s. For the purposes of discussion we will use the broad term, color-field painting, in our analysis of a number of individual artists who will illustrate the range of expression involved.

Greenberg's inclusion of Sam Francis (b. 1923) among his post-painterly abstractionists may seem somewhat surprising, since Francis during the 1950s was associated with American abstract expressionism and art informel in Paris, where he lived until 1961. In other words, he would be considered a "painterly" artist. His inclusion, nevertheless, is not illogical, since the direction of his painting over fifteen years has been toward that openness and clarity of which Greenberg speaks. In fact, despite his continuing use of the brush gesture, the drip and spatter, his relations to the color-field painters are greater than his differences, and he even anticipated some of them in his use of extreme openness of organization. *Red and Black,* 1954 (fig. 1109) is rich and dense in its structure; *Shining Back,* 1958 (fig. 1110) is far more open, although the drips and spatters are even more apparent. In later works, although some vestiges of splatters remain, the essential organization is that of a few free but controlled color-shapes, red, yellow, and blue, defining the limits of a dominant white space.

Helen Frankenthaler (b. 1928) has an even more immediate relevance as a transitional figure between abstract expressionism and color-field painting. She was the first American painter after Jackson Pollock to see the implications of the color-staining of raw canvas to create an integration of color and ground in which foreground and background ceased to exist. This concept was taken up by Morris Louis in 1954, and out of it emerged important aspects of color-field painting. She employs an open composition, frequently building around a free-abstract central image. Later works by her also stress the picture edge. A characteristic of Frankenthaler's handling of space is seen in *Interior Landscape,* 1964 (colorplate 251). The paint is applied in uniformly thin washes. There is no sense of paint texture—a general characteristic of color-field painting—although there is some gradation of tone around the edges of color-shapes, giving these a sense of detachment from the canvas. The irregular central motifs float within a rectangle which, in turn, is surrounded by irregular light and dark frames. These latter create a feeling that the center of the painting is opening up in a limited but defined depth.

1111. PAUL JENKINS. *Phenomena in Heaven's Way.* 1967. Acrylic on canvas, 48 x 64″. Martha Jackson Gallery, New York

Another painter whose major technique is the color-stain is Paul Jenkins (b. 1923). On large canvases he literally floats his highly diluted pigments, so that they take on unpredictable and often disquieting shapes as they are made to wash back and forth across the surface. Tones range from the most delicate tints to foreboding depths; and in very recent works, the artist has added passages of solid pigment, as thread-like drips, or constellations (fig. 1111).

Morris Louis (1912–1962) was one of the most talented new American painters to emerge in the 1950s. Living in Washington, D.C., somewhat apart from the New York scene and working almost in isolation, he and a group of artists that included Kenneth Noland were central to the development of color-field painting.

The basic point about Louis's work and that of other color-field painters, in contrast to most of the other new approaches of the 1960s—pop art, op art, light, motion, and so on—is that they continue a tradition of pure painting, particularly that of Pollock, Newman, Still, Motherwell, or Reinhardt. They are concerned with the classic problems of pictorial space and the statement of the picture plane. Louis characteristically applied extremely liquid paint to an unstretched canvas, allowing it to flow over the inclined surface in effects sometimes suggestive of translucent color veils. There is no brush gesture, although the flat, thin pigment is at times modulated in billowing tonal waves (*Kaf,* 1959–60, colorplate 252). His "veil" paintings consist of bands of brilliant, curving color-shapes submerged in translucent tones through which they shine principally at the edges. Although the resulting color is subdued, it is immensely rich. In another formula, about 1960–62, the artist used long, parallel strips of pure color arranged side-by-side in rainbow effects. Although the separate colors here are clearly distinguished, the edges are soft and slightly interpenetrating (*Moving In,* 1961, colorplate 253).

Ellsworth Kelly (b. 1923; who may also be considered a leading primary structuralist) was, during the 1950s, a leader of the hard-edge school of color-field painters. His preference at that time was for large, bright, slightly irregular, ovoid shapes contrasted with rectangular planes of color. The influence of Arp is evident at times. In the 1960s his shapes became more absolutely symmetrical, whether rectangular or in terms of flattened ovals (*Orange and Green*, 1966, fig. 1112), and he worked increasingly with regular alternations of color rectangles arranged like a color chart but with the added dimension of subtle and startling color relationships and contrasts (*Blue, Green, Yellow, Orange, Red*, 1966, colorplate 254).

Although Kenneth Noland (b. 1924), as noted, was close to Louis during the 1950s and, like him, sought a color-field painting essentially departing from the brush-gesture painting of De Kooning or Kline, his personal solutions were quite different. Using the same thin pigment to stain unsized canvas, he made his first completely individual statement when, as he said, he discovered the center of the canvas. From this point, between the mid-1950s and 1962, his principal image was the circle or series of concentric circles exactly centered on a square canvas (see colorplate 247). Since this relation of circle to square was necessarily ambiguous, about 1963 he began to experiment with different forms, first ovoid shapes placed above center,

and then meticulously symmetrical chevrons starting in the upper corners and coming to a point in the exact center of the bottom edge. These chevrons, by their placing as well as their shape, gave a new significance to the shape of the canvas and created a total harmony in which color and structure, canvas plane and edges are integrated.

Since 1964, working within personally defined limits of color and shape relationships, Noland has systematically expanded his vocabulary. The symmetrical chevrons were followed by asymmetrical examples (colorplate 255). Long, narrow paintings with chevrons only slightly bent led to a series in which systems of horizontal strata were explored, sometimes with color variations on identical strata, sometimes with graded horizontals (*Graded Exposure*, 1967, colorplate 256).

Both for his own qualities and to illustrate the range of this new abstraction, mention must be made of another artist associated with color-field painting, Al Held (b. 1928). He is one of the strongest of the new abstractionists both in his forms and in his use of color; but, unlike most of the other color-field painters who eliminate brush strokes and paint texture, Held builds up his paint to a massive over-all texture that adds to the total sense of weight and rugged power. He works over his paint surfaces, sometimes building them to a thickness of an inch, although since 1963 he has sanded down the surface to a machine precision. The powerful impact of the heavy pigment remains, however, central to the artist's intent. For a period in the 1960s, Held based paintings on letters of the alphabet (*The Yellow X, The Big N.*). In these, again, the open portions of the letters were subordinated to a minimum, to hold the edges of the canvas and establish the sense of great scale.

If the flat, unmodulated or the thinly stained paint surface is a criterion of color-field painting, Held should not really be associated with this direction. He is concerned with scale as a basic expressive end—not vast scale which simply crushes the spectator, but scale which may awe him, yet at the same time enlarges the human scale. The scale he seeks is not that of Rothko, who wishes to achieve a sense of intimacy in his large canvases by absorbing the spectator into them; Held's massive paint surface is like a wall that makes of the painting something akin to an architectural wall or a great relief sculpture. It is in this emphasis on the painting as an object, a reality in itself rather than an illusion of anything else, that Held considers himself a realist. The search for this kind of reality has, of course, been the quest of every serious abstract (or concrete) artist in the history of modern art. In his attempt to achieve this total reality by emphasizing the physical reality of the paint itself, the medium from which the painting is made, Held in a sense is going back to the very beginnings of modern art, to Gustave Courbet, who also insisted on the reality of the painting as an object, the reality of its surface, and the reality of the paint (*Ivan the Terrible,* 1961, fig. 1113).

The variety of color-field painting is again illustrated in a comparison of Kenneth Noland with Jules Olitski (b. 1922, Russia). Noland's work evinces a specific intellectual approach: as he successively examines circle, chevron, diamond, or stripe motifs, it is at times as though he is deliberately setting himself series of related problems.

1112. ELLSWORTH KELLY. *Orange and Green.* 1966.
88 x 65″. Sidney Janis Gallery, New York

Olitski, on the other hand, particularly in paintings of the late 1960s, seems to be a man of romantic sensibility reacting to the pure sensuousness of his large, assertive color areas. In earlier works he, like so many of his contemporaries, explored circle forms, but his were generally irregular, off-center, interrupted by the frame of the picture to create vaguely organic effects reminiscent of Arp. Moving away from these forms he began, about 1963, to saturate his canvas with liquid paint, over which he rolled additional and varying colors. In later works, he sprayed on successive layers of color in an essentially commercial process that yet admitted of a considerable degree of accident in surface drips and spatters. The dazzling, varied areas of paint are defined by edges or corners and sometimes internal spots of roughly modeled paint that control the seemingly limitless surfaces (colorplate 257). Sometimes apparently crude and coloristically disturbing, Olitski's flamboyant recent works are nevertheless hypnotic in their impact.

## THE SHAPED CANVAS

The search for new forms and expressive means has led painters of the 1960s into a number of experiments, some of which are probably only bypaths, while some may have considerable significance for the future. We have referred frequently to the tendency toward synthesis of the arts that has marked much of recent painting and sculpture. Happenings, developed by artists, are actually a form of theater, at times involving dance and music as well as characteristics derived from painting or sculpture. Sculptured tableaux, such as those of George Segal, are also closely related to theater. Kinetic and optical art as well as minimal art often break down or blur the distinctions between painting and sculpture.

Another new form of the 1960s, the so-termed shaped canvas, would also seem at first exposure to represent a synthesis of painting and sculpture. Yet, this is not actually the case. Although the traditional shape of a painting throughout history has been a flat rectangle, other shapes such as the square, diamond, tondo, or cross have also been used. The gothic frames of medieval or early Renaissance altarpieces resulted in irregular shapes with pointed tops and wings that could be placed at right angles to the wall. Other irregular shapes such as the oval or the quatrefoil emerged in Baroque or Rococo paintings. In modern painting there has been surprisingly little experiment with the actual shape of the painting until recent times. Jackson Pollock painted some extremely long, narrow, horizontal works and, in the early 1950s, Barnett Newman made some tall vertical paintings only a few inches wide, as though he were detaching and isolating his stripe as a separate presence.

As Alloway has noted, the different painters now experimenting with shaped canvas arrived at these forms by different routes. In all of them, however, the painting, although it may involve considerable three-dimensional projection, is still a painted surface, and characteristically attached to a wall. Frank Stella (b. 1936), one of the youngest and most talented of the artists associated with the new American painting, first gained wide recognition with a number of works exhibited by the Museum of Mod-

1113. AL HELD. *Ivan the Terrible*. 1961.
Acrylic on canvas, 12' x 9' 6".
André Emmerich Gallery, New York.

ern Art, New York, in 1960, in one of its periodic group shows of American artists—in this case entitled "Sixteen Americans." The paintings shown there were principally large, vertical rectangles, with an absolutely symmetrical pattern of light lines forming regular, spaced rectangles radiating inward from the canvas edge to the cruciform center (*Quathlamba*, 1964, fig. 1114). These paintings, in their balanced symmetry and repetition of identical motifs, were related to experiments by minimal or primary structure sculptors, such as Donald Judd (colorplate 258). They had, however, a magical and compelling power of their own. Over the next few years, using copper or aluminum paint, the artist explored different shapes for the canvas, which were suggested by his rectilinear pattern. The first element in such a repeated pattern became a notch in the canvas. This developed into U-shaped or L-shaped canvases in which the canvas became a sort of frame around the blank wall. In these, Stella used heavy framing edges which gave a particular sense of object solidity to the painting. After some explorations of more coloristic rectangular patterns with at times optical effects, Stella, about 1967, turned to brilliantly colored shapes, interrelating semi-circles with rectangular or diamond effects. These works sometimes suggest abstract triptychs, with their circular tops recalling later Renaissance altarpieces.

Other artists who have played variations on the shaped canvas are Neil Williams (b. 1934), Charles Hinman (b.

*above:* 1114. FRANK STELLA. *Quathlamba.* 1964. Metallic powder in polymer emulsion on canvas, 6′ 5″ x 13′ 7″. Collection Mr. and Mrs. Carter Burden, Jr.

*below left:* 1115. NEIL WILLIAMS. *Rollin Stoned.* 1966. Mixed mediums on canvas, 8 x 9′. André Emmerich Gallery, New York

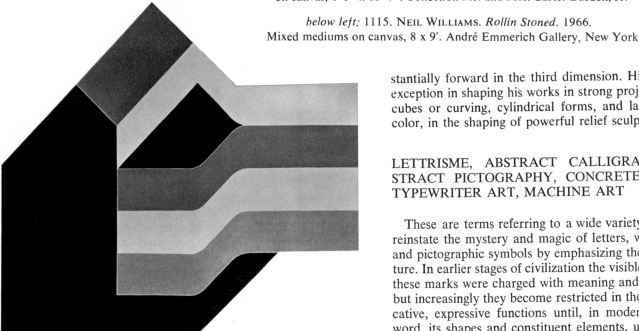

1932), Sven Lukin (b. 1934, Latvia), and Richard Smith (b. 1931, England). All of them may be related specifically to the tradition of hard-edge painting, with their precision of surfaces and edges. Williams (fig. 1115) moved from parallelogram images to the use of the parallelogram and invented shapes for the canvas. Lukin uses long, regular curving shapes that create a sense of outward flow in his canvases. Smith uses violent, jagged edges on his canvases which lend them a particular expressive effect (colorplate 259). In all these artists, with the exception of Hinman( colorplate 260), it should be noted that the variations in the shape of the canvas are essentially on the two-dimensional plane. The pictures do not project sub-

stantially forward in the third dimension. Hinman is the exception in shaping his works in strong projection, using cubes or curving, cylindrical forms, and large areas of color, in the shaping of powerful relief sculptural effects.

## LETTRISME, ABSTRACT CALLIGRAPHY, ABSTRACT PICTOGRAPHY, CONCRETE POETRY, TYPEWRITER ART, MACHINE ART

These are terms referring to a wide variety of efforts to reinstate the mystery and magic of letters, words, verbal and pictographic symbols by emphasizing their visual nature. In earlier stages of civilization the visible forms of all these marks were charged with meaning and significance; but increasingly they become restricted in their communicative, expressive functions until, in modern times, the word, its shapes and constituent elements, usually serves only as a strictly verbal mode of address. It has all but surrendered its visual or aesthetic force in conveying meaning.

Calligraphy ("beautiful writing") has always been a major art, especially in Oriental cultures. In its essential nature it is as much a visual art as it is verbal, in the sense of conveying personal feelings through the action of the hand and an instrument or medium. The total message is conveyed, so to speak, both visually and verbally. Of typography, also, somewhat the same thing may be said, although in this case mechanical limitations of type founding, type composition, and printing come into play.

Words, emblems, symbols, and messages, as art, include not only calligraphy and type, but also myriad other forms throughout the history of man: hieroglyphs, petroglyphs, medieval manuscript illumination, Kufic pottery, heraldic

symbols, words inscribed on Early Renaissance art, to mention but a few. More recently, the British arts-and-crafts movement and art nouveau have incorporated words and messages as an integral part of the pictorial structure of painting. To cubists, futurists, dadaists, constructivists, and collagists in the twentieth century, words and letters were a basic ingredient, and one thinks of works by Picasso, Braque, Carrà (see colorplate 92), Schwitters, Klee, Duchamp, Demuth, Stuart Davis, Jasper Johns, and Larry Rivers in this connection.

The closest approach to the present-day forms of artistic expression under what may be called "word-art" was dadaism. As part of their anarchic, nihilistic program was the intention to strip words of meaning or, at the very least, to reduce them to infantile babbling and set them in fresh and startling arrangements. But, as almost always happens, one attitude leads to its opposite, in this case forcing a new and highly discriminating examination of the fiber and fabric of words—and presently dadaists were creating strangely fascinating word-images. (It should be remembered that James Joyce and Gertrude Stein, in their different ways, were also re-examining the nature of words at that time; and later the American poet E. E. Cummings created daring forms of poetry and poetry printing.)

The distinctive quality of today's word-art is that strictly verbal meanings are secondary—when, indeed, there are meanings at all. In these forms of experiment, words, letters, or phrases are usually elusive: they may be no-sense, nonsense, cryptic, or rebus-like—and sometimes they are clear and "readable." The word-images are painted on canvas (the letters or graffiti-like scribbles are the only subject matter), or they may be printed, written, typwritten, or evolved from duplicating processes. Sometimes they employ collage, sometimes embossing or transparency. Pure word-art—that is, word-art unadulterated by pictorial imagery—is much more common in Europe than in the United States. Among notable European names may be mentioned Isidore Isou (b. 1925, Rumania); Dieter Rot (b. 1925), Ferdinand Kriwet (b. 1942; fig. 1116), Josua Reichert (b. 1937), Rolf-Gunther Dienst (b. 1939), and Winfred Gaul (b. 1928), all from Germany; John Furnival (b. 1933, London), Dom Sylvester Houedard (b. 1924, Guernsey), and Anton Heyboer (b. 1924, Indonesia; fig. 1117). In South America, Eugen Gomringer (b. 1925, Bolivia) and the Noigandres group of Brazil. In the United states, Emmett Williams (b. 1925), Ulfert Wilke (b. 1907, Germany; fig. 1118), Jasper Johns, Robert Rauschenberg, Allan Kaprow, and Chryssa, who uses neon tubes.

Concrete poetry differs from most other forms of word-art in that the primary emphasis of the creator is somewhat more on the verbal meanings and word- or letter-sounds than on visual appearance; but the latter is still so impor-

*below left:* 1116. FERDINAND KRIWET. *Rundscheibe Nr. XIII: Wen Labal Wen.* Graphic design, diameter 23¾".
Private collection, New York

*below right:* 1117. ANTON HEYBOER. *Lesbian.* 1964. Etching, 39¾ x 25⅝". Private collection, New York

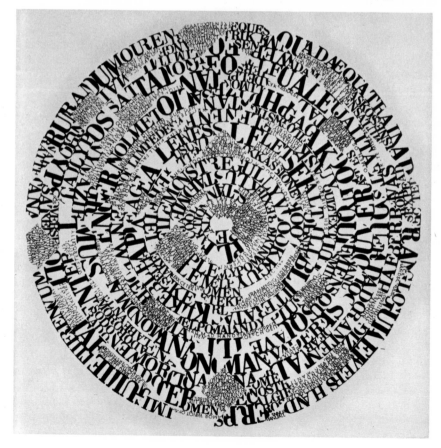

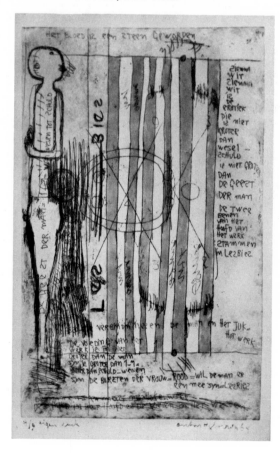

tant that it alone would distinguish concrete poetry from
other poetry.

## EROTIC ART

Sensuality, eroticism, and pornography have been the
more-or-less hidden commodities of art almost since its
beginnings. There is no need to discuss here the degrees of
explicitness or the intentions of the creators. Suffice it to
say that every period of art has dealt with erotic themes,
and almost all great artists have produced fine works in
this genre, ranging from disguised or mild lasciviousness
to appreciative representations of the sexual act and as-
sorted perversions. Among the things that distinguish the
spate of erotic art today is the fact that, for one thing, it
comes as another reaction to half-a-century of abstract art
that has aggressively rejected representation. Nevertheless,
with some of the artists working in this mood, abstract
elements are caused to behave erotically on canvas. On the
other hand, this form of art brings the disguised eroti-
cism of surrealist art out into the open, in paintings and
sculpture that cannot be misunderstood. Finally, eroticism
has never been so explicit while at the same time so public.
Perhaps it should be called voyeur art.

In this, erotic art recalls the theater of the absurd and
other avant-garde stage and dance performances, where
sexual acts are all but actually consummated on stage; and
four-letter-word literature of violence, perversion, and sex.
This is in no way intended to imply denigration, for artistic
expression must always be allowed to find its own paths:
time has a way of sorting things out. But this recent tend-
ency, world-wide as it is, is an actuality in modern art, and
as such it must be recognized in this book.

## PSYCHEDELIC ART

"1. Of or noting a mental state of great calm, intensely
pleasureful perception of the senses, esthetic entrancement,
and creative impetus. 2. of or noting any of the group of
drugs producing this effect, as LSD, mescaline, or psilocy-
bin." So run the definitions in the *Random House Dic-
tionary of the English Language.* Psychedelic drugs are
mind- or consciousness-altering substances and, according
to Masters and Houston (see Biblio.), these substances,
more potent than any that existed in the past, induce "ex-
periencing of states of awareness or consciousness pro-
foundly different from the usual waking consciousness,
from dreams and from familiar intoxication states. Sensory
experience, thought, emotions — awareness of self and
world — all undergo remarkable changes. Consciousness
expands to take in the contents of deep, ordinarily inac-
cessible regions of the psyche. The psychedelic artist is an
artist whose work has been significantly influenced by
psychedelic experience and who acknowledges the impact
of the experience on his work."

Art produced under the influence of drugs or from
memories of drug experience is not new. Particularly in the
late nineteenth century, painters and writers associated
with symbolism—the so-termed decadents—used drug ex-
periences as subject matter for their work. The disorienta-
tion, hypersensitivity, and transference of qualities were

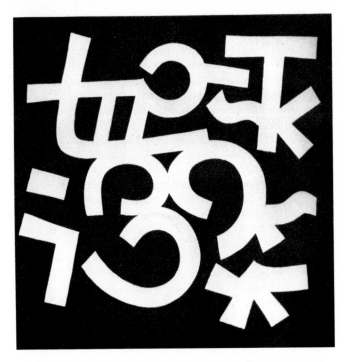

1118. ULFERT WILKE. *Rosc.* 1967. Acrylic on canvas,
70 x 68". Collection Mr. and Mrs. Milton S. Fox, New York

felt to evoke keener perceptions: new colors, strange and
dazzling lights, unknown shapes, lines that came alive with
change and movement. The art of the mentally deranged,
of certain mystics, and of disturbed children share some of
these characteristics.

The recent appearance of psychedelic art may be ac-
counted for in several ways: the easy availability and
enormously increased use of psychedelic drugs; the mixture
and confusion of appeals to several senses simultaneously
in the so-called mixed media performances; the ethos of
the hippies and flower-children; and the prevalent atmos-
phere of rebellion against "the establishment," whether in
society in general or in art specifically. Like all "new
forms" of artistic expression, psychedelic art, as though
by its own logic (or illogic?), knew where to turn for
sources of inspiration and nourishment: to the decadents
in literature and to artists like Redon, Gustave Moreau,
Aubrey Beardsley, Paul Klee, and Kandinsky, as well as
to art nouveau. The art is generally heavily figured, with
undulating, vermiculated lines, brilliant, acid colors, bursts
of bright light, and minute decoration, often of sequin-
like dots and shifts of color. Space is ambiguous, contra-
dictory, and amorphous, and results from tone and color
contrasts rather than from the conventions of linear per-
spective. Psychedelic art is world-wide in scope but seems
to have its largest practice in the United States. Some of
the artists are Isaac Abrams (b. 1939, colorplate 261),
Arlene Sklar-Weinstein (b. 1931), and Allen Atwell
(b. 1925). There could be no more striking demonstra-
tion of the variety of recent art than the contrast between
the rigors and discipline of color-field, systemic, or min-
imal art on the one hand, and on the other hand, the
surprise images of cosmic or mythic events induced by
"mind-liberating" drugs.

# Postscript

A book like this, by its very nature, cannot end—but it must stop, nevertheless. The scene changes so rapidly, and the number of artists and works of art is so vast, that legitimate generalizations or conclusions on exactly what is happening become almost impossible. But, still, there is no aspect of art historical research more exciting and rewarding than the study of the art of our own time. If a methodology for art history exists, this is its supreme test.

A particularly vexing problem is the recognition of achievements peculiar to individual countries or continents. With the acceleration of communications and the expansion of creative activity since mid-century, feelings now run high on this question. Until 1940 the problem was relatively simple. Paris was the center of the artistic universe and even movements like Italian futurism, German expressionism, Dutch De Stijl, or Russian constructivism took their points of departure from Paris. But since World War II, the United States, Japan, and Latin America have become major forces; Canada, Australia, Yugoslavia, Poland, and many other countries have ceased to be satellites. In recognition of this momentarily changing situation, the last sections of this book have been organized according to topic rather than country or artist. A glance at the Contents will make this clear.

The attempt has been made to balance and distribute the commentary so that too much emphasis is not placed on any single country. Thus, for instance, recent tendencies in motion and light, in optical art, and in figure and fantasy are treated principally in terms of European developments, while color-field painting is discussed largely in terms of American examples. It must be recognized that this distribution is arbitrary, because these movements are practiced everywhere in the world even though at a particular moment they may seem to be heavily concentrated in a given country.

In the last section, on American color-field painting, recent developments are charted according to a number of exhibitions which were influential in defining progress and attitudes at a given moment. The listing of such exhibitions could have been extended indefinitely on a world-wide basis. Of particular interest today are the international exhibitions which document and comment on current art. Of these, the most venerable is the Venice Biennale, founded in 1895, and comparable in prestige are the São Paulo Bienal and the Pittsburgh Biennial. The Guggenheim Museum has held its International Awards (now the Guggenheim International Exhibition) since 1956; and there are also international exhibitions in Paris and Tokyo. The Documenta quadrennial, in Kassel, Germany, is one of the most effective and best organized. Different from the large internationals at Venice and São Paulo, it is selected by one professional jury rather than by separate national juries. A survey of the contents of the 1968 version will suggest the international nature of painting and sculpture toward the end of the 1960s. Previous Documenta exhibitions had included a historical section on earlier modern art, but this was abandoned in favor of a special study of current American art. This seemingly innocent gesture on the part of the judges excited intense controversy among European artists, many of whom withdrew or threatened to withdraw in protest. Although other countries presumably will be featured in subsequent shows, the controversy illustrates the nationalism among artists —or, at least, their resentment of attention to America— despite the essentially international state of contemporary art. To demonstrate this internationalism, a few of the artists not included in this book but exhibited in Documenta are listed, selected almost at random, with their countries and the categories in which they might be included: Carl Andre (b. 1935, United States), primary structure; Ben Berns (b. 1936, Netherlands), light and primary structure; Joseph Beuys (b. 1921, Germany), constructivism, environmental sculpture; Antonio Calderara (b. 1903, Italy), color-field painting; Jorge Castillo (b. 1933, Spain), fantasy; Rupprecht Geiger (b. 1908, Germany), concrete art, hard-edge; Klaus Geldmacher (b. 1940, Germany) and Francesco Mariotti (b. 1943, Switzerland), light construction; Domenico Gnoli (b. 1933, Italy), pop art; Erich Hauser (b. 1930, Germany), primary structure; Utz Kampman (b. 1935, Germany), primary structure; Jiři Kolar (b. 1914, Czechoslovakia), fantasy; Thomas Lenk (b. 1933, Germany), primary structure; Francesco Lo Savio (1935–1963, Italy), color-field painting; Christian Megert (b. 1936, Switzerland), figure and fantasy; Walter Pichler (b. 1935, Austria), figure and fantasy; Sol Lewitt (b. 1923, United States), primary structure; Per Olof Ultvedt (b. 1927, Sweden), motion; Carel Nicholass Visser (b. 1928, Netherlands), constructivism, primary structure.

Although this list is in no sense complete, the distribution illustrates the wide dispersal of tendencies such as primary structures or minimal art at the end of the 1960s. The Documenta exhibitions and other great international shows are less important for searching out the newest developments as for literally *documenting* the chief directions of the past few years: While an individual international exhibition may present a distorted view because of the prejudices of individual or national juries, these internationals, taken together over a few years, give a fairly accurate picture of the current scene in painting, sculpture, and the graphic arts.

The revolution of modern art was, as we have seen, primarily a revolution in perception, won first by certain artists and then (much more gradually) by spectators of art. Although the battle is over, the revolution has not been completely won even after one hundred years. The academies of art and architecture, devoted to the perpetuation of ancient and Renaissance ideals, have steadily opposed the experimental artist or architect, and these academies are still alive.

It must be acknowledged, however, that the French academies and official art institutions, despite their bureaucracy and excessive conservatism, nevertheless were the force that maintained French supremacy in the world of art. For not only did they see to it that art was supported and encouraged by the government, but they also established a tradition of salons for the regular display of art; and for decades artists had no other way of presenting their works to the public.

Following this acknowledgment, it must be made clear that it was the rigidity and intolerance of the art acade-

mies in the middle of the nineteenth century that drove the experimental artists to seek other solutions. Opposition to the standardized curriculum of the Ecole des Beaux-Arts led painters like Delacroix and Courbet, and later, Monet, Pissarro, and Cézanne, to frequent the Académie Suisse, a free academy in which there were no lessons. Only a model was provided. Thus the experimental artists were drawn together by their opposition, became acquainted, and were strengthened by their association.

It is doubtful if Cézanne, or Gauguin, or Van Gogh would have painted very differently if they had studied at the Ecole des Beaux-Arts and been given free access to the exhibition salons. Their exclusion, nevertheless, inevitably drove them to more intensive exploration of the problems which they had initially set for themselves. Throughout history there are examples of artists who painted for themselves rather than for a patron. The vast majority, however, were always involved in a complex but functioning pattern of artist-patron relationships. The artist was serving a social need, whether it had church, state, or private patronage. The work of art was, in effect, the result of a collaboration between artist and patron. And it was this collaboration which the academic artists destroyed in their extreme effort to protect it. The avant-garde painter or sculptor in the nineteenth century had no alternative but to paint for himself, to explore problems of form or subject, which artists had always been concerned with, but which now were isolated and examined with a more specialized intensity than ever before. This led, seemingly inevitably, from Courbet, Manet, and the impressionists, to Cézanne or Seurat, to Picasso, Braque, and the cubists, to Mondrian and pure abstraction. From Van Gogh, Gauguin, Redon, and the symbolists stemming back to Delacroix's romanticism, emerged the wings of expressionism, and fantasy, dada, surrealism, and their offshoots. In discussing causes and influences it must not be forgotten that the moment seems to have produced a number of artists who at any period in history would have been geniuses. It is only that the time and circumstances, principally adverse, forced them to follow their own highly personal destinies.

The creative architects had an even more difficult time than the painters and sculptors. Since architecture demands a considerable expenditure of money, architects even today have problems in selling new ideas to their clients. While our account of architecture in the early twentieth century, since it concentrates on the new concepts, might give the impression that these dominated the scene, this was far from the case. The vast majority of buildings, public and private, followed the academic tradition in a more or less vulgarized form. Even those experimental buildings which have won acceptance in the mid-century have tended to be turned into academic clichés of modernism. Aspects of academic training did have some positive results. As early as the eighteenth century there were attempts within the academies to establish integrated programs in arts-and-crafts. A direct line can be traced from these, through the English arts-and-crafts movement and art nouveau, to the program of the Bauhaus in the 1920s, with its notable consequences for subsequent developments in modern architecture and industrial, product, and graphic design.

When we view modern art and architecture in the latter part of the twentieth century, more than a hundred years after its inception, many questions arise concerning its continuing originality, its vitality, its modernism. As has been pointed out frequently throughout the text, there is no question that the pioneers of the late nineteenth and early twentieth centuries made the great breakthrough, in effect establishing almost all the vocabularies for the continuing patterns of art and architecture. One may except a few movements such as abstract expressionism in the 1940s and 1950s, which actually has little to do with Kandinsky's original version. In architecture there have recently been developments, particularly in the areas of engineering and new materials, which go beyond the efforts of the pioneers. To say this is not to denigrate or dismiss the work of young artists or architects of our own day. It would be possible to contend that there was no essential originality in European art from the early Renaissance at the beginning of the fifteenth century, through the next four centuries. The basic vocabulary was the same; but no one could deny that the variations played by the Baroque, the Rococo, and even neo-classicism, constituted developments of that vocabulary beyond the dreams of its originators.

In the same way, in the later twentieth century, artists, still working within the traditions of cubism, abstraction, dadaism, or surrealism, have immensely enlarged the possibilities of these traditions, sometimes to the point—as in pop art, or primary structures, or color-field painting—where they may have created a new vocabulary. There are also, today, many new factors that are immensely important for the future, particularly the wide acceptance of every sort of avant-garde experiment by patrons and the public at large. It is dangerous when art can be dominated by fashions, but essentially it is a very good thing in that it gives the artist freedom to experiment on a scale unparalleled in history. In this lies the hope of the future.

# *BIBLIOGRAPHY*

Since this is a general book, not intended for the specialist, it was not deemed necessary to list all sources or background material. Books and museum or gallery catalogues have been pruned to a manageable list. With a few exceptions, periodical literature is not included, though it should be emphasized that as we approach our own day, periodical articles on contemporary artists and current movements become increasingly important. Most periodical literature will be found listed in *The Art Index,* available in any library.

The bibliography is organized as follows:

I. *General.* This is a list of books, informal rather than comprehensive, on literature, aesthetics, philosophy, and cultural history—essays and interviews—which I have found useful as background material.

II. *Dictionaries and Encyclopedias*
III. *Architecture, Engineering, and Design*
IV. *Painting and Sculpture*
   A. Movements (chronologically, by category; alphabetically, within each category)
   B. Countries
V. *Artists and Architects*

With the exception noted, the arrangement is alphabetical.

ABBREVIATIONS

P. General works available in Paperback
E.C. Exhibition Catalogue
B. Contains important recent bibliography. In addition, most of the listed museum exhibition catalogues have extensive bibliographies.
   MOMA. Museum of Modern Art, New York
   SRGM. Solomon R. Guggenheim Museum, New York
   WMAA. Whitney Museum of American Art, New York
   d.m.a. Documents of Modern Art, ed. by Robert Motherwell
Works cited here are in English, except for important sources, catalogues, and documents that are as yet untranslated.

## I. GENERAL

ARNHEIM, R. *Art and Visual Perception.* Berkeley-Los Angeles, 1954. P.
ASHTON, D. *The Unknown Shore.* New York, 1962.
BALAKIAN, A. *The Symbolist Movement.* New York, 1967. P.
BARNES, A. *The Art in Painting.* 3rd ed., rev. New York, 1937.
BARNES, H. E. *An Intellectual and Cultural History of the Western World.* 3 vols. New York, 1965. P.
BAUDELAIRE, C. *The Mirror of Art.* London, 1955.
———. *Painter of Modern Life and Other Writings on Art.* London, 1964.
———. *Art in Paris, 1845–1862.* London, 1965.
BLANSHARD, F. B. *Retreat from Likeness in the Theory of Painting.* 2nd ed., rev. and enl. New York, 1949.
CLARK, K. *Ruskin Today.* Harmondsworth, 1964. P.
COLLINGWOOD, R. G. *The Principles of Art.* New York, 1958. P.
———. *Essays in the Philosophy of Art.* Bloomington, Ind., 1964. P.

COPLESTON, F. *A History of Philosophy,* 7 vols. New York, 1946–63. P.
———. *Contemporary Philosophy.* New York, 1963.
ELLMANN, R. and FEIDELSON, C., eds. *The Modern Tradition. Backgrounds of Modern Literature.* New York, 1965.
EVANS, M., ed. *The Painter's Object.* London, 1937.
FIEDLER, C. *On Judging Works of Visual Art.* Berkeley-Los Angeles, 1949.
FOCILLON, H. *The Life of Forms in Art.* New York, 1958. P.
FRY, R. *Vision and Design.* Harmondsworth, 1961. P.
———. *Last Lectures.* Boston, 1962. P.
GILSON, E. *Painting and Reality.* New York, 1957. P.
GOETHE, J. W. VON. *Theory of Colours.* London, 1940.
GOLDWATER, R. *Primitivism in Modern Art.* New York, 1967. P.
——— and TREVES, M. *Artists on Art.* New York, 1945.
GREENBERG, C. *Art and Culture.* Boston, 1961.
HALL, J. B. and ULANOV, B., eds. *Modern Culture and the Arts.* New York, 1967.
HAUSER, A. *The Social History of Art.* 4 vols. New York, 1957. P.
HERBERT, E. W. *The Artist and Social Reform. France and Belgium, 1885–1898.* New Haven, Conn., 1961.
HERBERT, R. L., ed. *The Art Criticism of John Ruskin.* New York, 1964. P.
———, ed. *Modern Artists on Art.* Englewood Cliffs, N. J., 1964. P.
HILDEBRAND, A. VON. *The Problem of Form in Painting and Sculpture.* New York, 1907.
HOLT, E. G., ed. *A Documentary History of Art.* 2 vols. New York, 1957–58. P.
———, ed. *From the Classicists to the Impressionists: Art and Architecture in the Nineteenth Century.* Vol. 3. Readings. New York, 1966. P.
JANSON, H. W. *History of Art.* New York, 1962.
KAPLAN, A. *The New World of Philosophy.* New York, 1961. P.
KEPES, G. *The New Landscape in Art and Science.* Chicago, 1956.
———. *Education of Vision.* New York, 1965.
———. *The Nature and Art of Motion.* New York, 1965.
———. *Structure in Art and in Science.* New York, 1965.
———. *The Man-Made Object.* New York, 1966.
———. *Module, Proportion, Symmetry, Rhythm.* New York, 1966.
———. *Sign, Image, Symbol.* New York, 1966.
KUH, K. *The Artist's Voice.* Interviews. New York, 1962.
LANGER, S. *Philosophy in a New Key.* New York-Toronto, 1951. P.
———. *Feeling and Form.* New York, 1956.
———. *Reflections on Art.* New York, 1961. P.
LEMAITRE, G. *From Cubism to Surrealism in French Literature.* Cambridge, Mass., 1947.
LIBERMAN, A. *The Artist in His Studio.* New York, 1960.
NEWHALL, B. *The History of Photography.* New York, 1964.

PALMER, R. R. and COLTON, J. *A History of the Modern World.* New York, 1965.

PEVSNER, N. *Academies of Art. Past and Present.* London, 1940.

PHILIPSON, M., ed. *Aesthetics Today.* Cleveland-New York, 1961.

POLLACK, P. *The Picture History of Photography.* New York, 1958.

READ, H. *The Philosophy of Modern Art.* London, 1952. P.

——. *Art Now.* Rev. ed. New York, 1960.

RODMAN, S. *Conversations with Artists.* New York, 1957. P.

ROSENBERG, H. *The Tradition of the New.* New York, 1959. P.

RUSSELL, B. *A History of Western Philosophy.* New York, 1945. P.

RUTTER, F. *Evolution in Modern Art.* London, 1926.

SYPHER, W. *Rococo to Cubism in Art and Literature.* New York, 1960. P.

VALERY, P. *Aesthetics.* Vol. 13 of *Collected Works.* New York, 1964.

——. *Selected Writings.* New York, 1964.

VENTURI, L. *History of Art Criticism.* New York, 1964. P.

WILLIAMS, N. *Chronology of the Modern World. 1763 to the Present Time.* New York, 1967.

WORRINGER, W. *Abstraction and Empathy.* Cleveland-New York, 1967. P.

*The Academy.* Art News Annual XXXIII. New York, 1967.

## II. DICTIONARIES AND ENCYCLOPEDIAS

BENEZIT, E. *Dictionnaire critique et documentaire des peintres, sculpteurs, dessinateurs et graveurs.* 8 vols. Paris, 1948–55.

CUMMINGS, P. *Dictionary of Contemporary American Artists.* New York, 1966.

EDOUARD-JOSEPH, R. *Dictionnaire biographique des artistes contemporains, 1910–1930.* 3 vols. Paris, 1930–36 and suppl. 1936.

FLEMING, J., HONOUR, H., and PEVSNER, N. *The Penguin Dictionary of Architecture.* Baltimore, 1966. P.

HATJE, G., ed. *Encyclopedia of Modern Architecture.* New York, 1964.

HUYGHE, R., ed. *Larousse Encyclopedia of Modern Art from 1800 to the Present Day.* London, 1965.

LAKE, C. and MAILLARD, R., eds. *Dictionary of Modern Painting.* 2nd ed. New York, 1964.

MAILLARD, R., ed. *Dictionary of Modern Sculpture.* New York, 1960.

SEUPHOR, M. *Dictionary of Abstract Painting, Preceded by a History of Abstract Painting.* New York, 1958.

THIEME, U. and BECKER, F., eds. *Allgemeines Lexikon der bildenden Künstler.* 37 vols. Leipzig, 1907–50.

VOLLMER, H. *Allgemeines Lexikon der bildenden Künstler des XX. Jahrhunderts,* 5 vols. and suppl. Leipzig, 1953–62.

*Encyclopedia of World Art.* 15 vols. New York, 1959–68.

## III. ARCHITECTURE, ENGINEERING, AND DESIGN

ANDREWS, W. *Architecture, Ambition and Americans.* New York, 1955.

BACON, E. N. *Guide to Modern Architecture.* Princeton, N. J., 1963.

——. *Design of Cities.* New York, 1967.

BANHAM, R. *Theory and Design in the First Machine Age.* London, 1960.

——. *The New Brutalism.* New York, 1966.

*Bauhausbücher.* 14 vols. Munich, 1925–26.

BEHRENDT, W. C. *Modern Building.* New York, 1937.

BERNIER, G. and R., eds. *The Best in 20th Century Architecture.* New York, 1965.

BESSET, M. *New French Architecture.* New York, 1967.

BILL, M. *Form: A Balance Sheet of Mid-Twentieth Century Trends in Design.* Basel, 1952.

BLAKE, P. *The Master Builders.* New York, 1960.

CANTACUZINO, S. *Great Modern Architecture.* New York, 1966.

CONDIT, C. *The Rise of the Skyscraper.* Chicago, 1952.

CONRADS, U. and SPERLICH, H. G. *The Architecture of Fantasy,* New York, 1962.

DREXLER, A. *The Architecture of Japan.* New York, MOMA, 1955. E.C.

—— and DANIEL, G. *Introduction to Twentieth-Century Design.* New York, MOMA, 1959. E.C.

ELDREDGE, H. W., ed. *Taming Megalopolis.* 2 vols. New York, 1967. P.

FLETCHER, B. *A History of Architecture on the Comparative Method.* London, 1963.

GALARDI, A. *New Italian Architecture.* New York, 1967.

GIEDION, S. *Mechanization Takes Command.* New York, 1948.

——. *A Decade of Contemporary Architecture.* 2nd ed. New York, 1954.

——. *Space, Time, and Architecture.* 4th ed., enl. Cambridge, Mass., 1963.

HAMILTON, G. H. *The Art and Architecture of Russia.* Harmondsworth, 1954.

HAMLIN, T. F. *Forms and Functions of Twentieth Century Architecture.* 4 vols. New York, 1952.

HATJE, G., HOFFMANN, H., KASPAR, K. *New German Architecture.* New York, 1956.

HEYER, P. *Architects on Architecture.* New York, 1966.

HILBERSEIMER, L. *The Nature of Cities.* Chicago, 1955.

HITCHCOCK, H.-R. *Latin American Architecture Since 1945.* New York, MOMA, 1955. E.C.

——. *Architecture: Nineteenth and Twentieth Centuries.* 2nd ed. Baltimore, 1963. B.

—— and DREXLER, A. *Built in U.S.A.: Post-War Architecture.* New York, MOMA, 1952. E.C.

—— and JOHNSON, P. *The International Style.* New York, 1966.

HULTEN, B. *Building Modern Sweden.* Harmondsworth, 1951.

JENSEN, R. *High Density Living.* New York, 1966.

JOEDICKE, J. *A History of Modern Architecture.* New York, 1959.

KASPAR, K. *New German Architecture.* New York, 1956.

KULTERMANN, U. *New Architecture in the World.* New York, 1965.

LAVEDAN, P. *Histoire de l'urbanisme.* Vol. 3. Paris, 1952.

MADSEN, S. T. *Sources of Art Nouveau.* New York, 1956.

MARSCHALL, W. *Contemporary Architecture in Germany.* New York, 1962.

MEEKS, C. L. V. *The Railroad Station.* New Haven, Conn., 1956.

MILLON, H. A., ed. *Key Monuments of the History of Architecture.* New York, 1965.

MOCK, E. B. *Built in U.S.A. 1932–1944.* New York, MOMA, 1944. E.C.

MUMFORD, L. *The Culture of Cities.* New York, 1938.

——. *The Brown Decades.* New York, rev. 1955.

——. *Sticks and Stones.* New York, rev. 1955.

——. *Technics and Civilization.* New York, 1963.

——. *Roots of Contemporary American Architecture.* New York, 1952. P.

PETER, J. *Masters of Modern Architecture.* New York, 1958.

PEVSNER, N. *Pioneers of Modern Design.* Baltimore, 1965. P.

READ, H. *Art and Industry.* Bloomington, Ind., 1961. P.

RICHARDS, J. M. *Modern Architecture.* Baltimore, 1963. P.

RUDOFSKY, B. *Architecture Without Architects.* New York, MOMA, 1964. E.C.

SCHUYLER, M. *American Architecture and Other Writings.* New York, 1964. P.

SCULLY, V. J. *The Shingle Style.* New Haven, Conn., 1955.
SHARP, D. *Modern Architecture and Expressionism.* New York, 1967.
SIEGEL, A., ed. *Chicago's Famous Buildings.* Chicago, 1965. P.
SILVER, N. *Lost New York.* New York, 1967.
SMITH, G. E. K. *Sweden Builds.* London, 1950. P.
———. *Switzerland Builds.* London, 1950. P.
———. *Italy Builds.* New York, 1955. P.
———. *The New Architecture of Europe.* Cleveland-New York, 1961. P.
TUNNARD, C. *City of Man.* New York, 1953.
———. *American Skyline.* Boston, 1955.
——— and PUSHKAREV, B. *Man-Made America: Chaos or Control?* New Haven, Conn., 1963.
ZEVI, B. *Towards an Organic Architecture.* London, 1950.
———. *Storia dell'Architettura Moderna.* 3rd ed., rev. Turin, 1955.
*Twentieth-Century Engineering.* New York, MOMA, 1964. E.C.
*The New City: Architecture and Urban Renewal.* New York, MOMA, 1967. E.C.
*Denmark.* Architectural Review, CIV, 1948. Special issue on Danish architecture.
*10 Italian Architects.* Los Angeles County Museum of Art, 1967. E.C.
*USA Architecture.* Zodiac, No. 17. Ivrea, Italy, 1967.

## IV. PAINTING AND SCULPTURE

### A. MOVEMENTS

#### 1. Nineteenth- and Twentieth-Century Painting and Sculpture

ARNASON, H. H. *Modern Sculpture from the Joseph H. Hirshhorn Collection.* New York, SRGM, 1962. E.C., B.
BARR, A. H., JR., ed. *Masters of Modern Art.* New York, 1954. Survey of the collections in The Museum of Modern Art, New York.
BELL, C. *Since Cézanne.* New York, 1922.
CANADAY, J. *Mainstreams of Modern Art.* New York, 1959.
DENIS, M. *Théories, 1890–1910.* 4th ed. Paris, 1920.
DORIVAL, B. *Twentieth Century Painters.* 2 vols. New York, 1958.
DREIER, K. and others. *Collection of the Société Anonyme.* Yale University Art Gallery, New Haven, Conn., 1950.
GIEDION-WELCKER, C. *Contemporary Sculpture: An Evolution in Volume and Space.* Rev. and enl. ed. New York, 1961. B.
HAFTMANN, W. *Painting in the Twentieth Century.* 2 vols. New York, 1965. P.
HAMILTON, G. H. *Painting and Sculpture in Europe, 1880 to 1940.* Baltimore, 1967. P.
HOFMANN, W. *Die Plastik des 20. Jahrhunderts.* Frankfurt-am-Main, 1958.
———. *The Earthly Paradise: Art in the Nineteenth Century.* New York, 1961.
McCURDY, C. *Modern Art, a Pictorial Anthology.* New York, 1958. B.
NOVOTNY, F. *Painting and Sculpture in Europe: 1780–1880.* Baltimore, 1960. B.
OZENFANT, A. *Foundations of Modern Art.* New ed. New York, 1952. P.
RAYNAL, M. and others. *History of Modern Painting.* 3 vols. Geneva, 1949–50.
———. *Modern Painting.* New rev. ed. New York, 1960.
READ, H. *The Art of Sculpture.* New York-London, 1956.
———. *A Concise History of Modern Painting.* New York, 1959. P.
———. *A Concise History of Modern Sculpture.* London, 1964. P.

RITCHIE, A. C. *Sculpture of the Twentieth Century.* New York, MOMA, 1952. E.C.
SELZ, J. *Modern Sculpture. Origins and Evolution.* New York, 1963.
SEUPHOR, M. *The Sculpture of This Century.* New York, 1960.
TRIER, E. *Form and Space (Sculpture of the Twentieth Century).* New York, 1962.
VALERY, P. *Degas, Manet, Morisot.* Vol. 12 of *Collected Works.* New York, 1964.
VENTURI, L. *Modern Painters,* 2 vols. New York, 1947–50.
———. *Four Steps Toward Modern Art.* New York, 1956.
WRIGHT, W. H. *Modern Painting; Its Tendency and Meaning.* New York-London, 1915.

#### 2. Impressionism, Post-Impressionism, and Neo-Impressionism

DURET, T. *Histoire des peintres impressionnistes.* Paris, 1906.
HERBERT, R. L. *Neo-Impressionism.* New York, SRGM, 1968. E.C.
REWALD, J. *The History of Impressionism.* New York, 1961. B.
———. *Post-Impressionism from Van Gogh to Gauguin.* 2nd ed. New York, 1962. B.
SIGNAC, P. *D'Eugène Delacroix au néo-impressionnisme.* Paris, 1899.
VENTURI, L. *Les Archives de l'impressionnisme (Lettres de Renoir, Monet, Pissarro, Sisley et autres. Memoires de Paul Durand-Ruel. Documents).* 2 vols. Paris-New York, 1939.
———. *Impressionists and Symbolists.* New York, 1950.

#### 3. Art Nouveau and The Nabis

AMAYA, M. *Art Nouveau.* London, 1966.
CASSOU, J., LANGUI, E., and PEVSNER, N. *Gateway to the Twentieth Century.* New York, 1962.
CHASSE, C. *Les Nabis et leurs temps.* Lausanne-Paris, 1960.
HUMBERT, A. *Les Nabis et leur epoque, 1888–1900.* Geneva, 1954.
MADSEN, S. T. *Sources of Art Nouveau.* New York, 1956.
PEVSNER, N. *Art Nouveau in Britain.* London, The Arts Council, 1965. E.C.
RHEIMS, M. *L'Objet 1900.* Paris, 1964.
———. *The Flowering of Art Nouveau.* New York, 1966.
SCHMUTZLER, R. *Art Nouveau.* New York, 1964.
SELZ, P. and CONSTANTINE, M., eds. *Art Nouveau. Art and Design at the Turn of the Century.* New York, MOMA, 1959. E.C.
*Bonnard, Vuillard, et les nabis, 1888–1903.* Paris, Musée National d'Art Moderne, 1955. E.C.
*The Nabis and Their Circle.* Minneapolis Institute of Arts, 1962. E.C.

#### 4. Fauvism

APOLLONIO, U. *Fauves and Cubists.* New York, 1959.
CRESPELLE, J. P. *The Fauves.* Greenwich, Conn., 1962.
DUTHUIT, G. *The Fauvist Painters.* New York, d.m.a., 1950.
LEYMARIE, J. *Fauvism, Biographical and Critical Study.* Paris, 1959.
REWALD, J. *Les Fauves.* New York, MOMA, 1952. E.C.
*Le Fauvisme français et les débuts de l'expressionnisme allemand.* Paris, Musée National d'Art Moderne, 1966. E.C.

#### 5. Cubism

APOLLINAIRE, G. *Les Peintres cubistes; méditations esthétiques.* Paris, 1913.
———. *The Cubist Painters.* Eng. ed. New York, 1949.
BARR, A. H., JR. *Cubism and Abstract Art.* New York, MOMA, 1936. E.C.
EDDY, A. J. *Cubists and Post-Impressionists.* Chicago, 1919.
FRY, E. *Cubism.* New York, 1966. B. P.

GLEIZES, A. and METZINGER, J. *Du Cubisme*. Paris, 1912.
———. *Cubism*. Eng. ed. London, 1913.
GOLDING, J. *Cubism: A History and an Analysis, 1907–1914*. London, 1959.
GRAY, C. *Cubist Aesthetic Theories*. Baltimore, 1953.
HABASQUE, G. *Cubism. Biographical and Critical Study*. Paris-New York, 1959.
JANIS, H. and BLESH, R. *Collage*. Philadelphia-New York, 1962.
KAHNWEILER, D.-H. *The Rise of Cubism*. New York, d.m.a., 1949.
ROSENBLUM, R. *Cubism and Twentieth-Century Art*. New York; 1961. B., P.

### 6. German Expressionism

KUHN, C. L. *German Expressionism and Abstract Art. The Harvard Collections*. Cambridge, Mass., 1957.
MYERS, B. S. *The German Expressionists. A Generation in Revolt*. New York, 1957. B., P.
PFISTER, O. *Expressionism in Art; Its Psychological and Biological Basis*. London, 1922.
SAMUEL, R. and THOMAS, R. H. *Expressionism in German Life, Literature, and the Theatre (1910–1924)*. Cambridge, 1939.
SELZ, P. *German Expressionist Painting*. Berkeley, Calif., 1957. B.
ZIGROSSER, C. *The Expressionists. A Survey of Their Graphic Art*. New York, 1957.
*Le Fauvisme francais et les débuts de l'expressionnisme allemand*. Paris, Musée National d'Art Moderne, 1966. E.C.
*Painters of the Brücke*. London, The Tate Gallery, 1964. E.C.

### 7. Futurism

BRUNI, C. and DRUDI GAMBILLO, M., eds. *After Boccioni, Futurist Paintings and Documents from 1915 to 1919*. Rome, 1961.
CARRIERI, R. *Futurism*. Milan, 1963.
DRUDI GAMBILLO, M. and FIORI, T., eds. *Archivi del Futurismo*. 2 vols. Rome, 1958–62.
MARINETTI, F. T. *Das Manifest des Futurismus*. Berlin, 1912. E.C. 2nd ed., Herworth Walden, ed.
SANT'ELIA, A. *Manifesto of Futurist Architecture*. Architectural Review, CXXVI (1959).
TAYLOR, J. C. *Futurism*. New York, MOMA, 1961. E.C.

### 8. Abstraction-Constructivism

BARR, A. H., JR. *Cubism and Abstract Art*. New York, MOMA, 1936. E.C.
BIEDERMAN, C. *Art as the Evolution of Visual Knowledge*. Red Wing, Minn., 1948.
RICKEY, G. *Constructivism, Origins and Evolution*. New York, 1967. B.
SEUPHOR, M. *Construction and Geometry in Painting: From Malevitch to "Tomorrow."* New York, Galerie Chalette, 1960. E.C.
———. *Abstract Painting*. New York, 1961.

### 9. De Stijl

JAFFE, H. L. C. *De Stijl, 1917–1931. The Dutch Contribution to Modern Art*. Amsterdam, 1956.
HAMMACHER, A. M. *Mondrian, De Stijl, and Their Impact*. New York, Marlborough-Gerson Gallery, Inc., 1964. E.C.
*De Stijl*. New York, MOMA, 1961. E.C.

### 10. Bauhaus

BAYER, H., GROPIUS, W., and GROPIUS, I. *Bauhaus, 1919–1928*. 3rd ed. Boston, 1959. Based on exhibition New York, MOMA, 1938.
GROHMANN, W. *Painters of the Bauhaus*. London, Marlborough Fine Art Ltd., 1962. E.C.
PORTNER, P. *Experiment Theater. Chronik und Dokumente*. Zurich, 1960.
*Bauhausbücher*. 14 vols. Munich, 1925–26.

### 11. Dada and Surrealism

BARR, A. H., JR., ed. *Fantastic Art, Dada, Surrealism*. 2nd rev. ed. New York, MOMA, 1937. E.C. With essays by G. Hugnet.
BRETON, A. *Le Surréalisme et la peinture*. New York, 1945. Updated by his *Le Surréalisme en 1947*. Paris, Galerie Maeght, 1947. E.C.
———. *Les Manifestes du surréalisme*. Rev. ed. Paris, 1955.
FOWLIE, W. *Age of Surrealism*. Bloomington, Ind., 1960.
GASCOYNE, D. *A Short History of Surrealism*. London, 1935.
JEAN, M. *The History of Surrealist Painting*. New York, 1960.
LEVY, J. *Surrealism*. New York, 1936.
MOTHERWELL, R. *The Dada Painters and Poets: An Anthology*. New York, d.m.a., 1951.
NADEAU, M. *The History of Surrealism*. New York, 1965.
RAYMOND, M. *From Baudelaire to Surrealism*. New York, d.m.a., 1950.
READ, H. *Surrealism*. London, 1936.
RICHTER, H. *Dada, Art, and Anti-Art*. New York, 1965. P.
RUBIN, W. S. *Dada, Surrealism, and Their Heritage*. New York, MOMA, 1968. E.C.
WALDBERG, P. *Surrealism*. New York, 1965. P.
*Dada 1966–67*. Zürich, Kunsthaus, and Paris, Musée National d'Art Moderne, 1966–67. E.C.

### 12. Art in Mid-Century

ALLOWAY, L. *Guggenheim International Awards, 1964*. New York, SRGM, 1963. E.C.
———. *Systemic Painting*. New York, SRGM, 1966. E.C.
ALVARD, J. and GINDERTAEL, R. V. *Témoignages pour l'art abstrait*. Paris, Art d'Aujourd'hui, 1952. Supplemented by *Témoignages pour la sculpture abstraite* by P. Gueguen, 1956.
AMAYA, M. *Pop Art . . . and After*. New York, 1965.
ARNASON, H. H. *Abstract Expressionists and Imagists*. New York, SRGM, 1961. E.C.
BATTCOCK, G., ed. *The New Art*. New York, 1966. P.
———, ed. *Minimal Art: A Critical Anthology*. New York, 1968. P.
BAUR, J. I. H. *The New Decade: 35 American Painters and Sculptors*. New York, WMAA, 1955. E.C.
BRION, M. and others. *Art Since 1945*. New York, 1958.
FRIEDMAN, M. and VAN DER MARCK, J. *Eight Sculptors: The Ambiguous Image*. Minneapolis, Walker Art Center, 1966. E.C.
FRY, E. F. *Sculpture from Twenty Nations*. New York, SRGM, 1967. E.C.
GILSON, E. *Painting and Reality*. New York, 1957. P.
GREENBERG, C. *Post-Painterly Abstraction*. Los Angeles County Museum of Art, 1964. E.C.
HESS, T. *Abstract Painting, Background and American Phase*. New York, 1951.
HUNTER, S. and others. *New Art Around the World (Painting and Sculpture)*. New York, 1966.
KAPROW, A. *Assemblage, Environments, & Happenings*. New York, 1966.
LIPPARD, L. R. *Pop Art*. New York, 1966.
MELLOW, J. R., ed. *New York: The Art World*. New York, 1964. (Arts Yearbook 7).
MULAS, U. and SOLOMON, A. R. *New York: The New Art Scene*. New York, 1967.
PELLEGRINI, A. *New Tendencies in Art*. New York, 1966.

PONENTE, N. *Modern Painting: Contemporary Trends.* New York-Lausanne, 1960.

RITCHIE, A. C. *The New Decade: 22 European Painters and Sculptors.* New York, MOMA, 1955. E.C.

SEITZ, W. C. *The Art of Assemblage.* New York, MOMA, 1961. E.C.

————, ed. *Contemporary Sculpture.* New York, 1965. (Arts Yearbook 8).

————. *The Responsive Eye.* New York, MOMA, 1965. E.C.

SELZ, P. *New Images of Man.* New York, MOMA, 1959. E.C.

SWEENEY, J. J. *Younger American Painters: A Selection.* New York, SRGM, 1954. E.C.

————. *Younger European Painters: A Selection.* New York, SRGM, 1954. E.C.

TUCHMAN, M., ed. *New York School, The First Generation. Paintings of the 1940s and 1950s.* Los Angeles County Museum of Art, 1965. E.C. With statements by the artists and critics.

————, ed. *American Sculpture of the Sixties.* Los Angeles County Museum of Art, 1967. E.C.

*Hard-Edge.* Paris, Galerie Denise René, 1964. E.C.

*Painting and Sculpture of a Decade (54–64).* London, The Tate Gallery, 1964. E.C.

*Sculpture: A Generation of Innovation.* Art Institute of Chicago, 1967. E.C.

Bienal de São Paulo do Museu de Arte Moderna de São Paulo, from 1951.

La Biennale Internazionale d'Arte Venezia, from 1895.

Guggenheim International Awards (later, Guggenheim International Exhibition), from 1956.

International Art Exhibition of Japan, Tokyo Metropolitan Art Museum, annual 1932–35, biennial from 1935.

Pittsburgh International Exhibition of Painting and Sculpture, from 1929.

## IV. PAINTING AND SCULPTURE

### B. COUNTRIES

#### *1. Austria*

SOTRIFFER, K. *Modern Austrian Art.* New York, 1965.

#### *2. Great Britain*

HAMMACHER, A. M. *Modern English Sculpture.* New York, 1966.

RITCHIE, A. C. *Masters of British Painting, 1800–1950.* New York, MOMA, 1956. E.C.

ROBERTSON, B., RUSSELL, J., and THE EARL of SNOWDEN. *Private View: The Lively World of British Art.* London, 1965.

ROTHENSTEIN, J. *Modern English Painters.* 2 vols. London, 1952-56.

————. *British Art Since 1900. An Anthology.* London, 1962.

RUSSELL, J. *From Sickert to 1948. The Achievement of the Contemporary Art Society.* London, 1948.

*The English Eye.* New York, Marlborough-Gerson Gallery, Inc., 1965. E. C. With an introduction by R. Melville and B. Robertson.

*London: The New Scene.* Minneapolis, Walker Art Center, 1965. E.C. With essays by M. Friedman and A. Bowness.

*New British Painting and Sculpture.* Berkeley, University of California Art Museum, 1968. E.C.

#### *3. France*

DAULTE, F. *Le Dessin français de Manet à Cézanne.* Lausanne, 1954.

DORIVAL, B. *The School of Paris in the Musée D'Art Moderne.* New York, 1962.

FOCILLON, H. *La Peinture au XIXe siècle. Le Retour à l'antique. Le Romantisme. (Manuels d'histoire de l'art).* Paris, 1927.

————. *La Peinture aux XIXe et XXe siècles. Du Réalisme à nos jours (Manuels d'histoire de l'art).* Paris, 1928.

FONTAINAS, A. and VAUXCELLES, L. *Histoire générale de l'art français de la Révolution à nos jours.* Paris, 1922.

FOSCA, F. *La Peinture française au XIXe siècle.* Paris, 1956.

FRANCASTEL, P. *La Peinture française du classicisme au cubisme.* Paris, 1955.

FRIEDLAENDER, W. *David to Delacroix.* Cambridge, Mass., 1952.

GAUSS, C. E. *The Aesthetic Theories of French Artists, 1855 to the Present.* Baltimore, 1949.

GORDON, J. *Modern French Painters.* London, 1923.

HUNTER, S. *Modern French Painting, 1855–1956.* New York, 1956. P.

HUYGHE, R. *French Painting. The Contemporaries.* New York, 1939.

MARCHIORI, G. *Modern French Sculpture.* New York, 1963.

ROGER-MARX, C. *La Gravure originale en France de Manet à nos jours.* Paris, 1939.

SAN LAZZARO, G. DI. *Painting in France, 1895–1949.* New York, 1949.

SLOANE, J. C. *French Painting Between the Past and the Present.* Princeton, N. J., 1951.

WILENSKI, R. H. *Modern French Painters.* London, 1954.

*School of Paris, 1959, The Internationals.* Minneapolis, Walker Art Center, 1959.

#### *4. Germany*

LEHMANN-HAUPT, H. *Art Under a Dictatorship.* New York, 1954.

RITCHIE, A. C., ed. *German Art of the Twentieth Century.* New York, MOMA, 1957. E.C.

ROTHEL, H. K. *Modern German Painting.* New York, 1957.

THOENE, PETER [pseud.]. *Modern German Art.* London, 1938. With an Introduction by H. Read. P.

#### *5. Italy*

BALLO, G. *Modern Italian Painting from Futurism to the Present Day.* New York, 1958.

CARRIERI, R. *Avant-Garde Painting and Sculpture (1890–1955) in Italy.* Milan, 1955.

SALVINI, R. *Modern Italian Sculpture.* New York, 1962.

SOBY, J. T. and BARR, A. H., JR. *Twentieth-Century Italian Art.* New York, MOMA, 1949. E.C.

ZERVOS, C., ed. *Un Demi-Siècle d'art italien.* Paris, Cahiers d'Art (XXV, No. 1), 1950.

*Italian Sculptors of Today.* Rome, 1960. E.C. With an introduction by Lionello Venturi.

#### *6. Japan*

KUNG, D. *The Contemporary Artist in Japan.* Honolulu, 1966.

LIEBERMAN, W. S. *The New Japanese Painting and Sculpture.* New York, MOMA, 1966. E.C.

TAPIE, M. and HAGA, T. *Avant-Garde Art in Japan.* New York, 1962.

#### *7. Latin America*

MESSER, T. M. *The Emergent Decade.* New York, SRGM, 1966. E.C.

MYERS, B. *Mexican Painting in Our Time.* New York, 1956.

*New Art of Argentina.* Minneapolis, Walker Art Center, 1964. E.C.

#### *8. Russia*

GRAY, C. *The Great Experiment: Russian Art 1863–1922.* London, 1962.

HAMILTON, G. H. *The Art and Architecture of Russia.* Harmondsworth, 1954.

### 9. Scandinavia

OSTBY, L. *Modern Norwegian Painting*. Oslo, 1949.

POULSEN, V. *Danish Painting and Sculpture*. Copenhagen, 1955.

SODERBERG, R. *Introduction to Modern Swedish Art*. Stockholm, Moderna Museet, 1962. E.C.

### 10. Spain

SWEENEY, J. J. *Before Picasso; After Miró*. New York, SRGM, 1960. E.C.

*New Spanish Painting and Sculpture*. New York, MOMA, 1960. E.C.

### 11. Switzerland

*From Hodler to Klee. Swiss Art of the Twentieth Century. Paintings and Sculptures*. London, The Tate Gallery, 1959. E.C.

### 12. United States

BAUR, J. I. H. *Revolution and Tradition in Modern American Art*. Cambridge, Mass., 1951. P.

BROWN, M. W. *American Painting From the Armory Show to the Depression*. Princeton, N. J., 1955.

————. *The Story of the Armory Show*. New York, 1963.

DWIGHT, E. H. *Armory Show 50th Anniversary Exhibition 1913–1963*. Utica, New York, Munson-Williams-Proctor Institute, 1963. E.C.

GELDZAHLER, H. *American Painting in the 20th Century*. New York, 1965. Cat. coll. Met. Mus.

GOODRICH, L. and BAUR, J. I. H. *American Art of Our Century*. New York, 1961. Cat. coll. WMAA.

GREEN, S. M. *American Art: A Historical Survey*. New York, 1966.

HUNTER, S. *Modern American Painting and Sculpture*. New York, 1959.

JANIS, S. *Abstract and Surrealist Art in America*. New York, 1944.

MILLER, D. I., ed. *American Exhibitions*. New York, MOMA, 1942–current. E.C.

MOTHERWELL, R. and REINHARDT, A., eds. *Modern Artists in America*. No. 1. New York, 1951.

RITCHIE, A. C. *Abstract Painting and Sculpture in America*. New York, MOMA, 1951. E.C.

ROSE, B. *American Art Since 1900*. New York-Washington, 1967.

*American Abstract Artists 1936–1966*. New York, 1966.

*The New American Painting*. New York, MOMA, 1959. E. C. With an introduction by R. D'Harnoncourt and A. H. Barr, Jr.

*Roots of Abstract Art in America 1910–1930*. Washington, Smithsonian Institution, 1965. E.C.

*The Whitney Museum of American Art 1967 Annual Exhibition of Contemporary American Painting*. E.C. Originated as a biennial in 1933; first annual exhibition in 1937 starting with painting and alternating with sculpture.

## V. ARTISTS AND ARCHITECTS

AALTO: AALTO, A., FLEIG, K., co-ed. *Alvar Aalto. Collected Works*. Zurich, 1963.

GUTHEIM, F. *Alvar Aalto*. New York, 1960.

AGAM: REICHARDT, J. *Yaacov Agam*. New York, Marlborough-Gerson Gallery, Inc., 1966. E.C. Text based on conversation with Agam.

ALBERS: BUCHER, F. *Josef Albers: Despite Straight Lines. An Analysis of His Graphic Constructions*. New Haven, Conn., 1961.

HAMILTON, G. H. *Josef Albers. Paintings, Prints, Projects*. New Haven, Conn., Yale University Art Gallery, 1956. E.C.

ALBRIGHT: SWEET, F. *Ivan Albright: Retrospective Exhibition*. Chicago, Art Institute of Chicago and WMAA, 1964. E.C. Commentary by Jean Dubuffet.

ARCHIPENKO: ARCHIPENKO, A. and others. *Archipenko. Fifty Creative Years, 1908–1958*. New York, 1960.

ARP: ARP, H. *On My Way: Poetry and Essays, 1912–1947*. New York, d.m.a., 1948.

GIEDION-WELCKER, C. *Jean Arp*. New York, 1957. Documentation by M. Hagenbach.

READ, H. *The Art of Jean Arp*. New York, 1958.

SOBY, J. T., ed. *Arp*. New York, MOMA, 1958. E.C.

BACON: ALLOWAY, L. *Francis Bacon*. New York, SRGM, 1963. E.C.

LEIRIS, M. *Francis Bacon*. London, Marlborough Fine Arts Ltd., 1967. E.C. With an interview of Francis Bacon by David Sylvester.

BAERTLING: *Pentacle*. Olle Baertling, Oyvind Fahlström, Carl Fredrik Reuterswärd, Max Walter Svanberg, Olof Ultvedt. Paris, Musée des Arts Décoratifs, 1968. E.C.

BAIZERMAN: HELD, J. S. *Saul Baizerman*. Minneapolis, Walker Art Center, 1953. E.C.

BALLA: *Giacomo Balla*. Turin, Galleria Civica d'Arte Moderna, 1963. E.C. Documentation by E. Crispolti and M. Drudi Gambillo.

BALTHUS: PICON, G. *Balthus*. Paris, Musée des Arts Décoratifs, 1966. E.C.

SOBY, J. T. *Balthus*. New York, MOMA Bulletin, XXIV (1956–57), No. 3. E.C.

BARLACH: SCHULT, F. *Ernst Barlach*. 2 vols. Hamburg, 1958–60.

BAUMEISTER: GROHMANN, W. *Willi Baumeister. Life and Work*. New York, 1965.

BAYER: DORNER, A. *The Way Beyond "Art". The Work of Herbert Bayer*. New York, 1947.

BAZIOTES: ALLOWAY, L. *William Baziotes, A Memorial Exhibition*. New York, SRGM, 1965. E.C. With statements by the artist.

BEARDSLEY: READE, B. *Aubrey Beardsley*. New York, 1967.

BECKMANN: SELZ, P. *Max Beckmann*. New York, MOMA, 1964. E.C. Additional texts by H. Joachim and P. T. Rathbone.

BEHRENS: CREMERS, P. *Peter Behrens, sein Werk von 1900 bis zur Gegenwart*. Essen, 1928.

BERMAN: LEVY, J., ed. *Eugène Berman*. New York, 1947.

BERNARD: MORNAND, P. *Emile Bernard et ses amis*. Geneva, 1957.

BOCCIONI: BALLO, G. *Umberto Boccioni. La Vita e l'Opera*. Milan, 1964.

TAYLOR, J. C. *The Graphic Work of Umberto Boccioni*. New York, MOMA, 1961. E.C.

BONNARD: REWALD, J. *Pierre Bonnard*. New York, MOMA, 1948. E.C.

*Bonnard and His Environment*. New York, MOMA, 1964. Texts by J. T. Soby, J. Elliott, and M. Wheeler.

BOURDELLE: JIANU, I. *Bourdelle*. New York, 1966.

*Antoine Bourdelle*. New York, The Charles E. Slatkin Galleries, 1961. E.C. Texts by P. R. Adams, J. Cassou, and J. Charbonneaux.

BRANCUSI: GEIST, S. *Brancusi*. New York, 1968.

GIEDION-WELCKER, C. *Brancusi. 1876–1957*. New York, 1959.

BRAQUE: HOFMANN, W. *Georges Braque: His Graphic Work*. New York, 1961.

HOPE, H. R. *Georges Braque*. New York, MOMA, 1949. E.C.

MANGIN, N. S., ed. *G. Braque. Catalogue de l'oeuvre. Peintures. 1928–57*. Paris, 1959.

RICHARDSON, J. *G. Braque*. Greenwich, Conn., 1961.

BRAUNER: HOFMANN, W. *Victor Brauner*. Amsterdam, Stedelijk Museum, 1965–66. E.C.

BRETON: BRETON, A. *Le Surréalisme et la peinture*. New York, 1945. Updated by his *Le Surréalisme en 1947*. Paris, Galerie Maeght, 1947. E.C.

———. *Les Manifestes du surréalisme*. Rev. ed. Paris, 1955. *Homage to André Breton*. Milan, Galleria Schwarz, 1967.

BREUER: ARGAN, G. C. *Marcel Breuer*. Milan, 1955.
BLAKE, P. *Marcel Breuer: Architect and Designer*. New York, MOMA, 1949. E.C.

BROOKS: ARNASON, H. H. "James Brooks." *Art International*, March 1963.
HUNTER, S. *James Brooks*. New York, WMAA, 1963. E.C.

CALDER: ARNASON, H. H. and GUERRERO, P. E. *Calder*. Princeton, N. J., 1966.
CALDER, A. *Calder. An Autobiography with Pictures*. New York, 1966.
MESSER, T. M. *Alexander Calder. A Retrospective Exhibition*. New York, SRGM, 1964. E.C.
MULAS, U., ARNASON, H. H., eds. *Calder*. To be published, New York, 1969.
SWEENEY, J. J. *Alexander Calder*. New York, MOMA, 1951. E.C.

CARRA: CARRA, C. and others. *Le Néoclassicisme dans l'art contemporain*. Rome, 1923.
PACCHIONI, G. *Carlo Carrà*. Milan, 1959.

CEZANNE: MERLEAU-PONTY, M. "Cézanne's Doubt." *Art and Literature*, Spring 1965.
REWALD, J., ed. *Paul Cézanne. Letters*. New York, 1941.
———. *Cézanne, a Biography*. New York, 1948.
SCHAPIRO, M. *Paul Cézanne*. 3rd ed. New York, 1965.
VENTURI, L. *Cézanne. Son art, son oeuvre*. 2 vols. Paris, 1936.

CHAGALL: MEYER, F. *Marc Chagall*. New York, 1963.
MOURLOT, F. *Chagall, Lithographs*. 2 vols. New York, 1960–63.

CHILLIDA: SWEENEY, J. J. *Eduardo Chillida*. Houston, Museum of Fine Arts, 1966. E.C.

DE CHIRICO: SOBY, J. T. *Giorgio de Chirico*. New York, MOMA, 1955. E.C.

LE CORBUSIER (Charles-Edouard Jeanneret):
BOESIGER, W. *Le Corbusier & Pierre Jeanneret: Oeuvre complète*. 6 vols. Zurich, 1937–57.
CHOAY, F. *Le Corbusier*. New York, 1960.
LE CORBUSIER. *The City of Tomorrow and Its Planning*. New York, 1929.
———. *Towards a New Architecture*. 2nd ed. New York, 1946.
PAPADAKI, S., ed. *Le Corbusier: Architect, Painter, Writer*. New York, 1948.

CORNELL: PORTER, F. *Joseph Cornell*. Pasadena Art Museum, 1966–67. E.C.
WALDMAN, D. *Joseph Cornell*. New York, SRGM, 1967. E.C.

COURBET: BOAS, G. *Courbet and the Naturalistic Movement*. Baltimore, 1938.
MACK, G. *Gustav Courbet*. London, 1951.
*Courbet*. Philadelphia Museum of Art, Philadelphia, 1959. E.C.

CRAWFORD: ARNASON, H. H. *Ralston Crawford*. New York, 1963.

DALI: DALI, S. *The Secret Life of Salvador Dali*. New enl. ed. New York, 1961.
DESCHARNES, R. *The World of Salvador Dali*. New York, 1962.
GERARD, M., ed. *Dali*. New York, 1968.
SOBY, J. T. *Paintings, Drawings, Prints: Salvador Dali*. 2nd rev. ed. New York, MOMA, 1946. E.C.

*Salvador Dali 1910–1965*. New York, Gallery of Modern Art, 1965. E.C. With statement by the artist.

DAUMIER: ADHEMAR, J. *Honoré Daumier*. Paris, 1954.

DAVID: HAUTECOEUR, L. *Louis David*. Paris, 1954.

DAVIE: BOWNESS, A. *Alan Davie*. London, 1967.

DAVIS: ARNASON, H. H. *Stuart Davis*. Minneapolis, Walker Art Center, 1957. E.C.
———. *Stuart Davis. 1894–1964. Memorial Exhibition*. Washington, D. C., Smithsonian Institution, 1965. E.C.
GOOSSEN, E. C. *Stuart Davis*. New York, 1959.

DEGAS: BOGGS, J. S. *Portraits by Degas*. Berkeley, Calif., 1962.
GUERIN, M., ed. *Degas Letters*. Oxford, 1947.
LEMOISNE, P.-A. *Degas et son oeuvre*. 4 vols. Paris, 1946–48.
REWALD, J. and MATT, L. VON. *Degas. Sculpture, the Complete Works*. New York, 1956.
RICH, D. C. *Edgar-Hilaire-Germain Degas*. New York, 1951.

DELACROIX: BAUDELAIRE, C. *Delacroix, His Life and Work*. New York, c. 1927.
CASSOU, J. *Delacroix (Les demi-dieux)*. Paris, 1947.
HUYGHE, R. *Delacroix*. New York, 1963.
LASSAIGNE, J. *Eugène Delacroix*. New York, c. 1950.
WELLINGTON, H., ed. *The Journal of Delacroix*. London, 1951.

DELAUNAY: DELAUNAY, R. *Du Cubisme à l'art abstrait, documents inédits*. Paris, 1957. Edited by P. Francastel.
*Robert et Sonia Delaunay*. Ottawa, National Gallery of Canada, 1965. E.C.

DELVAUX: DE BOCK, P. A. *Paul Delvaux*. Hamburg, 1965.

DEMUTH: RITCHIE, A. C. *Charles Demuth*. New York, MOMA, 1950. E.C. With a tribute to the artist by Marcel Duchamp.

DENIS: DENIS, M. *Théories 1890–1910*. 4th ed. Paris, 1920.
———. *Journal. 1884–1943*. 3 vols. Paris, 1957–59.

DERAIN: DIEHL, G. *Derain*. New York, 1964.
SUTTON, D. *André Derain*. London, 1959.

DESPIAU: GEORGE, W. *Despiau*. New York, 1959.

DICKINSON: GOODRICH, L. *Edwin Dickinson*. New York, WMAA, 1965. E.C.

DINE: *Dine, Oldenburg, Segal*. Art Gallery of Toronto, 1967. E.C.

DIX: *Otto Dix. Gemälde und Graphik von 1912–1957*. Berlin, Deutsche Akademie der Künste, 1957. E.C.

VAN DOESBURG: DOESBURG, T. VAN. *New Movement in Painting*. Delft, 1917.
SWEENEY, J. J. *Theo van Doesburg*. New York, Art of This Century, 1947. E.C.

VAN DONGEN: *Van Dongen*. Albi, Musée Toulouse-Lautrec, 1960. E.C.

DOVE: JOHNSON, D. R. *Arthur Dove: The Years of Collage*. College Park, University of Maryland Art Gallery, 1967. E.C.
SOLOMON, A. R. *Arthur G. Dove, A Retrospective Exhibition*. Ithaca, N. Y., Andrew Dickson White Museum of Art, Cornell University, 1954.
WIGHT, F. S. *Arthur G. Dove*. Berkeley-Los Angeles, 1958. E.C. With an introduction by D. Phillips.

DUBUFFET: ALLOWAY, L. *Jean Dubuffet. 1962–66*. New York, SRGM, 1966. E.C. With statement by the artist.
PAUVERT, J.-J., ed. *Jean Dubuffet. Catalogue des travaux*. To be published, Paris.
SELZ, P. *The Work of Jean Dubuffet*. New York, MOMA, 1962. E.C. With texts by the artist.

DUCHAMP: HAMILTON, R. *Almost Complete Works of Marcel Duchamp*. London, The Tate Gallery, Arts Council, 1966. E.C.
LEBEL, R. *Marcel Duchamp*. New York, 1959. With chapters by M. Duchamp, A. Breton, and H. P. Roché.

*NOT SEEN and/or LESS SEEN of/by MARCEL DU-CHAMP/RROSE SELAVY, 1904–64.* Baltimore Museum of Art, 1965. E.C.

DUCHAMP-VILLON: PACH, W. *Raymond Duchamp-Villon, sculpteur (1876–1918).* Paris, 1924. With writings by the artist.
SWEENEY, J. J. *Jacques Villon, Raymond Duchamp-Villon, Marcel Duchamp.* New York, SRGM, 1957. E.C.
*Duchamp-Villon.* Paris, Galerie Louis Carré, 1963. E.C.
*Duchamp-Villon. Le Cheval Major.* Paris, Galerie Louis Carré, 1966. E.C.

DUFY: COGNIAT, R. *Raoul Dufy.* New York, 1962.

EIFFEL: BRESSET, M. *Gustave Eiffel, 1832–1923.* Milan, 1957.

ENSOR: HAESAERTS, P. *James Ensor.* New York, 1959.
TANNENBAUM, L. *James Ensor.* New York, MOMA, 1951. E.C.

EPSTEIN: BUCKLE, R. *Jacob Epstein, Sculptor.* London, 1963.
*J. Epstein, an Autobiography.* New York, 1955. Revised and extended version of *Let There Be Sculpture.* London, 1940.

ERNST: ERNST, M. *Beyond Painting, and Other Writings by the Artist and His Friends.* New York, d.m.a., 1948.
HUNTER, S., ed. *Max Ernst: Sculpture and Recent Painting.* New York, Jewish Museum, 1966. With introductory essays by L. R. Lippard, A. P. de Mandiargues, J. Russell and a statement by the artist.
LIEBERMAN, W. S., ed. *Max Ernst.* New York, MOMA, 1961. E.C.
RUSSELL, J. *Max Ernst, Life and Work.* New York, 1967.
WALDBERG, P. *Max Ernst.* Paris, 1958.

FAHLSTROM: *Pentacle.* Olle Baertling, Oyvind Fahlström, Carl Fredrik Reutersward, Max Walter Svanberg, Olof Ultvedt. Paris, Musée des Arts Décoratifs, 1968. E.C.

FAUTRIER: RAGON, M. *Fautrier.* New York, 1958.

FEELEY: BARO, G. *Paul Feeley: 1910–1966. A Memorial Exhibition.* New York, SRGM, 1968. E.C.

FEININGER: HESS, H. *Lyonel Feininger.* New York, 1961.
MILLER, D. I., ed. *Lyonel Feininger.* New York, MOMA, 1944. With essays by A. J. Schardt and A. H. Barr, Jr. and excerpts from the artist's letters.

FERBER: ANDERSON, W. V. *Ferber.* Minneapolis, Walker Art Center, 1962. E.C.
GOOSEN, E. C., GOLDWATER, R., SANDLER, I. *Three American Sculptors: Ferber, Hare, Lassaw.* New York, 1959.

FLANNAGAN: ARNASON, H. H. "John Flannagan, A Reappraisal." *Art in America,* Vol. 28, No. 1, 1960.
MILLER, D. I., ed. *The Sculpture of John B. Flannagan.* New York, MOMA, 1942. E.C.

FRIESZ: GAUTHIER M. and CAILLER, P. *Othon Friesz.* Geneva, 1957.

FULLER: FULLER, B. *Ideas and Integrities.* Englewood Cliffs, N. J., 1963.
MARKS, R. W. *The Dymaxion World of Buckminster Fuller.* New York, 1960.
McHALE, J. R. *Buckminster Fuller.* New York, 1962.

GABO: GABO, N. *Of Divers Arts.* New York, 1962.
MACAGY, D. *Plus By Minus: Today's Half-Century.* Buffalo, New York, Albright-Knox Art Gallery, 1968. E.C.
PEVSNER, A. *A Biographical Sketch of My Brothers—Naum Gabo and Antoine Pevsner.* Amsterdam, 1964.
*Naum Gabo, Antoine Pevsner.* New York, MOMA, 1948. E.C. With an introduction by H. Read and texts by R. Olson and A. Chanin.
*Gabo. Constructions, Sculpture, Paintings, Drawings, Engravings.* Cambridge, Mass., 1957. With introductory essays by H. Read and L. Martin.
*Naum Gabo.* London, The Tate Gallery, 1966. E.C.

GAUDI: COLLINS, G. R. *Antonio Gaudí.* Masters of World Architecture Series. New York, 1960.
HITCHCOCK, H.-R. *Gaudí.* New York, 1957.
LE CORBUSIER. *Gaudí.* Barcelona, 1958. With photographs by Joachim Gomis.
SWEENEY, J. J. and SERT, J. L. *Antoni Gaudí.* New York, 1960.

GAUDIER-BRZESKA: EDE, H. S. *A Life of Gaudier-Brzeska.* London, 1930. American edition as *Savage Messiah.* New York, 1931.
LEVY, M. *Gaudier-Brzeska, Drawings and Sculpture.* London, 1965.
POUND, E. *Gaudier-Brzeska, a Memoir.* London, 1916.

GAUGUIN: GOLDWATER, R. *Paul Gauguin.* New York, 1957.
GRAY, C. *Sculpture and Ceramics of Paul Gauguin.* Baltimore, 1963.
SUTTON, D. *Gauguin and the Pont-Aven Group.* London, The Tate Gallery, 1966. E.C. Notes by R. Pickvance.
*Paul Gauguin's Intimate Journals.* Bloomington, Ind., 1958.
*Gauguin. Paintings, Drawings, Prints, Sculpture.* Art Institute of Chicago, 1959. E.C.

GERICAULT: BERGER, K. *Géricault und sein Werk.* Vienna, 1952. Eng. ed. Lawrence, Kan., 1955.

GIACOMETTI: LORD, J. *A Giacometti Portrait.* New York, 1965.
SELZ, P. *Alberto Giacometti.* New York, MOMA, 1965. E.C. With autobiographical statement by the artist.

GLACKENS: GLACKENS, I. *William Glackens and the Ashcan Group.* New York, 1957.

GLEIZES: GLEIZES, A. and METZINGER, J. *Du Cubisme.* Paris, 1912, rev. ed. 1947.
ROBBINS, D. *Albert Gleizes. 1881–1953. A Retrospective Exhibition.* New York, SRGM, 1964. E.C.

VAN GOGH: BARR, A. H., JR., ed. *Vincent Van Gogh.* New York, MOMA, 1935. E.C. With notes excerpted from the letters of the artist.
COOPER, D. *Van Gogh. Drawings and Watercolours.* New York, 1955.
VAN GOGH-BONGER, J. and VAN GOGH, V. W. eds. *The Complete Letters of Vincent Van Gogh.* 3 vols. London-Greenwich, Conn., 1958.
LA FAILLE, J. B. DE. *L'Oeuvre de Vincent Van Gogh.* 4 vols. Paris-Brussels, 1928. 1 vol. ed. London-Paris, 1930.
NORDENFALK, C. A. J. *The Life and Work of Van Gogh.* London, 1953.
SCHAPIRO, M. *Vincent Van Gogh.* New York, 1950.

GONTCHAROVA: *Gontcharova. Larionov.* Paris, Musée d'Art Moderne de la Ville de Paris, 1963. E.C.
*Gontcharova, Larionov, Mansurov.* Bergamo, Galleria Lorenzelli, 1966. E.C.

GONZALEZ: KRAMER, H. *Julio Gonzalez.* New York, Galerie Chalette, 1961. E.C.
RITCHIE, A. C. *Julio Gonzalez.* New York, MOMA, 1956. E.C. With statements by the artist.

GORIN: *Jean Gorin,* Amsterdam, Stedelijk Museum, 1967. E.C.

GORKY: LEVY, J. *Arshile Gorky.* New York, 1966.
ROSENBERG, H. *Arshile Gorky.* New York, 1963. P.
SCHWABACHER, E. K. *Arshile Gorky.* New York, 1957.
SEITZ, W. C. *Arshile Gorky: Paintings, Drawings, Studies.* New York, MOMA, 1962. E.C.

GRIS: GRIS, J. *Letters of Juan Gris. (1913–1927).* Translated and edited by D. Cooper. London, 1956.
KAHNWEILER, D.-H. *Juan Gris. His Life and Work.* New York, 1969.
SOBY, J. T. *Juan Gris.* New York, MOMA, 1958. E.C.

GROPIUS: GIEDION, S. *Walter Gropius.* London, 1954.
GROPIUS, W. *The New Architecture and the Bauhaus.* New York-London, 1935.

GROSZ: BAUR, J. I. H. *George Grosz*. New York, WMAA, 1954. E.C.
GUSTON: ARNASON, H. H. *Philip Guston*, New York, SRGM, 1962. E.C.
HUNTER, S. *Philip Guston: Recent Paintings and Drawings*. New York, Jewish Museum, 1966. E.C. Includes a dialogue with the artist by H. Rosenberg.
HECKEL: VOGT, P. *Erich Heckel*. Recklinghausen, Germany, 1965.
*Erich Heckel*. Lugano, Galerie Roman Norbert Ketterer, 1966. E.C.
HELD: GREEN, E. *Al Held*. San Francisco Museum of Art, 1968. E.C.
HEPWORTH: HODIN, J. P. *Barbara Hepworth*. London, 1961.
READ, H. *Barbara Hepworth. Carvings and Drawings*. London, 1952.
HOFMANN: GREENBERG, C. *Hans Hofmann*. Paris-London, 1961.
HOFMANN, H. *Search for the Real*. Cambridge, Mass., 1967. Edited by S. T. Weeks and B. H. Hayes, Jr.
SEITZ, W. C. *Hans Hofmann*. New York, MOMA, 1963. E.C. With selected writings by the artist.
WIGHT, F. S. *Hans Hofmann. Retrospective Exhibition*. Los Angeles, The University Art Museum, 1957. E.C.
HOPPER: GOODRICH, L. *Edward Hopper*. New York, WMAA, 1964. E.C.
HUNDERTWASSER: *Hundertwasser. Recent Paintings*. Paris, Galerie Karl Flinker, 1967. E.C.
INGRES: ALAIN. *Ingres (Les demi-dieux)*. Paris, 1949.
ROSENBLUM, R. *Ingres*. New York, 1967.
WILDENSTEIN, G. *Ingres*. London, 1954.
ITTEN: ITTEN, J. *The Art of Colour. The Subjective Experience and Objective Rationale of Colour*. New York, 1961.
———. *Design and Form. The Basic Course at the Bauhaus*. London, 1964.
JAWLENSKY: WEILER, C. *Alexei Jawlensky*. Cologne, 1959.
JOHNS: *Jasper Johns*. New York, Jewish Museum. 1964. E.C. With texts by A. R. Solomon and J. Cage.
KANDINSKY: GROHMANN, W. *Wassily Kandinsky. Life and Work*. New York, 1958.
KANDINSKY, V. *Concerning the Spiritual in Art*. New York, d.m.a., 1947.
———. *Point and Line to Plane: Contribution to the Analysis of the Pictorial Elements*. New York, 1947. Edited and prefaced by H. Rebay.
*Vasily Kandinsky, 1866–1944. A Retrospective Exhibition*. New York, SRGM, 1962. Two catalogues with texts by K. C. Lindsay, H. K. Röthel, and J. Cassou.
KEMENY: *Zoltan Kemeny 1907–1965*. Bergamo, Galleria Lorenzelli, 1967. E.C.
KIRCHNER: GROHMANN, W. *E. L. Kirchner*. London, 1961.
KLEE: GIEDION-WELCKER, C. *Paul Klee*. New York, 1952.
GROHMANN, W. *Paul Klee*. New York, 1954.
HAFTMANN, W. *The Mind and Work of Paul Klee*. London, 1954.
KLEE, F., ed. *The Diaries of Paul Klee. 1898–1918*. Berkeley-Los Angeles, 1964.
KLEE, P. *On Modern Art*. London, 1948.
———. *Pedagogical Sketchbook*. New York, 1953.
———. *The Thinking Eye. The Notebooks of Paul Klee*. 2nd rev. ed. London, 1964.
*Paul Klee, 1879–1940*. New York, SRGM and Pasadena Art Museum, 1967. E.C. Two catalogues.
KLIMT: NOVOTNY, F. and DOBAI, J. *Gustav Klimt*. Vienna, 1967.
*Gustav Klimt and Egon Schiele*. New York, SRGM, 1965. E.C. With texts by R. M. Messer and J. Dobai.

KLINE: *Franz Kline Memorial Exhibition*. Washington, D.C., Washington Gallery of Modern Art, 1962. E.C.
*Franz Kline*. New York, Marlborough-Gerson Gallery, Inc., 1967. E.C.
KOKOSCHKA: HODIN, J. P. *Oskar Kokoschka: The Artist and His Time*. Greenwich, Conn., 1966.
HOFFMAN, E. *Oskar Kokoschka: Life and Work*. London, 1947. With essays by Kokoschka and foreword by H. Read.
*Kokoschka: A Retrospective Exhibition of Paintings, Drawings, Lithographs, Stage Design and Books*. London, The Tate Gallery. 1962. E.C. With essays by E. H. Gombrich, F. Novotny, H. M. Wingler, and others.
*Oskar Kokoschka*. New York, Marlborough-Gerson Gallery, Inc., 1966. E.C.
KOLLWITZ: KLIPSTEIN, A. *The Graphic Work of Käthe Kollwitz. Complete Illustrated Catalogue*. New York, 1955.
KOLLWITZ, H., ed. *Käthe Kollwitz. Diary and Letters*. Chicago, 1955.
DE KOONING: HESS, T. B. *Willem de Kooning*. New York, 1959.
*Willem de Kooning*. Northampton, Mass., Smith College Museum of Art, 1965. E.C. With texts by Dore Ashton and Willem de Kooning.
KUPKA: CASSOU, J. and FEDIT, D. *Frank Kupka*. London, 1965.
*Collection, L'Oeuvre de Kupka*. Paris, Musée National D'Art Moderne, 1966. E.C.
LACHAISE: KRAMER, H. and others. *The Sculpture of Gaston Lachaise*. New York, 1967.
NORDLAND, G. *Gaston Lachaise 1882–1935. Sculpture and Drawings*. Los Angeles County Museum of Art; New York, WMAA, 1964. E.C.
LA FRESNAYE: COGNIAT, R. and GEORGE, W. *Oeuvre complète de Roger de La Fresnaye*. Paris, 1950.
LARIONOV: *Gontcharova. Larionov*. Musée d'Art Moderne de la Ville de Paris, 1963. E.C.
*Gontcharova, Larionov, Mansurov*. Bergamo, Galleria Lorenzelli, 1966. E.C.
LAURENS: GOLDSCHEIDER, C. *Laurens*. New York, 1959.
LAURENS, M., ed. *Henri Laurens, sculpteur 1885–1954*. Paris, 1955.
*Henry Laurens*. New York, Curt Valentin Gallery, 1952. E.C. Includes statement by Laurens (XXe Siècle, No. 2, January 1952).
LEGER: DELEVOY, R. L. *Léger, Biographical and Critical Study*. Lausanne, 1962.
KUH, K. *Fernand Léger*. Urbana, Ill., Art Institute of Chicago, 1953. E.C.
*Fernand Léger. Five Themes and Variations*. New York, SRGM, 1962. E.C.
*Fernand Léger, 1881–1955*. Paris, Musée des Arts Décoratifs, 1965. E.C. With texts by the artist.
LEHMBRUCK: HOFMANN, W. *Wilhelm Lehmbruck*. New York, 1959.
LEWIS: ROTHENSTEIN, J. *Wyndham Lewis and Vorticism*. London, The Tate Gallery, 1956. E.C.
LICHTENSTEIN: *Roy Lichtenstein*. London, The Tate Gallery, 1968. E.C.
LIPCHITZ: ARNASON, H. H. *Jacques Lipchitz. 50 Years of Maquettes*. To be published New York, 1969.
BORK, B. VAN. *Jacques Lipchitz. The Artist at Work*. New York, 1966. With a critical evaluation by Dr. A. Werner.
GOLDWATER, R. *Lipchitz*. New York, 1959.
HAMMACHER, A. M. *Jacques Lipchitz. His Sculpture*. New York, 1960. With an introductory statement by the artist.
HOPE, H. R. *The Sculpture of Jacques Lipchitz*. New York, MOMA, 1954. E.C.
WIGHT, F. S. *Jacques Lipchitz. A Retrospective Selected by the Artist*. Berkeley, University Art Museum, 1963. E.C.

EL LISSITZKY: LISSITZKY - KUPPERS, S. *El Lissitzky.* Dresden, 1967.

LOOS: MUNZ, L. *Adolf Loos.* New York, 1966.

LOUIS: *Morris Louis. 1912–1962. Memorial Exhibition. Paintings from 1954–1960.* New York, SRGM, 1963. E.C.
*Morris Louis. 1912–1962.* Boston, Museum of Fine Arts, 1967. E.C.

MACDONALD-WRIGHT: *The Art of Stanton Macdonald-Wright, A Retrospective Exhibition.* Washington, D. C., Smithsonian Institution, 1967. E.C.

MACKINTOSH: BLISS, D. P. *Charles Rennie Mackintosh and the Glasgow School of Art.* Glasgow, 1961.
HOWARTH, T. *Charles Rennie Mackintosh and the Modern Movement.* New York, 1953.
PEVSNER, N. *Charles Rennie Mackintosh.* Milan, 1950.

MAGRITTE: BRETON, A. *Magritte, le sens propre.* Paris, Alexandre Iolas, 1964. E.C.
SOBY, J. T. *René Magritte.* New York, MOMA, 1966. E.C.
WALDBERG, P. *René Magritte.* Brussels, 1965.

MAILLART: BILL, M. *Robert Maillart.* Zurich, 1949.

MAILLOL: GEORGE, W. *Aristide Maillol.* New York, 1965. With biography by D. Vierny.
REWALD, J. *Maillol.* London, 1939.
————. *The Woodcuts of Aristide Maillol. A Complete Catalogue with 176 Illustrations.* New York, 1943.
RITCHIE, A. C., ed. *Aristide Maillol, with an Introduction and Survey of the Artist's Work in American Collections.* Buffalo, Albright-Knox Art Gallery, 1945. E.C.

MALEVICH: GRAY, C. *Kasimir Malevich, 1878–1935.* London, Whitechapel Art Gallery, 1959. E.C.
MALEVICH, K. *The Non-objective World.* Chicago, 1959.

MANET: HAMILTON, G. H. *Manet and His Critics.* New Haven, Conn., 1954.
HANSON, A. C. *Edouard Manet (1832–1883).* Philadelphia Museum of Art and Art Institute of Chicago, 1966. E.C.
JAMOT, P. and WILDENSTEIN, G. *Manet.* 2 vols. Paris, 1932.
SANDBLAD, N. G. *Manet. Three Studies in Artistic Conception.* Lund, Sweden, 1954.
VAUDOYER, J.-L. *Manet (Les demi-dieux).* Paris, 1955.

MANZU: REWALD, J. *Manzù.* New York, 1967.

MARC: LANKHEIT, K. *Franz Marc im Urteil seiner Zeit.* Cologne, 1960.
PROBST, R. *Franz Marc.* Munich, Städtische Galerie im Lenbachhaus, 1963. E.C.

MARCA-RELLI: AGEE, W. C. *Marca-Relli.* New York, WMAA, 1967. E.C.
ARNASON, H. H. *Conrad Marca-Relli.* New York, 1963.

MARCKS: *Gerhard Marcks. Skulpturen und Zeichnungen.* Cologne, Städtisches Museum Wallraf-Richartz, 1964. E.C.

MARIN: NORMAN, D., ed. *Selected Writings of John Marin.* New York, 1949.
*John Marin.* New York, MOMA, 1936. E.C. Texts by McBride, Hartley, Benson.
*John Marin Memorial Exhibition.* Los Angeles, The Art Galleries, University of California, 1955. E.C. With foreword by D. Phillips and appreciations by W. C. Williams and D. Norman.

MARINI: MARINI, M. *Graphic Work and Paintings.* New York, 1960. With an introduction by P. Bardi.
TRIER, E. *The Sculpture of Marino Marini.* London, 1961.

MASSON: HAHN, O. *Masson.* New York, 1965.
LEIRIS, N. and LIMBOUR, G. *André Masson and His Universe.* London-Geneva-Paris, 1947.

MATISSE: BARNES, A. C. *The Art of Henri Matisse.* New York, 1933.
BARR, A. H., JR. *Matisse, His Art and His Public.* New York, MOMA, 1951.
DIEHL, G. *Henri Matisse.* Paris, 1954. With documentation by A. Humbert.

LIEBERMAN, W. S. *Matisse, 50 Years of His Graphic Art.* New York, 1956.
REVERDY, P. and DUTHUIT, G. *The Last Works of Henri Matisse.* New York, 1954.
*Henri Matisse. Retrospective Exhibition of Paintings, Drawings, and Sculpture.* Philadelphia Museum of Art, 1948. E.C. Includes contributions by Matisse and L. Aragon.
*Henri Matisse. Retrospective 1966.* Los Angeles, University of California Art Galleries, 1966. E.C. With texts by J. Leymarie, H. Read, and W. S. Lieberman.

MATTA: RUBIN, W. *Matta.* New York, MOMA, 1957. E.C.

MENDELSOHN: WHITTICK, A. *Eric Mendelsohn.* 2nd ed. London, 1956.

MIES VAN DER ROHE: BILL, M. *Ludwig Mies van der Rohe.* Milan, 1955.
DREXLER, A. *Ludwig Mies van der Rohe.* New York, 1960.
HILBERSEIMER, L. *Mies van der Rohe.* Chicago, 1956.
JOHNSON, P. *Mies van der Rohe.* 2nd ed. New York, 1953.
SPEYER, A. J. *Mies van der Rohe. A Retrospective Exhibition.* Art Institute of Chicago, 1968. E.C.

MIRO: DUPIN, J. *Miró.* New York, 1962.
HUNTER, S. *Joan Miró. His Graphic Work.* New York, 1958.
SOBY, J. T. *Joan Miró.* New York, MOMA, 1959. E.C.
*Joan Miró.* Paris, Musée d'Art Moderne, 1962. E.C.
*Joan Miró.* London, The Arts Council, 1964. E.C.

MODIGLIANI: MODIGLIANI, J. *Modigliani. Man and Myth.* New York, 1958.
PFANNSTIEL, A. *Modigliani et son oeuvre. Etude critique et catalogue raisonné.* Paris, 1956.
SOBY, J. T. *Modigliani. Paintings, Drawings, Sculpture.* 3rd rev. ed. New York, MOMA, 1963. E.C.
WERNER, A. *Modigliani the Sculptor.* New York, 1962.
————. *Amedeo Modigliani.* New York, 1967.
WIGHT, F. S. *Modigliani. Paintings & Drawings.* Los Angeles County Museum of Art and Boston, Museum of Fine Arts, 1961. E.C.

MOHOLY-NAGY: MOHOLY-NAGY, L. *Vision in Motion.* Chicago, 1947.
————. *The New Vision and Abstract of an Artist.* New York, d.m.a., 1949.
MOHOLY-NAGY, S. *Moholy-Nagy. Experiment in Totality.* New York, 1950. With an introduction by W. Gropius.
*Moholy-Nagy.* Amsterdam, Stedelijk Museum, 1967. E.C.

MONDRIAN: MONDRIAN, P. *Plastic Art and Pure Plastic Art and Other Essays.* New York, d.m.a., 1947
SEUPHOR, M. *Piet Mondrian: Life and Work.* New York, 1957.
*Piet Mondrian 1872–1944.* London, Whitechapel Art Gallery, 1955. E.C. Includes the artist's essay, "Neo-Plasticism, General Principle of Plastic Equivalence" (1920).
*Piet Mondrian, 1872-1944.* Toronto Art Gallery, 1966. E.C. With texts by R. P. Welsh, R. Rosenblum, and M. Seuphor.

MONET: ROUART, D. *Claude Monet. Historical and Critical Study.* Lausanne, 1958.
SEITZ. W. C. *Claude Monet.* New York, 1960.
————. *Claude Monet. Seasons and Moments.* New York, MOMA, 1960. E.C.

MOORE: GROHMANN, W. *The Art of Henry Moore.* London, 1960.
JAMES, R., ed. *Henry Moore on Sculpture.* London, 1966.
MOORE, H. *Sculpture and Drawings.* 2 vols. London, 1955–57.
READ, H. *Henry Moore. A Study of His Life and Work.* New York, 1966.

MORANDI: ARCANGELI, F. *Giorgio Morandi.* Milan, 1964.
VITALI, L. *L'Opera grafica di Giorgio Morandi.* 2nd ed. Turin, 1965.
————. *L'Opera di Giorgio Morandi.* Bologna, 1966.

MOREAU: *Odilon Redon, Gustave Moreau, Rodolphe Bres-*

din. New York, MOMA, 1961. E.C. Includes an essay on Moreau by D. Ashton.

MOTHERWELL: ARNASON, H. H. "On Robert Motherwell and His Early Work." *Art International*, Vol. X, No. 1, January 1966.

————. "Robert Motherwell: The Years 1948 to 1965." *Art International*, Vol. X., No. 4, April 1966.

————. *Robert Motherwell: Works on Paper.* New York, MOMA, 1967. E.C.

O'HARA, F. *Robert Motherwell.* New York, MOMA, 1965. E.C.

MUNARI: MUNARI, B. *Discovery of the Square.* New York, 1965.

————. *Discovery of the Circle.* New York, 1966.

MUNCH: BENESCH, O. *Edvard Munch.* London, 1960.

DEKNATEL, F. B. *Edvard Munch.* Boston, 1950.

*Edvard Munch.* New York, SRGM, 1965. E. C. Texts by S. Willoch, J. H. Langaard, and L. A. Svendson.

NADELMAN: KIRSTEIN, L. *The Sculpture of Elie Nadelman.* New York, MOMA, 1948. E.C.

NAKIAN: ARNASON, H. H. "Reuben Nakian." *Art International*, April 1963.

O'HARA, F. *Nakian.* New York, MOMA, 1966. E.C.

NERVI: ARGAN, G. C. *Pier Luigi Nervi.* Milan, 1955.

HUXTABLE, A. L. *Pier Luigi Nervi.* New York, 1960.

NERVI, P. L. *The Works of Pier Luigi Nervi.* Stuttgart-New York, 1957.

————. *Aesthetics and Technology in Building.* Cambridge, Mass., 1965.

NEUTRA: NEUTRA, R. *Life and Human Habitat.* Stuttgart, 1956.

ZEVI, B. *Richard Neutra.* Milan, 1954.

*Richard Neutra, Buildings and Projects.* Zurich, 1955.

NEVELSON: GORDON, J. *Louise Nevelson.* New York, WMAA, 1967. E.C.

NEWMAN: ALLOWAY, L. *Barnett Newman: The Stations of the Cross.* New York, SRGM, 1966. E.C.

TUCHMAN, M. *New York School, The First Generation. Paintings of the 1940s and 1950s.* Los Angeles County Museum of Art, 1965. E.C.

*Six Peintres americains; Gorky, Kline, De Kooning, Newman, Pollock, Rothko.* Paris, M. Knoedler & Cie., 1967. E.C. With statements by the artists.

NICHOLSON: ALLEY, R. *Ben Nicholson.* London, 1963.

HODIN, J. P. *Ben Nicholson. The Meaning of His Art.* London, 1957.

READ, H. *Ben Nicholson. Paintings, Reliefs and Drawings.* 2 vols. London, 1948-56.

NIEMEYER: PAPADAKI, S. *The Work of Oscar Niemeyer.* New York, 1950.

————. *Oscar Niemeyer: Works in Progress.* New York, 1956.

NOGUCHI: GORDON, J. *Isamu Noguchi.* New York, 1968. E.C.

NOGUCHI, I. *A Sculptor's World.* New York, 1968.

TAKIGUCHI, S. and others. *Noguchi.* Tokyo, 1953.

NOLAND: FRIED, M. *Three American Painters: Kenneth Noland, Jules Olitski, Frank Stella.* Cambridge, Mass., Fogg Art Museum, 1965. E.C.

NOLDE: HAFTMANN, W. *Emil Nolde.* New York, 1959.

————. *Emil Nolde. Unpainted Pictures.* New York, 1965.

SELZ, P. *Emil Nolde.* New York, MOMA, 1963. E.C.

OLDENBURG: *Claes Oldenburg.* Stockholm, Moderna Museet, 1966. E.C.

*Dine, Oldenburg, Segal.* Art Gallery of Toronto, 1967. E.C.

OUD: HITCHCOCK, H.-R. *J. J. P. Oud.* Paris, 1931.

VERONESI, G. *J. J. Pieter Oud.* Milan, 1953.

OZENFANT: OZENFANT, A. *Foundations of Modern Art.* London, 1931.

———— and JEANNERET, C. E. *After Cubism.* Paris, 1918.

———— and ————. *La Peinture moderne.* Paris, 1927.

PASCIN: WERNER, A. *Jules Pascin.* New York, 1959.

PERRET: ROGERS, E. *Auguste Perret.* Milan, 1955.

PEVSNER: MASSAT, R. *Antoine Pevsner et le constructivisme,* Paris, 1956.

PEISSI, P. and GIEDION-WELCKER, C. *Antoine Pevsner.* Neuchâtel, 1961.

PEVSNER, A. *A Biographical Sketch of My Brothers—Naum Gabo and Antoine Pevsner.* Amsterdam, 1964.

*Naum Gabo, Antoine Pevsner.* New York, MOMA, 1948. E.C. With an introduction by H. Read and texts by R. Olson and A. Chanin.

PICABIA: HUNT, R. *Picabia.* London, Institute of Contemporary Arts, 1964. E.C.

PICABIA, F. *391.* Paris, 1960. Complete reprint of Picabia's periodical (1917–24), edited by M. Sanouillet.

SANOUILLET, M. *Picabia.* Paris, 1964.

PICASSO: BARR, A. H., JR. *Picasso. Fifty Years of His Art.* New York, MOMA, 1946. E.C.

————, ed. *Picasso. 75th Anniversary Exhibition.* New York, MOMA, 1957. E.C.

BOECK, W. and SABARTES, J. *Picasso.* New York, 1965.

BOLLIGER, H. and GEISER, B. *Pablo Picasso: Fifty Years of His Graphic Work.* New York, 1956.

DAIX, P. *Picasso.* New York, 1965.

———— and BOUDAILLE, G. *Picasso, the Blue and Rose Periods.* Greenwich, Conn., 1967.

JAFFE, H. L. C. *Pablo Picasso,* London, 1964.

JARDOT, M. *Pablo Picasso Drawings.* New York, 1959.

KAHNWEILER, D.-H. *Les Sculptures de Picasso.* Paris, 1948.

————. *Picasso. Keramik, Ceramic, Céramique.* Hanover, 1957.

PENROSE, R. *Picasso. His Life and Work.* London, 1958.

————. *The Sculpture of Picasso.* New York, MOMA, 1967. E.C.

RICHARDSON, J., ed. *Picasso: An American Tribute.* New York, 1962.

SABARTES, J. *Picasso lithographe.* 4 vols. Monte Carlo, 1949–64.

ZERVOS, C. *Pablo Picasso. Oeuvres.* 19 vols. Paris, 1942–67.

*Picasso, Sixty Years of Graphic Works.* Los Angeles County Museum of Art, 1966. E.C.

*Hommage à Pablo Picasso. Peintures dessins sculptures céramiques.* Paris, Grand Palais and Petit Palais, 1967. E.C. Organized by J. Leymarie.

*Hommage à Pablo Picasso. Gravures.* Paris, Bibliothèque Nationale, 1967. E.C.

PISSARRO: PISSARRO, C. *Letters to His Son Lucien.* 2nd ed. London, 1943. Edited by J. Rewald.

PISSARRO, L. R. and VENTURI, L. *Camille Pissarro, son art—son oeuvre.* Paris, 1939.

REWALD, J. *Camille Pissarro.* New York, 1963.

*C. Pissarro.* New York, Wildenstein & Co., 1965. E.C.

POLLOCK: O'CONNOR, F. V. *Jackson Pollock.* New York, MOMA, 1967. E.C.

O'HARA, F. *Jackson Pollock.* New York, 1959.

ROBERTSON, B. *Jackson Pollock.* New York, 1960.

MAN RAY: MAN RAY. *Self Portrait.* Boston, 1963.

*Man Ray.* Los Angeles County Museum of Art, 1966. E.C. With texts by the artist and his friends.

*Works of Man Ray.* London, Institute of Contemporary Arts, 1959. E.C. With text by the artist.

RAUSCHENBERG: SOLOMON, A. R. *Robert Rauschenberg.* New York, Jewish Museum, 1963. E.C.

REDON: BACOU, R. *Odilon Redon.* 2 vols. Geneva, 1956.

BERGER, K. *Odilon Redon, Fantasy & Color.* New York, 1965.

*Odilon Redon. Oeuvre graphique complet.* 2 vols. The Hague, 1913.

*Odilon Redon, Gustave Moreau, Rodolphe Bresdin.* New York, MOMA, 1961. E.C. With essays on Redon by J. Rewald and H. Joachim.

REINHARDT: LIPPARD, L. R. *Ad Reinhardt Paintings.* New York, Jewish Museum, 1966. E.C.

RENOIR: BARNES, A. C. and DE MAZIA, V. *The Art of Renoir* New York, 1935.

HAESAERTS, P. *Renoir, Sculptor.* New York, 1947.

PACH, W. *Renoir.* New York, 1960.

PERRUCHOT, H. *La Vie de Renoir.* Paris, 1964.

RENOIR, J. *Renoir, My Father.* Boston, 1962.

REWALD, J., ed. *Renoir, Drawings.* New York, 1958.

ROGER-MARX, C. *Les Lithographies de Renoir.* Monte Carlo, 1951.

RICHARDSON: HITCHCOCK, H.-R. *The Architecture of H. H. Richardson and His Times.* New York, 1936.

RICHIER: *Germaine Richier. 1904–1959.* Paris, 1966. With texts by J. Cassou, D. de la Souchère, G. Limbour, A. P. de Mandiargues.

RODIN: CHAMPIGNEULLE, B. *Rodin, His Sculpture, Drawings and Watercolors.* New York, 1967.

DESCHARNES, R. and CHABURN, J. F. *Auguste Rodin.* New York, 1967.

ELSEN, A. E. *Rodin's Gates of Hell.* Minneapolis, 1960.

———. *Rodin.* New York, MOMA, 1963. E.C.

———, ed. *Auguste Rodin, Readings on His Life and Work.* Englewood Cliffs, N. J., 1965.

GOLDSCHEIDER, C. *Rodin.* Paris, 1962.

———, ed. *Rodin. The Drawings and Watercolors.* Paris, 1963.

ROSENQUIST: *James Rosenquist.* Ottawa, National Gallery of Canada, 1968. E.C.

ROSSO: BARR, M. S. *Medardo Rosso.* New York, MOMA, 1963. E.C.

ROSZAK: ARNASON, H. H. *Theodore Roszak.* Minneapolis, Walker Art Center, 1956. E.C.

ROTHKO: SELZ, P. *Rothko.* New York, MOMA, 1961. E.C.

ROUAULT: COURTHION, P. *Georges Rouault.* New York, 1961.

ROUAULT, G. *Miserere.* Boston, 1963. With an introduction by A. Blunt and preface by the artist.

SOBY, J. T. *Georges Rouault. Paintings and Prints.* 3rd ed. New York, MOMA, 1947. E.C.

VENTURI, L. *Rouault. Biographical and Critical Study.* Lausanne, 1959.

ROUSSEAU: BOURET, J. *Henri Rousseau.* Greenwich, Conn., 1961.

RICH, D. C. *Henri Rousseau.* New York, MOMA, 1946. E.C.

SALMON, A. *Henri Rousseau dit Le Douanier.* Paris, 1927.

VALLIER, D. *Henri Rousseau.* New York, 1962.

SAARINEN, EERO: SAARINEN, A. *Eero Saarinen.* New Haven, Conn., 1968.

TEMKO, A. *Eero Saarinen.* New York, 1962.

*Eero Saarinen on His Work.* New Haven-London, 1962.

SAARINEN, ELIEL: CHRIST-JANER, A. *Eliel Saarinen.* Chicago, 1948.

SANT'ELIA: BANHAM, P. R. "Sant'Elia." *Architectural Review,* CXVII (1955), CXIX (1956).

SANT'ELIA. "Manifesto of Futurist Architecture." *Architectural Review,* CXXVI (1959).

SCHIELE: *Gustav Klimt and Egon Schiele.* New York, SRGM, 1965. E.C. With texts by T. M. Messer and J. Dobai.

SCHLEMMER: HILDEBRANDT, H. *Oskar Schlemmer.* Munich, 1952.

SCHLEMMER, O. *The Theatre of the Bauhaus.* Middletown, Conn., 1961. English translation of *Die Bühne im Bauhaus,* Munich, 1925.

SCHMIDT-ROTTLUFF: GROHMANN, W. *Karl Schmidt-Rottluff.* Stuttgart, 1956.

SCHNEIDER: GINDERTAEL, R. V. *Gérard Schneider Paintings.* Bergamo, Galleria Lorenzelli, 1967. E.C.

SCHOFFER: *Nicolas Schöffer.* Neuchâtel, 1963. With an introduction by J. Cassou and texts by G. Habasque and J. Ménétrier.

SCHWITTERS: SCHMALENBACH, W. *Kurt Schwitters.* Cologne, 1967.

THEMERSON, S. *Kurt Schwitters in England.* London, 1958.

*Schwitters.* Milan, Toninelli, 1964. E.C. With a note by E. Schwitters and biographical notes by H. Bolliger.

*Retrospective Kurt Schwitters.* New York, Marlborough-Gerson Gallery, Inc., 1965. E.C. With an introduction by W. Schmalenbach and biographical notes by H. Bolliger.

SEGAL: *Dine, Oldenburg, Segal.* Art Gallery of Toronto, 1967. E.C.

SERUSIER: DENIS, M. *Sérusier, sa vie, son oeuvre.* Paris, 1943.

SERUSIER, P. *L'ABC de la peinture.* Paris, 1950. 1st ed. 1921; 2nd ed. 1942, with a preface by M. Denis; 3rd ed. 1950, without preface but with extracts of correspondence by Sérusier and others.

SEURAT: DORRA, H. and REWALD, J. *Seurat. L'Oeuvre peint, biographie, et catalogue critique.* Paris, 1959.

FRY, R. and BLUNT, A. *Seurat.* London, 1965.

HERBERT, R. L. *Seurat's Drawings.* New York, 1962.

HOMER, W. I. *Seurat and the Science of Painting.* Cambridge, Mass., 1964.

REWALD, J. *Georges Seurat.* 2nd rev. ed. New York, 1946.

RICH, D. C., ed. *Seurat. Paintings and Drawings.* Art Institute of Chicago, 1958. E.C. With an essay on Seurat's drawings by R. L. Herbert.

RUSSELL, J. *Seurat.* New York, 1965.

SEVERINI: SEVERINI, G. *Du Cubisme au classicisme. Esthétique du compas et du nombre.* 4th ed. Paris, 1921.

———. *Témoignages; 50 ans de réflexion.* Rome, 1963.

*Gino Severini.* Rotterdam, Museum Boymans-van Beuningen, 1963. E.C.

SHAW: BLOMFIELD, SIR R. *Richard Norman Shaw. R. A.* London, 1940.

SHEELER: *Sheeler.* New York, MOMA, 1939. E.C. With an introduction by W. C. Williams and a note on the exhibition by C. Sheeler.

*Charles Sheeler, a Retrospective Exhibition.* Cedar Rapids, Iowa, Cedar Rapids Art Center, 1967. E.C.

SICKERT: BROWSE, L. *Sickert.* London, 1960.

SIGNAC: LEMOYNE DE FORGES, M.-T., ed. *Signac.* Paris, Musée National du Louvre, 1963. E.C.

SIGNAC, P. *D'Eugène Delacroix au néo-impressionnisme.* Paris, 1899, and later editions.

SMITH: HENDY, P. *Matthew Smith.* London, 1962.

SOULAGES: DORIVAL, B. *Soulages.* Paris, Musée National d'Art Moderne, 1967. E.C.

SWEENEY, J. J. *Soulages: Paintings Since 1963.* New York, M. Knoedler & Co. Inc., 1968.

SOUTINE: CASTAING, M. and LEYMARIE, J. *Chaim Soutine.* New York, 1964.

SYLVESTER, D. *Chaim Soutine, 1894–1943.* London, The Arts Council, 1963. E.C.

TUCHMAN, M. *Soutine.* Los Angeles County Museum of Art, 1968. E.C.

WHEELER, M. *Soutine.* New York, MOMA, 1950. E.C.

SPENCER: *Niles Spencer.* Louisville, Ky., University of Kentucky Art Gallery, 1965. E.C. With an introduction by R. B. Freeman and a tribute by R. Crawford.

DE STAEL: GINDERTAEL, R. V. *De Staël: A Retrospective Exhibition.* Boston, Museum of Fine Arts, 1965. E.C.

STELLA, FRANK: FRIED, M. *Three American Painters, Kenneth Noland, Jules Olitski, Frank Stella.* Cambridge, Mass., Fogg Art Museum, 1965. E.C.

STELLA, JOSEPH: BAUR, J. I. H. *Joseph Stella.* New York, WMAA, 1963. E.C.

SULLIVAN: MORRISON, H. *Louis Sullivan, Prophet of Modern Architecture.* New York, MOMA, 1935. E.C.

SULLIVAN, L. H. *Kindergarten Chats and Other Writings.* New York, d.m.a., 1947.

SZARKOWSKI, J. *The Idea of Louis Sullivan.* Minneapolis, 1956.

TANGUY: SOBY, J. T. *Yves Tanguy.* New York, MOMA, 1955. E.C.

TANGUY, K. (S.). *Yves Tanguy. Un Recueil de ses oeuvres.* New York, 1963. With a chronology by L. R. Lippard.

TAPIES: TAPIE, M. *Antonio Tapiés.* Barcelona, 1959.

*Antonio Tapiés.* New York, SRGM, 1962. E.C.

TCHELITCHEW: KIRSTEIN, L. *Pavel Tchelitchew.* New York, The Gallery of Modern Art, 1964. E.C.

SOBY, J. T. *Tchelitchew: Paintings, Drawings.* New York, MOMA, 1942. E.C.

TOBEY: ROBERTS, C. *Mark Tobey.* New York, 1959.

SEITZ, W. C. *Mark Tobey.* New York, MOMA, 1962. E.C.

TOMLIN: BAUR, J. I. H. *Bradley Walker Tomlin.* New York, WMAA, 1957. E.C.

TORRES-GARCIA: *Joaquin Torres-Garcia.* Amsterdam, Stedelijk Museum, 1961. E.C.

TOULOUSE-LAUTREC: COOPER, D. *Henri de Toulouse-Lautrec.* New York, 1956.

HUISMAN, P. and DORTY, M. G. *Lautrec by Lautrec.* New York, 1964.

JOURDAIN, F. and ADHEMAR, J. *T.-Lautrec.* Paris, 1952.

JOYANT, M. *Henri de Toulouse-Lautrec. 1864–1901.* 2 vols. Paris, 1926–27.

MACK, G. *Toulouse-Lautrec.* New York, 1938.

*Centenaire de Toulouse-Lautrec.* Paris, Musée Toulouse-Lautrec, Albi. E.C.

TURNER: GOWING, L. *Turner: Imagination and Reality.* New York, MOMA, 1966. E.C.

TWORKOV: BRYANT, E. *Jack Tworkov.* New York, WMAA, 1964. E.C.

UTRILLO: PETRIDES, P., ed. *Maurice Utrillo, l'oeuvre complet.* 2 vols. Paris, 1959–62.

*Maurice Utrillo.* Pittsburgh, Museum of Art, Carnegie Institute, 1963. E.C.

VANTONGERLOO: BILL, M., ed. *Georges Vantongerloo.* London, Marlborough Fine Arts Ltd., 1962. E.C.

VANTONGERLOO, G. *Problems of Contemporary Art—Number 5. Paintings, Sculptures, Reflections.* New York, 1948.

VASARELY: JORAY, M., ed. *Vasarely.* Neuchâtel, 1965.

VAN VELDE: BECKETT, S. and DUTHUIT, G. *Three Dialogues.* London, 1965.

PUTNAM, J., ed. *Bram van Velde.* New York, 1959. With statements by S. Beckett and G. Duthuit.

*Bram van Velde.* New York, Knoedler & Co., 1962. E.C. Text by J. van der Marck.

VAN DE VELDE: CASTEELS, M. *Henry van de Velde.* Brussels, 1932.

CURJEL, H. *Henry van de Velde, 1863–1957. Persönlichkeit und Werk.* Zurich, Kunstegewerbemuseum, 1958. E.C.

TEIRLINCK, H. *Henry van de Velde.* Brussels, 1959.

VAN DE VELDE, H. *Geschichte meines Lebens.* Munich, 1962.

*Henry van de Velde 1863–1957.* Otterlo, Netherlands, Kröller-Müller Rijksmuseum, 1964. E.C.

VILLANUEVA: MOHOLY-NAGY, S. *Carlos Raúl Villanueva & The Architecture of Venezuela.* Caracas, 1964.

VILLON: MOREL, A. and others. *Souvenir de Jacques Villon.* Paris, 1963.

VALLIER, D. *Jacques Villon, oeuvres de 1897 à 1956.* Paris, 1957.

WICK, P. A. *Jacques Villon, Master of Graphic Art (1875–1963).* Boston, Museum of Fine Arts, 1964. E.C.

VIOLLET-LE-DUC: GOUT, P. *Viollet-le-Duc; sa vie, son oeuvre, sa doctrine.* Paris, 1914.

VLAMINCK: GENEVOIX, M. *Vlaminck, l'homme.* Paris, 1954.

SELZ, J. *Vlaminck.* New York, 1963.

VUILLARD: RITCHIE, A. C. *Edouard Vuillard.* New York, MOMA, 1954. E.C.

ROGER-MARX, C. *Vuillard. His Life and Work.* New York, 1946.

———. *L'Oeuvre gravé de Vuillard.* Monte Carlo, 1948.

WACHSMANN: WACHSMANN, K. *The Turning Point of Building, Structure and Design.* New York, 1961.

WAGNER: LUX, J. A. *Otto Wagner.* Berlin, 1919.

WAGNER, O. *Einige Skizzen, Projekte und ausgeführte Bauwerke.* 4 vols. Vienna, 1890–1922.

WEBB: LETHABY, W. *Philip Webb and His Work.* London, 1935.

WEBER: GOODRICH, L. *Max Weber. Retrospective Exhibition.* New York, WMAA, 1949.

WHISTLER: LAVER, J. *Whistler.* London, 1930.

SUTTON, D. *Nocturne. The Art of James McNeill Whistler.* London, 1963.

YOUNG, A. McL. *James McNeill Whistler.* London, The Arts Council, 1960. E.C.

WRIGHT: GUTHEIM, F., ed. *Frank Lloyd Wright on Architecture: Selected Writings, 1894–1940.* New York, 1941.

HITCHCOCK, H.-R. *In the Nature of Materials; the Buildings of Frank Lloyd Wright, 1887–1941.* New York, 1942.

NADEN, C. J. *Frank Lloyd Wright, The Rebel Architect.* New York, 1968.

SCULLY, V., JR. *Frank Lloyd Wright.* New York, 1960.

WRIGHT, F. L. *An Autobiography.* New York, 1943.

———. *A Testament.* New York, 1957.

———. *The Solomon R. Guggenheim Museum.* New York, 1960.

———. *The Work of Frank Lloyd Wright.* New York, 1965.

WRIGHT, O. L. *Frank Lloyd Wright.* New York, 1966.

*Ausgeführte Bauten und Entwürfe von Frank Lloyd Wright.* Berlin, 1910.

WYETH: *Andrew Wyeth.* Philadelphia, Pennsylvania Academy of Fine Arts, 1966. E.C.

XCERON: ROBBINS, D. *Jean Xceron.* New York, SRGM, 1965. E.C.

ZADKINE: HAMMACHER, A. M. *Zadkine.* New York, 1959.

# INDEX

Page numbers are in roman type. Figure numbers of black-and-white illustrations are in *italic type*.
Colorplates are specifically so designated. Names of artists and architects are in CAPITALS. Titles of works are in *italics*.

# PHOTO CREDITS

Abel-Menne, M., Wuppertal (427); Adant, Hélène, Paris (175); Aerofilms, London (740, 741); Alinari, Florence (4); Andrews, Wayne, Grosse Pointe, Michigan (54, 66, 247, 248, 252, 402, 403, 407, 412); T. & R. Annan, Ltd., Glasgow (56, 57, 58); Architectural Review, London (742); Copyright Archives Centrales Iconographiques, Brussels (128, 129, 280, 281, 282, 283); Archives Photographiques, Paris (1, 16, 50); Archivo Amigos de Gaudí, Barcelona (123); Armen Photographers, Newark (1084); Foto Attualita, Venice (603); Australian News and Information Bureau, New York (770); Bacci, Attilio, Milan (1064, 1068); Baker, Oliver, New York (43, 170, 572, 674, 1027, 1033); Barr, Alfred H., Jr., New York (378, 383, 384); Barrows, George (117); Benevolo (261); Bettmann Archives, Inc., New York (60); Biaugeaud, Jean, Arcueil (791); Bladh, Oscar, Stockholm (735); Blomstrann, E. Irving, New Britain, Connecticut (385, 495); Boesch, Ferdinand, New York (1011, 1057); Bonache, R., Madrid (1070); Marcel Breuer & Associates, New York (795, 796, 797, 814, 815); Buffalo and Erie County Historical Society (251, 251a); Buhs, Ilse, Berlin (748); Bulloz, J.-E., Paris (38, 74, 446); Burckhardt, Rudolph, New York (545, 993, 994, 995, 1013, 1014, 1035, 1037, 1039, 1040, 1043, 1044, 1047, 1048, 1049, 1076, 1114); Studio E. Janet le Caisne, Paris (621); Canadian Government Tourist Bureau, New York (848); Leo Castelli Gallery, New York (1038); Galerie Charpentier, Paris (164); Chevojon Frères, Paris (614, 615, 619); Chicago Architectural Photographing Company (62, 63, 67, 253, 408); Clements, Geoffrey, New York (534, 542, 665, 669, 670, 705, 1050, 1062, 1067, 1073, 1083, 1100, 1101, 1104, 1115); Colten Photos, New York (557); Coppens, Martin F. J., Eindhoven (452); Cyr, E. J., New Canaan, Connecticut (803); Dell & Wainwright, Architectural Review, London (738); Despoisse, Claude, Paris (651); Doeser Fotos, Laren (397); Downtown Gallery, New York (680, 681); Duchamp, Marcel (476); Faxon, Floyd, Los Angeles (364, 391); Richard Feigen Gallery, New York (481); Fine Art Associates, Minneapolis (228); Fototechnischer Dienst, Rotterdam (399); French Government Tourist Office, New York (51, 127); Friedrich, Reinhard, Berlin (747); Fuller, Buckminster, Carbondale, Illinois (846, 847, 849); Gabo, Naum (498); Gasparini, Paolo, Caracas (661); Gendreau, Philip, New York (779); Photoatelier Gerlach, Vienna (258); German Information Center, New York (272); G. Gherardi-A. Fiorelli, Rome (758, 759); Gmelin, Emil, Dornach (274); Goeritz, Marianne, Mexico (1007); Graphics, Chicago (645); Sherwin Greenberg, McGranahan & May, Inc., Buffalo (370); Gropius, Walter (713); Guerrero, C. (641); Hackett, G. D., New York (582); Hammarskiold, Hans, Stockholm (642); Harvard University News Office (712, 808, 809); Hedrich-Blessing, Chicago (249, 706, 707, 716, 785, 798); Hervé, Lucien, Paris (254, 413, 414, 416, 417, 720, 721, 723, 725); Studio Yves Hervochon, Paris (394, 1079); Hettle et ses Fils, Roubaix (526); Hickey & Robertson, Houston (1081); Hyde, Jacqueline, Paris (584); Galerie "IM Erker," St. Gallen (322); Galerie Iolas, Paris (555, 1065); Ishimoto, Fujisawa City, Japan (771, 774); Martha Jackson Gallery, New York (853); Johnson, Philip, New York (799, 800); S. C. Johnson & Son, Inc., Racine, Wisconsin (708, 709, 710); Josse, Hubert, Paris (436); Juley, Peter A. & Son, New York (87, 222, 485, 508, 528); Kaprow, Allan (1026); Kersting, A. F., London (52); Kidder-Smith, G. E., New York (719, 734,

743, 756); Kiesler, Mrs. Frederick, New York (509, 801, 802); Klein, Walter, Dusseldorf (299); Kleinhempel, Hamburg (295, 296, 297, 303, 434, 548); Klima, Joseph, Jr., Detroit (374); Knoedler, M. & Co., Inc., New York (147); Landesbildstelle, Berlin (745); Landesgalerie, Hanover (478); Larousse, Paris (589); Leeser, Paulus, New York (855); Galerie Lefebre, Paris (1025); Galerie Louise Leiris, Paris (201, 204); Lescaze, William, New York (781); Copyright London County Council (49, 880); Galerie Maeght, Paris (563); Magnum Photo Library, New York (724); Foto Marburg, Marburg/Lahn (135, 137); Mardyks, Henri (514, 518); Marlborough Galleria d'Arte, Rome (977); Marlborough-Gerson Gallery, New York (856, 871, 988, 1022); Foto MAS, Barcelona (120, 121, 122, 124); Mates, Robert, New York (864, 910); Pierre Matisse Gallery, New York (601, 909, 991); Matter, Herbert, New York (634); McKenna, Rollie, Stonington, Connecticut (765); Mer, Jacques, Antibes (353); Foto Studio Minders, Ghent (115, 136); Moegle, Willi, Stuttgart (226); Monsanto Company, St. Louis (805); Moore, Peter, New York (684); Moosbrugger, B., Zurich (722); Mulas, Ugo, Milan (1002); Museum of Finnish Architecture, Helsinki (727, 730, 731, 731a, 732); Nash, Ernest, Rome (932); National Buildings Record, London (895); National Film Board, Canadian Consulate General, New York (766, 768); Nelson, O. E., New York (992, 1054, 1087); New York Convention and Visitors Bureau (782, 783); Foto van Ojen, The Hague (264, 398); Partridge, Rondal (726, 811); Pasmore, John (1001); I. M. Pei & Partners, New York (833, 834); Perls, Klaus G., New York (650); Perotti, Mario, Milan (372); Perron, Robert, New Haven (822); Photo Pic, Paris (19); La Photothèque, Paris (166); Picard, R., Paris (587); Pirelli Company, Milan (761); Pollitzer, Eric, New York (169, 1017, 1034, 1041, 1045, 1046, 1051, 1052, 1116, 1117, 1118); Port of New York Authority (789); Rabin, Nathan, New York (591, 1056); Rapuano, Michael, New York (812); Ratto, Gerald, San Francisco (840); Rheinisches Bildarchiv, Cologne (293, 486, 494); Richier, Germaine (915); Riper, David van, Chicago (1091); Rockefeller Center Inc., New York (788); Rosenberg, Paul & Co., New York (523, 525, 527, 531); Rosenblum, Walter, New York (1108); Roubier, Jean, Paris (47); Salas, Armando, Portugal (1006); Savio, Oscar, Rome (760); Sax, Elizabeth, Paris (467); Schiff, John, New York (696, 980); Schmidt, L. W., Rotterdam (500, 500a); Science Research Council, London (906); Serating, Robert, New York (827); Service Photographiques, Versailles (7, 10, 11, 18, 23, 33, 73, 145, 177, 178, 286, 341, 359, 361); Shulman, Julius, Los Angeles (794, 804, 806); Siegel, Arthur, Chicago (699); Sinigaglia, Gian, Milan (373); Smith, Edwin C., Essex (45, 46); Smith, Malcolm, New York (816); Staempfli Gallery, New York (598, 1085); Stewarts Commercial Photographers, Colorado Springs (810); Stoedtner, Dr. Franz, Dusseldorf (132); Stoller, Ezra, New York (728, 729, 786, 807, 818, 819, 826, 828, 828a, 836, 837, 842, 843, 844); Allan Stone Gallery, New York (1060); Strüwing Reklamefoto, Copenhagen (737); Studley, A., N. Y. (330, 333, 339, 428, 451); Stutz, O., Tegna/Ti, Italy (321); Sunami, S., N. Y. (443); Sutherland, Eric, Minneapolis (701, 985, 1032, 1053); Toledo Photographic Service, Ohio (75); Transacphoto, Grasse (744); Uht, Charles, New York (217, 369); University of Minnesota, St. Paul (231); U. S. Embassy, Brazil (718); Vaering, Otto, Oslo (275); Vasari e figlio, Rome (752, 753); Waddell Gallery, New York (1080); Warman, Morris, New York (825); Weill, Etienne Bertrand, Paris (541, 611); Wilp, Charles, Dusseldorf (1063); Witty, Derrick E., Sunbury-on-Thames (110); Foto Witzel, Essen (225, 292, 302); Wrubel, Arno, Dusseldorf (746); Yale University News Bureau (820).